arresting
images

arresting images

images

impolitic

art and

uncivil

actions

steven

c. dubin

routledge

london

new york

Published in 1992

Paperback edition published in 1994 by

Routledge
29 West 35 Street
New York, NY 10001

Published in Great Britain by

Routledge
11 New Fetter Lane
London EC4P 4EE

Library of Congress Cataloging in Publication Data

Dubin, Steven C.
 Arresting images : impolitic art and uncivil actions / Steven C.
Dubin.
 p. cm.
 Includes bibliographical references and index.
 ISBN 0-415-90435-8 (hardback) ISBN 0-415-90893-0 (paperback)
 1. Arts—United States—Censorship. 2. Art patronage—United
States. 3. Art and state—United States. I. Title.
NX735.D79 1992
700'.1'03—dc20 92-5776
 CIP

British Library cataloguing in publication data also available.

CONTENTS

Artists and academics are potentially professions of comment and criticism on society: they display a carefully modulated shagginess according to the responsibilities they carry. But how shaggy can they get? What are the limits of shagginess and bodily abandon?

—Mary Douglas, *Natural Symbols*, 1970

What do you think I am, some greenhorn just fell off the boat? You don't think I know what goes on there [in Greenwich Village]? All that mishegas. Men with men. Dogs with cats. *That* you're comfortable with?

—Sophie Berger in *Brooklyn Bridge*, 1991

LIST OF PLATES

Plates following page 214

1. Andres Serrano, "Piss Christ" 1987, Courtesy of Stux Gallery, New York City.

2. Andres Serrano, "Milk, Blood" 1986, Courtesy of Stux Gallery, New York City.

3. Jim Prinz, David K. Nelson's "Mirth and Girth" 1988, Used by permission of the artist.

4. Bill Stamets, Arrest of "Mirth and Girth," School of the Art Institute of Chicago (SAIC) 1988, Used by permission of the photographer.

5. Dread Scott, "What Is the Proper Way to Display a U.S. Flag?" 1988, Courtesy of Wessel O'Connor, Ltd., New York City.

6, 7. Steven E. Gross, Veterans' protest outside of the Art Institute of Chicago 1989, Used by permission of the photographer.

8. Robert Mapplethorpe, "Self Portrait," Copyright © 1978 The Estate of Robert Mapplethorpe.

9. Jim Marks, demonstration outside Corcoran Gallery of Art with projection of Robert Mapplethorpe's "Honey," 1989, Used by permission of the photographer.

ACKNOWLEDGEMENTS

Where does a book originate? One important source for this project can be traced to a kitchen in Skokie, Illinois where I spent many Friday evenings in the 1970s. Skokie was known to me as the home of an elderly great-aunt and uncle. It became known to the world in 1977 and 1978 as the epicenter of a prolonged dispute between neo-Nazis and village leaders over the First Amendment guarantee of free speech. In this domestic setting I viewed the human consequences of the battle.

Here was a couple in their eighties, survivors of the perils of both the "old country" (and the trauma of immigration) and their adopted one (for many years they ran an outdoor newsstand on Chicago's South Side). Although not Holocaust victims like many other Skokie residents, they had lost relatives to it; the pictures of disappeared kin on the wall were one of the telltale signs. You may even be familiar with such people: no more than the size of a typical preteen in the current generation, their heavily accented English not always adequate to express their most important thoughts. Yet their warmth, generosity and resilience more than compensated for any lack of eloquence or physical stature.

It was incomprehensible to my aunt and uncle that Nazis might actually stage a rally in their community, a place where they had finally achieved some measure of peace and security. The prospect of Nazi uniforms and rhetoric was tremendously disturbing to them, and week after week I saw the psychological toll it exacted. My

head told me one thing: if the rights of a group I deplored could not be guaranteed, could my own be assured at some future point? Rationally I knew that the Nazis had to be allowed to hold their meeting. But my heart felt differently, and my impulse to protect my relatives' sensibilities made it appear reasonable to enforce restrictions on speech that offended not only them, but a majority of people.

A complicated set of legal maneuvers prevented the Nazis from reaching Skokie. Nevertheless, I can't help but believe that my relatives' lives were altered by the possibility of a fascist demonstration there, as was my own. For my aunt and uncle it confirmed a suspicion that the world was dangerous for people like themselves, and the desire to let down their defenses was understandably short-circuited. For me there was heightened appreciation for the fact that symbolic expression can have a profound impact, especially when it's aimed at groups that are relatively powerless, and even if a direct effect is difficult to substantiate in a scientific way.

I know firsthand how threatening images can be; I also understand the impulse to obliterate them. However, this is generally folly, because such representations are typically symptomatic of much larger forces that are not so easily eradicated. You acquire only transitory relief by trying to exclude what offends you from view. It is more productive to directly confront the causes that generate particular ideas and then challenge them with other images and with more, reasoned speech. Many of the same feelings and lessons I took from that kitchen in Skokie apply to contemporary controversies over art, and guide the present inquiry.

In retrospect, I can't believe I wrote my earlier book without the benefit of a computer, post-its or the Hungarian Pastry Shop. But more importantly, I've had the assistance of many people who contributed in various ways to the completion of this project with news clippings, technical support, and intellectual advice and challenge. In particular, I thank Sarah "Missy" Lauzen, Kenneth Burkhart, George Chauncey, Jr., Dean Stein, James Boyles, Lee Frissell, Elizabeth Childs, Eric Carlson, Randy Martin, Judith Balfe, Daniel Wheaton-Weiss, Lucy Egan-Breault, Marie Rudden, the library staff at the State University of New York—Purchase, and all the artists, arts administrators and gallery personnel who endured my questions and shared their files with me. In addition, it continues to be my good fortune to have the support of—and to be influenced by the work of—Howard S. Becker, Nachman Ben-Yehuda, Wendy Griswold, Lester Kurtz and Barry Schwartz. Finally, I am grateful to SUNY—Purchase for a Junior Faculty Development Grant which provided crucial release time for writing, and a Faculty Support Fund Grant which helped defray transcription costs.

I dedicate this book to my late grandparents, Morris and Bala Baellow. My bubbe's inability to write in English turned out to be a blessing: she pressed me into service as her scribe at an early age. And by watching my zayde faithfully read his *Jewish Daily Forward*—more than likely he was the only subscriber in our Kansas City postal zone—I bore witness to an unquenchable passion for ideas. I offer this work as one installment toward repaying my immense debt to them.

INTRODUCTION

Although art may sometimes shock us, so do many recent attempts to regulate it.

Since at least the late nineteenth century, artists have heeded innumerable calls and have served a wide array of masters. As a result artists now assume a multitude of roles, and contemporary art may take on a variety of meanings. It mirrors social reality or ignores it; it can help define social conventions or defy them. Art might be balm or irritant, bringing people together or wrenching them apart. Whether it inspires reverence and admiration or provokes disdain, the reaction to art in the late twentieth century is often a strong one.

"Where to begin?" Virginia Woolf asks of the character Lily Briscoe in *To The Lighthouse*. "Every line placed on the canvas committed her to innumerable risks, to frequent and irrevocable decisions. . . . Still the risk must be run; the mark made."[1] Lily was indeed a pioneer, not only exploring the frontiers of abstract painting opened up by the modernist movement, but also hazarding to be a self-directed "new woman." Lily represents both the immense freedom artists have been accorded since the dissolution of the academy system, as well as the perils that doing their work can now entail. She pays a high price for her autonomy: the strong possibility that she and her work will be misunderstood, scorned and

rejected, with the corresponding psychological costs of tentativeness and self-doubt.

Today's artists are Lily's beneficiaries. Many of them routinely push boundaries—artistic, moral, and sexual; those of decorum, order and propriety. Artists are significant symbolic deviants in our society, their work calling out negative responses from large numbers of people. But this is neither surprising nor unique: every society draws its moral line in the sand, and these sands, of course, shift from era to era and from place to place. In other words, yesterday's bandit often becomes today's folk hero;[2] yesterday's demon, today's sanctified. Transgressions are commonly transformed by time and social alchemy into conventions.

Deviance signals that something is awry, and can contribute to society's flexibility and growth. But if society mobilizes its defenses to stave off challenges to the status quo, deviance may also unwittingly lead to rigidity. Deviance therefore has a dual character. It is transgressive yet positive; within it are the seeds for change, but also the potential for social inflexibility and stasis.[3]

Contemporary battles over art demonstrate both of these possibilities. On the one hand, a conspicuous segment of artists has introduced social and political themes into their work in recent years. In many instances this reveals the self-conscious emergence of groups that were marginalized previously—women, gays and lesbians, Hispanics, Asians and African Americans, for example. In fact, the arts have provided an extremely important means for expressing the collective identity of these groups; who they are and what they desire. These themes have been hammered out on computer keyboards and meticulously inscribed on handcrafted paper; sprayed onto walls and canvas and fixed onto emulsified paper; thrust into conventional musical and theatrical formats, and used to map out newer territories like performance and video art. Whether or not you agree with the messages themselves, it is difficult to deny the passion that drives their expression. Emotion is often close to the surface—hopes, fears, anger, dismay, and yes, chutzpah. If this art defies expectations, if it's messy or troublesome, these attributes are in service of a goal: to document social change over approximately the past three decades, to register a response to both what has and what has not ensued, and to point the way toward an even more inclusive and equitable future.

On the other hand, becoming more visible also enlarges the probability of becoming easy and recurrent targets. Art that reflects the relatively recent empowerment of various groups has been rejected by others as threatening, blasphemous or obscene. In particular, certain religious leaders and conservative cultural critics have rallied to draw in the wagons around established values, and around established artistic products and technologies. Whereas the primary interest of the first constituency is to honor and preserve traditional religious and moral values (and the types of cultural expression which have these values as their basis), the goal of the second is to protect the sanctity of the artistic canon. Both of these groups resist significant revisions to the systems of belief they uphold. And despite

important social and cultural differences between them, they are allied in their opposition to shifts in power and values occurring in contemporary society.

The battles that have raged over art during the past several years are largely symbolic struggles. It has been easier for relatively powerless people to establish a social beachhead in the world of making images than it is for them to penetrate the relatively unyielding realm of organizations, institutions and political structures. And the battle has been engaged in the cultural sphere by the opposition because it is *somewhat* more acceptable in the 1990s to assail a group's speech or their images of themselves than it is to attack them directly.[4]

The assault on artists who bear new values and ideas is a classic case of killing the messenger for the message he bears. But in this instance the messenger is even more menacing because *he* might as likely be a *she*, and *they* could embody diverse ethnic and racial backgrounds or sexual orientations. This may be largely a war of words and representations, yet it betrays profound social divisions. Significant social schisms may have been displaced into the cultural realm, but they have merely been transferred, not resolved.

"Arresting Images" aims to capture the dynamic of these disputes. Certain images do indeed seize our attention: they grab us, hold us in check, and refuse to let go—until we are able to sort through a mixture of emotions. Images can intensely compress complex ideas and sentiments. They often project what Walter Benjamin called "aura,"[5] an elusive, charismatic and sometimes haunting presence. As artist Leon Golub reflected, "A description is flatter and less sensory. If you say 'suck' [it's less powerful than] if you see such an action portrayed."[6] And School of the Art Institute of Chicago Director Tony Jones observed "No matter how much discussion you may have at your local neighborhood bar, and in the columns of the [Chicago] *Tribune* and *Sun-Times*, one single image can sometimes nail [complicated issues] down so powerfully that people have a gut reaction that is instantaneous."[7] In a more frivolous vein, *Saturday Night Live* proposed something similar in the fall of 1989 when a performer suggested that obscene art is "art you want to look at every few minutes." This blend of attraction and repulsion, desire and aversion, marks a very potent type of material.

The reception art does in fact receive represents the other meaning inherent in this book's title. The earliest incident that I explore in detail describes the seizure and "arrest" of a painting of the late Mayor Harold Washington (wearing women's lingerie) by a group of Chicago aldermen and police in May, 1988. This was an extreme reaction, to be sure, but it demonstrates the enormous power that particular images exude and the momentous responses they can elicit.

Humanists have traditionally focused on this first consideration, the nature of the art object itself. They customarily examine art in formalist terms to establish its place in the art historical record. Confirming provenance and tracing influences are therefore typical concerns, with an emphasis on questions largely *internal* to the work. However, this approach has withstood numerous assaults recently: from

art movements that "dematerialized" art to contemporary critical theorists who have challenged notions of "authorship," argued for multiple readings of the same artistic "text," and raised questions about the role of social factors in canon formation and perpetuation.

Social scientists have primarily targeted social factors in outlining what they define as the "art world," a complex, interdependent network of participants regulated by conventions.[8] They have chiefly been interested in how the production and distribution of art is structured, concerns largely *external* to the work. Unfortunately, in extreme examples they might as well be talking about the manufacture of widgets as of Watteaus or Warhols.

Generally these approaches have been quite separate in practice.[9] But although my background is in the social sciences and not the humanities, one of my goals in this book is to draw from both strategies and put each into operation. A book on controversial art cannot overlook factors such as political climate, community tolerance levels and the social construction of acceptability, considerations that humanists would not generally be prepared or inclined to address. And yet a social scientist who would overlook aesthetics and aura—characteristics of art objects—runs the risk of arrogantly dismissing those who react negatively to art as merely uninformed at best, reactionaries and philistines at worst. And further, a social scientist who concentrates primarily on the internal operations of an art world runs the risk of presenting an hermetic view, one which fails to confront the complicated ways in which different social worlds penetrate and interact with one another.

One of the most obvious lessons to be drawn from art controversies is that the art world is not an insular protectorate. What artists do does indeed have an impact on the wider world, and that world most certainly intrudes into art, too. Artists today are increasingly brought into contact with other social spheres—for example, the government (at all levels), religion and economics—so in order to develop a comprehensive picture of what is occurring within the art world, an investigator has to expand the focus outward as well.

Let me share my own AHA! experience, that moment when it became clear to me that this combination of approaches was necessary. I had been monitoring the controversy that developed over Andres Serrano's photograph "Piss Christ" [see Plates section], and was focusing on who his detractors were, how they had framed their objections, and the pressure they were exerting on the National Endowment for the Arts (NEA) and the Southeastern Center for Contemporary Art (SECCA, the institution that channelled NEA money to the artist through its fellowship program). I had seen small black—and—white reproductions of the work in various news articles, but I was essentially unimpressed and unmoved. But as the controversy continued to simmer I decided to visit the New York gallery that represents Serrano and examine his oeuvre in order to put this image into context.

I was not prepared to be so strongly affected. Two images in particular threw

me off balance. The first is a sinister piece called "The Scream," a 1986 image that confronts the viewer with what appears to be a German Shepherd hanging from a thickly knotted noose. Its jaws are fully extended to emit what must have been an enormous, final howl of distress, now frozen in time. As a confirmed animal lover I found this extremely unnerving, and it immediately raised ethical questions in my mind. Yet the damnedest thing happened: I couldn't keep myself from looking at it. I would move on to other slides, but I kept turning back to it again and again. I was absolutely fascinated, and felt compelled to look. I finally asked one of the gallery assistants to tell me what she knew about it, and she replied that it was a coyote road-killed in Maine, not a dog. This allayed some of my concerns, but it didn't help me discover why I couldn't resist its power, why I wasn't merely repulsed.

But another image proved to be even more provocative for me. On first viewing, this Serrano work, also from 1986, would seem to have minimal potential for causing offense: it does not appear to depict three dimensional objects, but instead resembles a pleasant enough symmetrical design of one white square placed immediately next to a red square. No big deal [see Plates section]. It is only with the addition of the title "Milk, Blood" that you understand this is one of his early experiments with bodily fluids, a long-standing theme in his work. As the grandson of a kosher butcher, my immediate reaction was "You don't do this; you don't mix milk and meat. It *just isn't* done!" Once again this reaction startled me, for although I do not observe the kosher laws, this image struck me as a violation of a very basic sort. Categories which I long ago rejected intellectually, I suddenly desired to uphold emotionally; they seemed natural and inviolable. But not only had they been juxtaposed, they seemed to bleed into one another down the middle of the photo. Unthinkable, and yet here was the record of this transgression.[10] This image proved to be the key to my understanding of a large portion of Serrano's work which dismisses taken-for-granted categories and mixes otherwise separate elements, especially the sacred and the profane.

Contemporary artists regularly fiddle with what many people hold to be "natural categories," such as *chaste* and *polluted*, *masculine* and *feminine*, *in* and *out*, *public* and *private*. In the case of Serrano's "Piss Christ," sacred imagery is mixed with profane bodily waste products (or "the sacred and the endocrine," as one critic charged). With performance artist Karen Finley the confusion is over ingestion and elimination: she daubs the outside of her body with chocolate; she mashes canned yams over her buttocks, a region of the body from which they would normally be expelled. And Robert Mapplethorpe's photographs disturb the peace in two regards. His homoerotic depictions challenge the sexual hierarchy, and his portrayals of White and Black men together also contest the racial hierarchy.

The negative reaction to these symbolic transgressions evokes the work of anthropologist Mary Douglas on moral pollution. As she points out, dirt equals disorder in the social world, and significant portions of social behavior are struc-

tured to ensure that contamination does not occur. These regulations also tend to reflect and reinforce the order of social arrangements. Any infraction resounds throughout society, rattling the sanctity of other categories and threatening additional distinctions as well.[11] Controversial artists have all committed these figurative affronts in some manner or another. They have run afoul of convention, a gambit novelist Robertson Davies cautioned against with somewhat circuitous logic: " . . . we break patterns at our peril. After all, they become patterns because they conform to realities."[12]

Serrano's photos taught me a great deal about the force of some images, a latent power which is activated and released by what each person brings to their viewing because of their biography, their present mood, past experiences with art, and a wide variety of additional factors. I left the gallery both confused and enlightened. I was neither as humane nor as sophisticated as I might have felt myself to be earlier in the day. Rather, I was some curious amalgam of contradictory feelings and impulses. I was unnerved, but I reveled in that state for some time: I respected a body of work that was able to puncture my sense of smugness to such a degree. Since I had already accepted the idea that art can be discomforting before I entered the gallery, this was a tension that I found to be interesting to sustain. However, there is no denying that my situation was privileged. Most people do not have the time, access, nor inclination to mull over such issues. And while I had one reaction, it was not difficult to realize that, had it been another day, were I another person, or had the artist used symbols that I was more securely and immediately attached to, my reaction could have just as easily been anger or fear or contempt.

My intention is to examine both art and the social reaction to it. And from the situation I just described it should be apparent that humanistic and social scientific approaches are not antithetical. It is pertinent to invoke the notion of *Verstehen* here, a concept associated with the nineteenth century social theorist Max Weber. Weber maintained that a critical tool for the social scientist was the ability to empathize with your subjects, to see the world through their eyes. He argued that if you want to understand what motivates people to act you have to be able to fathom their values, the range of choices they have, as well as the constraints they confront. As he suggested, "one need not have been Caesar in order to understand Caesar." In fact, all types of warriors—generals and foot soldiers alike—can be studied in this way.[13]

One of the foremost themes in this book is that a combination of two critical elements is required for art controversies to erupt: there must be a sense that values have been threatened, and power must be mobilized in response to do something about it. I borrow this notion from an earlier study which considered the constraints placed upon the freedom to read,[14] and it will become evident that the potential for controversy will not be realized unless both elements are present. I will present cases demonstrating that although critical values are assailed in certain instances, the failure to arouse people and to consolidate resources consigns

some probable contentious situations to the domain of nonevents. This may be due to a paucity of leaders who have established their credibility or amassed followings, a lack of preexisting organizational expertise, or community fatigue or disinterest because of other circumstances. In such instances what might otherwise explode, instead fizzles—for predictably good reasons.

The time frame of the events studied in this book will be primarily from 1988 through the present. The incidents that have occurred during this interval share features which mark this period in a distinctive way. And yet this collection of struggles also demonstrates continuity with events which preceded it, so many historical precedents will be discussed as well. In addition, while I have been referring to "art," I do not intend to restrict the discussion to elite forms of cultural expression alone. One of the most important ongoing debates in the contemporary art world has centered on the contrasts and continuities between high and low, elite and popular, nonprofit and commercial cultural endeavors. The upshot of the proliferation of books, exhibitions and forums that have scrutinized these categories is that they are not tidy, separate compartments, but instead represent increasingly blurred distinctions.[15] There is an enormous amount of cross-fertilization today, so that real-world examples frequently offer a mixture of characteristics. But even more to the point, the censorship impulse has gained such momentum during this period that both students and well-established artists, commercial performers coming "from the streets" as well as those offering the "great works" of the Western world, have felt its effects.[16] Although I had originally intended to concentrate on visual arts and photography, it quickly became obvious that many of the same forces negatively affecting these two fields were readily able to pass through the semipermeable boundaries that mark off different artistic territories. The examples I discuss will therefore be wide ranging, although there will be some skewing toward cases where visual expression has been a target.

I have to admit that there have been times, while I conducted the research for this book, when other social issues seemed to be more urgent or more likely to have a direct impact upon how people lead their lives. Two personal observations will suffice. I travelled from New York City to Washington, D.C. in March, 1990 to attend events surrounding Advocacy Day, an annual pilgrimage of arts professionals to lobby congressional representatives for continued government support of the arts. In 1990 there was a sense of urgency because of congressional threats to significantly restructure or dismantle the NEA. On the early morning trip downtown to meet an artists' bus, I shared the subway car with a homeless man who was sprawled across a seat, sleeping. He presented an unposed and distressing sight: his head rested in a cardboard produce box he had turned upside down, a container that was marked "American Lady" and featured the Statue of Liberty and an American flag. And on the return trip my gaze was drawn to a vast deteriorated area of D.C. strewn with rubble, a post-apocalyptic spectacle. What looked like several primitive shacks were in evidence, and at intervals there were

fires burning in barrels, around which people huddled to warm themselves on this extremely chilly evening. These two scenes framed the trip for me, both of them dramatically portraying contemporary misery.

These sights are as emblematic of the current urban landscape as those documented by the Farm Security Administration photographers of rural conditions during the depression of the 1930s. I sensed that if I had seen photographs of such contemporary scenes I might have suspected some artistic license had been taken to set them up, and could have possibly doubted their veracity. But I was not viewing them in a magazine or gallery; they were in undeniably real, confrontational distance.

When I thought about these down-and-out individuals it seemed to me somewhat frivolous to be concerned about whether or not artists get government grants, or whether they are allowed to function with absolute freedom. How can you possibly compare one set of circumstances with the other? However, we must recognize that there are important connections to draw between these situations. It is often those artists who confront inequity and injustice in their work who have found they have constricted opportunities to successfully distribute what they produce. Artists who insist that people without a voice be given one have typically been assailed by critics who fault either the message itself or the "quality" of its presentation. And it has frequently been the case that artists who belong to groups which have been the most systematically excluded from full political and economic participation in this society find that they must confront similar barriers within the art world. It is both divisive and diversionary to attempt to measure the relative depth of pain different groups experience. When the government draws back from a commitment to inclusion and entitlement, when it retreats from providing a wide range of services on behalf of the commonweal and instead expects financial well-being and humanitarian concern to "trickle down," this affects the most sequestered artist as well as the man and woman on the street.

A review of a book assessing the 1980s in *The New York Times* was entitled "A Thousand Points of Blight," an obvious parody of George Bush's 1988 campaign reference to the thousand points of light he expected to illuminate the social landscape during his administration.[17] Instead there is a great deal of evidence that levels of material deprivation, spiritual malaise, and ideological posturing have all dramatically increased over the past few years. These issues are all linked, and the erosion of basic freedoms is equally as serious an issue as the denial of material comfort. One problem may appear theoretical while the other seems more immediate, the one rather remote while the other is more proximate, but their connection to similar social currents is unmistakable.

Undoubtedly readers will have noticed that I have only mentioned the word "censorship" once in this discussion. Odd, don't you think, when it has become a staple of the news during the past several years? But censorship is a cryptic entity, not unlike cold fusion (does it exist or doesn't it?), or quarks (observable

to only a certain degree, although the effects can be hypothesized and plotted). Some people espy censorship everywhere: it permeates the basic structures of society. But for others this is a rare bird indeed, and sightings are exceptional, even for the trained eye. It is nearly impossible to delimit the concept in a meaningful way.

A peculiar and tiresome contest almost inevitably ensues whenever the subject of censorship is raised. Participants engage in a game of "what if?" They attempt to push each other's sense of morality, propriety, and vulnerability to the nth degree: "What would you do if someone said or did . . . ?" The implicit assumption is that *everyone* will eventually say "enough!" and draw a censorious line. The lesson: there always have to be limits. Players in a parallel competition also up the ante to discount each others' allegations of persecution, trading charges of "so what?" If X claims to have been censored, Y may cite the experiences of another time and place when punishments were much more severe. But then Z may chime in that she wasn't even given a fair opportunity to produce things which might be subjected to censorship. It is not unusual for A to then question why artists would be so presumptuous as to ask for unconditional control over their work when most other members of society do not share similar expectations in regard to their own occupations. These are tedious, frustrating exchanges, generating more heat than light.

The term censorship will be used sparingly because I intend to treat this notion as problematic, not as a given. Like the concept of "obscenity," the charge has become so widespread as to dilute its meaning significantly. At times censorship has been naively attributed to all manner of occurrences, in other instances its presence has been denied, and at still other moments, some artists have worn it as a badge of honor.

I plan to explore the nature of censorship, both covert and overt. Most importantly, I propose to characterize it as a *social process* whose initiation is not the exclusive domain of either the political right or the political left. There are commonalities among incidents where censorship is alleged which form a template, regardless of the political orthodoxy which may underlie each attempt at control. The most productive research strategy is to examine the degree of control which is proposed in a particular case, by whom, why, and in reaction to what type of work or creator. These features can be ferreted out of seemingly disparate examples, demonstrating that similar reactions are called out whenever someone's ox is gored.

In addition, while censors may be the enemy of art and other types of expression, time is usually the enemy of the censor. References to censorship generally freeze a moment in the ongoing struggle between proponents of license and restraint. These are *episodes*, not necessarily finales. A suggestive example comes from the 1989 Academy Award winner in the category of Best Foreign Film, "Cinema Paradiso." This is the sentimental tale of the importance of a Sicilian movie theater

to the local villagers, and in particular to a small boy who is befriended by the elderly projectionist. The auditorium becomes the site where sexual and class tensions are constantly played out, where people gather to be entertained both on stage and off.

Add to this setting the parish priest, the archetype of a censor. We encounter him at a prescreening where he rings a bell whenever a scene meets his disfavor. The projectionist obligingly inserts a scrap of paper into the film reel in response, to mark where he will excise the offending segments afterward. The general audience therefore views an expurgated version, as prescribed by the vigilance of the church.

This appears to be a classic case of censorship: it significantly alters the artist's vision, and adjusts what the audience may view in accord with official dictates. But at the movie's end there is a revelation which demonstrates the temporal aspect of censorship. When the old man dies, his now-mature former sidekick returns to the village. Then he discovers his legacy: the projectionist left him a can of film, a compilation of deleted kissing scenes he spliced together in a glorious tribute to passion. The scenes outlived the decree that they be banned, illustrating the resilience that culture often has.

This is not to argue that attempts to modify artists' intentions do not also bring creative anguish or even personal harm to them. A glut of historical examples document such injuries. But those who try to quash expression are seldom completely successful, nor is their success for all time. Their targets have a knack for springing back, even though this may occur after the deaths of the creator, the judge or the originally intended audience. This temporal feature must continually be borne in mind, for "censorship" often connotes a drastic act, good for eternity. In actuality, incidents of censorship in non-totalitarian countries typically are emergency measures, and rarely are they the last word. And as recent events have taught us, not only do totalitarian regimes fail to completely regulate culture, but their entire repressive apparatus can abruptly collapse.

An assistant state attorney working on the attempted obscenity prosecution of the rap group 2 Live Crew in Florida in 1990 lamented the makeup of the jury hearing the case. One particular source of his concern was a 76-year-old retired sociology professor from New York: "She was extremely liberal. She was a sociologist, and I don't like sociologists. They try to reason things out too much."[18] How can you resist trying to live up to such a bizarre indictment? My training as a sociologist will obviously guide this analysis, reasoning from the legacy of such seminal individuals as Max Weber and Emile Durkheim. From the latter we know not to be surprised that fervent battles rage over the definition of acceptable expression; that is to be expected in every age and locale. The challenge is to discover the reasons why specific targets have been designated and to detail how the battle has been joined.

In large part I employ a thematic strategy rather than one which is chronological or medium-based. To some degree this approach relinquishes the escalating sense of crisis stemming from the multiplication of art controversies during this era which a straightforward journalistic account might capture. At times these events spun off one another at a dizzying pace, one vigorously contributing to the next. But much is also gained with my choice of technique: a sense of coherence regarding how incidents are linked by topic, thereby highlighting which types of artistic work critics habitually go after once this dynamic gets established. This enables the reader to step back from the density of events and gain some clarity about the broader configurations of the territory.

Several distinct conditions are emphasized which heighten the probability of controversy occurring over art. One is the nature of the subject, particularly the extent to which work either displays satisfactory categorical fit, or violates understood and accepted beliefs. An adverse response is more likely when art blends together what social conventions generally separate. There is also the degree of fit between the audience and the work. What would be legitimate in one setting and before certain audiences is more apt to be devalued when it is thrust before others who are inexperienced or caught unawares by this type of work. And that raises the question of what discourse individuals bring with them to evaluate art. When critics carry a frame of reference they have derived primarily from within the contemporary art world, they may not like a particular creation, but it would probably not lead them to toss out the entire category which it represents. But those whose convictions originate in other social spheres (for instance, politics or religion) may throw the baby out with the bathwater, seeing both as irreversibly befouled. Add fundamental social and demographic shifts and generally unsettled social conditions to this mix and you have fertile ground in which art controversies may germinate.

Chapter One surveys significant social, political and cultural trends in the late 1980s and early '90s, the context which spawned art controversies. These disputes were commonly diversionary moves calculated to deflect attention away from such broader conditions. Chapter Two is a case study of the reception critics and defenders accorded a scornful portrait of Mayor Washington in Chicago. I examine the minutiae of this event to demonstrate the fundamentals of my approach. Chapters Three through Six concentrate in turn on the themes of race, religion, patriotism and sex in art, all significant factors in arousing conflict. Chapters Seven and Eight expand the exploration of sex as a "hot button," examining homosexuality and AIDS. Chapters Nine and Ten describe the moral entrepreneurs who orchestrated these squabbles, and report the subsequent reactions of artists to them. Chapter Eleven explores the history and contemporary state of the National Endowment for the Arts, a key battle site during this time period. And Chapter Twelve looks at tribalism, identity politics and the pervasiveness of intergroup conflict, and their relation to clashes over freedom of expression.

I

THE POLITICS OF
DIVERSION

Is there a generation which has not felt William Butler Yeats was speaking to it when he wrote "things fall apart; the centre cannot hold"?[1] His vision of the loss of innocence, misdirected moral fervor, and the sense of apocalypse must surely have a special resonance for a significant portion of people in the present day. I offer a sketch of the social time and place in which contemporary art controversies have arisen in order to situate them in an understandable context.

SHIFTING BOUNDARIES

The late 1980s and early '90s have been heady times on the international scene. A democratization movement swept across Eastern Europe after Soviet leader Gorbachev announced his liberal twin doctrines of glasnost and perestroika, forcing Communist-dominated governments from power beginning in 1989. The progress of this campaign could be monitored by frequent reports of the toppling of public statues of Stalin, Lenin, and other Communist party rulers. The citizens of Komarov, Czechoslovakia hoped to exchange the statue of Stalin in their town square for Western currency; in Warsaw, militant youths assaulted a statue of Lenin for three days, whereupon public officials dismantled and mothballed it.[2]

When the statue of Lenin was removed from Scinteia Square in Bucharest, Romania, it was displayed dangling by the neck from a crane, and planners of the 1991 All-Union Sculpture Exhibition in Moscow for the first time decided to omit the obligatory images of this former leader.[3] And in an effort to revise the historical record a public monument was erected in Moscow to memorialize the victims of KGB violence, while in Mongolia a proposal was made to add this warning to a statue of Stalin in the capital of Ulan Bator: "This man killed countless Mongols."[4]

Artists working in established modes, mass media image makers, and pop glitterati were all facilitators as well as beneficiaries of these upheavals. In Romania, the former government television station quickly became the de facto seat of power, making events in that country "the first revolution on live television."[5] Significantly, one of the initial acts of the new provisional government was to suspend the mandatory registration of typewriters.[6] Poland published Jerzy Kosinski's The Painted Bird, and Czechoslovakia's new president Vaclav Havel not only saw the national premiere of a play he had written sixteen years earlier, but also attended a "command performance" of the theretofore-denounced Rolling Stones.[7] In Romania the number of newspapers and journals quadrupled in less than a year, while East Germany contributed its first Playgirl of the Month (posed in famous locales) to world audiences. The Soviet movie "Little Vera" created a portrait of Russian youth sharing the obsession with "sex, drugs and rock and roll" of their Western counterparts, and Hungary experienced an explosion of pornography on its newsstands, prompting one female teacher to lament "People are mixing liberty with bad taste."[8]

These events opened up new possibilities for East-West relations, a prospect captured in a full page ad in The New York Times for the cold remedy Drixoral. Under a picture of Presidents Bush and Gorbachev ran the wish "IN THE NEW YEAR, MAY THE ONLY COLD WAR IN THE WORLD BE THE ONE WE'RE FIGHTING," with the corresponding pledge to send their product to our friends in the Eastern Bloc.[9] Real circumstances soon thereafter translated into a large headline proclaiming the end of the Cold War,[10] dissolving tensions that had dominated international relations for over 40 years. As go trade barriers, so went the Berlin Wall. All this was accomplished with dizzying speed, neutralizing the threat of what President Reagan had designated the "evil empire" not so long before.

But confusion tempered any sense of relief or celebration that might derive from this rapprochement between the US and the Soviet Union. This is poignantly expressed by Rabbit Angstrom, John Updike's central character in a tetralogy of books spanning the 1950s to 1989: "It's like nobody's in charge of the other side anymore. I miss it . . . The cold war. It gave you a reason to get up in the morning."[11] There is also a feeling of uselessness recorded here, for who this archetypal American man is and what he knows about the world are no longer the certainties they once had been.

In 1989 Senator Daniel Patrick Moynihan warily raised the question of what would fill the vacuum opening up when the Eastern Bloc vanished as the embodiment of malevolence. His apprehension was well founded, for when the threat of external enemies dissipates, societies characteristically begin to search for internal demons. The Salem Witch Trials of the 1600s are just one such example; the Red Scare and Palmer raids after World War One expand the list; and the post-World War Two McCarthy investigations of purported domestic communist activities as well as the Rosenberg trial are primary contemporary illustrations.

In each of these situations a society was examining its boundaries to determine which people and ideas deserved inclusion.[12] From society's point of view, think of this as a search for collective identity, a sifting or cleansing procedure. But it is crucial to recognize that specific groups and individuals sustain significant costs with such purgings: loss of liberties, and sometimes loss of life. What Mr. Moynihan first intuited as a negative consequence of the disintegration of the Communist world was often repeated later as one of the standard explanations of why artists and their work were declaimed at this time.

Compounding this anxiety was the specter of American military and industrial power deteriorating in relation to the rest of the world, with a corresponding weakening of US leadership and authority. Yale historian Paul Kennedy advanced these notions in *The Rise and Fall of the Great Powers*,[13] a popular book that spawned two positions in response: "declinists" who concur that the evidence points to the continued worsening of the US position, and "revivalists" who believe any such descent can be reversed.[14] There can be little doubt that much of the bounty of natural resources and technological know-how that originally supported the American rise to power has been depleted. Different resources increasingly provide the basis for success in an electronic and information age. Although these shifts can now be perceived, what their long-term social-psychological impact will be is harder to gauge with much accuracy.

American insecurities regarding dominance in the world system probably have not been so pronounced since the Soviet launching of the Sputnik satellite in the 1950s, or the Iranian hostage crisis in the early 1980s. The imprisonment of 52 hostages for 444 days was a significant blow to the American ego. And now because of the diffusion of the Soviet menace, it has been necessary to seek out a substitute adversary. Japan has emerged in the American mind as a fierce competitor for world markets and leadership. Advertising campaigns have expressed alarm over the expanded market share some Japanese goods capture (automobiles are a particularly strong example), or the increased financial clout the Japanese wield in American business affairs more generally. Such ads have not-so-facetiously envisioned a foreign takeover of some of America's most beloved landmarks—envisioning Rockefeller Center becoming "Hirohito Center," for example[15]—and one arts commentator lamented that the sale of the media conglomerate MCA/Universal to Matsushita dispatched "yet another message about an economic colossus being

cut down to a new, lesser size."[16] "Japan-bashing" has been used to characterize these assaults, which range from a book alleging that pro-Japanese lobbyists exert a dangerous amount of influence on US political decision making, to an increase in actual verbal confrontations and harassment.[17]

CRISIS AT HOME

A seemingly endless array of serious domestic issues compounded these develop-ments: AIDS, homelessness, crime, drugs, a seriously overburdened health care system, the persistence of poverty as well as the economic squeezing of the middle class—all problems familiar to most Americans. Many of these difficulties were compounded by Reagan's "New Federalism," a policy which transferred more authority to the states, but less money. By the late 1980s governmental inattention, ineffective social policies and scandals made it appear that either no one was in control in American society, or that self-interest was the primary motivation of those who were. Charges of mishandling of funds surfaced over the B-1 bomber and the operation of Housing and Urban Development (HUD) programs, for example, while revelations of government officials using their positions to create personal fiefdoms became frequent. Fiscal irregularities and moral hypocrisy also brought down evangelists Jimmy Swaggart and Jim Bakker, capsizing these self-appointed religious leaders for going into the same treacherous moral waters they routinely cautioned against. These tin gods were found to have muddy feet, indeed. And the legacy of public cynicism derived from Watergate was fortified by the Iran-Contra scandal. Here was another occasion when the behavior of public officials raised public anger, and disbelief when the principal players were accorded leniency.

A popular phrase which signified the '80s ethos of personal acquisition and a climate of supposedly unlimited financial possibility was "Whoever has the most toys when the game is over is the winner." But with an economy that alternately stalled and faltered as the '80s ended and the '90s began, and with even a prominent state governor using images of the Great Depression to portray the situation,[18] this sentiment came to appear offensively narcissistic and ill-advised. Such avaricious behavior bequeathed the enormous budget deficit and the Savings and Loan scandal, primary sources of public dismay.

The budget deficit underwrote much of the apparent economic prosperity of the 1980s. But although there were symptoms of trouble which would belie this facade of health, the malignancy which now seriously endangers the body politic was belatedly diagnosed. Denial of the condition was only gradually replaced by acceptance. In a July, 1990 Gallup Poll, concern over the deficit replaced illegal drugs as the most important problem facing the country.[19] A majority of the respondents also disapproved of the way President Bush was handling both the

deficit and the S&L scandal, a result confirmed by a *New York Times* poll taken shortly thereafter.[20]

The budget deficit raises questions of faulty policy making as much as mismanagement. These features combine with personal greed and professional misconduct to distinctly stamp the S&L crisis. The S&L crisis derives largely from bank officials underwriting high-risk real estate ventures. These schemes brought significant profits to a few individuals in the short run, but ultimately bankrupted many institutions. The public was then left with responsibility for the huge fiscal mistakes these banking officials had made. This situation was complicated by the allegation that a bipartisan group of five senators used their influence to get federal regulators to ease their inquiry into the actions of the head of one such institution, pressure that a special counsel characterized as acting like "an 800 pound gorilla."[21] In addition, the President's own son Neil was centrally involved in another, later-defunct institution, the Silverado Banking, Savings and Loan Association. Official investigations there revealed a combination of speculative operations and sweetheart deals hitherto unimagined, earning the enterprise the nickname "Desperado."

The extent of the financial excesses of the 1980s can now be understood only because of the cleanup they have necessitated in the 1990s. When the boom finally collapsed, it left casualties everywhere in its wake. There have been personal consequences: investors who lost money in failed endeavors formed support groups, and at least one suicide resulted from a retiree's despondency over losing his life savings.[22] And there has been the damage to the President and the presidency. "Jail Neil Bush" posters modelled on FBI "wanted" notices surfaced in Washington, D.C. soon after the President's son was indicted for conflict of interest.[23] This earned him the appellation of a "white-collar Willie Horton,"[24] a mocking reference to George Bush's 1988 ad campaign, where he had represented lawlessness and the inadequacies of liberal social policies in the person of one notorious criminal, a Black man. But the corollary to crime in the streets was revealed in a series of highly publicized trials focusing instead on board rooms, fancy hotels, and patrician residences.[25] By February 1991 the pervasiveness and costliness of white collar crime earned a fugitive S&L executive a featured segment on TV's "America's Most Wanted."

There was a conspicuous political cost attached to this financial crisis. From mid-August to early October, 1990—a period when the debate over government sponsorship of the arts was especially heated—Mr. Bush's approval rating fell fourteen percentage points. And further, an impressive 76 percent of respondents felt that lawmakers made decisions based upon what they thought would get them reelected, whereas only fourteen percent felt decisions were made on the basis of what was best for the country.[26] The public became wise to the fact that certain issues become political footballs in the hands of their elected representatives, and that the rules of the game can be changed or ignored to suit one's own immediate

purpose. Even the euphoria from the Desert Storm campaign rapidly evaporated as the economy continued to be sluggish in 1991, and people once again directed their concern toward domestic issues.[27]

THE POLITICS OF DIVERSION

In light of such pressing difficulties, it might seem surprising that art commanded such public attention. But politicians did everything they could to avoid confronting certain problems head-on. None wanted to be treated as Representative Dan Rostenkowski was in the summer of 1989, when senior citizens, enraged by possible Medicare cuts, chased him down the streets of his home district in Chicago. Politicians typically cultivated the *appearance* of concern and mastery, but direct responsibility was to be dodged at all costs.

Style took precedence over substance in politics in the 1980s: bromides replaced real programs, and the sound bite became a staple of political dialogue. The columnist Russell Baker characterized the 1988 presidential race as a three-bite campaign: "(1) 'Read my lips [no new taxes]'; (2) 'I pledge allegiance to the flag . . .' and (3) Willie Horton."[28] Such 15- and 30-second messages were eye-catching and emotion-laden. Sound bites could either conjure up the toughness of a Clint Eastwood character or ooze with the mawkishness of a patriotic movie of the '40s or '50s. They were also geared toward diverting attention away from other problems and deficient remedies for them. A New York City program instituted in 1985 epitomizes this concern with maintaining a facade: abandoned buildings throughout the South Bronx and other ravaged parts of the city were outfitted with imitation windows, complete with paintings of curtains and potted plants. These facsimiles were literally window dressings, stand-ins for nonexistent programs to address the manifold problems of urban decay.

In September 1990 voters in Massachusetts terrified office holders throughout the country when they showed up at the polls in record numbers to "throw out the rascals": incumbents were routed in the primary, and both of the successful candidates for the governor's race defeated opponents holding major party endorsements. Voter volatility was matched by internal party dissension. This was particularly marked for the Republicans, faced with the challenge of proceeding without their leader Ronald Reagan, and the predicament of moving from being outsiders to insiders, from a party of opposition to one capable of governing under extremely complex conditions.[29] But some of the most conservative and religious fundamentalist supporters of the GOP started to feel their needs were no longer being addressed by the party. As a letter writer to *The Washington Times* declaimed, he was "euchered [sic] into voting for [Bush] in November 1988." He went on to insist that "near as I can tell, Comrade Bush since his inauguration has rolled over for:

The communists.

The femino-communists.

The eco-communists.

The race-communists.

The 'arts'-communists.

The juridico-communists.

And any other communist with a come-hither look in his or her eye."[30]

Republicans were desperate not only to keep control of the country, but also to maintain unity within their own party. Yet in an op-ed piece Richard Viguerie—a key strategist and fundraiser for fundamentalist causes—declared that "Bush Loses the Right Wing," and reported the formation of new conservative groups with names such as "Republicans for a New President" and "Conservatives for a Winning Ticket."[31] These became markers for the fragile coalition the Republicans were managing, one which demanded constant scrutiny and delicate balancing. And it was jeopardized to a degree by any sympathetic treatment the administration might extend to artists, whose allies the letter writer quoted above suspiciously assessed.

The weight of all these problems fostered an acute public nostalgia for which evidence was rife. A book of pop homilies by Robert Fulghum was at the top of the *New York Times* paperback best seller list for the entire year of 1990. The title expresses this longing for a return to a social and biographical time when most matters were far simpler: *All I Really Need to Know I Learned in Kindergarten*. An exhibition of portraits and landscapes by the late President Eisenhower offered a type of art that was understandable and comforting ("He did them for recreation and to relieve stress"),[32] and recalled a period when much of society enjoyed a surface calm and values appeared to be widely shared. The Tony award for best play in 1990 was awarded to a dramatization of John Steinbeck's "Grapes of Wrath," a domesticated way to confront misery: on stage, and in another historical moment. And an extraordinarily popular song counseled "Don't Worry, Be Happy."

This yearning for a more simple and innocent past surfaced as well in the postmodernist method of appropriation, the impulse to freely borrow images from many eras and incorporate them into high art (for instance, in the work of Jeff Koons, Cindy Sherman, and Sherrie Levine), as well as into mass media productions (for instance, MTV videos). It was manifest, too, in the increased interest in "collectibles," that is, endowing commonplace items such as lunch boxes, toys, baseball cards, or any type of kitschy memorabilia with an emotional significance and monetary value out of proportion to any inherent value they might have had

originally.[33] Underlying all these examples is the impetus to recapture a moment (real or fictive) when social categories and roles were more fixed, and when the sense of family and community restrained individualism in service of the greater good.

Perhaps nothing captures the intersection of nostalgia, anxiety, and the need for diversion as much as the public's response to a corporate decision in June, 1990. Binney and Smith, manufacturers of Crayola, introduced eight vibrant new colors, while "retiring" eight more traditional colors to a Crayola Crayon Hall of Fame.[34] Negative public reaction was immediate and intense, initiating at least three grass-roots movements to symbolically restore order. The most telling of these was CRAYON—the Committee to Re-establish All Your Old Norms. This acronym captured the dismay many people feel when constantly confronting change, and their immense desire to return to and protect the familiar. To quote from just one of scores of letters of protest the company received, "Choosing colors that a child would understand would make more sense than colors that *look like a foreign language* [emphasis mine]."[35] This mixed image betrayed a widespread sense of confusion and assault, feelings that the writer transferred onto a relatively insignificant matter. The subtext reads, "Is *nothing* sacred? Secure?"

In May 1990 more Americans felt the country "has pretty seriously gotten off on the wrong track" than felt the country was going in the right direction, a reversal of sentiments from just six months before.[36] And the consideration of some international evidence confirms this sense of dis-ease. A similar sense of gloom dubbed "le malaise français" was also reported at this time in France. Symptoms included fear of the erosion of national status and power because of a newly reconfigured Europe (especially due to the reunification of Germany); intolerance of nonwhite immigrants; and growing individualism and consumerism.[37] But while faced with such vital issues, one of the most hotly debated questions of the day was the government's attempt to simplify the rules of spelling. Updating and streamlining the language could have helped to integrate nonindigenous people, but the outcry of intellectuals to conserve the status quo prevailed in the matter.[38]

A leitmotif is woven throughout this comparative evidence: whenever a society is overwhelmed by problems and its sense of national identity is shaky or diffuse, a probable response is for states to attempt to exercise control by regulating symbolic expression. Whether the target is art or language, governments try to demonstrate their continued efficacy by initiating diversionary conflicts. Although such struggles do not always produce tangible results or clear-cut victories, they temporarily deflect attention away from other concerns. They also release a great deal of emotion and energy, and may therefore consume the resources people can bring to bear on substantive issues. Distractions of this sort belie desperation, but they are strategically important. And they frequently center on the arts, a relatively defenseless sphere of activity.

A WINDFALL—FOR SOME!

Visual art became *the* hot investment of the '80s. Throughout the 1980s modern and impressionist art brought a higher rate of return than stocks, bonds, gold, diamonds, or even Old Masters.[39] Critic Peter Schjeldahl captured the moment precisely: "Money and contemporary art got married in the '80s. The couple was obnoxious and happy."[40] Huge amounts of cash bought cachet for investors, and heightened some artistic reputations. But such bliss was short-lived, and salvation borne by monied "angels" remained an unrealized fantasy for many segments of the visual and performing arts worlds. Envision this scene like Atlantic City: squatting behind a wall of elaborate betting parlors, low-rise squalor was the everyday reality for most.

Prices soared to previously unmatched levels in the expansive art market of the 1980s: the $82.5 million paid for Van Gogh's "Portrait of Dr. Gachet" in 1990 made the 1987 sale of his "Irises" for $53.9 million look like a bargain.[41] In a list published in 1989 of the ten most expensive paintings, the least costly was a Picasso, purchased for $24.8 million in 1988. Yet while prices spiraled upward, and trends were much remarked upon, the inevitability of a crash became more and more apparent. At the same time as auction houses registered record prices for especially important works, by 1990 many other paintings failed to make their pre-auction estimates. Skim off this surface cream, and much of the rest of this nouvelle concoction had soured.[42]

Galleries also reaped hearty profits at the peak of this trend. The first SoHo gallery sprouted up in a formerly industrial area of New York in 1968. By 1975 the number had surged to 84, and in 1991 there were at least 250.[43] But this number was somewhat reduced from the peak, for the beginning of the new decade of the '90s started to claim casualties in what turned out to be an overexpansion of facilities. Rumors of insolvency replaced gossip about munificent new sales records, and the mood in America's art capital became tinged with fear and gloom.

Most artists, of course, were scarcely touched by all this frenetic activity. In fact, artists as a professional group have experienced a *decline* in their real earnings since the 1970s.[44] Every major survey of artists' earnings has documented a similar situation: only a minuscule portion of artists can support themselves entirely through their artwork, although this fact is overshadowed by the relatively few examples of extraordinary wealth accumulated by some highly visible individuals. In the most recent of these surveys, conducted by Columbia University's Research Center for Arts and Culture, more than half the respondents earned less than $3,000 from their art in 1988, whereas only four percent reported art earnings of more than $40,000.[45] It is the latter group that is more commonly in the foreground in the public's mind, however. These exceptions are typically cited by the media as exemplars, so that failure to achieve such a level of success appears to reflect

individual deficiencies or negligence. The art world is not a perfect microcosm of the larger economic world; however, it is affected by most of the dominant economic trends, and when the relative levels of impoverishment in society increased during the 1980s, this paralleled conditions which have existed for artists for quite some time.

The same economic sluggishness which spelled disaster for individual artists and for certain visual arts institutions was especially rough on performing artists and their sponsoring organizations. The team of Baumol and Bowen documented the existence of an "income gap" in performing art institutions in 1966. What they found was that these groups consistently show a discrepancy between their production expenses and the amount they can generate from box office receipts.[46] This gap has widened over the years.

In the nonprofit sector, this has led to an increased reliance upon outside sources of funding such as the government, foundations, and corporations. In the dance world, the expansion of troupes throughout the '60s and '70s was tempered by fiscal difficulties in the '80s. The result: mergers of some groups for their mutual survival, the declaration of hiatuses, or in some extreme cases, disbanding of companies.[47] In those situations the gaps were too wide to traverse. Municipal symphony orchestras also confronted deep financial woes: in some cities seasons were canceled, and in others groups were dismantled.[48]

The for-profit arts sector has been affected by large economic currents as well, leading to a conservatism in the types of projects organizations will undertake. Broadway productions are so costly that only tried-and-true formulas will attract the requisite investment, and publishers likewise are extremely cautious. In both examples experimentation is left to marginal sectors (for instance, Off-Broadway houses, specialty imprints), and the overall number of new plays and books has diminished.[49] In sum, after a decade and a half of relatively good fiscal health for arts organizations, the '80s were a period of retrenchment. As a representative of a large foundation observed at a conference entitled "Support for the Arts in an Unsupportive Time," "It's like homelessness. If two things go wrong, if you have a bad season and one of your funders falls out, you could go under."[50]

THE CONTEMPORARY ART SCENE

A critically acclaimed play during the 1989–1990 season in New York presented an artist as the protagonist, a character who's selfish, ambitious, devious, opportunistic, *sans* morals. He doesn't hesitate to exploit his subjects' feelings or their misfortunes if this will contribute to his own success. He keeps his wife on a pedestal, yet he secretly makes lascivious drawings of her and he frequents prostitutes in the urban underground. He makes political compromises: he won't attack government officials because of favors he'd received previously. And he

can't waste his time with oil painting, but instead employs the latest technology to exploit a larger market with multiple editions of his work. A broad caricature of today's artist? Perhaps, but the setting is 18th century England, and the man is the engraver William Hogarth.[51]

More than one sharp wit skewered artistic posturing and folly during that same season on the stage. Tom Stoppard's "Artist Descending a Staircase" savagely mocked the modern artist: one character had sculpted a nude from sugar (his "sugar cubist" period), while another records silence and random sounds (what he prefers to designate "tonal debris"). As the playwright remarks, "Imagination without skill gives us modern art."[52] But he aims his harshest criticism toward the arrogance of the modern world of art, how distanced it has become from the general public, how "anything goes"—yet with the expectation that the art that ensues will be accepted and valued by the public. Stoppard pulls no punches in the following speech:

> There are two ways of becoming an artist. The first way is to do the things by which is meant art. The second way is to make art mean the things you do. What a stroke of genius! It made anything possible and everything safe!— safe from criticism, since our art admitted no standards outside itself; safe from comparison, since it had no history; safe from evaluation, since it referred to no system of values beyond the currency it had invented. We were no longer accountable. We were artists by mutual agreement.[53]

The question then arises, What was the art produced in the late 1980s and early 1990s like, and how did it get to be that way?

Artists no longer carry the mantle of instructing the illiterate in church doctrine (as they did in fifteenth-century Europe, for example), nor do they primarily transmit dominant social and political ideologies.[54] Instead, artists in the West have turned their concerns largely inward since the late nineteenth century, to grapple with problems endemic to color and canvas, to explore conscious and unconscious meanings, and to experiment with a variety of narrative structures on stage and in texts. This modernist impulse challenged long-standing traditions in many artistic fields, and introduced new subjects as well as new methods of inquiry and execution.

The retreat from nature as a primary source of artistic inspiration, or the rejection of social, religious or political doctrines as predominant themes in cultural products has not been absolute, however. Some artists have continued to draw from these sources, and some movements have championed art with a distinctly political iconography and with an explicitly social purpose. Social realism in the 1930s is the best example, when art was made for a mass public with an easily understood iconography that exposed inequality and misery and espoused remedial actions. But while American art has risen in status in the world's eyes since the

end of World War Two, it has distanced itself more and more from everyday life. What has evolved is an increasingly secret society, one imbued with mystery, power, and exclusivity. In the recent past, it is also a world resented by many people outside it.

Sometimes contemporary art is complicated and confusing, other times it appears to be overly simplistic. The public's bewilderment is compounded by what can sound like seat-of-the-pants theorizing, used to defend what many view as lacking in skill, and to justify what they would only reluctantly admit to the category of "art." Jasper John's well-known epigram is a case in point: "Take an object. Do something to it. Do something else to it."[55] The man on the street may hear John's insouciance as arrogance ("He calls *that* art!" "The price is *how much?*"); experience it as insulting; and roundly assail it in retribution.

The burden of explaining this increasingly complex art scene has fallen to contemporary art critics. And for some time now they have attempted to assess art that is elusive or perplexing. For Harold Rosenberg, the task was to grasp the "anxious" and "de-aestheticized object," where there was pronounced uncertainty over whether it was art or not, and where the process that brought it into being might be more important than the product itself.[56] For Peter Fuller, the challenge was to evaluate the impact of what he termed *kenosis*, or the self-emptying of paintings, whereby artists seem to abandon their skills and forswear image for idea.[57] As he tersely explained, "The late modernism of the 1970s thus disappears into an anaesthetic black-hole, or, to use a less conceptually suspicious analogy, up its own arse."[58] And, as one of the bad boys of the new journalism, Tom Wolfe laid bare the relatively unchallenged hype of an art world where metaphysics had triumphed, where what was left was "an abstraction of an abstraction, a blueprint of the blueprint, a diagram of the diagram."[59]

More recently the tone of criticism has turned from flippancy to anguish. For Arthur C. Danto, these are "bad aesthetic times," heralding the "end of art."[60] And according to Robert Hughes, we are in a cultural "slump," "a state of continuous hype but diminished expectation."[61] Both are reacting to art that has been consistently described as cool, self-conscious, nihilistic and grandiose. Julian Schnabel is an artist generally touted as representing the '80s, a figure who became known as much for the size of his canvases as for his public relations flare. And between Mark Kostabi's mode of operations, his public statements, and his finished works, he managed to anger nearly everyone. Supervising a staff of people to generate designs as well as to execute the work at his "Kostabi World," he arrogantly thumbed his nose at both art world conventions and public civility.[62] But those receiving notoriety one moment were quickly forgotten in the next: Robert Longo's fame rose and declined so swiftly that at decade's end he was derisively called Robert Long Ago.[63]

By the 1980s art movements such as abstract expressionism, conceptualism, and minimalism—along with the paradigms they spawned at a frenzied pace from

1945 onward—finally succeeded in destroying much of what art had looked like for centuries. Realistic masterpieces from the hands of inspired creators were hardly the norm. In 1990 a SoHo gallery "mounted" an "Untitled" exhibition/ installation consisting of a totally empty gallery, revealing a dearth of provocative ideas for making art.[64] The century-long progressive annihilation of the art work appeared to reach exhaustion because of its own success, just as it had also managed to alienate much of the general population.

In an important respect the controversies that intensified around art in the late '80s reflect a comeuppance, punishment for the distance many artists had put between themselves and the rest of the world. An example was the earth-art project Mel Chin proposed to the NEA, using plants that absorb toxic metals to clean a waste site. Chin claimed to be employing an "invisible aesthetic" in "Revival Field," in this instance his markedly unconventional artistic medium being the contaminated soil.[65] But NEA chairman John Frohnmayer's rejection of the grant confirmed the perception of many people that this must be a case of "the emperor's new clothes."[66]

It's not necessary to read through much of the news commentary on controversial art before realizing that art can humiliate people, and this was one reason some retaliated against it so frequently in the late '80s. The Cincinnati coordinator for the American Family Association asked in a guest column in a local newspaper, "Have we no higher destiny than to slavishly swallow all the stinking, foul-smelling garbage that New York City is dumping on us . . . [?]"[67] Another columnist claimed "the artistic community has its own 11th commandment: *Thou shalt grant federal funds to art that's too intellectual for you to understand, you rube.*"[68] And even the *Wall Street Journal* expressed contempt over the art world's detachment and advocated reality testing: "A lot of people we know use vacations to take their families to indulge in fantasy at Disney World. Perhaps some federal money could be set aside to send the U.S. arts academy in the opposite direction for a long-overdue vacation in the real world."[69]

THE RETURN OF THE REPRESSED

This editorial was ironically prophetic. For at the same moment that some artists were being accorded their "fifteen minutes of fame" (or infamy)—the art community's version of yuppie success—others were plunging head first into the world and developing their social consciences. A significant number of artists began to incorporate political and social topics into their work in the 1980s, a discernable trend unmatched in magnitude since their mobilization against the Vietnam War.[70] This tendency burgeoned in two main directions. The first surveyed the landscape for signposts of racism, sexism, and homophobia. The immediate intention of these practitioners: to dismantle antiquated, derogatory expressions and erect more

satisfactory depictions of diverse groups in their place.[71] The ultimate goal: to redress past symbolic assaults and thereby contribute to a more just society. The second, related course was set by the devastating impact of AIDS. Artists targeted governmental mismanagement and inattention to the problem, channeled grief and resignation into action, and put a human face on a frightening pandemic.

As previously noted, modernism drained art work of many of its real-world referents and violated the general public's sense of what art should look like. This drove the initial wedge between the art world and the rest of the populace, predisposing many to be leery of what artists create. Especially from 1945 onward, art came from a privatized world where personal feelings predominated, to which few were privy to understanding what art works meant. The campaign launched in 1984 to remove Richard Serra's large, nonrepresentational sculpture from a public plaza in New York illustrates the rejection of modernist assumptions and techniques. People were not angered by any overt message in the "Tilted Arc," but they were enormously put off by what they saw as an imposing, ugly hunk of rusted steel, whose artful qualities eluded them.

The socio-political movement in art reintroduced subject matter in the '80s, with the intention of bridging the chasm that the modernists had created. Language dominated much of this work; yet unlike the arcane, exclusive situation that Tom Wolfe had prophesized, this new group of artists attempted to draw the larger world into a dialogue about social issues, not just talk amongst themselves in a secret tongue. But because these messages challenged established notions of what the social world should look like and threatened people's vested interest in the status quo, they often facilitated argument and heated recriminations.

Art controversies were kindled by both of these sources of disenchantment with what artists were doing: either they had become too aloof, or they were publicizing matters that might be better left unremarked. There was already the image of the artist as media bad boy or darling—obnoxious, but too snotty or precious to be truly threatening. New on the scene was the artist as the bearer of distasteful or discomforting news, and these frank messengers of the present and harbingers of the future generated much more concern.

Artists like Barbara Kruger and Jenny Holzer are pivotal figures in the transition from private to public. Their work relies heavily on language, but as skeptics they examine its contradictory qualities, digging beneath the surface of official pronouncements and uncovering the various levels of meaning that messages incorporate. Other artist/activists set out to intentionally deconstruct the taken-for-granted as they pursued specific social agendas in the '80s and '90s. When this method was combined with explosive topics like sex, race, religion and power, the results were startling. They provide the subject matter for the present inquiry.

2

THE BACHELOR
STRIPPED BARE

I resent the insinuendos.
 Mayor Richard J. Daley, 15 May 1965

Gentlemen, get the thing straight, once and for all—
the policeman isn't there to create disorder,
the policeman is there to preserve disorder.
 Mayor Richard J. Daley, 23 September 1968

Art controversies consist of many grave moments. Combatants struggle furiously and exchange a surfeit of bitter rhetoric. A great deal can be at stake: saving faces or slapping them, restoring order or protecting the right to disrupt it. Ego incites and sustains much of this parry and thrust. Typically it seems impossible to bring these confrontations to closure once they are under way. An opaque quality beclouds the participants' ability to understand that the pervasive sense of contention and disruption will not last forever. But these struggles *are* generally flashes in time, and although they can have some far-reaching effects, there is always a return to some measure of the status quo ante.

These same battles customarily appear quaint or simple in the retelling, as time drains the passion from the issues and leaves a much more transparent body of evidence. When we examine this material retrospectively it is easy to feel smug about it: how could the principals ever get so worked up over such matters? Especially against the backdrop of whatever we're presently facing, we can hanker for what in retrospect appears foolish, when the beliefs at stake could not possibly be as important as current ones.

I begin by analyzing the controversy surrounding a painting of the late Mayor Harold Washington displayed at the School of the Art Institute of Chicago (SAIC) in 1988. This incident was as heated and divisive as these occurrences ever

become: violence was a distinct possibility at several points. It was also enormously portentious and exhibited an interestingly mixed character. This struggle came directly out of Chicago's civic and political history, loudly echoing past events. But it also signaled something new, reflecting some major changes in public life which had occurred in that city as well as in many other locales. This episode presaged the virtual epidemic of conflicts which followed shortly; embedded within a familiar scenario was the germ of things to come. This was, then, an important transitional moment, one which allows me to conduct the type of interpretive analysis I have just proposed to do.

"MY KIND OF TOWN, CHICAGO IS"

It is fitting that Chicago be the site for such an incident, because public images have an intriguing and frequently contested history there. On the South Side, for example, an enormous stone gate marks the entrance to the old stockyards, virtually all that remains on a vast, abandoned urban prairie. This beautiful nineteenth century architectural remnant stands on ground saturated with blood, bearing muted witness to the horrors chronicled by Upton Sinclair's *The Jungle*. And who can forget the pictures of demonstrators bloodied by the police in the streets of Chicago during the Democratic Convention of 1968? Meanwhile inside the hall, Mayor Daley cut off power to the microphones so that speakers were unable to report these events to their fellow delegates or to the television audience. Public relations took precedence over the right to dissent. And much later an Illinois governor nixed a tourism campaign featuring an Alberto Vargas nude and the entreaty "Come to the city where Life was created (and Playboy, too)."[1] Again, the desire to put the best (covered) foot forward has had great consequence in shaping public representations in this city.

In 1983 Harold Washington assumed its helm, becoming the first Black elected mayor in Chicago. His victory especially delighted minority groups and political progressives; the sense of triumph was reflected in a poem sold in broadside form in stationery shops: "Black's [sic] have become united . . . we've set up our own political sanhedrins. We're learning to stick together like 'Spaghetti' instead of pulling apart like 'Uncle Ben's Rice.' "[2] Washington's first term in office was unduly difficult, however, because the programs he advocated were stymied by the City Council. That body was deadlocked by White aldermen representing working-class ethnic wards, the bedrock of the Democratic machine previously sustained by the late Richard J. Daley. This impasse was widely referred to as the "Council Wars," but it began to break up after Washington was reelected in April, 1987, largely due to a reapportionment plan which gave more representation to minority groups. He was then in a much stronger position to exercise his will.

Washington was just beginning to consolidate his command when he died suddenly in November, 1987.

The dreams of his constituents were shattered. A period of intense communal mourning ensued, grief mixing with disappointment over a leader's unrealized potential, anger blending with an acute sense of calamity. His death elevated his reputation; it also created a power vacuum. Crowds filled the streets outside City Hall during a chaotic internecine power struggle in the days immediately after Washington's passing, the people anxious for news of who would assume the leadership role. The interim choice was the dapper and soft-spoken Eugene Sawyer, a Black man whose selection disappointed Black activists because they viewed him as a puppet of White ethnics and Black conservatives.

Different political factions subsequently vied to capitalize on Washington's accomplishments and share his charisma, prompting one commentator to use the epithet "legacy police" to denote those claiming to be his legitimate heirs.[3] This faction of aldermen flexed their muscle on May 11, 1988 when they marched from the City Council chambers to SAIC and removed a painting of Washington from a student exhibition in a nonpublic part of the building [see Plates section]. This was after they led the City Council in debate on a resolution which at first claimed the artist had "demented and pathological mental capacities," and finally emerged as a statement condemning the work as a "disgrace to the city."[4] The aldermen met with the school's director and then had police "arrest" the painting; to their minds the work was so inflammatory that this was necessary in order to avoid a riot.[5]

The incident virtually monopolized public and private discussions over the next few weeks, and commanded national attention as well. In response to intensive public pressure the school issued a public apology in the major Chicago newspapers; SAIC agreed to intensify its efforts to recruit more minority faculty members, administrators and students;[6] the City Council consequently dropped a threat to withhold funds from the school or its sister institution, the Art Institute of Chicago;[7] the painting was returned to the artist David Nelson, but with a gash across it; and the ACLU took on the case as a violation of the artist's rights under the First, Fourth, and Fourteenth Amendments.[8] What type of image could prompt such a furious response?

THE BACHELOR STRIPPED BARE

One of the most important characteristics of this painting was that it was displayed only briefly, so that few people had the opportunity to view it firsthand. Crude reproductions appeared on TV, images which were then replicated in newspapers or magazines, generations removed from the original. Alternately there was the dramatic and much-reprinted photograph of the painting (now wrapped

in brown paper) being carried out of SAIC under the arm of a Black alderman, the vanguard of a police and aldermen convoy. For most Chicagoans the painting could only be evaluated at a distance or with this punitive association in mind, not strictly on its own terms.

Crudeness is an attribute of how the subject is handled artistically as well. Washington is displayed in a full-length, frontal manner, staring directly at the viewer in this four-by-three-foot painting [see Plates section]. He is clothed only in a woman's brassiere, panties, garter belt and hosiery. A slight foreshortening of the arms makes them somewhat flipper-like and draws attention to the swelling of his entire midsection. In fact, the center portion of his body appears as an immense balloon over which the brassiere is stretched across the top while the other garments cling onto the bottom. An important iconographic element is a pencil he is clutching in his right hand, a reference to the fact that he dropped a pencil when he had his heart attack. Aides thought he was reaching to pick it up when he slumped over, fatally stricken.

The painting is primitively rendered and falls somewhere between a cartoon and a photograph. The head appears to be grafted onto a body without a neck, and there is only one breast, encased in a brassiere whose straps hang unnaturally. Some features are just partially modelled: the figure's legs look more like Xmas stockings or snow boots than human appendages, for example. Standing stiffly at attention, Washington seems like someone in a mug shot. His face registers a rather bewildered look; he is presented as a grotesque gender-incorrect paper doll waiting to be dressed.

This is art that lampoons what others revere, and as such was a direct assault on the character of someone no longer around to defend himself. It broached the subject of ability: someone as ridiculous or perverted as this could hardly make important governmental decisions. The capacity to rule and fitness for power are both thrown into doubt. This painting contested what a large sector of people thought should be undisputed, and beyond the pale of discussion.

Many precedents can be cited, of course, in a long history of art that is critical of public officials or official behavior. One of the best known examples is caricaturist Charles Philipon's symbol "Le Poire," the representation of French Emperor Louis Philippe as a pear in Parisian newspapers from 1832 to 1842.[9] In 1934 the Metropolitan Museum in New York removed student cartoons of Charles G. Dawes, Senator William E. Borah and Hitler from an exhibit, the latter clothed only in a pair of shorts, and shown with a cloven foot.[10] And also in 1934, Assistant Secretary of the Navy Henry Latrobe Roosevelt (cousin to the President)—distressed over a depiction of licentious military personnel—pulled Paul Cadmus's "The Fleet's In!" from the walls of Washington's Corcoran Gallery, a painting not to be publicly displayed again for over 45 years.[11]

There is also a local history of suppression of images. In 1935 Chicago Mayor Edward Kelley was offended by Erskine Caldwell's play "Tobacco Road." He had

the license to the theater rescinded, and no other playhouse dared to pick it up; it was not produced there again until 1972.[12] More pertinent to the incident under discussion, nude statues at the Art Institute were moved or dismantled in 1899 and 1916 in response to public pressure. In the earlier case a satirical poem addressed to the Commissioner of Public Works read as follows in the newspaper:

> Commissioner McGann, he's the man
> Who won't have statues sans clotheses.
> He's honest and true, a good man for you,
> Who'll take 'em from under our noses.[13]

And as a final example, when the watershed Armory Show of 1913 moved from New York to Chicago, a state vice squad investigation was initiated against two paintings: "Prostitution" (the work pointed out its evils), and Duchamp's "Nude Descending a Staircase." In a surprising contrast to the Nelson/Washington incident, however, students joined the attack in that instance: they burned Matisse in effigy, taking his modernism to be a "betrayal of art."[14]

NEGOTIATING THE CONTEXTUAL MAZE

Multiple interpretations emerged to explain the Washington portrait and the reaction to it. For nearly every witness there was a different view of what had happened. The event could be regarded as artist-generated, or the result of factors far beyond his control. Supporting the first position were those who saw this as a satiric gesture which got out of hand.[15] They were joined by others who believed the painting was part of a larger "performance art" piece, one that highlighted cultural currents and exposed socio-political hypocrisies.[16] That was the assumption of SAIC Director Tony Jones, who claimed that an imposter presented himself as Nelson while the real artist circulated in the school building in disguise while the affair unfolded. According to Jones, "That has people in the school very worried, because they feel manipulated without being aware that that's what was happening. We assumed we were in one position when in fact we were in something different."[17]

Many observers, as well as the artist, used "iconoclast" to describe his stance, a term employed since the seventh century to characterize those who destroy what are unacceptable images to them (in the original sense, unsuitable religious depictions).[18] Nelson cited a specific source of inspiration from local, popular culture: the transformation of Washington into a deity in a poster which showed him floating in the clouds above Chicago with Jesus at his side, and the admonition "Worry Ye not." Nelson despised such visual hagiography: "I guess in the city, it's almost like there's certain icons, like Washington is a deity and you can't touch

him. It wasn't Washington I wanted to poke a hole in. It was the deity [sic] aspect."[19] He had targeted other authority figures before; showing the President of SAIC as a suckling infant, for example. And he also built upon a tradition of aggressive, emotional realism dating from the 1940s, commonly referred to as "Chicago Imagism."[20]

For other observers, in contrast, what ultimately transpired was due to much larger forces. Some cited timing as the key factor: a TV ratings "sweep" period transformed an insignificant incident into a media event.[21] Still others noted that financial vulnerability molded how this situation was framed and received: the Art Institute was about to launch a fund-raising drive to expand school facilities and was understandably cautious.[22]

A number of additional, opposed views emerged. This was a sign of the political naivete and political infancy of the Black community, according to one argument. As such this was a reactive stance, as explained by a key Black alderman: "The people have spoke [sic]. The people spoke to us and we got reactive."[23] Another possible way to see this was as a proactive stand: the Black community experienced an affront and was standing up for its rights and demanding respect. This parallels how those concerned about pornography attempt to link it directly to the negative treatment of women. They offer the argument of "adverse climate," a compelling one for those who can construct a history of past assaults, and a slippery, non-persuasive concept to other groups. Similarly in this case, groups discerned expressions of racism or homophobia in what transpired based upon their vested interests and past histories.[24]

This painting obviously touched individual and collective nerves. In fact, it is difficult to imagine another work that could have crystallized so many unspoken fears and insecurities and tapped into Chicago's nervous system to such an extent at that instant. The challenge is to disentangle the cultural, biographical, contextual and historical synapses that it triggered. The reaction to this painting was overdetermined: any one of several factors *might* have elicited the immensely negative response to it. What in fact transpired was that a dizzying additive process was set into motion, whereby a number of factors interacted synergistically to create an explosion of great intensity.

One such factor deals with image, what we can call the cultural or reputational component. A connection can be drawn between the typically virile image of Chicago and the contradictory theme of the painting. Chicago has a long-standing and widely accepted reputation, more familiar than for most American cities. Whether it be Sandburg's image of the city of "the big shoulders" or the association with 1920s gangsters, Chicago is typically portrayed as brash, violent, and most of all, masculine. This is an image that has been alternately resisted and cultivated. At the same time that Mayor Washington insisted that something be done about Chicago's "rat-a-tat-tat" image, the chairman of the International Visitors Center there saw it as something to capitalize on when he proposed a museum of crime

and corruption.[25] An "Untouchables" tour escorts interested parties to important sites throughout the city, while Chicago's name has become a synedoche for gangsterism worldwide. In Austria, for example, a right-wing political party registered its concern with increasing rates of street crime with the slogan "Vienna Should Not Become Chicago."[26] It is a reputation which is constantly reinvigorated: during a brawl in 1990 between rival campaign workers over the display of election posters, one man was shot three times and run over by a van.[27]

Since the death of Mayor Richard J. Daley—commonly seen as a father figure—anyone occupying his office has had to wrestle with this view. For Jane Byrne, Washington's immediate predecessor, this posed great difficulties. European observers were puzzled when they tried to understand her election in a city characterized as a "world symbol of masculinity."[28] Extremely sensitive about her public persona, she fired her official photographer after a picture of her and her daughter surfaced in a national magazine; they were caught clowning as gun molls with actors John Belushi and Dan Ackroyd during the filming of "The Blues Brothers."[29] And as it subsequently turned out, a Black man would also have manifold problems leading a city that is heir to a legacy of racial divisiveness, and stubbornly resistant to change.

Washington sought to neutralize some of the difficulties of succession by self-conscious identification with the revered forefather. He jokingly referred to himself as the "sepia Daley," and even retrieved Daley's desk from storage for his own use.[30] But what was more problematic to contend with was a biographical factor. Washington's bachelor status generated rumors regarding his sexual conduct and orientation. Such gossip was a whispered subtext that surfaced as tales of homosexuality, child molestation, and transvestism. In fact, the artist Nelson cited such a rumor as another of his sources of inspiration: hearsay reported that Washington was wearing women's underwear beneath his business suit when he was taken to the hospital after his fatal heart attack.[31]

Some sensationalistic headlines picked up this theme when they announced "Ex-Chi Mayor 'art' is 'dragged' away"[32] or "Late Chi mayor dragged through art flap."[33] An early-morning radio commentator brazenly suggested the work be dubbed "The African Queen,"[34] and even the *New York Times* acknowledged this sexual angle when they described the painting and then noted "Everything about him is ambiguous."[35] To savvy observers the link was clear, with the painting's title evoking another meaningful association: "Mirth and Girth" was unmistakably similar to the name of an organization for overweight gay men, Girth and Mirth.

These were coy references, like the speculative stories that circulated during Washington's life. They alluded to a widely suspected but unsubstantiated facet of Washington's incumbency. Even in death, only a few commentators were willing to bring it up, among them a well-respected Black journalist,[36] an ACLU representative, and writers in the Chicago gay press. The subject was barely broached during a symposium convened by a local art college to confront the

controversy, and when it was, there were vigorous attempts by panel members and audience members alike to keep the subject of homosexuality in the closet.[37] Yet the association between life and art undoubtedly channeled the reaction to this work, in spite of the desire on the part of many Washington supporters to deny this possible connection.

We can also cite contextual elements which helped guarantee the response. A number of events had already contributed to a racially charged mood in the city. For example, an "equity law" had been proposed to protect home values by establishing a state-financed fund to pay the difference between a home's sale price and its appraised value. The intention of the legislation was to decrease the probability of the rapid racial transition of neighborhoods through panic selling. The message it broadcast to many was one of racism, however, with its tacit acceptance of the notion that property values decrease when Blacks move into a neighborhood. Some lawmakers who opposed it called the measure "the Ku Klux Klan without the hood."[38]

It is evident to anyone observing Chicago politics in the past decades that race habitually overrides other issues there. Alliances which arose across racial lines during the civil rights movement have largely dissipated. Mutual suspicion dominates, heightened by the rhetoric of nationalist leaders such as Louis Farrakhan of the Nation of Islam. In fact, the most racially divisive matter centered on mayoral aide Steve Cokely, a supporter of Farrakhan. Shortly before the incident over the painting, Cokely made anti-Semitic remarks, such as accusing Jewish doctors of injecting Black babies with the AIDS [sic] virus, and charging that Jews were in a conspiracy to rule the world. Acting Mayor Eugene Sawyer at first resisted pressure to fire Cokely, earning him the respect of some fellow members of the Black community who felt Sawyer had worked too closely with anti-Washington forces, and that he was not the late Mayor's legitimate successor. But when he finally acceded, many Blacks were outraged that Cokely's right to free speech had been abridged. This opened a wound that was enlarged by the painting and then irritated by the outcry that the artist's rights had been curbed.

What followed was a dredging up of past insults along with a reluctance by either side to admit fault. As the leader of Operation PUSH (a successor to Jesse Jackson) asserted when she defended Black leaders under fire: " 'You didn't ask the Art Institute to apologize,' she bellowed. . . . 'We ain't [sic] apologizing no more. . . .' she said. 'We are grown . . . we can count too.' "[39] These remarks highlight the sense of impropriety and outrage the painting evoked because it appeared relatively soon after Washington's death, and also underscore the newness of Black political power in Chicago. Blacks saw the painting as part of a pattern of assaults, not as an isolated incident.[40]

This racial climate was augmented by sexual politics in the city. Just before the painting was seized, George Dunne (president of the Cook County Board and head of the county Democratic party) was accused of trading patronage jobs for sexual

favors from several young women, alleged to be lesbians. Rather than garnering a negative public reaction, his potency at age 75 was publicly celebrated. As a female county commissioner admitted, " 'I'm glad to see we have a heterosexual at the head of government'." [41] Add to this the fact that a proposed local human rights ordinance extending protection to homosexuals had been stalled in the City Council, largely because of pressure from churches in Black communities.

Finally, there were historical precedents for the official suppression of art in the public realm in Chicago. In 1979, City officials covered and attempted to remove a sculptural piece from a municipal building satirizing Mayor Bilandic's failure to handle a prolonged snow emergency. The art hit a strategic target, implicitly contrasting the ineptness of the current regime with the efficiency of the old. In effect it tapped the widespread sentiment that the problem with municipal services would not have occurred, "If Mayor Daley were alive. . . ."[42] The effectiveness and reputation of a public servant were on the line, and defenders of the administration rushed in to deflect the assault.

Several years later the same artist created a similar tableau that captured Washington and his rival Edward Vrdolyak stalemated in debate, an artwork that Washington himself told aides to leave alone.[43] This reflects a pattern of restraint that Washington established, a pattern that extended to his resisting attempts to remove a Black poet on a city-sponsored Dial-a-Poem program, defending an artist whose frescoes in a neighborhood library provoked an outcry for being "fertility symbols," and refusing to support the assertion of two Black aldermen that the City seal was racist and should be redesigned.[44] But Washington's strong civil liberties stance kept the anti-art forces at bay only temporarily. With his absence, this history of prior attempts to limit artistic expression furnished precedents for conduct which later commanded a great deal of popular support.

It now should be clear how this painting, presented at this historical juncture in Chicago, was destined to provoke controversy. The next task is to examine exactly how that controversy was shaped, by whom, and in what terms.

OF NOOSES AND NOSTRUMS

Although there were moments of folly, this was not a frivolous event. Those who reacted against this representation demonstrated a fundamentalism of belief similar to that which surfaced in later incidents such as the Islamic rejection of Salman Rushdie's *The Satanic Verses*, and Christian renunciation of Martin Scorsese's "The Last Temptation of Christ." New interpretations that countered traditional images also challenged received truth in all these cases, notions which supporters believed were to be revered and upheld—unaltered—on faith.

In this particular instance threats of violence were directed against the artist, the art school, and the school's director. For the most part this intimidation was

not translated into direct action,[45] but violent language became a staple for both sides. What transpired was in essence a symbolic lynching: group characteristics were blurred and information was distorted, representative victims were targeted, and mob action was both threatened and committed. What is most unusual is that in some respects the traditional roles of perpetrator and victim in such a scenario were reversed.

Three historical images were constantly invoked in the seizure of the painting: gangland-style confrontations from the 1920s, the vigilante or posse of the American West, and the Gestapo storm trooper of Nazi Germany. These analogies surfaced frequently in news articles, in a few instances modified by a note of triviality, such as characterizing the scene as a "panty raid."[46] Further, as in other highly emotional occasions of collective action, key facts in the scenario were difficult to ascertain: the number of aldermen who confiscated the painting, the number of threats directed at individuals and institutions, and even the age of the artist were all subject to variable reports. Most important, however, was the confusion regarding the artist's background. Some of his detractors immediately assumed David Nelson was Jewish, which to their minds would have explained everything about his work.[47]

Both sides to this controversy felt they had been violated and both acted to enforce their views. The painting's supporters maintained that an illegal action had been taken and that a legal remedy was necessary. They argued that the "hecklers' veto" had triumphed, that is, the denial of rights of free expression on the basis of real or imagined threats to those wishing to express themselves.[48] By seizing the painting to the supposed end of *preventing* a riot, the Black aldermen ironically used the same rationale that was used historically against Blacks to prevent them from publicly demonstrating for, and exercising, their civil rights.[49]

But for those who were offended by the painting, their call to action was supported by another set of assumptions: "There's a higher moral law than the Constitution and that's what I'm concerned about. Nothing else counts," one alderman proclaimed.[50] Such individuals felt that the first punch in this skirmish had been thrown by the artist, and they justified their response as redress for a provocative action. To their minds a lynching or symbolic emasculation had already occurred, and the Black community was the victim, not the perpetrator, of the transgression in this case.

Nothing highlights the racial polarization in Chicago at this time more than the conjunction of the Cokely firing and the display and seizure of the painting of Mayor Washington. For many in the Black community, the "muzzling" of a public official was an assault against that community; it signaled the necessity for closing ranks and protecting one's fellows, albeit in a manner some might term the tyranny of the masses.[51] As a community organizer passionately argued at a rally for Cokely: "We're here to tell the Jewish community and sell-out Negroes that we'll not allow them to snatch the manhood of Black men in this community. . . . It's Steve

Cokely tonight, but it'll be us tomorrow."[52] This sentiment was echoed by Allan Streeter, one of the aldermen who seized the painting: "In his ward publication, Streeter said that he would not be a part of any move to 'silence or castrate another Black person' [beyond Cokely] and added that [Mayor] Sawyer should not bend to pressure from outside groups in dealing with Blacks."[53]

Blacks therefore enacted the roles of both victim and aggressor, in the latter respect inverting the standard drama. And once again, there is an uncanny precedent which undoubtedly contributed to the outlook of Blacks in Chicago. In 1987 a judge declared that any resident of the South Side [a predominately Black portion of the city] who did not vote for Harold Washington in his campaign for a second term "ought to be hung." In March 1988—shortly before the incident over the painting—the state Judicial Inquiry Board filed a complaint with the Illinois Courts Commission charging that judge with violating the state code of conduct.[54] Not only did the image of lynching have currency, but the judge's protestations that his remark should not be taken literally were officially vetoed. For some this was another example of a supposed aggressor actually being the victim.

Inflammatory remarks were not restricted to Blacks, however. In an editorial that only thinly veiled his racism, the well-known local columnist Mike Royko confirmed the worst that many Blacks must have feared. After mocking Black street jive, speculating that the Black aldermen had never been to the Art Institute before they removed the Washington painting, and assigning them the sobriquet "alderboobs," Royko cut loose: "If anything, I find a painting far less offensive than an alderman. A painting is nothing more than an inanimate object. You just hang it on a wall and it stays there. Some aldermen are inanimate, too, but you can't hang an alderman that way, although it would be fun."[55]

The following reading of events picks up the diverse threads of this account. An irreverent young White artist felt that a recently deceased Black mayor should be humbled because his image had become sacrosanct. His painting aggressively offerred an alternative, unflattering point of view reflecting larger racial and gender ambiguities. It symbolically castrated the man, paralleling a traditional reaction to "uppity niggers" who exceeded their prescribed social position. The message was "Get back, Black man; off your pedestal!" Both the painting itself and its fate in the hands of its detractors were additionally distinguished by dimensions of rape, a traditional method of controlling women. This feminine identification was heightened because of a conflation of Washington's biography with his inheritance of a city weakened first by its loss of a powerful paternalistic leader, and then by the impact of critical structural problems—many of the same ones that have contributed to the decline of other major US cities in the 1980s. Chicago was becoming flaccid, and its late mayor was portrayed similarly. In an over-masculinized city, this had an ironic potency.

The reception to this painting was orchestrated by actors from two worlds which do not customarily penetrate one another: an elite cultural institution and

city government. The social positions of the relevant parties within their own domains was similar, however. A student was on one side, and minority members newly empowered in municipal politics on the other. Neither faction brought with it much practical experience in accommodating or negotiating conflict when they confronted each other in this new territory. Armed with perspectives formulated in very different contexts, these parties and their allies constructed the operative rules de novo. The outcome called up a familiar scenario, as a "frontier mentality" triumphed. The staging of an ersatz lynching occurred because legitimate authority did not appear to exist, and government officials became outlaws when they used force in an extralegal manner.

This image was the tinder that ignited what was already an incendiary racial situation. In the classic sense, it was a disaster waiting to occur. But for some it was also an opportunity to flex political muscle, consolidate local alliances, and generate political capital. As mentioned earlier, many of the participants in the seizure of the painting were those who most zealously joined the "legacy police." In some respects they needed to publicly affirm their allegiance to the late Mayor, and/or wished to counter being cast as racial traitors because of any association with the firing of Cokely. In either connection they upstaged the acting Mayor by taking matters into their own hands. Political opportunism? Most likely; but this action also illustrates the changing order of politics, and as such warrants a more concentrated look at the factors generating such events.

THE PRECONDITIONS OF CONTROVERSY

Specific circumstances heighten the likelihood of conflict over art. First, art controversies are most liable to occur when prolonged public struggles have fractured the community; when distinct social cleavages have left individuals estranged from one other; as civic spirit becomes deflated by weariness and despair, and alienation replaces a sense of common cause. In a number of American cities in the past two decades, old coalitions have broken down, as have barriers to participation based on race, ethnicity and gender. Groups which were formally served to a greater or lesser degree by old-style, machine-based power brokers have succeeded in wresting more control into their own hands. Coincidentally, however, this has caused other groups to feel *dis*enfranchised and has left them with their sense of the world shattered.

A statement by a Black alderman in Chicago demonstrates the depth of the division and strength of the emotion these developments can occasion. He responded to the assertion of a White, former public official that an act of censorship should not have taken place in the Nelson/Washington case by charging "That's a white fellow talking for black people again. We will not allow whites to tell us what to do."[56] Significantly, this statement was made during a time of civic

mourning, dismay, and confusion. When there has been a recent ascendence to power or recent transfer of power within a community, the right to rule is so new and the record of accomplishments may be so slight that public officials can feel defensive. Their inability to remedy social ills or to magically heal social rifts compels politicians to search out "problems" where they are more apt to prevail in the actions they take.

Second, when the legitimacy or effectiveness of governmental leaders is in question, the probability of conflict over art is enlarged. Art has an uncanny ability to locate the "soft underbelly," the most vulnerable part of an individual or the group s/he represents. It can challenge the most mundane abilities, for example, the Bilandic case in Chicago in 1979. Other artists have aimed their works similarly in Philadelphia, focusing on trash removal problems or creating work seen as metaphorically commenting on the catastrophic Move incident.[57] This condition may derive from an immense stock of social problems for which there are no quick or simple solutions, and from which diversion is sought.

But art also confronts the sacred, so that to the sin of insolence we can add the possibilities of error from "fundamental truths," subversion, blasphemy, and immorality. While we might imagine that sex is the major flashpoint in art controversies, upon reflection it becomes apparent that *whatever* is unsettled in a community may provide the spark; many forms of artistic expression can be seen as threatening. Public officials therefore are likely to react when art critically assesses them and social conditions for which they can be held responsible, or when art addresses more elusive matters such as moral fabric and national ethos.

And finally, controversy most generally erupts when art is displayed in places that are public or publicly supported. The question of accountability is paramount here, and artists who disregard this responsibility are subject to the most criticism. Threats to withhold funds can most easily be made and enforced in these situations, thus directly affecting the fate of artists and their work.

I have, therefore, proposed *when* public art controversies are likely to occur— at times when there is a high degree of communal fragmentation and polarization, and widespread civic malaise and low communal morale. *What* becomes controversial are generally those works which address volatile, unsettled issues. And *where* this takes place is most typically at strategic public locations. While any of these conditions is likely to spark trouble, their combination virtually assures conflagration. To extract the fullest degree of meaning from the Nelson/Washington conflict, we can use this set of preconditions to examine other incidents (and non-incidents) to determine to what extent they apply to other situations.

THE LAST SHALL BE FIRST

Looking at three examples of art work, and the different reactions they provoked, provides a time lapse exposure of Chicago's political terrain. Mayor Daley died in

December, 1976, and he was "feted" by a large exhibit fifteen months later at an artist-run "alternative space" just north of Chicago's Loop. "Daley's Tomb" consisted of the work of forty five artists, including a Renaissance style painting presenting Daley as an angel, hovering over City Hall as deals were enacted below; an architect's proposal to add crosses to major downtown buildings, thereby transforming the city into a giant memorial park; a musical sarcophagus; and pinball machines, file cabinets, and other miscellanea.[58] Many of the artists incorporated Daley's words and deeds into their presentations, albeit radically reformulated in most cases. Even though it is difficult to imagine a more satirical or overtly political art exhibit, there was no public outcry or negative critical response.

Approximately one year later Michael Bilandic, Daley's immediate successor, was the target of the satirical sculpture. As mentioned, Bilandic was lampooned as the head of what was perceived to be an inept and insensitive bureaucracy, after weeks of winter storms had immobilized and frustrated city residents. In addition, there were specific complaints that predominantly Black areas were routinely underserved by city services during this period. February, 1979 was also the month when the primary elections were scheduled, and Bilandic's record was directly on the line. Loyal patronage employees of the city's art council covered up the offending work and attempted to have it removed, an action overturned in court.[59] Shortly thereafter, Bilandic lost his bid for his party's nomination. And finally, in 1988 there was the incident which swirled around the painting of Mayor Washington.

Recall the criteria regarding public art controversies I delineated above: low communal morale combined with high communal fragmentation and polarization; artwork that addresses sensitive issues; and public locations. "Daley's Tomb" was presented during a period marked by low community morale and a sense of loss, but more time had passed after his death than was the case in the Washington incident. In addition, Daley commanded a high degree of allegiance from a wide variety of people, although his support was eroding by the time of his death, particularly in the Black community.[60] In some ways he was "everyone's Mayor," and even many of those who disliked him would acknowledge that his personal identity was tightly interwoven with the city's. While disaffection with Daley and his machine was definitely present, opposition had not yet coalesced to a significant degree. In particular, the vexing issues of Black enfranchisement and empowerment had not fully erupted. And finally, as irreverent as the work in this show was, it was relatively hidden from public view. Although reviewed in the media, it was exhibited in a place known primarily to the avant garde. This site was also a cooperative venture, not beholden to public funds for its operation, nor subject to governmental oversight. While the potential to offend was certainly present in this instance, the public issue did not emerge.

In the Bilandic incident, however, all the criteria were met. Sufficient time had passed after Daley's death for groups to have waged battles for power; civic morale was low and polarization increasing; and an image was presented in a public setting

which went for the political jugular vein. Controversy erupted. Such was also the case with the Washington painting, with the same conditions present, although much exaggerated by then.

Evidence from Philadelphia further confirms that the conjunction of these highlighted factors maximizes the potential for controversies over art. The political landscape of Philadelphia is roughly comparable to Chicago's: rule by a White "boss" from 1972 to 1980; a liberal White man next became Mayor for one term; and then a Black mayor was elected in 1983. Mayor Wilson Goode's administration was dogged by problems, both mundane and persistent (sanitation strikes and trash removal difficulties), and spectacular and unique (the police bombing of the Black militant Move house in 1985). It also had difficulties dealing with art.

The City established the "Art in City Hall" project in 1985 to bring juried shows to the halls outside the Mayor's office and the City Council chambers. There have been several instances of discord over art, related either to issues of race or to the efficacy of the City Administration. For example, in 1985 artworks in two shows were mistakingly interpreted as making reference to the Move incident: one painting featured huts and stick figures, and the other pictured a burning house. Both pieces were threatened with removal but subsequently allowed to stay, but only after the artists successfully explained the symbolism and intent of their work in different terms.

In 1987, however, an artist's work was ejected from a show after it directly addressed a municipal problem. "Doorway with Pilasters" featured a doorway framed by columns made of trashcans, littered by actual trash from Philadelphia streets.[61] It was presented just after the Mayor had failed to win support for a trash-to-steam plant proposal which might have alleviated the city's chronic trash disposal difficulties.[62] And later that year Goode ordered the removal of photographs depicting the annual Mummers' parade because he judged them to be racist. In point of fact, the black and white photos depicted participants' faces with blue and green makeup, a modification of the traditional blackface which had been deemed insensitive to the Black community.[63] But it is evident that this work was disapprovingly evaluated through a distinctly racial lens.

These incidents were all played out against a set of conditions meeting the criteria for public art controversies. Increased Black political participation in Philadelphia has been accompanied by increased racial polarization. This has been evidenced by a White backlash (for instance, the well-publicized burning of the home of an interracial couple who moved into a White, working-class neighborhood in 1985).[64] And the fact that a Black mayor and other key City officials were held to be responsible for the murder of other Blacks in the Move incident (also in 1985) has produced a very complicated and sensitive political scene.

There is an additional and important similarity between these instances of regulating images in Chicago and Philadelphia. In both cases overt actions against the offending pieces were necessary because other, more subtle controls were

inadequate. There was no prescreening of what students exhibited in the show at the School of the Art Institute. In fact, the artist reported that he created the painting in one night at his home, shortly before the show. As a faculty member averred: "I heard the painting was not done in any class. If it had been, any teacher would have talked to the student about the appropriateness of this sort of thing."[65] What could not be intercepted in process was instead removed after the fact.

Circumstances were similar in Philadelphia in the case of the trash sculpture. The artist submitted a proposal which was evaluated and accepted, but he later altered it during the actual creation. A major element of the rationale for banning the piece was that it didn't conform to the original design, but instead had slipped through a screening apparatus that should have caught potential problems before they surfaced.[66] In each case emergency measures were called out when more subtle devices did not successfully check problems.[67]

CONFLICT REDUX

Regulatory outburst is just one of the possible forms civic controversy can assume. At different times the very same social conditions may produce clashes which target vulnerable activities other than art (basically, anything or anyone who looks, sounds or thinks differently from the norm). Such struggles emerge during periods when the sense of community is tenuous and many people may be looking for representations of who they are and are not. This helps to explain the *magnitude* of the response against art, secondary to frustration, disappointment, and previously unfocused yet pervasive anxieties. Art congeals inchoate concerns and provides a convenient scapegoat. It acts like a magnet, attracting scraps of civic discontent. And we can also understand the *direction* of the negative response, which typically is aimed against critical or incomprehensible forms. Either way, aspects of art works themselves—particularly when they are displayed in public contexts or executed with public funds—can insult large numbers of people and be seen as bad-mannered intruders, not good neighbors.

Radically different types of art can elicit remarkably similar responses, whether from "the community" or from their designated representatives. In the case of nonrepresentational art there is a problem in relation to the range of what many people recognize and accept as legitimate art. If communities are consulted in advance in regard to proposed works that are nonrepresentational in nature, they frequently attempt to force the projects toward something more traditional and understandable: monuments, not masses of visual mayhem.[68] On the other hand, people can read the meanings that are incorporated into representational art, and they often find them offensive. The public pressure in these cases is commonly directed toward stripping work of its overt social or political commentary. Publics

often desire that artists generalize their work to the "human condition," not particularize the message to a specific group's concerns.

Dichotomizing the art world into representational and nonrepresentational spheres may not accurately reflect contemporary realities, however. With postmodernism, concrete imagery is used in unexpected ways, blurring traditional distinctions. Be that as it may, the public frequently responds negatively to such innovative expressions, as if they are either overly facile or unfathomable. And while this reaction parallels the negative response to nonrepresentational forms, it may be even more pronounced: the familiarity of much postmodernist imagery sparks recognition and allows partial readings, but can ultimately frustrate those who are uninitiated into the aesthetics of this world. With this proviso in mind, when art of either major type is subject to review processes—especially those built into ongoing programs—it is likely to be subjected to attempts to standardize or neutralize it, to the end of routine, "clean" representations. Both types of negative response therefore tend to summon a similar outcome.

It is also important to recognize that instances where the artist is a passive and unknowing victim are probably rare. Some artists and some artworks are provocative by almost any standard, and what happens to them is rather predictable. Still other reactions are truly unexpected, and unintentionally provoked. We need to examine what an artist contributes to any problematic scene. This does not automatically impute blame, nor does it detract from the significance of the regulatory acts directed against them, but it should temper the sense of shock and outrage somewhat.

Works of art are the product of interaction between creators and others. What emerges is generally the result of imagined audience responses, and in certain instances the consequence of their active intervention. Those artists who do not take the role of the potential audience into account are likely to experience difficulty, as are those who are able to anticipate audience responses but deliberately disregard them and instead inflame controversy.

Although the range of problematic situations and possible outcomes is great, seemingly disparate phenomena can be analyzed along two important dimensions. First, the *production* of the work and the artist's relation to the larger world must be considered. An artist can either draw directly from the immediate social and political milieu (for instance, in the case of the Washington painting), or act as if the outside world does not exist (for instance, Richard Serra's "Tilted Arc"). Concurrently, *reception* and the nature of the community in which it occurs must be examined. A community's aesthetic may be in formation, with diffuse definitions of good/bad and proper/improper (for instance, during and just after Washington's tenure), or its aesthetic may be highly articulated (for instance, during and just after Daley's tenure).

Controversy is not aberrant; it should be expected whenever there is vulnerability along any of these dimensions. "Daley's Tomb" did not provoke controversy

because there was an established aesthetic at the time and the challenges mounted by this show could not disrupt this. Although the exhibit championed an alternative aesthetic it played to a select and sympathetic audience, a strategy which effectively engineered its reception. So while important values were obviously violated, the relative invisibility of the exhibit prevented potential opponents from mobilizing power against it.

In the Washington incident, on the other hand, values and incipient power were fused, making it impossible to contain the controversy. Individuals on both the production and reception sides—the artist and the aldermen, respectively—had to be somewhat aware of the possible consequences of their actions. But once an image that was intended only for a discerning audience was instead yanked into the public arena, diverse constituencies were drawn in, each felt threatened in different ways, and the situation quickly spun out of control. The painting was like a fumbled football in a game without referees: everyone was grabbing for it, each side deemed possession critical for its own ends, and yet there was no one to call "Time out!" or "Out of bounds!"

Such controversies have increased: there has been more support for the idea of public art since the mid-60s, but at the same time there are more competing definitions about what is desirable in many spheres of contemporary life. When art explores any idea, supporters of an opposing position are likely to feel excluded or offended. This echoes conditions in the 1930s, another time when there was low value consensus and a large number of art controversies, the latter in part due to the steady supply of art works produced under direct government sponsorship. In the 1930s the devils often took the shape of persons associated with foreign ideas like communism, and with possible radical action. Today, however, we are plagued more commonly by inner devils. The negative portrayal of a leader and his capabilities—and by implication, the social groups he represented—provided the troublesome themes in the Washington incident. The array of irritants expanded considerably after 1988, however.

3

HUE AND CRY

Censorship is to art
what lynching is to justice.
Henry Louis Gates, Jr., 1990

What sex was for the Victorians, race may be for Americans in the late twentieth century. It would be absurd to suggest that sex no longer makes people uncomfortable; enough controversies still swirl around the topic to attest to its continued salience. But this taboo has been squarely confronted, and now sexual matters are spoken about almost obsessively. They are a talk show staple: a giddy emigré sex therapist has disarmed us all with her frankness. But race makes people *squirm*, and can call out enormous fear or rage. One need only recall the apprehension about Spike Lee's movie "Do The Right Thing" to appreciate the tendency of racial themes to unnerve large sectors of the public. Media observers and government officials alike worried that the "long, hot summer" Lee depicted could spill from the screen onto actual city streets in 1989. In these critics' minds, perhaps it would be better to leave such themes unaddressed.

Gunnar Myrdal highlighted the discrepancy between the "American Creed" of equality and opportunity and the actual treatment of Blacks in his classic study *An American Dilemma* in 1944. And the report of the National Advisory Commission on Civil Disorders chronicled the drift toward two societies—Black and White, separate and unequal—in 1968. Despite the civil rights movement and some social advances, much of what these studies documented remains true today; racial equality and harmony are prospects that continue to doggedly elude America.

44

And these difficulties are destined to increase. The decade of the 1980s recorded the most significant growth in the minority proportion of the population during the twentieth century, a shift of such magnitude it was described with the unusually spirited adjective "breathtaking."[1] The expansion of Black, Asian, Hispanic, American Indian and other racial communities far outpaced the increases recorded by White Americans during the last decade. The change is more than merely numerical, however: many groups are resisting the assimilationist, melting-pot model, passionately insisting instead on preserving racial self-identity and pursuing self-determination.

Race is one of several significant "hot buttons," that is, issues that predictably agitate people.[2] To probe the subjects of race, religion, patriotism or sex (especially nonprocreative sex) can challenge dearly held assumptions, and invites swift and powerful reactions. Yet these are the very issues that many artists concentrate on, most especially since the mid 1980s. Artistic work commonly incorporates social and political concerns both intrinsic and extrinsic to the art world. But when outsiders attempt to combine art and politics for their own purposes it can seem intrusive; then these pursuits often repel one another, much like the similar poles of two magnets. In other words, artists resist politicization of their work in ways *they* did not intend. There is, therefore, both an affinity and antipathy between these realms.

Political issues beget social dramas. Controversies over art have erupted in a number of locales, largely because art can crystallize otherwise unexpressed sentiments and display them prominently. As we have just seen, such disputatious events signal how various groups uphold incompatible definitions of the situation and jockey for power. A morality play is generally enacted as each party promotes its own values and attacks its opponent's assumptions and integrity. And akin to the Nelson/Washington example, narratives unfold that can be read, much like any script.

In this chapter I will examine how the arts (and popular culture) sometimes have been used for expressing fresh viewpoints on timely questions, and at other moments communicate what some people consider retrograde notions. The main focus will be on race, and in subsequent chapters I will survey the topics of religion, patriotism, and sexuality, and their incorporation into contemporary artistic expression. But just as the art world has provided fertile soil for raising these matters, it has also been the place where significant social battles have been engaged in response.

NEW ENTITLEMENTS/OLD REACTIONS

The civil rights movement propelled racial issues into the foreground in the 1950s and 1960s; similar movements on behalf of other marginalized groups

followed apace. Women, lesbians and gay men, a wide range of racial and ethnic groups, and the disabled have all launched similar campaigns to break through their relative invisibility, counter their predominant public images, and gain an increased measure of the rewards this society has to offer. These have been tumultuous quests, for there has been a great deal of resistance to these movements and the people and values they represent.

This resentment is manifest in a number of ways. Documentation shows that hate crimes have increased in the US. California's Lieutenant Governor predicted that "California faces a wave of hate crimes greater than we have seen since the heyday of the Ku Klux Klan,"[3] this in a state known for its "live and let live" philosophy. In elections in Louisiana in 1990 and 1991, former Klansman David Duke garnered 55 percent of the White vote in a race for US Senate, and then made a serious bid for the governorship. Duke's support was nourished by the frustration and discontent people feel over civil rights advances.[4] A letter to the editor in the Midwest fervently expresses this viewpoint: "I get so tired of hearing about the 'poor' black people and the 'poor' minorities. What started out to be equal rights has turned into more like special rights. . . . I am tired of paying for my ancestors' mistakes."[5] For each step taken toward racial equality, there are plenty of individuals ready to push two steps backward.

The same perspective that writer represents was embodied in a Ku Klux Klan telephone ploy in the same locale. The Klan distributed a phone number to Kansas City-area school children, with recorded messages that imitated the theme music and voice of "Mister Rogers." One told of a Black child—a "nigger drug pusher"—whom the Klan lynches. The second referred to AIDS as "divine retribution" and contained the following dialogue: "Can you say 'loathsome perversion?' Sure you can. Charles and Martin don't live in this neighborhood. They live way out beyond the bounds of decency. That's not a nice neighborhood at all."[6]

Such hostility targets many types of people when they push for their rights. It is customary for those who denounce minority groups to append their descriptions of their opponents with contemptuous adjectives. Martha Clarke's theatrical work "Miracolo d'Amore" was mocked as a "feminist revenge," and California Congressman William Dannemeyer has demanded the right "not to be affronted by *militant immorality or perversion*."[7] All these volleys were hurled from the strongly held conviction that certain groups may be gaining a more advantageous social position at the expense of others.

An interesting index of how controversy over art increases when it reflects changing social viewpoints is a list compiled by the conservative Heritage Foundation of "Some Controversial NEA-Funded Works." Merely five works are noted before 1984 (spanning the first nineteen years of the NEA's history) and only two of the five represented minority concerns, that is, they explored homosexual themes. From 1984 to early 1991, twenty seven "questionable" decisions are

recounted; *every one* confronted issues of sex, religion, patriotism or race in a questioning, unconventional manner.[8]

When these topics emerge in a myriad of symbolic expressions, controversy has frequently followed. For example, a high school literature anthology was maligned by parents in the Chicago area in 1972. As the title "Speaking for Ourselves" implies, the book included the work of twenty writers representing the views of different ethnic groups. The authors mentioned by name in news accounts of this episode were James Baldwin, Saul Bellow, Bernard Malamud, Gwendolyn Brooks, Richard Wright, and Langston Hughes—all Blacks or Jews. The core of the parents' complaints was what they deemed "nasty pages" containing passages with four-letter words.[9] And it is pertinent to note that the school district in which this occurred was a southern suburban one, an area where many residents had settled after fleeing the racial transition of Chicago neighborhoods, and where the fear of racial difference was magnified.

Racial and sexual dimensions are apparent in the rejection of disco music as well. Disco initially emerged from "outsider cultures" in Black, Latin and gay settings in the 1970s. Dyed-in-the-wool rock 'n' roll fans rejected what they saw as an effete and pretentious form of expression, part of a "lifestyle" markedly different from their own. The leader of the reaction in Chicago remarked "it's gotten to the point where it is like cultural invasion." And it is surely not incidental that a media consulting firm that polled opponents reported that they found disco "short on 'balls.' " This anti-disco fervor culminated in Chicago's Comiskey Park when fans attending a disco demolition night sponsored by a local radio station blew up 10,000 albums. Shouting their byword "disco sucks," they erupted into a mob on the field, forcing the cancellation of the second game of a scheduled major league baseball double-header.[10]

Two additional examples amply demonstrate how representations which reflect new entitlements typically draw out adverse reactions. A figure of a crucified woman entitled "Christa" was removed in 1984 from the Cathedral of St. John the Divine, one of the most socially conscious parishes in New York City. Supporters saw the work reflecting recent feminist thought, whereas the official who ordered the banishment argued "this symbol is theologically and historically indefensible . . . [I support] the woman's cause both inside and outside the church . . . [but the statue is] symbolically reprehensible."[11] This admits a willingness to accept new ways of *thinking* about women, yet betrays a strong resistance to accepting material embodiments of those thoughts. It is also important to note that the film that prompted the adoption of the Motion Picture Association of America's NC–17 rating was "Henry and June," a film that depicted lesbian desire. The film was initially rated "X," even though it explored the sexual material cerebrally as much as physically. That original rating was not acceptable to Universal Pictures. Its challenge was successful largely because this major studio threatened

to upend the entire rating system if the "legitimate" categories would not accommodate the obvious changes in sexual mores that are now making it to the screen.

CYCLES OF RECEPTION

Once artists finish their work, it is largely out of their control. Or to put it another way, art works are *never* completed—they are continually reinterpreted and reevaluated by successive publics. Acceptance and rejection alternate in cycles of reception, so that the artist's intent is only one factor that contributes to the judgment of any product. In Pasadena, California, for example, a muralist painted what he meant to be a satirical mural in a restaurant, depicting city workers loafing, ignoring crime, and taking bribes. But patrons largely missed his point, seeing instead a tribute to the city.[12] In this case the relatively undisguised intent was misconstrued. In other instances wider cultural currents lead observers to endow works with a panoply of meanings, and viewers often repudiate works they believe disguise questionable motives.

Critic Arthur C. Danto is shortsighted when he makes the following remark after encountering a Mapplethorpe self-portrait that shows the photographer with a bullwhip inserted into his anus [see Plates section]: "*It would be known in advance that such an image would challenge, assault, provoke, dismay*—with the hope that in some way consciousness would be transformed."[13] Just how would it be known, and whose consciousness is he referring to? Danto assumes a monolithic audience, negatively predisposed to this type of subject matter. What he does not allow for is that the same image could also amuse, excite, or confirm already established identities. And for audiences in the future, who can say what the reaction might be: boredom or aversion, curiosity or repugnance? Danto may have recorded his own reaction accurately, but his response hardly exhausts the possibilities.

Perhaps nothing demonstrates how shifting attitudes provoke contradictory evaluations of the same work as the treatment of a statue in New York City. While its subject is not race, the fate of the work provides a template for disputes stemming from a wide range of causes. Frederick MacMonnies conceived the design for "Civic Virtue" in 1891, and it was commissioned for Manhattan's City Hall Park in 1909. The sculptural group consists of a fig-leafed, sword-bearing male figure ("civic virtue") vanquishing the two female representations of "vice" and "corruption" wriggling beneath him. It is emblematic of its time, the type of monument customarily decorating municipal plazas. Such works are generally accepted as part of the local environment and are not carefully scrutinized.

When it was initially planned it was congruent with the social ideas of the Progressive era. By the time the sculptural group was actually erected in 1922, however, social attitudes had changed. It then seemed to be insensitive toward women, out of step with a world affected by the suffrage movement. The sculptor's

defense of the work was that it was an allegory: "He [Civic Virtue] looks out into the distance so concentrated on his great ideal, that he does not even see the temptation. To suggest this temptation; its dual nature which dazzles while it ensnares, its charm and insinuating danger, one thinks of the beauty and laughter of women; the treachery of the serpent coils of a sea creature wrapped about its prey."[14] But critics rejected his metaphoric interpretation because it collided with current realities, and in 1941 the statue was exiled to the relative peace of the new Queens Borough Hall. MacMonnies lamented "This limitation of art by a literal mind is ridiculous."[15]

A substantial period of quiescence and acceptance was superseded by one of protest and rejection in the 1970s when the "second wave" of feminism hit. The Queens chapter of NOW voiced its objections at that time, and groups as well as individuals wrote to local newspapers to complain about the artwork with regularity; it has been a standard agenda item at the monthly meetings of the Queens Women's Network.

The statue has remained the same since early in the century; it is the political environment that has been radically transformed. In 1987 Claire Shulman was serving as the first elected female borough president in Queens, successor to Donald R. Manes who committed suicide in the wake of a vast governmental scandal. She took over at a time when the public trust had been seriously compromised, and female leadership had yet to be tested. Shulman's perception that the female figures portrayed women as "evil and treacherous" did not sit well with someone trying to establish her own legitimacy in the adjacent building.[16] Shulman proposed that the statue be moved one more time, a recommendation that has been stymied only because the estimates have been so costly, an expense that could hardly be justified in a time of fiscal constraint. The latest idea to counter "Civic Virtue" is to perhaps use Percent for the Arts funds at the nearby criminal court building to commission a sculpture which would "elevate"—not denigrate—women.[17] While this might complete one cycle, it would not necessarily preclude the genesis of new ones in the future.

REFLECTION AND RECONSTRUCTION

This diverse evidence regarding new entitlements and the resistance to them sets the stage to appraise race as one delicate social spot. The goals here are to determine in what ways race has provided a lens through which artistic works are made and evaluated, and to demonstrate how larger social dilemmas regarding race get played out in the relative safety of the symbolic realm. However, these concerns do not exist in isolation; instead, they commonly dovetail with other issues.

We can't reconstruct the range of nineteenth century reactions to Mark Twain's

novel *The Adventures of Huckleberry Finn*, but we can observe what some contemporary audiences have thought of it. In various times and places the book has been attacked for being racist, especially because of what is taken to be its inclusion of racial epithets. One battle over the book was waged in the northern Chicago suburb of Waukegan, Illinois in 1984. A Black alderman's reading of the text found innumerable mentions of the word "nigger," a fact that the alderman claimed automatically classified it as racist. A Chicago man backed up this position and rewrote the book by changing 166 references from "nigger" to "slave," "black," and "black man" instead, terms less abhorrent to the modern ear.[18] Defenders of the book countered that it is in fact a satirical indictment of nineteenth century bigotry. But literalness won out: the Black alderman successfully forced an all-White school board to take *Huck Finn* off the required reading list and reclassify it onto a supplemental list.[19]

Waukegan is one of those locales that once stood beyond the urban rim but gradually has been drawn into the city's orbit. At the time of the controversy the school population was one-fourth Black, and the town had a much larger minority population than is the norm for that part of the Chicago region. It also had a history of strained race relations. As the only elected Black official in the city, the alderman's sensitivity to racial matters was marked, and his defense of the interests of his constituency was unmistakable: "It's strange how white folks can always tell me what offends me and doesn't offend me."[20] He pressed for this official action as a gesture toward racial sensitivity, in order to protect the impressionable minds of schoolchildren. He and other detractors rejected a complex text that could be interpreted in a number of ways, one that documented a racist system yet at the same time also subverted it to some extent. But under adverse social and political conditions they desired certainty, not ambiguity.

Echoing the destruction of reviled images in Eastern Europe from 1989 onward, American statues have similarly attracted the wrath of those who feel these sometimes represent outmoded and dangerous ideas. In Austin, Texas, for example, a campus statue of Confederate leader Jefferson Davis has been vandalized several times as an unwelcome symbol of racism. This is on a campus with a small Black enrollment (less than four percent), and where a campaign to erect a statue of Martin Luther King, Jr. had raised only $2000 of a projected $500,000 when Davis was hit with painted slogans.[21] Attackers desired to do away with residues of an oppressive system, which they judged to be poisoning the environment of contemporary race relations.[22]

Public officials were motivated similarly when they ordered the dismantling of a post-Reconstruction era obelisk in downtown New Orleans. The monument commemorated an attempted coup against the federal government staged by a White paramilitary group. In more recent years it had become a rallying site for White supremacist groups, but the city's Black mayor, who was seeking reelection, considered it a political liability that should be eliminated. During the memorial's

ninety-eight-year history the social ground had shifted sufficiently to make it impossible to continue to buttress the work.[23]

The same rationale lead to significant alterations in the score of the classic American musical "Show Boat," whose setting in the South in the 1880s naturally deals with Black/White relations. Lyrics have been changed a number of times in deference to more contemporary racial sensibilities. The best-known transformation was in the ballad "Ol' Man River." In the original version the first line was "Niggers all work on the Mississippi/Niggers all work while de white folks play." When Paul Robeson recorded it in 1932 he substituted "colored folks," and it gradually evolved to "Here we all work." Feelings may have been spared in this editing process, but the gist of the intended meaning was lost. Universalizing the situation seriously contradicted history, unexpectedly diminishing the depiction of the injustices of the Jim Crow period. In addition, attempts to reintroduce the original elements have met with resistance. When a new recording of the bona fide score was undertaken in 1988, an all-Black chorus that had been contracted to sing withdrew in objection; they were subsequently replaced by an all-White group.[24] And in a related instance, Virginia legislators voted to grant emeritus status to their state song "Carry Me Back to Old Virginia," effectively retiring it. Because of their discomfort with some lyrics which now sound like racial slurs, they decided to substitute a new song described as "a salute to Virginia's modern potential."[25]

Music was also the artistic realm addressed by a controversial proposed sculpture, but where sexism rather than racism became the foremost issue. In 1990 an artist released his design to honor jazz great Duke Ellington with a monument at the northern end of New York's Central Park. The model placed Ellington next to a grand piano, on a platform supported atop the heads of nine naked women. The artist claimed this imagery was harmonious with the classical image of the muses, inspiration flowing from their heads. But a local columnist saw a three-story bowling trophy supported by "beasts of burden"[26] rather than Caryatids, and the female Manhattan Borough President reportedly saw red.

The design calls yet another image to mind: the extravagantly choreographed scenes of Busby Berkeley movies in the 1930s where women's bodies were used as the interlocking components of elaborate, kaleidoscopic designs. You can almost imagine such a sculpture revolving like a giant carousel or music box, sending melodies throughout Harlem. Because some people voiced serious reservations about this proposal, it was consigned to that bureaucratic netherworld where rounds of approval have to be forthcoming before a blueprint becomes reality. In this instance the cycle of reception was truncated before it advanced very far.

All these situations share two characteristics. First, groups have mobilized to confront, and in some cases obliterate, what they find to be residual symbols of racism or sexism. These actions involve an almost magical intent, as if editing out historical references will also nullify the pain of past events. But such actions have

limited consequences and largely fail to transform the underlying forces that these symbols represent. And second, these have all been defensive actions undertaken by the relatively powerless, sensitive to representations that contradict how they would like to see themselves presently. The rather chimeric desire to combat archaic images underlies many art controversies, as additional examples demonstrate.

SMILING FACES/SEETHING ANGER

It is often startling just how different perceptions of the same cultural product can be. This frequently becomes evident in the case of movies, which are customarily reviewed by a number of film critics. When two of them characterized "Fort Apache, The Bronx," for example, one noted "the overall effect is one of overwhelming depression," whereas the other saw it as "a smart, lively and often raucously funny cop picture."[27] Did they indeed view the same thing?

While certain cultural products may seem innocuous to some, others detect insidious signs of injustice in them. In the case of "Fort Apache," the filmmakers met formidable resistance from the community where it was being made. The name recalled John Wayne movies, suggesting an invidious comparison between the South Bronx and the lawlessness of the Wild West. Beyond that there was community concern that only negative characters and behaviors would be shown, thereby reinforcing stereotypical attitudes toward the poor generally, and Hispanics more particularly. This kind of concern derives in large part from the fact that there is sparse reporting of life in minority and underprivileged neighborhoods besides crises and criminal behavior. Coverage of ordinary daily life is unusual, and depictions of positive material even rarer. Movie representations therefore are endowed with great power, either to sustain or potentially to contest social beliefs. As one opponent argued, "*Fort Apache* is not 'just another film'—or some isolated example. It is one of a million little pieces being fit together in a terrifyingly repressive pattern that reinforces the racism and sexism necessary to maintain the status quo."[28]

Community displeasure coalesced with the formation of the Committee Against Fort Apache (CAFA), a citywide coalition of one hundred organizations. And the pressure they exerted did have a tangible impact upon the film: producers agreed to affix a disclaimer stating that it did not represent "law-abiding" individuals who are "trying to turn the Bronx around." This was a counterpoint to a tale that primarily peoples its action with drug addicts, pimps, and a suicidal transvestite, a tragicomic Third World "Our Town." And it marks the emergence of a type of interest group politics based upon the common identity of shared minority status that was to mature considerably later on.

Ten years hence a similar scenario unfolded regarding another movie, "The Bonfire of the Vanities." The Borough President strongly criticized the movie as

an example of "Bronx bashing" because of its largely negative characterizations,[29] and a New Jersey judge refused permission to use a courthouse filming location because he disapproved of the story line. The contested scene was to show Blacks rioting in court over the acquittal of a White Wall Street bond trader charged with running over a teenager with his Mercedes (his mistress was actually at the wheel). The judge insisted upon changes in the script; otherwise, this depiction "could seriously undermine the confidence of black citizens in our court system."[30]

The scene was shot elsewhere, and the judge's decision was later overturned as a violation of the First Amendment. But this was an extended and acrimonious incident. This film, too, included a disclaimer about not representing the gamut of behavior to be found in this part of the social world, a small gesture meant to offset what many members of lower class and minority communities insist is a standard strain of insults and exclusions.

Complementary to these direct actions has been the development of a critical, debunking attitude in a number of academic disciplines. This approach aims to decode messages that may be included in everyday representations and force a reconsideration of them. One such advocate is Ariel Dorfman, for whom children's literature contains parables about authority relations: parent to child, and the developed world to the Third World. Babar is not just an elephant, but represents the neocolonial mentality. Disney's locales are patronizing neologisms: Backdore, Footsore, and Howdoyustan in India; Unsteadystan and South Miseryland in Southeast Asia. Pernicious subtexts are woven throughout what he calls "industrially produced literature," lessons about hierarchies and obedience which blunt rebellion and help sustain the world as it is.[31]

The same type of concern was evident in a 1981 film festival held in New York entitled "Sex, Violence and Racism in Cartoons." The purpose of screening such works as "Goldilox and the Jivin' Bears" (1941) and "Coal Black and de Sebben Dwarfs" (1942) was to unmask the stereotypes that reduced their subjects to silly caricatures. As a reviewer bitterly asked, "How could Al Jolson's blackface *image* [in the cartoon "Clean Pastures," 1937] erase the *fact* of Joe Louis in newsreels?"[32] Other observers have noted that more recent children's entertainment extends this tradition, with two characters from the enormously popular "Teenage Mutant Ninja Turtles" depicted as a boar and rhinoceros, Rock Steady and Bebop. The names of these loutish critters represent two types of Black music, and they have been criticized for perpetuating racist assumptions.[33]

Actions to directly contest the perpetuation of demeaning racial stereotypes have gone beyond mere theorizing, as evidenced by the examples of protests over movies just recounted. Black activists and artists also challenged a well-known Quaker Oats character as a despised icon of Black subservience in the 1960s and '70s. Betye Saar's 1972 "Liberation of Aunt Jemima," for example, juxtaposed one image of the woman with a gun, against another with her holding a White baby before a backdrop of smiling faces. The company yielded to pressure so as not to

lose their immensely popular trademark, and over the history of the character she
has abandoned Black dialect for standard English; her kerchief was progressively
cropped back and then finally dropped altogether; and her features became less
African and more "modern."[34] Overt pressure is no longer necessary. Quaker Oats
is now more acutely aware of what the contemporary market will bear, and now
acts accordingly.

This type of character already had been consigned to history in a previous
transformation in a different symbolic realm. In the 1934 film of "Imitation of
Life," Aunt Delilah (Louise Beavers) hands her pancake recipe over to her White
employer, who then launches a successful business with it. In one of the most
egregious scenes Miss Bea (Claudette Colbert) orders her maid to strike a pose
with a full smile, a likeness that is caught and reproduced on restaurant signs and
packages. Director Douglas Sirk preserved the intertwined stories of mistress and
servant in his 1959 version, but completely dropped the pancake scenario.

The refusal to abide antiquated representations continues to occur. In 1989 a
mural design proposed for a Harlem park was rejected by the local community
board because members felt it was an unfavorable, "minstrel"-type image. The
work was intended to honor the entertainer Bill ("Bojangles") Robinson, but was
regarded as an insult instead. The issue was resolved only with the substitution of
another photo to be used as a model, one that did not have what some had seen
as the stereotyped "white lips" of a minstrel in the original image.[35]

One of the more tangled battles of this ilk addressed many of the same matters,
but added an international twist to the cultural conflict. The Parsons School of
Design, an affiliate of the New School for Social Research, mounted an exhibit of
Japanese graphics in 1989. One of the 350 works by commercial artist Shin
Matsunaga was an advertisement for a soft drink that featured a happy-go-lucky,
cartoon-like Black figure with large lips, top hat and tie. This figure was the
company's logo, not Mr. Matsunaga's creation. Both a dean as well as the Black
Student Association felt it was racist and pressured the New School administration
to either take the image down or post a disclaimer next to it. Both requests were
rejected. Following these failed attempts to effect their will, the drawing was
defaced by an instructor who scrawled "This is racist bullshit" over the piece, and
drew a large "X" across it. In addition, he signed his name to what he had done,
a brazen gesture repeated later by about forty students.[36]

This work is not an anomaly, but rather a typical portrayal from Japanese
culture. According to historian Joseph Boskin the Sambo image was introduced
into Japan over 100 years ago.[37] And anyone who has visited that country in recent
years is well aware of the extent to which racial images that would be deemed
unsuitable in the United States have permeated popular culture there, especially
goods manufactured for children such as toys, clothing, bubble gum, and so on.
Although Japanese businessmen claim these images are not discriminatory—one
company spokesperson claimed consumers "enjoy it [Sambo] with good will"—

they have become an important and appealing marketing device in an extremely xenophobic society.[38]

High government officials made controversial public statements in 1986 and 1990 that additionally confirmed Japanese racist attitudes: one was critical of the intelligence of Blacks, while the other compared them to Tokyo prostitutes. Each of these slurs proposed that Blacks were a drain upon society. But there is evidence that approval of the public expression of such attitudes and the display of these images is diminishing in Japanese society. The Japanese government became worried that these sentiments might sour the climate for Japanese business in the US, and it undertook a campaign to eradicate racist representations. In fact, the disputed logo is one of the symbols that has been retired.[39] Part of the reason this strategy has been successful is that it highlighted the offensive characterizations that Westerners made in the past of the Japanese with topknots and buck teeth.[40]

The New School administration argued that freedom of expression would be seriously compromised by taking the picture down, and refused to capitulate.[41] Opponents argued just as strongly that it should have never been allowed to appear, and that it deserved to be challenged and despoiled. The dispute continued to seethe even after the exhibit ended its fully scheduled term, however, erupting later during a "Day of Love and Outrage" with student demands for more minority representation in the student body, faculty, and administration, an event which also included the burning of copies of the school's course catalog.[42]

OUT OF THE ART GHETTO

Incidents such as these illustrate how certain images have been deemed racist when judged from a vantage point different from the time and place they were originally created. But the impulse to rectify past racial injustices is not the only course these art controversies may take. In fact, some of the most impassioned confrontations derive from contemporary works which do not shy away from the most difficult material. Some artists have deliberately chosen to engage their audiences on a visceral level, tackling ideas that are generally considered hands off. This becomes complicated because we often prefer to wish troubled race relations away, and therefore have relatively little experience dealing with the topic when it is addressed artistically. Contemporary art which examines racial themes is commonly satirical, ironic, and multi-dimensional, making it subject to many interpretations. Typically, then, it raises many more questions than it answers, so that the reception it summons is mixed at best, furiously hostile at worst.

A few present-day Black artists have escaped the aesthetic stranglehold of realistically recording "the Black experience" and have embarked upon idiosyncratic explorations of racism in the art world and in the world at large. To cite an example: Robert Colescott is a subversive painter par excellence. He seems

hell-bent upon attacking the fine art canon by insinuating Black images into classic canvases. He relocates Picasso's demoiselles from Avignon to Alabama; he endows Van Gogh's potato eaters with exaggerated Black features, and retitles his own rendition "Eat Dem Taters." Van Eyck, deKooning, and Matisse are all treated similarly—with enormous irreverence and wit. Both popular cliches and revered images become grist for his sardonic mill: a dark-hued Shirley Temple [Black] strolls down an idyllic garden path with "Bill Robinson White," and interracial satyristic scenes are presented with lusty frequency. Colescott does not shrink away from what's most forbidden; he playfully dirties his hands with it.

This is a complex body of work which creates a great deal of self-consciousness in viewers. It's very difficult to figure out how to respond to a Colescott exhibit. Is it polite to laugh at stereotypes? Could he be reinforcing social cliches at the same time that he's holding them up for critical examination and, most likely, ridicule? Is the work acceptable because the artist is Black? There are no simple answers to these questions, and Colescott has sparked controversy. On the Akron stop of a nine-city tour, for example, his retrospective was condemned by some local Black leaders. The debate was lengthy, but was contained within the bounds of dialogue; repressive actions did not occur.[43]

The fate of the artist David Hammons has been different. Hammons likewise confronts racial issues in his work, sacrificing diplomacy for candor and inventiveness. In December, 1989 he had a fourteen- by sixteen-foot painting on tin erected on government property in Washington, D.C., part of an outdoor installation series in conjunction with a show entitled "The Blues Aesthetic: Black Culture and Modernism." The painting presented a bust-length portrait of Jesse Jackson with White skin, blond hair and blue eyes, a publicist's dream candidate for political office. Across his chest, Hammons wrote the title (and challenge): "How Ya Like Me Now?" Before three White art handlers were able to complete the installation, however, a group of about ten Black men became engaged in an argument with them about the piece, and then tore it apart with sledgehammers.

The artist's intent was to address the fact that Jackson's race has been an obstacle to his electoral success. Were he Caucasian instead, his political fate might have been quite different. Many people understand this as a fact of life, but it generally remains off-limits in public discourse. Hammons characterized the work as a "very on-the-edge experience." But as he further explained, "Black America has a lot of trouble looking at visual puns. . . . We're used to hearing them from comedians—not seeing them. And when we do see visual comedy, it's usually against us, with large lips and watermelon, that sort of thing."[44] Jackson himself appreciated the multivalence of the painting and found it to be inoffensive, but it was damaged to such an extent that it had to be replaced at that site solely by a sign that explained what had happened.

Hammons's creations have been vandalized before.[45] His subject matter *is* discomforting and challenging, and problems have occurred with it when he has

displayed works in public. In these instances the luxury of studied deliberation is much less available than in a gallery situation. In addition, the probability that people will bring a wide range of attitudes toward art with them is heightened, as is the possibility of being caught off guard by the artwork, and reacting strictly on an emotional basis. Consider, too, that Washington, D.C. had a Black mayor at this time who had been highly criticized in the national press for personal misconduct and official ineptitude. Marion Barry had been in the headlines through-out the year, most spectacularly for his arrest on drug charges. But many Blacks felt he had been set up and that the countless condemnations levelled against him had been racially motivated. This sustained and consistently negative attention had created a sensitive climate of opinion; once again the social environment provided hearty conditions for the growth of controversy.[46] But Hammons is irrepressible, and the Jackson work endures, albeit in changed form: it is now displayed behind a barricade constructed from sledgehammers, a tangible allusion to the ongoing interaction between artist and audience.

"WHAT DO THORNTON WILDER AND PIGMEAT MARKHAM HAVE IN COMMON?"[47]

Indeed, what could one of the most traditional of American playwrights and a Black burlesque comic possibly share? Answer: controversy, because of the consolidation of their work into a theater production by The Wooster Group in 1981. Although this event predates the primary time frame of this study, it provides an important example of how the government can rebuke the beneficiaries of its largesse.

The Wooster Group is one of the oldest and most respected experimental theatrical collectives. Founded in 1980, it has roots in two earlier companies: the Free Southern Theater, an integrated troupe that performed in Mississippi in the 1960s, and the Performance Group, both of which involved the important theater figure Richard Schechner.[48] It has long been known for its ensemble productions that feature a nonlinear, abstract aesthetic. The troupe's works are dense collections of eclectic materials and incorporate various media such as stage performance and video. In the words of the company itself, ". . . like collages, they [their perfor-mances] have been constructed . . . with the structure, dynamic and meaning of the piece as a whole being derived from the choice and placement of the elements. . . . Personal risk, exposure and the expression of repressed material can go hand-in-hand with purely abstract aesthetic aims."[49]

Although autobiographical elements are often incorporated into these produc-tions, the boundary between what is documentary and what is fabrication is indistinct. The casting is anti-naturalistic, that is, men play women, children take adult roles, and Whites play Blacks. Sensitive subjects have been broached routinely,

including sex, suicide, and madness. And in order to construct their own productions, the company has appropriated sections from works such as T.S. Eliot's "The Cocktail Party," Eugene O'Neill's "Long Day's Journey Into Night," and Arthur Miller's "The Crucible." Generally they have borrowed without authorization, and they encountered legal difficulties with respect to Arthur Miller. Ironically, the troupe did pay royalties to the estate of Thornton Wilder for the use of material from "Our Town" in their controversial presentation of "Route 1 & 9," a right that the estate later rescinded.[50]

Two of the live performance sections were at the center of this controversy. In one, White actresses in blackface phoned real restaurants, attempting to order fried chicken for delivery. They used what would generally be heard as urban, Black dialect in their calls. And in the other, four White actors in blackface reenacted a 1965 Pigmeat Markham routine entitled "The Party," a risque mix of sexual bravado and raucous jokes.

Wrapped around these segments were several others. The opening presented a stiff recreation of a 1960s-style film interpreting the play "Our Town" to a schoolroom audience. Another video scene used a soap opera style to enact a scene between the young lovers in the Wilder play, and one other vignette from Wilder (set in a cemetery) was also presented by the actors on stage. In an additional video segment, faceless couples were shown copulating. In other words, a number of components were juxtaposed, including sentimentality versus lust, controlled and unrestrained emotion, Black and White, live versus filmed performance, and so on.

As confusing as this may sound, "Route 1 & 9" was structured much like other Wooster Group pieces had been, and this mélange of subjects and artistic forms should have seemed familiar to most of its audience members. What was unexpected, however, was that many critics and viewers felt the production was weak, somewhat incomprehensible—and, most importantly—racist. The controversy brewed with charges and counter charges exchanged in many newspapers and magazines, and was eventually brought to a boil when the New York State Council on the Arts (NYSCA, a major funder) announced it was awarding the Wooster Group only sixty percent of their previous year's allocation for use in the 1981–82 season. The remaining forty percent was what NYSCA estimated had been used to produce "Route 1 & 9."

The Wooster Group countered NYSCA's action with an eloquent defense of their work, a thirty one-page retort which cited sources as diverse as Wittgenstein and male drag. It also included a series of appendices containing such documents as the 1933 court decision overturning the obscenity ban on *Ulysses*, as well as an impressive array of letters of support from important avant garde artists, arts organizations, and even a writer on *New York Post* stationery. While some of these correspondents had mixed reactions to this specific production, none could find a pattern of offense, and all were disturbed about NYSCA's punitive action. As

Mabou Mines' Ruth Maleczech questioned, "Are there things better left unsaid? Imagery better left unexposed? The implication is that silent racism is preferable to an exposure of its existence."[51]

NYSCA felt the production contained offensive racial mimicry that could be interpreted as slurs, and that the Wooster Group had not qualified or disclaimed their intentions. But the troupe's position paper dismissed these charges. As it contended, "though Route 1 & 9 may raise the issue of racism in the minds of its audiences, it is not 'about' racism because it was not created to discuss this, or any other theme. . . . In the most profound sense, the piece has nothing to do with blacks."[52] They argued that they were reworking elements in a metaphoric way: the depictions of White, small-town America as well as Black, urban culture were stereotypical. In addition, meaning develops out of the *relation* between the parts in this type of theater, so that separating out sections as if they were coherent, freestanding elements seriously misrepresents the design and misinterprets the company's intentions.

This was an instance where extremely complex material was read in only one way by those who held vital purse strings. Instead of appreciating the possibility that quoting racist material might not in itself be racist, NYSCA drew back from being associated with work that *could* cause offense. It is important to note that the controversy was one that was largely confined to a White artistic world,[53] but that it had the potential to be used by self-appointed defenders of "the 'public's' sensibilities and money," and might therefore potentially break out of the arcane downtown world of experimental theater. NYSCA took the safest route by dissociating itself from this work, yet missed the opportunity to appreciate the multitude of meanings likely contained within it.

NYSCA's twofold strategy of separating the parts of an intricately fused work of art and exacting retribution from the Wooster Group for its attempted exploration of dicey themes set precedents for subsequent actions. What NYSCA saw simplistically (and through a bureaucratic frame of reference), the Wooster Group viewed in a much more multifaceted and troubling way: "Images which express the furtive desire to dissolve . . . boundaries evoke the greatest cultural anxiety," they argued, "and are either suppressed altogether or tolerated briefly only in highly ritualized contexts."[54]

WHAT'S IN A NAME?

The limits of tolerance had been seriously tested within the art world shortly before the dispute over "Route 1 & 9," in another conflict that pitted artist against artist, A show entitled "The Nigger Drawings" (1979) raised similar concerns over racism and public accountability, and literalness versus ambiguity in artistic work. The controversy occurred at the respected New York City nonprofit gallery Artists

Space (a locale that would again become a major battleground ten years later) and demonstrated some of the ubiquitous aspects of artistic conflicts, characteristics that exist regardless of the political affiliations of the parties involved.

"The Nigger Drawings" were a series of abstract pictures combining charcoal drawings and enlarged photographs. The works were each composed of three panels, the images suggesting dark landscapes. They were created by Donald Newman, a 23-year-old White artist who went by the name of Donald. The artist cited the use of the word "nigger" as his way of both diffusing the pejorative meaning of the term and intentionally identifying with the travails of a marginalized group, applications he claimed artists had made for seventy five years: "Its use in this context continues to be its de-racialization, which cannot forsake its etymological history of ignorance and bigotry. The word's use in titling works of art, particularly when their content is not to be deemed explicitly racist, constitutes part of this process."[55] He describes his work as both romantic and harsh, and wanted a designation which "would be provocative in a poetic way."[56]

At issue was the title, not the work itself, which garnered an extremely positive review in *Art in America*, for example. But some people took "The Nigger Drawings" to be capricious and insulting, a serious racial affront. Commentators coined the word "brutality chic" to characterize Donald's gesture as a nihilistic, antihumanistic impulse coming out of the punk subculture of the time.[57] As such, they believed it could not go unchallenged. A Black woman recoiled in horror at the show's name and its associations: "Almost at once the stench of southern jails, cocked guns, dog bites and the ever present red-screaming cries of 'nigger' were around me. The time was not 1962, however, as a child caught between the desegregation of Columbus Ohio schools; it wasn't my life's experiences in Georgia, the Carolinas, Mississippi or Alabama (1967–1972), but it was New York City, 1979, challenging the very existence of myself and other blacks. . . ."[58] The show similarly prompted a cartoon that depicted crucified and lynched Black men on a gallery wall with the caption "We do hang black painters exclusively, but that's purely an aesthetic decision!" It also led the gallery's director, Helene Winer, to claim "I felt like a Southern Sherrif [sic]" when she faced her critics during a heated three-hour confrontation at Artists Space *after* the show had completed its run.[59]

Many viewers opined that the use of "nigger" was not inherently racist;[60] only a portion of the people who spoke publicly about the show made the literal equation between racist words and racist intent. Helene Winer recalls that she directly questioned Donald about the title and was satisfied it did not arise from bigotry. She had no concerns about the exhibit: "I didn't quite like that he'd chosen to call attention to his show, or make it slightly more high impact than maybe the work itself would cause [sic]. [But] I didn't think the use of the word would be problematic, frankly. I never considered that in an alternative space that's small and that shows new art by unknown artists; there's no audience but the art world and related people."[61]

But outrage among some of those very individuals spawned a protest group (the Emergency Coalition), and an impassioned letter writing campaign to NYSCA. Two themes ran through these letters. First, there was the assertion that the title "The Nigger Drawings" was a blatant expression of the racism operating within the art world, a factor that was generally apparent only if someone stepped back to notice the systematic exclusion of Blacks from exhibition opportunities. One incensed Black artist wrote, "To think that Artists Space, another clone of the Council is funded to put on a show that's an insult to everyone on a multitude of levels is saying to these [minority] groups that no matter how good you get, no matter how much you are needed, you ain't what we are and therefore will never drink from the same fountain we do."[62] In this sense, only the fact that Donald's gesture was overt was a surprise. And second, there was the demand that NYSCA separate itself from art that demeans ethnic, racial, or sexual groups, and punish Artists Space for faulty judgment by withholding funds.[63] Artists were calling for greater policing of their fellows since they believed some artists obviously could not deal responsibly with their creative freedom.

As mentioned, Donald represented the punk subculture. He had recently returned from England (original home to the movement), and sported blue hair, pale skin, and black attire. According to one of his advocates, critic Peter von Brandenburg, Donald was a "laissez-faire militant" who took his "posture of absolute unconcern" seriously.[64] Opposing him were Black artists who felt ostracized by the art world—from the most venerable museums to alternative spaces— and their White supporters.

Black artists recognized this chance to dramatize the segregation of the art world. Winer claims that one Black artist disclosed directly to her, "It's too bad you left the door open because we're really going to exploit it." Artists Space was a strategic yet ironic target. It, too, was positioned on the margins of the art world. But as political liberals, its staff and board members were destined to actively wrestle with the charge of racism. According to Winer, "We were being exploited in a way, becoming victims of a larger cause. And we had very little say in it, about who to talk to, how to correct it. [But] that was not the issue, *us* making the correction. I always felt we didn't make a good enough villain to be subjected to such a situation. But, an adequate villain."

Von Brandenburg and Newman characterize the White antagonists as a leftover avant garde, an "old new left" that didn't understand what it was viewing. To von Brandenburg they represented a group of so-called radicals who were reluctant to surrender the mantle to a new generation of artists, using Stalinist techniques to enforce their outmoded beliefs. Newman derisively portrays them as "hippies smoking dope and dancing to Crosby, Stills, Nash and Young in their lofts; my friends had 'crown of thorns' haircuts." Both men argue that this was a transitional moment—the "tail end of something"—when the proverbial "fifteen minutes of fame" was concluding for one circle and about to begin for another.

Much of the dispute headed straight to the funding source, skirting direct confrontation with the artist or the gallery staff. In fact, the controversy swelled behind their backs. According to Winer, "I was sort of the last to know [there was trouble]. It never bothered anyone in my presence." She reports that she attended a NYSCA meeting where director Kitty Carlisle Hart informally mentioned " 'I understand we're having a bit of a controversy at Artists Space.' And I said 'No, not that *I* know of.' And I thought, 'I wonder what that was about?' And I honestly didn't have a clue." The protestors' surreptitiousness was met by defensive action. For example, Winer and her staff closed Artists Space for the day when they learned at the eleventh hour that some people were planning to stage a teach-in/demonstration inside the gallery. The unspoken and the misspoken became the norm in this situation.

NYSCA responded to the pressure of quarrelsome media coverage and the letter writing campaign by sending Artists Space a telegram that conveyed its distress over the show and claimed that "We believe art should bring people together and not be divisive."[65] And according to Winer, shortly thereafter NYSCA funds that Artists Space was expecting were indeed cut. But what might have been one gallery's loss was another constituency's gain. This incident marked a turning point in exhibiters and funders recognizing that they should be more sensitive to racial matters and should attempt to incorporate racial minorities into their programs.

This dispute reflected the enormous amount of emotion that can be called out by some artistic productions, in this case not by the work itself, but the label appended to it. It put some artists in the uncomfortable position of trying to do the right thing by urging repressive actions they would likely condemn otherwise. As Newman's contemporary frame of reference now leads him to reflect, "I was very surprised that it [the protest] was coming from people who themselves had done very radical things and who espoused Marxist art theory, [yet] acted like Jesse Helms . . ." What emerges most clearly from this dispute is the sense of violation and hurt this work caused, the fears it raised regarding what was going on in the culture, and the literalness with which the work was evaluated. As Winer recapitulated the controversy, "We were defending against censorship and protecting the right to use even confrontational language or different language by artists for purposes of their own. I wish the artist in our case had had better purposes. He had none, frankly."

The divisions this uproar caused were extremely slow to heal, and the personal consequences reverberated for some time: von Brandenburg claims he was "blacklisted" and couldn't publish in certain magazines for five years, Newman eventually abandoned his art work, and Winer occasionally continues to confront lingering resentment when people learn she was the director of Artists Space when "The Nigger Drawings" were shown. All three individuals were extremely circumspect in their remarks. But this was a watershed event and its scenario was to be repeated

in many respects in the future, with different individuals taking on roles as accuser or transgressor.

FROM EXCLUSION TO INCLUSION

An important study released early in 1991 on race relations and racial attitudes in the US highlighted an important contradiction. In surveys conducted since 1970, White Americans have given a stronger endorsement to policies such as busing for school integration, strategies which could help bring about a more equitable society. However, White Americans have not altered their prejudicial attitudes toward other groups: they still believe Blacks and Latinos to be less intelligent, more violence-prone, less hardworking, and so on.[66] In other words, people now understand it is not as acceptable as it once was to offer resistance to racial justice, but the beliefs that nurture such opposition continue to endure.

In the artistic world there have been attempts to puncture these persistant stereotypes that retard social change, employing both reactive and proactive strategies. Some artists and curators have specifically set out to challenge racial stereotypes. The exhibit "Prisoners of Image: Ethnic and Gender Stereotypes Yesterday and Today" (Alternative Museum, New York City, 1989) simultaneously displayed artifacts and other material that incorporated stereotypes, and artistic works that confronted and disputed such representations. A great deal of the art work in the monumental "Decade Show: Frameworks of Identity in the 1980s" (New York City, 1990), cosponsored by the Museum of Contemporary Hispanic Art, The New Museum of Contemporary Art, and The Studio Museum in Harlem, similarly attacked outmoded cultural images, and presented alternatives deemed more satisfactory by the groups being depicted. And a show entitled "15 Contemporary Artists of Mexico" (Mexican Fine Arts Center Museum, Chicago, 1990) included works such as "The True History of the Conquest of New Spain," which placed the beaming mascot of the Cleveland Indians baseball team onto the forehead of a basalt Olmec Indian head, contrasting a demeaning depiction from popular culture with a dignified remnant of an ancient culture. Many more examples could be cited from what has become a cavalcade of self-consciously revisionary work.

Some art world participants have tried on occasion to take this process a step further, by confronting what they see as the systematic exclusion of certain social groups—and art reflecting their experiences—from the hallowed halls of the institutionalized art world. This has certainly been the raison d'etre of the Guerrilla Girls, the semi-anonymous group of women that periodically covers the walls of downtown Manhattan with posters which expose the sexist practices of art museums, galleries, and critics. It is also what motivated women in an "Artists Missing in Action" protest against the Los Angeles County Museum, where they

denounced the long-standing exclusion of women artists from a series of shows by accusing a curator of having "Visiona Narrowsa."[67] And in Richmond, Virginia the Arts Council, under pressure because of its sponsorship of earlier controversial shows, tried to avert a crisis by insisting that a show be re-juried because judges initially failed to include any Black artists.[68]

On occasion this last type of situation has forced what might otherwise be art world curiosities into fervent, public struggles. For when politicians or interest groups attempt to redress inequities of representation through so-called affirmative action strategies in the arts, the omnipresent problems of these schemes are sharply thrown into focus. This is not to argue that it is only in the artistic realm that charges of institutional bias, tokenism, talent versus demographics, or reverse discrimination arise. Far from it; but these issues are more likely to garner headlines and stimulate sustained public debate when they relate to Broadway shows than when they spring out of the local factory.

A case in point occurred in Detroit when the state legislature withheld $1.3 million in state aid from the Detroit Symphony Orchestra until it hired additional Black members. This group was particularly vulnerable to such pressure because a declining audience base had made the orchestra ever more dependent upon public support. Politicians demanded that in return for this money the orchestra must have more than two Black musicians out of ninety eight members, particularly because Detroit is sixty percent Black. This was an especially difficult situation for two reasons. First, the standard practice of the orchestra was to hold blind auditions, that is, musicians performed behind a screen in order to prevent discrimination. Now it was being instructed *not* to be color-blind. And second, the pool of qualified classical musicians who are Black is extremely small, a social fact that can only be remedied by the establishment of training programs that will nurture talent over an ample period of time.

Artistic quality cannot be concocted overnight, but meeting quotas and deadlines may appease politicians without solving long-standing problems. This matter caused a sense of unfairness among many in the music world when a Black bass player was indeed hired, and generated fears regarding unwarranted governmental interference. The issue merited extensive media coverage, including a front page story in the New York Times,[69] coverage that would be unlikely if this had concerned the hiring of one man in another realm of work.

A similar situation developed in Chicago, in yet another instance of art and politics refusing to be amicable bedfellows. In 1990 a significant battle ensued over mounting "The Chicago Show."[70] The promise of this show and its eventual undoing are evident in its prospectus and an accompanying informational document: "This exhibition will showcase the talent and cultural diversity of the artists residing in Chicago and environs"; "The organizers are sensitive to the many concerns and ramifications of such an important show. Efforts to be as inclusive and representational as possible are an integral part of the program's development."[71] But while

the show's goal might have been "cultural diversity," its selection process was not congruous with that outcome.

Organizers relied upon a blind jury method to sift through over 1400 applicants for ninety exhibition slots. That is, jurors looked at slides of work, unaccompanied by data on the artists such as race or sex. Without this information it was therefore highly unlikely that a broad racial mix would be obtained. Interestingly, the six minority artists whose work was juried into the show (three Black, two Asian, one Hispanic), represented an acceptance rate closely approximating their presence in the application pool (there were less than 100 minority applicants). When the jury had done its work, however, it was clear this would not be a satisfactory outcome for an exhibit partially sponsored by a city agency. Nor could these numbers be politically sanctioned in a city now run by an interim White mayor (Richard M. Daley, son of the late "boss") presiding over a delicately balanced racial coalition.

Blind juries aim for quality, not racial parity. If diversity were indeed the goal, a curated show would have been the best means to insure that end. If that had been the method of choice, someone would have been empowered to invite the participation of artists whose work—and racial identities—supported the chosen theme. However, faced with a roster of artists whose racial composition was a potential political handicap, public officials suspended the formal procedure and supplemented the list with twenty additional minority artists drawn from the original pool. But an action which was intended to deflect controversy, instead attracted a great deal more.

The situation was complicated even further when the city's Department of Cultural Affairs decided to mark the invited entries with an "i" and the juried entries with a "j." This second-class citizenship compelled some minority artists and an important corporate sponsor to threaten to withdraw. Critics had a heyday responding to this procedural mess, claiming that the decision to suspend the rules and in essence override the original jury's deliberations was "a kind of reverse red-lining," "aesthetic colonialism," and "jury-mandering."[72] As one disgruntled White artist who was *not* included in the show complained, "The [jury] process is democratic. Like our form of government, it has its failings, but within the rules agreed upon by all who participate, everyone has a fair and equal opportunity. Once the rules have been set, they should not change after the selection."[73]

City officials attempted to turn an art exhibit into a racial "demonstration project." Perhaps this was a noble mission, but it was hopelessly bungled. Organizers had been well-intentioned when they called for entries: they extended special outreach efforts to minority neighborhoods and institutions, blanketed the art community with notices in English and Spanish, and offered technical assistance grants to help inexperienced artists prepare their applications and slides. But they unwittingly sabotaged their objectives by their subsequent conduct, and managed to alienate just about everyone. Minority leaders were furious, as were otherwise progressive leaders of various art groups.

By the time the show was finally installed with the full complement of 110 artists (90 plus 20, with no distinctions made between them), it was hardly possible to look at the art without hearing the reverberations of the acrimonious charges and counter-charges. Reviews were mixed, but tended toward the negative. Although one critic called "The Chicago Show" "a knockout," evaluations of "stale and mediocre," and "mealy-mouthed Milquetoast" predominated.[74]

The political machinations that unfolded once again revealed a city crosscut by racial tensions, and one in which new political players were emerging. For example, the aforementioned Mexican Fine Arts Center Museum usurped a leadership role in demanding greater inclusion of its constituents, a part that it had never played, since it was a relative newcomer on the Chicago cultural scene. During its brief history it has thrived on a great deal of support bestowed by foundations, the business community, and city agencies. The museum's institutional experience is an example of greater enfranchisement bringing tangible rewards, yet accompanied by a feeling of *relative* deprivation: expectations probably outran opportunities.

By revealing and then deepening racial divisions in such a sensational way, this dispute influenced subsequent decision-making occasions related to the public art world. An ad hoc group called the Alliance for Cultural Equity arose out of this turmoil, and pressed for significant minority representation in an art collection the City of Chicago would purchase for the new Harold Washington Library Center. The Department of Cultural Affairs proceeded extremely carefully in conducting its search for this material, and issued a guarantee that fifty percent of the artists to be included would be women, and sixty three percent would be minority artists.[75]

"The Chicago Show" demonstrates that even the best plans can go awry. As the director of the Illinois Arts Alliance commented while the drama was being played out, "The intentions of everyone concerned are sensitive to the arguments of the other, and sensitive to what the real goal is and what they would like to see occur. You don't have religious fundamentalists and the fear of art [operating] here. But they [all] feel in terms of what principles they're honoring that they can't budge."[76] The art world is no longer protected from the intrusion of real-world concerns, but obviously their accommodation has been somewhat turbulent.

THE FALL (AND PAINFUL RESURRECTION) OF "MISS SAIGON"

Nowhere was this more evident than in the controversy surrounding the play "Miss Saigon," which assumed national (and international) dimensions in 1990. In the words of theater critic Frank Rich, "Actors' Equity has, I fear, stumbled into its very own Vietnam."[77] The analogy was apt: not only did it allude to the subject matter of the play, but it also characterized a protracted and complicated struggle

that required people to determine which side held the moral high ground, pitted them against one another based upon their allegiances, and forced them to reconsider American ideals and practices that revealed regrettable past behaviors. It was a touchstone event, and much like the David Nelson painting of Mayor Washington, the casting of "Miss Saigon" brought many strong emotions to the surface.

The facts of the situation are fairly straightforward. British producer Cameron Mackintosh planned to bring his successful musical from London to New York in April, 1991. By July, 1990, it had already racked up a record $24 million in advance sales. But Asian-American and other theater workers complained about the casting of Jonathan Pryce (a Caucasian) in one of the principal roles as a Eurasian pimp. As a consequence of pressure from these union members, Actors Equity voted to bar Pryce's reprise of his Olivier award-winning London performance, in accord with union rules which allow foreign actors to appear on the American stage only if they have been certified to have "star" status, or if they provide "unique services" that American actors cannot duplicate.

But Equity reversed itself and decided to allow Pryce to appear after Mackintosh threatened to withdraw the production, and 140 Equity members petitioned the union to reconsider its action. The union admitted that it had "applied an honest and moral principle in an inappropriate manner."[78] That principle was equal employment opportunity, one of several doctrines which were held up for careful scrutiny during this dispute.

The complaint against Pryce was channelled through the Committee on Racial Equality of Actors' Equity, and a number of groups of Asian artists spoke against the prospect of a Caucasian capturing what they felt should be an Asian role. The long history of Whites assuming Asian characters was recounted in many news stories: Warner Oland and Sidney Toler as Charlie Chan, Boris Karlof as Fu Manchu, Peter Lorre as Mr. Moto, David Carradine starring in "Kung Fu," and Katherine Hepburn and Walter Huston as the leads in "Dragon Seed."[79] "Miss Saigon" was regarded by Asian-American actors as yet one more unfortunate chapter in a painful tradition of fraud and exclusion. As a representative of the Pan Asian Repertory Company declared, "In an ideal world, any artist can play any role for which he or she is suited. . . . Until that time arrives, artists of color must fight to retain access to the few roles which are culturally and racially specific to them."[80]

This statement denotes both an impatience with the failure of the art world to expand opportunities for minorities, and a refusal to yield any additional roles to nonminority performers. The pool of professional minority theater personnel is in fact meager, and their employment prospects terribly bleak. Only about 400 of 40,000 Equity members are Asian, while the Screen Actors Guild counts 8,250 total minorities among its 62,500 members.[81] And of 100 Equity shows produced between April 1989 and May 1990, thirty three shows had no ethnic minority

actors, and twelve others had only one or two.[82] Equity president Colleen Dewhurst decried the casting of Pryce as comparable to using blackface in a minstrel show, a remark that was turned against her when her own 1970 performance in Brecht's "Good Woman of Szechwan" was later recounted.[83]

While minorities claimed that only they could play this role, many others reacted against what they took to be "trendy racism."[84] In fact, major newspaper editorials were nearly unanimous in their conclusion that this was the wrong case to contest. Just sample the following titles: "Taking the Fight to the Wrong Mat," "Bad Show From Actors' Equity: Union picks the wrong cause to fight, and producer cancels 'Miss Saigon,'" and "Lost Courage, Lost Play" ("The cause is just, but the effect is perverse").[85] What these quotes intimate is that there are a multitude of ironies in this example. For one, the role is that of a Eurasian, not a Caucasian, thereby opening up the possibility of different types of actors taking the role. As some critics pointed out, however, in many societies *any* mixture of racial characteristics typically consigns a person to "minority" status, so that using a Caucasian in this role was in some ways a misrepresentation. For another, "Miss Saigon" requires a large cast and crew, including thirty four on-stage minority roles—an occasion unduplicated in recent memory. But perhaps most importantly, by arguing for exclusive rights to certain roles, Pryce's opponents were unwittingly ghettoizing minorities and potentially limiting their being considered suitable for a wider range of roles in the future. As columnist Anna Quindlen cautioned, "Once you open certain doors, they swing both ways."[86]

At issue were the linked notions of freedom of artistic choice and nontraditional casting, whereby producers exercise the right to choose any actor they want for any role, irrespective of how it was originally written or cast. Examples of such color-blind casting would be a Black Shakespearean protagonist (besides Othello), or a rainbow community of characters populating "Our Town." Nontraditional casting is a principle that has attracted many supporters in the past several years, reflected by the establishment of the not-for-profit Non-Traditional Casting Project, based in New York. That group opposed the original Equity decision, fearing its implications for closing off prospects for minority actors in other situations.[87] Interestingly, many Black playwrights oppose the principle of nontraditional casting on historical and aesthetic grounds. Some fear a distortion of history, while others like Amiri Baraka lament, "It's still the great books with colored covers."[88] Notwithstanding this concern, many actors, producers and directors were appalled at Equity's attempt to dictate casting decisions and thereby truss their artistic vision. In fact, lofty references to the nature of the actor's craft were frequently bandied about in the media, touting the ability to so transform oneself into another character that the audience can suspend disbelief and accept the action on the stage, regardless of an actor's own racial characteristics. Pryce himself rebuffed the notion that befitting *his* ethnic heritage he should only play Welshmen the rest of his life as an unnecessary constraint on his talent.[89]

Disgruntled minority members of the theater world directed the anger built up from past inequities and unresolved complaints onto "Miss Saigon" and Jonathan Pryce. While their feelings were indeed well-grounded, these targets were somewhat inappropriately forced to shoulder the responsibility for circumstances over which they were not truly accountable. The matter was formulated much the same way as in the case of "The Chicago Show," here the issue being dramaturgical skill versus demographic inclusiveness. Unfortunately, as these disputes escalate they tend to bring the worst out in people, as the arrogance of the following attests: " . . . since when are the arts a democracy? Perhaps the only justifiable aristocracy on earth is that of the talented. . . Does Equity think people leave a theater saying, 'He wasn't very good, but at least he was Asian?' "[90]

Squabbles continued to spin off the main storm center for some time: there were arguments about allowing the Filipina star to replicate her London role, discontent over how auditions were conducted for the company, and even concern about the verisimilitude of the original cast because none of the actors playing American soldiers had been Black.[91] Protests were predicted for the play's opening even before it was fully cast, and demonstrators indeed confronted playgoers at the premiere.[92] And for a few months after the initial conflict, close scrutiny was directed toward casting decisions in a variety of other situations. Two nontraditional casting choices for movies were reviewed by ethnic interest groups, but allowed to stand without significant protest: Richard Gere as a Eurasian in a Kurosawa film, and Lou Diamond Phillips as a Navajo-Mexican in a Robert Redford production.[93] A California community theater group canceled an interracial "Romeo and Juliet," however, and an UCLA African-American student theater group staged a protest over the school's lack of commitment to Black productions.[94] The climate in the creative world was marked by caution since it was evident that casting decisions could offend groups sensitive to previous slights and misrepresentations.

True to form for these types of disputes, more questions were raised than answered. But the legacy of this controversy was that groups such as the Asian Pacific Alliance for Creative Equality were formed in the controversy's wake, and Asian-American concerns were propelled into the public's mind in a singular way, especially the issues of what types of portrayals were deemed acceptable in 1990, and presented by whom.

BRINGING A WAR HOME

The problems of ethnic representations and who should control them have been linked to the allied issues of invisibility and advocacy in relation to other ethnic and racial groups. For example, in 1987 the musical group the Cure created something of a furor with their song "Killing an Arab." Its title is as provocative as "The Nigger Drawings," and the composer offered an artistic justification of it

similar to the defense mounted for "Route 1 & 9." The song drew from Albert Camus' *The Stranger*, the 1946 existential novel whose central action is the inexplicable murder of an Arab in the heat of the day. The act is meaningless, except of course to the victim, and—by extension—to Arabs generally.

The song was protested by the Arab-American Anti-Discrimination Committee, which wished to have it removed from the album on which it appeared. The composer Robert Smith refused, releasing a statement that argued the song "was designed to illustrate the utter futility of the actual action of killing [and] the fact that it was an Arab who was shot seemed totally immaterial. . . ."[95] Once again an artist was pleading that the entire piece of work be considered in order to fully grasp its meaning, even though any effort to do this was handicapped because the title was so diverting. To Arab-Americans this was another dehumanizing assault upon their community, one that has been scapegoated with increasing frequency since the Iran hostage fiasco and Operation Desert Storm, and because of continuing Arab-Israeli tensions. The song seemed to both confirm the relative powerlessness and invisibility of Arabs in the West—most commentators remarked that musicians would hardly dare substitute the names of other groups in the title—and threaten to perpetuate their marginalization or even destruction. Like so many other besieged communities, Arab-Americans sought redress for what they could not dismiss as a trivial antic.

In the end an accord was struck: the song would remain on the album and continue to be performed in concert. But in a very unusual move, radio stations would be urged to drop it from their playlists, and albums and videos would contain the following: "The song KILLING AN ARAB has no racist tones whatsoever. It is a song which decries the existence of all prejudice and consequent violence. The Cure condemns its use in furthering anti-Arab feelings."[96] There was also the pledge to do almost obligatory penance: the group agreed to stage a benefit for orphaned Arab children. But as in most similar situations, these apologetic gestures diminish but do not extinguish the initial sting of the attack.

Pressure groups were also instrumental in shaping the fate of another cultural product with Arab subject matter. In 1988 the National Endowment for the Arts demanded that the literary magazine *Red Bass* return grant money it had used to produce an issue entitled "For Palestine," and also required it to publish a disclaimer of any NEA involvement in the project. The introduction to the collection of essays by such people as Noam Chomsky, John Genet and Edward Said called it "a plea for solidarity with the peoples of Palestine and the young fighters . . . who are resisting with force the illegal occupation of their country"[97] To the NEA, however, this was a political and not a literary document, an assessment partially derived from pressure exerted by the Anti-Defamation League of B'Nai B'rith. From their point of view, the anti-Israel theme was what predominated.

The journal yielded to the NEA's demands, which were shrouded in procedural terms: the "For Palestine" issue had not appeared on their original grant proposal.

But other works related to the plight of the Palestinians, but not supported by government funds, have also been met with difficulties. In 1989 the Palestinian theater troupe El-Hakawati was scheduled to perform "The Story of Kufur Shamma" at Joseph Papp's Public Theater, one stop on a multi-city US tour. Papp canceled the appearance, citing the sensitive nature of the company and its work, the potential to offend Jewish audiences, and the need to "balance" such political statements with another (that is, Israeli) point of view.

The truth is that the play in question was hardly polemical, although it was prejudged to be political merely by the fact that it was Palestinian. Underlying this response was the racist assumption that all Palestinians are terrorists, which largely precludes viewing them as displaced persons. Reviews of the play (after it was presented in an alternative venue) remarked that it was a play about the social condition of being a refugee—the sorrow, dislocation, loss of identity and possessions—nearly devoid of explicit references to Israel. It was therefore largely allegorical, affording the viewer the opportunity to see the Palestinian situation, yet also to superimpose the experiences of any number of other groups onto the actors. In this instance there was anecdotal evidence that Jewish institutions or even a Jewish board member had pressured Papp into this cancellation, the first time he had ever reneged on a commitment in this manner.[98]

All three of these controversies turned on the fears that segments of particular ethnic communities hold regarding symbolic expressions they believe could stoke the flames of hatred and discrimination against them. A tug-of-war unfolded in each case when the different parties attempted to counter or deny the affront. Something similar occurred in Germany in 1985 on the occasion of the premiere of a play by the late Ranier Werner Fassbinder. The play "Garbage, the City of Death" featured a real estate magnate named "The Rich Jew," a sleazy speculator whose misdeeds are covered up by government officials. In this production his named was changed to "A," but part of Frankfurt's Jewish community believed anti-Semitic productions could follow elsewhere, and that the tone of the play would not be substantially altered by merely modifying one name. As the curtain went up that first evening, a group of thirty protesters took over the stage and unfurled banners reading "subsidized anti-Semitism," alluding to the fact that the theater was municipally supported.

Merely six months before, President Reagan and Chancellor Kohl together laid wreaths on the graves of SS troopers at Bitburg. This touched off a large wave of concern, taken as evidence that a revisionist notion of history that would diminish the magnitude and importance of the Holocaust was gaining support. The Jewish protesters were sensitized by the need to fight anti-Semitism wherever they found it, no matter how insignificant the example might seem to others. As one protester announced, "I was in Bergen-Belson [concentration camp] and I remember when Goebbels said that it was he who decided who was a Jew. And I say that *we decide* what is anti-Semitic."[99]

Whatever the aggrieved party in any example, dredging up horrific examples of oppression lends an air of credibility to complaints that is nearly impossible to rebut. We also saw that in the Nelson/Washington incident, as Black leaders used the history of racial discrimination to call for present-day self-determination, and as justification for ridding the environment of offending images through repressive actions.

This play drew many underlying tensions to the surface. There was a paradoxical quality to the protest, however. As a German journalist understood, if the play were staged, the anti-Semites would have won. But if the play were halted, that also could be turned into a victory of sorts: it would confirm the presumption that Jews wield inordinate power.[100]

Some additional international examples also cast light upon how controversial art is perceived and restricted. In Israel, the Hebrew translator of *Mein Kampf* believed it was crucial for Israelis to be able to judge Hitler's document first hand. Twelve publishers disagreed, however, finding it "too abhorrent."[101] As a society that feels it's under a constant state of siege, Israel has had state-imposed censorship on movies and plays. In 1989, for example, the play "The Ninth Wave" was banned as racist and capable of inciting riots. This tale of a bridegroom killed by Israeli troops just prior to his marriage provided the occasion to recount Israeli atrocities against Palestinians since 1948. And in the controversial movie "Green Fields," the Arabs never speak. At the same time that this effectively demonstrates the gap between Arab and Jew in Israeli society, it also highlights the general silence about Arab travails.[102] Using the social antennae that artists often have, they have located an extraordinarily rich—and controversial—subject in the Arab-Israeli conflict.[103]

THE WAR OVER HEARTS AND MINDS IN THE LIVING ROOM

These examples highlight once again the artistic restrictions that can result from the conjunction of values and power. Those communities which have established organizations to lobby in their behalf are the most likely to be successful in challenging an image, a film, or a television program if it transgresses what they hold dear. It is generally not simple to mount an effective amelioration campaign with an ad hoc group assembled after an issue arises. Not only can valuable time be lost in the formative stages, but links with powerful and influential people just are not there. If such strategic connections already have been established, however, there are generally debts that can be called in at critical moments.

Some additional examples from public television extend these observations. When programmers stay within a fairly predictable safe zone, subscribers and the general public will remain pacified. British comedies of manners and explorations of the intelligence of dolphins or chimps are crowd pleasers. And although nature

shows that depict the inevitability of death within the food chain might be disturbing, they are unlikely to enrage viewers. Audiences willingly accept natural struggles, but their ire can be raised quickly when social struggles are explored instead. Such was the case with several shows broadcast in the 1980s on PBS: "Death of a Princess" (a "dramatized" documentary about the execution of a Saudi princess for adultery), "Nicaragua Was Our Home" (about Sandinista mistreatment of Miskito Indians, financed by the Reverend Moon), and "The Africans," a series that blamed the West for most of the problems Africa faces. The National Endowment for the Humanities was the major funder for "The Africans," which it later denounced as "narrow and politically tendentious" and an "anti-Western diatribe."[104] Because NEH chair Lynne Cheney felt the programs lacked balance, she raised difficult questions about the appropriateness of the government underwriting something that was so critical of its own conduct.

But a far more controversial PBS telecast was 1989's "Days of Rage," concerning the Palestinian intifada. The documentary was scheduled to be broadcast on WNYC-TV, the New York City–owned station, but they rejected it as propaganda. It was then picked up by WNET, the major public broadcasting station in New York. Before it was aired, however, protests started streaming in (it had already been screened in other parts of the country). The original complaint was that it was a biased piece of work in which the creator's sympathies prevented her from probing beyond tales of woe to uncover the complexity of the Arab-Israeli situation, and that she interviewed unrepresentative Israelis (primarily zealous settlers in the occupied territories or peace movement members). Producer-director Jo Franklin-Trout admitted there was a definite point of view in the film: "It's one-sided in the sense that it doesn't have . . . Ping-Pong balance. . . ."[105] But she was overwhelmed by the magnitude of the negative response that her advocacy generated.

These questions about balance and point of view were augmented by charges of hidden sponsorship, charges which emerged in an investigative piece in *The New Republic*, and which were further elaborated on by several major newspapers. PBS rules stipulate that funders have no editorial control over material the network broadcasts, nor can there be the perception of such control or the promotion of products of the sponsor. In the case of "Days of Rage," Franklin-Trout obtained financing largely through selling videocassettes of her earlier films, and the advance order of videocassettes of "Days" by the Arab American Cultural Foundation. And not only did this group claim sponsorship of the documentary, but journalists discovered that Franklin-Trout had served on the group's board for two years.

Jewish groups reacted negatively to the proposed broadcasts, and Jewish subscribers of PBS threatened to withdraw their financial support. A compromise was finally worked out whereby PBS sandwiched the original film between two reports from an Israeli perspective and a panel discussion representing a range of views on the subject. The package was renamed "Intifada: The Young Palestinians," with the added material costing PBS nearly as much to produce as the original film had

cost its maker.[106] The broadcast garnered only average ratings when it finally aired, and was assailed by Franklin-Trout as "intellectually dishonest."[107]

From PBS's point of view, this was a wise, workable compromise. It partially deflected the criticism from its detractors while not capitulating with a total cancellation. It also protected itself from possible attack in Washington, D.C., where pro-Israeli lobbyists could have potentially applied pressure to lawmakers when they reviewed continued funding for the network. But this form of presentation implied that such a volatile topic needed to be counterbalanced at the moment of broadcast to ensure that viewers could correctly separate "fact" from "contrivance." Such oversight had never entered into PBS's programming decisions to such a degree previously.

The controversy was barely contained before another battle broke out, however. Four months later PBS showed a documentary entitled "A Search for Solid Ground: The Intifada Through Israeli Eyes." On the face of it, it appeared to raise many of the same questions of sponsorship and point of view that "Days of Rage" had. Funding was obtained through four private individuals—all active in Jewish philanthropic causes—whose initial contact with the film maker was made through the Israeli consul general in New York. However, PBS absolved this film of any wrongdoing because the sponsors were not allowed to view the work until it was aired publicly, and the director prefaced it with a statement indicating that no Palestinians had been interviewed and that a "mainstream" Israeli position was being presented. In the end PBS decided to append the broadcast with a thirty-minute panel discussion, much less of a postscript than was offered with "Days of Rage."[108]

One television critic cleverly noted that "Solid Ground" was being broadcast during the PBS pledge week,[109] possibly an olive branch extended to its audience in light of the previous brouhaha. PBS again acted in a politic manner, accurately surveying the terrain it must survive in. The various outcomes in these disputes reveal more about the effectiveness of established pressure groups and the power of threatened consumer boycotts than they do about whatever relative power different groups could have *inherently* because of their ethnic, racial, religious or sexual makeup. Conspiracy theories aside, some groups have been better organized for political action for a longer period of time than others. This gives them an advantage which habitually means the difference between winning and losing in these types of situations.

A BAD RAP?

It would be reassuring to consign such quarrels to a niche separate from American society. After all, they spring from a foreign conflict that impinges on American concerns because of the strong ties between the US and Israel. But other

controversies clearly point to our own inner turmoil and our inability to reach a state of peaceful coexistence or equity between the different groups that make up American society.

A series of incidents in San Diego, for example, exposed a desire to suppress images that challenged a Chamber of Commerce view of the city. San Diego is a border town, a 1980s Sun Belt success story situated just above its less fortunate neighbor to the south, Mexico. In 1986 officials removed a sculpture from outside the Federal courthouse, a work that presented an immigration agent searching an undocumented worker atop a donkey cart. The piece had a satiric slant: it reproduced the sort of prop typically used to make souvenir tourist photographs in Tijuana. In this case, however, happy sightseers were replaced by waylaid emigrants against the painted catchphrase "La Raza, si, Migras no" ("The People yes, Immigration no").[110] The rationale for the removal was "security reasons," even though the sculpture was surrounded by a fence erected by the artist. But quashing this reminder of the human consequences of patrolling real and symbolic borders was likely motivated more by embarrassment and guilt than merely concern for the physical defense of the site.[111]

Two other artistic ventures similarly perturbed city officials. In 1988 a bus poster designed by an artists' collective proclaimed "Welcome to America's Finest Tourist Plantation," just before the Super Bowl was bringing TV crews and thousands of visitors to the city. This message likewise alluded to San Diego's dependence on and exploitation of nonwhite workers for its prosperity, an unpleasant reminder for a city attempting to project the most positive image. Several of the same artists later produced another billboard, this one picturing Martin Luther King, Jr. with a text reading "Welcome to America's finest (a) city (b) tourist plantation (c) Convention Center." This time San Diego's unofficial slogan of "America's finest city" was held up against the city council's refusal to rename a street after King, and also the official veto of a proposal to rename the San Diego Convention Center in honor of the slain civil rights leader. Artists incurred a cost for these acts of conscience: the works were nearly banned, and there was prolonged debate over their propriety, producing serious threats of the withdrawal of public funds.[112]

It's not so easy to draw a clear distinction between how other societies deal with artistic representations of sensitive subjects, and how we do so in the US. For example, when a film by the Black music group Run-DMC was banned in South Africa because "whites are portrayed as moronic bunglers while blacks are the heroes,"[113] such suppression may seem absurd, outrageous, or even immoral. But it differs only in severity—and not intent—from repressive actions that Black American performers also have encountered on their home turf.

No other new form of expression has earned as much condemnation (alongside impressive commercial success) as rap music. It has been dismissed as "a locker room with a beat" because of its raunchy lyrics, and extolled as "the black network

we never had" for giving voice to the feelings of the Black underclass.[114] At the same time that distinguished professors argued that rap fits within Black oral traditions, prosecutors attempted to have it judged criminally obscene. *Anything* this controversial obviously deserves closer scrutiny.

Rap emerged in the mid-1970s as a genuinely collective expression of lower-class Black urban youth culture. This rhythmic talking captures an authentic slice of life from this part of society and broadcasts it across racial and economic lines, to the great discomfort of many people. Yet its fans are legion, too, who by 1990 were drawn from various social locations. Rap has become both a great social leveller and a social provocateur.

The variety of rap I'd like to discuss here is what's become known as "gangster rap." Violence is the central theme in gangster rap, the violence of the gang bang, the violence endemic to the drug culture in contemporary urban America. This is also the variety of rap that takes on political issues most directly, such as racial oppression and police brutality. Although it shares a sexism and homophobia which has been characteristic of other forms of rap as well, I'll defer a discussion of these aspects until later.[115] It is primarily gangster rap's political commentary that has brought down the wrath of its opponents, an intense reaction matching the rappers' own posturing.

N.W.A. (Niggers With Attitude) is a good example of this genre, a group whose name immediately discloses its aggressive, confrontational stance. Their album "Straight Outta Compton" featured sirens and gunshots in the background, a musical tour of the ghetto with the clamorous atmosphere intact. The group's infamy stems from one particular song, "—— tha Police," a courtroom fantasy where each rapper angrily berates the police for their mistreatment of Black teenagers, and one boasts "Takin' out a police will make my day." Between verses, the listener hears each rapper being arrested.

The last part of the fantasy came close to becoming reality. In April, 1989, pressure from the Anaheim police forced promoters to remove N.W.A. from the top of the bill at a local performance. Then, in a high-tech variant of an all-points bulletin, police throughout the country faxed messages to one other about the group, trying to derail their appearances. It was an ingenious scheme because cops often moonlight as security guards for concerts; if no guards are available, promoters are unwilling to proceed with a show. N.W.A.'s engagements in Detroit, Washington, D.C., Chattanooga, Kansas City, Milwaukee, and Tyler, Texas were either jeopardized or canceled because of such police mobilization.[116] Then in an unprecedented move, an FBI spokesperson sent a letter on Department of Justice stationery to the president of Priority Records stating that "—— tha Police" "encourages violence against the police and disrespect for the law enforcement officer," a negative sentiment he claimed was condemned throughout the law enforcement community. This intimidating letter (which included the song's lyrics) also entered

the fax network, further solidifying the wall of police resistance to N.W.A., and making it even more difficult for them to perform.[117]

Groups such as N.W.A. confirm every fear and stereotype that White Americans hold about Black youths, much the same beliefs that were corroborated by another group, Public Enemy. Public Enemy has been associated with controversy in a number of ways, starting with their combat fatigue dress and on-stage bodyguards with fake Uzi machine guns. They wrote "Fight the Power," the theme song for Spike Lee's movie "Do The Right Thing," a much-debated piece of work in its own right. Many observers also cited this song as the anthem for rioting Black college students at the annual Labor Day Greekfest in Virginia Beach, Virginia in 1989, an incident that resulted in large numbers of injuries, arrests, and significant property damage. And in a continuation of art intersecting life, Public Enemy made a video in 1990 called "Brothers Gonna Work It Out," in which they faulted the police and local residents for the violence in a thinly disguised incident like the one which happened the year before in Virginia. Nicknamed the "Prophets of Rage" and the "Black Panthers of Rap," their music and public statements seem to have had more direct impact on people than is typically the case.[118]

As supporters of the Rev. Louis Farrakhan, they are most notorious for the statements of their "minister of information," Professor Griff. Griff made a number of anti-Semitic statements in a 1989 interview, including the accusations that Jews financed experiments on AIDS with Black South Africans, that they underwrote the American slave trade, and that they are responsible for the "majority of the wickedness that goes on across the globe."[119] In the uproar that followed, PE leader Chuck D apologized for the remarks, he dismissed Griff from the group, and then disbanded Public Enemy for "an indefinite period."

This appeared to be an abrupt end for a group that had won the 1988 *Village Voice* critics' poll for the best album, "It Takes A Nation of Millions To Hold Us Back." Yet shortly thereafter Griff confirmed to a reporter that his remarks were "100 percent pure," and he performed background vocals with the group in a concert in Kansas City, Missouri.[120] And before 1989 was over the group had released their new album "Fear of a Black Planet," featuring songs about the portrayal of Blacks in films, the lack of response by the police to 911 emergencies in minority communities, and interracial relationships. But problems developed anew over the cut "Welcome to the Terrordome" (also released as a single), which directly addressed the controversy of the preceding summer.

The public debate was revived with the references to Public Enemy's martyrdom at the hands of its Jewish critics, the allusion to the supposed murder of Jesus by similar forces, and the use of the phrase "so-called chosen" (reflecting a Black Muslim belief that they [not the Jews] are God's "chosen people"). The Anti-Defamation League of B'Nai B'rith registered a strong protest with PE's record company, and the rift that had reverberated throughout so much of the earlier

public dialogue was widened even more by this new declaration. Controversy remained with the group: when Professor Griff was invited to Columbia University by a Black students organization to speak on "education in the year 2000," the issues of anti-semitism, freedom of speech, hate speech, and the responsibilities involved in using student activity funds were all vigorously debated. Four hundred people heard him talk while 1500 protested, in the ongoing saga of a provocative and important musical group, and the complex arena of civil rights and community sensitivity.

Artists have thrown some mean punches—and have taken quite a few on the chin—when their own work or work created by others touches the volatile domains of race and ethnicity. In many instances these were defensive rather than offensive actions, quite probably reflecting the history of limited opportunities certain racial and ethnic groups have had within the art world, as well as the pervasiveness of certain derogatory images. Also in many instances, these sparring matches lasted only a few rounds; sometimes just being in the ring with "the big guys" is sufficient to register that you're a serious contender. But opponents go the distance in other high-stakes competitions, pledging to defend sacred symbols to the death.

4

SPIRITUAL TESTS

And I saw a strong angel proclaiming with a loud voice,
Who is worthy to open the book, and to loose the seals thereof?
And no man in heaven, nor in earth, neither under the earth,
was able to open the book, neither to look thereon.
And I wept much, because no man was found worthy to open
and to read the book, neither to look thereon.

Revelation, Chapter 5

Karl Marx's gravesite continues to be the most popular attraction in London's Highgate cemetery,[1] contrary to the fate that has befallen many of the memorials to his realpolitik successors. But history has not confirmed Marx's grim prediction about religion. In spite of his analysis of religion as an antiquated, superstitious and enslaving force, it has continued to flourish throughout the world. Religion remains a primary source of social values and identity, and it not only structures everyday life for incalculable numbers of people, but has also provided the underpinning for some of the most significant social and political movements in the modern world.

Global trends have American equivalents. Religion has been central to the life of the US since colonial times. And even though there is the formal separation of church and state, religion and politics are the warp and woof of many public conflicts, entwined whenever basic standards and practices are at issue. Sacred and secular may be distinct categories in theory, but in a complex, industrialized environment there are manifold opportunities for them to converge. Art is one of the settings where this frequently occurs.

The issues of representation, visibility, advocacy and inclusion emerged throughout the preceding discussion of race. Similar matters will also be important in examining religiously based controversies over art. Many of the racial controversies

stemmed from groups rejecting archaic and demeaning portrayals of themselves. In many of the religious controversies, attempts to recast images threaten established centers of power. Such disputes thereby highlight the counterreaction to protect and restore long-established symbols.

Religion is both doctrine and institution. When the winds of change imperil dogma, they also rouse organizations into action. In struggles to alter old symbols or substitute new ones in their place, the ad hoc Davids of innovation confront the Goliath of church authority—and its often considerable muscle.

OF HISTORY AND BOUNDARIES

Art loyally served religious ends for many centuries. But in the West since the 1500s that relationship has been steadily transformed. Art's primary purpose is no longer the transmission and exaltation of spiritual ideas. At present art is just as likely to focus on material values, and in many instances directly turns against its former patron.

This original connection between art and religion has been exhaustively explored by art historians, historians, and even sociologists. Emile Durkheim's influential study *The Elementary Forms of the Religious Life* explored the functions of religion in society from "primitives" to nineteenth century Parisians. Durkheim viewed religion as society personified or divinized. He proposed that primitive religious rituals were communal celebrations that savored the vitality of the group, and art—in the form of dance movements, dramatic enactments, and visual representations— was a consequence.

Durkheim also explored the important distinction between the sacred and the profane. He characterized the sacred as transcendental and extraordinary, inspiring love, awe, and on designated occasions, dread. The opposite sphere is the profane: the instrumental and mundane, having a much more transitory nature. As he stated, ". . . the sacred and profane have always and everywhere been conceived by the human mind as two distinct classes, two worlds between which there is nothing in common."[2]

Societies typically devise rites to keep these realms separate and to regulate any encounters between them. Taboos restrict contact, and purifying rites insure that transactions with the sacred will not contaminate it. These lines of demarcation are carefully patrolled and enforced. In recent times, however, artists have muddied the categorical waters by presenting uncanny combinations of sacred and profane elements. This is profoundly disturbing, for it challenges basic ways of organizing experience.

If you carefully examine the reaction against some contemporary art, opponents disclose their sense of tumult and uneasiness. Just after the touring Robert Mapplethorpe retrospective opened in Boston, critics took it as a sign that "uncon-

trolled decadence abounds," and the chairperson of a group called Citizens for Family First declared, "Someone has to speak up and say the rules aren't being enforced. . . . If someone doesn't speak up, society will deteriorate into utter chaos."[3] Some conservative journalists share this perception, such as an investigative reporter for the *New York City Tribune* who decried the use of government funds for a "cesspool of 'art' filth" he characterized as a "striking mixture of sacred and erotic images." And a columnist for the allied *Washington Times* concurred in his review of an art exhibit: "The playpen 'confines infants as a penitentiary does adults.' What does the artist favor, I wonder, a world without children's playpens, without restraints of any kind, where you can urinate all over the place?"[4]

This sense of impending apocalypse accounts for a great deal of the negative religious response to art. One of the primary ways artists in the recent past have challenged traditional images and concepts has been through their incorporation of sexual referents into their work. Religious leaders and institutions have never had an easy time with sexual depictions. In an example of the cycles of reception, Pope Pius IV ordered that Michelangelo's nudes in the Sistine Chapel be covered with loincloths approximately two decades after their completion. But modern sensibilities dictated that they be uncovered and restored to their original form during the chapel's massive cleaning in 1989, as was the case with the work of Masaccio and others in Florence's Brancacci Chapel.[5] And as art historian Leo Steinberg documented, portrayals of the Christ child changed over time, dependent upon attitudes toward sexuality in general and the corporeality of Jesus more specifically.[6] In the late 1980s, more was involved than the naturalistic presence or discreet absence of a penis, however. Artists now combine the sacred and profane with an insouciance that has befuddled and angered many observers.

INTERNATIONAL BOUNDARIES

Because of the formal separation of church and state in the US, it is reasonable to expect that religiously based art controversies elsewhere in the world would have an official imprimatur and perhaps a virulence that is not duplicated in this country. And there is some evidence that this is the case. A montage that superimposed the face and bare breasts of Marilyn Monroe over the Virgin of Guadalupe unleashed a hailstorm of criticism when it was displayed at the Museum of Modern Art in Mexico City in 1988. Threats to burn down the museum led officials to remove the work, and there were also threats against the artist's life. He had meddled with an extremely important and popular symbol, one that serves both as a venerated sign of Mexican nationality as well as a familiar theme in popular culture. The artist's intentions were reported as pointing up how consumer society exploits sacred symbols. But as in the cases of Chicago art student David Nelson and photographer Andres Serrano (to be explored later in this chapter),

iconoclastic gestures carry a high probability of misinterpretation. In this instance south of the border satire became "satanic blasphemy."[7]

In England, such accusations have legal backing. A blasphemy law which dates to the early seventeenth-century allows the British government to ban " 'any contemptuous, reviling, scurrilous or ludicrous matter relating to God, Jesus Christ or the Bible' that is presented in an indecent and intemperate way."[8] In the first prosecution under this measure in nearly a century, the editor of *Gay News* was given a nine-month suspended sentence for publishing a poem entitled "The Love That Dares to Speak Its Name," after a jury found the work to be blasphemous because it presented Christ as a homosexual.[9] In 1989 the British Board of Film Classification found the film "Visions of Ecstasy," based upon the writings of St. Theresa and the Bernini sculpture "The Ecstasy of St. Theresa" to be in violation of the edict, and blocked its release to theaters or on videocassette. The movie depicted the sexual fantasies of St. Theresa of Avila, which included her kissing and caressing Jesus, and being embraced by a female character who represented her own psyche. The film maker shares a modern impulse with many other artists which leads them to explore the carnal themes suggested in religious tales and rituals, material that has typically been stifled within public dialogue in the past.[10]

This statute furnishes legal teeth when religious jaws drop. A similar type of incident occurred when the Church of Scotland tried to close down "Hanging the President," an allegorical play about apartheid in South Africa which includes homosexual acts in prison. A London tabloid quoted a member of Parliament decreeing "Ban Evil Gay Sex Play,"[11] the type of reaction that disquieted producers when they considered taking the play "Spunk" from New York to London. Based upon the writings of Zora Neale Hurston, the title caused embarrassed backers to tightly clutch their purses because "spunk" is slang for semen in Britain.[12]

There are strong prohibitions in general against certain kinds of sexual material in England. Regulations such as the Obscene Publications Act and the Offenses Against the Person Act of 1861 have been used to restrict gay material to such an extent that the subtitle of an article reviewing the contemporary situation proclaimed "Erections outlawed, videos non-existent." This, in a society that was simultaneously diverted by a series called "Heil Honey, I'm Home!" on its tellys, a sitcom about the home life of Hitler, Eva Braun, and their neighbors the Goldensteins.[13] While these latter examples do not denote blatant church involvement, they demonstrate the ambiguities of culture in a society where church and state are closely aligned.

One performer who has consistently run afoul of religious leaders is the rock star Madonna. In 1990 her "Blond Ambition" tour was assailed by several Catholic groups when it reached Italy, including the Italian bishops conference and the editors of the Vatican newspaper *Osservatore Romano*.[14] Their criticism adversely affected ticket sales, so much so that the singer was forced to cancel a second performance in Rome. Ever since her debut, Madonna has riled detractors with

her unique mixture of sacred symbols such as the crucifix and her name with a brazenly sexualized performance style. Her technique has been evident since she performed "Like a Virgin" on a nationally televised awards show in a wedding dress, an outfit that was gradually torn away by her writhing on the stage. And her record "Papa Don't Preach" attacks all types of authority—Papal, presidential or paternal—and insists that she retain control over her reproductive decision-making, even though she also somewhat defies liberal expectations in the song when she opts to keep her baby as a single mother.

Madonna has the additional distinction of enraging a variety of religious leaders. In her 1989 video "Like a Prayer," Jesus is transmogrified into a Black man wrongfully accused for an attack on a White woman. The performer and her video were denounced by Italian Catholics as well as American fundamentalists because Madonna acquires stigmata and dances in her slip to the singing of a Black choir. A version of the video was used in a Pepsi commercial, but Rev. Donald Wildmon of the American Family Association successfully pressured the company to withdraw the ad after only one showing by threatening a boycott of all Pepsi products. And Jewish leaders subsequently condemned a version of "Justify My Love" that incorporated a passage from the Book of Revelation: "And the slander of those who say they are Jews, but they are not, they are a synagogue of Satan." Rabbi Abraham Cooper of the Simon Wisenthal Center blasted the song as offensive and dangerous, alarmed that it could fuel anti-Semitism.[15] This was after MTV had already banned a video version of the song on the basis of its sexual content, a first in its history. The imagery included what appeared to be two women kissing, and a group sexual encounter. As should be evident, then, religion can intrude into the public realm of culture, whatever the formal nature of religious/secular arrangements.

"A DEATH SENTENCE IS A RATHER HARSH REVIEW"[16]

Kipling's admonition that East and West might never meet was severely tested during the six months beginning in September 1988. At that time East and West faced off as a violent series of events propelled Salman Rushdie and his novel *The Satanic Verses* onto the world's stage. It is a scenario for which the last act has yet to be written.

The book was published in Rushdie's adopted country of England on September 26, 1988 by Viking Penguin, and Muslim critics almost immediately attacked its fanciful rendition of sacred tales. Within the next few weeks a number of countries with substantial Muslim populations banned the book, including India, Pakistan, Egypt and Saudi Arabia. An angry Muslim crowd in Bradford, England nailed copies of the book to wooden stakes and burned them in January, 1989, and seven

people were killed in anti-Rushdie riots in February in Pakistan and India. On Valentine's Day the Ayatollah Khomeini issued his infamous edict, or *fatwa*: Rushdie was to be put to death by Muslim assassins for his blasphemy, an order that was backed up within a few days by a bounty of $5.2 million. The author went into hiding on February 14, 1989, and except for a few brief forays into public starting in late 1991, has remained under police protection in a series of "safe houses" in England.

Insight into Rushdie and his plight can be gained through a 1908 essay by Georg Simmel. Simmel depicted "the stranger," a social position that encompasses "near and far *at the same time*."[17] The stranger is inclined to objectivity because he is not bound by ties that prejudice his perceptions; he is both inside and outside, *in* but not *of* the group. Other social theorists later extended this concept, focusing on the "marginal man" and the cultural conflict created for individuals by immigration, incomplete cultural assimilation, or by virtue of being a racial or cultural hybrid.[18] The existential state of the stranger or marginal man can arouse great anxiety; it also confers enormous freedom.

Salman Rushdie classically illustrates these concepts. Raised as a Muslim in predominately Hindu India, he confronted a fresh type of bigotry at the age of fourteen when he was sent to Rugby School in England. Several years of rough treatment as a dark-skinned foreigner facilitated his conversion from a conservative to a radical, and most likely contributed to the development of his keen critical and satirical sense. After graduating from Cambridge he travelled to his family's relocated home in Pakistan, but this was neither his homeland, nor the type of society he had gradually grown accustomed to in England. Cosmopolitan in the truest sense, he quickly returned to London and became a writer.

Although Rushdie may have removed himself physically from the East, it continued to provide a reservoir of experiences and emotions from which he drew in his work. He has been no stranger to controversy. *Midnight's Children* (1981), his account of the birth of an independent India in 1947—its promise and subsequent reality—angered Mrs. Gandhi. She successfully sued Rushdie over references he made to her in the book, securing a public apology and the removal of a libelous passage from all successive editions.[19] *Shame* (1983) angered supporters of Pakistani leaders Bhutto and Zia, and led to police intimidation and raids against Pakistani bookstores which stocked the work.[20]

But of course it was *The Satanic Verses* that provoked the fiercest response. What a peculiar twist of fate: this book, more than any other, incorporated the disparate aspects of Rushdie's life. *The Satanic Verses* is a medley of East and West, fantasy and reality, what one reviewer termed a "modernist *Arabian Nights*."[21] Its opening scene describes the two main characters falling to earth from a plane that has been hijacked and bombed, a symbolic representation of birth (or rebirth) and the challenge to the immigrant to create himself anew. But what launches an adventure for some readers instead sounded like a travesty to devout Muslims. One hallucina-

tory scene that created great distress was set in a brothel, where the prostitutes took on the names of Muhammad's wives in order to enhance business. Another sensitive detail is that Rushdie's fictional prophet Mahound carries what had been a name for the Devil, and bears an uncomfortable resemblance to the actual Islamic prophet Muhammad. Rushdie's book also insinuates that the Koran was written by Muhammad himself, not received from God.

Much of the offending material was concentrated in one chapter, and many of Rushdie's sharpest barbs were aimed at contemporary Britain, not Islamic tradition. But orthodox critics primarily separated the religious themes out of the text for express consideration. The author's defense rings familiar: "my novel tries in all sorts of ways to reoccupy negative images, to repossess pejorative language."[22] Yet to the fundamentalist mind, Rushdie's fabrications went too far, violating revered beliefs that were beyond interpretation.

Of the three major monotheistic religions, Islam maintains the most negative stance toward the plastic arts. This religion prohibits the depiction of human or animal forms in its places of worship, allowing only floral and vegetable motifs or quotes from the Koran.[23] Because of its severe standards, other instances of Islamic rejection of symbolic representations within a range of media predate and postdate the Rushdie affair. For example, in the 1950s an issue of the international edition of *Life* magazine was banned because it depicted Muhammad, and the ambassadors of several Islamic states successfully secured the removal of a statue of the prophet from the roof of the Appellate Division Court House in New York because of a proscription against such portrayals.[24] In 1976 there was an uproar over a Lebanese-British production of a film entitled "Mohammad, Messenger of God." Even though the prophet was not going to be depicted on screen, several extremist sects were enraged by the project. They threatened to blow up the production, at which point a group of Muslim scholars was hired as overseers. After these men later withdrew their approval, a cadre of Black Muslims took hostages at the Washington, D.C. headquarters of B'nai B'rith to try to prevent the movie's American premiere. The film did in fact open, but to uniformly negative reviews.

Following the death decree issued against Rushdie, additional incidents illustrated the fundamentalist Islamic response. Just a few weeks later the tomb of the poet Dante Alighieri became the target of a bomb threat. A scholar at a conference had referred to the fact that Dante placed Muhammad in a part of hell reserved for traitors in his masterwork. This enraged an Islamic group which called Dante a "false prophet" and declared that his work should no longer be read.[25] In another incident hundreds of Moslem demonstrators in Bangladesh protested slippers they claimed defamed their beliefs because they bore a logo that looked like the Arabic characters for Allah.[26] And near the first-year anniversary of Khomeini's proclamation against Rushdie, a Tunisian author was denounced for his comic book interpretation of the Koran. A Moslem himself, he was cited for altering the word of God and presenting stereotypical drawings of Arabs.[27] All of this evidence

points to the uncompromising nature of the fundamentalist Islamic position and the impassioned actions of its true believers. In this respect they are similar to other conservative religious groups—regardless of denomination—which closely dictate the conduct of their adherents' lives and sanction unambiguous, revealed truths over the type of consensus that is reached through rational argument.

The Satanic Verses became a clay pigeon, fired at by those who were struggling either to protect theocratic purity, or to consolidate their own power in complex political situations. In India, for example, Prime Minister Rajiv Gandhi's Congress Party was facing an uphill reelection battle. In order to demonstrate his party's concern for the sensibilities of the large Muslim community (and, hopefully, guarantee their support) Gandhi issued a public ban against the book just over a week after its publication in Britain.[28] In Iran, the death order followed the lengthy and disastrous war with Iraq, and the ensuing loss of an easily identifiable, external enemy. The decree was a sign that leaders who favored liberalization of economic and political relations with the West were losing whatever influence they might have had within Iran. It signified that preserving the internal, religious revolution took precedence, the rest of the world be damned.[29] In Egypt, the book was feared by government officials as a possible catalyst for a renewal of the type of Islamic-Christian violence which previously had culminated in the assassination of President Sadat by Islamic fundamentalists in 1981. Not only did the government ban the book, but they also arrested Allaa Hamed, author of The Vacuum in a Man's Mind, which insulted Moslems in much the same way The Satanic Verses did.[30] In Britain, some politicians with large Muslim constituencies jumped upon the bandwagon of condemnation, while in Turkey there was official silence: the country was torn between its Western allies and a strong Islamic heritage embedded within a secular state.[31] The book was, therefore, subjected to various readings, and adapted for a multitude of local uses.

Aftershocks continued to be felt after the death threat was issued against Rushdie. An anti-Khomeini Islamic leader in Belgium was murdered along with his assistant in a Brussels mosque.[32] Ten more people were killed in rioting in Rushdie's home city of Bombay. Muslim demonstrations in the West confirmed European fears and stereotypes of foreign "guest workers" and helped strengthen the appeal of racist right-wing political parties, for instance, in France. And British Muslims petitioned the government to extend the aforementioned blasphemy laws to religions other than Christianity, so that a legal injunction could perhaps cool the fevers of enraged opponents.

Appeals for judicial relief began before most of the violent protests. They were finally exhausted over a year later when England's High Court ruled that Islam would not be afforded the same safeguards as Christianity, and that charges of blasphemy and seditious libel were therefore inapplicable to The Satanic Verses.[33] This sent Muslims another message about their exclusion from British society and their relative political impotence. To have granted such an extension of the

blasphemy laws would have opened up the possibility for *many* conservative religious groups to demand similar protection, and then empower them to prosecute ideas they found distasteful. The decision therefore restricted the use of a potentially powerful weapon against speech, but it also heightened an already acute sense of unfairness on the part of socially marginalized groups in Britain. There is speculation that the loss of this symbolic battle may lead Muslims to field their own candidates in parts of London and in older industrial cities and towns where they are concentrated, a strategy that could significantly alter the balance of power in British politics for some time to come.[34]

Muslim outrage was exacerbated further by the official treatment of a Pakistani-produced film called "International Guerrillas." This movie was banned from distribution in England as potentially criminally libelous. It had been a box-office hit in Pakistan, and depicted Rushdie as the leader of an international Jewish terrorist conspiracy against Islam. The Rushdie character delights in torturing others; in one scene he nails a woman to a cross and torments her by reading passages from his notorious novel.[35] In the cinematic climax Rushdie is killed by a bolt of lightning sent by God. In the real world, the ban on the film was eventually lifted—at Rushdie's urging.[36]

Still other artistic works were affected as well. Three months after the death threat was issued, the American film "Veiled Threats" was withdrawn from the Los Angeles Film Festival because it was highly critical of Khomeini, and therefore considered untimely. And a satirical London play initially titled "A Mullah's Night Out" had multiple difficulties. Two of the three actors quit before rehearsals began, and the title was eventually changed to "Iranian Nights." The production proceeded under the watchful eye of security guards.[37]

Threats against US targets—particularly bookstores—helped to intensify the debate within political and intellectual circles. At least three major US bookstore chains removed the book from their shelves to protect their employees, decisions that were later reversed due to the outcry from employees and the general public. Two bookstores were actually firebombed in Berkeley, California. These events prompted a number of supportive gestures, from group readings by major writers in Chicago and New York, to a statement by an international roster of 160 writers that was reproduced in more than twenty publications, and the resignation of three members of the Nobel Literature Prize selection committee because that body refused to publicly express support for Rushdie. A hard-core rock band from Texas wrote a song about the suppression of ideas called "Kill the Words," and the first statement issued by a newly formed Soviet chapter of the writers' group PEN joined the compassionate chorus.

But this was not an unbroken wall of approval. There were numerous and sometimes surprising expressions of contempt for the novel. Former President Jimmy Carter, whose political downfall is at least partly attributable to his inability to negotiate a settlement of the Iran hostage crisis, condemned the book as a

"direct insult" to Moslems, moderate and fundamentalist alike.[38] Cardinal John O'Connor of New York likewise denounced it, although he also spoke against the death threat. He refused to read the book but declared, "A huge number of Muslims have considered it [an insult]; if they consider it so, it's not for me to say that it isn't, and therefore I just wouldn't bother reading it."[39] Papal authorities spoke out against it, as did Britain's chief rabbi and the British foreign secretary.[40] And authors Roald Dahl and John le Carre both questioned Rushdie's motives and cited his insensitivity, Dahl branding him an "opportunist."

The erosion of support for Rushdie became evident when the publication of a paperback edition was discussed. The costs of rallying behind this author have been high: at least ten British bookstores were bombed, and threats against Viking Penguin and its employees continued. It was widely quoted that the company was spending $3.2 million per year on additional security. The publisher postponed the paperback and dodged inquiries that would pinpoint a publication date. Most damning for Rushdie's cause was an internal memo that was published in the muckraking *Mother Jones*, where a board member at the publishing house reported "we all feel it would be better not to publish the paperback because it is just throwing petrol on dying embers. People often forget that commonsense is more important than principles. Some principles have to be fought to the death, but I am quite clear that this isn't one of them."[41]

Even more disappointing to Rushdie's supporters was a signed editorial eight months after the Ayatollah's decree in the major trade publication *Publishers Weekly*, that also counseled against the paperback. The gist of the argument was that the sensibilities of moderate Muslims would be offended even more, and that foregoing the new edition would speed the return to normalcy.[42] But many others feared that the lack of an inexpensive paperback version would seriously limit the novel's availability in the future. Some people felt the non-decision denoted cowardice and capitulation, and some even felt it constituted censorship, an interesting charge given that the novel had sold 1.2 million copies in English by mid-1990.[43]

Rushdie is labelled a "coconut" by British Muslims: brown on the outside only.[44] Fundamentalists view him as treasonous for turning his sharp tongue against his own heritage. But Rushdie celebrates the blending of cultures, characterizing *The Satanic Verses* as "a love-song to our mongrel selves. . . . I am a bastard child of history. Perhaps we all are, black and brown and white, leaking into one another, as a character of mine once said, *like flavours when you cook*."[45] Rushdie's fate is an extreme form of punishment for the sin of critically self-examining his birthright, a transgression that Philip Roth comically sketched on a more tame level in *The Ghost Writer*. Roth, of course, was excoriated for his unflattering portrayals of Jews, especially the priapic Alexander Portnoy. Roth's young protagonist in *The Ghost Writer* upsets his parents after writing a short story that includes an adulterous affair with a Gentile and an unflattering portrait of a querulous Jewish family. This author/character is not subjected to physical harm for his breaches of faith. Instead,

he must endure a guilt-inducing psychological attack from a respected judge who takes him to task for the harm his work supposedly does to his coreligionists. It is a bitterly humorous passage that raises the same accusations of self-loathing and betrayal that were directed at Rushdie.[46]

Rushdie admitted that he deliberately fused the sacred and profane in his work, and that his use of language was a willful attempt to reclaim language and endow it with new meanings: "Just as the Asian kids in the novel wear toy devil-horns proudly, as an assertion of pride in identity, so the novel proudly wears its demonic title. The purpose is not to suggest that the Quran is written by the devil; it is to attempt the sort of act of affirmation that, in the United States, transformed the word Black. . . ."[47] But as Susan Sontag noted, the book's title—which refers to passages dictated to Muhammad by the Devil which the prophet later repudiated—became a red flag that attracted much of the adverse response.[48] This is a phenomenon we have noted previously, and will observe again.

Khomeini issued his sentence against Rushdie just a few months before he died. But this proclamation was renewed, not rescinded, by the patriarch's successor. After 22 months of living under the threat of death, cut off from the bonhomie of his friends and eventually estranged from his wife, Rushdie "the stranger" publicly declared his faith. In a statement intended to mollify his critics, Rushdie announced his decision "to enter into the body of Islam after a lifetime spent outside it."[49] He pledged to uphold the central tenets of the religion, disavowed agreement with any offensive statements made by his characters in *The Satanic Verses*, and promised not to authorize a paperback version of the book. A moderate Muslim leader in London declared that now the author had "a clean slate," and quoted him as saying "There is no difference between Rushdie and Islam."[50] But Iranian leaders labelled him an apostate, and maintained their opposition to the man and his work. His peace overtures rejected, Rushdie remains in cultural limbo, arguably the most notorious artist of the twentieth century.[51]

NEVER ON SCREEN

When questions emerge at the borders of religion and the state in the US, letters to the editor, political lobbying, and street demonstrations are generally the vehicles people use to press their points of view. In New York, for example, Muslim leaders are campaigning to have the festival of Eid at the end of the holy month of Ramadan added to the list of holidays when alternate side of the street parking restrictions are rescinded. Because Christian, Jewish and Greek Orthodox observances are already recognized, this would be a significant symbolic victory for local Muslims. There are now no Islamic holidays on the list, a reflection of this community's slack political muscle. And in what has become an annual ritual, communities throughout the country bicker over public displays of menorahs and

creches in December. The upshot of these quarrels is nicely compressed into an editorial cartoon: a teacher faces a group of attentive but rather forlorn students and instructs them, "Then, depending on if the ACLU sues us, the angels will bow and sing 'Silent Night' or 'Rudolph, the Red-Nosed Reindeer.' "[52] Holiday displays have become increasingly secularized: generally they must be balanced by other traditions, or by nonreligious seasonal elements such as Santa or candy canes— what some deride as the "two reindeer rule."

These debates often lapse into ritualized name-calling, and the discontent they raise can be summoned up in other disputes. Shortly after the Nelson/Washington incident, for example, members of the Coalition Reinforcing our Social Standards picketed the Chicago Park District's offices to protest the removal of an Easter cross from a municipally operated conservatory the preceding March. Their signs included "District Evicts Christ," and "Hang ACLU at Art Institute." And after the furor over Andres Serrano's photograph "Piss Christ," foes of government funding of the arts frequently complained that tax dollars paid for putting a crucifix in urine,[53] but could not be used to erect one on the proverbial town square.

Such struggles are typically acrimonious but localized, the last example notwithstanding. A case in point: emotions flared in Schuylerville, New York over a crucifixion scene that had hung in a public school auditorium for twenty five years. A judge ordered it removed because it did not have any neutralizing features, and therefore might convey a message of government endorsement of religion. The mural's angry supporters, on the other hand, saw it as a general depiction of "man's inhumanity to man."[54] Losing such battles engenders an immense sense of unfairness and discontent, and signals several things to the defeated: government overstepping its bounds, public morality slipping, and the power of established groups gradually eroding.

Yet some religious controversies make it to the national stage, as the opposition to Martin Scorcese's film "The Last Temptation of Christ" did in the summer of 1988. This occurred *before* the Rushdie affair, and was commonly referred to in retrospect as the US equivalent. The movie was based upon Nikos Kazantzakis's 1955 novel of the same name, a work for which he was excommunicated from the Greek Orthodox Church. The story presents a Jesus riddled with doubts and questions, torn between spiritual matters and seductions of the flesh. It is a portrayal where the humanity of Jesus is emphasized rather than his divinity. Jesus is presented as a reluctant leader, one who watches along with a multicultural array of other men while Mary Magdelene has sex with a customer and fantasizes about marrying and becoming a father, while he is being crucified. It took director Martin Scorcese (described as "the most innately religious of major American film makers")[55] five years to secure financing for the movie. An attempt to produce it in 1983 failed, due to some extent to a protest campaign mounted by Rev. Donald Wildmon.

In 1988 protesters pulled out all the stops. Wildmon claims he sent out an

astonishing three million letters to Christian lay people condemning the film, and he also alleges that MCA/Universal received 122,000 protest letters in one day. But it is difficult to evaluate these numbers for he also claims that 25,000 people turned out for a protest at the studio the day prior to the film's release, a crowd that *The New York Times* estimated at 7,500, and Dan Rather placed at 5,000 on the CBS Evening News.[56] Allowing for some inflation of numbers here, it is clear that this became a major religious campaign, one that attracted a broad range of fundamentalist and mainstream Christian sects, some Catholic leaders and laity, and Greek Orthodox adherents. In Chicago some Muslims also joined in the protest outside the theater where the film premiered, as did an Orthodox rabbi in New York City.[57] What was it about this movie that so enraged these demonstrators?

Two lines of argument emerge in this crusade. First, there was the motive of preserving one "true" religious interpretation of the life of Jesus. One protester in Chicago proclaimed "Christ was a perfect God and a perfect man," while another declared "I consider this movie a kind of spiritual abortion. *You don't fictionalize the truth.*"[58] A protester's sign at Universal Studios announced "Don't Change HisStory," and Wildmon characterized the Kazantzakis/Scorcese view of Jesus as "a weak and highly unstable man." New York's Cardinal O'Connor, commenting on the work sight unseen, felt the film was flawed because it presented "Christ as a lie."[59] All these comments reveal an intolerance of ambiguity and an insistence upon the sanctity of received wisdom.

Second, there was the paternalistic impulse to protect the "weak" who would not be able to separate fact from fiction in this case, and for whom questioning could only spell disaster, not the possibility of spiritual growth. Employing a crude theory of effects, Wildmon proposed that the movie could lead people astray: "Many moviegoers do not differentiate between what is postured as reality and what is supposedly fantasy."[60] Maverick Catholic priest Andrew Greeley took another position. He accused the fundamentalist protesters of displaying the antiquated heresies of Docetism and Manichaeism, which denied Jesus's human nature and expressed repulsion at the erotic nature of life. For Greeley and many others, the Kazantzakis story was profoundly religious and forced people to actively struggle with their own beliefs—an inherently healthy process, in this view.[61]

In New York the film premiered in August at a large midtown theater. It was 94 degrees and the air was heavy with humidity, the sixth week of an unrelenting heat wave. Surrounding streets had been blocked off by police barricades, creating an eery quiet at odds with the typical Friday pace. But the scene changed dramatically at 54th Street and Avenue of the Americas: there were groups of police on foot and on horseback, hundreds of protesters praying, waving signs, and admonishing would-be ticket buyers, and the line of hundreds more ticket holders snaking around the block and through an adjoining building plaza. It was an extremely charged scene, exaggerated by annoyance over what grew into a several-hour wait to enter the theater, the persistent chanting and surging forward

of the protesters, and the oppressive, steamy weather. Everyone was on edge, including the police: they had come under criticism for their erratic, violent actions in quelling a protest of young radicals and street people the weekend before in Tompkins Square Park. And because the theater had received phone threats of violence, everyone had to undergo security searches in the lobby and guards were also posted alongside the screen. With the possibility of smoke bombs going off within the theater, or an attack launched against the screen when controversial scenes were projected, moviegoers were anxious and droll that first day. Their attention could never be fully focused on the movie; one eye had to suspiciously drift from time to time to one's neighbors, and to the exit signs.

In some places the protests continued for weeks, although they diminished in size substantially. Studio heads had tried to diffuse criticism by offering an advance screening of the picture for evangelist leaders. But Wildmon and others refused the offer, claiming the studio did not act in good faith because they delayed the preview so much that there would not be time for any of their criticisms to be addressed by further editing. More liberal religious leaders did agree to preview the film, however, and many of them subsequently endorsed it.

At one juncture anti-Semitic slurs were hurled at studio bosses, condemning them for unfairly sponsoring an attack on a religious system different from their own. Although many key individuals at Universal were indeed Jewish, neither the director nor the screenwriter was.[62] A Los Angeles theater was vandalized in protest, Catholic fundamentalists in France threatened theater owners who booked "The Last Temptation," and one theater there was gutted in an arson fire.

Distribution was largely limited to theaters owned by the same conglomerate as the movie studio, and it was initially held back from Southern and Midwestern locations. Officials in Escambia County, Florida banned the film, an order that was later reversed by a judge.[63] And when it was issued on videotape approximately one year after its commercial release, distributors took a cautious approach: there were no ads or posters heralding its arrival. But evangelist Pat Robertson felt that justice finally triumphed in this affair. When there was a disastrous fire at Universal Studios in 1990, Robertson interspersed clips of the fire with frames from "The Last Temptation" during a broadcast of his "700 Club." To his mind, this was an obvious example of divine retribution.[64]

The history of film censorship has been extensively documented. The Production Code, established by the major movie studios in 1930 and enforced through the 1950s, was initiated and administered in concert with the Catholic Church and its League of Decency.[65] "The Last Temptation of Christ" thus joins a list of other films that have been targeted by religious groups as objectionable. For example, in 1951 Roberto Rossellini's "The Miracle," about a woman who claims to have conceived divinely, enraged Catholics and called out a similar response: condemnation by New York's Cardinal Spellman, pickets, and bomb threats against theaters. The case was appealed up to the Supreme Court after its exhibition license

was revoked, where a victory secured important First Amendment guarantees for movies.

The controversy most similar to "The Last Temptation" swirled around Jean-Luc Godard's "Hail Mary" in 1985. The film retold the story of Mary and Joseph, but in this version Joseph is a taxi driver and Mary a teenaged basketball enthusiast he first meets as she's pumping gas. The film bears the distinction of being the first ever condemned by a pope (Pope John Paul II), and being the first instance in 400 years that a pope directly intervened in the suppression of a work of art. The film caused turmoil wherever it was shown in Europe, the responses ranging from bomb threats and canceled bookings to Godard being hit in the face with a pie at the Cannes Film Festival.

It had acquired a notorious reputation by the time it arrived in the United States. In New York, Cardinal O'Connor blasted it from the pulpit of St. Patrick's Cathedral, and 5,000 protesters recited the rosary and shouted "Shame!" at moviegoers. Months later in Chicago, it was condemned by an ecumenical array of protesters: Black Muslims, Greek Orthodox, and Hispanic Catholics. The City Council passed a resolution urging a Chicago theater not to show it (there was only one dissenting vote), and Joseph Cardinal Bernardin led a special prayer service for 1,500 at Holy Name Cathedral.[66] The sense of distress was heightened there because the film was booked during the Easter season.

Many reviewers pinpointed the mixture of sacred and profane as the source of the film's problems. One sums up this position the best: "It's the juxtapositions in 'Hail Mary' that create the most shock: the classical framing and the vulgar dialogue, naked flesh and sacramental poetry, transcendent natural images . . . followed by profane screaming matches."[67] Many other reviewers and moviegoers also noted that these juxtapositions were distracting, and the repetitive and quizzical nature of the film tempered any erotic qualities with equal amounts of tedium and confusion. This is yet another example of people protesting the *idea* of a work of art and elements within it, without actually experiencing it on their own and then forming their own opinions.

DEFENDING AGAINST SLINGS AND ARROWS

Doctrinal defenders fight to preserve belief systems.[68] But as this society has become more secularized, art controversies have targeted the banal as well as the divine. For example, the movie "Silent Night, Deadly Night" was protested throughout the country, and in Milwaukee the city and county governing boards voted to support the grass-roots opposition movement. Demonstrators were dismayed by this storyline about a serial killer who dressed in a Santa outfit, and they adopted slogans such as "Deck the halls with holly, not bodies."[69] While this is little more than a curiosity, another distinct category of controversies involves

the church as an institution, where it attempts to repel what it sees as attacks on its reputation.

Sometimes doctrinal and reputational issues blend together. A book entitled *Eunuchs for the Kingdom of Heaven*, by German theologian Uta Ranke-Heinemann, was blasted by John Cardinal O'Connor as "Catholic-bashing." The book dissects the Catholic Church's denigration of sex in general and women in particular, and urges more personal choice in making sexual decisions. Although the book was a best seller throughout Europe, O'Connor read only the dustjacket to reach his conclusion that the publisher Doubleday was a "purveyor of hatred and scandal and malice and libel and calumny." The Cardinal bolstered his argument by citing the "frivolous" use of church personnel in a variety of advertisements.[70]

In some instances religious satire carries an unusually severe bite. Christopher Durang's play "Sister Mary Ignatius Explains It All for You" is an example of an incisive spoof that has attracted controversy throughout the country. Some Catholics find it aggressive and upsetting, whereas others appreciate its comical look at a Catholic upbringing. The Catholic League for Religious and Civil Rights has orchestrated protests against it in New York City, St. Louis, Missouri, and Long Island. These protests have been remarkably similar. In Missouri, for example, complainants pressured the state legislature to take action because the venue where the play was presented was supported by tax revenues. The legislature proposed to cut $60,000 from the state arts council's budget because of its refusal to sever connections with the theater group, preferring to earmark the money to finance farm shows since "county fairs are a lot more wholesome."[71] The cut was later restored, but the state senate then voted a ban on the controversial company.

Each locale added a new wrinkle to the struggle. At Nassau Community College on Long Island, for example, academic freedom became a factor because Catholic groups wished to ban a proposed staging by the theater department. But the president and the board of the college eventually agreed that this would set a dangerous precedent for overseeing the curriculum generally and decided to go ahead with the production. Even though public discussions were held after each performance, some community members were not appeased, and they unsuccessfully lobbied to have the school's funding decreased by the state.[72] And finally, in 1990 the Costa Mesa, California City Council adopted a measure that prohibited groups from using city arts grant monies for "obscenity" or "religious or political activity." "Sister Mary Ignatius" was the first work cited in violation of that measure.[73]

Other disputes more clearly fall within the reputational domain. For example, the TV movie "Judgment" was turned down early in the idea stage by both CBS and NBC, and ABC later halted it after the network had ordered a script. HBO finally picked up the sensitive project about a 1984 case in Louisiana where seven priests were accused of molesting parish boys and the church was forced to make a multimillion dollar settlement. The movie focused specifically on how the church

bureaucracy obstructed the establishment of guilt and accountability for a problem that is costly in morale, authority, and dollars.[74]

The Catholic Church took similar affront at a play presented in New York City in 1990, "The Cardinal Detoxes." The work is a 35-minute monologue by an archbishop in an alcohol detoxification center. He had killed a pregnant woman while driving intoxicated, and attempted to enlist church officials to bribe a judge on his behalf. The church wished to close down this unflattering characterization, working an unusual angle: it held the lease to the former parochial school where this Off-Off-Broadway production was being staged. In signing that document the RAPP Theater Company had agreed to allow the church to stop any production it found "detrimental to the reputation of the church." In court, lawyers for the church argued it was blasphemous, did harm to the church, and "made a mockery of the Roman Catholic Mass."[75] The court found that the church had the right to evict the troupe (a step that would have to be pursued through a civil action in housing court), but refused to block further performances. A few days later building inspectors tried to padlock the theater for code violations, a move they claimed was "unrelated" to the archdiocese's suit. This nearly caused a riot by audience members, but the play continued unharrassed thereafter.[76]

As artists have tackled controversial topics with greater frequency, the negative religious response has continued apace. When the artists' collective Gran Fury initially attempted to display their posters in the 1990 Venice Biennale, their work was considered blasphemous and the group had to shelter it overnight in a pizza parlor. One poster featured a photo of the pope with a text critical of the church's stance toward sex and contraception, while another presented an erect penis. The images were emancipated from their temporary lodgings the next day and displayed after legal authorities decided to clear them, even though the director of visual arts protested "It is not art."[77] And New York's Cardinal O'Connor continued to be an armchair critic in March 1990 when he paralleled the tale of Satan tempting Jesus in the desert with the purported increase of Satanic activity by young people and the proliferation of such imagery in rock music. The Catholic Church has continued to become involved in controversies over expression and representation, as in the example of the film "Stop the Church" (see Chapter Twelve).

Fundamentalist leaders have also persevered to find evidence to confirm their theory of a pervasive "anti-Christian bias" in contemporary arts and entertainment. They have taken offense from cartoons: Bart Simpson intoning sarcastically before a meal, "Dear God, we paid for all this stuff ourselves, so thanks for nothing!" And they reacted against some dialogue in an episode of the dramatic series "Lifestories," an installment that had been postponed because it dealt with AIDS. When the main character hears his hospital roommate praying, he admonishes him: "You're wasting your breath. God doesn't listen to the prayers of faggots. Haven't you been paying attention in church? We're going to burn in hell for all

eternity."[78] Fundamentalist leader Donald Wildmon is so incensed about this type of content that his first major crusade of 1991 was directed against a new Norman Lear series, "Sunday Dinner." Wildmon judged this to be the latest in a long list of programs where Lear and others promulgate their "secular humanism" and thereby demonstrate their anti-Christian stance. But typically, Wildmon launched his crusade *before* the series ever aired. "Sunday Dinner" turned out to be a critical failure, barely distinguishable from many other sitcoms and hardly a didactic primer on antireligious doctrine.

A CASCADE OF CRITICISM

When Andres Serrano made a certain photograph in 1987 he did not suspect that it would incur the wrath of politicians and spiritual leaders; nearly bring down a 25-year-old government agency; and consign him to a notorious niche in art history. But Jesse Helms called Serrano "a jerk" because of "Piss Christ," and Alphonse D'Amato tore up a catalog containing his work because he judged it to be "filth" and "garbage." Both of these outbursts disturbed the decorum presumed to distinguish the Senate floor. The adverse reaction to the photo helped to spur the most intensive scrutiny ever directed at the National Endowment for the Arts, and became a central issue in the debate over its reauthorization. The furor over this image managed to pull together a number of themes discussed thus far: the mixture of sacred and profane elements, the isolation of a single example from a larger body of work, the discrepancy between provocative titles and otherwise aesthetically accomplished depictions, and the artistic quest to come to terms with complex questions of religious belief.

That's a huge load for one work to shoulder, but the "Piss Christ" was forced to do just that. One of Serrano's major foes was the Reverend Wildmon, fresh from his battles over Scorcese's "The Last Temptation of Christ" and Madonna's "Like A Prayer." Wildmon took all these creations as evidence of a sweeping assault on Christians, signs of an imminent Armageddon. Witness Wildmon's concern as it surfaced in a letter to a constituent: "We should have known it would come to this. . . . The bias and bigotry against Christians, which has dominated television and the movies for the past decade or more, has now moved over to the art museums. . . . Maybe, before the physical persecution of Christians begins, we will gain the courage to stand against such bigotry."[79] The perception of symbolic violence, and its near equation with physical attack, disclose a position of exaggerated terror and duress.

The "Piss Christ" is a photograph of a crucifix submerged in urine. It was one of eight works by Andres Serrano which were included in an exhibition entitled "Awards in the Visual Arts," an annual fellowship competition held since 1981. The program was sponsored by The Southeastern Center for Contemporary Art

(SECCA) in Winston-Salem, North Carolina, and funded in 1988 by The Equitable [Life Insurance] Foundation, The Rockefeller Foundation, and the National Endowment for the Arts. The winners were chosen through an intricate process that began with the solicitation of a large pool of nominations which was then narrowed through rigorous jurying by a group of well-respected art professionals. Ten winners were eventually chosen to represent each of ten geographical areas. They received $15,000 for work they had already completed, which was displayed in museums and galleries in Los Angeles, Pittsburgh, and Richmond, Virginia.

Most of the adverse response to Serrano's work was not registered until after the tour was completed: it closed in Richmond on January 29, 1989, and much of the criticism emerged during the Easter season. In Richmond the controversy was primarily waged in the "Letters to the Editor" columns of the local papers and through outraged messages sent to the Virginia Museum of Fine Arts. The lag derives from the fact that it took Wildmon's American Family Association (AFA) some time to crank up its oppositional machinery. This became an emotional issue, so much so that a man appeared at the information desk of the museum early one morning in a very agitated state. The director tried to calm him down, but the man "related how he had been to Germany at age 15 with his parents and had seen a museum in Munich totally devoted to corrupt art. He said that what was being done now [that is, the "Piss Christ"] should be in such a place."[80]

But although the controversy began in Richmond, it could not be contained there. AFA members were encouraged to write to the show's sponsors with their complaints, and some Equitable agents who were AFA associates pressured their parent company to disassociate itself from the work. Equitable's chairman consequently apologized to Wildmon. This religious mobilization also provided the basis for a concurrent crusade led by Jesse Helms against the NEA, who saw "Piss Christ" as a "sickening, abhorrent, and shocking act by an arrogant blasphemer."[81]

There was a groundswell of support for the recriminations voiced by political and religious leaders. For example, a man wrote to Serrano's New York gallery in a breathless accusation, "How dare you a mere weak human being so dependent upon Almighty God for every breath that you take insult Him for all of the good that He has showered on you including your artistic talent which you throw back in His Holy face by attacking Him with your hellish, horrible painting [sic] of Our Suffering Savior on the Cross."[82]

After all the hype and negative publicity, you'd expect Serrano to be the Devil incarnate. Nothing could be further from the truth. In person he is soft-spoken, direct, and thoughtful. He has shunned the spotlight, preferring instead that the work itself be the center of attention. He lives away from arty, downtown Manhattan, in a decidedly unfashionable neighborhood in Brooklyn. The apartment he shares with his wife, also an artist, has the fetishistic feel of a collector: stuffed animal specimens and creatures preserved in jars share space with a shelf of skulls arranged in descending size. The walls of the tiny bathroom are dense with

crucifixes, two church pews serve as seating in the living area, and the bed has an ecclesiastical look as well. The professional paraphernalia of the photographer elbows for room alongside finished products: Serrano's own prints, and paintings by artists such as Howard Finster and Leon Golub. This is the home of a reluctant public figure.

The "Piss Christ" also confounds expectations. Serrano works in a large format. This piece is sixty by forty inches: at five feet high it has an impressive presence, even when it is displayed in the vast spaces of a SoHo gallery. And he uses glossy, highly saturated Cibachrome colors. Reproductions are disappointing because they fail to transmit either the magnitude or the brilliance of his images. "Piss Christ" is a lustrous work: a crucifix appears suspended in a glorious yellow firmament, illuminated by an unseen light from above, and buttressed by a bright red backdrop. When the intense red and yellow merge it is reminiscent of the surprise of discovering the mixture of blood and yolk once you've cracked open a fertilized egg. Most viewers would likely be touched by the sense of majesty and spirituality the photograph evokes—that is, until the *appearance* of the image is tempered by the *reality* of its execution. As Serrano explains, "as a photographer it's just important to me to be descriptive or literal, you know. . . . I could just use piss for the beautiful light that it gives me and not let people know what they're looking at. But I do like for people to know what they're looking at because the work is intended to operate on more than one level."[83]

This photo has to be considered in the context of Serrano's oeuvre in order to be fully appreciated. Serrano began his tableau photos in 1983, often using meat within scenes which combine carnality and religiosity. "The Rabble" (1984) presents a crucifix in the center of a crowd of outstretched hands, an object of desire like a rock star to his adoring fans. But on second glance, those hands are chicken claws. "Cabeza de Vaca" (1984) shows the severed head of a cow, blood at its neck and an eye that mercilessly locks the viewer's gaze. The startling counterpoint to the corporeality of the flesh and hair is the marble base on which the head rests like a sculpture. And "The Pieta" (1985) is a portrait of a beautiful young woman wrapped in black cloth, gently cradling the carcass of a large fish before her.[84] In 1986 the artist began to simplify his approach and use just bodily fluids, as in his "Milk, Blood" of that year.[85] In Serrano's words, "In using the bodily fluids . . . this photograph at first looks like an abstraction. It can be appreciated on that level. But then when you know what I'm dealing with . . . it takes on a whole different meaning, too."

As Serrano has stated many times, he had a palette that now included red and white, but his desire to expand his color spectrum lead him to experiment with using urine. He created a series of images in 1987 and 1988 by dunking sculptural objects into a Plexiglas vat of his own urine, including "Piss Pope," "Piss Satan," "Piss Discus" (the "Discus Thrower"), and "Piss Elegance" (a fashion model). "Piss Christ" takes its place within this genre of work whose unusual puns can both

amuse and offend. Serrano later augmented his materials with his wife's menstrual blood and his own semen. To his critics this was additional evidence of his derangement; to both the artist and his supporters, however, this work continued to broaden his artistic vision.

That vision can be deciphered in a number of ways. Serrano draws upon his own Catholic upbringing—what he sees as the Catholic obsession with the "body and blood of Christ"—as well as his cultural heritage as the son of a Cuban mother and an Honduran father. Serrano cautions, "You can't say it [the work] is anti-Christian bigotry and ignore the fact that this person was once a Catholic, had a Catholic upbringing, has worked a lot with Christian imagery in the past, and as an artist feels very much aligned to other artists who have worked with Christian imagery consistently, such as Goya and Luis Bunuel and many others." His work draws together passionate and surrealistic traditions in art, the ardor that suffuses some Hispanic Christian customs, and the corporeal aspects of rites central to Christian doctrine such as the Eucharist.

Over time the religious themes were combined with the interest in bodily fluids, and eventually linked with a preoccupation with death. Serrano explains, "my work has been compared to the sacred and profane. But you can't have one without the other. And so my obsession with death also reflects my obsession with life and mortality." His photos raise questions similar to those the image of Jesus presented by Kazantzakis and Scorcese did: how human was Jesus, and is divinity compromised by association with banality? As one art critic asked in Serrano's defense, "Had the crucifix in 'Piss Christ' really been defiled? Or had the urine been sanctified?"[86]

The dual nature of Christ has troubled believers throughout the ages. Serrano targeted a domain that people do not like to think about, as evidenced by the adverse reaction to "The Last Temptation of Christ." When he transected an already charged issue with our complicated feelings about bodily products, he managed to tap into a tremendous preserve of ambivalence and anxiety. While we know that urine is the end product of a vital cleansing process, we generally tend to be repelled by it. Serrano also took it from the private realm into the public. Blood and semen are similarly emotionally loaded, and even more so now because of the AIDS epidemic, when the very same life-giving liquids may also be life-threatening. But while it is much less complicated to think of life and death or God and man as completely separate categories, Serrano and other artists will not allow their audiences to sustain such a state of naivete. As the artist muses, "I don't see why anything that an artist could create would be so horrific to an individual that they could not stand it. . . . [A]rt may be disturbing but I don't think it's really threatening."

A final aspect to Serrano's work is its implicit critique of the commodification and commercialization of religion. "Piss Christ" contains a kitschy plastic figurine that has come to represent religion for profit in our time, and captures it in the

same glossy format that could pitch any product or idea. This and other Serrano images raise disturbing questions, although ironically at a safe distance: his pretty pictures pose no danger of splashing onto the viewer or smelling badly. But Serrano's task is to at least broach the contradictory aspects of his religion and to examine the earthy, gritty aspects in tandem with contemporary, sanitized versions. Martin Scorcese described his mission similarly: "I didn't want a Christ who glowed in the dark."[87] Both men view their work as potentially reinvigorating religious ideas that have been debased as they are incessantly hawked through the electronic media. Each calls for a more personal involvement with religious beliefs, and struggles against them becoming transubstantiated into dogma.

Politicians besieged the NEA with questions about its funding procedures because of "Piss Christ." The agency had contributed $75,000 to the SECCA awards program, and although the NEA had no direct control over how that money was awarded, the Senate and the House tried to hold it accountable for what many members saw as an insulting mistake. Led primarily by Jesse Helms (R-NC) in the Senate, and by Dick Armey (R-TX) and Dana Rohrabacher (R-CA) in the House, debate raged throughout the summer and fall of 1989 over punishing the agency. In July the Senate passed a bill cutting NEA funding by $45,000, an amount equal to the awards to Serrano and to a travelling exhibit of Robert Mapplethorpe photographs that had also raised congressional ire that summer (see Chapter Seven). In addition, the bill banned the two sponsor institutions from receiving any NEA funding for the next five years: SECCA, and the Institute of Contemporary Art (ICA) in Philadelphia.

In later compromises the punitive funding cut was retained, but the outright ban on grants to SECCA and ICA was replaced by a proviso that any awards to them would be subject to the oversight of the House and Senate Appropriations Committee.[88] Most important, however, was the passage of the "Helms amendment," a measure that barred Federal funds from underwriting materials that could be deemed "obscene," or lacking "serious literary artistic, political or scientific value." But far from quelling the controversy, the ambiguities of the law—and the fact that it also lumped homoeroticism with sadomasochism and the sexual exploitation of children as additional areas of proscribed subject matter—helped set the terms of the debate over public funding of the arts for the next several years, and called out a furious sense of resistance on the part of artists and their supporters.

Two gestures after the Helms amendment was passed help define the terms of that dialogue. When a gallery show of Serrano's work was reviewed by the *New York Times* three months later, it provided the opportunity to heap praise on the photos and to assail Helms and his cronies. But the defense was mounted in terms that could only be understood by those who were already extraordinarily well-versed in art history: the reviewer made reference to the Byzantine Iconoclast Controversy of the eighth and ninth centuries, medieval cosmology, and a specific

painting by Gauguin, in order to contextualize the images and direct an informed response to them.[89] But these were justifications that largely ignored the fears and offense the "Piss Christ" had raised for many people, and showed a certain contempt for these feelings by accentuating the gap between the art world and the general public.

At the other extreme was a project proposed for Artpark in Lewiston, New York by a San Francisco-based group called Survival Research Laboratories (SRL). SRL generally stages remote-controlled robotic spectacles of violence. The plans of "Bible Burn" called for covering sexually explicit props with Bibles "requisitioned" by SRL supporters from hotels, churches, homes, and so on, using them in "unholy rituals," and then having robots burn them.[90] It was to be, the founder of the group stated, "the ultimate nightmare for the right-wing religious male."[91] The performance was canceled by Artpark, and a subsequent protest by artists resulted in arrests. The deliberate provocation and nihilism of this project should not be surprising; it is a rejoinder to the moralistic and legalistic attempts to reign other artists in. But it does contrast with most of the other examples in this chapter, where artists struggled with personal visions that challenged the doctrines and institutional authority of the church.

Common to most of these religious examples has been the struggle between proponents of one revealed version of the truth and those who promote a more individualized and critical approach to life and how it should be lived. People who belong to the first group feel the heavy pull of tradition and obligation, and load certain symbols with enormous power and significance. Those in the second are more open to a variety of interpretations. These same lines of contention are drawn in other domains, as the next chapter will demonstrate.

5

RALLY 'ROUND THE FLAG

Washing a Flag: Treat It 'Like Lingerie'
Title of pre-July 4th article on proper flag care, 1990

These colors don't run or burn.
Desert Storm T-shirt, 1991

Letters to Ann Landers offer a glimpse into what's troubling Americans. If a topic appears in her column, it's a safe bet that the same thing is on the minds of many other people. A good example of this was her July 4th column in 1990. A bewildered writer tried to reconcile the fact that it is illegal to litter or spit on the sidewalk, yet nude dancing is permitted as a form of "expressing yourself." The correspondent from Knoxville continued, "Crazier still—it is OK to burn the American flag. The U.S. Supreme Court says so because of that 1st Amendment thing again. . . . Please explain this to me."[1] Landers sensibly replied that the First Amendment guarantees freedom of expression even when it attacks the system that permits it. To her credit, Landers argued that this is the law's beauty and its strength.

But many people were not so clear-headed about this in 1990. During the preceding year there was a national debate about the First Amendment and the freedom to dissent. It revolved around what the flag means and how it should be treated, and a primary source of the controversy was a display at the School of the Art Institute of Chicago (SAIC). Student "Dread" Scott Tyler's mixed media installation piece "What Is the Proper Way to Display a U.S. Flag?" set off an even more pitched battle than the David Nelson portrait of Mayor Washington had done nine months earlier, in 1988.

Dread Scott's conceptual art piece is deceptively simple, consisting of three elements: a photo, a shelf holding a book, and an American flag [see Plates section]. The sixteen-by-twenty-inch silverprint was mounted at eye level and contained the title of the work and a photocollage which included flag-draped coffins and a South Korean flag-burning demonstration. Mounted on the wall below that was a shelf containing a ledger where viewers could write comments. And spread upon the floor beneath this was a three-by-five-foot flag. The piece *seemed* to entice the audience to step on the flag to register their reactions in the book. Although this was the easiest way to record comments, it was not absolutely necessary to trample the flag; it was possible for viewers to stretch in order to reach the shelf and write a response. Dread Scott's placing the flag on the floor was sufficient to infuriate many people; his apparent invitation to step on it heightened their dismay and enlarged the ranks of his opponents.

"What Is the Proper Way" is one of a series of participatory art works that Dread Scott has been producing since 1987. It was included in a collection of twelve such pieces as part of a two-person show at the Near NorthWest Arts Council Gallery in November, 1988, with the title "Our Aim Is To Destroy Them!" Each of his works shared a similar format: a photocollage mounted on the wall which posed a political question, combined with a ledger for registering reactions. Dread Scott displays these pieces in a variety of locales, so that comments made by housing project residents might follow pages of reactions of viewers from an artistic or academic setting. This mixture of audiences is important to the artist, who claims that "writing into the ledger books is something which actually unleashes in a certain sense class struggle around a particular work of art."[2]

Dread Scott typically provides a stack of take-away prints of the photocollage. In one case his text proposed "If you believe that the United States should be overthrown by a revolution and are currently participating in activity to do so, please feel free to take a print." In another instance he wrote "If you're not going to come out silently with your hands up, please feel free to take a print." With "What Is the Proper Way," the flag replaced this standard third element. But in all these examples, audience involvement is essential for this artist.

Many of Dread Scott's early photographs were aesthetically oriented portraits. He describes this work as "sort of [in] the Surrealist camp, but ideologically a lot of it was in sort of the Dadaist camp." But changes in the artist's creative work paralleled a personal and political transformation. In 1985 he became associated with a group called No Business As Usual, whose slogan was "Prevent World War III No Matter What It Takes." Politics then superceded aesthetics; abstract questions and "pure beauty and stuff" were no longer satisfying to him. Dread Scott now appropriates his own images, combining parts of his original work with pictures from magazines and other popular sources; a section from his photo of a woman's face can be juxtaposed with police beating demonstrators in South Africa, for instance.

Dread Scott's metamorphosis was prefigured in biographical details. He was reared in Chicago's Hyde Park, a middle-class, racially integrated Southside community around the University of Chicago. He attended the elite Latin School on the Northside for twelve years, as a Black student in a predominately White environment. He encountered constant racial taunts while there and fought frequently. Dread Scott was caught between social worlds and was constantly subject to be judged as lower class and culturally separate from his peers in school. He recalls understanding how exceptional his situation was when he travelled with his soccer teammates to a match on the Southside: "Although I'm definitely not from the ghetto, [and] as little as I knew about it, you know, I'd seen it, I'd been through it, I'd walked through it, I'd grown up around it. They'd never been south of the Loop." From that time forward his awareness of class and racial inequities was acute. As he journeyed through the city he could no longer disregard the immense public housing projects which sprawl across the Southside.

Dread Scott is commonly linked with David Nelson because of their shared SAIC affiliation, yet they are markedly different artists, with dissimilar styles and motives. He dismisses Nelson as a cynical creator of one-dimensional work. According to Dread Scott, Nelson's portrait of Mayor Washington employed a "bad anti-aesthetic. A sort of mass aesthetic saying that the *National Enquirer* is what the masses are really into, 'aren't they dumb, aren't we enlightened?'. . . deep down it's pretty damn shallow and pretty damn offensive." Dread Scott is careful to detach himself from any association with his fellow student: "[Nelson] doesn't mind promoting racism, doesn't mind promoting homophobia, doesn't mind promoting, you know, the oppression of women. I want to liberate people from all of that." And whereas Nelson was the diffident actor in a drama for which he was largely unprepared, Andres Serrano reports that when he questioned Dread Scott about the flag piece he admitted "I meant for it to do everything it's done."

TIME, PLACE AND PERSON

"What Is the Proper Way" was exhibited in the aforementioned show at a Chicago alternative gallery with no difficulties. And at the same time that Dread Scott's piece was shown at SAIC, the Peace Museum in Chicago was the tranquil host to "Committed to Print," an exhibit of overtly political art from the past twenty five years. There were many works in that show which had the potential to offend viewers, given the abundance of material from a leftist and anti-government perspective. But as already noted, the politics of place are critical, and when works are shown in certain venues they are more assured of an understanding, supportive audience.

The Art Institute and SAIC serve a much broader public and are susceptible to charges of perversion of their public responsibilities. SAIC, of course, had been

under fire for the painting of Mayor Washington, and the Art Institute was next accused of illegal possession of a Thai sculpture in the summer of 1988. The Thai government claimed that an important stone lintel the Institute possessed was stolen property, and demanded its return. Pickets dramatized the Thais' claim daily, but the museum denied the charges. SAIC was a convalescing and vulnerable institution when this new fracas broke out.

Paradoxically, Dread Scott's piece was included in a show which was designed to hasten the healing process: "A/Part of the Whole" featured the work of minority students at the school, the title superbly capturing the fractional nature of intergroup relations. This was a juried show sponsored by Ethnic American Students United, and overseen by invited minority experts.[3] Such an arrangement contrasts with the fellowship competition where David Nelson's painting appeared without being previewed. But the controversy over Dread Scott's work displaced the therapeutic intentions, and Chicago once again took center stage in an intensely emotional symbolic brawl. After it was over, school president Tony Jones adopted a metaphor suggested to him to describe the preceding year: every organization has P.R. disasters, but SAIC managed to have its own versions of Bhopal and the Exxon Valdez in quick succession.[4]

This debate about patriotism and protest, loyalty and legal safeguards for unpopular opinions, involved powerfully concentrated symbols. For instance, the artist's adopted name "Dread" incorporated several messages. An historical component derives from the 1857 Supreme Court case *Dred Scott v. Sandford*. That litigation confirmed the legal status of Dred Scott as a slave (that is, property) in Missouri, although it was more ambiguous on the larger question of the extension of slavery into the territories. Pro-slavery advocates declared a victory, but the case accentuated rather than settled the controversy, and was a contributing factor to the Civil War. "Dread" also alludes to the dreadlocks of Rastafarians, an outward sign of a Black cultural movement steeped in resistance. Dread Scott is not a Rasta, but identifies with self-affirming opposition movements, and wears his own hair in an abbreviated dreadlock style. Finally, there is the notion of inspiring dread in people, an idea that pleases this artist, a self-proclaimed revolutionary and "proletariat internationalist."

Dread Scott's appearance, his rhetoric, and his art all challenged long-held stereotypes about Blacks. This was startling in a city where campaign buttons once were clandestinely sold which carried no names, slogans, or candidate likenesses on them, but merely a watermelon. That was in 1983 when Harold Washington first ran for mayor, and that emblem required no embellishment to transmit its racist message.[5] Chicago had experienced manifold changes by 1989, but there was also a tremendous impulse to embrace eternal verities such as country and flag. Chicago, and the rest of the country, was caught in a patriotic fervor which equated the social fabric with the cloth of the flag. To many minds the two were equivalent, so that an assault on one was invariably seen as an attack on the other.

THE FLAG AS CANVAS

The flag may be the most polyvalent symbol Americans have. Its use is pervasive, from hawking products to displaying diverse political sentiments. George Bush figuratively wrapped himself in it during the 1988 presidential campaign, his visit to the nation's largest flag factory being just one of many examples. And Madonna donned it over a red bikini and black boots in an MTV public service announcement. The spot was part of the 1990 "Rock the Vote" campaign to encourage music fans to support candidates who promote freedom of speech, and defeat those who attempt to limit it through such measures as record labelling. As she intoned, "Dr. King, Malcolm X/ Freedom of speech/Is as good as sex./ And if you don't vote/ You're going to get a spankie."

The flag figures prominently in some of the most dramatic images of American life in the twentieth century, and can embody conflict or consensus. Gordon Parks's "Government Charwoman" (1942) positioned a Black woman gripping a broom and a mop in front of a large American flag. The photo is a dignified vision of a laborer in Grant Wood style; simultaneously, it subtlely records the occupational fate of another segment of society. The famous 1945 photo of the US flag being raised on Mt. Suribachi commemorates the American victory at Iwo Jima in World War II, a triumphal scene familiar to almost all citizens. In the 1960s and '70s Abbie Hoffman stood defiantly resplendent in an American flag shirt, a gesture that landed him in court,[6] and on one occasion prevented all but his face from being shown on network television. In 1976 White opponents of school busing in Boston lunged at Black demonstrators, using a flagpole with the flag fluttering beneath it as their saber. And in the gift shop of the Art Institute of Chicago you may buy a postcard of a World War One parade (c. 1917–18) where a huge crowd formed before the flag-bedecked museum. The scene reflects a time when there was greater consensus over the meaning of the flag, over fifty of which decorate the building.

The flag has long been a staple of protests by disaffected groups to dramatize their causes. International Workers of the World leader Bill Haywood made the flag into a protest poster during a series of miners' strikes from 1901–03, changing the stripes into lines of running commentary on the political situation. He was arrested subsequently for desecration of the flag.[7] This sort of adaptation has increased since the 1960s, as with a 1989 ACT UP subway poster which adopted exactly the same means to dramatize government action and inaction regarding AIDS.[8] In another variation, disability rights advocates changed the constellation of the star field to the international disability insignia to press their case at the Capitol in 1990. And homeless people living in New York's Tompkins Square Park made a tent out of flags to highlight their plight in 1989, while a demonstrator at a 1990 international AIDS conference in San Francisco combined a skull mask with the flag as a shawl to indict the government's record on fighting the epidemic.

The flag is quite literally used as a Rorschach blot onto which groups project their concerns, with no hestitation over altering it to meet their distinctive needs.

The flag also has been worked into the design of swimsuits, sweaters, jackets, boxer shorts, slippers and rugs. In 1989 an enterprising entrepreneur tapped the safer sex market with the Old Glory Condom Corporation, touting the product logo "Worn With Pride."[9] And that same year Hudson's, an upscale New York City casual wear clothier, ran a slick ad campaign with flag motifs. One installment featured a picture of a demonstration at an unidentified site where at least a half dozen American flags were being burned. The headline declared, "Americans May Not Be Loved Around The World, But Our Fashions Are." The text ended with the declaration "We may be hated, but we look cool."[10]

Folk artists have perennially incorporated the flag into everything from quilt designs to painted fishing lures, as have professional artists from Childe Hassam to Jasper Johns and Edward Ruscha. But some contemporary artists have taken a more critical view, much like the satirical song in the musical "Hair" in which two characters sing of the flag in mock-twangy style, "Don't put it down, best one around."

The widespread anti-authoritarian and anti-war sentiments of the 1960s surfaced in a notable art exhibit in 1966. A New York City patrolman walking the beat halted abruptly when he looked up at the second-floor window of a Madison Avenue gallery. What he saw was the sculpture "The United States Flag in a Yellow Noose," by former Marine Marc Morrel. The flag was stuffed with foam rubber and hung by a noose as if it were a body. Other pieces included "The United States Flag in Chains" and "The United States Flag as a Crucified Phallus." The latter was a large cross made from ecclesiastical flags, dangling like a puppet, with a phallus made from a US flag. There were thirteen soft sculptures in the show, which also included anti-war songs playing in the background.

Gallery owner Stephen Radich was charged with "casting contempt" upon the flag under a turn-of-the-century statute, and an eight-year legal battle ensued. The Assistant District Attorney mounted an argument that presaged the thinking of the Chicago aldermen who had the painting of Mayor Washington impounded. He claimed "If we were to allow individuals to show great disrespect to the flag, the People contend that the public would be aroused to the point where there would be possible riot and strike."[11] Such a public response to the show *had not* occurred. Nevertheless, Radich was convicted by a three-judge panel and fined $500.

The trial is noteworthy on several grounds. The prosecutor maintained that sculptures were more provocative than paintings or photographs; their three-dimensional quality purportedly made them more "real," and more apt to arouse passions. Moreover, he contended that their exhibition represented conduct, not speech, because of their nonverbal character. Therefore, regulating their display would not violate guarantees of free expression. Museums and professional arts

organizations kept a hands-off attitude in this case, although artists and other dealers rallied to the cause. Interestingly, critic Hilton Kramer testified as an expert witness for the defense. He maintained that the quality of Morrel's work was low—the position of many arts professionals—yet he admitted that it was indeed a legitimate form of expression and merited being called art.

The decision was upheld on appeal, and the case eventually made its way to the Supreme Court in 1970. This time the professional art world did come to Radich's defense via an *amicus curiae* brief, but the Supreme Court also upheld the conviction. In 1974 Radich was finally vindicated when a Federal District Court judge decided to re-hear the case on its merits.[12]

In 1969 Morrel's "The United States Flag in Chains" generated controversy in another locale: Decatur, Illinois. The president of the Decatur Art Center's Board of Directors and the director of the gallery were both convicted of improper display of the flag in that instance, although these decisions were later reversed by the Illinois Supreme Court.[13] This was a time of heightened concern for the flag, as represented by the introduction of legislation for the establishment of Flag Day just one month prior to Radich's first trial. Artists continued to challenge the use and meaning of the flag, as they did in the "People's Flag Show" at New York's Judson Memorial Church in November, 1970. Over two hundred works incorporating the design of the flag or critical commentary on it were displayed. A flag was burned on the opening evening, and a symposium was held on the repressive use of flag desecration laws. The exhibit was later shut down by the District Attorney's office, and organizers Faith Ringgold, Jon Hendricks and Jean Toche ("the Judson 3") were arrested for flag desecration. They were convicted and sentenced six months later to one month in jail or a fine of $100 each.[14]

The controversy over Dread Scott's piece reinvigorated the incorporation of the flag into artistic work. For example, Robert Longo presented "Black Flags" in 1990, a show where he displayed twelve bronze flags with a funeral tone. Mark Heresy produced "Flags," twenty one banners created out of diverse materials: bullets, currency, human hair, and pornographic pictures. Donald Lipski burned holes in the flag, unraveled it, wove it into balls, and wrapped it around pitchforks, saw blades, and the roots of saplings. Barbara Kruger turned the side of L.A.'s Museum of Contemporary Art's Temporary Contemporary into a flag-like mural, where the stripes posed a series of political and rhetorical questions. And the Codanceco dance company performed an emotionally ambivalent dance upon it. As just this small sample reveals, the flag continues to stimulate the artistic mind.

ART AND AUDIENCE

Conceptual artists privilege ideas over craftsmanship and prize audience participation in defining, refining and completing their work. On those measures "What Is the Proper Way?" succeeded marvelously. The exhibit opened on February 17,

1989. Local news stations reported it on the 23rd, and the next day the social drama began. Veterans—primarily from the Vietnam era—stormed the exhibit and attempted to confiscate the flag and close the show. From then until the exhibit officially closed on March 16 (two days early), what Tony Jones characterizes as a "muscular debate" ensued. There was political grandstanding by both defenders and detractors, a flurry of legislative and legal maneuvering, and daily demonstrations. And the piece became truly participatory.

The ledger books captured audience reactions to the question Dread Scott posed, often with an ardor that erupted in expletives and threats. Some people were simple and direct: "Shit Head," "Who the fuck you think you are JAGOFF!!" Others used their own biographies to challenge the artist's right to denigrate the flag: "You skunk—my father's flag was draped over his coffin." Or, "Scott unless you served you don't know what it means to cover a body with the flag. I'll get you Scott." Certain respondents adopted the '60s "Love it or leave it" slogan, sometimes appending it with racial slurs or "fag." And some were chillingly vague yet blunt: "Watch your back."[15]

In addition, veterans developed a protocol which fused artwork and audience into a symbiotic relationship. Each day they entered the gallery, picked up the flag from the floor, ceremoniously folded it, and placed it upon the shelf. This was a remarkable ritualized effort to restore order to a situation where the vets felt a sacred object had been profaned by breaking the customary rules for its display. But the attempt to avert pollution was foiled: just as predictably, gallery personnel or other observers would reposition it on the floor, only for the cycle to repeat again and again. Conceptual art seldom achieves such a level of interaction.

Events spilled out beyond the boundaries of the gallery, however. President Bush called the work disgraceful, and legislators in Chicago, Springfield, Illinois, Washington, D.C. and elsewhere—from tiny Illinois towns to states distant from the action—scurried to enact additional safeguards for the flag.

The street also became a place where the issue was engaged. Dread Scott's supporters (including many students) demonstrated outside the Art Institute complex in support of freedom of expression. They were there to answer his critics, who maintained regular outdoor protest vigils. Such patriotic, anti-Dread Scott gatherings culminated on March 5 when 2,500 people met to denounce the exhibit, and on March 12, when crowds estimated from 2,000 to 7,000 turned out [see Plates section]. This was not a rarified piece of art; rather, it was repeatedly hailed or reviled, and dominated the news during its exhibition period and beyond.

STAGE LEFT, STAGE RIGHT

Key actors on both sides of this dispute unabashedly played to the cameras to grab audience support. The nom de guerre "Dread" was only one component of the artist's public personna. He generally appeared in public wearing a black beret

and a kefiya around his neck, and proudly displayed a T-shirt with the rap group Public Enemy ["Fight the Power"] on it. He exuded self-confidence, condemned as "cocky" or "uppity." Dread Scott peppered his rhetoric with ideas from Mao Tse-tung, Trotsky and Marx, and continual references to imperialists, political contradictions, the proletariat and the oppressed (reaping a talk show host's slander as a "commie pinko fag").[16] He is most certainly one of the few radicals to be profiled in *People Weekly*: he is a supporter of, but disclaims membership in, the Revolutionary Communist Party.[17] His style and bravado gave new meaning to the notion of radical chic.

Dread Scott was up against a throng of politicians who rallied to the flag's defense, a band that local columnist Mike Royko satirically characterized in the following: "Through the camera's first glare, filled with hot air, they speak through the night that our flag shouldn't be there."[18] Two of the artist's most visible opponents were Alderman Ed Vrdolyak and State Senator Walter Dudycz. When Vrdolyak stepped forward to defend the flag, it appeared to be another episode in a local career long distinguished by political opportunism. Vrdolyak was a nemesis of Harold Washington's, and was a candidate for the Democratic nomination for Mayor at the time of the flag flap. He was sadly behind in the polls, however.

Vrdolyak tried to pressure his opponent Richard M. Daley, then the State's Attorney, to arrest someone for the display. He goaded Daley as timid and ineffective. But Daley demurred, refusing to be caught up in a legal whirlwind where it appeared he could not emerge as the victor. Daley wisely left it to others to pursue legal strategies, although he did join the shrill chorus of opposition: he compared the exhibit to handing someone a loaded handgun and "inviting them to commit suicide."[19] Unable to make political hay from the situation, Vrdolyak succeeded only in increasing his insincerity quotient. In the end this incident did not figure prominently in the race for interim Mayor, despite the best efforts of some to draw it in.

The relatively unknown Walter Dudycz stepped forward as the most indefatigable protector of the flag. He had the credentials and the motivation to lead the charge. A former Chicago cop and a first-generation American of Eastern European origins, Dudycz and his brothers had all served in the military, and he had served in Vietnam. As he reflected, "Only in America can a common man of two immigrant parents with five brothers and sisters from the West Side of Chicago become part of the government."[20] Dudycz's zealousness led to his omnipresence inside and outside the Art Institute, as he initiated a series of super-patriotic gestures.

In one instance the State Senator picked the flag up from the floor, for which he was questioned by the police for interfering with the exhibit, and later released. A few days later he removed the flag once again and attached it with plastic fasteners to a flag pole. When a staff member cut it loose to return it to its original position, Dudycz claimed his property had been criminally damaged. Although he threatened a lawsuit, he drew back in order to not "create a martyr." And on yet

another occasion he folded the flag and placed it in a red, white and blue US Priority Mail envelope, addressed to President Bush at the White House and affixed with three dollars in postage. After he advised onlookers that it was against the law to obstruct the mail, he put the envelope on the shelf and left the gallery. This ploy, too, failed to interrupt the exhibit: since the package had not actually been mailed, attorneys advised SAIC officials that they could open the envelope and return the flag to the floor.

The Dudycz crusade failed to derail the exhibit, and exposed the State Senator to a great many jibes. A columnist for one neighborhood newspaper called him a "weenie," and another affirmed that Dudyzc was "a good egg" who "had it scrambled."[21] But Royko threw the strongest satirical punch after dredging through Dudycz's history. In the detritus of Dudycz's past campaign for office, Royko discovered plastic bags that the politician had imprinted with his name, an image of the flag, and the logo "Pride, Patriotism, Participation." These sacks were used to hand out piles of campaign literature, and were also designed to be used as car litter bags. In other words, Dudycz had used the flag for self-aggrandizement and pressed its image into service to clean up messes—hardly the type of respect you would imagine from a flag enthusiast. Dudycz defended himself by noting Dread Scott had used an actual flag in his art work, whereas he had merely reproduced a picture of it. Nevertheless, Dudycz's credibility was strained even more by this revelation, and he was widely cast as a jester because of his actions.[22]

RALLY 'ROUND THE FLAG

The exhibition of "What Is the Proper Way" was almost derailed before the SAIC show went up. Dread Scott initially submitted three works, and the flag piece was the one the jurors chose. The day before the show was to open, a Black juror called to ask the student to substitute another work in its place; he brought the request of school administrators who were frightened that this use of the flag might be illegal or cause a disturbance. Dread Scott's reaction was "I'm not going to censor myself. You guys can censor me." He claims that administrators backed down after faculty members threatened to strike and other students pledged to prevent the show from opening without the inclusion of his work.

Once it was in place, the Windy City Vets attempted to secure an injunction against the piece. But a Cook County judge rejected their request. He ruled that Dread Scott's work did not violate state or federal laws regarding proper treatment of the flag. "This exhibit is as much an invitation to think about the flag," Judge Kenneth Gillis argued, "as it is an invitation to step on the flag."[23]

The daily demonstrations and the two large rallies on two consecutive Sundays in March then became the most direct way for outraged citizens to express their feelings. With patriotic songs blaring over a public address system, and with chants

including "One, two, three, four, get the flag up off the floor!," demonstrators from many states converged on Chicago's Michigan Avenue. There they heard politicians, veterans, and others affirm their allegiance to the flag as a fundamental American symbol. The participants bedecked themselves in military uniforms; hats and jackets from benevolent associations such as the Elks, VFW, and ladies' auxiliaries; and all manner of patriotic garb. And they proudly carried flags and picket signs, such as "Stop Commie Art," or enlarged photographs of Arlington National Cemetary, the Illinois Vietnam Veterans' memorial, and the Iwo Jima Memorial in Washington, D.C. As a participant reflected about the crowd's resolve to be there, "Without symbols, how will we know who we are?"[24]

There were scattered incidents where the intense enmity between demonstrators and counter-demonstrators erupted into clashes, and a few arrests resulted. Two men were also charged with criminal damage to state-owned property early on the morning of the March 12 rally after they painted more than forty American flags on the sidewalk in front of the museum. If city workers had not washed them off, demonstrators would have been forced to step on the images.

The passion and earnestness of these demonstrators was evident by their willingness to come to the big city near the end of a Chicago winter, and by their behavior once they arrived. A candid first-person account written by one sojourner communicates those feelings. A down-state woman recorded her impressions for a local newspaper, first reflecting on parades she had attended since the end of World War One. Her determination to register her displeasure over what Dread Scott had created kept her going: the caption to an accompanying picture read, "The wind was blowing off Lake Michigan and this made it difficult. . . . At one point in the afternoon, the wind blew Virginia [the author] off her feet but she kept the flag held high."[25] Her heart went out to disabled vets and mothers of MIA's who addressed the crowd, and she unabashedly expressed the fury she felt toward him that had fueled her trip: "An effigy of the student had been placed on the ground like he had placed the flag for people to 'artfully' walk on—I re-frained—I wanted the real thing with my stiletto heeled shoes!"[26] This elderly lady was emboldened by what she perceived as a treacherous assault on a sacred symbol.

A leaflet distributed in the area of the protests reveals an important source for the anxiety many demonstrators felt. Carrying the imprimatur of the Illinois Veterans of Foreign Wars, the handbill was entitled "You remember the REAL America." It reminisced to when "riots were unthinkable," "ghettos were neighbor-hoods," and "you weren't made to feel guilty for enjoying dialect comedy." It also recollected "when a boy was a boy, and dressed like one [and] a girl was a girl and dressed like one," and "when everybody didn't feel entitled to a college education." In other words, it called its readers back to a less complex time, before racial and other minorities pressed for their rights and upended taken-for-granted assumptions, categories and activities. The leaflet was a desperate cry to halt change and recover a lost sense of national identity and purpose, even if the cost might

include the subordination of other groups. And this turmoil provided an occasion for professional hate groups to mobilize. Dread Scott reports that Nazis and organizers for other White supremacist groups attended these rallies, people the artist characterizes as "shock troops" and "bully boys." From his vantage point, "They weren't about winning people over to a nice reasoned argument. Or fighting for anything even remotely progressive. I mean they were thoroughly reactionary."

Race was an interesting complication in this scenario. On the one hand, the fact that Dread Scott was Black heightened the resentment toward him and his work. For some people, this was another unruly minority person who was un-American and out of control. After all, by what right did this twenty-four-year-old upstart dare to sully basic American emblems? Such attitudes surfaced in chants like "The flag and the artist: hang them both high." On the other hand, Dread Scott hit a sympathetic nerve with Blacks who felt that the promise of America—as symbolized by the flag—was far from the reality that many African-Americans have experienced.

There was not "a" Black reaction; there were a mixture of responses, as in any other community. When the *Chicago Defender* (the preeminent Black newspaper in the city) conducted an informal opinion poll, there were more comments critical of Dread Scott and SAIC than supportive ones. But one respondent did remark "it is probably wrong to walk on the symbol of our country. But then again, I can understand people who say 'What has this country done for me?' "[27] Black editorialists were divided: one called Dread Scott a "jerk," "full of fervent ideas and new hormones," while others applauded his courage to challenge a flag under which Blacks had been enslaved at one time, and used as "cannon fodder" during the Vietnam War.[28] Perhaps the most powerful diatribe of this sort was by a writer who recounted the history of slavery, lynching, and legal discrimination, and then reproached any Black person who might consider joining the anti-Dread Scott demonstrations: "You go down to the Art Institute to protest a system represented by a flag that had never considered you as a first-class citizen. You are without doubt a white man's nigger and an abysmal idiot!"[29]

Dread Scott's race did not generate the negative response to this artwork; it probably would have occurred at this time and place regardless of who the artist had been. But the fact that this artist was Black certainly enlarged the size of the target, and helped determine who would be shooting at it.

FOR AND AGIN'

The general public's response was so complex that it defies easy characterization. It would be an oversimplification to portray down-staters or immigrants as fervent patriots in the Dudycz manner, wary of cosmopolitan follies that debase the traditional—even though there is certainly a great deal of evidence to corroborate

that impression. In Morris, IL, for example, veterans picketed the local McDonald's because the parent organization was a corporate contributor to the Art Institute. In Crown Point and Lowell, IN, families erected colorful red, white and blue displays around their homes. Some Illinois school districts banned school trips to the Art Institute, and in Chicago itself, the ethnic press—that is, *La Raza*, *La Voz de Chicago*, and *Polish Zgoda*—maintained a regular vigilance over events. Poles completing a US citizenship course offered by the Polish Welfare Society and the Polish-American Congress celebrated the flag and the freedom it represented to them, as did a suburban Greek restauranteur in his wall display charging "Use Me Right."[30] And the inevitable song was penned, "Nothing Is Sacred Anymore."

Others resisted the patriotic tide, however, and cautioned against unreflective and over-zealous replies. Writers in Bourbonnais, Libertyville, and Kewanee all counseled restraint, fearing the long-term consequences of repressive measures. The headline "Fascism masquerades as super-Americanism" came from a newspaper article published in Rockford, IL,[31] not from an avowedly Left publication. Yet support was not forthcoming from some seemingly predictable sources. A junior high school art teacher who was an SAIC graduate and non-veteran fashioned a counter display which was shown at Chicago's Vietnam Museum. Gary Mann's "How To Display 'Dread' Scott Tyler" featured a flag hanging on the wall, a book for comments, and a life size sketch of Dread Scott on the floor, drawn in the manner of a homicide victim. It elicited many viewers' fantasies about castration, evisceration, and torture.[32]

This does not mean that Dread Scott was without support in the artistic community. Many rallied to his defense, such as a student at the California Institute for the Arts in Valencia who recreated the display while it was still on exhibit at SAIC. The West Coast version was received similarly in this politically conservative region, with veterans as old as 88 years protesting it. The art work/audience interaction reached its apex when the flag was stolen and turned in to the local sheriff's department, an act that veterans obliquely accepted responsibility for.[33] And the Committee for Artists' Rights and the Chicago Artists' Coalition sponsored Inalienable Rights/Alienable Wrongs, an extensive series of exhibitions, discussions and other events centering on the turmoil on the Chicago art scene [see Plates section].

Dread Scott's work tautly stretched people's emotions, regardless of their position towards it. A letter writer to the *Chicago Tribune* stated in resignation: "Sometimes I feel I've lived too long. I don't really want to belong to a world like this. The inmates have taken over the crazy house."[34] And the sense of anxiety and violation jumped the boundaries of the Chicago area. A woman from Tuscumbia, AL recorded her gloom in verse: "And since the judge gave his decree,/That flag is no better than debris./So goodbye, Mr. Cohan, you're now passe./Our flag is a mat in the world of today."[35] But *The Daily Oklahoman* cautioned against yielding to complacency, viewing Dread Scott and his artistic statement as part of a "Marxist

revival."[36] For those heeding this call, a variety of punitive legislative actions were proposed and passed.

DON'T MOURN, ORGANIZE

Although the veterans failed in their attempt to have "What Is the Proper Way" declared illegal, this did not put an end to political and judicial wrangling. While it was not unlawful to display the flag on the floor, anyone actually walking on it was subject to arrest for a felony. A sign explaining this was posted at the entrance to the exhibit. A Virginia schoolteacher unintentionally violated the Illinois flag desecration statute when she stepped on the flag to get to what she mistakenly thought was a register for visitors. She was arrested, and was subject to a punishment of up to three years in jail for what she did.[37] But for many politicians this law was not sufficient protection, and they fought for additional measures.

Many Chicago aldermen write columns for community newspapers, which provided a ready-made soapbox for the anti-Dread Scott and anti-SAIC campaign. Politicians beyond Chicago's boundaries also aired their indignation in their own comparable publications, and either worked for local flag protection ordinances or lobbied the state legislature for stricter measures. The Chicago City Council passed a resolution condemning the display, as did village boards in outlying areas. The debate over the Chicago resolution included attacks on the school's management, which one alderman challenged by bemoaning "I wish the Art Institute collectively as a board would use its head. They're dreamers. They're probably all artists. I think they're walking along the Elysian fields."[38] And hyperbolic descriptions of Dread Scott's work marked the debate. As the measure's sponsor brazenly proclaimed, "There has never been a more dastardly act in the City of Chicago."[39]

These gestures had no teeth in them, but on the day that the exhibit closed, the City Council met in special session and enacted a new flag desecration bill that did. The March 16th bill was broad in its scope, making it a misdemeanor to "deface, defile, or trample" a US, state, city or foreign flag, or to display it with "any word, figure, mark, picture, design, drawing or any advertisement of any nature." The state legislature followed suit in June. On the same day that that assembly voted on the state fossil, legislators made it a felony to intentionally display the flag on the floor.

The Chicago law stood until it was successfully challenged by local artists who had assembled a show at a private gallery featuring flags in their work. Sponsored by the Committee for Artists' Rights, organizers initially refused admission to Senator Dudycz and the press because they feared another out-of-control media event. They finally escorted Dudycz through the entire exhibit and "made him have an art education. We learned we need to take a very aggressive stand. *We*

have to control the media and the politicians."[40] Interestingly, the exhibit was given the green light by the same Judge Gillis who turned back the earlier veterans' challenge. He assailed the law's "chilling effect" and struck it down by declaring that "For every artist who paints our flag into a corner there are others who can paint it flying high."[41] "What Is the Proper Way" was one of the nine disputed works held in limbo before the judge ruled.

Other government bodies which retained fiscal authority were not pleased with SAIC, either, and devised their own punishments. A Chicago Park District committee voted to cut off more than twenty eight million dollars from eight museums located on district property until the Art Institute explained its position on the flag work. It took aggressive lobbying and emotional testimony from a variety of supporters to convince the Park Board to reverse itself and restore the threatened funds.

The outcome was different with the Illinois General Assembly. State legislators voted to condemn the SAIC while the exhibit was running. They were joined by their colleagues in Indiana with a similar measure. Then in June they reduced an expected allocation from sixty four thousand dollars to one, and also punished the Illinois Arts Alliance (IAA) Foundation—which had publicly rallied to the defense of SAIC—with a similar symbolic one dollar allotment. IAA Executive Director Alene Valkanas felt SAIC had been unfairly pilloried over the Nelson incident. She believed that the painting of Mayor Washington would have never been juried into a SAIC show, although the public was led to believe that the school *chose* to display it. Valkanas called an emergency session of her board when the news broke about Dread Scott's presentation, and opened debate on a resolution she had had drafted by a professional public relations person. She got overwhelming support from those who attended the meeting to release the statement. As she argued, "We are talking about students, and talking about risk and experimentation and testing and that's all part of the process of education. And all kinds of things happen, all kinds of explosions in the chemistry lab."[42]

But Dudycz finally managed to score a victory through budgetary punishment of SAIC and IAA. He proudly boasted "I am not a vindictive person, but when [school officials] refuse to acknowledge our request [to justify the exhibit], they have failed their students and their institution."[43] Sadly, the legislators misfired. The lost money had been earmarked for community outreach programs such as the visiting artist speakers' series, the teacher training program, and the Video Databank. Their punitive action did not affect the academic program, but instead ravaged the SAIC activities most likely to benefit these politicians' constituents.

The Art Institute, SAIC's sister institution, suffered guilt by association. Some people cancelled their memberships, and jittery corporate contributors demanded a great deal of assurance that their support would not become an embarrassment. Dudycz, veterans' groups and others published lists of corporate donors, and threatened actions beyond the one-day McDonald's boycott cited earlier.

This was a propitious issue for politicians. Dudycz confirmed that he had aspirations for the office of Cook County Board President, and many other state legislators were on the alert for occasions to display their mettle. Two years hence, in 1991, the state was to be reapportioned to reflect population shifts. These are invariably hard-fought battles, and Dread Scott's work became a pawn in a much bigger game where politicians were already jockeying for strategic positions. What better opportunity to amplify their public profiles and consolidate their political strength than to blather about defending traditional American values and symbols?

ART AND REALITY

Merely five days after "A/Part of the Whole" closed at SAIC, the US Supreme Court heard oral arguments in a case which guaranteed that the treatment of the flag would remain a volatile political issue. *Texas v. Johnson* stemmed from an incident when Gregory L. Johnson burned a US flag in Dallas outside the Republican National Convention in 1984. Johnson's cohorts stood nearby chanting "America, the red, white, and blue, we spit on you" as he completed the act. He was found guilty of violating a Texas statute against defiling the flag, but appealed the judgment. Johnson is a member of the Revolutionary Communist Party, the group that Dread Scott identifies with.

In a five to four ruling on June 21, 1989, the Supreme Court found in Johnson's favor and overturned the lower court ruling.[44] Justice William J. Brennan, Jr. wrote for the majority, a coalition of liberal and conservative judges: "If there is a bedrock principle underlying the First Amendment, it is that the Government may not prohibit the expression of an idea simply because society finds the idea itself offensive or disagreeable. . . . The way to preserve the flag's special role is not to punish those who feel differently about [it]. It is to persuade them that they are wrong. . . ."[45] This decision in effect nullified regulations regarding flag desecration in forty eight states. The decision reaffirmed the paradoxical quality of a free and open society, that legal protections must be extended even to those who most revile it.

Civil libertarians celebrated, but a torrent of criticism poured forth from high officials and from the man on the street. President Bush denounced the decision, saying "Flag burning is wrong, dead wrong," and he promised to search for fresh ways to shield this symbol. Conservative columnist Patrick Buchanan reacted viscerally and invoked a cosmic model of natural law: "When someone spits in your mother's face, you don't sit them down and 'persuade them they are wrong.' You put a fist in their face. . . . To honor one's parents, to love one's country, to cherish one's flag—these are not options; they are mandated for all men for all time."[46] The Senate voted ninety seven to three to condemn the Court's ruling, and many legislators called for new measures to protect the flag. Two days after

the Supreme Court decree, a Gallup Poll reported that 71 percent of the American public supported a constitutional amendment that would make flag-burning illegal.[47] A controversy which had incubated in Chicago was delivered onto the national stage.

This conflict dipped into the same reservoir of communal anxiety that fed controversies dealing with race, religion and sex. The constant invocation of the notion of "desecration" suggested that a secular symbol was being endowed with religious majesty, which dictates spiritual reverence. And the supporters of the flag demonstrated a remarkable literalness in their beliefs, directly equating a piece of cloth with what it represents.

As historian Alan Brinkley points out, nativism and anti-radicalism activated waves of protectionism for the flag in the 1890s, just after World War One, and during the 1960s. These were all turbulent periods when the glue of social cohesion seemed to be drying out. Before the Civil War, and during subsequent periods of tranquility, mandating respect was not as necessary. Then patriotism was a natural outgrowth of shared values and goals, not something to be enforced. But technological developments, normative changes, and demographic transformations precipitated social disruptions that were met by attempts to legislate loyalty and respect by decree.[48] Dread Scott noted that "things sort of develop in a spiral and certain conjunctures get more acute," leading to the effort to make patriotism mandatory. In such times, defense of the tangible can allay concerns about more illusory concepts.

A flag code was formulated by various patriotic societies in the 1920s, but it was not enacted by Congress until 1942. Flag Day was instituted in 1949, an early legacy of the Cold War. And as the Vietnam War protests heated up in 1968, Congress passed a law to punish anyone who "knowingly casts contempt upon any flag of the United States by publicly mutilating, defacing, defiling, burning or trampling upon it."[49] The anti-government sentiments shared by large numbers of young people at that time led to frequent alterations of the flag itself or its standard display: for example, burning the flag, flying it upside down, or wearing it on the seat of your pants. And inevitably, these deeds produced a spate of legal proceedings. A number of such cases made it to the Supreme Court, which has a record of affirming the right to use the flag in "symbolic speech." The *Spence* case, where a Seattle man was convicted for attaching a peace symbol to the flag and flying it upside down in 1970, is just one instance where the Supreme Court, in 1974, reversed a lower court decision in this regard.

When both houses of Congress voted their disappointment with the Johnson decision they made it clear that these were times to ride the patriotic waves or risk being drowned by the surge. Democrats feared what would happen to them back in their home districts if they failed to go along with this pro-flag fervor, so they concentrated on devising a new law. President Bush, in the meantime, lobbied

for a constitutional amendment. By October both houses of Congress had passed a flag protection bill, in hopes of derailing the more extreme measure of an amendment. The legislation focused on acts of mutilation, defacement, burning or trampling, while attempting to side step the question of political, symbolic speech. But politicians' motives were apparent beyond all the patriotic posing and bluster: this was an easy issue that deflected attention away from more serious problems. It was driven more by partisan interests than anything else, as recorded in this interesting slip-of-the-tongue made by Republican Representative Bob McEwen in the House: "I pledge allegiance to the flag of the United States of America, and to the Republicans [sic] for which it stands. . . ."[50]

The new legislation was quickly put to the test. On October 30, 1989, four demonstrators burned an American flag on the steps of the US Capitol. Two of them were well-known for their previous activities: Gregory L. ("Joey") Johnson and Dread Scott. District judges in Seattle (where another incident occurred) and Washington, D.C. declared the law unconstitutional in subsequent hearings, and in June of 1990 the Supreme Court struck it down. Attorneys David Cole and William Kunstler argued in their brief that the US flag was born of a "desecration" of the British standard. Cole and Kunstler maintained that the two flag-burning incidents were cases of political communication, where the participants announced their motives in advance. They challenged the law as content-based (it excluded this one symbol from criticism), and viewpoint-based (it proscribed opposition, while affirming supportive gestures). In their view "people must be as free to destroy it [the flag] as they are to wave it."[51]

Even before these legal questions were settled, the difficulties of defining the statute's main terms became apparent: what exactly was a flag, and what was desecration? Was a picture of a flag protected? What about a flag with less than fifty stars? A flag stamp gets cancelled; was that desecration? One columnist even wondered if a prisoner tattooed with a flag on his chest could be executed.[52] This sophomoric guessing game became a national obsession, represented by Garry Trudeau's "Doonesbury" comic strip: the cartoonist published a picture of the American flag and then challenged readers to devise a way to dispose of it legally, should Bush's proposed constitutional amendment be passed. His conclusion was that you would have to keep the image until the paper crumbled—no lining the bird cage, using it to start a fire in the fireplace, or throwing it into the garbage![53]

The sharp edges of the public's anger were steadily rounded off by the sense of absurdity. People gradually recognized that the country was not in imminent danger from roving hordes of unpatriotic, destructive flag burners. The momentum for a constitutional amendment diminished when this mood shift combined with the legal setbacks to legislating flag protection. And this episode of national frenzy—set off in large part by Dread Scott's mixed-media

artwork—left the Bill of Rights intact. However, SAIC endured a great deal of censure for its presentation of this student's work, with long-term implications for the institution.

SAFETY PRECAUTIONS

The School of the Art Institute was a beseiged institution in early 1989. Many people faulted it for presenting controversial works, and according to director Tony Jones, "The fact that you exhibited it meant you had to believe in it. Not believe in the principle that you could exhibit it, but you believed in the content of the work." In the case of Dread Scott, Jones claimed that "we neither condone or condemn the content. [For example] You support the right of the book to be there [in a library] for us to be able to read it." But that analogy was unacceptable to SAIC's critics; as Jones heard many times, " 'It may be his [Dread Scott's or David Nelson's] work but it's your walls.' "

Security promptly became a concern. Tension was acute within the gallery where the exhibit took place because Dread Scott's opponents directly contended with his supporters over the placement of the flag. Its position on and then off the floor was a real and figurative issue. Public exposure in the media also brought persistent threats. According to Jones, "I really couldn't have female staff in the office answering telephone calls of the kind that we were getting. I mean, it wasn't just, 'I disagree with your position.' . . . There were specific threats. And a lot of very violent sexual commentary. Extremely abusive. And it was extremely distressing. So I pulled them all off the phones. And the faculty answered the phones."

SAIC faculty volunteered to act as gallery guards, police were positioned within the building, and strict security checks were instituted, complicating the movement of students, faculty and staff into the building. Jones felt compelled to close the school for several days, and at one point he also restricted the exhibit to SAIC affiliates because of the emotion-pitched atmosphere.

Dread Scott also reports phone threats to himself and his mother, at their home and at her job. He describes receiving information that Chicago police officers were plotting to kill him, and he experienced significant disruptions in his mail service: many business letters never arrived, and other correspondence was delivered in a mutilated condition. In such a highly charged climate, it's difficult to discern where histrionics leave off and legitimate paranoia begins.

While there was a great deal of student support for the exhibit, their opinions were split. Negative sentiments were expressed more frequently as events dragged on and daily life at the school became increasingly complicated. Some students joined the veterans' bid to get an injunction against Dread Scott's work. Others requested tuition refunds, not because they were offended by the work, but because the atmosphere became so tumultuous that they could not do their work.

And still others were peeved that Dread Scott's work was getting all the attention, whereas the purpose of the exhibition and the other participants were being ignored. This situation was exacerbated by Dread Scott's own behavior, which branded him an extremist and opportunist in many people's minds.

The extraordinary incidents of 1988 and 1989 left the Art Institute and SAIC extremely wary. In order to protect itself in the future, SAIC implemented new procedures and publicly issued new guidelines. These were defensive actions, designed to contain difficulties within organizational boundaries and to buffer the school from public scrutiny. In April, 1989, plans for the senior fellowship show were announced, the competition that had included David Nelson's work the year before. Citing "severe overcrowding and potential security problems," SAIC moved the exhibition to two off-campus sites: an annex where many school offices had been relocated, and another, temporarily donated space. A "Dear Colleague" letter announced this to a select audience, which was invited to pre-arrange tours. Each tour was limited to two people to be guided by student escorts, and scheduled to last two and a half to three hours so that the entire range of work could be viewed.[54] This was an expedient way to severely restrict who would view the competition, and was obviously designed to guarantee that works were seen in context and with the assistance of informed guides.

That same month the chairman of the Institute's board of trustees announced the formation of a committee to reexamine SAIC's exhibition policy. When the new rules were released to the membership and the press in June, the most important feature was that SAIC "will determine when, if, how long and where art work will be displayed." In addition, the school reserved the right to "relocate or remove any work from exhibition that may be hazardous to the health and/or safety of viewers or participants, or that may be disruptive to the educational process."[55]

These were extraordinarily broad powers and extremely prudent means to insure future tranquility. The recommendations formalized what had hitherto been casual assumptions, and promised to provide the tools necessary to intervene into divers circumstances. The David Nelson and Dread Scott affairs forced SAIC to explore and then articulate its educational policy. As Jones reflected, "Is it the responsibility of an educational institution to provide an environment in which there can be a free-flow debate and a forum for ideas, no matter how provocative, how controversial, how blasphemous, how outrageous those ideas may be? Is it your responsibility to create an environment in which those things can go on without any fear of a chilling effect or without any prohibition or censorship? And the answer is unequivocally 'yes.' That's what educational institutions are for. The second question is, is it the responsibility of the institution to exhibit the results of that debate? The answer unequivocally is 'no.' It's not. . . . you protect the mission and have the mission in isolation. You don't have that [exploratory student] work interfacing with people on the outside."

That's the reasoned response of a seasoned administrator. The regulations and their underlying philosophy seem to insure a balance between personal freedom and organizational accountability, experimentation and institutional survival. However, healing is a long-term process in situations such as these. School officials barred "What Is the Proper Way" and the work of another student from the Bachelor of Fine Arts Exhibition held in May, 1990 after they failed to sign a waiver reiterating the new policies. Jones declared "Enough already," and argued that it was time to turn the spotlight on other students' work. But this decision revived old injuries, and more than thirty graduating students withdrew their work in protest and set up an alternative exhibition with the support of local art dealers.

Yet Dread Scott evinced little malice toward SAIC and its administrators in an interview conducted just a few weeks before that incident: "I think they're actually trying not to censor and trying to walk sort of a tightrope I mean, when you've got all your Board of Trustees saying [to Tony Jones] 'Look, you know, we want your job,' . . . the predominant wind is to take it out. . . . [but] administrators ain't fascists, you know. Tony Jones may be Marshall's [Field's] servant, but he's not like some silly-putty zombie that can just be molded any way."

In Jones's office there is a plaque with a drawing of the US flag and the motto "This is our flag, be proud of it." It also has a label which identifies the Kiwanis Club of St. Charles, Illinois as the presenter of this "reminder" of the importance of American symbols. Jones displays it with honor, for he feels as proud of the flag as the Kiwanis are; SAIC's struggles on its behalf certainly tested questions of social responsibility, freedom of expression, loyalty and patriotism.

POSTSCRIPT

After passions cooled down in Chicago and throughout the US, Americans witnessed the significance of flags to political movements throughout the Eastern European Bloc and other locales. Flags have typically been used to symbolize the destruction of the old (in Romania, the center of the banner was cut out), or the construction of new political entities (the Union Jack combined English, Scottish and Irish icons to represent the United Kingdom; the Palestinian and Ukranian flags symbolize current nationalist aspirations). And in the US, the flag received renewed support because of the conflict with Iraq's Saddam Hussein in 1990–91.[56]

Ads hawked the flag continually in newspapers: one offered it from the unlikely burg of Arab, Alabama, and another sported an anachronistic sketch of a long-haired, bell-bottomed man about to set the flag ablaze, with the admonition "Don't Burn It—Wave It! Tell flag-burning hippies 'Go home!'" And "Hotel Queen" Leona Helmsley sang "God Bless America" as she threw the switch on a giant American flag made of lights (148 by 104 feet) on the Empire State Building. She,

too, admonished flag burners in her remarks.[57] The number of flags flown over the Capitol to be given to constituents soared; rings, T-shirts, robes, socks, and nearly every conceivable piece of clothing was emblazoned with it; and the flag was even used to publicize female mud wrestling at the Hollywood Tropicana.

The flag predominated at the Mardi Gras in New Orleans in 1991, accompanied by impersonators of the Statue of Liberty and Betsy Ross. And in San Diego, more than 15,000 people formed a giant American flag to show their support for the troops. They wore red, white or blue T-shirts and some held stars, in an exercise that recalls "living photographs" of national emblems executed primarily on military bases earlier in this century. But such displays have been rare since World War Two, with the erosion of communal consensus over values and symbols.[58] The patriotic passion that blossomed in response to Dread Scott's art came into full flower over the Persian Gulf War.

Artists bucked this trend in modest but significant ways. An anti-war exhibit was mounted in Torrance, California just shortly after hostilities commenced. "The Price of Intervention: From Korea to Saudi Arabia" featured political posters, some of which incorporated the flag into their critical commentary. Artist David Hammons displayed an American flag rendered in the colors of the African National Congress at The Institute for Contemporary Art P.S.1 Museum in Queens, New York. It went unremarked until the war began, at which time threats were made against the gallery and a number of politicians registered their displeasure over it. Hans Burkhardt produced thirty paintings collectively entitled "Desert Storms," prominently featuring the flag in what a reviewer dubbed "visceral expression-ism."[59] And artist Shawn Eichman—one of Dread Scott's consorts in the October 30, 1989 flag-burning incident at the US Capitol—was convicted along with Joe Urgo of destruction of government property and attempted arson of government property when they tried to burn a flag at a military recruiting station in Times Square, and poured fake blood and oil over the side of the building. Faced with a potential eleven-year jail sentence, they received two years probation, a fine and community service.[60]

In May, 1991, the flag saga came full circle when Chicago hosted a parade to honor the allied combatants in the Persian Gulf War. The procession moved down Michigan Avenue and passed before a reviewing stand set up in front of the Art Institute. The building was flag-bedecked, recalling a similar scene after World War One. Local politicians were highly visible, and Dread Scott made an appearance. But in this instance the politicians ran the show, while Dread Scott was consigned to the sidelines with a small band of anti-war protesters. In little more than two years the flag had been successfully wrested away from its artistic challenger and reclaimed by traditionalists.

The flag remains a contested symbol. For many it is a tangible embodiment of nationhood and history, deserving of veneration. In perplexing times it is something

to cling to. But others refuse to uncritically endow the flag with such significance. When artists have taken such a defiant stance, they and their products have been met with harsh denouncements.

Resistance to unquestioned respect for the flag violates a widely held sense of propriety. And propriety becomes the operative word in other spheres of activity as well. This is particularly the case when changing notions of sexuality and "appropriate" sexual conduct are addressed by the arts, and then either accepted or rejected by disparate audiences.

6

THE BODY AS SPECTACLE

... it is often taken for granted that
art-making is directly related to
sexuality—as a form of expression,
repression, obsession, or compensation.
 Lucy Lippard, 1980

. . . art is in the bloodstream of human
beings, not their gonads.
 Washington Times editorial, 1991

The Civil Rights movement not only altered the pattern of American race
relations; it also provided the model for other empowerment movements. One of
these was the women's movement, and another was gay liberation. Each targeted
sexual roles and sexual relations, and they borrowed an array of goals, strategies,
and sometimes personnel from their predecessors and from one another. These
efforts coalesced in the 1960s and pushed into subsequent decades, transforming
attitudes, social institutions, and personal interactions.

Artists have been at the forefront of some of these changes, and have reflected
them in their work. Take the case of a "performance piece" presented at a New
York City art gallery on May 1, 1991. "Love. Spit. Love." featured three nude
couples—lesbian, gay, and heterosexual, respectively—kissing and caressing be-
neath American flags. The work attracted huge crowds, and some of the participants
then made the round of TV talk shows. It was ratings sweeps month, and they
appeared *au natural*. The event was designed to counter gay bashing and censorship,
two growing trends that the organizers viewed with disapproval. In many respects
it is a signature work for its time, drawing upon such topical material. It is difficult
to imagine this piece being presented at an earlier moment.

Or is it? If "Love. Spit. Love." recalls anything it is the "happenings" of the
1960s, when freedom and the body were celebrated, and everyone was encouraged

to explore their creative impulses. "Love. Spit. Love." displays continuity with social trends which began decades before, yet with its forthright acceptance of the varieties of sexual expression it is also a measure of the social distance traversed since then. It was a big hit with the "Downtown crowd," an uncomfortable but intriguing experience for Phil Donahue's studio audience, and the event provided confirmation of the licentiousness and "obscenity" of the contemporary art world for long-standing critics.

This presentation also highlights the importance of sex as a theme in art, and as the basis of art controversies. In some instances the issue has been gender: artists frequently challenge traditional gender roles and gender inequality. In other situations, they feature dramatic expressions of sexuality. Typically these matters merge, with sexual displays addressing how we configure male and female, and masculine and feminine, in our society. When this occurs, some of the costs and benefits of conformity or deviance from the norm often become apparent as well.

FIDDLING WITH THE LAW

Freud, of course, periodically speculated about the association between art and sex. He argued that the sexual instinct invigorated artistic creation, with artists sublimating their sexual interests and rechanneling that energy into socially approved channels. Freud was elaborating a long-standing public hunch about artists as sexual extremists—either over- or under-sexed. Freud's name was invoked in 1967 in an invitation to an avant-garde music event, the "Opera Sextronique," written by Nam June Paik and performed by the late Charlotte Moorman. "Music history," it declared, "needs its D. H. Lawrence [,] its Sigmund Freud." These artists intended to inject a sexual element into an otherwise staid artistic medium. But an incident which seems fanciful in retrospect succeeded in making legal news.

The work was presented before an invited audience of 200 in a midtown New York theater on February 9, 1967. Ms. Moorman performed one of the sections on her cello while sporting a bikini equipped with small electric lights; they flashed on and off as she played. She finished another movement in a topless gown. Moorman was arrested for public lewdness under a statute that forbid an "act which openly outrages public decency." She spent a night in New York's notorious Tombs in a cell with women whose crimes ranged from homicide of a spouse to drug use, prostitution, and theft from Macy's. When she recollected the incident years later for her home town newspaper in Little Rock, Arkansas, she recalled that her fellow inmates tried to pull her hair out when she explained her own misconduct to them.[1] Moorman's trial was not only an individual arraignment, but turned into an indictment of an entire generation.

Criminal Court Judge Milton Shalleck largely dismissed expert testimony on Moorman's behalf. He instead used this occasion to wax poetic about feminine

beauty and to castigate the bearers of new values that he neither understood fully, nor approved. In a grandiloquent 29-page decision, he placed Moorman in "[t]hat small group of rushing, impetuous persons (most of them youthful) wandering fretfully somewhere for some unknown goal of intangible value and for uncertain reason." He speculated that her performance was "the result of the unsequential momentary place in the sun of the bearded, bathless 'Beats' whose cranial hirsute talents challenge the femininity of a lady's fall and whose life may yet cause historians to label their generation as the 'scared age.' "[2] Shalleck was scrutinizing a lifestyle here, which he specifically located in Greenwich Village.

Shalleck could not resist the temptation to be "cute"; his reference to this case being "virgin legal territory" is but one example. And he took a swing at fashion designers (whose "proclivities" he questioned) who, he felt, mocked and demeaned women with their contemporary lines of clothing. To his mind, Moorman's conduct further contributed to the decline of demure femininity. The judge saw a world that was beginning to spin out of control, in what he characterized as the transition of "our once 'fair' city to our 'fun' city." Shalleck convicted Moorman of the charge of indecent exposure, but with some reluctance. He viewed her as unable to resist bad influences, and therefore gave her a suspended sentence because of her "frailty."[3]

This was one episode in a career of quirky performances. Moorman performed under water; suspended by a parachute harness from helium balloons; atop majestic clock towers in Italy; and upon military tanks at Guadalcanal. She played a cello made of three television screens, another made of ice, and wore various masks and costumes, including a bra made of small TV screens, and breast propellers hand-crafted by Paik. She was even invited back to Little Rock to perform, an event that raised some eyebrows but which was reported on with equanimity. As is often the case, Judge Shalleck singled one performance out of a corpus of work, and judged it by standards endemic to a different realm.

This incident cannot be recounted without some sense of wistfulness; this merely involved exposed breasts, after all, within an exclusive, art-world context. Today it's likely that many people yearn for a return to the days of simply bared body parts, or to the time when Chicago censors excised the buffalo birthing scene from Walt Disney's "The Vanishing Prairie" because it was one of the raciest things around. Those situations are a far cry from coping with the explicit sexual behaviors or the elaborate and exotic sexual ideologies that are widely publicized today.

SECURING A PLACE AT THE BANQUET

Whether you agree with him or not, Judge Shalleck *was* onto something. Moorman's work was a precursor of striking social changes in sexual and artistic

expression. Other artists such as Carolee Schneeman were simultaneously pushing the boundaries of feminine images in the 1960s. In "Eye Body" [1963] her naked form became an Earth Goddess, adorned with painted flowers and live snakes. And in "Site," a collaborative piece with Robert Morris, she recreated Manet's bold, nude prostitute "Olympia." A controversial painting which shocked the public in 1863—this woman defiantly engaged the viewer; she was not the typically passive object of male sexual fantasies—was proudly reclaimed in 1964.

In this respect Moorman and Schneeman were continuing a lengthy artistic tradition of reflecting and refracting social change within their work. For example, Degas' washerwomen, ironers, and women at their bath generally charm and edify viewers in the late twentieth century. They seem to be benign remnants of another time and place, delightful paintings for most audiences. But in fact, Degas was recording the social disruptions and ambiguities of his age. The ladies who were attending to their toilet were prostitutes getting ready for customers, not gentle-women in middle-class boudoirs. His technique and subjects were startling to his contemporaries, who rejected his work as " 'ugly,' 'dislocated,' 'nervous,' 'terrible'—in other words, modern."[4] A reexamination of his work through a feminist lens helps to recover the radical aspects of Degas' work.

Throughout the 1970s and 1980s many artists drew from their own experiences as women in making their art. They cast a fresh eye on perennial themes and experimented with new subjects and techniques. At the same time, they challenged some of the long-standing constraints of the art world and the world at large. Their results parallel what we observed in regard to racially and religiously themed art: a push toward new representations, and a challenge to portrayals which seemed outmoded, contemptuous, or even menacing.

Judy Chicago epitomizes these developments. From 1974 to 1980 she headed a large collaborative project to create "The Dinner Party: A Symbol of Our Heritage." This is a gallery-sized mixed-media installation, consisting of an open, triangular table, 46½ feet on each side. It is prepared for a ceremonial banquet featuring thirty nine place settings with hand-painted china plates, ceramic flatware and chalices, and embroidered napkins. Each rests on an embroidered runner. The place settings represent notable female figures from the mythical or real past: "primordial goddess," Kali and Sappho; Anne Hutchinson, Sacajawea, Sojourner Truth, and Susan B. Anthony, for example. Each selection cleverly and distinctly represents the achievements of the woman and her historical context through the image on the plate. The plates progress from flat to high relief, symbolizing the gradual emergence of women from cultural and social constraints. Each image also simulates female genitalia. The entire work rests upon a triangular "Heritage Floor" of hand-cast porcelain tiles which present the names of 999 exemplary women.

"The Dinner Party" is a melange of story telling, traditional handiwork, ritual and feminism. "The Dinner Party's" focus on food and nourishment reflects a traditionally female domain. This is a common subject in art made by women,

especially for female performance artists in the 1980s and '90s. In addition, Chicago brought what are typically anonymous types of craft-work into the world of art, blurring the distinctions between these realms. And the communal nature of the project was unusual; it drew from counter-cultural ideology, and presaged later collaborative artistic projects, especially those responding to the AIDS crisis. Chicago documented the formation of consciousness-raising groups among the more than 400 workers who contributed to the piece. These brought a technique for personal transformation into a workplace whose goal was to also alter the world of art.[5]

This combination of sociology and art was hailed by some critics, particularly female ones. Carrie Rickey found herself to be of two minds regarding the piece, and her review of it took the form of an interior dialogue. One voice raised a wide range of aesthetic and political doubts, while the other declared it a landmark and proposed that art historians and feminists would adopt the abbreviations BDP and ADP: "Before Dinner Party" and "After Dinner Party."[6] And it could be a powerfully emotional experience for female visitors: they were often moved to tears.

But many others damned the work. This intellectual rebuff came primarily, but not completely, from men. Robert Hughes fired a barrage of verbal assaults against "Chicago's relentless concentration on the pudenda": it was "hokey" and "static"; the colors of the ceramics reminded him of a "Taiwanese souvenir factory"; and "It is simple, didactic, portentous, gaudily evangelical and wholly free of wit or irony." These phrases merely embellished his condemnation; in essence he rejected the notion that there was a need to rediscover and commemorate women from the past. In his critique of Chicago's autobiographical writings, Hughes wrote "The aim of this jargon-laden Femspeak is to set up a myth of women artists as a hated underclass, which they were not in 1975 and are not today; in such a scheme, vagina hatred is imputed to men as automatically as penis envy once was to women."[7] Hilton Kramer concurred: "The Dinner Party" was "vulgar," "solemn," and "an outrageous libel on the female imagination." Kramer judged it to be failed art because it was "so mired in the pieties of a political cause."[8] The only redeeming feature that these men cited was the quality and authenticity of the embroidery work.

"The Dinner Party," a celebration of women's history, sexuality, and achievement, toured throughout the US and worldwide from 1979 through 1988, and then went into storage. In many locales it was shunned by museums and shown at sites sponsored by grass-roots organizing efforts. But artist Chicago was resolute that the work should have a permanent home; if not, "I will not have achieved my goal of introducing women's heritage into the culture so that it can never be erased again."[9] Her dream seemed close to fulfillment in 1990 when the trustees of the University of the District of Columbia (UDC) authorized a bond issue for $1.6 million to renovate the school's Carnegie Library into a multicultural arts

center. "The Dinner Party" was to be the centerpiece. They agreed to a financial arrangement wherein Chicago and her not-for-profit corporation Through the Flower, Inc. would share monies received for the display of the work and reproductions of it. The bond money would *not* have come from the operating appropriations for the school, nor would UDC receive title to the work.[10]

But a new episode in the cycle of reception to Chicago's work began when *The Washington Times* blasted this decision in a front-page story. It was a strategic offensive: three short lead paragraphs highlighted UDC's fiscal problems, summarized the National Endowment for the Arts' contribution to the work's development, and claimed that it was considered "obscene" and had been banned from "several art galleries."[11] The article also insinuated that there was impropriety in the relation of a trustee to the designated administrator of the UDC project, and strongly implied that they might share a lesbian relationship. In a climate overheated by other artistic controversies, this was a dangerous combination of sexual imagery and public money.[12]

The newspaper later clarified some misrepresentations in the original piece, but the damage was done. Negative reactions took two distinctive paths. Little more than a week later, the House voted to cut $1.3 million from UDC's appropriation for the next year (the school is supported by Federal and District of Columbia funds). This was a retaliatory action very like what the Illinois Legislature did to the School of the Art Institute because of Dread Scott's work. It was intended to punish the UDC trustees for making what a majority of the House of Representatives saw as an ill-advised financial commitment in a time of heightened fiscal constraints. But the Congressional action was misdirected: it was certain to exacerbate UDC's financial crisis, yet it would not prevent the acquisition of the artwork.

Two California Republicans were at the forefront of the attack: Robert K. Dornan denounced "The Dinner Party" as "ceramic 3-D pornography," and Dana Rohrabacher dismissed it as "weird sexual art."[13] They were joined by colleague Stan Parris of Virginia—a conservative with a long-standing disdain for the District—who decisively stated his disapproval in sponsoring the punitive measure: "I have no desire to censor this or any other work, no matter how offensive. But I do have a quarrel with those who would insist that we use public funds to *promote and proselytize* their own special interests on an unsuspecting public."[14] "The Dinner Party" became entangled in debates over home rule for the District of Columbia, as well as the controversy swirling around the National Endowment for the Arts and its support of supposedly "obscene" art. The NEA was mentioned throughout these deliberations, and Pat Williams (D-MT) feared that this was a "dry run" for the debate over the reauthorization of that agency, set for later in the legislative session.[15]

UDC students acted next. On September 26, 1990 they took over campus buildings in protest of the trustees' decision to quarter Chicago's work, an action

which lasted a tumultuous eleven days. UDC was already a troubled institution: it had had five presidents and acting presidents in eight years, and there were accreditation problems and difficulties meeting the payroll. And the school's football team had been eliminated because of financial considerations—another font of anger.[16] It is not surprising that students in this working-class, predominately minority university acted the way they did. The misinformation and governmental response, added onto a simmering educational environment, helped to insure it. The most militant students believed that the quality of their training (and extracurricular life) was being compromised by the proposed support for a piece of art. There was little room for reasoned debate with funds being so scarce.

The stand-off culminated when Judy Chicago voluntarily withdrew her offer to UDC. She felt that the meaning of "The Dinner Party" had been distorted, and threw her support to the strikers because "It is a work of art aimed at promoting empowerment and a monument to those who have struggled for freedom."[17] The students abandoned their protest a few days later, having won many concessions from the administration.

Some critics dismissed this work as kitschy or dogmatic when it was first displayed. But the objections that Representative Parris voiced betray a great deal more fear. A decade had passed between these two waves of critics, years when women made gradual but significant social gains—in the House of Representatives, and in society in general. With its overt sexual imagery, and the knowledge that it was created by women acting in concert, "The Dinner Party" unnerved men who held the purse strings and controlled its destiny. Their belief that they must protect unsuspecting and vulnerable viewers from harmful material was becoming wearisome, but it was an acceptable way to rationalize their punitive actions against whatever challenged their own positions and point of view.

CROWD PLEASERS?

We've encountered this resistance to accepting new images of self previously: the removal of the statue of the crucified woman at the Cathedral of St. John the Divine in 1984, for instance. Many artists have persevered in presenting women and sexuality in inventive ways, however, much to the chagrin of certain cultural critics and media executives. But for every Barbara Kruger, Jenny Holzer or Sue Coe, there are scores of other image-makers who would be satisfied by keeping women "barefoot and pregnant." Witness, for example, the billboards advertising the 1991 Broadway play "The Will Rogers Follies." Amazonian-sized showgirls in skin-tight cowhide outfits were branded on the buttocks with Will Rogers's initials, making them his personal herd of beautiful "doggies." They give new meaning to the text from Barbara Kruger's poster design for a pro-choice demonstration in Washington, D.C. in 1989, "Your Body Is a Battleground."

Richard Goldstein maintains that "In America today, the most popular entertain-
ment reinforces orthodoxies, while the most powerful art is a weapon of dissent."[18]
Goldstein furnished data for this thesis several years earlier in his article on an
interactive video game entitled "Custer's Revenge," where a crudely modelled
soldier pursues and ultimately captures an Indian woman. The outcome? He ties
her to a stake and rapes her, although the manufacturer denied any connection to
misogyny or genocide. The company president maintained that the woman is
smiling and "having a good time."[19] And while there certainly is a great deal of
additional evidence to validate Goldstein's ideas, particular examples also challenge
this pattern.

At the same time in the early to mid-'80s, other mass media forms eschewed
retrograde ideas and positively reflected changes in women's roles and sexuality.
For example, the spunky, single Christine Cagney on TV's "Cagney & Lacey" had
a series of lovers, and in one episode bought a home pregnancy kit—a far cry
from the days when the word "pregnant" could not be used on TV, married
couples were shown in separate beds, and the pregnancy of an unmarried woman
would guarantee the scorn of her community. The next step was taken on network
television when the single, main character on "Murphy Brown" announced her
pregnancy during the last episode of the 1990–91 season; that show earned the
number one position for the week.[20]

The mass media are neither uniformly socially progressive nor conservative. A
number of factors, internal as well as external to the industry, interact to affect
what they present at different moments. In the case of TV, the treatment of
different subjects responds to larger social currents. In 1987, for example, the
headline of a newspaper article proclaimed "New Sex Mores Are Chilling TV
Ardor,"[21] a reference to the fact that the AIDS epidemic was tempering depictions
of freewheeling sexual behavior. Bed-hopping did not seem prudent in an increas-
ingly health-conscious age. Yet this circumspection was taking place at the same
moment that in-house censors—"standards and practices" divisions—were being
trimmed to reduce production costs, making it a potentially liberating time for
writers and story lines. Intranetwork rivalry is another obvious consideration, and
when the Fox Network began operations in 1987, it helped to neutralize the
impact of shifting sexual standards: Fox carved out a niche for itself through the
raunchy humor of "Married . . . With Children," setting a new standard for sexual
innuendo. The competition from this upstart venture, in combination with the
bolder offerings of cable TV and video rentals, has sent the three established
networks scrambling to snare viewers.

Television executives must navigate between the Scylla of sponsors made skittish
from the threat of boycotts by interest groups, and the Charybdis of bored or
jaded viewers. Going too far to appease either side risks being plunged into perilous
waters. With a conservative strategy you can secure tranquility; with a pluckier
approach, you may increase your ratings but might also set off controversy. As

Ariel Dorfman surmised about popular culture more generally, "To go against the grain is political; to flow with it is entertainment."[22]

Network officials face a predicament when they consider the topic of abortion. As one of the most divisive social issues of our time, it would seem to be a natural topic for television. And we would expect pro-choice story lines to be routine if we are to believe what the Reverend Wildmon writes in *The Home Invaders*. He reports that media moguls are overwhelmingly drawn from the more liberal ranks of society, and that they agree that a "Woman has [the] right to decide on abortion" at a rate of from 90 to 97 percent in three different surveys.[23] But while abortion may have emerged from the back alley, it has remained in the shadows of dramatic TV.

The rarity of references to abortion on TV belies its ubiquitous presence in modern American life. Characters in regular television series seldom mention it; when they do, there is the ever-present risk of sponsor defections. To wit: abortion became the main theme of an episode of *China Beach* in the 1989–90 season, but sponsors failed to support it when it was initially run. This then prevented the installment from being rebroadcast in the summer of 1990.

With the weakening of standards and practices divisions, sponsors now engage "screeners," professional viewers who advise potential sponsors regarding particular program episodes. Pizza companies wish to avoid blood, for example, because of the possible association with tomato sauce. Virtually every prime-time program is prescreened in this manner.[24] But this does not mean that standards and practices divisions or other internal mechanisms no longer operate. The development and ultimate fate of two major made-for-TV movies regarding abortion amply demonstrate their continued operation.

In 1989 NBC broadcast "Roe v. Wade," a story about the Supreme Court case which decriminalized abortion in 1973. It took three years to develop the film, and observers reported that the writer was required to present from seventeen to nineteen different drafts. The author reflected, "Every word had to be legislated. . . . there were times when I wondered if I had become a good German and given up the heart of the piece."[25] All the parties involved agreed that this was an extremely laborious process, where "balance" between pro-choice and anti-abortion positions was the priority. The goal was not to preach or change minds; it was to capture and hold the largest potential audience. NBC also produced a one-hour news program after the broadcast to help ensure that both sides were given "proper consideration."[26]

Projects that are so audience-driven, which strive so deliberately to please everyone, often tap-dance their hearts out to legions of sadly disappointed viewers. As the producer of a 1985 TV movie on the death penalty grumbled, "to say that every debate has an equal A side and B side turns everything into vanilla custard. There are arguments in life that have winners and losers."[27] And even though vanilla custard is more palatable to many people than spicer fare, "Roe v. Wade"

still proved to be too controversial. It was difficult to pitch this production to sponsors. All the commercial slots were eventually sold, but at discount rates to "buzzard advertisers" who swooped in to buy dead time. Revenues were more than one million dollars below what the network had expected.[28]

The same process of mollification was attempted in the case of CBS's "Absolute Strangers." This movie was about a 1989 case where a Long Island man sought the court's permission to terminate the pregnancy of his wife. She was comatose and brain-damaged from a car accident, and the procedure was required to save her life. Anti-abortion advocates challenged the New York court's decision to allow the abortion; they attempted to represent the injured woman's interests and to win guardianship over the fetus. The Supreme Court refused to hear the case, the abortion was performed, and the woman began the process of recovery. The Reverend Wildmon and the American Family Association campaigned against this movie, just as they had done with "Roe v. Wade." They pressured sponsors to withhold their support, although producer Henry Winkler insisted that even-handedness had prevailed in the portrayal of the opposing sides.[29]

To return to Goldstein's premise, while some segments of popular entertainment support social and sexual orthodoxies, others "push the envelope" to various degrees.[30] Nevertheless, a comprehensive study released in 1990 reported that the television industry has provided only limited opportunities for women behind the camera, and the characters women most commonly portray continue to be vulnerable, or adjuncts to male endeavors.[31] There is always a complex mix of values and the bottom line in any commercialized artistic endeavor. The popular arts are not by nature either conservative or progressive.

NO WAY TO TREAT A LADY

Visual artists have tackled abortion and other feminist issues, with a variety of results. One of the oddest controversial incidents regards a painting that was banned from a small college in Virginia. The painting presented an American family scene, with a child represented by the remains of an actual aborted human fetus. School administrators feared the work violated a state law restricting the transport and display of dead human bodies. They also claimed it violated propriety because it was a "disgusting morsel of human tissue." On the one hand, the definition of what is human was involved; on the other, the limits of free speech.[32] A few years later the Heritage Foundation cited Shawn Eichman's "Alchemy Cabinet," which incorporated the remains of her own aborted fetus, in its chronolgy of "misused" NEA funds.[33] Such depictions give material form to what large segments of the American public consider an abhorrent idea; they frighten and disgust people because they make the theoretical, real.

The feminist collective calling itself Guerrilla Girls brought a number of related themes together in a billboard they designed for display throughout New York City in the spring of 1991. The poster presented an image of Mona Lisa with a green fig leaf over her mouth, with the logo "First they want to take away a woman's right to choose. Now they're censoring art." Their message was that abortion and censorship were linked; both raise issues regarding personal freedom, public/private distinctions, and social control. What they wisely perceived is that control of art is seldom an isolated phenomenon, but generally a marker for broader pressures for regulation in society. For instance, several contributors to a volume entitled *Nonsenseorship* (1922) noted that a fanatical interest in literary censorship paralleled Prohibition, and that various "vices" were thus linked together in reformers' minds.[34] The Guerrilla Girls sniffed something similar nearly seventy years later.

The Guerrilla Girls were not only addressing art censorship, but also the growing militancy of anti-abortion groups and certain restrictive governmental policies. For example, since 1988 the federal government has banned federally funded family planning clinics from *talking* to their clients about abortion. This gag rule primarily affects the poorest women, who rely upon Title X clinics for care. In May, 1991 the Supreme Court upheld this order in *Rust v. Sullivan*, although both the House and the Senate voted to sidestep the prohibition when they considered appropriations measures in November. President Bush was unyielding on this matter, however, and vetoed the bill. This demonstrates that certain forms of speech, be they informational or interpretative in nature, have been curtailed in recent years. Invariably the targets have been the relatively powerless or their advocates.

In addition, anti-abortion groups have used similar pressure tactics to those employed by media watchdog groups to impose their will. For example, in 1990 the Dayton Hudson Corporation (a large retail concern) reversed its twenty two-year support of Planned Parenthood under the threat of a boycott by the Christian Action Council, although it later decided to restore its grant.[35] And according to a story published in the *Los Angeles Times*, legal experts claimed that the government's implementation of the NEA anti-obscenity pledge involved a certification process similar to the anti-abortion pledge demanded from clinics receiving government funds. In both cases recipients of federal monies were restrained from acting in specific ways.[36]

Since "The Dinner Party," feminist-inspired art work has moved from celebration to trenchant social criticism. Visual artist Sue Coe, for example, addresses a wide array of political and social issues, from military intervention in the third world to racism and sexism. Her 1983 photo-etching "Woman Walks into a Bar, Is Raped by Four Men on a Pool Table, While 20 Watch" brings a notorious incident in New Bedford, Massachusetts into harrowing focus. Feminist artists

have also adapted the collective work mode used by Judy Chicago to more militant ends, a style which has been embraced by other political artists (especially those who target AIDS).

The SisterSerpents collective disrupted public tranquility in Chicago when their first poster "Fuck a Fetus" was displayed in 1989. The text read "For all you folks who consider a fetus more valuable than a woman." Several gallery exhibits followed, such as "Snakefest '91: Art Against Dickheads." That show included a parody of Andres Serrano's "Piss Christ": "No. 1705366, This man yelled sexual comments to a woman," a Ball jar containing a scrotum preserved in yellow fluid. SisterSerpents targets male hubris and authoritarianism at the same time that it makes art-world jibes.

The Guerrilla Girls are the paragon of this type of work. Dubbing themselves "the conscience of the art world" in 1985, the Guerrilla Girls name names and denounce racism and sexism within the art world. By mid-1991 they had produced thirty posters, many of which provide statistics on the exclusion of women and racial minorities from art institutions. One 1985 poster listed forty two male artists and asked, "What Do These Artists Have In Common? They Allow Their Work To Be Shown In Galleries That Show No More Than 10% Women Artists Or None At All." A 1986 poster presented a four-year survey of the meager percentages of *New York Times* art reviews of one-woman shows, while another offered a list of forthcoming shows which were "Under Surveillance" for their representation of women and minority artists. In 1989 a poster showed a half-blank white field and the explanation "You're Seeing Less Than Half The Picture Without The Vision of Women Artists And Artists Of Color."[37]

The group's membership remains anonymous, although representatives appear in public with gorilla masks. In combination with otherwise customary female garb, their appearance is jolting—as are their accusations. They tend to disrupt the surface calm with which the art world generally operates. That is most certainly the case with their 1990 work, where Jesse Helms, who many artists considered to be the nation's number one Philistine, was instead shown to have a great deal in common with the art world elite. The Guerrilla Girls blurred the line between "us" and "them" with their poster which began with the boldface headline, "Relax Senator Helms, The Art World *Is* Your Kind Of Place!" With the statements which followed, they pointed out abundant similarities in two seemingly disparate worlds. A sample: "Because aesthetic quality stands above all, there's never been a need for Affirmative Action in museums or galleries"; "Museums are separate but equal. No female black painter or sculptor has been in a Whitney Biennial since 1973. Instead, they can show at the Studio Museum in Harlem or the Women's Museum in Washington"; "The sexual imagery in most respected works of art is the expression of wholesome heterosexual males"; and "The majority of exposed penises in major museums belong to the Baby Jesus."

When the Guerrilla Girls point fingers, people twist with embarrassment,

defensiveness, and anger. Their work forces art world participants to scrutinize themselves for evidence of complicity in perpetuating social ills. The group has frequently been maligned for their oppositional character, their broad generalizations, and their championing of equal participation and representation over aesthetics. But proponents and foes alike admit that "the girls" know the art world's pressure points. And when they apply the squeeze they reveal where the art world and the larger world converge, to the great discomfort of many.

FOR THE SAKE OF THE CHILDREN

Apropos the Guerrilla Girls' remark regarding exposed penises, such displays are routinely controversial, whether they be Robert Mapplethorpe's homoerotic photographs, or pictures of nude youngsters. American society is particularly anxious about sexuality and children, and engages in a form of collective denial that children have sexual thoughts and feelings, or that they act on them. It is virtually taboo to challenge this notion, even in the face of evidence to the contrary. This sometimes results in absurd responses, as in the case of a sculpture which was removed from New Haven's Wooster Square Park in 1983. "Playmates," the life-sized realistic tableau of three adolescent boys ogling a *Playboy* magazine, was condemned by priests, nuns, nurses and some parents. Its location near a Catholic church and a school intensified the opponents' resolve; they mentally reconstructed the sculpture to imagine a scene where the *children*—not the pin-up—were nude.[38] Other similar incidents are not so laughable, and have profound implications for an artist's reputation and civil rights.

In 1989, for example, a New York State assemblyman and the *New York Post* waged a campaign against the Bronx-based organization En Foco and their journal, *Nueva Luz*. The publication is intended to foster the careers of minority artists who have limited opportunities to show their work. The photographs in question were by Ricardo T. Barros, and present his nude wife and children (without faces, focusing on the curves of their adjacent bodies). The grievance was that these were in dubious taste, and that their publication was funded by the public through the NEA, the New York State Council on the Arts, and New York City's Department of Cultural Affairs.

But while the *Post*'s editorial railed against the work, it also admitted it was difficult to judge such material: ". . . though explicit, [the photographs] don't seem shockingly offensive." Nonetheless, it still called for stricter oversight in the disbursement of taxpayers' money: "Art that is avant garde to the point of offensiveness . . . would seem to cross the line. . . . It's not likely that the average person would see much artistic merit in the *Nueva Luz* photography—not in an age of rampant child abuse."[39] Despite the efforts of the newspaper, the assemblyman, and the Bronx District Attorney to punish *Nueva Luz*'s editors for their artistic

decisions, arts agency administrators refused to yield to the pressure. However, both En Foco and the photographer learned that they must be cautious in their future choices in order to avert trouble.[40]

What happened to Alexandria, Virginia artist Alice Sims is much more dramatic. Sims created the "Water Babies" series where she superimposed nude photos of daughter Ariel (age one) and a young friend upon photos of water lillies to create arcadian scenes. But in July, 1988, a worker in a photographic developing lab saw the nude images and believed that a child pornographer was at work. Police subsequently put the Sims home under surveillance, and then acting in concert with postal inspectors and agents from the Virginia Department of Social Services, confronted the Sims family. After a lengthy search of the premises they removed cameras, film, pictures, videos and address books, as well as the two Sims children (son Beau was six). The suspected crime was "producing sexually explicit photographs of children under the age of 18," and the children were taken into emergency protective custody.[41]

They were examined at a hospital for possible physical abuse, and then placed in a temporary foster home. The zealous U.S. Postal Inspector Robert Northrop insisted that this was a serious, insidious situation. Nevertheless, the judge at an emergency custody hearing held the next day ruled that the children be returned to their parents. He decided that while there was no evidence to indicate abuse, there had been an impressive outpouring of testimony in support of the parents. Eventually the Commonwealth of Virginia dropped the charges because of a lack of criminal intent.[42] While this was a positive outcome, it could not obviate the personal and professional damage done to Alice Sims and her family.

Aspects of the Sims incident were echoed by another set of incidents in San Francisco in 1990. On April 25 Joe Semien was arrested on two felony and ten misdemeanor charges for photos he had sent to a lab for processing. A lab employee alerted officials after noticing images which might violate the law, in this case a California statute which forbids depicting the genitals, pubic or rectal area of those under the age of fourteen "for the purpose of sexual stimulation of the viewer."[43] Semien had been hired by photographer Jock Sturges to make negatives from color slides of his work which he then intended to make into prints. These were to be gifts to families he had photographed. A large proportion of Sturges's work is of nude families, taken in naturalist settings. But once again a cautious processor perceived the possibility of child abuse, whereas many others instead saw beauty and innocence (including curators at the Museum of Modern Art and the Metropolitan Museum of Art (NY), who have purchased prints for their collections). Shortly thereafter, San Francisco Police and FBI agents raided Sturges's home.

They did not bear a search warrant when they arrived, but first "secured" the apartment and then conducted a sweeping, three-hour search with warrant in hand. Police and agents confiscated an enormous quantity of material, including thousands of negatives and prints, business records, correspondence, and equip-

ment. Sturges reports that he was not allowed to privately consult with a lawyer he had summoned—until they serendipitously discovered they were both conversant in Russian and they retreated to the bathroom to speak.[44] As Sturges related, "Scales have been falling from my eyes ever since [the raid]. . . . I began to grow up abruptly, because I learned the Bill of Rights doesn't work anymore."

The San Francisco Board of Supervisors approved a resolution urging the US Attorney to drop the investigation. Four days after they passed this motion, and nearly three months after Semien had been arrested and subsequently released on bail, the charges against Sturges's assistant were suspended. He was promised that his record would be cleared if he remained "clean" for six months.[45] The FBI continued its investigation of Sturges, however, and retained his impounded property, even though he was never charged with a crime. They subpoenaed galleries in Boston and Philadelphia which handled his work, and contacted many of the families in the US and in France whom Sturges had used as subjects. Longtime acquaintances became too frightened to pose for him again, and he also lost commercial clients.[46] In addition, he admits that "I'm self-conscious a lot. I'm no longer able to do the same type of work."

Sturges, a soft-spoken man, was reluctantly thrown into the national spotlight. His professional conduct demonstrates the care he takes to prevent exploiting his subjects, many of whom he has known for years. Sturges never asks his subjects to sign a general release. Whenever he proposes to use an image in a show or for publication, he instead asks for permission for the specific use. In that way the subjects regulate their display, and Sturges can only use photos in those instances where he has maintained a relationship with the person. In the event that someone photographed as a child or adolescent later feels embarrassed by Sturges's work, or if anyone is uneasy about their image appearing in a particular context, they can just say "no." Sturges has relinquished an exceptional amount of control with this procedure, but it conforms to his intention to explore the aesthetics of the human body, not to use it for erotic purposes. As he states, "If anyone refers to my work as shocking, they're exposing themselves."

In the Sturges case, the government's actions radicalized an otherwise apolitical artist. And in an unusual development, a federal grand jury refused to indict Sturges when it was convened seventeen months later; its ruling confirmed the egregiousness of this extensive government probe. Even so, considered in tandem with the Sims case, the power of government officials to step in and threaten people with imprisonment, separation from their families, or the loss of their livelihoods was vividly demonstrated. Yet these are not the only such official actions in recent years, as a result of the enactment and clever enforcement of an arsenal of legal measures. The pillories and scarlet letters of Hester Prynne's mid-seventeenth century Puritan Boston are gone. But the sense of community outrage they represented is now channelled through more sophisticated procedures, designed to match the more complex sexual "crimes" of our own day.[47]

Government agents have been armed with an array of statutes in the past few years to fight alleged abuses of children by artists and photographers: the Child Sexual Abuse and Pornography Act of 1986; Chapter 110, Sexual Exploitation of Children, to amend Title 18 of the United States Code; and the 1988 Child Protection and Obscenity Act, which saddled photographers and publishers working with the nude figure with strict new regulations. They were required to assemble records on the age and identity of all models, and to maintain those files indefinitely. These requirements were extended back to materials produced since 1978, thereby threatening to overwhelm photographers and related personnel with reams of paperwork. As *Popular Photography* cautioned its readers, "Until a verdict is rendered [in a challenge to the law], we recommend your subjects keep their pants on."[48]

A long legal battle over the law's constitutionality ensued, but Congress passed a revised version in October, 1990. This statute was intended to overcome the constitutional problems of the 1988 bill, and was approved in a late-night Congressional session as part of a larger crime bill. The Justice Department delayed implementation of it for ninety days in February, 1991 after a broad coalition of individuals and groups ranging from the American Library Association to photographers for *Penthouse* magazine challenged its legality.

These measures draw from the spirit of former Attorney General Edwin Meese's fourteen-month, six-city traveling pornography commission in 1985 and 1986, which set out to overturn the conclusions of the 1970 report to the President on the same subject. That earlier study uncovered no direct relationship between sexually explicit material and antisocial behavior. But Meese utilized victim testimony and sensationalistic slide shows to drive home the point that pornography had gotten worse, new technologies brought it directly into the home, and it now posed more of a danger than it had in the past. He had to finesse his way around the evidence to decide that the link between pornography and violence exists— an allegation, not a solidly documented conclusion. And any number of observers noted that there was a salacious quality to the commission proceedings themselves, a point highlighted when a theater company expropriated the attorney general's report and used it verbatim as the script for one of their productions.[49]

When the commission was set up an ACLU spokesman remarked, "I'm afraid there is a train marked 'censorship' which has just left the station."[50] Meese's efforts picked up speed along that moralistic track after he created the National Obscenity Enforcement Unit in 1986 (now the Child Exploitation and Obscenity Section). It has trained detachments of local personnel to make SWAT-team-like raids on suspected offenders.[51] And it has developed a strategy of multi-state prosecutions against dealers in allegedly obscene materials, a tactic which can quickly drain defendents' resources and cause them to "cry uncle." Attorney General Dick Thornburgh assigned obscenity prosecutions the highest priority, and from 1988 to 1989 there was a 400 percent increase in such suits.[52]

In addition, prosecutors have extended the scope of the 1970 Racketeering Influenced Corrupt Organizations Act (RICO). RICO originally targeted organized crime, drug empires, and illegal Wall Street maneuvers, but now includes pornography and popular entertainments such as rap music in its gunsights. Defendents in RICO cases risk long jail terms and the forfeiture of their assets, even if the illegal activities for which they are convicted are only minimally connected to these business pursuits. The threat of such indictments is sobering to record executives, for instance, whose clients include singers and musicians who incorporate the vernacular of the streets into their work (such as 2 Live Crew).[53]

The commercial child pornography business has nearly disappeared as the result of these, and earlier, measures.[54] But many people draw an alarming link between images made by artists and acts committed by child abusers. For example, American Family Association researcher Judith Reisman argued that Robert Mapplethorpe's "Honey" (a young child lifting up her dress, thereby exposing her genitals) "advertises the availability of this vulnerable child (and, by extension, all children) for photographic assault and rape."[55] And a female sociologist who has written extensively about women and about rape noted that even though she had not viewed "Honey," she had been told—and believed—that it "was a standard crotch shot of the girl."[56]

This underscores the suspicion that artwork deviously harbors disgraceful themes. Such a belief helped to spark the controversy over a show staged by Atlanta puppeteer Jon Ludwig as part of the 1990 Arts Festival of Atlanta. A local Methodist minister complained when he witnessed the puppets simulating oral sex. Even though "adults only" signs had been posted, and only a few children were in attendance (with adult chaperones), the minister was appalled that an art form that is so closely associated with children was adapted in this way. As he reported, "The foreplay I'd say went on about five minutes. Then he leaped head-first into the oral sex act with all the slobbering and carrying on."[57] The fact that NEA funds had gone to the Festival and to the puppetry center with which the artist was affiliated—but not directly to this production—merely confirmed the suspicions of evangelist Pat Robertson and others that even the government had gotten into the pornography business, by a circuitous route.[58]

WOMEN WARRIORS

Some observers regard the flurry of repressive reactions towards sexual images in the late 1980s as a moral panic or a sex panic.[59] The notion of moral panic was elaborated by Stanley Cohen in 1972 to describe those moments when societies create folk devils onto which they project a variety of fears. The media play an important role in fanning such hysteria, and these episodes typically divert attention away from complicated, societal-wide problems. Panics explode with great force:

the public is roused to action and roundly condemns and punishes certain people and behaviors. But gradually there is a return to a sense of normality and complaisance.[60]

This concept has obvious applications to the epidemic of art controversies of the late 1980s. However, calling it a sex panic captures only a portion of what was happening. As we have observed, a variety of topics became battle scenes; sex joined the subjects of race, religion, and patriotism, for instance, as disputed regions. Sex is an extremely important theme in the contemporary moral panic, but not the sole one. And combatants already had been feuding over "appropriate" images of sexuality and the definition and value of pornography and obscenity for some time before they pulled artists and their work directly into the debate.

During the 1970s and 1980s, for example, different factions of women had strongly taken issue with one another because of their rejection of pornography or their support for an anti-censorship stance. On one side were women who endorsed the feminist decree "Pornography is the theory; rape is the practice." These women believed that pornography demeans women, sanctions violence against them, and activates real incidents of sexual assault. Groups such as Women Against Violence in Pornography and the Media (WAVPM) and Women Against Pornography (WAP) endorsed this view, as did theorists Andrea Dworkin and Catherine MacKinnon. Beginning in 1983 these two women commanded attempts to enact local ordinances which would treat pornography as a form of sexual discrimination, and would restrict its production and distribution as a violation of women's civil rights. They led vigorous campaigns in Indianapolis, Minneapolis, and Suffolk County, New York, but even when they were able to get laws passed, they could not stand up to constitutional challenges. Nevertheless, these women continued to insist that pornography creates a dangerous environment for women to live in.

Facing off with them were other feminists who believed their sisters were misguided; supporters of the Feminist Anti-Censorship Taskforce (FACT) represent this position. First, they felt that anti-porn feminists were attributing too much importance to the role of pornography in creating or sustaining women's oppression. Simply put, eliminating pornography would not significantly alter the relative position of women in society, which stems from a complex array of religious, political and economic factors. Second, "sex positive" feminists feared that the views of their anti-porn rivals recapitulated age-old social myths which have been invoked by self-appointed guardians of the "fair sex" in order to suppress women's sexual expression. These include the assumptions that sex is degrading, and that women are victims in sexual encounters, not full, active players. Finally, these women supported the development of images where mutual desire is depicted. They preferred more and different images, not suppression: "It is time to organize for our pleasures as well as our protection" one writer declared in a pro-pornography manifesto.[61]

The amplitude of this debate decreased significantly by the end of the 1980s, but feminists and others revived some of these arguments in regard to a more elite context in the controversy over a novel in late 1990. The protagonist of Bret Easton Ellis's *American Psycho* is 26-year-old, Harvard-educated Patrick Bateman, a successful Wall Street investment banker. Ellis describes Bateman's yuppie lifestyle with exhaustive detail, dropping the names of au courant clothing designers, foods, and consumer goods with the obsessiveness of a trendy insider. Bateman epitomizes the greed of the junk bond '80s and the frantic clamor to amass material success. He represents the antithesis of the ascetic Calvinist burgher: with no apparent concern for his inner well-being, he's free to concentrate on where to party and how to look right. He cashes in his chips here and now; no spiritual sweepstakes for this character.

These themes merely summoned boredom from advance readers, not outrage. But Patrick Bateman's sinister side was also revealed in the prepublication stage, a bundle of malevolent impulses that burst out in grotesque mutilations, vicious sexual attacks and multiple murders, all described in sickening detail.[62] Ellis received a 300,000 dollar advance from Simon & Schuster, but some female employees at the publishing house were disturbed by the book's excesses, and the designer for Ellis' previous books refused to proceed with plans for the jacket when he learned about the book's content.[63] Portions of the book leaked out, and scathing reports appeared in *Time* and *Spy* magazines, accompanied by vivid, verbatim excerpts. *Spy* even conducted an experiment by submitting a seven-page section of the book to "skin" magazines and vanity publishers, without Ellis's name attached. It was rejected in all but one instance (by a vanity press) as unsuitable.[64] *American Psycho* became notorious before its sheaves hit the bindery.

As the controversy grew, Simon & Schuster decided to cancel its contract with Ellis shortly before the publication date—a costly move, since the author was entitled to keep his hefty advance. The book was quickly sold to Vintage for release in a trade paperback edition. The Authors Guild protested Simon & Schuster's decision as a breach of contract, not an act of censorship. But the group also speculated that the decision was made at a high corporate level at the parent company Paramount Communications, thereby signaling the erosion of editorial control from publishers to business managers.[65] The book was published without fanfare: there was no author's promotional tour (there had been threats against his life) and no advertising. Some booksellers opted to carry *American Psycho* but publicly disavowed endorsing it, and the publisher also included a disclaimer in the book that it did not intend to "disparage any company's products or services" which were mentioned.[66]

This book posed a dilemma for many people. Norman Mailer wrote an impassioned critique in *Vanity Fair*, and included a long passage from the original manuscript to enable the reader to reach her own conclusions. He found it to be a numbing and ambitious failure, and lamented "How one wishes he [Ellis] were

without talent!" But in the end he argued for the book's publication, even though he felt that Ellis had created an ill-advised and distasteful work: "A novel has been written that is bound to rest in unhallowed ground if it is executed without serious trial."[67] But Roger Rosenblatt wrote a scathing prepublication review of it in the *New York Times Book Review* where he declared that "[Patrick Bateman] does things to the bodies of women that Mr. Ellis does to prose."[68] He recommended "snuffing" the book, and backed Simon & Schuster's decision to cancel it. He, too, denied this was censorship, and applauded the courage and good moral and business sense of rejecting a worthless book.

Women were the most vocal critics of *American Psycho*.[69] The Los Angeles chapter of the National Organization for Women (NOW) spearheaded the campaign against the book, labelling it a "how-to novel on the torture and dismemberment of women."[70] They also called for a boycott of Random House publications,[71] and established a phone line where callers could hear a passage from the book detailing the torture and rape of a woman with a nail-gun. Such prominent feminist authors as Gloria Steinem and Kate Millett gave their approval to the NOW strategy, and former NOW president Ellie Smeal deemed the book's publication "irresponsible": "It's like throwing gasoline on the flames of the rising violence against women in this country."[72]

Letters to the editor columns were abuzz. A woman letter writer to the *Kansas City Star* supported the boycott and called for curbing our insatiable cravings for violence as well as for other harmful things—salt, caffeine, alcohol, tobacco, etc. An op-ed writer in the *New York Times* deplored the omnipresence of female flesh on outdoor advertisements, a type of public depiction that routinely incorporates violence and "borders on the pornographic." She described a figure in a poster on a bus shelter: "Her six-inch wide mouth was parted in either agony or ecstasy. Her breasts were spilling out onto 23rd Street." And the leader of a California anti-pornography group made the direct equation between a fictional manual on violence and real-world acts: "Freedom of speech is an important right, but when it cost [sic] the lives of women and children, it is in direct contradiction with the basic values of our democracy."[73]

As many people dismissed such notions as embraced them. Norman Mailer countered that the book would likely have a reverse effect; instead of inciting violence, it would likely make it more repellent—at least to sane readers.[74] NOW eventually backed away from its original stance, deciding to leaflet bookstores and to undertake their own education campaigns rather than restricting readers' choices. And a reviewer in a gay magazine, who initially felt the impulse to join this feminist crusade, also opted for a less emotional strategy in the end: "In the long run, it may well be safer and more challenging to change our cultural environment by expressing our own views than by trying to police the expression of antipathetic ones."[75]

Ellis became a literary darling at a young age and was annointed a spokesperson

for the "twentysomethings" by the *New York Times*. He claimed to represent an age cohort that was betwixt and between, overshadowed by the exploits of the baby-boomers who preceeded them in such awesome numbers. Ellis cast his as a generation of strangers adrift in their own culture: "twentysomething lacks coherence: we are clue-less yet wizened, too unopinionated to voice concern, purpose-fully enigmatic and indecisive."[76] He admitted shock at the negative reception *American Psycho* received. Ellis felt that what he had intended as satire was misinter-preted by a "new sensitivity" which required strict adherence to "politically correct" ideas.[77] As such, this dispute signalled the operation of powerful pressure groups on the cultural scene as the 1980s became the 1990s. It also demonstrated the emergence of a battle between absolute defenders of free speech against those who viewed some forms of speech as hurtful to particular groups, and in need of restriction. This was not the first controversy of this sort, nor was it the only one (see Chapter Twelve).

At the very moment that this controversy raged on, another novel was released which also chronicled the exploits of a misogynist. Philippe Sollers' *Women* was a smash in its native France, and was released in English translation by Columbia University Press. Full of literary and artistic allusions, but also presenting a female terrorist group called WOMANN (the World Organization for Male Annihilation and a New Natality), the book was viewed as literature, and a satire. Verbally sharp but not the orgy of violence that *American Psycho* was, *Women* passed onto the literary scene with scant notice. Its view of women was no less critical, but the violence this book's protagonist commits was more restricted to words and thoughts, not deeds. In addition, its Continental success and its release by a university press also helped insulate it from the supercharged climate where many American cultural products were being closely examined and criticized.

SEX PLAY

The fusion of issues of sex and gender—so apparent in many of the preceding examples—is no more evident than in the work of Judith Bernstein. Beginning in 1966, Bernstein invaded the preserve of the public male bathroom and appropriated scatological graffiti she found there. In 1969 she began to draw screws, which eventually evolved into what were unmistakably phallic images. The scale of these charcoal sketches became enormous, measuring up to thirty feet. As artist Laurie Anderson remarked in one review, "The scale of Bernstein's seven new drawings, *Phallic Screws*, made Claes Oldenburg look like a miniaturist."[78]

Bernstein was an odd creature, a woman working in an art world where the almost exclusively male Abstract Expressionist movement had reinvigorated the heroic image of the artist in the post-war period, and where Oldenburg populated the environment with his large Pop Art sculptures (including the twenty-four foot,

phallic "Lipstick (Ascending) on Caterpillar Tracks"). Bernstein was making her own bold gesture, in a contest of who was bigger and more potent: "I feel the phallus has stood for power for so many centuries, and I feel that we women want to be part of that power."[79]

Her challenge to male domination in the art world and in the world at large was answered in Philadelphia in 1974. The scene was the Philadelphia Civic Center Museum, and the event was a show entitled "Woman's Work—American Art 1974." Jurors invited Bernstein and approximately one hundred other female artists to participate. But Civic Center officials rejected her entry "Horizontal" (nine by twelve feet), claiming it was inappropriate for that setting. When a public debate ensued over whether or not the "hairy screw" drawing was pornographic, an exasperated Bernstein declared she felt like "Linda Lovelace of the art world."[80] She lost this battle, but scores of supporters appeared at the show's opening reception sporting "Where's Bernstein?" buttons. Her conceit to confront male domination—and to do so by using sexual imagery in an artistic variant of one-upmanship—foreshadowed the subsequent experiences of other artists.

The conflict between what is art and what is pornography was neatly condensed in an editorial cartoon from the *Atlanta Constitution*. Two men stare at a large framed picture, with only a black spot in the middle. The one dressed in a suit remarks, "It says to me that man is alone in space, left to ponder that loneliness by himself . . ." Another, casually dressed and portly, holds a sign reading "National Arts Endowment Funds Porno!"; he counters by declaring, "I say it's a 'G' spot!"[81] It's not difficult to envision such an exchange in a Woody Allen movie, or as a joke on a late-night talk show.

This image captures the conflict between the standards and sensibilities of an elite art world, and the man on the street. As we have noted, contemporary art trends violate traditional notions of art and the artist. It's not immediately apparent to John Q. Public how and why the minimalist painting within the cartoon could qualify as art. It's also extremely difficult to come up with a concise, persuasive explanation. And the recent infusion of distinctly sexual content into other types of art has also confused the general public. How, exactly, *can* much of it be distinguished from pornography?

The argument that simply because an artist does it—*that* makes it art—does not wash much of the time. The circuitous logic of these artistic justifications is markedly transparent, to wit: "performance art critics don't come any more credentialed than I do, and I declare it: Annie Sprinkle is a performance artist and this performance was art, not pornography. I'd be glad to say it in a court of law. It wasn't anywhere near as obscene as homelessness or our support of the war in El Salvador. Not by half."[82] Such reasoning would not pass muster with an introductory logic instructor, nor with an outraged taxpayer. The writer does not offer sufficient evidence to persuade anyone that art could be detected here, other than the previously converted. Unfortunately, this writer also corrupts the meaning

of obscenity. She uses the term so loosely that she invites similarly inappropriate applications by her fiercest opponents. A number of artists and their critics squared off over the issue of pornography and obscenity in the late 1980s and early '90s. This occurred because sexual topics offered such a rich field of possibilities for exploration.

Mike Kelly is a visual and mixed-media artist who ventures into the sexual realm in his work. He frequently works with nontraditional materials, for example, children's toys found in thrift shops. This in itself earns him maverick status since he challenges the distinctions between high and low culture. Kelly arranges these toys into sexual poses: a glob of them formed into a vagina-shaped construction, or sock monkeys sewn together into a sexual embrace. His work confronts social myths about childhood purity and blurs the boundaries between adult and child. Kelly also plaits political commentary into his work, such as the severed heads of politicians (including President Bush) impaled upon posts. Since he deals with sexual, scatological *and* political themes, all of these likely contributed to Chairman John Frohnmayer's decision to deny an NEA grant to Boston's Institute of Contemporary Art for a show of Kelly's work. A peer panel had recommended the grant in the category of special museum exhibitions, but the NEA National Council voted to reject it. Apropos NEA policy, no reason was given for the decision.[83]

The aforementioned Annie Sprinkle also ran afoul of critics in 1990. Sprinkle regards herself as a "post-porn modernist," a term deriving from her appearance at Franklin Furnace's[84] 1984 "Second Coming." That was a month-long exhibition and performance series on sexual themes organized by the collective Carnival Knowledge, formed in 1981 to counter the Moral Majority and attacks on reproductive rights. One of its goals was to try to develop a "feminist pornography." The Franklin Furnace event was picketed by the Morality Action Committee, a hitherto-low profile Christian group. They also coordinated a postcard campaign whereby protesters (many of whom lived in remote places like Tennessee and had not seen the show) wrote to Franklin Furnace's patrons. Two corporate sponsors (Exxon and Woolworth) withdrew their support as a result, and Consolidated Edison almost followed suit. In addition, the NEA requested that the agency not be credited where it was not fully responsible for the show.[85]

Sprinkle participated with other sex industry workers in "Deep Inside Porn Stars," a rap session cum showcase for autobiographical tales of girlhood and maturity.[86] Her appearance helped propel Sprinkle off 42nd Street (she had performed in 150 pornographic films) and into avant-garde art venues. Sprinkle's life and philosophy have become her text; personal transformations, her brand of performance art. Sprinkle regularly presents slide shows, with the same earnest deadpan of a junior high school science teacher. But she and her own behavior—not some exotic species—are under scrutiny, in their various permutations.

In one such instance, the slides include a graph entitled "Amount Of Cock Sucked," juxtaposing the Empire State Building to an erect penis. Computed with

the average of six inches per organ, the images are comparable at 1475 feet. A second slide contrasts the weekly income of the average woman to Sprinkle's own, more than two and a half times greater! And in another series we first see photos of Ellen Steinberg: shy, scared of boys, wearing orthopedic shoes. But Ellen wasn't very happy, so she created Annie Sprinkle: sexy, fearless exhibitionist, in six-inch high heels. But Annie, too, is fading into the past, with "Anya" now emerging. Annie, the feminist who loves men becomes Anya, the humanist who loves men and *adores* women. Annie masturbates, Anya meditates while she masturbates. Annie has sex with transsexuals, midgets and amputees; Anya makes love to the sky.[87]

Sprinkle is by turns ditzy sex kitten, part vaudevillian scamp, part *Playboy* fantasy. She conveys something of the nasty quality of playing "doctor" as a child; along with that transgressive feeling is the sense of giggly and gawky childhood games, long outgrown. In fact, in one of her signature works Sprinkle plays a nurse who invites audience members to inspect her cervix with a flashlight. She combines the feeling of just discovering sex with the canny sensibility of someone who's made sex her profession.

When Sprinkle performed "Annie's Cervix" at sites which received NEA funds, religious leaders, cultural critics, and Congressmen all recoiled in offense. The Reverend Wildmon considered this to be proof of the continuing cavalcade of "NEA pornography"; *The New Criterion* bemoaned "the transmission of [dubious] cultural values"; and Representative Dana Rohrabacher informed his colleagues that tax dollars were being "flushed into the sewer of fetishes, depravity, and pornography."[88] All these judgments were based on the horrors chronicled in a four-part investigative report published in the now-defunct *New York City Tribune*. The reporter recounted a ten-year history of government support for what he considered decadent art, guiding the reader on a journey through a Dantean hell of atrocities.[89] It was not long before rhetoric turned into action.

In May, 1990 the fire department closed Franklin Furnace's basement performance area for building code violations. The space had operated without official interference for fifteen years, until someone called in a complaint that it was an illegal social club. This was just a few weeks after a fire at the Happy Land social club in the Bronx where 87 people died. City inspectors were closing hundreds of illegal bars and clubs in response to that disaster, including many after-hours gay establishments. Franklin Furnace does not own the building it is located in, and the building codes were much different when it was built over one hundred years ago. The Franklin Furnace performance series was forced "In Exile," relocated to Greenwich Village's Judson Church.

Franklin Furnace staff could not help but wonder if the city's fresh concern for its citizens was not augmented by an official wish to punish their organization for the type of work they regularly present. Franklin Furnace has given artists such as Jenny Holzer and Barbara Kruger their initial exposure; they have subsequently

crossed over to broader audiences and success. But it also sponsors some of the most idiosyncratic creations, such as an anonymous artist who fasted for forty days in a monastery-like cell, and another who lived outside for a year: "We showed all his stuff," Director Martha Wilson recounted, "his shoes, his sleeping blanket. He woke up, had breakfast, defecated, walked. A lot of people don't think this is art. That's okay, too. There has to be someplace for art that artists consider to be art."

The Franklin Furnace gallery was hosting Karen Finley's installation "A Woman's Life Isn't Worth Much," wall paintings and dialogue dealing with women's oppression, the right to abortion, and rape; it opened the day before the city moved for closure.[90] And the performance on that evening was Diane Torr's "Crossing the River Styx," a meditation on the impact of AIDS and death on the artistic community. Both of these artists were confronting difficult, controversial material related to sex.

The federal government moved next. On July 13, the general counsel of the NEA wrote Wilson for detailed information on the artists and the work Franklin Furnace intended to sponsor with a 20,000 dollar NEA grant then under consideration. A few days later this was followed by a letter from a General Accounting Office (GAO) attorney, sent to answer a "congressional request." [91] This was an apparent reference to an order by Senator Jesse Helms, who had pressured the GAO to launch an investigation in March on the possible misuse of NEA funds. The GAO requested information about performances by four artists dating back to 1984: Johanna Went, Karen Finley, Frank Moore, and Cheri Gaulke. All are performance artists, all incorporate strong sexual themes into their work (sometimes working in various stages of undress), and all were mentioned by name in the *New York City Tribune* series.

Although the NEA claimed that their inquiry was routine, it was a new requirement for Franklin Furnace. These same demands were also previously unheard of by the Kitchen, another avant-garde New York performance space which was similarly investigated. It had been targeted in both the newspaper expose, as well as *The New Criterion* editorial which condemned Annie Sprinkle. These requests smacked of harrassment, and helped create what C. Carr considered a "new outlaw art," sentenced to a "new demimonde: a bohemia of the unfundable."[92]

THE BODY AS SPECTACLE

That netherworld boasted a particularly infamous resident, Karen Finley. This "nude, chocolate-smeared young woman" was also thrust into the limelight by a newspaper account, in this case a column written by Rowland Evans and Robert Novak. They reported that the NEA was likely to award Finley a grant for solo

theater performance at a forthcoming National Council meeting. Evans and Novak were outraged, but this confirmed what they saw as President Bush's "suspect cultural agenda."[93] A *Washington Times* editorial chimed in less than a week later, chiding the NEA as "a kind of federally funded porn palace," supporting "frauds" and "alienated elites who demand subsidies for their cultural subversion."[94]

Adverse public opinion swiftly mounted, so much so that NEA chairman Frohnmayer conferred with the panelists of the solo performance and mimes category by phone to apprise them of the delicate situation and to help plot a course of action. The panelists defended their original choices, one arguing "It's clear that people are not walking into [a performance by] Holly Hughes thinking they're going to a Mickey Mouse Club [presentation]. . . . This stuff is not being presented blindly and sort of hitting somebody on the street at 4:30 in the playground. Her work is presented in mature environments where people who are interested in having performance art in their lives are going."[95] Frohnmayer, the baffled administrator, most candidly expressed the tension between provocative art and judicious organizational behavior in the following exchange with a panelist: [Frohnmayer] "Let me ask the very crass and difficult political question: what am I going to say when one of our critics comes in, gets the file, sees the site report and says, 'Geez, they funded a guy who whizzes on the stage?' "[96] [Panelist] ". . . who knows? who cares? They're good."

One panelist summarized the situation by saying "This is a new pair of shoes for America to try on. And not a real good time for them to try on the shoes." When the NEA's National Council met in May it decided to postpone consideration of the entire category of solo performance until an August meeting. But in June, Chairman Frohnmayer polled Council members by telephone and decided to approve fourteen of eighteen recommendations, yet overrule a peer panel endorsement which recommended grants for three gay performance artists. And even though one of the peer panelists had cautioned the chairman against heeding "trial by headline," Frohnmayer also nixed the grant to Finley because of the negative spotlight placed on her by Evans and Novak. Many artists confirm that they knew the original targets were all gay and lesbian, and that Finley was moved into the condemned category only belatedly as a result of the negative newspaper column.[97]

All four artists had been unanimously recommended for support, for an overall total of 23,000 dollars.[98] Karen Finley became the most visible and notorious representative of this nascent field. Her renown was such that she was even transformed into a character in *Doonesbury*, and comically skewered throughout a week's worth of strips.[99]

Finley elicits strong responses from supporters and detractors alike. If you read reviews of her work, be prepared for a shower of adjectives and comparisons. But it's unavoidable: her performances are intense, they roam across a wide expanse of emotions, and bring together such a bizarre amalgam of elements that one's inclination is to develop a familiar framework to try to understand what you've

just seen. During one segment of "We Keep Our Victims Ready" (premiered at San Diego's Sushi Gallery in September, 1989, and presented at the Kitchen in April, 1990), Finley romps on the stage in red rubber boots, her hair tied up with a red cloth. She evokes Lucille Ball masquerading as Sasquatch, both in her look and comic manner. When she partially strips off her clothing, pours gelatin into her bra and then jiggles around, she confirms herself as a physical commedienne, a body artist.

But there is also a demon lurking within, what one critic called "A raw quaking Id . . . Finley represents a frightening and rare presence—an unsocialized woman."[100] In the fantasy "Cut Off Balls" she castrates Wall Street bankers, rolls their testicles in manure and chocolate, and then sells them in gourmet shops. In "Refrigerator" she unwinds a lurid tale of rape and incest in the family kitchen. Karen Finley gives new meaning to Freud's notion of the "return of the repressed." Anything may spew from her mouth, and often does.[101]

Reading Finley's scripts yields merely a hint of what a performance is like. They are extraordinarily visceral, and must be seen—and heard. She takes on multiple personnas as she screams out against hatred and injustice. She can become male or female, victim or victimizer. Finley's mood is labile, fluctuating between giggles and painful cries in a matter of moments. At times she seems to enter a trance-like state and incants her tales of violence, sexual abuse, and racial hatred. You may pick up the cadence of fundamentalist preaching, with its repetitive, hectoring quality. Finley also sounds like she's keening, reciting a mantra, or speaking in tongues. In New Age parlance, she appears to be "channeling" other beings through herself.

Finley's professional training as a visual artist also grips an audience's attention.[102] She literally turns her body into a canvas. In "I Hate Yellow" (part of "The Constant State of Desire") she takes off her clothes, puts uncooked eggs and stuffed animals into a plastic bag, smooshes everything together into a viscous mess, and then smears the gooey toys over her body. She sprinkles herself with glitter and confetti, adorns herself with paper boas, and voila! But what do you have? It's difficult to say; this is an unclassifiable, yet intriguing spectacle. And in the "Why Can't This Veal Calf Walk?" section of "We Keep Our Victims Ready," Finley undergoes another transformation. First she slathers her nearly naked body with chocolate she scoops out in handfuls from a heart-shaped box. Next she sprinkles herself with tiny red cinnamon candies, followed with a layer of alfalfa sprouts, and topped off with Xmas tinsel. She has become "stuccoed" according to one critic.[103] When she splays her arms she is once again a dazzling sight, quite unlike anything else. And there is also an olfactory dimension: if you sit close enough to the stage you may smell the sweetness of the chocolate under the heat of the lights and the earthiness of the sprouts.

Finley's performances tease and assault a multitude of senses. Finley raves, screams, and accuses. She shatters norms of decency and reality,[104] and she shakes

up her audiences. But although she is not easy to abide, she can also have a mesmerizing impact. Her own grandmother has called her a "toiletmouth" because of her recurrent use of profanities, and her behavior has been termed "feral."[105] A viewer of a performance in San Francisco conveyed the extreme discomfort she can induce: "If you're a man you have to wonder, 'Is this how other nice, normal-looking women secretly feel?' "[106] Finley can seem subversive and sinister.

Her "crimes" are undoubtedly connected to her breaches of what's expected as feminine behavior. Her incorporation of food into her acts follows the traditional association of women with nurturance. But there's the irony of the chocolate coming from a heart-shaped box: what generally symbolizes a gift here represents instead the fact that women are treated like dirt, according to Finley's own testimony.[107] She is discomforting on an even more primal level, however: she challenges basic boundaries. With her multiple personalities, she demonstrates how uncertain the borders between the self, others, and the world may be. There is a distinctly schizoid quality to her work. Finley also blends the sacred and profane, combining ritual with vulgarities, reverence with blasphemy. She inverts the natural order of ingestion and elimination, and makes the private public. In one of her most notorious acts she smears yams over her buttocks, facilitating her renown for rubbing food on the outside of her body rather than consuming it. Her equation of the sprouts with sperm also represents this upset order; it has been "spilled" on the outside, its natural objective defeated.[108]

Karen Finley provides a substantial target with this array of social violations. Audiences are often frustrated, angry, disgusted, and uncomprehending. One researcher discovered that even though Finley's performances have a strong feminist intent, it is generally misconstrued. There is a large gap between what Finley *intends* to communicate to her viewers, and what they actually receive. These negative responses predominate, regardless of a viewer's expectations or gender.[109] It is also easy to fault her style of presentation as boring, repetitive, amateurish and unaccomplished, as did theatre critic Clive Barnes, who cited her for "Sailing along on the crest of her mediocrity."[110] Her political commentary can also be facile and muddled. She cites the Chinese students in Tiananmen Square and Jennifer Levin (the casualty in the Central Park "preppie murder case") as victims in the same breath. She links Tawana Brawley (who concocted a tale of racial assault) with actual racially motivated murders in Howard Beach and Bensonhurst, New York. As one unpersuaded critic remarked, "The core of her material is undigested, cookie-cutter Lower East Side cant."[111]

She also has her admirers, however, and is a staple on the performance art circuit. Part of her current notoriety stems from the fact that Evans and Novak propelled her into a larger critical arena, where people were much less familiar with the conventions of her artistic field. With her three rejected compatriots—nicknamed the "NEA 4"—a new NEA saga was written.

CANCELLED PERFORMANCE

John Frohnmayer's decision to refuse grants to the four performance artists spurred outrage within the artistic community. When advance word leaked out that the chairman was going to reverse the peer panel's decisions because of "certain political realities," guests at a Seattle luncheon he was addressing walked out in protest.[112] They were incensed that political pressures were overriding the NEA's internal procedures, although this was understandable in light of another Frohnmayer comment: "Our [the NEA's] constituency *is* the Hill."[113] But for other observers, this was a sign that the agency realized it would finally be held accountable for its decisions. David Gergen, a *U.S. News & World Report* editor, bellowed "Who Should Pay For Porn?" His answer, of course, was "Not us outraged taxpayers!"

Gergen's diatribe in the magazine sharply revealed how threatening he felt contemporary artists can be. He introduced a gallery of rogues to his readers as a public service. Karen Finley was no garden-variety feminist; "her work is intended to advance her *aggressive* feminism."[114] Holly Hughes "wants to advance lesbianism," and Tim Miller's aim is "to encourage education, understanding and eventual acceptance" of the gay community. John Fleck got off comparatively lightly; a brief description of his act was meant to stand as sufficient indictment. Gergen saw a unwholesome cabal at work: "They want to engage in wanton destruction of a nation's values, and they expect that same nation to pay their bills."[115] The writer applauded Frohnmayer's decision as evidence that the head of the NEA was finally taking a moral stand.

This controversy occurred on strategic turf. As a comparatively recent arrival on the artistic scene, performance art is relatively unknown to the general public. Its conventions are still being formed, so that it can be difficult to understand what differentiates it from solipsistic play-acting. Performance art does not have strong ties to elite arts organizations such as museums or long-established theaters, and therefore does not have influential defenders. And while its lack of institutional-ization has made it an attractive field for otherwise marginalized artists, association with this constituency has contributed to its lack of legitimacy, and its vulnerability. In other words, performance art is an obvious target, not unlike shooting fish in the proverbial barrel.

The roots of performance art may be traced to the Italian Futurists and the remarkable artistic experiments of post-revolutionary Russia.[116] However, it draws most directly from the conceptual movement of the late 1960s, which led to the shift away from objects and towards process.[117] It is an example of what Arthur C. Danto calls "disturbatory art," that is, art which is confrontational, in which there is an immediate connection between artist and audience. It is art that "exploits artistic means to social and moral change."[118] Performance art also shares

features of the consciousness-raising central to the women's movement; it tends to be autobiographical and confessional. As John Fleck stated, "What I do in therapy comes out in performance."[119]

Performance art is a multidisciplinary hybrid, drawing especially from visual arts, theater, and dance. Supporters feel it is more than the sum of these things; detractors dismiss it as much less.[120] Holly Hughes describes it as "everything that doesn't fall neatly into another category. Dance that involves text; sculpture that comes off the pedestal."[121] In her own case, Hughes started out as a painter, but "there was always some level of frustration with painting and sculpture which had to do with the static quality of the object and so I felt like I was translating. It wasn't my first language." Martha Wilson's view is similar, indicating impatience with traditional disciplinary lines: "[Performance art] is visual art that happens to move in real time."

Performance art is notorious for being self-indulgent, annoying, unpolished and tedious; it typically plays to very limited audiences. It can be refreshing, but is often puerile and trite. It is a markedly individualistic field where the concept and performance originate with the same person. There often is no mediation by a dramaturge, director, or other theater personnel. According to Wilson, "The goal of theater is the suspension of disbelief and the goal of performance art is to bring you up short." Signature pieces result that are not generally reenacted by others, although some do enter a "canon" of notable works. And audience members are more like witnesses than mere spectators.

Like so much provocative art, performance art collapses distinctions between sacred and profane, and public and private, with a marked irreverence for established institutions. The performance duo Les Cargo, for instance, impiously mocks the church through a series of imitation rites, including "Ritual of Turn and Cough," and "The Ceremonial Eating of the Unborn" (communion with caviar on cocktail rye bread). These are enacted by a "priest" in full vestments made of lox, salmon and cream cheese. As with Karen Finley, aromas waft through the audience, linking performer and spectator. And this fragrant connection is also an element in Lenora Champagne's "Isabella Dreams the New World," as she gleefully chops hard-boiled eggs into a salad and reflects on sexual matters.

This fecund symbol was presented at a performance in solidarity with her rejected artist/colleagues, as was the work of Les Cargo. As Champagne explains, "Performance art is a lot about transforming traumatic experiences. . . . There's something about food . . . you transform it every day, and it's fun to play with. Everybody has associations with it. And because women have these really ambivalent relationships to food—about what makes you fat and what makes you thin and about what your mother made you eat—performance artists have taken food and used it as paint. Painting with your vegetables [as Rachel Rosenthal does] or with this chicken [as Champagne does] or with chocolate the way Karen [Finley] does is fun and makes you feel queazy. . . . Food becomes like shit."[122] Performance

artists thereby use the resources readily at hand to transmute one thing into another. But beyond their own immediate experience, they challenge established social roles: "I didn't want to *cook* chicken," Champagne declared. "That wasn't the role I wanted. It's transforming what I didn't want into a new relationship. What *I'm* cooking is something else."

Other performance artists veer into even more threatening territory. In "Saliva," Keith Hennessy smears his naked body with a concoction made from the spit of audience members, pigment, and nonoxynol 9, a spermicidal ingredient in sexual lubricants. This anonymous transfer of body products addresses AIDS in a eerie way. Johanna Went uses giant tampons with fake blood and shit in her work, and Frank Moore (a man with cerebral palsy) propounds "Eroplay," which involves nude interaction with the audience. A great deal has transpired since Carolee Schneeman symbolically gave birth to her art as she removed a rolled text from her vagina ("Interior Scroll," 1975). Although there is little doubt that this would be offensive to many people, it is far more innocent than what one observer of the performance scene has dubbed "the obscene body" of more recent years: "aggressive, scatological, and sometimes pornographic."[123]

Many critics assign these attributes to the NEA 4. John Fleck was most frequently cited for his "Blessed Are All the Little Fishes" (1989), a performance where he turns an on-stage toilet into an altar where he urinates, he mimes vomiting into it, and also hauls out a live goldfish. He often addresses androgyny in his work: in "I Got the He-Be-She-Be's" he simulates making love to himself, and Fleck will tuck his genitals between his legs so as to appear to be a woman. In his 1991 NEA grant application he wrote "behind splattering tuna and bread crumbs, the yards of unraveling tissue paper, the piercing operatic arias of unrequited love to a goldfish, there is a serious mind at work here."[124] While Fleck addresses sexual matters, comedy reigns.

Tim Miller, a founder of New York's PS122 and Santa Monica's Highways Performance Space, represents another facet of the gay community. Miller is more blatantly political in his work, so that anger over the AIDS epidemic, the necessity for political engagement, and affirmative self expression take precedence. He takes an "in-your-face" approach, as in his NEA application where he "told Jesse Helms to keep his Porky Pig face out of the NEA and out of my asshole."[125] After the NEA's rejection of the solo performance grants, Miller issued a new version of the Declaration of Independence, imaginatively presenting a new litany of acts of official misconduct, and reasserting individuals' rights: "This pursuit [of life, liberty and happiness] is not easy, especially for the homeless, lesbian and gay people, Latinos, women and African-Americans who this society screws over and would like to make invisible. That to secure these rights, an artist has a big responsibility to these troubled times, and when a government gets too big for its own wing tips and tries to tell its citizens what to think and feel, it is the job of the artist to speak truth to King George Bush in a challenging and angry way."[126]

Holly Hughes is the author and performer of such works as "The Well of Horniness," "The Lady Dick," and "World Without End." Women's sexuality is one of her primary themes, as are her experiences as a lesbian.[127] And she prominently features power in her narratives. As she recalled, the media magnified these topics: "I was [cast as] a dominatrix, someone who was shoving her lesbianism down everyone's throat, which would be a wonderful thing, I'd love to do that."

Performance art has become particularly attractive to women and gays and lesbians because it allows them to create roles that are underrepresented in traditional theatre, or merely have not yet been created. As Lenora Champagne remarked, "There's a power in being able to create a vision of the world. And embody it. You don't get that when you play a part that doesn't say what you want it to say."

The NEA theater panel which had initially recommended the grants was understandably upset that their judgment had been overruled. But during the May 13, 1990 NEA National Council meeting, where that full body first confronted the issue, "pragmatics" was the dominant theme. Member Wendy Luers captured the dilemma precisely: "I have natural urges [toward freedom of expression] and then I have pragmatism that is hitting me." Much of the debate centered on second guessing the radical right's response to their decision-making, to the point of envisioning potentially explosive stories in the *Washington Times*. Amid references to being "in the frying pan" and "adding fuel to the fire," Frohnmayer stated in exasperation, "there are five hand grenades on the table,[128] and politically, you don't win either way. If you delay . . . they [Congress] are going to say, 'They are cowards over there.' If we make the grant, you are going to have the headlines on the hand grenades. . . . So we are in a no win situation, folks." Political expediency decidedly outweighed artistic merit in this affair.

There were a variety of reactions by the artistic community: Rachel Rosenthal turned down her solo performance grant, Richard Elovich proposed that grantees and others contribute to a fund to "re-grant" the cancelled allotments, and the Los Angeles Theatre Center commissioned new works from Miller and Fleck. The four artists filed administrative appeals, but Frohnmayer denied them. On September 27, 1990, the rejected artists then filed suit against the NEA and Frohnmayer in the US District Court of California. The plaintiffs argued that by "practice and custom," a peer panel recommendation for a grant was tantamount to its award. They alleged that this supposition was breached because of political pressures and thereby violated their First Amendment rights (a substantive claim), and the NEA's own procedural safeguards.[129]

For example, they challenged Frohnmayer's telephone survey of National Council members as a legitimate expression of that body's sentiments. Instead of being an interactive session, individuals gave their opinions to the NEA's general counsel in isolation (some Council members were chafed by this method as well). According to one of the artists' attorneys, David Cole of the Center for Constitutional Rights,

"for some reason in this case, they [NEA staff] decided to short-circuit the process. [But] in an area like this where there are sensitive First Amendment concerns, you have to follow procedures."[130] During that telephone canvassing, respondents offered appraisals of the controversial grantees such as "junk and garbage," "bad 'schtick,' " and "sophomoric" and "more angst than art,"[131] without commentary by their fellows.

Cole argues, "Nobody says they're [automatically] entitled to the money. What they *are* entitled to is a fair consideration and to not be turned down because of the sexual or political content of their work. It's one thing if the NEA turned them down because they said 'we have 18 other performance artists who are better than you and who we believe deserve this more than you do.' But that's not what happened. Eighteen were recommended unanimously and then the chairperson decided to cut out four, clearly in response to public concerns and concerns from conservative members of Congress."

Generally it is easier to confirm procedural abuses than it is to prove the intrusion of politics into what is supposed to be a nonpolitical decision making process. In the case of the NEA 4, however, the extensive documentation that the agency produced of its own deliberations and actions provides convincing verification that politics negated artistic merit. Even before this material was made public, Cole expressed the sentiments that many other thoughtful observers of these events held: "I think the suppression of speech around the issue of sexuality is very problematic. All the arguments around the moral tone and the moral fabric of society are crap. We're supposed to be engaged in a debate about the moral fabric and not *enforce* a moral standard on society."

In addition, the four artists sued for damages under the Privacy Act. In Finley's case this was because somehow information from her NEA application was leaked to Evans and Novak for their critical column on her.[132] Controversy continued to dog both her and Hughes. The National Council postponed five grants in August, 1990 because of possible conflicts of interest in the peer panel system. They all involved avant-garde performance venues, and in two of the cases these particular controversial artists were to be co-grantees. The issue was settled by the November meeting and the awards were given to Hughes and Finley, in conjunction with the Downtown Art Company and the Kitchen, respectively. And in November, 1991, Hughes and Miller received individual grants in a new round of competition, with Frohnmayer emphatically stating, "I will not blacklist."[133] Although these decisions allayed some of the concern that artists held regarding the drift of the NEA, it could not nullify all the ill will generated by disputes over sexually oriented art, and especially those works with gay themes.

Artists could not be certain about what these decisions represented. Was the NEA now committing itself to support radical or sexually unconventional artistic work? Or was this a ploy to silence a few noisy artists? Whatever the intention, NEA critics like Wildmon criticized the decision to support Finley and Hughes

for months thereafter. In April, 1991, for example, his newsletter mistakingly alleged that the NEA was funding a Hughes performance which would include explicit sex and twelve-year-old girls.[134]

One of the most important consequences of the NEA 4 conflict was that it brought the fear of homosexuality to the forefront. There had been profuse evidence that homophobia was at work in the negative reaction to countless other artists and art works during this time period. However, it was barely mentioned in public discussions by most non-gay members of the arts community. When the arts community came under fire, many artists and arts administrators initially mounted their defense around the most conventional, acceptable segments, leaving marginalized members like gays and lesbians to protect themselves. The NEA 4 incident slowly converted mass denial into recognition: it introduced homophobia into the public dialogue and helped reinvigorate artistic responses. Artists Holly Hughes and Richard Elovich insisted that gays and lesbians take the lead in fighting for freedom of expression since they were high-risk groups for having their rights abrogated. They also challenged other artists and the arts establishment to embrace this portion of the struggle.[135]

7

GAY IMAGES AND THE SOCIAL CONSTRUCTION OF ACCEPTABILITY

The road to Selma didn't lead to the right to sodomy.
William Dannemeyer, 1991

We're here! We're Queer!
We're fabulous! Get used to it!
Queer Nation protest chant, 1990

Congressman William Dannemeyer (R-CA) issued a dire warning in 1989. "Currently we are a divided nation," he declared. "Such a division has not existed in America since the Civil War."[1] And what did he cite as the basis of this split: possibly class or race? Religion or ideology? No; these factors were all overshadowed by what the Congressman feared as the gravest social danger of all—homosexuality.

For Dannemeyer and many others, gays are not a benign presence. Instead, openly gay men and women seem to them to challenge biblical authority and undermine traditional morality. Dannemeyer proffered an explicit recommendation to combat this presumed problem: ". . . we must reinstate traditional prohibitions against homosexuality in order to establish a sense of order and decency in our society, to reconnect us with our normative past."[2]

Orthodox religious believers see gays as a threat to the family unit, a judgment that has been corroborated in their minds by the onset of the AIDS epidemic and its initial locus in the gay male community (at least in the US). For particularly spiteful fundamentalists, this is a clear example of divine retribution for a grievous sin. But such beliefs rest atop a more basic presumption: religious traditionalists feel they are forced to give up no less than "natural categories" of masculine and feminine and "normal" sexual behavior if they tolerate homosexuality.

Same-sex relationships are unsettling to a fundamentalist way of thinking to an

extent that other subjects can hardly match. In an article which appeared in the *American Family Association Journal*, a critic of popular culture railed against the lack of standards in contemporary culture, and cited the Judeo-Christian tradition of a God that characteristically made distinctions: between light and darkness, the separation of the Sabbath from the secular week, and—by extension—the distinction between male and female.[3] To blend attributes from any of these sets of categories is to challenge the notions of sacred and profane, and to raise basic questions about how reality is socially constructed.[4] Homosexuals defy accepted notions about "proper" affectational choices and sometimes confound gender expectations; their overt presence can disturb other people.

That partially explains the adverse reaction to Madonna's music video of "Justify My Love." One of its most controversial aspects was a scene where the singer kissed an actress sporting a mannish appearance, an act that prompted letter writers to the *Los Angeles Times* to declare "We used to like her videos, but now yuck, yuck and double yuck!!!"[5] But it is important to note that the writers in question were two sixth grade girls. Such a response is somewhat understandable from these youngsters, given the insecurities involved in forming a sexual identity at that age. But the fact that a major newspaper would deem it newsworthy or acceptable to publish such an opinion reveals a great deal about the persistent prejudice against gays in our society, and the resistance to positive depictions of same sex affection.

One of the most effective ways to demean a man in many societies continues to be to question his masculinity, and allude to the possibility that he may be homosexual. This was, of course, a dominant motif in the derisive painting of Mayor Washington in Chicago, and also has surfaced in depictions of despised foreign leaders. In 1986, for example, the *New York Post* once again helped define tabloid journalism by publishing a story based on the report of unnamed informants that Moammar Khadafy was drug-crazed and wore women's clothing, makeup, and gilded high heels. The article was accompanied by the rendering of a spit-curled general adorned with lipstick, earrings and beauty marks: "Dressed in drag, Libyan leader Moammar Khadafy *might look like this*."[6] And after Saddam Hussein's troops were routed from Kuwait in 1991, locals added long hair and lipstick to a large portrait of the dictator and then defaced it. All these symbolic representations combined specific targets with broader social anxieties.

Running counter to such images are those generated by gay artists themselves. The types of work gay artists have produced have been affected significantly by larger events. Art from before the Stonewall Rebellion in 1969 (when an angry gay crowd[7] with drag queens in the forefront defiantly battled with police at a Greenwich Village bar) differs markedly from material created afterwards. And then the onset of the AIDS crisis in 1981 radically altered both subject matter and predominant methods of artistic presentation. But whether homosexual content

has been disguised or boldly presented in art, other social groups have often rejected the images which express the beliefs and values of this sexual minority.[8]

THROUGH THE VEIL

Living life in the closet makes it more difficult for others to see and understand what goes on inside. Homosexual argot captures an important aspect of this with the phrase "dropping your hairpins," or giving off signals that a savvy recipient can decipher to identify someone as gay. A similar notion is captured in a distinction made by Erving Goffman in his study *Stigma*. Goffman proposed that people with characteristics that their society was likely to stigmatize could face two different predicaments. If the characteristics are overt, the challenge to those who possess them would be to manage the tension that comes from hostility, social discrimination and rejection. But "passing" is a possibility if those characteristics are covert. Here the problem is to manage information and regulate self-disclosure.[9]

Of course these distinctions merge in real-world situations, but they are useful in characterizing certain artists and their output. In general, pre-Stonewall art that deals with homosexual subject matter has a muted quality because artists adopted evasive strategies to avoid controversy. The meaning of their work is only apparent through decoding signals or possibly bringing in supplemental biographical information about their lives. Contrariwise, an overt stance is much more common for post-Stonewall gay artists. The imagery they employ is accessible to larger publics, and they are increasingly likely to conduct their lives in the open. Controversies have also proliferated as a result.

There are striking examples of pre-Stonewall artists whose work broadcasts homoerotic messages which can be unscrambled. The photographer F. Holland Day (1864–1933) is one such case. Day shocked the public with the first image of a male frontal nude displayed in a photo exhibit at the Boston Camera Club in 1898. His dreamy portraits of swarthy, lower-class young men posed with classical accoutrements betray an intense interest in the male physique, in addition to a deep intimacy with his models (some of whom he assisted financially). But his major biographer hedges throughout her book when it comes to confronting Day's homosexuality. She claims "It was a mark of Day's genius that he could disguise in his models a real-life vulgarity,"[10] thereby virtually equating homosexual desire with obscenity. And when she describes his photographic recreation of the passion of St. Sebastian (a common homosexual subject), she uncomfortably finds "previously sublimated or disguised . . . homoerotic masochistic posturing," instead of the "exalted sainthood" that marked his earlier religious subjects.[11] It is hardly

surprising that Day was cautious in his work and circumspect in the conduct of his life when even the opinions of latter-day critics are apt to be value-laden.[12]

F. Holland Day's artistic output also provides interesting antecedents for Robert Mapplethorpe, a photographer whose gay life was markedly open, and for a non-gay photographer, Andres Serrano. Day repeatedly photographed Black men, albeit in an overly romanticized manner: his chauffeur was presented as an Ethiopian chief, for example.[13] And his interest in religious themes led a starved and long-haired Day to assume the persona of Jesus and reenact the crucifixion in 1898. The photographic chronicle of this "historically accurate" recreation provoked a critical outcry, primarily because it recorded an event that had actually taken place, not a scene conjured up in a painter's mind and then transferred by brush to canvas.

There was a tangible reality to the photos that profoundly unsettled viewers. The editors of the *British Journal of Photography* wrote, "Mr. Holland Day's photos [are] repulsive because we are conscious that the individuality of the originals has not been, cannot be, so completely masked or subdued as to destroy the mental persuasion that we are looking at the image of a man made up to be photographed as the Christian Redeemer, and not at an artist's reverent and mental conception of a suffering Christ."[14] And another reviewer could have just as easily been writing about Mapplethorpe's sado-masochistic subjects or Serrano's combination of religious icons and bodily products when he drew back from the immediacy and concreteness of the photographic document: "In looking at a photograph you cannot forget that it is a representation of something which existed when it was taken."[15]

This explains in part why photography became such a "hot medium" during the contemporary period as well. We understand intellectually that photographs can seriously mislead; people cannot hold up the Eiffel Tower, notwithstanding conventional tourists' snapshots. Nevertheless, photographs appear to have an immediacy that other artistic media do not. We tend to assume that if the camera saw it, it existed. We also generally suppose that what the camera produces is less mediated than a painting or a book, which we know has to be explicated or interpreted by the artist.[16] Photographs have a singular ability to strike us viscerally, even more so when they depict unorthodox people or behavior. It's one thing to understand—and perhaps even accept on an abstract level—that homosexuals exist. It's quite another to confront photographic documentation of actual people and authentic acts.

Close scrutiny of the work of photographer Minor White also reveals disguised homosexuality. White worked primarily in the 1940s and '50s, a time when homosexuality could be a public liability. According to critic Ingrid Sischy, his output can be decoded to reveal a creative life that was stunted by the fear of being exposed as a homosexual. His work is marked by indirect expressions and substitutions, the rocks and cracks in stones standing in for parts of human bodies,

for instance. White learned to be cautious early in his career when an exhibition of his work was canceled in San Francisco "on the grounds of taste."[17] "Amputations" was accused of being unpatriotic, a charge that seems frivolous now; the images depicted the horrors of war by focusing on the gashes on the surfaces of rocks, not actual human bodies.

White subsequently depicted the human male torso, but in a "tasteful" manner. Sischy is a harsh commentator. She feels White trivialized his work by deflecting his energy into "a career spent avoiding calling a spade a spade." In the final analysis, she views him as "crippled, rather than inspired, by repression."[18] His tortured writings also expose an archetypically covert, pre-Stonewall, guilty homosexual, during this period when Edward Steichen's "The Family of Man" offered a prototype for the artistic representation of ideal social life.

Concealed references in the work of some visual artists now known to have been homosexual also require unraveling in order to extract their full meaning. Some Charles Demuth (1883–1935) watercolors show sailors with their genitals exposed; yet although there are only men in certain scenes, in others there is ambiguity about the gender of particular partners. But a large proportion of his paintings depict flowers, fruits, and vegetables, subject matter that can invite comparisons with human sexuality without directly portraying it. These latter paintings have been highlighted most commonly in public exhibitions, along with his industrial scenes and "poster portraits," images which primarily use words and numerical references to describe famous personages such as Georgia O'Keefe, Arthur Dove and William Carlos Williams, and the not-so-well-known such as Bert Savoy, a successful female impersonator in the 1920s.[19]

Curatorial decisions have manipulated Demuth's oeuvre: in 1950 officials excluded his painting "A Distinguished Air" from a retrospective at the Museum of Modern Art because they considered its sexual theme too controversial,[20] and the tame scene "From the Kitchen Garden" (1925) adorned the cover of the catalogue for the retrospective mounted by the Whitney Museum in 1987–88. While the full range of his work was displayed in that show, room after room of delicately executed flower paintings dominated. In addition, the small size of most of Demuth's sexually explicit drawings isolated them even more amidst his larger paintings of neutral subject matter.

Marsden Hartley (1877–1943) was another homosexual artist whose subject matter was typically natural, with mountains and seascapes being frequent subjects. Yet other works touchingly record his liaisons with men who met early and tragic deaths. His famous "Portrait of a German Officer" (1914) memorializes his lover Lieutenant von Freyburg who was killed in battle. Executed in what Hartley called "Cosmic" or "Subliminal Cubist" style, the painting contains numerical references to the soldier's age and regiment, and iconic allusions to his uniform such as the Iron Cross, spurs, tassels, and feathers.[21] The work is opaque without this information, looking like a vibrant jumble of colors and shapes.[22]

Hartley also commemorated his relationship with Alty Mason, a Nova Scotia fisherman lost in a boating accident. His initial artistic response came in "Northern Seascape, Off the Banks" (1936), portraying the ocean as the source of the tragedy, but not the victims. It was two additional years before he created the poignant family scene "Fisherman's Last Supper" (1938), where Alty and his brother are marked as doomed members of a clan taking their final meal together. This elegiac painting captures a universal feeling of tragedy by placing these men within the familial context that is fated to be irrevocably altered. But Hartley's personal feeling of loss comes out most fully in the portrait of his lost love, "Abelard the Drowned, Master of the Phantom" (1938–39). This painting crackles with a sexual charge when the viewer knows the nature of the link between the artist and his subject. "Abelard" presents the massive dark-complexioned figure in a rather pensive pose, a rose tucked behind his ear as an enigmatic and delicate counterpoint to his thick black hair, eyebrows, mustache, and chest hair.[23]

But perhaps nothing reflects the subterfuge which homosexuals in creative fields felt they had to endure than the role played by Rock Hudson in the film *Pillow Talk* (1959). This comedy with Doris Day represents the zenith of pre-Stonewall self-deception. It is a remarkable document of stereotypes and misconceptions, with masquerade and misrepresentation the primary leitmotifs. Most of the world discovered that Rock Hudson was a homosexual when his imminent death from AIDS was revealed in 1985. But there was little to indicate his furtive life in the portrait by *Saturday Evening Post* photographer Sid Avery in the 1950s: Hudson is shown fresh from a shower, hair tousled, a towel discreetly covering his midsection. As the putative all-American heterosexual, Hudson is presumably arranging yet another female conquest while he chats on the phone.

That's precisely the nature of his on-screen role of Brad Allen, who shares a Manhattan telephone party line with the Doris Day character, Jan Morrow. Brad is a playboy who is constantly making arrangements for liaisons, which ties up the line and enrages Jan. A struggle for control ensues, with Allen accusing Morrow of being a prude and having "bedroom problems." She responds near the film's end that *his* difficulties could not be worked out in a thousand bedrooms.

Morrow realizes Allen is a champion of insincerity when she repeatedly picks up the receiver to hear him singing a supposedly original love song to different women, while in fact it's the same tune with only the lady's name changed. True to '50s comedic conventions, Brad falls for his adversary when he actually sees her, and attempts to woo her by manufacturing another persona, "Rex Stetson" the wealthy Texan. Try to visualize the levels of deception here: Hudson the homosexual is playing a heterosexual Don Juan, and his movie character then poses as a sweet, naive out-of-towner in order to make a new conquest. If it sounds complicated, imagine what it must have been like for the star himself to keep these different personalities straight! At one juncture the Rex character arouses Jan's suspicions about his sexual orientation: he eats a snack dip with his

pinkie extended in the air, and wants to take the recipe home to his mother, obvious and derogatory gay stereotypes. But this, too, is a pretense: it allows "Rex" to move in for a kiss, the opening he needs to assure Jan he's romantically interested.

Other running gags require Hudson to deny his authentic self. His dual characters require that he segregate his audiences, lest he be revealed to be someone he is not—the ongoing challenge to someone in the closet. In order to maintain the charade, he is forced at one point to duck into an obstetrician's office where he is mistaken for a "pregnant man." In response to what evolves into a running joke, a doctor advises his disbelieving nurse that this patient may have "crossed a new frontier." Sadly, however, Hudson was entrapped in a cycle of denial in order to protect his screen personality, a fabrication that likely would have been subverted— and deemed unmarketable[24]—had he revealed who he truly was during a sexually repressive time.

Playwrights have similarly used artifice in their creations. Both Edward Albee's "Who's Afraid of Virginia Woolf?" and Tennessee Williams's "A Streetcar Named Desire" are widely interpreted as gay-themed dramas encased within heterosexual wrappings; reading the subtext reveals an entirely hidden dimension. But homosexually inclined artists now have many more opportunities to be gay in both their private and public lives than ever before. These opportunities are not limitless, however, for there continues to be pressure to engage in denial and deceit. A case in point: in 1991 a television mini-series entitled "A Season of Giants" purported to tell the stories of Michelangelo and Leonardo da Vinci, both homosexuals. But their sexuality was wildly distorted: Michelangelo had an erotic dream about a Bolognese noblewoman, and Leonardo was presented as asexual.[25]

OUT OF SIGHT, OUT OF MIND

When you review the negative responses to certain art works in the past, it's not difficult to understand why depictions of homosexual behavior or a "gay sensibility" were relatively infrequent or concealed. Take the example of gay writer James Baldwin. *Giovanni's Room* (1956) chronicled the calamitous liaison between an American bisexual expatriate and an Italian bartender. Baldwin created a novel that would be more palatable to 1950s readers and critics by fashioning the main character as confused rather than resolved about his sexuality (he is engaged to an American girl), and by making him White rather than Black (Baldwin himself was Black). He was, as one literary historian explains, "playing the game,"[26] a strategy that nevertheless garnered mixed to negative reviews for the book. But his 1962 novel *Another Country*, because it dared to enter the dangerous territories of both homosexuality and interracial relations, occasioned far more serious condemnation.

Community members and politicos swiftly responded when the book was included on the reading list of a Chicago city college. A group called Citizens for Decent Literature and Movies pressured the City Council to take action, whereupon a committee approved a resolution denouncing the novel after a clamorous eight-hour hearing. Although the Council did not have the legal authority to directly enforce the measure, they did have latent power by virtue of their right to confirm all appointments to the school board. Mayor Daley concurred in the Council's judgment, yet the school board was able to resist this official pressure and public opinion: after a two-month battle it voted to keep the book on the reading list, but stipulated that students who objected to it could be assigned another selection.[27]

The tenor of the debate is clearly transmitted by a hateful *Chicago Tribune* editorial that branded Baldwin's work "disgusting" and charged that it contained the "vilest words in the vocabulary." The writers of the piece went on to defend Negro citizens whose integrity they felt had been compromised by the book's portrayal of them as homosexuals, and they finally exploded with the following tirade: "We freely concede that our own book section some years back contained a namby-pamby review of this book by a professor who was moved by the author's 'compassion' for queers and misfits. But such dicta are binding neither on THE TRIBUNE nor its editor."[28] Impassioned reactions like this probably explain why a publisher decided to deceptively package a contemporaneous novel. Christopher Isherwood's *A Single Man* (1964) was remarkable for its matter-of-fact account of a day in the life of a gay man. When it was issued in paperback in 1968 by Lancer Books, the cover quoted from a review in the homosexual journal *One*, yet it showed a man looking pensively downward, while a woman clings to his shoulder and arm. Because she was pictured in her slip and a robe, they look like a couple facing domestic difficulties. The main theme of a man coping with the death of his male lover was thereby camouflaged.

Another artist encountered difficulties years earlier for work that merely depicted male sexuality, although not with direct homosexual referents. Paul Cadmus first ran afoul of the government over his 1934 painting "The Fleet's In," which depicted drunken sailors carousing with women in New York's Riverside Park. The portrayal infuriated Assistant Secretary of the Navy Henry Latrobe Roosevelt, who had it removed from a show of PWAP art (the Public Works of Art Program, a forerunner of the better-known WPA projects) at Washington's Corcoran Gallery. Cadmus expressed surprise at the response, and disavowed any libelous intent;[29] but the painting was subsequently consigned to Washington's Alibi Club, and not returned to public view until 1981, when an art history professor intervened on its behalf.[30]

Cadmus was warily given another chance when he was commissioned to execute a mural for the Parcel Post Building in Richmond, Virginia, under the auspices of the Treasury Section of Fine Arts in 1939. His subject of "Pocahontas Saving the Life of Captain John Smith" seemed relatively safe—until the design was exhibited

at Vassar College. The fact that one of Pocahontas's breasts was fully exposed did not raise any ire. But a warrior's bared buttocks in the center of the mural did provoke a din of protest, as did the rendering of another warrior with an animal skin dangling between his legs. The pelt bore a remarkable resemblance to a set of male genitals because of the way it was positioned. Government officials ordered Cadmus to remove the fox's snout that disconcertingly simulated a penis.[31]

Although these works did not contain explicitly homosexual themes, the tight sailor uniforms in "The Fleet's In!" allowed Cadmus to emphasize the buttocks and prodigious endowments of some of the servicemen. And in "Pocahontas" his foregrounding of masculine anatomy was anathema in a culture accustomed to odalisques, yet not so comfortable with the male body. The homoerotic elements are an easily observed subtext in these paintings, created by an artist who admitted in an interview at age 86 that the Stonewall Rebellion "made him more comfortable about being gay."[32]

An attempt to publicly commemorate that beginning of the modern gay movement also encountered a difficult reception. The sculptor George Segal was commissioned by the Mariposa Foundation (a gay rights and educational organization) to create a statue for Christopher Park, adjacent to the site of the Stonewall Rebellion. He created a life-sized work entitled "Gay Liberation," featuring a lesbian couple and a gay male couple. The figures touch one another on the leg and the arm in a casual, not erotic manner. But opponents emerged from many directions when the piece was to be erected in 1980. Some thought it was ugly, while others saw it as too large and inappropriate for a small, nineteenth century public space. Further criticism came from those who feared it would attract hordes of tourists, and some even expressed concern that it would be "an invitation to public sex."[33] Disapproval was also voiced by some members of the gay community, particularly those who felt the work was racist because it featured only White figures. After all these opinions had been aired, it became clear that even in a community with a reputation for an enlightened and tolerant atmosphere, public art proposals can become highly volatile issues.[34]

The sculpture received a brutal reception when it was displayed on the campus of Stanford University in 1984, where an assailant attacked the bronze tableau with a hammer. The act stunned the university community, but also mobilized it in anger. According to one student, "I feel as if we have lost four valuable members of our community." And another sorrowfully stated, " ... each of us ... who walk past the sculpture every day, feels personally assaulted. The sculpture as it stands now is no longer a monument to gay liberation, but is tangible evidence of the violence perpetrated against gay people."[35]

"Gay Liberation" likewise elicited mixed responses in Madison, Wisconsin (1986–1991), where another cast of it was shown first at the Madison Art Center and later installed in a public park. Some sympathetic critics nevertheless found it "stiff and static" or commented on its "abject *ordinariness*," but others condemned

it as "gay propaganda" and "insulting to straight people."[36] It was vandalized several times by teenagers and young men, while neighborhood residents were quite solicitous of its welfare. Some of them cleaned it when it was blemished by paint, and wrapped the figures in hats and scarves when it was cold.[37] At a hearing held to determine whether to continue to display the work, one local citizen testified to the potential of public art as a catalyst to candid civic dialogue: "It's clearing the air. It's making people who feel compassion and support for homosexuality say their piece. And it's making people who feel the opposite say their piece too."[38]

These varied reactions undermine Hilton Kramer's claim that Segal's work " . . . is inevitably sentimental, condescending and mawkish. The sense of elevation we look for in public sculpture is missing."[39] By viewing Segal's work within a gallery context, this armchair critic failed to understand its impact upon other people.

If the male nude and discreet depictions of gay people can so unnerve some segments of the public, then more candid portrayals—particularly when they appear on mass media such as radio or television, or if produced with government support—carry the potential to cause even greater disturbance. One month prior to the Nelson/Washington incident in Chicago, for example, the New York State Council on the Arts (NYSCA) was strongly criticized by state legislators for certain grants they had awarded. The subsidies in question primarily dealt with topics related to sexual minorities, as broadcast in the New York Post headline of March 16, 1988: "Cuomo Orders 'Drag' $ Probe." Included in the list of so-called offenders was a photography exhibit on transvestism, a lesbian feminist literary magazine, an archive of lesbian and gay writers, and a film of a gay rights march in Washington, D.C. But once the critical charge was sounded by the Post's investigation, other projects with strong social and political components were also singled out: grants to a Manhattan tenants' advocacy group and to the production of a film about a Sandinista leader became additional targets.

NYSCA's chairperson Kitty Carlisle Hart was summoned to Albany to face legislators' questions and to defend the agency's grant procedures. The case had already been tried in the pages of the New York Post. Post writers repeatedly equated support for artistic projects with "promotion" of deviant and "offbeat" behavior. In one editorial, transvestism was characterized as a psychological disorder which now had the imprimatur of the state.[40] Hart successfully vindicated the agency by emphasizing the centrality of social and political issues to many spheres of activity, including the arts. In some ways the defense was made easier because of the absurd and uninformed nature of the charges: the critics failed to realize that the project on transvestites mostly concerned straight men; they automatically collapsed all nonconventional gender and sexual behavior into the despised and feared gay category.[41]

When gay characters have appeared on television, even the simplest expressions

of same-sex affection have generated problems. After two male characters on the popular series *thirtysomething* were shown lying in bed together—engaging in post-coital chatter, with blankets prudently pulled up to mid-chest—the producers had to pay a large price. Jittery advertisers withdrew more than one million dollars worth of support from this episode. They reacted similarly to the tune of 500,000 dollars to a later installment where the two men saw each other at a New Year's Eve party and exchanged a kiss on the cheek. But because of their rarity, such affirmative scenes can assume inordinate importance for gay people. As one activist attested after the first episode, "I actually cried (I'm a sentimental kind of guy). To see something validated which is very ordinary in my life, which as a kid I never saw validated . . . and to know that my parents and young people growing up trying to figure out who they are and what it means to be gay or not to be gay [would also see this] was extremely moving. . . . Later when I pulled myself together I thought, 'My God, I would have this kind of emotional surge from something as cheap and ordinary as that?' Well, yes!"[42]

The episode with the bedroom scene was one of the few to be excluded from summer reruns, a network choice to avert an additional loss of revenue.[43] And another flap ensued because two female characters on *L.A. Law* kissed one another. In reaction, Reverend Donald Wildmon pledged to contact the advertisers on that show and to pressure them to disavow their support for portrayals of homosexuality as normal and acceptable.[44]

Although today we tend to think of radio as merely background diversion, this medium has also faced problems when it has presented gay-related material. For example, an incident occurred in Cincinnati in 1981 which was amazingly prescient in respect to later events there. John Zeh, producer of the lesbian and gay program "Gaydreams" on a community radio station, was indicted for distributing obscene material harmful to juveniles. The charges stemmed from a broadcast in which Zeh humorously read a report on sexual lubricants, a broadcast that some children recorded and replayed to their parents. The prosecution was undertaken by Simon Leis, the county prosecutor who had garnered a reputation for his zealous, anti-obscenity crusades and anti-gay campaigns. Zeh was exonerated two years later, but only after losing his job and his apartment, and facing the possibility of a lengthy jail term. The court decided that the program was not deliberately aimed at children, and in accord with regulations at that time, everything that was broadcast on the radio did not have to be suitable for children. According to the station manager, "Cincinnati is a conservative town and Zeh was like a college student 'mooning'—like turning your butt to the whole world and saying 'Kiss it.' "[45]

In 1986 the Federal Communications Commission (FCC) targeted Robert Chesley's "Jerker," a two-man play in which the characters engage in sexual fantasy play over the telephone, for possible obscenity violation. The play had been read over KPFK in Los Angeles, a Pacifica-affiliated, listener-supported station. The

Justice Department eventually decided not to prosecute, but only after Pacifica had incurred approximately 100,000 dollars in legal fees to defend itself.

Over time FCC statutes were broadened to allow the agency to regulate not only the constitutionally specific category of obscenity, but also the more indeterminate "indecent." In 1988 regulations also swept aside the notion of a "safe harbor" (when children were presumed to be asleep and any type of programming was permissible), extending the ban on "indecent" language to twenty four hours.[46] Radio stations feared that material *could* be judged indecent, and they became more cautious in their programming since there were not clear-cut guidelines defining the field.

For example, WBAI, the Pacifica station in New York, had regularly broadcast Allen Ginsberg's "Howl," a poem that indicted conventional society of the 1950s, and includes explicit homosexual references. In 1988 the poem was scheduled to be broadcast as part of a series on censorship entitled "Open Ears/Open Minds." But the five Pacifica stations opted instead to broadcast an interview with the poet, fearful of possible legal repercussions because of their earlier struggle with the FCC. In that interview Ginsberg accused the FCC of "evasive double-talk," and of creating a chilling effect where stations were censoring themselves, in effect doing the bidding of the government. Ginsberg blasted the FCC as being a "spiritual death squad for literature," quite possibly a reference to the fact that WBAI had also feared broadcasting a reading of James Joyce's *Ulysses* after the FCC enacted its new "decency" clause.[47] In May, 1991, the United States Court of Appeals for the District of Columbia struck down the twenty four-hour ban, a ruling upheld by the Supreme Court in March, 1992. The FCC was ordered to reinstate a "safe harbor."

DARK STRANGER

If Salman Rushdie was a stranger of the British Commonwealth, photographer Robert Mapplethorpe was his American counterpart. Mapplethorpe left his Catholic home in Queens at age sixteen and hardly looked back. An interview with his father published after Mapplethorpe's death goes a long way toward explaining why. The elder Mapplethorpe, a retired electrical engineer, lived in a vastly different world from the one his son gravitated to and eventually embraced. Father and son were strikingly different people, from matters of decorative taste to social beliefs and sexual practices. In 1990 the father, surrounded by the ceramic and plastic ephemera distinctive of lower-middle-class homes, made it clear to a *Washington Post* reporter just how much mutual misunderstanding, incomprehension and distance there had been between him and his son. He had little interest in Robert's photographs, even less tolerance of the homosexuality that was such an important

theme in the work, and no concern about the storm of controversy that swirled around the retrospective exhibition which toured the country from 1988 through 1990. "I could care less" epitomized his response.[48]

The differences between these two generations of men from the same family almost seem to characterize different species of creatures.[49] Robert Mapplethorpe, like most openly gay individuals, was forced to refashion a radically new identity for himself. This process requires casting off many elements from the past and embracing new beliefs, values, and modes of behavior. But it is doubtful whether this ever entails a total renunciation of one's origins. His life was once summed up as "the middle of a contradiction—part altar boy and part leather bar."[50] Blend this mixture of influences with society's widespread rejection of homosexuality, and you find that gays are generally familiar with the condition of marginality.

But rather than being a negative condition in Mapplethorpe's case, these circumstances nourished his artistic sensibility as he turned his creative eye to the fast-lane gay society of the 1970s and early 1980s in which he was an active participant. Many people judged the images that he brought from there to be documents of exotic specimens engaged in peculiar conduct. Through them he captured a sense of post-Stonewall exuberance that pushed sexual frontiers— before the onset of the AIDS crisis. In the 1990s his sexual photographs, along with his floral images, have become elegies to a lost world.

After an art education at Pratt Institute in Brooklyn, Mapplethorpe drifted into New York City's avant-garde punk underground, embodied in his close friend, singer Patti Smith. He spliced this world with another: Times Square, and its commercialized pornography industry. Mapplethorpe frequently cited gay porno as an early source of inspiration, evident by his incorporation of such images into his early collage work. He had his first gallery show of photos in 1976, followed by three more in 1977. His association with well-connected personalities (for example, the collector Sam Wagstaff and John McKendry of the Metropolitan Museum) expedited his successful career as a "bad boy" in the art world. Mapplethorpe quickly became known for his work in three classic genres: male and female nudes, still lifes, and celebrity portraits.

There is a cool, detached formality to Mapplethorpe's images, even when the subject matter is emotionally loaded. He has often been compared to Edward Weston (known for his exquisite work with natural subjects), and to fashion photographers Irving Penn and Richard Avedon. Much of Mapplethorpe's work is sexually charged, and a sense of fragile beauty, the inevitability of mortality, and even innocence runs through various photographs. He anthropomorphized flowers into figures brimming with erotic power: in "Tulips" (1984) two blossoms seem to reach for one another against a stark black background, one yearning with receptivity as the other sensually descends from above. And he also objectified human beings, literally putting them on pedestals or isolating body parts as objects

to be admired and desired. The title of the disputed exhibition "The Perfect Moment" conveys this attempt to capture the apex of beauty before decay commences.

His self-portraits record a similar trajectory, and the contradictory nature of the artist. In 1975 he leaps into the frame, with just his boyish face, outstretched arm, and a sliver of his chest making it into the photo. In 1978 he becomes the Devil incarnate with his leathers and a bullwhip stuck into his rectum, twisting behind as a tail; he bends his upper torso backwards to confront his audience with a threatening stare. In 1980 he could be either the leather-clad smart aleck with a cigarette dangling from his mouth, or the ethereal waif with lipstick pout, mascaraed eyes, and naked, vulnerable torso. In 1983 he again looks menacing in a leather coat and gloves, challenging the viewer with a machine gun and a defiant stare.

But the inevitable entropy had set in by 1988, accelerated by the progress of Mapplethorpe's AIDS. Now the counterpoint to the artist's gaunt face is a skull-topped cane he defiantly grasps in the foreground; both images appear to float in black space.[51] And in another photograph from that same year, only a chipped human skull is pictured. Mapplethorpe died at the age of 42 in 1989, while his retrospective was receiving a positive (and substantial) reception in Chicago. By an odd twist of fate his last portrait assignment was a shot of Surgeon General C. Everett Koop for *Time* magazine. As Dr. Koop recalled, "It was a poignant experience to have my picture taken by a man dying of a disease I've spent so much time trying to educate the public about."[52]

THE MEASURE OF THE MAN

Several "generations" of critics arose in response to Mapplethorpe's work. One of the most consistent points of dissension was that his work was over-aestheticized. According to Mapplethorpe, "I don't think there's that much difference between a photograph of a fist up someone's ass and a photograph of carnations in a bowl."[53] But to many critics this became boring and tedious, an approach that was all surface and no substance. In Donald Kuspit's estimation in an article entitled "Aestheticizing the Perverse" there was "a hot emotional point to the cool visual tale Mapplethorpe tells,"[54] but one that largely was glossed over, sometimes in elaborate custom-designed frames incorporating mirrors and expensive fabrics. Some lamented the lack of moral evaluation in this body of work, comparing its "rhetoric of artifice" to Fascist aesthetics.[55] Yet most of these detractors conceded that Mapplethorpe was a serious artist who had earned a place in the contemporary photographic pantheon. By the late 1980s, Mapplethorpe had lost the power to shock most people in the art world. His work became ordinary and acceptable as

it became more well-known: "Elegance spoils it as pornography," one critic remarked, "and avidity wrecks it as fashion."[56]

Mapplethorpe was also cited for the possible racist implications of his image-making. As with other images that bring up difficult topics, Mapplethorpe's photographs provoked a variety of reactions. One reviewer indicted him in 1986 for removing his Black models to a hermetic environment which cloaked the troubled history of race relations in the US. But another felt that by placing Black men on pedestals and highlighting the sensualness of their skin, Mapplethorpe successfully subverted the racial hierarchy in the studio.[57] This theme was developed by an observer who noted that "Thomas in a Circle" (1987)—where a crouched nude man pushed against the sides of a spherical structure that surrounded him—could be interpreted as a metaphor for a Black man struggling to preserve his heritage "in an ever-closing circle of white culture."[58]

More than anything else, the mere fact that he addressed race was sufficient to cause discomfort. "Thomas and Dovanna" (1987) embodies the prototypical White racist nightmare: a naked, muscular Black man dances with a White woman clothed in a white gown, dipping her as she follows his lead. But was the photographer demolishing or confirming the cliché here? Mapplethorpe's regular use of Black models, and especially his focus on only certain body parts, most frequently disturbed reviewers. "Man in Polyester Suit" (1980) was routinely reproached for underscoring racial stereotypes of Black men as hyper-sexed [see Plates section]. The photo presents a Black man in a three-piece suit, the image cropped at about mid-chest and above the knee. In startling contrast is his imposing penis, heavily dangling from his unzipped pants. One possible reaction picks up the inherent humor and absurdity of the situation: it could be confronting racist assumptions by exposing them in a comical way. But in accord with another reading this is a racist image itself, reminiscent of a scene in Saul Bellow's *Mr. Sammler's Planet*: in that instance the protagonist is confronted by a Black mugger in an apartment building vestibule, and is most upset when the man brandishes his penis at him like a weapon. There was more insult than injury in this fictional instance.

The most thorough critique of Mapplethorpe's use of Black men was offered by a Black gay man, Essex Hemphill. His reaction to this last photo, as well as to other images, was that Mapplethorpe exploited and objectified Black men by focusing on body parts, a practice in accord with assessing the work potential of slaves. He accused Mapplethorpe of engaging in a "colonial fantasy" where Blacks were available to "service the expectations of white desire."[59] Hemphill's outrage was based on the perception that Mapplethorpe's fetishization of limbs and organs ignored what might be going on in Black men's heads. As he argued, "This blindness allows white males to pursue their sexual fantasies about black males without ever actually entering a ghetto, a jail, or a black man's shoes, or a black man's bad day to see if he feels like stripping down for aesthetic and/or erotic reasons."[60]

Non-gay critics took similar affront, faulting Mapplethorpe for equating the

desirability and worth of men to the size of their sexual equipment, a process similar to what routinely happens to women. The sexual orientation of a critic only has relevance if it appears to jaundice one's view. Arthur C. Danto cites, for example, "the perfect male nude, viewed from the rear—from its vulnerable side. . . ."[61] What an odd comment, given the vulnerability of the naked male both fore and aft, except when considered in the context of the fear of sexual violation through penetration, a fear evidently heightened for this reviewer when he wrote about the depiction of homosexual desire.

But as Hemphill's critique makes clear, opinion in the gay community was divided over Mapplethorpe, as reflected in the response after the gay magazine *The Advocate* posthumously named the photographer "man of the year" in 1990. His memory was feted because of the assault that right-wing critics launched against his work in 1989. Some readers dissented from the editors' judgment in letters published in a subsequent issue, one writer declaring "Mapplethorpe is to art what the Crips and Bloods gangs are to community neighborhoods."[62] This last opinion notwithstanding, while the many critiques of Mapplethorpe's work took issue with certain aspects of it, they also acknowledged its importance and right to exist. A new set of political critics emerged in 1989, however, who vilified Mapplethorpe, questioned the status of his work as art, and also challenged its right to receive public funds and to be shown in particular contexts.

THE SOCIAL CONSTRUCTION OF ACCEPTABILITY

In a cynical world we are prone to believe that politicians do not experience moments of epiphany so much as somehow incubate new strategies for self-aggrandizement within their minds. Whatever the case, a critical moment report-edly occurred for Senator Jesse Helms (R-NC) in July, 1989. In a home decorated with religious and nature scenes, Helms showed his wife Dorothy a catalog of "The Perfect Moment," the touring Robert Mapplethorpe retrospective. She quickly put it down, and he quoted her crying out in dismay, "Lord have mercy, Jesse, I'm not believing this."[63] Helms himself took special offense at the shot of a small girl who is caught at the instant when she lifted her dress and thereby exposed herself ("Honey," 1976). He admitted his embarrassment over speaking to a reporter or to his wife about this picture.[64]

There was a great deal that upset the domestic tranquility of the Helms household that day, including the challenge inherent within Mapplethorpe's photo-graphs to at least two important social hierarchies, sexual and racial [see Plates section]. Helms directed particular outrage against images that broached both interracial and homoerotic themes: "There's a big difference between 'The Mer-chant of Venice' and a photograph of two males of different races [in an erotic pose] on a marble table top," he argued.[65] The reaction of the Helmses was

important in setting the terms of a prolonged and acrimonious debate, and led to canceled plans at a museum, congressional action, and extended legal battles.

That debate was guided in part by a new generation of cultural critics. Richard Grenier, writing in the *Washington Times*, rekindled Biblical fury by labelling Mapplethorpe "the great catamite." He also fantasized about dousing the body of the late photographer with kerosene and burning it. In the same publication Judith Reisman equated "Honey" with child abuse, and accused Mapplethorpe of "photographically lynching" the man in the polyester suit.[66] But it was Patrick Buchanan who launched the most sustained attack in print, through a series of venomous columns. Buchanan detected a struggle for the soul of America in the battle over the arts. On one side was a small band of arts and gay rights radicals, out of touch with most of society, and suffering from "an infantile disorder."[67] They promoted filth and degradation in the guise of mediocre art, and a lifestyle that was suicidal, witness Mapplethorpe's death from AIDS. In Buchanan's view, the goal of this new *Kulturkampf* was to overturn tradition and create a pagan society.[68] On the other side were the stalwart defenders of the good, the true and the traditional, like himself.

The credentials of these reviewers derived as much or more from their political as their artistic concerns. Yet some well-established art critics sounded a very similar sense of alarm. Hilton Kramer characterized what was actually a "tamer" retrospective at the Whitney in 1988 as "this bizarre exhibition."[69] And adopting the self-appointed role of guardian of standards and the public's morals, he joined the fray after "The Perfect Moment" became controversial. Kramer decried what he saw as Mapplethorpe's attempt to "force" the public to accept "loathsome" sexual values by publicly exhibiting images "designed to aggrandize and abet erotic rituals involving coercion, degradation, bloodshed and the infliction of pain."[70] Kramer would have no part of this, and utilized a ploy which almost became *de rigueur* for conservative critics: "I cannot bring myself to describe these pictures in all their gruesome particularities. . . . [And therefore] [s]hould public funds be used to exhibit pictures which the press even in our liberated era still finds too explicit or repulsive to publish?"[71] Making judgments from such an elevated position may shield others from potential harm, but it also short-circuits their opportunity to reach independent conclusions.

The pictures that Kramer referred to most frequently were from the X, Y, and Z portfolios. The Y portfolio contained flower photos, moderating the X portfolio that chronicled sado-masochistic homosexual behavior, and the Z portfolio that featured the sexuality of Black men. But at the Hartford, CT Atheneum, for example, viewing these images was strictly a matter of choice. A separate admission was charged for this show at the museum's entrance, and the entire exhibit was in a series of upstairs galleries. There was no chance of accidentally stumbling into it, or glimpsing any of it in passing. In addition, once in the exhibit area a visitor had to stand on a separate line that slowly made its way down the length of the

X, Y, Z section, after reading another notice that it contained potentially offensive material. Rows of prints from each series were spread horizontally across library display cases, and the images were much smaller in size than ones on the walls. In other words, everything was done to minimize the shock value of these images, a successful procedure judging by the hushed viewers and their generally serious mien.

"The Perfect Moment" was scheduled for a tour of seven cities throughout the country.[72] And as the show travelled, there were widely disparate responses to the same material. In Philadelphia and Chicago the show went largely unremarked, beyond generally amiable reviews. Chicagoans were too distracted by the events happening a mile or so south down Michigan Avenue, as veterans and others protested Dread Scott's flag installation. Months later, a commentator deemed the timing of the Mapplethorpe exhibit there to be "the lucky moment."[73] It was also while the show continued to attract record-breaking crowds to Chicago's Museum of Contemporary Art that Mapplethorpe died, an event respectfully noted by the local gay press.[74] The next stop was Washington, D.C., and from there on the exhibit took on a controversial aura.

The range of reactions it evoked—from nonchalance to outrage to veneration—demonstrates that art and artists judged to be outlaws at one time and place can flourish at other sites. To claim that Mapplethorpe's photographs were inherently scandalous misses an important point: for controversy to be activated, something must be added from *outside* the objects themselves. This was more likely to occur once the photographs were subject to evaluation by people who were relatively unfamiliar with the contemporary art world, or by those who were automatically repelled by topics like homosexuality. Such opinions were the leavening that caused the conflict to rise. It is foolish to focus exclusively on "inflammatory" cultural artifacts; thorough investigators must expand their view to consider the social circumstances under which definitions of offense emerge.

NOT IN MY BACKYARD

The Corcoran Gallery of Art is the US capital's oldest art museum, located just a couple of blocks from the White House. Engraved over an entrance is the motto "Dedicated to Art." It was not difficult to appreciate the irony of that epigram during the summer of 1989 when the museum canceled the Mapplethorpe exhibit at the eleventh hour. It was a stunning decision, with far-reaching consequences.

The Corcoran had weathered other controversies. In 1851 the founder of the collection shocked his contemporaries by his display of a copy of the nude sculpture "The Greek Slave," by Hiram Powers. When the original work toured the country a few years earlier, discretion had prevailed: men and women had been admitted separately to view it.[75] As mentioned, government officials removed the Paul

Cadmus painting of "sailors and floozies" from an exhibit there in 1934, and five years later another conflict occurred. A searing anti-fascist painting of Mussolini's Italy by Peter Blume was rejected from the Corcoran's Sixteenth Biennial, a move that prompted the American Artists' Congress and other groups to protest. The explanation that the curator offered confirmed the protesters' worst fears: "the *Eternal City* may have been rejected because the jury considered it political propaganda and out of place in an art exhibit."[76] There were also suspicions that the veto was dictated by concern for the sensibilities of foreign diplomats, and so the painting was subsequently exhibited at another locale. And in more recent times, the museum deleted the preface from the catalog of "Recent Graphics from Prague." Critics of the decision believed that the institution bowed to pressure from the Czech government, which wished to deflect attention away from its repressive policies.[77] But these were all minor brushfires next to the Mapplethorpe firestorm.

On June 12, 1989, Director Christina Orr-Cahall announced that the heated political climate in Washington made it unwise for the Corcoran to go forward with its commitment to host the Mapplethorpe retrospective. Vocal members of Congress were still steaming over government support of Andres Serrano's "Piss Christ," and the Dread Scott affair a few months earlier was fueling an explosion of official flag-waving that continued for the remainder of the summer.[78] Representative Dick Armey had collected over one hundred signatures on a letter calling for a review of NEA procedures, and copies of "The Perfect Moment" catalog were allegedly circulating in Congress. Orr-Cahall felt that the appearance of such controversial images in close proximity to Capitol Hill could jeopardize the NEA's future. The Corcoran itself was also vulnerable because it has no endowment of its own and is dependent on a federal program for a significant infusion of money.

Orr-Cahall defended her actions by alleging "I don't think there was censorship at all. The [show's catalogue] is out, the exhibit has been seen elsewhere and will be seen elsewhere. I think censorship would have been editing the show."[79] But many people took her to be naive at best, villainous at worst. As Mapplethorpe's dealer Robert Miller declared in a public statement, "When one thinks of the terrors that Washington generates and sends out into the world, the thought that depiction of the naked human body might be disturbing to Washington seems ludicrous."[80] Rather than squelching controversy, the Corcoran's director fanned the flames even higher.

The reaction of the artistic community was swift—and creative. Three days after the cancellation was announced, up to one hundred protestors marched at the Corcoran in a demonstration coordinated by the D.C. Gay and Lesbian Activist Alliance, the National Gay and Lesbian Task force, and Oppression Under Target (OUT).[81] On June 30, nine hundred to one thousand demonstrators witnessed an imaginative use of technology when slides of Mapplethorpe's work were projected onto the Corcoran's facade [see Plates section]. This unconventional extension of

the museum's walls enabled images which were not allowed to be seen inside to be shown outside instead.

Artist Lowell Nesbitt decided to withhold a bequest to the museum that would be worth over one million dollars upon his death, and students at Corcoran's school of art demonstrated several times. In one instance, three female students erected an eight-foot papier-maché penis on the school's grounds, a figure wrapped in an American flag and holding a bottle of urine and a cross.[82] Their representation thereby managed to incorporate most of the previous major artistic flash points into one site. And another institution, the small, artist-run Washington Project for the Arts (WPA), stepped in as the new sponsor of the exhibit in the District of Columbia. A familiar pattern was established: publicity boosted attendance records to nearly forty times normal.[83]

Artists also boycotted the Corcoran, its reputation now significantly sullied. Annette Lemieux withdrew her solo show, as did six sculptors who had been scheduled for a group exhibition. A third show was also endangered, a joint effort of Soviet and American painters entitled "10 + 10." The international nature of this exhibit was a source of embarrassment, for it seemed to highlight growing domestic repression at the same time that the Cold War was thawing and the Eastern Bloc was experiencing more freedom. Once the Corcoran earned a reputation as an unpredictable and unreliable institution, negotiations for other future shows were also threatened.

Damage control became the order of the day. One of the ways the museum attempted to redeem itself was via the proposal by an ad hoc curators' group to mount an exhibition on censorship, including work by the artistic gadflies Serrano and Mapplethorpe. One curator contacted the New York-based artists' collective Group Material about assembling such a show, but after considering it the group declined the offer.[84] Finally, after being the target of intense criticism for three months, Orr-Cahall issued an apology on September 18. It was an important gesture, but some artists felt that it did not go far enough. Orr-Cahall expressed regret over offending parts of the art community, but did not appear to acknowledge that the Corcoran had done anything wrong. After several more months of public pummeling, Orr-Cahall tendered her resignation on December 18, 1989. By the next spring "10 + 10" was back on track, opening the possibility of the museum returning to some level of normalcy.

But the costs to the institution had been immense; the Corcoran was in a bureaucratic shambles. Three other major curatorial and administrative positions were vacated within a year of the cancellation. Staff morale in general was low, and the unwieldy character of the board—and its difficulty in reaching a consensus in most matters—was revealed to the general public. Confusion remained over who had authorized the cancellation of the Mapplethorpe exhibit, necessitating an eventual restructuring of governance procedures. In her letter of resignation, Orr-Cahall claimed that her personal feelings were compromised by her responsibilities

as an executive.[85] To this day, however, there are many unanswered questions about how the Corcoran decided to abort its own program.

Defenders of that decision had a field day in the press. The "letters to the editor" column of the *Washington Times* was a predictable venue for a well-tuned conservative response: "Billing Mr. Mapplethorpe's work as art and demanding federal dollars to pay for it is equivalent to Larry Flynt [editor of *Hustler*] asking the National Institutes of Health for a grant to study female anatomy."[86] But then, the rank and file has such leaders as William F. Buckley as models. Buckley applauded the Corcoran's courage, good sense, and absolute right to say "no" to "The Perfect Moment," and threw in a jab to Serrano, whom he accused of "the kind of infantile antinomianism that thinks it amusing to paint swastikas on the walls of synagogues."[87] And James J. Kilpatrick joined the chorus: even though he had not heard of Mapplethorpe until the Corcoran cancellation, and apparently had not viewed the images firsthand, he still labelled the work "prurient junk."[88]

Detractors of what the Corcoran did were less certain of how to present their case. It was difficult for many people to get beyond their outrage when the Corcoran claimed it was acting in the best interests of Mapplethorpe, and in the best interests of the arts community. This did not seem to be a benevolent gesture. Most importantly, the incident caught most artists and arts administrators off guard. In the recent past they had not had to dwell on the intersection of artists' rights, public funding and accountability, and legal issues related to free expression, nor had they been pressured to decide where they were prepared to take a stand when these matters became complicated. Confusion now reigned as the attackers held court advantage.

Even important leaders seemed befuddled by what was happening, as reflected in a statement made by National Gallery Director J. Carter Brown: "We have to keep the First Amendment rights apart from any controversy."[89] On the contrary, First Amendment rights were one of the key issues, yet slighted in this circumspect and prudent statement. There was also a conspicuous reluctance to rally around Mapplethorpe's sado-masochistic imagery; it was simply too difficult for many people to come to terms with, and on short notice. In a lengthy editorial where the *Washington Post* took the Corcoran to task for its bungling performance, there was the denial that homophobia was a pivotal factor in the cancellation scenario.[90] The refusal to acknowledge the possible contribution of such bias in this and many other art controversies was striking. It took an accumulation of many incidents before there began to be a public dialogue on anti-homosexual bias.

Senator Jesse Helms pledged that the cancellation at the Corcoran was not the end of the matter. Beyond the internal consequences for one museum, far-reaching repercussions of this event indeed continued to issue from Congress. Helms sustained the conflict, with the proper use of public funds being the primary question at this juncture. Obscenity had entered into the debate, but initially as a catchphrase, not a legal distinction.

TIGHTENING THE SCREWS

Jesse Helms led the charge against art for five months, in the summer and fall of 1989. His canny tactics kept his opponents dodging punches from several directions. He excelled at turning out memorable quotes: "If someone wants to write ugly nasty things on the men's room wall," he declared in a disparaging tone, "the taxpayers do not provide the crayons."[91] This first principal guided his legislative maneuverings as he attempted to constrict the NEA's operation.

Helms launched a three-pronged assault. His initial maneuver was a "sneak attack," bringing a measure attached to an appropriations bill to a voice vote when only a handful of his fellow Senators were present. Known as the Helms Amendment, it barred the use of Federal funds to "promote, disseminate or produce obscene or indecent materials, including but not limited to depictions of sadomasochism, homoeroticism, the exploitation of children, or individuals engaged in sexual acts; or material which denigrates the objects or beliefs of the adherents of a particular religion or nonreligion." As noted in Chapter Four, it also cut 45,000 dollars from the NEA's appropriation (an amount equal to the support for Serrano and the Mapplethorpe exhibit),[92] and proposed a five-year ban on the supporting institutions, SECCA and ICA. This measure passed the Senate, but a House bill only authorized the 45,000 dollar-cut, not the five year ban nor the ban on obscene art.

Helms deployed another stratagem when a Senate and House Conference Committee was assembled to work out a compromise. The Senator sent committee members a packet of Mapplethorpe photos: the children "Honey" and "Jesse McBride," as well as the man in the polyester suit and a picture of a penis perched upon a pedestal. On the Helms scale of offensiveness, he rated these a "5" on a scale of from 1 to 10.[93] But after the committee appeared to be leaning toward softening the bill, Helms fortified his approach: he requested that all the pages and the women ("ladies") leave the chamber so that he might show his colleagues the pictures. Helms hoped once again that a firsthand confrontation with the evidence would secure his victory, but he was also vigilant to protect the sensibilities of those who, he believed, might not be sufficiently robust due to their age or gender to tolerate such a visual assault.

Senator Helms's final tactic was to threaten to bring matters to a voice vote "so that whoever votes against it [the anti-obscenity clause] would be on record as favoring taxpayer funding for pornography."[94] Helms had managed to steer the debate in such a way that pornography—pro or con—was the main issue. It appeared to be a wise move, for it seemed unlikely that any legislator would be willing to face irate constituents after voting for what many members of the general public considered offensive art.

Helms's gambit had a mixed outcome: the conference committee eliminated the five-year ban on SECCA and ICA, although it required the NEA to notify

Congress before awarding a grant to either institution.[95] It also prohibited federal funding of art that could be considered obscene, a compromise suggested by Congressman Sidney Yates (D-IL) in accord with the 1973 Supreme Court decision *Miller v. California*. This was a relaxation from the original Helms proposal. *Miller* prescribes that three distinct tests must be met before the designation of obscenity applies; the vague notions of "indecency" and "denigration" were dropped from the bill.

As Andres Serrano joked afterwards, "The [original] wording was 'obscene and indecent.' I always assumed that Mapplethorpe was the obscene one and I was the indecent one. And so when they knocked indecent out of the language, I thought it was okay for me!"[96] Nevertheless, the arts community was not off the hook with this measure, the first content-specific restriction placed upon the NEA. It was not completely clear who would apply the Miller test or where, even though under its principles the notion of "obscene art" is virtually an oxymoron. But the answers to these questions would soon be forthcoming.

"VAS YOU EVER IN SINSINNATI?"[97]

When "The Perfect Moment" moved from Washington, D.C. to Hartford, Connecticut, it enjoyed a momentary respite from notoriety. The Hartford Atheneum was extremely cautious in its presentation of the show. In addition to logistic considerations already recounted, the museum prohibited admission to anyone under seventeen unless accompanied by a parent. It also implemented the separate admission charge to guarantee that no public funds were used to underwrite this show. The Atheneum sponsored public forums to establish a context for understanding Mapplethorpe's photographs, and issued a set of questions and answers with a defensive, apologetic tone that carefully explained the work and the museum's sponsorship of it.[98]

From fifteen to twenty five demonstrators appeared on opening day, primarily members of the Connecticut Citizens for Decency, an anti-pornography and anti-abortion group. They picketed against the backdrop of two young gay men kissing on the steps, and in front of a crowd that swelled to four times the normal attendance.[99] The large crowds continued and the peacefulness of the sojourn was maintained. It was a welcome lull: the reception in Cincinnati was vastly different.

Cincinnati is an easy and recurrent target of jokes. This is not on the magnitude of New Yorkers dumping on New Jersey, nor Chicagoans chiding Gary, Indiana, yet so-called sophisticates have singled out Cincinnati as an outpost of Philistinism for a long time. As Tom Wolfe wrote, " . . . believe me, you can get all the tubes of Winsor & Newton paint you want in Cincinnati, but the artists keep migrating to New York all the same."[100] The official response to Mapplethorpe guaranteed the continuance of that dubious reputation.

Cincinnati had an inflated ego in the nineteenth century. The "Queen City" was the major cultural center west of New York, and its leaders were convinced it was destined to become even more important as the country expanded. They grossly miscalculated. Post-Civil War growth in cities such as Chicago, Cleveland and St. Louis elbowed out this city on the Ohio River, consigning it to a diminished role on the national stage. However, the arts did flourish there, from painting to literature, music to pottery. Many cultural institutions were established with nineteenth-century enthusiasm and wealth, leaving the city with a substantial legacy.[101]

And like practically every other American city, Cincinnati has a heritage of art controversies as well. In the mid-nineteenth century, Hiram Powers' "The Greek Slave" raised eyebrows here, just as it had in Washington, D.C. with Mr. Corcoran's guests. A committee of clergymen was charged with evaluating its suitability for display, and they ultimately gave their assent "since her hands were chained, her undraped condition was beyond her control, and she would not endanger public virtue."[102] The writer Lafcadio Hearn shocked Cincinnati in the latter part of the century with his accounts of the underside of life in the city, his own debauched lifestyle, and even an account of artists using undraped models in their painting studios![103]

In more recent times, a production of "Equus" was reviewed by the police before it was allowed on stage in 1989; the nudity in the play had become a cause for concern. Religious organizations effectively blocked "The Last Temptation of Christ" from being screened until fourteen months after its release,[104] and "Hair," "Oh! Calcutta," and the Playboy Channel have all run into opposition. And Cincinnati is also the place where Larry Flynt was convicted on obscenity charges for his magazine Hustler.

One of the most extended contemporary disputes centered on a sculptural installation by Andrew Leicester for the main entrance to a riverfront park, proposed as part of the city's 1988 bicentennial celebration. Bicentennial Gateway became known as "the flying pigs" because it featured two bronze pairs of the winged creatures atop a group of pillars. The iconography invoked Cincinnati's nineteenth-century nickname, "Porkopolis," but this did not please some citizens, whipped up by local media who knew a good story when they saw one. The panel that approved the design was headed by the Contemporary Art Center's (CAC) Dennis Barrie, and the work was eventually installed after much farcical quarrelling.[105]

The Contemporary Art Center occupies a unique niche in the ecology of arts organizations in Cincinnati. It is the parvenu among the stodgy, nineteenth century dowagers. According to CAC's chief curator Jack Sawyer, "As a contemporary art museum, our mission is to be an outsider; that's a natural position for us. . . . We haven't really collected objects, so that baggage is not on us. . . . We're always seeking out art which doesn't have a place in the culture. For the most part the

people on our board are like the three women who founded the place in 1939 [as the Modern Art Society], pulling away from the comfort and security of Cincinnati."[106] Even its locale is distinctive: it is housed above a Walgreen's Drug Store in downtown Cincinnati, part of a mercantile arcade where restaurants and shops link old structures with more modern ones.

Many observers have noted the contradictory character of this city, as has mystery writer Jonathan Valin. In *Day of Wrath*, lead character Harry Stoner confronts an archaic plaster statue of a Black jockey on a lawn. He is surprised only by its conspicuousness, for he envisages hidden armies of them "like a race of imprisoned elves, waiting to be returned to daylight. . . . Racial prejudice didn't die in this city; it just got stored in the basement with the rest of the supplies."[107] This tendency to push difficult matters from public view is most clearly represented by how Cincinnati has opted to regulate sexual information and conduct.

The city has taken advantage of its geographic location to rid itself of the commercial sex industry: there are no X-rated movie theaters, video or bookstores in Cincinnati. Pornographic material is only available for sale across the river in Kentucky. This marks a civic compartmentalizing of desire unmatched in other US cities of this size. Newport, Kentucky ("Sin City") has been a center of vice serving a tristate area for decades. But as Eelise LaShay of the Brass Mule and some of her colleagues from other Monmouth Street establishments testified on a Donahue show, police have been cracking down there as well. It seems that the concentration of clubs has made it difficult to attract a diversity of businesses to the area.[108] As a consequence, people are now forced to go to other Kentucky towns to meet their needs for sexual goods and services. The CAC's Sawyer recounted that a coworker offered the judgment that "New Orleans is dirty and fun and corrupt and Cincinnati is well-organized, clean and boring."

Cincinnati is a prime instance of the nexus of values and power. According to research conducted at the University of Cincinnati's Institute for Policy Research, this city falls "in the center" on important social and economic questions. In other words, for mid-sized cities it is no more liberal or conservative than others on issues such as pornography, censorship, or abortion.[109] But values are just one part of the equation. What makes the decisive difference in Cincinnati are seasoned moral crusaders and key government officials who can mobilize against anything that violates their sense of propriety.

Local businessman Charles Keating—later notorious as the head of the insolvent Lincoln Savings and Loan in California—founded Citizens for Decency through Law in 1956.[110] Cincinnati is currently the headquarters of the National Coalition Against Pornography, as well as a local morality organization that spearheaded the anti-Mapplethorpe campaign, the Citizens for Community Values (CCV). The CCV initiated its campaign against the Mapplethorpe exhibit before it arrived in Cincinnati with a mass-mailing reminiscent of Helms's techniques; in this instance, there were detailed descriptions of seven of the photographs. The CCV's position

was that these images were obscene, and anyone displaying them in public should be prosecuted. Eventually the Contemporary Art Center was the target of threatening phone calls, as were board members. And shortly before the opening of the exhibit, the chairman of CAC's board resigned; the bank where he was a vice-president had received calls of protest as well.[111] According to a CCV spokesperson, "Cincinnati is the pinnacle. We enforce the law to the nth degree."[112]

The Mapplethorpe exhibit also provided another opportunity for Simon Leis to exert his authority. An important player in the prosecution of gay broadcaster John Zeh, Leis has been a public official in Cincinnati for twenty years. Leis built his career upon crusading for decency, in the positions of county prosecutor, judge, and in 1990 as sheriff of Hamilton County. In addition, the county prosecutor Arthur Ney was Leis' handpicked successor,[113] and the judge in the case had been Leis' assistant at one time. The judge and the sheriff attended all the same schools, and belonged to the same athletic club.[114] A picture emerged of an old boy's network, a circle of supportive officials sharing the same values and mutually dependent upon one another's support. When CAC's head Dennis Barrie was charged with pandering obscenity, there was an amazing sense of deja vu: the prosecutor and the defense attorney had previously faced off in a case involving the distribution of *Penthouse* magazine. That trial was presided over by Judge F. David J. Albanese, the same man who would handle the Mapplethorpe/Barrie litigation.[115]

THE LONG ARM OF THE LAW

Before 1990, much of Cincinnati's reputation derived from being the corporate headquarters of Procter and Gamble, and from its renowned chili. The Mapplethorpe exhibit amended that, perhaps forever.

The CAC was determined that the show go on. The gallery was careful to dissociate itself from the public funding debate that had swirled around Serrano and had dominated the Corcoran debate. According to Sawyer, "In one of our private meetings the staff said that it was better that we lose our jobs and the CAC become a store front operation than to back away from showing the photographs—rather than go through what the Corcoran did, because then we couldn't attract anyone worth showing." The retrospective was sponsored in Cincinnati by a grant from a local business, and by increasing the usual admission fee from two to five dollars. The CAC also excluded itself from being a beneficiary of the Cincinnati Institute of Fine Arts, a local umbrella group that raises money to support a myriad of cultural endeavors. Although the CAC had received nearly one quarter of its budget from that source the previous year, it did not wish to hamper the group's fundraising efforts because of the developing controversy in

1990. The CAC posted warning signs about the graphic nature of some of the photographs, and at this site *no one* under the age of eighteen was to be admitted.

The CAC attempted to clarify its legal situation on March 27 (before the exhibition opened) by requesting that a jury examine the controversial images and determine whether they were obscene. A judge denied this request ten days later, forcing the CAC to proceed with the exhibit without knowing if it could be in held in violation of any criminal statutes. A tense period ensued, with Barrie and the CAC receiving threatening phone calls, and CAC staff fielding and diffusing various rumors. On the evening of April 6, thousands of people lined up for a members-only preview of the show. Their ranks were swelled by a flurry of new affiliates who suspected the exhibit could be shut down by a police raid, and wished to view it before such an action could occur.

The mounting uncertainty over the exhibition's fate was shattered when a showdown occurred on the official opening day, April 7. Nine members of a Hamilton County grand jury were among the first visitors. After their viewing they decided that seven of the photographs were obscene, and charged the CAC and director Dennis Barrie with two misdemeanor counts each of pandering obscenity and illegal use of a child in nudity-related material.[116] Later that afternoon police armed with a search warrant cleared the gallery of visitors in order to videotape the exhibit.

This effort to collect evidence prompted an enraged crowd to shout "Gestapo go home" and "Sieg Heil." This was a highly emotional and hazardous situation, intensified because the enclosed arcade area was jammed with people, and the primary means of entry and egress from the gallery are two escalators connecting the first and second levels. In fact, over two thousand people filled the atrium and snaked in lines onto the sidewalks outside. The county prosecutor had waited until the exhibition opened to the public in order for a crime to be committed. The police chief heralded this as an example of restraint, a demonstration that "there are no raving Neanderthals running amok."[117] Yet Sawyer felt that the police and other public officials *were* frightenly out of control: "We really didn't believe it would come to police action because it was just inconceivable that they would come into an art museum. . . . I think if they had brought Dennis [Barrie] out in handcuffs there very well could have been a riot."[118]

Several months of legal wrangling followed, during which time the exhibit was allowed to remain open. "The Perfect Moment" completed its run against a backdrop of city/county jurisdictional disputes, and arguments over what specific charges should be brought (the indictment for the childrens' portraits were later amended to include "a lewd exhibition or graphic focus on the genitals"). By the time the case was eventually heard in September, the tour was completing its two-year journey in Boston. The period leading up to the trial prolonged the agony of the CAC and Barrie, the first US museum director indicted for obscenity in the

course of doing his job. As the title of an op-ed piece written by Barrie declaimed, "Pandering? That's Nonsense. . . . I'm a museum director."[119]

Not unexpectedly, everyone appeared to have an opinion in this case, views that were aired continuously. A great deal of support for Barrie and the CAC came from outside Cincinnati. For example, the Art Dealers Association of America took out an ad in support of them in the *New York Times*, and the Association of Art Museum Directors pledged to pay any fine which might be imposed on Barrie. The Coalition of Writers' Organizations also voted its endorsement, as did the College Art Association, which terminated its consideration of Cincinnati as a possible convention site in 1995. But affirmative gestures were also initiated locally, including a resolution passed by the University of Cincinnati's Faculty Senate. The results of a telephone poll of Hamilton County, Ohio residents revealed that 63 percent of the respondents opposed the prosecution of the arts center,[120] and the art reviewer for *The Cincinnati Enquirer* gave the show a generally favorable assessment.

However, that critic laced his commentary with some value-laden observations which tempered the review's overall impact, remarking on "the sadness of his [Mapplethorpe's] life," and noting "a feeling of self-loathing, a cry of despair" that the photos evoked for him.[121] These comments made it difficult to distinguish a supporter from an opponent. And opponents were legion—and vocal—in Cincinnati. A trio of doctors used their credentials to bulwark their testimony, claiming that the disputed exhibit "forces upon us a bizarre, sexual vision" by presenting "degrading acts that diminish us all." As one of these physicians also asserted authoritatively on television, to people struggling with "addictions" to pornography, seeing the sado-masochistic or homoerotic images in an art museum could give them the green light to engage in similar (destructive) behaviors themselves.[122]

Their collective judgment was bolstered by a retired professor of economics who was also the local coordinator for the American Family Association. He claimed that moral pollution precipitated effects as deleterious as physical pollution, and alleged that mounds of scientific evidence had demonstrated the evils of pornography. In his estimation, "Cincinnati needs an art program which will lift us up instead of drag us down, which promotes the good, the true and the beautiful, instead of the false, the ugly and the depraved."[123] And another professor sounded the alarm over depictions of unbridled sexual desire and its inevitable connection to social decay: "A society . . . which cannot distinguish between liberty and license, is a society that will experience the sexual chaos, the sexual excesses and the decline of family values which so conspicuously mark our age."[124] Many such anxious pronouncements could be recounted, but they were all comically skewered by a local cartoonist: "Jim Borgman's World" presented a scene where all types of people are going about their business on a Cincinnati street in various stages of undress, under signs trumpeting commercial sexual encounters. Two fully

dressed women react with shock, one saying to the other "I *told* you that exhibit would undermine our community values, Edna!"[125]

AS SIMPLE AND AMERICAN AS APPLE PIE

Appeals by the defense attorneys failed to derail the trial. Not even the argument that some of the contested photos appeared in books in the collection of the county public library was sufficient to cause the judge to dismiss the charges. In fact, three decisions by the judge in the pre-trial stage greatly distressed the defendants and their supporters. First, Judge Albanese ruled that the jury could only hear testimony about the seven allegedly obscene images out of 175 photographs in the retrospective. A key section of the Miller test states that to be judged obscene, "the work, *taken as a whole*, lacks serious literary, artistic, political, or scientific value."[126] The judge took this to mean each photograph as a whole, not the complete exhibition. He rejected the view that there was an integrity to the entire selection or, as the director of the Walker Art Center later testified, that "Pictures speak to each other; they become part of a totality."[127]

Second, Albanese denied a request for adjournment by ruling that the CAC was a gallery rather than a museum. Under Ohio law, museums are allowed to display obscene materials for educational and cultural purposes. But the CAC's rules of incorporation failed to meet this semantic test, and the institution was subject to prosecution.[128] And finally, the judge refused to restrict the juror pool to the city of Cincinnati, which presumably would generate a more liberal panel. He instead ordered that it be drawn from Hamilton County as a whole. These procedural setbacks seemed to bode ill for the CAC and Barrie.

Jury selection also troubled the defense. On the face of it, the jury pool did not offer people who appeared naturally inclined to endorse CAC's point of view. For example, they were generally non-museumgoers: only three of fifty had seen the Mapplethorpe exhibit, and most had not gone to museums aside from school trips. But beyond this, Judge Albanese appeared to favor the prosecution when he allowed the questioning of some women to continue even after they admitted to holding strong religious and moral opinions, and acknowledged that they would have a difficult time examining the evidence. Although they were eventually excluded from the panel, the judge's apparent willingness to consider them as prospects seemed like an ominous sign. In the end, four men and four women were selected. Only one was a resident of the city, and one held a college degree. They were a predominately working-class group, with little interest or experience with art.[129]

The prosecution's case was rudimentary: they presented only three police officers who confirmed that the photos were displayed at CAC. Their supposition

was that the photos were prima facie evidence of the CAC's and Barrie's guilt.[130] But the defense was intricate, backed by four days of expert testimony. It was assembled in anticipation of a much more formidable selection of adversaries, so that this turned out to be a lopsided contest.

The CAC compiled a list of over fifty curators who were willing to talk about the merits of Mapplethorpe's work, although Sawyer reports "in the early stages it was unclear as to who was willing to identify themselves with this photographer." CAC officials laid out the "intellectual geography" for the lawyers: "We wanted to make it difficult for anyone with a countervailing view . . . you wanted your own big guns because you assumed they [the prosecution] would have theirs." Well-heeled art professionals presented a crash course in aesthetics, art history and criticism to this relatively unsophisticated audience of jurors. Defense witnesses were alchemists who recast images of extreme sexual acts into figure studies, and transformed the arc of the urine being directed into a man's mouth into a classical study of symmetry. This was a strategy to deflect attention away from the difficult subject matter of the photographs, onto formalist considerations such as composition. It was well-conceived, and extremely well-executed.

The defense's case was also strengthened by affidavits of support signed by the parents of both of the children whose photos were in dispute. These were important because Ohio law prohibits "any material or performance that shows a minor who is not the person's child or ward in a state of nudity." Not only did the parents verify that the photos had been taken with their permission, but they were also dismayed that religious and political leaders were now presenting them as evidence of visual child abuse. They had never viewed them as anything but innocent and natural portrayals.[131] The little boy Jesse McBride (age nineteen by the time of the trial) shared his parents' opinions, stating in an interview that "It's [the picture] angelic. It's art."[132] And Jesse contributed a unique display of support: he allowed himself to be re-photographed nude as an adult in the same pose, a portrait which was printed in the *Village Voice*.[133]

The defense did not go completely unchallenged, however. The prosecution called one expert witness to rebut the testimony that championed the photographs as art. That person was the aforementioned Dr. Judith Reisman, whose credentials included writing songs for *Captain Kangaroo* and conducting research for the American Family Association. Reisman concentrated on the subject matter of the photos, not their formal qualities. She blasted the anonymity of the sex acts they portrayed, and dismissed the claims for them as art because they failed to express human emotion. Reisman noted that only one even showed a face, for example. Her attack on the childrens' pictures was similarly disparaging; she assessed them as dangerous public displays that legitimized child abuse.[134]

Reisman's criticisms were considered opinion, not the statements of an expert. As such they were not sufficient to sway the jury, whereas the "apple pie" approach of Barrie's attorney H. Louis Sirkin was apparently more persuasive. Sirkin

compared the Miller standard to an apple pie for the jurors. If a recipe called for three ingredients to make an apple pie, he argued, merely one or two of them would not be sufficient to get the desired result. Mutatis mutandis, a ruling of obscenity could only occur if all three conditions of Miller were met. After merely two and a half hours of deliberation, the jury obviously accepted the food metaphor and acquitted Barrie and the CAC on all charges. Barrie had faced up to one year in jail and a fine of 2,000 dollars, and the CAC could have been fined 10,000 dollars.

The verdict was a surprise to many people, supporters and detractors of the Mapplethorpe exhibit alike. Some commentators touted this as a resounding victory for the American justice system and for freedom of artistic expression, in articles with titles such as "Grand Juries" and "Rank-and-File Rebuff to Censorship."[135] But beyond the gloating there was also a sense that a considerable degree of luck had been involved: the prosecution had essentially failed to assemble a plausible case. As one of the jurors stated afterwards, "If the prosecution could have come up with just one credible witness—a sociologist, a psychologist, somebody, anybody—maybe we would have voted differently."[136]

But more importantly, it seems that the victory turned upon an uninformed group of people deferring to expert opinion. The barrage of professional artistic testimony convinced the jurors to put aside their beliefs and acquiesce to what the authorities had to say. It is disquieting to acknowledge that strong class elements were at work here, with elite intellectuals initiating their inexperienced fellows into the workings and understandings of the art world. In important respects the specialists finessed their way through without forthrightly addressing the disturbing nature of the content of these photos.

It was an important victory that marked not only the triumph of these particular defendants, but also underscored the legitimacy of art world participants to decide what could be consecrated as art. Yet while this battle was won, the proponents of free expression had not fully confronted all the issues which Mapplethorpe's photographs raised. They had not decisively won the war.

The impact of the case was felt well beyond the courtroom. Three days after gay rights advocates demonstrated at the outset of the trial, two gay Cincinnatians were arrested for holding hands in a parked car. A month later the charges against the men were dismissed, but gay leaders feared that this was merely the latest incident in what they identify as an ongoing moral crusade against gays in Hamilton County.[137] The Gay and Lesbian March Activists also launched a boycott against Chiquita bananas in response to the Mapplethorpe prosecution. Leaders accused the company's major shareholder of supporting public officials in their campaign against Barrie and the CAC.[138]

The CAC's legal expenses were 350,000 dollars. But assistance was forthcoming before and after the trial from many outside sources, and the debt was retired within a year.[139] By then Dennis Barrie was even hailed as a "folk hero" in a local

newspaper story.[140] But what is destined to be a legacy of the prosecution is that it opened up a rift in Cincinnati's art community: most of the major arts institutions were not willing to openly support the CAC in its struggle and jeopardize their own situations. The CAC was left in relative isolation, targeted by the collusion of politicians and moral leaders, too controversial to attract many corporate sponsors, and separated from its fellow arts organizations by its advocacy of "difficult" work.[141]

Jack Sawyer still vividly recalls the ugliness in the air over the Mapplethorpe exhibit in Cincinnati and the sense of siege and duress the CAC felt for months. He also remembers tuning in a rerun of "To Kill a Mockingbird" on cable television shortly before the police raided the gallery and the additional resolve the movie engendered: "I watched the film very intently, which had affected me quite strongly when I first saw it when I was very young. And I felt (and I'm sure Dennis did, too) a strong identification with Gregory Peck on his rocking chair out front of the jailhouse, setting himself apart from the people in his community. It made me realize that my only ability to defend what I think is right is with my words and my body, and that every once in a while you may have to lay that on the line. And that is very tonic."

WHAT GOES AROUND . . .

Following the reception Cincinnati accorded the Mapplethorpe exhibit, there was every reason to believe that Boston would follow suit. After all, its reputation as a bluenose burg was earned over decades of campaigning by vigilant anti-obscenity societies and by the activities of watchful public officials. But Mapplethorpe's supporters abandoned the defense and took an impressive proactive stance in Boston. They not only talked about freedom of expression— they asserted it. Boston completed the retrospective's tour, with local groups and institutions offering significant new lessons about the social construction of acceptability.

Adversaries attempted to mobilize public sentiment against this show, but without much success. A thirteen-member coalition of groups calling itself the First Amendment Common Sense Alliance was the primary opponent. But it was unable to convince Boston Mayor Raymond Flynn, the State Attorney General or a municipal magistrate to take action. The State House of Representatives did pass some punitive legislation in a late-night session, only for it to be stalemated in the State Senate.[142] And The Pilot, newspaper of the Catholic archdiocese of Boston, ran an editorial, a commentary, and a full-page ad in protest, but the tabloid Boston Herald counseled "hands off."[143]

While the opposition was spotty and largely ineffective, supporters were shrewd. The strongest evidence of this was a number of "solidarity shows" installed at

other Boston sites. The Museum of Fine Arts presented "Figuring the Body," an exhibit on the human form; Harvard's Fogg Museum displayed another selection of Mapplethorpe's work; and the Photographic Resource Center assembled "The Emperor's New Clothes: Censorship, Sexuality and the Body Politic," drawing on images from fashion, art and pornography. In no other city did arts institutions join in common cause like this, and nowhere else did the arts community gain the upper hand and control the terms of the debate. This remarkable closing of artistic ranks was also evident when a *Boston Globe* critic reviewed the retrospective as "A poetic and seductive 'Perfect Moment,'" and characterized Mapplethorpe as an Apollonian, not a Dionysian.[144]

The local public television affiliate WGBH upped the ante even further. In answer to many conservative critics who sneeringly noted the photos generally had not been printed in newspapers or shown on TV because of their highly charged nature, WGBH broadcast them on the Ten O'Clock News the evening before the exhibit opened to the public. Nor did they shy away from presenting the most controversial images, including the man urinating into another's mouth, and the self-portrait with bullwhip. This addressed but did not lay this issue to rest: Rev. Wildmon and at least two other individuals complained to the FCC. Wildmon sent a tape of the broadcast to the FCC and claimed that it contained material that was indecent and obscene. The FCC rejected the indecency complaint on jurisdictional grounds (the broadcast was after ten p.m.), and felt the obscenity charge was "unsustainable" applying the Miller test.[145]

Finally, a crowd of about two hundred and fifty people demonstrated in support of the exhibit on its opening day, easily overwhelming those who opposed it. This event occurred just two days after the formation of a Queer Nation chapter in Boston, a local branch of the militant direct action group that had been formed in New York City earlier in the summer.[146] The coalescence was fortuitous: Queer Nation had its first opportunity to demonstrate against homophobia in the service of defending the work and reputation of a deceased artist who had been reviled in other locales.

It was a fitting end to a tumultuous circuit through the country, and marked some distinctive changes in the gay community and in the public mood. The Mapplethorpe affair also confirmed two typical features of art controversies. Opposition breeds enormous interest, and "The Perfect Moment" consistently broke attendance records. For example, nearly eighty thousand people viewed it in Cincinnati, a figure larger than the CAC has recorded for most *years*.[147] And controversy adds cachet that also increases a work's market value. Record auction prices followed in the exhibit's wake, a boon to the coffers of the Mapplethorpe estate. Its commitment to AIDS research and to promoting photography has been unwittingly strengthened by the actions of those who most feverishly oppose Mapplethorpe and his work. These are ironic lessons

dating back at least to the time of Nero, lessons which Tacitus observed in his *History*.[148]

A FALSE ALARM

The range of reactions to the work of Rushdie and Mapplethorpe are merely two of the most distinct examples of the social construction of acceptability. The same process occurs with regularity, albeit with less dramatic and sometimes mixed results. A case in point is a mini controversy which developed over the exhibit "Diamonds Are Forever: Artists and Writers on Baseball." The show was organized by the New York State Museum and was presented in Chicago in July, 1989 as the eighth stop on a ten-city tour. It received a benign reception at every other location, but the director of a Chicago nonprofit sports organization singled out an Eric Fischl painting entitled "Boys at Bat" (1979) for criticism. Ziff Sistrunk claimed that the painting "promoted" homosexuality and child molestation. He further asserted that the exhibit underrepresented Black contributions to the sport, and he challenged the depictions there were of Black players.

The charges seemed absurd. Not only were Black baseball players portrayed, but the work of Black artists such as Howardena Pindell and Jacob Lawrence was included. In fact, this exhibit had a better record of racial inclusion than is generally the case. The interpretation of the Fischl painting was similarly preposterous. The work pictures a nude man in a baseball cap in the foreground of a suburban backyard, hitting a baseball. A uniformed boy (eight years old? perhaps ten?) somewhat anxiously looks on, cradling a bat upright in his hand. The quote that the exhibitors chose to accompany it was by Donald Hall about fathers and sons. The painting appears congruent with many of Fischl's works, which are generally expressionistic bourgeois suburban scenes with some nudity. Although some of his work is inlaid with traces of adolescent sexual fantasy or activity, it is an immense leap to accuse "Boys at Bat" of promoting homosexuality or child molestation. This certainly had not been the interpretation of audiences in other cities.

The ingredients necessary to spark controversy appeared to be in place: sex, race, a city with a past history of artistic turmoil, and a publicly funded and operated exhibit space, the Chicago Cultural Center. An outraged Southside resident wrote to the Commissioner of Cultural Affairs "The penis oriented 'Bat-e' by Margaret Wharton, the gob of sewage of 'Rank' by Robert Rauschenberg, as well as the well publised [sic] nude baseball player, and Christ playing baseball ["Untitled," by Steve Gianakos] . . . [demonstrate that] our Art is worst [sic] than the bombing by Americans of the two cities in Japan!"[149] And Sistrunk shrilly announced, "This picture has nothing to do with baseball. If Mayor Richard J. Daley were alive, this exhibit would be clean. I am prepared to die for this issue."[150]

But even the invocation of the late, great Mayor could not ignite the conflict: Sistrunk could hardly mobilize more than fifteen boys for a protest.

A number of factors help to explain why this effort miscarried. First, the campaign's instigator was an unknown leader of an inconsequential group. Sistrunk simply did not have the political capital, nor the financial or membership resources, to conduct a successful campaign. This was an example where certain values might have been compromised, but the sense of outrage could not be coupled with sufficient power to correct the situation. Second, there was civic fatigue. The previous conflicts at the School of the Art Institute had exhausted many segments of the public; another long and divisive battle hardly seemed worth the effort. Public weariness also probably shortcircuited significant official actions or grass-roots mobilizing against Mapplethorpe in Boston. People there had the advantage of learning from the turmoil and folly at other locales. Third, there were bigger fish to fry on the national scene. This issue arose at the very moment when Congress was debating how to punish the NEA because of the sponsorship of Serrano and Mapplethorpe. In fact, Chicago's elder statesman Representative Sidney Yates (a staunch supporter of the NEA) was in the thick of the battle. This quirky interpretation of the Fischl painting did not ring true—or loudly enough to pick up arms over.

Finally, the Cultural Center presented the Fischl painting in such a way to minimize any potential it might have to shock. It was positioned at the most secluded end of the exhibition hall, on the back side of a partition. It could not be glimpsed from the entrance, nor seen unless a viewer purposely sought it out. And after Sistrunk voiced his concerns, staff posted a sign warning visitors that some works could possibly cause offense. These precautions appeared to be adequate for the material in question, and the exhibit continued without additional problems.

MISREADING METAPHORS

In another Chicago incident seven months earlier, an artist who was presenting male nudes did not fare so well. Joe Ziolkowski ("Joe Z.") participated in a show sponsored by the alumni association of the School of the Art Institute, which was mounted in the lobby of a Loop office building. The show was a mixed-media installation, with pieces dealing with a range of social and political issues from the 1980s, including women's rights, the environment, and US involvement in El Salvador.

Only Joe Z.'s work confronted issues of male intimacy. Two of his photos were included from the "Beyond Boundaries" series, which features nude men suspended by their heels with rope. The photos are inverted when they are hung, so that the figures seem to eerily bob up like human buoys [see Plates section]. The artist

claims that his images depict loving and caring between men, but that something is always pulling them down.[151] He seeks to explore universal questions regarding power, sexuality, and intimacy—whether the individuals be gay or straight—and does not believe that his work is primarily homoerotic. Yet within hours of its installation, one of his images prompted complaints from people working in the building. The two men in one of the photographs were nude, but they were pictured above the waist and were separate from one another; that did not cause any problem. In his second photo, however, two full-length nude men embraced each other, with their genitals touching.

The building's management acceded to their tenants' objections and ordered that either that photo be covered or removed, or the entire show might have to come down. The landlord claimed the right to approve any displays in the building and maintained that the site was a "fishbowl," observable to passersby on the street as well as anyone entering the lobby. As a consequence, "Beyond Boundaries 3" was covered with paper and a sign was posted next to it, explaining that the action had been taken at the request of the management.

Joe Z. intends his work to stimulate discussion around sexual issues. In this case, however, that potential exchange was quickly truncated. To his mind the disputed image addressed a male issue, not a distinctly gay one. In fact, the only image in his portfolio that he would cite as distinctly homoerotic is one where a solitary man is bent over in what the artist describes as a totally vulnerable position. The man has gone limp, with a "go ahead, do whatever you want to me" air. Otherwise, "I don't see it [my work] as something to get off on."

But as this artist found out, there is something profoundly disquieting about seeing the male sex organ. Joe Z. does not focus on it, but views it just another body part, like a thumb or a toe. If he intended to create eroticism or pornography, he would show the penis erect. This has not been his choice, yet people have balked at both displaying and publishing his work. In this case the repressive action was uncomplicated: the site was private, and individual distaste was easily honored. It was deemed a wise business decision, backed up by a chatty news item in *Crain's Chicago Business*. The incident demonstrated the validity of the real estate maxim "location, location, location" in determining if particular images will find comfortable homes in particular settings. But as we have seen, things get much more complicated when public monies are involved.

Joe Z.'s work has obvious cultural resonance in the age of AIDS, where intimacy has become suffused with the threat of death. And that is a theme taken up by the 1991 movie "Poison," written and directed by Todd Haynes. "Poison" interweaves three narratives, entitled "Hero," "Horror," and "Homo." The first tells the story of a seven-year old boy who commits patricide and then mysteriously flies out the window. The second follows a doctor who accidentally drinks a sex drive potion and turns into a leper sex killer; and the third probes one man's obsession for a fellow criminal. It is a pastiche of film styles, drawing as much

from investigative documentaries as from B-grade noir suspense movies of the 1940s and '50s. It is also flavored with a generous dash of camp parody. Haynes cites the writings of Jean Genet as an inspiration (most clearly the source for the "Homo" segment) but there are many indications that this is fantasy: prisons were never bathed in such erotic light, nor do reform-schoolboys gambol in such lovely gardens.

It is farfetched (but conceivable) that someone could take this avant-garde movie literally. The Reverend Wildmon, basing his opinion on segments of advance reviews instead of a first-hand viewing, damned the film in successive letters to members of Congress. In the March 15, 1991 version he condemned the film for homoeroticism and explicit scenes of homosexual anal intercourse. His conclusion: "Poison" was pornographic, and should have never received a twenty five thousand-dollar NEA grant for post-production costs.[152] But his judgment differed from the peer panel of professionals which awarded the grant, it clashed with major movie reviewers throughout the country, and contradicted the conclusion of jurors at the Sundance Film Festival who awarded it the Grand Jury Prize for best feature film.

This is another example where parable was confused with fact, and where a few elements were isolated from a work of art and required to bear the weight of the whole. All three narratives deal with outcasts, transgression and punishment. In this sense they are profoundly moral. The film is iconoclastic, and more inferential than explicit. The homosexual theme nevertheless set off an alarm for Wildmon.

The attack snapped a period of relative quiescence from attacks on the NEA, and appeared to have the potential to cause major problems for the agency and its chairman John Frohnmayer. The grant was made directly to the artist, not channelled through another institution. And the filmmaker had submitted a complete script with his application so that the content was sanctioned in advance. There was evidence that Frohnmayer's conservative enemies regarded this as an opportunity to oust him, knowing that the White House and particularly Chief of Staff John Sununu had no patience for continued strife over the NEA. "Poison" provided another target in a battle which was already over two years old. In this instance the strategy was worked out in advance by Sununu and conservative leaders at a Republican Party breakfast.[153] But before this issue was settled, Sununu was himself under investigation for alleged misuse of funds by appropriating military airplanes and government and corporate vehicles for personal trips.

Frohnmayer came out forcefully for the first time in support of the agency's artistic decisions. At a press conference he prefaced his remarks with a reiteration of his own small town background and commitment to traditional American values. He then stated "I don't suppose most Americans would object to their tax dollars being used for a film [about how] violence is destructive to the family."[154]

He thereby took the most cautious route in mounting his defense. The "Hero"

segment does deal with family violence: at the end we discover that the boy murdered his father to stop the man from beating his adulterous wife. But Frohnmayer ran wide around the gay and AIDS themes. While he recognized that "Poison" was explicit at points, it was not "prurient nor obscene."[155] This was another instance where a gay artist found himself under assault for depicting matters that are consequential to his community, yet only begrudgingly was extended support from mainstream individuals.

Gay-themed art has changed dramatically since the closeted, pre-Stonewall days. And as gay artists have become more frank in their work, truthfulness and sincerity have evoked a backlash from some segments of society. It is unlikely that a veiled seduction scene like the one between Lawrence Olivier and Tony Curtis in the 1960 film "Spartacus" would raise many eyebrows today. Yet it was excised from the original, and finally reinstated when a restored version was released in 1991. For the first time in thirty years viewers could watch the slave Antoninus attentively wash his master's back as he is questioned about his preferences. In the end, the master Crassus declares his sexual interest via a gustatory analogy: "My taste includes both snails *and* oysters."[156] And once again, we witness the resilience of cultural products.

There has been an enormous amount of social change in the intervening period. Robert Mapplethorpe's work—which freezes the post-Stonewall sense of sexual experimentation and exuberancy in time—would have been inconceivable just a few years earlier.[157] And because of the AIDS epidemic, making similar work now is somewhat improbable. It has been virtually impossible to separate gay life from the epidemic since the early 1980s, when representations of the community and its social, political, sexual, and health concerns became inexorably linked.

8

AIDS: BEARING WITNESS

If AIDS did not exist, we would have had to invent
another pretext for repression . . .

Richard Goldstein, 1990

Picture a society marked by governmental excesses and religious decline. Artists impiously mix sacred and profane elements in their work, and they commonly depict nudity. These practices reflect a widespread emphasis on the material rather than the spiritual. And a virulent epidemic brought from foreign shores has unnerved the public. Familiar, you say? Yes, but the description is of late fifteenth century Florence, not only twentieth century fin-de-siecle America.

The parallels between these times and places are startling. In Florence, Girolamo Savonarola attacked the rule of Lorenzo de Medici and the Pope, deploring the decline in spiritual values. Appealing to a populace that was terrified by a syphilis epidemic imported via Columbus, Savonarola's followers joined him in staging "Bonfires of Vanities" in 1495. These were gigantic infernos where art works and other treasures were burned, as outward signs of a spiritually bereft life. Savonarola identified scapegoats, tapped into civil discontent, and then whipped people into a fury. This was a desperate symbolic attempt to reestablish order.[1]

Modern-day Savonarolas claim that the decadence of artists like Robert Mapplethorpe inexorably leads to death. They believe that the excesses of the 1960s, particularly the sexual revolution, brought on the horrors of AIDS in the 1980s. Moral judgments aside, the AIDS epidemic hit the artistic community with dreadful force. The most significant initial forms of transmission of the disease in the West

were homosexual behavior and intravenous drug use. The prevalence of both practices provided quick entree into certain artistic worlds. But beyond the undeniably tragic consequences of the disease, AIDS has become a crucible in which artists have converted sorrow and loss into tributes to those who have been lost. The disease has also spawned enraged indictments of indifference, medical inadequacies, and social discrimination. Few artists have been untouched by the epidemic; many creative works bear its impact.

COMFORT AND JOY

In 1985 the Screen Actors Guild (SAG) ruled that it was dangerous to engage in open-mouthed kissing in a theatrical role. They declared that this was a work-related risk that unnecessarily jeopardized their members' health. The measure passed after the revelation of Rock Hudson's illness, and it seemed wise to Patty Duke, a candidate for the SAG presidency: "Caution is always the best course," she advised.[2] Time and increased public understanding have tempered AIDS hysteria significantly. The disease has acquired a human face as it has spread, a development in part attributable to artistic depictions.

The variety of creative responses to the disease and its catastrophic toll is immense. These reactions unmistakably mark the art of the 1980s and '90s. A signature creation is the AIDS Quilt. Coordinated by The Names Project, a San Francisco-based volunteer organization, the quilt memorializes individuals felled by the disease. Lovers, friends, family, or whomever sew a three by six foot panel commemorating one life. The sections are subsequently laced together and publicly displayed, although the project has grown to be so massive that arenas or outdoor spaces can accommodate only a portion of it. The AIDS Quilt draws upon traditions of craft and community participation (as did Judy Chicago's work), and is harmonious with the heritage of using quilts to commemorate significant life-cycle events such as birth or marriage. Sewing is typically thought of as feminine. But in this situation the craft is used largely (but not exclusively) by and for gay men, with little concern for sustaining some "masculine" standard. The quilt successfully communicates the range of survivors' emotions, including grief, sadness, anger and whimsy.

The challenge is to abstract a life within this small space. Each designer uses a favorite piece of clothing, a toy, a motto—any array of symbols—to capture the essence of an individual. The viewer may then construct some notion of these lives from a relatively meager amount of information. The accoutrements of drag queens and leather men are featured, as are the playthings of children. Sex and politics emerge in some sections, for example, the piece for the smarmy, closeted lawyer Roy Cohn: "Bully Coward Victim." But whether well-known or anonymous, the cumulative effect of all those memorialized is a tangible visualization of the scope

of the epidemic, and the variety of lives it has affected. The quilt was first displayed during the 1987 National March on Washington for Gay and Lesbian Rights. Like most quilts, it is designed to provide comfort. It has not been the focus of significant controversy: it is a memorial, it is not explicitly sexual, and it has been supported primarily through private donations.

Choreographers also have threaded the theme of AIDS through contemporary dance. AIDS has hit the dance world particularly hard. Many major troupes have denied its devastation, but other companies have addressed it in their work. Yet because dance tends to deal with illusions and allusions, and actual texts are usually slight, the conditions for controversy are not generally present. Like the AIDS quilt, dance pieces tend to be elegies, not sharp, didactic critiques. Therefore, Edward Stierle's "Empyrean Dances" or Bill T. Jones's "Red Room" or "D-Man in the Waters" tend to soothe or inspire. They provide more catharsis than agitation.[3]

Dance has the greatest probability of provoking controversy when it incorporates nudity, but even then, reaction is not guaranteed. In the finale of Jones's "The Last Supper at Uncle Tom's Cabin/The Promised Land" (1990), several dozen dancers steadily strip off their clothing. The net result is a scene of young and old, lean and stocky bodies of all colors, in a utopian community of equality. Wherever it was presented, participants were recruited from the vicinity to perform with the regular troupe. The non-sexual panorama concluded a work about racial and sexual marginality, religious belief, discord and harmony, and was acceptable in communities from Brooklyn to Los Angeles to Lawrence, Kansas.

Only at the edges of the professional dance world, where broad concerns about institutional survival and audience sensibilities are not so acute, is AIDS likely to surface in a critical manner. Where dance merges with performance art, for example, controversial work is more likely.

ENLIGHTENED AND UNENLIGHTENED COMMUNITIES

A similarly mixed situation occurs with movies and videos. Hollywood has a feeble record of presenting positive gay depictions. It is notoriously difficult to shepherd a gay-themed film to completion. The fate of the novel *The Front Runner* is one of the best-known examples of multiple, frustrated attempts to bring such a project to the screen. In 1988 a production company once again tackling the novel ran a full page ad in *Daily Variety* juxtaposing the "myth"—"If I play a gay role, I'll never work in this town again"—with the "fact," a lengthy list of recognized actors who have played such parts in their careers.[4] Their purpose was to assure potential performers that a gay role would not mean career suicide.

AIDS unnerves Hollywood decision makers even more; their eyes are constantly

on the bottom line. With the exception of a few movies such as "Longtime Companion" and "Parting Glances," AIDS has remained only an infrequent subtext in major films. Marital infidelity brings disastrous consequences in "Fatal Attraction," for example, reflecting the dangers of casual sex in the age of AIDS. This is covert social commentary which does not mention the disease by name.

Independent video artists, on the other hand, have seized the opportunity to use this technology to record the impact of AIDS on individuals and communities, to document government action and inaction, and to disseminate safer sex and drug use information. Productions such as "Testing the Limits," "Ojos que no ven" ("Eyes That Fail to See"), "PWA Power," and "Doctors, Liars and Women" capitalize on video's immediacy, relatively uncomplicated conventions, and low cost (compared to film) to transmit their urgent messages.[5] Such videos are generally shown in not-for-profit galleries or "alternative" health contexts, where they are unlikely to elicit complaints. But if they are exhibited in wider or more mainstream settings, trouble can occur. In Canada, for instance, a cable company dropped "Toronto: Living with AIDS" (a collection of eleven videos) because one installment depicted physical affection between two men. This was deemed "offensive" and "in bad taste."[6]

AIDS has been a subtext in contemporary theater as well. "Prelude to a Kiss," for example, never mentions homosexuality or AIDS. But the story of a young bride whose soul is transferred into the cancerous body of a decrepit old man is easily construed as a metaphor for the disease. However, there also have been a number of plays which directly address AIDS: Harvey Fierstein's "Safe Sex," William Hoffman's "As Is," Tony Kushner's "Angels in America," William Finn's "Falsettos," and Larry Kramer's "The Normal Heart." Each has a distinct artistic agenda and employs different techniques, but all confront AIDS as a fact of gay life. There have been few problems in presenting these works: theater audiences are self-selecting, and tend to be well informed about what they are about to see. And playwrights and directors do not need to appease commercial sponsors or attract the vast public that mass media forms like television and movies must.

However, problems can arise in certain settings. When "The Normal Heart" was first presented at Joseph Papp's Public Theater in 1985, it was immediately acknowledged as a ground-breaking (albeit polemical) work, and enjoyed a successful run. Its reception was vastly different in Springfield, Missouri in 1989. A proposed production at Southwest Missouri State University (SMSU) enraged some locals, and the controversy made its way to the State Legislature, SMSU's primary funding source. The play was summarily dismissed by a Representative who fumed "This is a play in which Jesus Christ is blasphemed and Mayor Koch is defamed."[7] These features might secure it an honored place in some communities; this was not the case in the Ozarks.

This same legislator helped form a group called Citizens Demanding Standards, Inc. (CDS), which encouraged phone and letter-writing campaigns, and pressured

the state legislature to take punitive fiscal action against the university. The play became a public issue because a connection with governmental funds (and therefore public accountability) could be drawn. The State government was not swayed by this one woman's objections. But the opposition stirred up so much anti-gay and anti-AIDS hysteria that metal detectors and bomb-sniffing dogs were positioned in the theater's lobby during the eight-performance run. Even though the play proceeded undisturbed, the organizer of the ad hoc student support group People Acting with Compassion and Tolerance was not so fortunate. His house was destroyed by an arson fire while he attended the play's premiere, and he lost all his possessions and two pet kittens. This Bible-Belt venue, world headquarters of the Assemblies of God church, was an uneasy host to a difficult piece of work.[8]

VICTIMS, "INNOCENT" OR OTHERWISE

Other media and artistic forms have become typical sites for AIDS-related artistic conflicts. Television is a prime example. Controversy has dogged the production of AIDS stories, whether as made-for-TV movies or episodes on weekly series. This is not to suggest that this theme has burgeoned; rather, television has been as slow to recognize and respond to the epidemic as has the public at large, the government, and the medical establishment. But when such story lines have been proposed, the range of reactions has become prosaic: nervous sponsors and network executives don't want to alienate anyone, homophobic fundamentalists resist any depictions of gay life except disparaging ones, and gay and AIDS activists insist upon their own brand of "the truth."

Caution has marked the introduction of AIDS onto the small screen. In 1988, for example, when AIDS was primarily concentrated among gay men and drug users, characters on three daytime soap operas contracted the disease. They were all women, and none had a history of drug use. Verisimilitude is hardly a hallmark of television stories, nor should it necessarily be a requirement. But the circumspection of cautious scriptwriters superceded any impulse to accurately reflect epidemiology in these cases.[9]

Television's breakthrough movie on AIDS was "An Early Frost" in 1985. Its producers confronted the same type of protracted negotiation process that their colleagues would face later in presenting movies about abortion: multiple rewrites, and pressures to maintain standards of "taste" and skirt advocacy. For example, the understanding family matriarch was prevented from telling her gay grandson that she liked his "friend" (that is, his lover). That might be construed as an endorsement of homosexuality.[10] The narrative centered on the family and its reaction to their son's dual announcement about being gay and being ill. It had an overall "tidy" quality: the middle-class protagonist still looked vigorous, and the

story shifted away from his gay life to his position within his family. "An Early Frost" broke ground, but gently.

The fate of another movie provides an interesting contrast. PBS's American Playhouse commissioned "Longtime Companion," which follows a group of gay men in New York City from the moment AIDS is first announced in the press until it directly affects their circle. The executive producer of the series failed in his attempts to raise funds for the project; as a consequence, American Playhouse became the sole bankroller for the first time ever. These difficulties were compounded when a distributor was sought. Again, no one was interested. The Samuel Goldwyn Company eventually picked up the film, assuring it a commercial release in 1990 in addition to its screening on public television.[11]

In 1991, one of the minor characters on *thirtysomething*, whose gayness is taken for granted, disclosed that he had just tested positive for the HIV virus. Peter was one of the men shown in bed in the controversial post-sex scene. His story was not foregrounded in this new episode; the spotlight was on his boss Michael instead, who was already reeling from the loss of another friend in a car accident. This strategy was understandable in a series known for its emphasis on characters and not subjects, although it did make a weighty contemporary concern seem like a "throwaway." While sponsors did not flee as they had with the earlier episode, Reverend Wildmon rebuked the show. He opted to assess blame and guilt instead of offering compassion, and faulted *thirtysomething* for failing to concede that "Peter contracted AIDS because he chose an aberrant lifestyle."[12] And true to his style, Wildmon published the names, addresses and phone numbers of sponsors to help people register their own dissatisfaction, too.

At just about the same time, an installment of another series almost did not make it onto the air. In late 1990 NBC was propping up its faltering *Lifestories*, a weekly collection of fictionalized stories about medical issues. Aired at eight p.m. on Sundays, it was up against imposingly stiff competition. The network president knew from the beginning that the episode about a TV newscaster who develops AIDS would have difficulty attracting sponsors; this was compounded by the problems the entire venture was experiencing.[13] The fate of the series was in jeopardy, and the "Steve Burdick" episode was yanked from the schedule. The Gay & Lesbian Alliance Against Defamation (GLAAD) and others pointed out the absurdity of ignoring AIDS on a medical series, and it was eventually rescheduled for a weeknight at ten p.m. The episode had more spine than most other AIDS dramas. It depicted family conflict, job discrimination, and the effects of political pressure on the media. It also broached the irrelevance of religion as the reporter lies in his hospital bed and ridicules his roommate's prayers (see Chapter Four).

A different type of opposition greeted an episode of NBC's *Midnight Caller*. AIDS was a natural topic for the San Francisco-based series, with the main character the host of a late-night radio call-in show. But a proposed episode enraged AIDS activist groups because it featured a bisexual man infected with HIV who continued

to have sex with other men and women. The episode originally reached a climax with the man's murder by one of the women he had infected. Demonstrators voiced their objections by disrupting the filming and demanding script changes. Modifications were made: the talk show host saves the man's life and convinces him to get counseling, and dialogue was added to assure viewers that this behavior was not to be taken as representative of other HIV-positive individuals. Some protesters remained dissatisfied, and then attempted to pressure potential advertisers from supporting the show.[14] This episode was followed a year later by another in which a former girlfriend of the show's protagonist is stricken with the disease. This supplanted the sensationalistic drama of a "killer" on the loose with a tale of personal relationships and impending loss.

Potential critics of all political stripes are extremely sensitive about this issue. More AIDS programs have been produced, but their supporters proceed cautiously. "Andre's Mother" focused on the relationship between a dead man's mother and his lover; the men's relationship is only obliquely presented. This was a story about survivors and displayed no sex. Yet even such a discreet story had a difficult time getting produced, and it evoked irate telephone calls to New York City's PBS station when it was first aired. "Our Sons" showed a man in the advanced stages of the illness, yet the plot primarily centered on the clash between two mothers, and the reconciliation between the ill son and his mother. Again, the gay relationship was largely pushed to the sidelines.

Television accounts of AIDS point a finger by what they do and do not present. Network executives appear to be more comfortable with stories of the so-called "innocent victims" of the disease such as Ryan White, the young hemophiliac who contracted the disease through contaminated blood products. Or programs on AIDS prevention may target heterosexuals—cautionary tales for teenagers, in several instances. While these efforts are laudable, they simultaneously highlight the dearth of similar chronicles of the suffering of gay men and drug users, and the absence of vital information for these groups.[15] To offer such stories would be to acknowledge the common humanity of all those with AIDS. Yet some people still insist that certain sufferers are more innocent than others, and do not wish to appear to be condoning "deviant" lifestyles.

NOT SO HOT

The fate of an AIDS-related video project reveals how frightened network television executives can be of gays, sex and AIDS. "Red, Hot and Blue" was a private, joint British-US venture in 1990. The format was a collection of music videos performed by different popular artists, each produced by innovative directors. The project's goals were to educate audiences about AIDS and heighten safer sex awareness, and to raise money for AIDS service groups. Organizers planned

TV screenings in both countries, sales of the video and recording, and even the marketing of clothing which sported designs by activist artists.

The music featured modern renditions of classic songs by Cole Porter. It was an inspired choice: Porter was a closeted homosexual who married so that he might steer his way through cafe society more comfortably. Porter sprinkled subtleties, gay allusions, and multiple meanings throughout his work, features which the contemporary artists enlarged in a way the composer could not in his own lifetime. These modern interpreters transformed Porter's lyrics about romance, obsession and loss into eerie, poignant and erotically charged performances.

The project appeared to be the latest in a series of socially conscious collaborative music enterprises. But this one went begging for support. Potential corporate sponsors shied away from the undertaking: over seventy five international organizations were approached to be backers, yet all of them declined to participate. So, too, did some performers who might have seemed to be naturally inclined to join in because of their past charitable activities.[16] Nevertheless, organizers successfully assembled a 90-minute program, aired on Britain's Channel 4.

ABC scheduled a US broadcast for December 1, 1990 (World AIDS Day), at 11:30 p.m. But the network significantly altered the presentation, deleting six of the videos and appending the commentary of big-name celebrities. ABC dropped the most provocative segments, including the Jungle Brothers' "I Get a Kick" (showing a giant condom and squirting liquids), and Jimmy Sommerville's "From This Moment On" (featuring a Black man and a White man kissing and embracing). Much of the added material focused on Porter, converting an AIDS program into an artistic tribute. This editing paid homage to a great composer whose birth centenary was about to arrive, but it also dulled and subverted the original aim of the project. Once again, concern over the sensibilities of a mythical viewer—or fear of the possible response of their self-appointed lobbyists—caused television executives to constrict audience choices. As one reviewer remarked, "When it comes to AIDS, American TV for the most part still wears a Victorian corset."[17]

The fate of "Red, Hot and Blue" reflects a pattern of distortion and silence regarding AIDS and AIDS prevention on television. When the major condom companies prepared ad campaigns in 1987, and soon after the first public service announcement (PSA) for condoms had aired, The Concerned Women of America: Contraceptive Campaign generated over a hundred thousand letters of protest to each of the major networks. Since then local stations have had the option of whether or not to accept paid ads or PSAs for condoms, but affiliates of the major networks have uniformly opted not to.

For all intents and purposes, the words "condom," "rubber," and "prophylactic" are banned from the television airwaves. Even the Centers for Disease Control (CDC) is prevented from presenting straight forward, factual information in this medium. In one PSA the CDC was forced to adopt absurd, confusing references to safer sex condom use ("like putting your foot into a sock").[18] More than one

media critic has questioned the wisdom and morality of the major TV networks routinely featuring sex but not taking the responsibility to disburse crucial facts during an epidemic which is sexually transmitted.[19] Protecting viewers' sensibilities appears to be more important than protecting their lives. The bottom line triumphs again: sex sells, but the condom industry simply is not large enough to warrant the networks' attention.[20]

BEARING WITNESS

Commercialized entertainment may have opted largely to turn its back on AIDS; many artists working in other domains have chosen other strategies. The epidemic has mercilessly cut a wide swath through artistic ranks, inadvertently providing the basis for a profusion of new work. Some of this art playfully transmits basic messages, as did a billboard in Grand Rapids, Michigan. It sported hundreds of colorful condoms and the giant message "AIDS: Wear 'Em," eliciting a mixed local response.[21] And another artist adapted traditional Japanese painting techniques to relay a safer sex message: Matsami Teraoka's "Geisha in Bath" shows a woman in her customary work site, biting open a package of condoms.[22] Other works have become tragic records of the plague's devastation. One of Annie Sprinkle's slide shows of former lovers shifts from a gallery of sexual freedom and diversity to a registry of casualties, with the added knowledge that many of them died of AIDS. The epidemic has forced the artistic innocence of the 1980s to season at an accelerated rate, yielding unusual new strains of creativity.

Hybrid forms have emerged, such as Diamanda Galas's "Plague Mass," a haunting blend of diverse musical styles and a howling delivery. Her work defies easy classification.[23] But much of the most powerful and controversial work has surfaced in the visual arts. Visual artists who incorporate AIDS as a theme into their work have helped to reorient the field in recent years. Whether they primarily emphasize the human dimensions of the disease or directly address social and political issues, visual artists have become key manufacturers of AIDS images. This was amply demonstrated, for instance, in the 1990 "Decade Show" organized by three New York City museums. Visual artists have also borne the brunt of critical reactions.

Nowhere was this more evident than in the controversy over the show at New York City's Artists Space, "Witnesses: Against Our Vanishing," in November, 1989. Guest curator Nan Goldin sought to chronicle the impact of AIDS on artists from the East Village and Lower East Side of New York City. In this sense "Witnesses" resembled exhibits which document the creative Jewish communities which flourished in cities such as Vilna, Warsaw or Bialystok in the 1920s and '30s, only to be systematically wiped out in the Holocaust. Goldin presented visual art and photographs by and about a contemporary creative community being

obliterated by disease, not a fascist ideology. But the exhibit struck some deep chords of anxiety within the NEA and with unsympathetic reviewers, leading to a misapprehension of its purpose.

Something similar had happened on a much smaller scale when Joe Ziolkowski's work was perceived as erotic and possibly obscene, even though this was not the artist's intent. In the case of "Witnesses," the gallery director, the curator, artists, funders, and the public all held divergent views on what this exhibit represented, and how, why, and even if it should be presented. Reviewing this range of opinion retrospectively brings forth a sickening sense of tragic inevitability: controversy was almost certain when such conflicting beliefs came together.

The show was mounted at an extremely sensitive moment. The summer of 1989 was when Serrano's "Piss Christ" was decried by public officials, the Mapplethorpe exhibit was cancelled by the Corcoran Gallery, and the Congressional debate over "obscene and indecent" art began. By October the modified Helms amendment on NEA content restrictions had been signed into law, and a new NEA chairman had just been approved, John Frohnmayer. Many artists were troubled by the fight for NEA reauthorization, members of Congress were outraged by what they saw as a governmental imprimatur on smut, and Frohnmayer was in a much-scrutinized hot seat. The conditions for a confrontation had been mellowing for several months, and they ripened in this Tribeca gallery in early November. This was to be the first showdown on what the restrictive legislation really meant.

The Endowment had pledged ten thousand dollars out of a thirty thousand dollar budget for "Witnesses." Before the show opened, Artists Space director Susan Wyatt alerted the NEA that the show and its catalog included explicit sexual content. Wyatt did this so that the NEA would not be caught unawares, or "blindsided" by the nature of the exhibit after it had opened.[24] Wyatt saw this as a potential test of restrictive legislation that Congress had recently passed regarding publicly funded art. On November 9, Frohnmayer announced he was suspending the grant based upon his disapproval of the catalog, which sharply castigated political and religious leaders for their positions on homosexuality and AIDS: "I believe that political discourse ought to be in the political arena and not in a show sponsored by the endowment," he cautioned.[25] He judged the work to be political rather than artistic in nature, and thereby disqualified for NEA support. This was a considerable stretch from the language of the law which prohibited certain "obscene" depictions. Later, Frohnmayer also cited an alleged "erosion" of artistic quality from the initial conception of the project to its final form.

Artists Space decided not to accede to the NEA's demand to give up its grant, and intense negotiations commenced between the aggrieved parties and with their legal consultants. There was even an eleventh-hour meeting between Frohnmayer and angry artists and arts administrators at Artists Space, at which time the NEA chairman was able to view the exhibit in person. On November 16, a few hours

before the exhibit opened to the public, Frohnmayer reversed himself and restored the grant. But the NEA specified that its funds could be used only for the show, and not for the disputed catalog. The Robert Mapplethorpe Foundation provided the capital to underwrite the publication.[26]

This was a compromise which allowed both the government and the gallery to save considerable face. The NEA also finessed its way through this muddle by noting that the grant had been approved in FY 1989, *before* the cautionary, restrictive language was inserted into NEA policies. So while Artists Space scored a victory, this did not settle the question of what the government would deem an acceptable use of its money. It did not directly confront the issue of subsidies to art with overt sexual content, particularly when it was homosexual in nature.

The resolution of the dispute helped mobilize a boisterous crowd for the opening reception. Artists Space is located just above the confluence of two north-south New York City arteries. The streets form a wide triangle to become a natural plaza, with a subway entrance in the middle. Admission to the gallery was assured for those who arrived when the doors first opened, twenty minutes ahead of the scheduled six p.m. But the crowd quickly expanded, swelled by those who had been following the controversy. The streets filled with hundreds of would-be viewers and also with demonstrators, coordinated by Art+Positive, an AIDS activist arts group. The protesters loudly registered their dissatisfaction with the Helms Amendment and the treatment of Artists Space, as well as events which had preceded the current difficulties, such as the vilification of Mapplethorpe's work by Congressional critics and Corcoran officials. They marched, chanted ("Not the church, not the state, *we* decide what art is great"), and held aloft signs in the brisk autumn evening. These included "S/M + Art=SMART," a clever counterpoint to critics. Their overall message was that homoeroticism was indeed a legitimate form of expression, and deserving of government support. The premiere of "Witnesses" became a packed, unabashed success, a prelude to its record-setting run at Artists Space.

The events there elicited other demonstrations of support. Composer and conductor Leonard Bernstein spurned a National Medal of Arts because of the turmoil. At the awards ceremony at the White House two days after "Witnesses's" opening, President Bush tried to make light of the unstable arts situation. He came to the event from meeting the living Butterball, the official Thanksgiving turkey: "I was just trying to calm the national turkey and that went well," he quipped.[27] The Artists Space dispute also mobilized a much wider range of artists than had responded to previous controversies. PEN, the national writers' group, was especially noticeable with its endorsement of the show and its disapproval of the NEA's actions.[28] But this schematic presentation of events does not do justice to the complexity of the issues raised at Artists Space. A more detailed look at the motives and feelings of the major players in the drama is necessary.

COLLISION COURSE

As noted, Frohnmayer was freshly appointed when this conflict unfolded. It was the first concrete test of where his primary sympathies and loyalties lay: with his Washington "bosses," or with artists. The NEA and its new director were subject to intense scrutiny from all sides. The artistic community felt enormously betrayed when Frohnmayer attempted to appease Congressional cultural critics by rescinding the Artists Space grant. This decision was particularly hurtful because Frohnmayer was not a member of the Washington establishment, and at first appeared to be a probable ally of artists. But the honeymoon between artists and the new chief came to an abrupt halt. Frohnmayer bears a physical resemblance to James Stewart, but he did not behave like the actor's character in "Mr. Smith Goes to Washington."

This was likely a no-win situation for Frohnmayer, who was susceptible to attack whatever he chose to do. He hosted a dinner for the National Medal of Arts winners on the same evening as the opening of "Witnesses." At that event he reflected, "I feel like John Kennedy after the Bay of Pigs."[29] The analogy was apt. Politicians in both situations did what they thought was correct, only to watch their schemes unravel and miscarry before their eyes. And in both cases, leaders chose courses of action which haunted them for a long time.

As the director of Artists Space, Susan Wyatt was also in a delicate post. She noted the parallels between Frohnmayer's position and her own, perched between the demands of funders, the needs of artists, and the desire to keep their respective organizations intact. In the case of Artists Space, this meant sustaining a well-respected and long-lived alternative space which had been operating since 1973. It was also an institution with its own legacy of crisis, the "Nigger Drawings" incident of 1979 (see Chapter Three). Wyatt had been a staff member at Artists Space at that time and recalls it as a very destructive event: ". . . it took me a year, basically, to get over the anger. Not only did it take four months of our lives, completely devoted to it, but it's still something that comes up and haunts us to this day. And I just didn't want to see that happening again."

This organizational history was one factor which lead Wyatt to develop a practical, preemptive, and self-protective (that is, institution maintaining) stance. She had closely followed how Helms and other members of Congress had blasted Serrano and Mapplethorpe, and noted what a destructive incident the Corcoran's cancellation of Mapplethorpe had been for that institution. She also understood that the debates over the "Nigger Drawings" and Serrano's work largely took place *after* their display was over, and that their work was abstracted, distorted and misunderstood. Wyatt was determined that if controversy were inevitable, it should happen when the work was available for public scrutiny: "I would have been very foolish to think that that catalog would not have come to Jesse Helms's

attention, in one way or another, eventually. And that he wouldn't use it given what he's [already] done. . . . I think it's great that the controversy happened at a time when the work could be seen and judged for itself."

Wyatt first articulated the strategy she later adopted at the national conference of the National Association of Artists Organizations (NAAO) in Minneapolis in early October. At that time she suggested that artists' groups should contact the NEA and query officials about the legality of the work they were presenting, in light of the restrictions of the Helms Amendment. Wyatt believed that this was a sensible way to test the law's limits, and could potentially empower the NEA to do battle with Congress.

Her view was that if NEA officials were armed with tangible examples of how difficult it was to define obscenity, they could overturn the law. Besides, she felt that a blacklist was being formed of unfundable individuals and organizations (Serrano and Mapplethorpe, for example; and the Institute of Contemporary Art and the Southeastern Center for Contemporary Art), and "if those two artists organizations were guilty, then we were all guilty. And maybe we should all join the blacklist." Wyatt's proposal was controversial among NAAO delegates. Others countered that NEA beneficiaries should just take the money and do what they planned to with it, and not consult the agency in advance.

Wyatt soon had the opportunity to put her scheme into action. She wanted the grant but she also wanted the NEA to survive. She had an apocalyptic sense: "I could see my entire field defunded and destroyed." She also personally felt the weight of potentially jeopardizing the future of the entire NEA. Wyatt—not the NEA, the curator, nor the artists—devised the plan to separate the work in the show from the catalog, even though this is a spurious distinction. The essay by David Wojnarowicz was the most problematic, and he expressed many of the same sentiments through his pieces on the wall as he did in the catalog. But Wyatt was attempting to anticipate the arguments of Helms, Rohrabacher, Armey, et al., and to beat them at their own game: "Those people say, 'do it on your own time and your own dime.' And that's why I thought, okay, we'll do it on our own time and our own dime." The goal was to insulate the most provocative material from the critics of public support by taking it off limits.

Wyatt, of course, had the vantage point of an administrator of an organization which predated the "Witnesses" show, and which she was determined would still be there after any commotion died down. It was her job to guarantee that the enterprise would be left reasonably intact.[30] If you look on the back page of the "Witnesses" catalog you see the lengthy list of governmental, foundation, and corporate sponsors of Artists Space who help underwrite its annual budget of over seven hundred thousand dollars. This is an impressive track record, which could not be impetuously compromised over one event. And as Wyatt explained, most of their funding is awarded annually, which means that sponsors must be solicited

year after year. This is a precarious position which dictates caution, conservatism, and keeping an eye on the long-term consequences of organizational choices as well as immediate artistic issues.

While Wyatt wanted to keep her artists informed, she admits that this did not occur. Tempering this impulse was her belief that it was *her* responsibility to make the important decisions. In retrospect, she felt confident about her approach— Congressional critics "didn't get away with murder here." Wyatt claimed that she elected to uphold principles over money and acted on behalf of the artists' interests. But her perspective was but one of several.

Curator Nan Goldin naturally had other interests and priorities. Artists Space approached Goldin to organize a photography show, granting her the right to determine the topic. She quickly decided to spotlight AIDS because of her firsthand experience of the impact of the disease. Goldin left New York in 1988 to enter a drug treatment program in Boston. By the time she returned, many friends and acquaintances had died. She conceived of this show as a memorial, a therapeutic experience for sick and/or grieving artists, and a way to increase public awareness about the disease.

"Witnesses" was a logical extension of the type of work Goldin has done throughout her own career. She has continuously photographed herself and her friends in the most intimate situations. Together the images form a home movie or diary of her community. As she stated, "I have pushed the boundaries of what people normally consider private. I've shown myself battered by my boyfriend, I've shown myself having sex. . . . I think people keep the wrong things private."[31] Goldin turned this cumulative record into an ever-changing slide show, a selection of which was eventually published as *The Ballad of Sexual Dependency*.[32] In some instances she photographed the same people over a ten or fifteen year period of time. Tragically, death from AIDS is now a crucial part of this group's ongoing saga.

Goldin gathered the photographs, assemblages, paintings and sculptures of two dozen artists. They embodied diverse sexual orientations; some had AIDS, others did not. A number of individuals in the show were AIDS fatalities; a few died even while the show was being organized. The participants and their subjects represent overlapping social circles, generally considered marginal by mainstream society.[33] The memorial character of "Witnesses" was therefore paramount, serving as a means of honoring the dead and reconnecting survivors. As Goldin poignantly explained, "This was my way of making amends to them for not being there when they died. To you know, keep them. [I experienced] denial that they're actually gone. It's like you're not in town anyway, so you think, you haven't seen them, and you think when you come back they'll be there. . . . So I think this show was to publicly say goodbye to them."

Goldin believed participation in the exhibit was therapeutic. It was, as she further explained, for "those who've died *and* those who are trying to heal and

keep going." She cited one artist who was HIV positive who felt better from working on his entry for the show: it forced him to mobilize his energy and gave him an outlet for his rage. In another case an artist she had lost touch with contacted her about her plans for the show. Ill with AIDS, he pleaded to be included, a request which Goldin met.

She also saw the show as an important means of diffusing information to people beyond her circle and easing the public's fears about the groups which have been the primary victims of AIDS. In discussing homosexuality (a category she does not deem abnormal) she stated, "I think it's especially important now to be showing this group that has been marginalized and allowed to die, and show the reality of them during these plague years. These are the people who are being killed, either by intent or by negligence, and they need to be heard from. And I think people need to see what the reality of homosexuality is."

The works in the show were mixed: they represented different media, diverse purposes, and were of varying quality. This didn't bother Goldin: "I don't mind that it's uneven because it wasn't done for the market. It's really a different way of looking at art." "Witnesses" reached its full power when the viewer understood the interconnections between the artists. It was then that the former vibrancy of a community was revealed, and the magnitude of the losses could be suggested. The counterpoint to Peter Hujar's sensuous nude self-portrait were the postmortem photos taken of him by his friend David Wojnarowicz. Darrel Ellis painted his own versions of photographs taken of him by other artists such as Robert Mapplethorpe, also lost to AIDS. And Philip-Lorca diCorcia pictured an ill Vittorio Scarpati in his hospital bed; Scarpati's ink drawings (like medieval scientific illustrations of his own physical decline) were included; and Scarpati's wife Cookie Mueller wrote an essay for the catalog. She did not live to see the show, however: she, too, died of AIDS, days before "Witnesses" opened.

This small sample of social ties provides merely a glimpse of the density of the relationships in this artistic *Gemeinschaft*. Scattered throughout the show there were portrayals of mutual friends and lovers, before-and-after shots of the onset of AIDS. Linda Yablonsky alluded to these associations in a metaphysical way in her catalog essay. Noting that today's air reportedly still contains molecules from Julius Caesar's dying breath, she wrote "The air doesn't just feel closer, it is. With every long sigh that escapes my lips I can keep afloat not just the memory of those friends lost to AIDS and cancer and drugs, but their actual first words!"[34]

But anger pushed aside philosophical speculation in other parts of the exhibit. In a memento mori based on the experiences of Mark Morrisoe, Ramsey McPhillips crammed a lucite box with a bloodied sheet, shards of broken glass, and a blood-spattered book. It represented an incident when the late Morrisoe angrily shattered a vase and cut himself with it out of frustration over his shabby treatment in a hospital. Not only was this visually shocking, but so was the accompanying fragment of Morrisoe's writings: "They have stopped listening to me, so I wrote everything

down in a note; who was trying to murder me and how, and then smashed the vase . . . so I would have something to mutilate myself with by carving in my leg 'evening nurses murdered me' . . . and then I took the butter pat from my dinner tray and greased up the note and stuffed it up my asshole so they would find it during my autopsy."[35] And David Wojnarowicz's "Untitled (Hujar Dead)" was a collage of images and text denouncing the official indifference to AIDS. His fury was barely contained within the frame: "there's a thin line a very thin line and as each T-cell disappears from my body it's replaced by ten pounds of pressure ten pounds of rage" [see Plates section].

Goldin felt vexed as "Witnesses" became controversial. She was deluged by press requests for statements from the early morning hours on, and advised by reporters that this was her big moment and she needed to be pithy. She recalled hearing from one journalist at 5:30 a.m.: "You're famous. If you don't talk today nobody's gonna want to hear from you ever again." The media also became a primary channel for news: Goldin learned through reporters that Frohnmayer had withdrawn the NEA grant for "Witnesses," rather than hearing from Artists Space directly. Needless to say, this was an awkward and frustrating situation. As the curator, Goldin's primary allegiance was to defend the entire show, which included the catalog as an integral part.

Goldin had only a transitory affiliation with Artists Space and therefore did not hold the same concern for institutional reputation and durability that its director naturally would. Goldin describes herself as having led a marginal life and being unsophisticated regarding politics, holding a generally paranoid perspective. She has tried to lead a life separate from government observation, and had never applied for an NEA grant until the year she put together "Witnesses." Goldin was inexperienced with the intricacies of bureaucratic bargaining and appeasement, and was representing only herself and her artists with this show. While she would have preferred that the show/catalog package be defended on principle—and to the utmost—she was not the primary decision-maker in this case.

Susan Wyatt called "Witnesses" "Nan Goldin's AIDS quilt."[36] Goldin felt the work provided a continuum and a context for confronting AIDS. Not all the artists or their subjects were ill, but all aspects of life were shown, including death and sex. Goldin wanted there to be positive depictions of sex and sought to provide a place where frightening feelings could be expressed and explored in a supportive environment. In these respects she succeeded in her curatorial duties, although critics of the venture failed to understand her intentions, seeing mainly perversion instead.

The motives of David Wojnarowicz, another major player in this drama, were also misconstrued. He was even less closely tied to Artists Space than was Goldin. And the outrage permeating his work was stoked to a more intense level by Frohnmayer's punitive action. Wojnarowicz felt that major principles were at stake in this contest between sponsor and artist. But because he had no institutional

stake in the outcome of the dispute, he saw the actions of Artists Space as shameful acquiescence. His was yet another perspective on the same situation.

Wojnarowicz's essay "Post Cards From America: X-Rays From Hell" was the most controversial part of his contribution to "Witnesses." His writing is a powerful harangue, mixing sorrow, indignation, fatigue and reverie. As a person with AIDS, his emotions are without doubt authentic, and raw. What his critics most commonly cited from this work was the gallery of rogues about which he fantasized. He condemned Cardinal John O'Connor as a "fat cannibal" from a "house of walking swastikas." He imagined dousing Jesse Helms with gasoline, or throwing William Dannemeyer from the Empire State Building. Wojnarowicz's charges and proposed retribution were levelled at public figures who he felt obstructed the distribution of safer sex information, and thereby contributed to more deaths from AIDS.[37]

But the New York Post fumed that this was a "vicious and puerile attack" and an "obscene mockery at public expense."[38] In this regard the editorial writers echoed some of Frohnmayer's own sentiments from a few days before. Citing the real-world battles prompted because of the NEA's support of Serrano and Mapplethorpe, Frohnmayer cautioned "I think the last thing we need is for public funds to be used to try to rub it [political or sexual commentary] in the face of the critics."[39] Wojnarowicz's writing was a political hot potato. But as much as Frohnmayer may have hoped to quash such a voice by revoking the NEA grant to Artists Space, he did not recognize that this artist could take chances without incurring the same risks that Wyatt and others faced. Wojnarowicz's organizational independence afforded him enormous freedom to speak his mind and vent his anger. He was the wild card in this controversy.

Wojnarowicz recounts a type of marginal existence similar to Goldin's.[40] His biography contains a glut of family miseries, including physical abuse, divorce, mental illness and suicide. As a teenager growing up in New York's Hell's Kitchen, he drifted into the netherworld of male prostitution. He later worked as a janitor and explains that he essentially did not speak with anyone for several years. While his experiences with high school art teachers were not constructive, he gradually developed his writing and his art as a way to communicate with the world. During a three-hour interview he peppered his comments with the word "naive," and made several references to being invisible. Important aspects of his working style and his self-perception were disclosed in the following: "[With photography], I never learned anything about aperture settings or speed of film. I just do it to pull something out of it. . . . I always resist getting to know something in terms of machines or operations, just learning to turn it on and go from there on my own. Part of it is resistance to manuals of any sort. I remember thinking that those are the people who rule the country, the people who can figure out the manuals."

In the late 1970s Wojnarowicz joined the post-punk band "3 Teens Kill 4— No Motive," its name taken from a New York Post headline. A larger audience started

to take notice of his work as an anonymous guerrilla artist stencilling burning houses, a human head with a target scope in the center of his face, bomber planes, explosions, and little army men with machine guns onto the streets of the Lower East Side. He also stencilled images onto derelict cars on the Bowery and painted on the walls of abandoned Hudson River piers. He achieved an even wider notoriety as a painter from the East Village "art scene" which burgeoned in the early 1980s. He survived the effervescence and rapid collapse of that artistic moment, having been pulled into the world of collectors, galleries and critics.

It has never been an easy relationship: Wojnarowicz is by turns cynical and distrustful of the art world, and amazed that there have been times when some collectors would buy anything with his name on it. But many others are scared of his work and resist it. Wojnarowicz claims "I've never acted like a racehorse and done what I was supposed to do," and he continues to live a financially precarious existence in a loft above a former Yiddish theater in the East Village. He is also a gay man with AIDS.

Wojnarowicz's creativity has perpetually flowed into new channels, including film, performance, photography and installation. He integrates these different forms with his writing, painting and collage work, so that it is impossible to peg him exclusively as one type of artist. That is why the official separation of catalog text from his photomontages in "Witnesses" seemed particularly despotic. His work is fueled by direct experience with abuse, injustice, the deaths of friends and lovers, homophobia, and more recently, AIDS phobia. It is not difficult to fathom the rage in his work and his conduct, goaded by these origins, working as an independent creator, and having his singular vision arbitrarily divided into the acceptable and unacceptable, the fundable and unfundable.

Wojnarowicz felt that Artists Space should have gone the distance on his behalf. This meant defending and protecting the show *and* the catalog. To do anything less was unprincipled, and capitulation. He recounts that he had to deal with the "panic attacks" of Artists Space officials from the moment he submitted his essay to them. He claims that Susan Wyatt asked him to change the essay and/or agree to a disclaimer being published alongside it. Because he adamantly rejected both suggestions, however, specific details of these proposals were never discussed. However, he did agree to sign an agreement that he would assume all the costs of any legal actions taken against his work. The artist was struggling with his hands tied: he could not dictate the strategy of the counterattack since the NEA grant was not made directly to him. In fact, Wojnarowicz maintains that he was continually kept in the dark over what was happening and that Artists Space was more concerned about appeasing him than keeping him informed as a full player.

The actions that Artists Space took confused many people. For example, Steven Pico, an artist and civil liberties advocate, sensed that the gallery was cannily laying the groundwork for a legal challenge to the restrictive NEA language by tipping off the agency to the nature of "Witnesses." To his mind, this was shaping up to

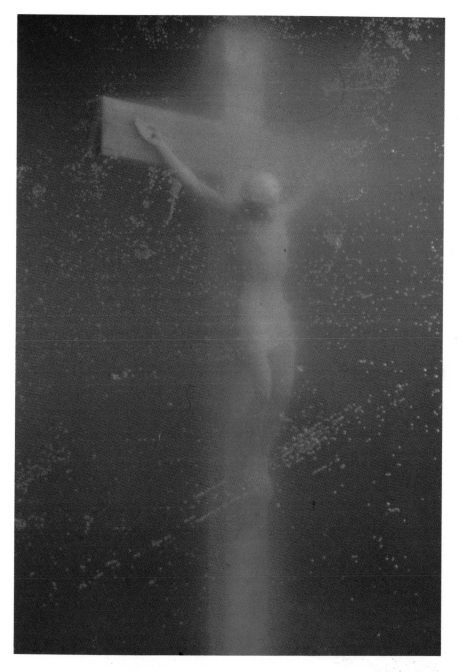

1. A visually striking, even transcendent photograph, Andres Serrano's "Piss Christ" became an abomination to many viewers when the title betrayed its union of sacred and profane elements.

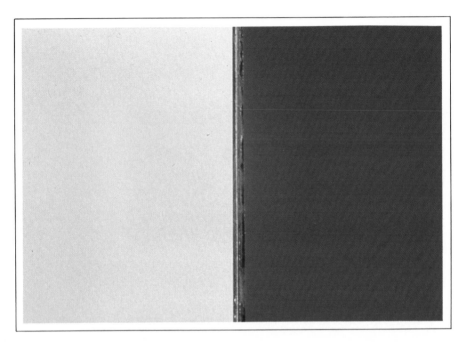

2. Serrano's "Milk, Blood" suggests a visual breach of sacrosanct cultural boundaries, with the discomfiture that may attend any such violation.

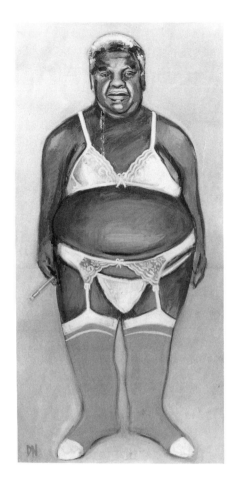

3. David K. Nelson's iconoclastic view of a deceased Chicago mayor triggered an immediate and extreme official response: (4) the "arrest" of a disturbing painting.

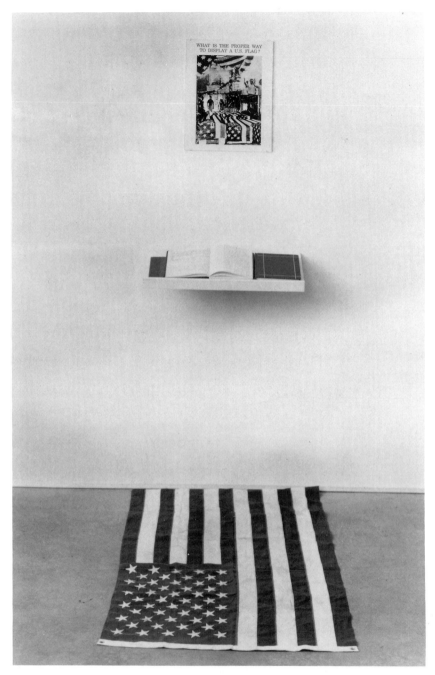

5. Dread Scott's mixed-media installation was deceptively simple and uncannily still—(6, 7) until the cacophony of audience replies made it truly interactive.

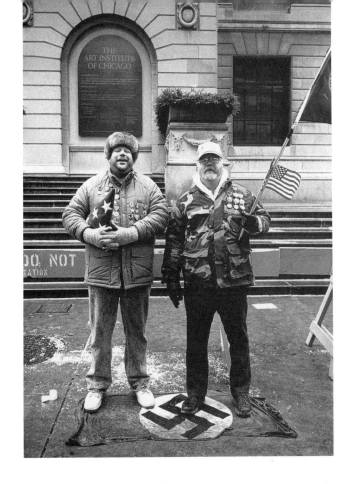
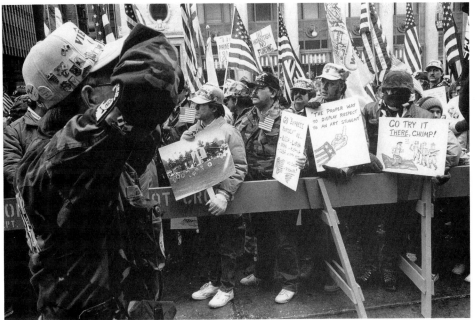

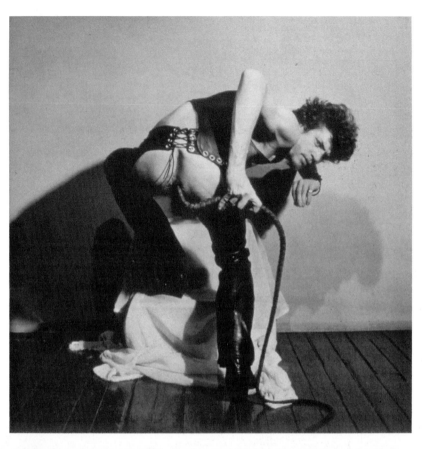

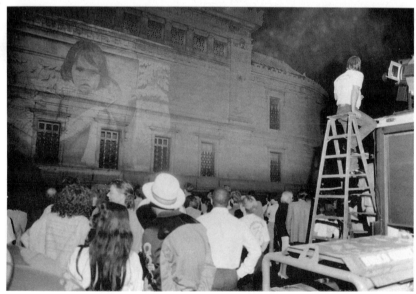

While some people argue that Robert Mapplethorpe (8, 10) subverted sexual and racial stereotypes, others claim that he regularly reinforced them. Political pressure exiled his work from exhibition at the Corcoran Gallery of Art in Washington, D.C., (9) but this punitive act also induced his defenders to appropriate the *outside* of the building for an uncommon, affirmative display.

**Robert Mapplethorpe (11) and Joe Ziolkowski (12) unapologetically de-
pict same-sex affection, relationships, and desire—both before and
during the age of AIDS—as do many of their contemporaries. But
such images frequently push people's hot buttons, even when eroti-
cism is not the primary intention of the artists.**

13, 14. David Wojnarowicz's collages are complex and multi-layered, densely packed with symbols and text. Enraged religious fundamentalists and politicians have simplistically interpreted and denounced this work; Reverend Donald Wildmon even extracted small sections to misrepresent the whole. Can *you* detect any offensive material?

"If I had a dollar to spend for healthcare I'd rather spend it on a baby or innocent person with some defect or illness not of their own responsibility; not some person with Aids..." says the healthcare official on national television and this is in the middle of an hour long video of people dying on camera because they can't afford the limited drugs available that might extend their lives and I can't even remember what this official looked like because I reached in through the t.v. screen and ripped his face in half and I was diagnosed with Arc recently and this was after the last few years of losing count of the friends and neighbors who have been dying slow vicious and unnecessary deaths because fags and dykes and junkies are expendable in this country "If you want to stop Aids shoot the queers..." says the governor of texas on the radio and his press secretary later claims that the governor was only joking and didn't know the microphone was turned on and besides they didn't think it would hurt his chances for re-election anyways and I wake up every morning in this killing machine called america and I'm carrying this rage like a blood filled egg and there's a thin line between the inside and the outside a thin line between thought and action and that line is simply made up of blood and muscle and bone and I'm waking up more and more from daydreams of tipping amazonian blowdarts in 'infected blood' and spitting them at the exposed necklines of certain politicians or government healthcare officials or those thinly disguised walking swastika's that wear religious garments over their murderous intentions or those rabid strangers parading against Aids clinics in the nightly news suburbs there's a thin line a very thin line between the inside and the outside and I've been looking all my life at the signs surrounding us in the media or on peoples lips; the religious types outside st. patricks cathedral shouting to men and women in the gay parade "you won't be here next year – you'll get Aids and die ha ha..." and the areas of the u.s.a. where it is possible to murder a man and when brought to trial one only has to say that the victim was a queer and that he tried to touch you and the courts will set you free and the difficulties that a bunch of republican senators have in albany with supporting an anti-violence bill that includes 'sexual orientation' as a category of crime victims there's a thin line a very thin line and as each T-cell disappears from my body it's replaced by ten pounds of pressure ten pounds of rage and I focus that rage into non-violent resistance but that focus is starting to slip my hands are beginning to move independent of self-restraint and the egg is starting to crack america seems to understand and accept murder as a self defense against those who would murder other people and its been murder on a daily basis for eight count them eight long years and we're expected to pay taxes to support this public and social murder and we're expected to quietly and politely make house in this windstorm of murder but I say there's certain politicians that had better increase their security forces and there's religious leaders and healthcare officials that had better get bigger dogs and higher fences and more complex security alarms for their homes and queer-bashers better start doing their work from inside howitzer tanks because the thin line between the inside and the outside is beginning to erode and at the moment I'm a thirty seven foot tall one thousand and one hundred and seventy-two pound man inside this six foot frame and all I can feel is the pressure all I can feel is the pressure and the need for release.

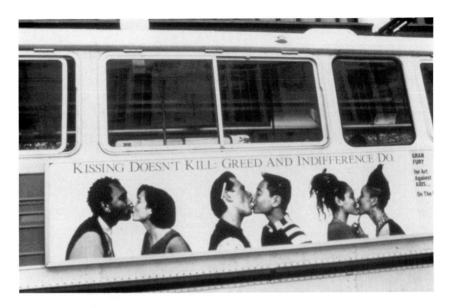

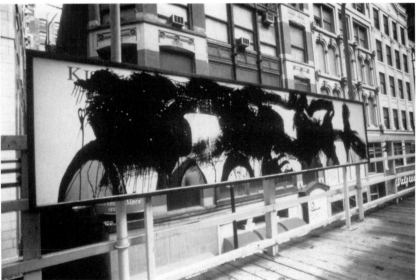

15, 16, 17, 18, 19. At the same time that artists incorporated **AIDS** and other social issues into many of their creations in the late 1980s and early '90s, adversaries rejected such messages with an arsenal of weapons, ranging from old-fashioned tarrings to high-tech pillories.

THE WAR
ON
HOMOEROTIC
ART

Senator Claiborne Pell, Chairman
NEA Reauthorization Committee
Subcommittee on Education, Arts & Humanities
United States Senate
Washington, DC 20510

David, Michelangelo, 1501—04

AIDS IS
KILLING ARTISTS
NOW HOMOPHOBIA
IS KILLING ART

INALIENABLE RIGHTS/
ALIENABLE WRONGS

Sept. 15 - November 15, 1989

A two-month dialogue by artists and art supporters in celebration
of freedom of expression in the arts.

Sponsored by Committee for Artists' Rights, Chicago Artists'
Coalition and **New Art Examiner**

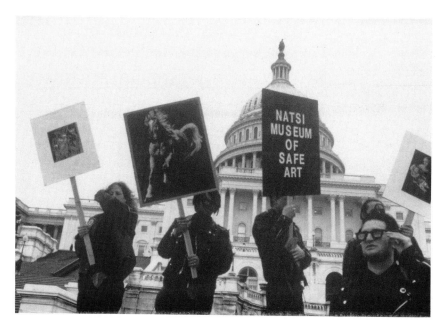

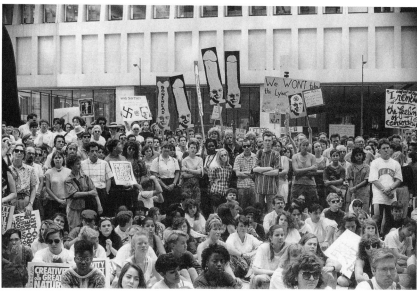

20, 21, 22, 23. Artists mounted a variety of counterassaults against those who attempted to censure them: they demonstrated in rallies throughout the country, and they creatively committed their beliefs to innumerable exhibitions, panel discussions and public walls.

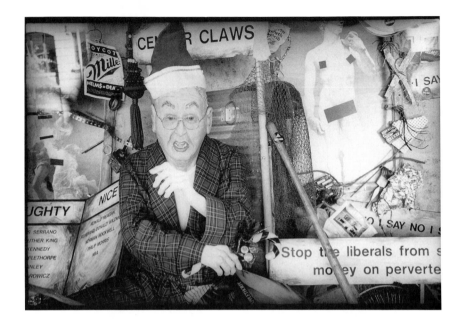

SEPARATED AT BIRTH?

Senator Jesse Helms... and Senator Joe McCarthy?

24, 25, 26. The repressive tactics of Senator Jesse Helms (**R-NC**) turned *him* into a singular target. Artists, either commercial or guerrilla in orientation, relentlessly skewered this politician.

HELMS' DEGENERATE ART SHOW

It is not the function of art to wallow in dirt for dirt's sake, never it's task to paint men only in states of decay, to draw cretins as the symbol of motherhood, to picture hunchbacked idiots as representatives of manly strength...Art must be the handmaiden of sublimity and beauty, and thus promote whatever is natural and healthy. If art does not do this, than any money spent on it is squandered.
 -Adolph Hitler

The self proclaimed, self anointed art experts would scoff and say, 'Oooh, terrible,' but I like beautiful things not modern art... There's a big difference between the 'Merchant of Venice' and a photograph of two males of different races (in an erotic pose) on a marble table top...If someone wants to write ugly nasty things on the mens' room wall, the taxpayers do not have to provide the crayons.
 -Senator Jesse Helms

27. Combining the music of Berlioz with images by Caravaggio, the social criticism of singer/songwriter Tom Lehrer with the graphics of ACT UP, Robert Hilferty recorded the evolution of a political demonstration from an inside perspective. His video brought the action out of the streets and into the living rooms of public television viewers—but only in those locales where Catholic opposition was surmounted.

be a perfect test case, particularly when Frohnmayer characterized the catalog as "political" rather than "artistic." According to Pico, "It brought out the weakest area of that law, which is the political value question. The heads of the NEA had come out specifically and named what their objection was, and it was something that was political. So that's the best possible case It's obvious control of political speech. Whereas when you're getting into [the] visual, it's a different ball game, and it's so much harder for the average person not from the visual arts to articulate anything about it; it's just not their language. But to criticize or reject funding on [the basis of] a political message or idea—I think they could have won the case."[41]

Wojnarowicz shared this sense of missed opportunity. He felt that Wyatt gave Frohnmayer too many chances to develop different rationales for his punitive action: "I confronted Susan and said, 'You're giving this guy all the room in the world to save face, from jumping from one position to another until he comes up with one that's successful. Why are you waiting [to press a lawsuit]?' " Wojnarowicz felt he was "sold out" by Susan Wyatt, and that Artists Space "collaborated" with Frohnmayer and the NEA. The artist did not believe that those in control of the situation cared about any violations of his right to free expression: "The majority of people who are in the more powerful galleries and museums, most of them could give a shit about civil rights, could give a shit about the First Amendment or anything of that nature. I know bottom line that if things were to get repressive enough that the only art they were allowed to sell were things like refrigerators, they'd be just as happy to sell a refrigerator—as long as they could command a half or three-quarters of a million dollars for it."

In the end, Wojnarowicz saw the administrators at Artists Space and NEA officials as masters of public relations, posturing and bluffing: they talked about artists' rights, but were not willing to fight for them if it could jeopardize their budgets. Many artists felt that Artists Space stumbled badly in this instance. As Steven Pico argued, "Artists Space could have stemmed the tide of this [government restrictions on content] and changed it legislatively. Now that they have not done that, galleries across the country are not going to take a stand in solidarity. They're going to be afraid to stand out as an individual institution and threaten their funding." Wojnarowicz concurred: "They [Artists Space] walk away with maybe one hundred thousand dollars [sic][42] plus their grant plus sending a message out to every institution not to touch this kind of stuff. . . . They certainly gain a great deal but who loses? People like me with a certain sexual orientation who want to speak [out]."

At least four key players, four distinct perspectives, and four instances of acting in accord with one's vested interests: this clash of viewpoints initiated an immense debate over "Witnesses," which lamentably misinterpreted the original intent of the organizers and participants. The show was conceived as a memorial and a consciousness-raising device. Of necessity it dealt with sexuality and social

commentary, which prompted critics to recast it as obscene or too political. More than two years later there was a resolution of sorts to the conflict. Frohnmayer faced a largely gay and lesbian audience during an angry town hall meeting in Los Angeles in January, 1991. The beleagured NEA chairman was forced to reflect upon what had happened at Artists Space and at a multitude of subsequent controversial sites. He then admitted "I screwed up" the handling of "Witnesses."[43]

FORKED TONGUES

While "Witnesses" did not provide a definitive test of the NEA "obscenity" clause, another opportunity to review public sponsorship quickly developed. A retrospective of David Wojnarowicz's work was being produced by the University Galleries at Illinois State University (ISU) in Normal, Illinois, little more than two weeks after "Witnesses" closed. "Tongues of Flame," an exhibition and catalog, were partially underwritten by a fifteen thousand dollar NEA grant awarded in FY 1989 (in the same cycle as the grant to Artists Space). In this case the catalog presented an extensive selection of the artist's writings. It included five chapters from his autobiographical work in progress, a sample of which had been submitted with the original NEA application. In this instance the argument that there had been a drift from the initial conception to the completion of the project would sound extraordinarily contrived.

One of the reprinted chapters was "Post Cards from America: X-Rays from Hell," Wojnarowicz's most recent written work. This material may have been barred from public support in New York, but neither the government nor the local sponsors were tempted to separate moral wheat from evil chaff in rural Illinois. It was all there, and all of it was supported by government funds.

The exhibit and associated events drew record crowds, favorable reviews, and the support of the university administration. It attracted the Mayor of Normal who found it "depressing" but not offensive, and then confirmed the validity of presenting it in this institutional setting.[44] There were, in fact, few local complaints. The gallery director noted that the type of work ISU students produced after the exhibit appeared was more socially oriented, and the organizing meeting of a branch of ACT UP was held in the gallery amidst the Wojnarowicz retrospective.[45] Yet, even though it met community standards in the heart of Middle America, and the NEA elected to be mute about the exhibit, certain people elsewhere took exception.

Representative Dana Rohrabacher (R-CA) raised the first formal objection. Rohrabacher sent a "Dear Colleague" letter to members of Congress nearly one month after "Tongues of Flame" opened, alerting them to the "orgy of degenerate depravity" the NEA was helping to sponsor at ISU. To Rohrabacher's eyes "The art is sickeningly violent, sexually explicit, homoerotic, anti-religious and nihilistic."

And he supplemented his dispatch with an image he cropped from the corner of Wojnarowicz's "Untitled (Genet)," depicting Jesus with a syringe in his arm.[46] Rohrabacher's message: this was an outrageous use of public funds.

Rohrabacher's tactic of zooming in on a section of a work and then holding it up to critical scrutiny is a familiar one. There was something comparable in the controversies over the play "Route 1 & 9" and the song "Killing an Arab." And the Reverend Wildmon then employed the same tactic in his own letter to members of Congress. His was more than two pages of dense tirade against the NEA as a patron of pornography, with innumerable misrepresentations of the NEA's procedures and intentions. It was supplemented by a pamphlet with a collection of 14 images extracted from works in Wojnarowicz's retrospective catalog. These were primarily, but not exclusively, from the "Sex Series."

In the "Sex Series" Wojnarowicz incorporated small portions of pornographic images into his collages, taken from magazines he found in the apartment of friend and mentor Peter Hujar after his death [see Plates section]. His was a democratic selection, drawing upon heterosexual as well as homosexual scenes. Wojnarowicz inserted them as circles at the edges of his work. Because they were darkened photographic negatives, they were extremely difficult to decipher. The following exchange from an interview with Nan Goldin, conducted while she directly viewed and explained the work in "Witnesses," confirms the ambiguous nature of this material:

NG: There is a heterosexual couple. I mean this is the most sexually explicit work in the show, these tiny little bubbles.

SD: Yeah, except it's. . . .

NG: Is that a homosexual or a heterosexual. . . .

SD: It looks like it's lesbian.

NG: It *is* lesbian.

SD: Yeah, that's lesbian.

NG: Well, maybe that's. . . .

SD: It's interesting that we can't tell.

But Wildmon presented fragments as if they were autonomous works, a conscious misrepresentation.

Frohnmayer angrily responded after he secured a copy of Wildmon's letter. He reminded the Reverend about the Biblical proscription against bearing false witness, and chastened him for implying that the NEA was a purveyor of pornography, or that the grant was approved *after* the obscenity measure was passed [it was not]. But he also distanced himself from Wojnarowicz's work: "The images are disgusting

and offensive to me, and undoubtedly to a large majority of the population. I have sworn to obey the law, and I intend to do just that. I would hope, that with procedures I am implementing at the Arts Endowment, images such as these would not again be funded."[47] It fell to Wojnarowicz to devise his own defense.

COURTROOM SHOWDOWN

David Wojnarowicz decided to fight back. With the assistance of a team of private lawyers and attorneys from the Center for Constitutional Rights, Wojnarowicz filed a million-dollar lawsuit against Wildmon and the American Family Association. The complaint included two counts of copyright infringement, defamation of character (libel), and violation of the New York Artists and Authorship Rights Act, and the Federal Lanham Act (prohibiting unfair competition). The complaint argued that Wildmon's actions reduced Wojnarowicz to "being a mere pornographer and not a serious visual artist."[48] It also alleged that Wildmon intentionally "mutilated" Wojnarowicz's material by presenting portions of his works of art as if they were complete. Wildmon did not label these images as details, even though they ranged from only 2.05 percent to 16.63 percent of the total area of the actual works.[49] Wildmon distorted Wojnarowicz's intentions, which could only emerge through the interplay of all the elements within his work.

The two men faced one another in court in June, 1990. Based on the testimony the judge heard, he issued a temporary injunction against Wildmon to stop publication of the disputed pamphlet. He requested that both sides then submit post-trial memoranda. Lawyers for plantiff Wojnarowicz argued that Wildmon's actions were calculated and intentional, and that Wildmon copied the most offensive images. They asserted that his misrepresentation would harm Wojnarowicz's career in the future: now characterized primarily as a gay pornographer, dealers and museums would not wish to be associated with him. Wojnarowicz's counsel maintained that their client's situation was different from that of Mapplethorpe and Serrano. They were both better-established artists when they became controversial—Wojnarowicz was merely "emerging"—and critics represented the work of the other two artists more accurately, albeit negatively.

The remedy Wojnarowicz's lawyers sought consisted of a permanent injunction against distribution of the pamphlet, a second mailing to the original recipients to correct the misrepresentations, a corrective ad in a major newspaper, and money damages.[50] At the end of the summer the judge authorized the first parts of the remedy, but awarded Wojnarowicz only one dollar. He claimed that libel had not been proven, nor had the damage to the artist's career been established. It was a symbolic but frustrating victory for Wojnarowicz, who quipped "I'll use it [the dollar] to buy either an ice-cream cone or a condom, depending [upon] how hot

I feel."[51] But this concluded an episode where he had been able to take a much more proactive stance than had been possible in the incident at Artists Space.[52]

SOUTHERN DISCOMFORT

A scenario that shares similarities with what occurred at Artists Space was played out in Richmond, Virginia, six months later. In both instances anxiety about sexual depictions caused critics to wrongly perceive artists' intentions. Carlos Gutierrez-Solano was one of twelve artists contributing to Coastal Exchange III, sponsored by the 1708 East Main Gallery in Richmond and the Arts Council of Richmond. His installation piece "In Memorium" was time- and site-specific: he designed it for this show as a tribute to three friends who had died recently of AIDS. Because this was an installation, it was the only work that was not prescreened by the sponsors. Inside the gallery, Gutierrez-Solano placed paintings of male couples on glass, a glass and neon funeral pyre, and an excerpt from an Edna St. Vincent Millay poem including, "Yet many a man is making friends with death/Even as I speak, for lack of love alone." The controversial element was painted in red on the gallery's front window: three larger-than-life nude men, with one sporting an erection before the buttocks of another man provocatively posed on his hands and knees. Gutierrez-Solano's final component presented three anti-gay and AIDS-phobic comments; for example, "If you want to stop AIDS, shoot the queers."

Almost instantly, the themes of grief and social intolerance were supplanted by the sexual motif. Angry callers complained to the gallery and to law enforcement officials. The zealous Richmond Commonwealth Attorney Joseph D. Morrisey advised gallery officials that they might be arrested on obscenity charges, so they covered parts of the window painting with plain paper. Thereafter, the installation truly became interactive. Its defenders wrote messages on the paper ("Silence=Death," "Come inside and judge for yourself"),[53] and routinely ripped the paper from the window overnight. People also plastered the perimeter of the window with pictures of renowned art works with black tape over their eyes, and posted anti-Morrisey posters around town.[54] A local art critic was not so supportive, however. He opined that Gutierrez-Solano's work was unworthy of so much attention, and argued "Nobody should be forced to see anything they don't want to see, and it's easy to say that this 'art' crossed that well-established line."[55]

The Arts Council of Richmond shared these sentiments and distanced itself from the exhibit. This organization was uneasy because of previous events: a controversial nude sculpture which was included in a show they coordinated at the local airport the previous year was removed because of public pressure, and their June Jubilee show had to be re-juried because it did not include any Black artists.[56] They wished to stay above this fray and so passed full responsibility for the exhibit over to the

1708 Gallery, a private, alternative space. The ACLU filed suit on behalf of the artist and the gallery, and a judge—who also happened to be an ordained Baptist minister—ruled that the work was not obscene and could be shown as it had been designed.[57] The magistrate obviously did not share the art critic's assumption that this work had transgressed a critical boundary. Rather, he judged it in its entirety, accepting sexuality as a legitimate part of a work addressing AIDS.

COLLECTIVE BARGAINING

The locus of the problems just recounted was individual artists showing their work in group contexts. But the AIDS epidemic has also invigorated an uncommon artistic species, the guerrilla-type arts collective. Their creations have been a part of the social landscape since 1986, when the now ubiquitous "Silence=Death" logo began to appear on Manhattan walls, lightpoles—nearly any available public surface. A number of these groups have evolved since the Silence=Death Project began, including Gran Fury, Art+Positive, Boy with Arms Akimbo, Helms's Angels, and Stiff Sheets. Such groups share some basic characteristics. First, their membership tends to be anonymous. These artists obstruct the penchant for valorizing a few creative individuals in our society; they simply refuse to make themselves known. Membership may change over time, as can the group's name.[58] This parallels the notion of the "death of the author" in postmodernist theory, and helps insure that primary attention will be directed towards the work, not an heroic, inspired individual.

Second, these are cooperative ventures. As one participant in Akimbo stated, "We brainstorm collectively so that we won't be limited to one person's view-point."[59] And nothing is off limits, either because of the subject or the "ownership" of an idea or image. According to Douglas Crimp, this strategy of appropriation dictates " 'If it works, use it' or 'If it's not yours, steal it.' "[60] Finally, the primary tactic is confrontation, and the principal goal is social change. This is not art which prettifies or pacifies.

Gran Fury, the graphic arts affiliate of ACT UP, is the best known of these groups. Their history and output is recorded in *AIDS demo graphics*, a catalog of activist art created in response to the epidemic. Their work incorporates essential information, accusations of official malfeasance, condemnations of apathy and discrimination, and self-affirmation. Their "in-your-face" posture undoubtedly has heightened public awareness of AIDS. It has also spurred a number of clashes.

The New Museum of Contemporary Art in Lower Manhattan sponsored a watershed AIDS exhibit in 1987, "Let the Record Show." An ad hoc group took the Silence=Death logo and the spirit that animated it as the basis for a window installation. This occurred in a supportive institution in an open-minded part of the city. The working relationship between the artists and the museum was

amicable, and the public response was positive. That ad hoc group then became Gran Fury, an eleven-member collective whose works became controversial elsewhere.

At the same time debate raged over "Witnesses," another dispute was erupting across town. The Henry Street Settlement is located not too far away from Artists Space. But one establishment is in an area formerly occupied by manufacturers and wholesalers and now home to many artists and their institutions, while the other is a nearly century-old settlement house located in the midst of what is still a densely populated low-income area. One is an alternative art space, the other a social service agency. Organizers at both sites planned AIDS art shows which would coincide with the first Day Without Art, a national day of action and mourning. Yet neither of these exhibits proceeded smoothly.

Humberto Chavez was invited to curate an exhibit of works by 47 artists and art groups called "Images and Words: Artists Respond to AIDS." Gran Fury, apropos their manner of working in public contexts, designed a banner reading "All People With AIDS Are Innocent," with a caduceus underneath. They intended to display the eight-by-twelve foot banner across the front of the Henry Street building. It seemed like a powerful, yet subtle humanitarian statement. However, Chavez and Gran Fury claim they were told by the head of the Arts for Living Center at Henry Street that the banner was "too political" and that it would not be well-received by conservative members of the community.[61] No specific names or groups were ever identified, but Chinatown and a large Orthodox Jewish population are included in the ethnic mix of this area. Both communities tend to be conservative on issues such as sexuality.

Settlement house officials stated that banners were never allowed on the outside of the building, although sculptures were displayed there at that very time. This therefore raised questions about the banner's status as "art" and Gran Fury's legitimacy as an artists' collective. In frustration over the squabbling, which also resulted in the official refusal to display Gran Fury's work in windows facing the street, the curator decided to cancel the show and scout for another location.

It's ironic that such a problem should arise at Henry Street Settlement. AIDS outreach is an important component of the programming for this Lower East Side institution, as are the arts. And this is not restricted to "arts and crafts": when the Armory Show was reconstituted on its fiftieth anniversary, Henry Street was one of the sponsors.[62]

Other arts officials intervened to help work out a compromise to allow the exhibition to proceed. They helped secure a City permit to display the banner over the street, outside the settlement house. Like the counterpart situation at Artists Space, these artists had little affinity with the sponsors. The artists held tightly onto their principles, relatively unconcerned with the tolerance level of hypothetical audience members. As one of the artists in the show remarked, "Henry Street wanted to do the right thing, which is have a show on AIDS. It's

fashionable and correct and good. And they want to soft pedal it. And they think they can have it both ways, but you can't soft pedal AIDS."[63]

But the organization seemed to be wary, even though it undertook the project with the best intentions. Such attitude shifts stem from anticipating problems of local accommodation over the long haul. And in this instance there was a particular logic that likely operated behind the scenes. Henry Street had future plans to locate an AIDS hospice in the area. Similar plans elsewhere frequently have drawn out enormous fears and anger, what is now known as the NIMBY syndrome: Not In My Backyard! Gran Fury's artistic statement of compassion for otherwise despised groups (intravenous drug users, homosexuals) could have congealed the opposition prematurely, had it been displayed with Henry Street's sanction. Henry Street is a venerable institution which chose the conservative course in this instance, perhaps opting to save its resources for larger battles.

Gran Fury faced a more protracted problem with the display of one of their images in Chicago. The collective was asked to participate in "Art Against AIDS," a national fund-raising effort sponsored by the American Foundation for AIDS Research (AmFAR). Art Against AIDS had already raised several million dollars in New York and Los Angeles, primarily through galas and auctions. There was a similar elite emphasis in Chicago, with a formal dinner dance and a tie-in with the annual Chicago International Art Expo, where the exhibiters were asked to donate a portion of their earnings. However, a public art component was also added. "On the Road" was mounted in cities such as San Francisco, Washington, D.C. and Chicago to increase AIDS awarness and also spotlight both national and local arts talent. This meant placing images on billboards, exterior bus panels, interior bus and subway cards, bus shelters, etc.

Gran Fury contributed a slick design evoking ads for the "United Colors of Benetton," the upscale clothing manufacturer. The poster presents three couples kissing underneath the tag line "Kissing Doesn't Kill: Greed and Indifference Do" [see Plates section]. The duos are interracial, and represent heterosexuals, gays and lesbians. The banner was shown at the Whitney Museum in 1989 as part of "Image World: Art and Media Culture." It was prominently displayed so that it could be seen by passersby on Madison Avenue.[64] AmFAR modified the poster from that presentation; they dropped the additional logo of "Corporate Greed, Government Inaction and Public Indifference Make AIDS a Political Crisis." Even so, its proposed showing in Chicago mobilized some familiar, vocal opponents.

Local and state political leaders and some officials at the Chicago Transit Authority (CTA) initiated a campaign against its public display. CTA officials demanded that a disclaimer be attached to the posters, but this was objectionable to Art Against AIDS since they were already printed. Then, at the eleventh hour, CTA officials claimed they had a commercial customer for the space. The local ACT UP affiliate was displeased and threatened to disrupt CTA operations if the posters did not appear. ACT UP was already angered that Governor James

Thompson and Mayor Daley had been appointed honorary co-chairmen of the local Art Against AIDS effort. There was also the memory of events in the preceding year: the CTA refused to display a safer sex series sponsored by the Kupona Network, an AIDS couseling and education organization primarily serving the Black community. The ACLU threatened suit, and that series was eventually hung. ACT UP had staged public demonstrations previously against the CTA's general inattention to disseminating AIDS information, and was poised to do so again.[65]

In the Chicago City Council, Alderman Robert Shaw—one of the prime movers against the painting of Mayor Washington—grandstanded against Gran Fury's work. He railed that it was indecent and would recruit children to a deviant lifestyle. Shaw suggested the possibility of a boycott of the CTA by the Black community if the posters appeared, and also sought to enact a resolution denouncing them during a special Council session in August. But only a handful of aldermen showed up: Mayor Daley was missing, and reportedly told his supporters to also absent themselves. Even if the resolution had passed, it would have been only advisory.

Shaw echoed a State Representative who rebuffed the poster as "a subtle seduction of young people on the CTA."[66] In June the State Senate passed legislation prohibiting "physical contact" or "embrace . . . within a carnal, erotic, or sexual context by members of the same sex in advertising on vehicles that carry individuals under age 21." In the House, however, one Representative skillfully blocked the bill's consideration on a technicality, forestalling any reconsideration until after the AmFAR campaign was completed.[67] Although these proposed legal restrictions were stymied at two levels, they sustained the controversy at a high pitch.

Mike Royko managed to whip emotions up a little more with a column where he proposed that the poster was a disingenuous "plug" for the "gay lifestyle": "I suggest the creators of the poster cut out the con job, with the kissing and the talk of greed and indifference. . . . [Instead] Show a . . . couple of guys in a bathhouse."[68] ACT UP retaliated with their own anti-Royko broadside. The impasse was finally broken when a circus reportedly dropped its CTA advertising order, thereby freeing up space for Art Against AIDS. But less than twenty four hours after the Gran Fury poster was first displayed, someone defaced them with tar or in some cases tore them down from elevated train platforms and buses [see Plates section]. This was a shocking finale to an extended struggle.

Gay leaders decried the vandalism, likening it to the practices of cross-burning, tar and featherings, and lynchings. But the Illinois Right-to-Life Newsline christened this renegade "the Captain of Decency" on their phone message, and the Pro-Life Action News counseled their callers to boycott the CTA, which they proclaimed "a moving mortal sin."[69] The defacement raised neither ire nor approval from the administrators of Art Against AIDS/On the Road. They chose not to focus on it, feeling it diverted attention away from the issue of AIDS awareness and prevention. They were nonplussed that the controversy kindled reporters'

interest more than the project and its purpose. Previously there had been problems with the use of images by Adrian Piper and Robert Mapplethorpe in the Washington, D.C. endeavor, but the Art Against AIDS project also sought to minimize the controversy there.[70]

The negative reaction in Chicago was disturbing to the artists involved, but it was intelligible; as one of Gran Fury's members commented, "Never have we been so visible. What that has meant is that there's more forces opposed to us that we must fight back against."[71] Such scenarios have become somewhat routine because of the adversarial nature of much of Gran Fury's work. Recall, for example, the difficult reception the group encountered at the 1990 Venice Biennale (see Chapter Four).

Gran Fury ceaselessly broadcasts a radical message. When the collective General Idea appropriated Robert Indiana's now hackneyed $\begin{smallmatrix}LO\\VE\end{smallmatrix}$ and transformed it into $\begin{smallmatrix}AI\\DS\end{smallmatrix}$ for a public AIDS awareness campaign, Gran Fury reconfigured it once again, to $\begin{smallmatrix}RI\\OT\end{smallmatrix}$ In 1991 they returned to the highly visible windows of the New Museum to collaborate with Prostitutes of New York (PONY) on an AIDS-education display. This work included a "Love-O-Meter" surrounded by breasts and penises and describing the services that sex workers provide. The exhibit also included sex-positive videos, encouraging safe sexual activity in an era when many people are anxious about having sex. And also in 1991, they brought their distinctive blend of commercial advertising techniques and political commentary to another public poster campaign, "Women Don't Get AIDS, They Just Die From It." Here they highlighted how stringent CDC guidelines fail to recognize AIDS-related illnesses typically striking women but not men. Their messages often provoke disapproval from a priggish public while their agit-prop techniques inflame some art world purists.[72]

VICTIMS OR COMBATANTS?

Some artists and their supporters have themselves expressed dismay at certain representations of AIDS. Perhaps this is inevitable. Because of all the difficulties artists have encountered when they have confronted the disease in their work, and because images not only reflect but help to shape reality, AIDS activists have converted loss and grief into proprietary claims, attempting to assert "ownership" over this domain. After all, they have a great deal at stake over how and to what extent the epidemic is portrayed for the public. This was demonstrated most clearly through their reaction to the documentary work of Nicholas Nixon.

Nixon's photos of people with AIDS were shown at the Museum of Modern

Art in 1988. Nixon focused on the physical ravages of the disease: the ghastly skin lesions, wan bodies and sunken spirits. ACT UP contested this approach. The group felt Nixon dwelt on isolated and defeated victims, not on the political concomitants of the disease, and not on those fighting back against disability and discrimination. They picketed the MOMA show, and handed out a leaflet entitled "NO MORE PICTURES WITHOUT CONTEXT." They insisted that AIDS was not tantamount to a death sentence, and demanded the visibility of PWAs [People with AIDS] who are "vibrant, angry, loving, sexy, beautiful, acting up and fighting back."[73]

Other people shared the negative appraisal of documentary photographers entering the world of the PWA, capturing some aspects of it, and then moving on to whatever subject might next pique their curiosity. But these same objections called out different strategies. One was to evade direct depictions of AIDS or PWAs. That was the approach of a large show "The Indomitable Spirit," organized under the auspices of New York's International Center of Photography. Nearly one hundred photographers were invited to submit work that revealed human strength and compassion in the face of adversity. Most of it was not done directly for the exhibition, therefore yielding a mishmash of images: a majestic cheetah in the jungle, a portrait of Elizabeth Taylor, a victim of a long-ago shark attack, an Andres Serrano abstract photo of the trajectory of a male ejaculation. Each print was reinterpreted to fit this context, and the explanatory cards verged on the inane in many cases. The show was unfocused and maudlin, and missed the mark by failing to communicate anything consequential about AIDS.

Nan Goldin chose a different course. She, too, objected to Nixon coming from the outside and creating sensationalistic images. Goldin did not have that option: "I guess it's enviable that he can walk away from it and so many of the people and myself can't, either because of our own HIV status, or because of our friends' HIV status, or because of the number of our friends that have died this year." Goldin's personal commitment was to support art coming directly from people's experiences. Nixon's voyeuristic approach subliminally helped direct Goldin's selections when she assembled "Witnesses," so that Nixon's portfolio would not be *the* representation of the epidemic, but merely one of many. Her policy was not therefore one of intolerance and exclusion, but instead allowed for expanding the range of portrayals available.

Goldin's was an unusually reasonable voice in the passionate struggles over images between increasingly dogmatic adversaries. We need to look more closely at the conservative reaction to art in the late 1980s and early '90s, and then examine the varied responses of artistic communities to this censure.

9

DEFENDERS OF THE FAITH: TWENTIETH CENTURY PURITANS AND CONNOISSEURS

The death-dealing powers of strychnine
are the same whether administered as a
sugar-coated pill or in its natural state.
<div align="right">Anthony Comstock, 1883</div>

I would rather give a healthy boy or a
healthy girl a phial of prussic acid than
this novel [Radclyffe Hall's *The Well of
Loneliness*]. Poison kills the body but
moral poison kills the soul.
<div align="right">James Douglas, 1928</div>

A bottle of poison with a different label
is still a bottle of poison. [re: the NC17 film rating]
<div align="right">Reverend Donald E. Wildmon, 1990</div>

It is tempting to draw parallels between moral crusades of the past and
the present. Their rhetoric definitely invites comparison, as the above epigrams
demonstrate. But as much as today's campaigns exhibit continuity with those
which preceded them, they also display distinctly contemporary qualities. Today's
ethical strategists must tailor their schemes to combat evils that would only be
hinted at in the past. They have targeted different media and employ new
techniques to sway public opinion. While the current struggles do evoke a sense
of deja vu, they are not merely benign replays of history.

The curmudgeonly social commentator H. L. Mencken remarked after the
Scopes trial[1] in the 1920s, "It is too early, it seems to me, to send the firemen
home. . . . The fire is still burning on many a far-flung hill, and it may begin to
roar again at any moment Heave an egg out of a Pullman window and you
will hit a Fundamentalist almost anywhere in the United States today."[2] As it turns
out, the coals have remained hot throughout this century. Religious leaders,
politicians, cultural critics, and occasionally others have stoked them into the

flames that flared up in the late 1980s. All these judges were armed with the bellows of orthodoxy, whatever the particular doctrines they were defending.

Many of those who lead drives against art fit Howard S. Becker's classic definition of moral crusaders. These social actors are profoundly disturbed by other peoples' conduct and earnestly set out to do something about it. Their point of view is characteristically "elitist," whatever their actual social origins: they know what's unquestionably right, and wish to impose their beliefs on the unenlightened or the recalcitrant. Their objective is to get their doctrines encoded into regulations so that they will have the force of law behind them. These rule creators frequently generalize their efforts beyond their original source of discontent, and their successes authorize the empowerment of rule enforcers.[3]

Sometimes individuals or organizations become synonymous with their moral crusade. The Women's Christian Temperance Union (WCTU) is indistinguishable from the late nineteenth- and early twentieth-century campaign for Prohibition, for example. And the names of Dr. Thomas Bowdler and Anthony Comstock—both vigilant protectors of public sensibilities in the nineteenth century—have been turned into eponyms for their censorious actions. They were determined that art and literature (high and low, fiction and nonfiction) be cleansed of obscene elements. In post-World War Two America it was the tireless Frederic Wertham, M.D., sounding the alarm about sex and violence in popular culture: "Educated on comic books, they [juvenile delinquents] go on to a long postgraduate course in jails. . . . comic books represent systematic poisoning of the well of childhood spontaneity."[4]

These campaigns resulted in legal restrictions as well as the enactment of self-regulating production codes (in the motion picture and comic book industries, for instance). Some of the formal constraints brought about by these movements and ardent evangelists of purity have since been revoked or modified to reflect changing social conditions. However, they precipitated decades of struggle and repression, and seriously hampered the creation and dissemination of a wide variety of cultural materials. The battles over "obscene" literature are now largely over, at least as pertains to adults. And the self-monitoring of the movie industry requires only sporadic fine-tuning. But conspicuous individuals have emerged to induce other controversies more recently. Such modern moral entrepreneurs have concentrated primarily on different creative domains, where repressive structures have never been erected. Although some of the most important recent art controversies have resulted from spontaneous actions (for example, the Washington/Nelson affair), others have been cannily managed by familiar commanders and established organizations.[5]

THE "GREAT WAR" AND A CHRISTIAN CRUSADER

The Reverend Donald E. Wildmon is a meek man who has inherited the crusading mantle of several of his notorious predecessors. He sees himself as the

little guy fighting against the Goliath of modern moral corruption, in the tradition of Biblical warriors. With a self-deprecating manner Wildmon recounts wearing a J. C. Penney suit the first time he flew first class. He was the guest of television network executives in Los Angeles, on an adventure where he characterized himself as "like a Mississippi catfish out of water."[6] He, too, is a sinner, but only recalls misdeeds of adolescence: speeding tickets, smart-aleck remarks to a high school English teacher, and stealing a watermelon. Wildmon adopts a folksy style of writing—he uses "Brrrrrr!" to describe a wintry scene of picketing a 7-Eleven store for its vending of alleged pornography—to insure his identification with real people and real sensations.[7]

Wildmon has been a reluctant warrior since his moment of epiphany: just before Christmas of 1976, he was relaxing one evening in his recliner before the fireplace. His dog was by his side, his wife and a daughter were washing the dinner dishes. The world, and his Mississippi home, seemed at peace. But when his spouse and four children joined him before the television set, that tranquility was shattered: all three channels were blasting profanity, violence and sex into the Wildmon den. The shock of that moment set him on his moral crusader's course.[8]

We have already seen some of the activities Wildmon has undertaken. He threatened and initiated boycotts against "The Last Temptation of Christ" (MCA/Universal), *Sunday Dinner* (CBS/Norman Lear), and Madonna (Pepsi). He mounted massive letter-writing campaigns against NEA support for artists Andres Serrano, Robert Mapplethorpe and David Wojnarowicz. In addition, Wildmon attacked NBC for showing the first lesbian kiss on *L.A. Law,* led a boycott against Waldenbooks (the largest US book chain) and its parent company K-Mart because they sell *Playboy* and *Penthouse* magazines, and pressured Blockbuster video (the largest video retailer) not to stock NC–17 rated films. One of his oddest preys was an episode of CBS's *Mighty Mouse: The New Adventures.* Wildmon claimed that he saw Mighty Mouse snorting cocaine, whereas creator Ralph Bakshi insisted it was the odor wafting from a chunk of cheese, or crushed vegetables and flowers. Even though Wildmon initially directed his campaign for decency towards the commercial realm, he now moves easily between targeting the marketplace and government sponsorship, fine art and commercial culture. He complained "We're spending 175 million dollars in this area [the arts, via NEA] that benefits primarily the rich and perverted."[9]

The engine of Wildmon's diverse actions is the theory of a "great war" between incompatible world views. On one side is Christianity, and on the other, "secular humanism." The stakes in the inevitable clash between these doctrines are enormous: the future of the United States, nay, the fate of all of Western civilization in the long run. Fundamentalist Christians characterize secular humanism as a "religion" that "denies God and deifies man."[10] This makes man the measure of all things and renders all values relative. Therefore suicide, abortion, euthanasia and nonprocreative sex become permissible; there are no moral absolutes to keep

such behaviors in check. As an elderly Arkansas woman suggested, "We've raised a generation of children who think the Ten Commandments are the 10 suggestions."[11]

For Wildmon, television (and the media in general) is the mouthpiece for this socially destructive creed. More accurately, he proposes an interesting sexual division in his book *The Home Invaders*: pornography broadcasts this message to men, while television panders to women and children.[12] Pornography comes from "the Evil One," and viewers can be "hooked with one look."[13] Television and other forms of entertainment target the most vulnerable, often in their own homes.

Wildmon hectors his readers with the repetition of ideas and phrases. He punctuates his prose with insinuations and he converts suggestions into proof by shrouding them with a thin patina of scientific "fact." He discloses a well-developed sense of persecution: he concludes that "anti-Christian" bias is rife in the media, and that the values of Christians are being seriously compromised. Wildmon takes his sense of stewardship seriously; the content and cadence of his books are not unlike hellfire-and-brimstone sermons.

Different fundamentalists concentrate on various other ills and venues. Some target schoolbooks, especially since the classroom has become a place where prayers are no longer allowed. Others cite *Roe v. Wade* as a triumph of secular humanist values over morality, and gay rights ordinances represent a legal endorsement of homosexuality as normal and legitimate. In all these instances there is the sense of apocalypse: diabolic powers of darkness have been unleashed, and they must be reigned in to avert the total destruction of society.

This position was dramatically represented in a *New York Times* op-ed piece by the president of a group that specializes in textbook reform. He wrote a gleeful farewell to a Manhattan cable channel specializing in sexual material that was being forced from the air: "the internalized constraints and taboos that created boundaries of civil action inside the First Amendment have all but disappeared. . . [because of television]. New appetites and temptations have cascaded into the dreams of plant managers, keyboard operators and baby sitters. A disturbing drift has occurred. What was derided, suppressed or forbidden not so long ago has become ordinary and expected. Main Street grows a little weirder."[14] The intolerance of diversity, the fear of social chaos and the insistence upon traditional restraints, and the confusion regarding cause and effect all typify the fundamentalist view.

Never mind that the constitution guarantees separation of church and state. Wildmon and his coreligionists are resolute that Christian ethics be the bench mark for how Americans conduct themselves. He has parlayed his beliefs into a behemoth pressure group, the American Family Association (AFA, formerly the National Federation for Decency, founded in 1977), with hundreds of local affiliates. The Tupelo, Mississippi-based AFA raised 5.2 million dollars in 1989, largely via appeals made through two radio programs and its monthly magazine, with a reported distribution of 380,000.[15] Wildmon was named "Marketer of the Year"

by *AdWeek Magazine*; his efforts have brought earthly prizes at the same time that he tends to his spiritual duties.[16]

TRADITIONAL TARGETS; TRADITIONAL TACTICS

Donald Wildmon's *AFA Journal* is a monthly compendium of the excesses of secular humanism. It regularly features summaries of immoral or anti-Christian themes in television and movies; accounts of heinous crimes that are indeterminately linked to the use of pornography; and special reports on religious and social topics. In tandem with spotlighting offensive material, the AFA also prescribes action: it identifies network officials and commercial sponsors of television episodes, easily enabling AFA members to write directly to them to register their indignation. The *AFA Journal* is reminiscent of the *Malleus Maleficarum*, published by the Catholic Church in 1486. In essence this was a textbook which amassed evidence to aid Inquisitors in recognizing witchcraft, and dictated suitable punishments. The devil may have become more technologically sophisticated in our own day, and the church hardly has the political power it did in Medieval Europe. But the methods, motives and mindset of all these religious crusaders are startlingly similar.

So is the room for error. The *Malleus* relied upon anecdotal evidence, reported in a climate of fear by those who wished to bolster the Catholic Church's strength in a time of dramatic social change and apostasy. The writers of the *Malleus* saw witchcraft as an "undisciplined religion," a negative mirror image of the true faith—and a competitor. Witches were "the bane of all social order," "a vast revolutionary body." This book highlighted who was the most vulnerable to the witches' influence, what types of malevolent things they did, and how they were a contagious threat to traditional morality. The Inquisitors who followed its guidance also unjustly persecuted many people, especially women whose changing roles and status made them ambiguous creatures.[17]

Wildmon and his confederates exploit unsubstantiated assumptions and hearsay. When they report sex crimes they frequently add that the culprit *allegedly* consumed pornography, or that a violent offense *seemed* analogous to one which had been recently televised. But they never establish causality, they merely imply it. Sometimes there is no verification that a perpetrator even saw the supposed "trigger" material, for example. Their repetition of similar stories from nationwide sources creates the impression that there is, indeed, an uncontrolled epidemic of sexual violence of enormous proportions.

The AFA media observers employ a jaundiced perspective, and they often screw up their reports as they try to validate their viewpoint. One example will suffice. The AFA account of a *thirtysomething* episode was introduced by the sensationalistic headline "Campbell Soup, Corning ads on ABC show with promiscuous, perverse sex." It first noted that the two homosexual characters exchanged a kiss on the

cheek and a hug at a New Year's Eve party: "again portrayed as if their aberrant lifestyle is normal." That was the extent of their physical intimacy. It goes on to misattribute one of the major character's actions to another, and reports that "Gary disappears from the party leaving his baby (by some other woman) in Melissa's care."[18] That 'other woman' was none other than Suzanne, Gary's wife!

By presuming that illicitness pervades television programs, the AFA overlooks more conventional behavior even when it is apparent. The AFA strains its credibility with such ruses. These inaccuracies are not anomalies, but distinguish the organization's modus operandi. For example, a full-page ad the AFA took out in the *Washington Times* and other papers to berate the NEA for its support of Annie Sprinkle was markedly disingenuous. The text was replete with factual errors and misrepresentations.[19]

Wildmon and the AFA also ape strategies devised by more contemporary allies. Jerry Falwell and other evangelists perfected the art of direct mail in the 1970s and 1980s, and Wildmon has become a pro. When Falwell's Moral Majority solicited funds to continue its battle against homosexuality (among other social ills), it would include "scare packages." These were sealed envelopes emblazoned with warnings: "CAUTION: CONTENTS OF THIS MATERIAL MAY BE HARM-FUL TO MINORS!" Inside were depictions of homosexuals, albeit not explicit ones.[20] The *New York City Tribune*'s Walter Skold prefaced his four-part expose on Franklin Furnace and other "misappropriators" of NEA funds with a similar note of forewarning, as did Reverend Wildmon when he sent out his severely cropped versions of David Wojnarowicz's art work. Pat Robertson apologetically included them in a red envelope he urged recipients to destroy posthaste. And Jesse Helms invited male guests at a barbecue fund-raiser for his reelection to look at some of the disputed NEA-supported photographs. He advised them, "you won't want to look long because you just ate and you could get sick."[21] Exhibitionism in the service of loftier ideals puts moral entrepreneurs into the paradoxical position of trafficking in the very stuff they despise. But they routinely do it behind the fanfare of these discretionary prologues.

It is difficult to assess the effectiveness of Wildmon and the AFA. His power is informal, extra-legal. He claims victory when it is not necessarily his, or when he scores only hollow victories. In 1990, in alliance with Christian Leadership for Responsible Television (CLeaR-TV),[22] the AFA targeted Burger King as one of the leading sponsors of sex, violence, profanity and anti-Christian stereotyping on television. Burger King officials met with representatives of CLeaR-TV, even though the corporation maintained that the boycott against them had had no impact on revenue. As a result of these meetings, Burger King ran ads in several hundred newspapers affirming its commitment to "traditional American values" and the family.[23] It was a startling, and seemingly apparent victory by Wildmon et al.

However, Burger King maintained that it was not changing its advertising policy,

and in fact quickly thereafter sponsored the television movie "The Stranger Within." The film included the featured character "shooting at the family dog, drowning his mother's boyfriend under the ice, [and] attempting to bury her and a policeman alive." The company verified that the presentation fit within their guidelines. Wildmon, on the other hand, reported the Burger King campaign as the AFA's number one accomplishment in 1990.[24]

Wildmon also launched the aforementioned boycott against Blockbuster Video to force the widespread chain to refuse to stock NC–17-rated videos. Company officials claim they received less than one thousand preprinted AFA postcards on the issue. In addition, they found that when they called some of the complainants that these people were not actually their customers. Blockbuster did decide to bar these videos, and it is difficult to know to what extent such a vocal pressure group as the AFA might have influenced the final decision.[25]

The AFA and similar groups are dogged trackers of a multitude of contemporary evils. They likely have some impact by causing others to adopt defensive and evasive strategies. But their rhetoric routinely exceeds their achievements. Such was the case in October, 1991, when a coalition of groups, including Morality in Media, the American Family Association, Americans for Responsible Television, and the National Coalition Against Television Violence, endorsed "Turn Off the TV Day." Their protest against excessive sex and violence miscarried: Americans sat before their sets in *greater* numbers on the critical date than they had on that day the year before.[26]

CHRISTIAN BROTHERS

The American Family Association was a seasoned organization before Andres Serrano began his artistic investigation of bodily products and religious themes. Artists exploring provocative subjects under government largesse provided a splendid, fresh opportunity for Donald Wildmon and others to ply their moralistic trade. Even though Wildmon's name may have become a familiar one in recent years, he does not act alone. He is one of a loose collection of fundamentalist leaders whose public fortunes ebb and flow. In 1981, for example, he teamed up with Jerry Falwell in the Coalition for Better Television. It was an association of like minds but colliding egos, so this turned out to be a short-lived alliance. Nevertheless, in spite of differences in personal style and some special obsessions, these fundamentalists have a great deal in common.

When writer Perry Deane Young attended a Moral Majority training session in 1981, he discovered many of the elemental tactics that fundamentalists use to mobilize support for their causes. Two precepts were key: "People give [money] against, not for," and "People give because somebody hit their hot button."[27] Those notions have been borne out in countless moral battles and are shared by the

"community" of crusading religious leaders. One button they have been pushing with a Pavlovian zeal is that of sexuality. The dramatic emergence of gay themes in contemporary art has provided a ready target for grandstanding ethical guides.

Dr. James Dobson, founder and director of the Pomona, California-based Focus on the Family, is a prime example of such evangelical leaders. Dobson is a psychologist who built a fifty-sixty-million-dollar empire upon his theories of child-rearing and his cultural criticism. Dobson's authoritarian approach to parenting counsels stern discipline, a rebuttal to the permissiveness of Dr. Spock that he details in more than ten books. His first, *Dare to Discipline*, has sold over two million copies, and his radio broadcasts and magazine reach millions of people. Dobson detects the same conflict between religious and secular values that Reverend Wildmon and Representative Dannemeyer do. In fact, when an excerpt from Dobson's *Children at Risk* appeared in the *AFA Journal*, it carried the title "The second great civil war," duplicating the imagery Dannemeyer employed in his own book.[28] In this selection Dobson deplores the erosion of traditional restraints, especially within the cultural and political arenas since the 1960s. It is an indictment which highlights the destructive features of popular culture, sexual freedom, and sexual variety.

Dobson may be an important fundamentalist theorist, but he is also a man of action. In 1985 and 1986 he was a member of the Meese Commission, the group whose verdict against obscenity and pornography now undergirds a legislative and judicial assault on a wide variety of expressive material. He also conducted a death row interview with mass murderer Ted Bundy, aired on the tabloid TV show *A Current Affair*. In that encounter Bundy tried to absolve himself by shifting the blame for his abhorrent actions onto the irresistible allure of pornography. Bundy, ever the slick sociopath, provided melodramatic confirmation of many fundamentalist beliefs.[29] And finally, Dobson had an indirect hand in initiating one of the most bitterly fought contemporary cultural battles, the obscenity prosecution of the rap group 2 Live Crew for their album "As Nasty as They Wanna Be." In 1989 a Focus "youth culture specialist" transcribed the lyrics and counted the number of obscenities and sexual references in this music. He sent his report to people nationwide, it was picked up by Reverend Wildmon, and eventually made its way to Miami lawyer Jack Thompson. Thompson then sent copies to Florida's Governor and local sheriffs, one of whom—Broward County's Nick Navarro—instigated legal proceedings against the musical group.[30]

The Reverend Louis Sheldon oversees a much smaller operation, the Coalition for Traditional Values in Anaheim, California. But his position is a familiar one. Sheldon has targeted the evil of homosexuality in particular. In 1989 he sponsored a symposium where William Allen, then chairman of the US Civil Rights Commission, delivered an address with the scandalous title of "Blacks? Animals? Homosexuals? What is a Minority?" He has spearheaded campaigns against local gay rights

ordinances in several California communities, with some success. He also appealed (unsuccessfully) to Health and Human Services Secretary Louis Sullivan to stop sex and AIDS education in schools, and to establish a national center where homosexuals could be "cured."[31] Sheldon's concern about the "triumphs" of secular humanist values led him to establish an umbrella group of other conservative organizations, Taxpayers for Accountability in Government. He has used that group to channel his outrage over the NEA's sponsorship of certain works— especially those with homosexual themes—and maintains a lobbying office in Sacramento to exercise his political muscle.[32]

Pat Robertson, a venerable moral crusader, inaugurated the Christian Coalition in 1989 to combat decadence and social decline. The Mapplethorpe photos were included in his first fund-raising drive. Discussions of so-called perverse art is a regular feature of Robertson's *700 Club* television program: "Ladies and gentlemen, if you're not shocked, you're dead. You know, this is *your* [tax] money." And his co-host once questioned "would we federally fund a picture of our President having sex with a cow? Where is the limit?"[33] This perception of culture run amok has led Robertson and the Christian Coalition to work to defeat legislators who support the NEA. They campaigned against the reelection of Representative Pat Williams (D-MT, who was instrumental in negotiating the NEA's reauthorization in 1990) and six other Congressional art supporters by accusing them of favoring "pornography."[34]

In 1991 the Reverend Wildmon shepherded a statement that eventually collected over eight hundred church leaders as signatories, which he then sent to the major television networks and movie producers, imploring them to cease the anti-Christian bias in the mass media. The group did not threaten a boycott, but suggested it as a possible course of action unless positive (or at least neutral) Christian images were not forthcoming.[35] And the Southern Baptists strongly condemned the NEA at their annual convention in June, 1991. Declaring that human sexuality was "a divine gift," they passed a resolution that stated "Scripture condemns any abuse of sexuality, including premarital sex, adultery, rape, incest, pornography, promiscuity, prostitution, and homosexuality." They also passed a resolution directing the President and Congress to set standards to guarantee that obscene and sacrilegious art would not be funded by the government.[36] Their Christian Life Commission also leapt into the fray.

The longer the controversies over both high and low culture continued, the more lengthy became the roster of leaders on the religious right jumping on the bandwagon. The indefatigable Jerry Falwell did not climb aboard until fairly late. In May of 1991 he and his Liberty Foundation joined forces with Senator Jesse Helms to work for the abolition of the NEA.[37] Even Ollie North added his voice. In 1990 his Freedom Alliance attacked the Gay Men's Health Crisis (GMHC) production of sexually explicit safer sex comic books, and the NEA support of the work of Serrano and Mapplethorpe. In 1991 he appeared before the assembled

Southern Baptists, blasting what he called "a veritable Sodom and Gomorrah on the banks of the Potomac."[38]

Such political and religious links are not uncommon. The wife of the Secretary of State, Susan Garrett Baker, sits on the board of Focus on the Family, and the head of Focus's political research group in Washington, D.C. (the Family Research Council) is Gary Bauer, a former Reagan domestic advisor.[39] In fact, fundamentalists became more significant players on the national political scene from the election of Jimmy Carter onward. They have certainly been influential in bringing conservatives like Reagan to power.

Political conservatives in the US have customarily focused on three central issues: economic libertarianism, militant anti-communism, and social traditionalism.[40] Recent national and international developments have significantly decreased the saliency of the first two points, leaving social traditionalism as a primary focus. Values have become paramount, especially for religious conservatives. But the influence of religious fundamentalists upon the political sphere is now waning, as conservatism moves from a party of opposition to a majority party. As this occurs, fundamentalists are increasingly distressed that national leaders will not implement a comprehensive, traditionalist agenda. But political realities demand accommodation and compromise, not absolutism. The religious right's hostility toward art and the NEA betrays a desperate attempt to reshape society in a way that is absurdly out of step with contemporary reality. As a fundamentalist minister lamented on a television talk show whose subject was "Miss Gay America" (a drag queen competition): "We've reached the post-Christian era, now that homosexuality is accepted."[41]

Homosexuals are a particular bane to fundamentalists because their behavior is interpreted as biblically proscribed, and they *purportedly* do not have families. Family life is the core of existence for traditionalists because it is in this context that "wholesome" values can be transmitted. In fact, the Moral Majority termed teachers and some school texts "value alterators,"[42] thereby acknowledging the power of education to open up minds and challenge orthodoxy. But fundamentalism is the insistence upon a rigid and timeless set of moral absolutes.

Focus on the Family uses the symbol of a Victorian couple admiring their child. This is a quaint, acutely anachronistic image: only one US family in four is "traditional" today.[43] In 1991 the AFA cited seven companies as the top sponsors of "pro-homosexual programs," and targeted two of them for major boycott efforts. The envelope this AFA information came in stated: "Imagine, after what they do to your family, they still expect you to buy their products." The social world has indeed changed in the past several decades. But like the small-town, religious temperance crusaders who were repudiating the mores and political ascendence of new immigrant groups in the cities, today's religious fundamentalists are fighting a retrograde action to salvage idyllic yet obsolete and romanticized social arrangements.

For fundamentalists it cannot be a question of coexistence with unconventional social conduct; there is *a* correct mode of conduct. Patrick Buchanan recognizes, but does not approve of, one of the prime movers of change in American beliefs: "[Dr. Alfred] Kinsey had an impact on our society as great as the genuine geniuses to whom he is often compared: Newton, Galileo, Einstein."[44] It's strange that Freud is not included in this pantheon, because the radical ideas of all these men initially evoked widespread public disbelief and anger. Many contemporary artists also have been disturbers of the peace, heralding novelty and variety as they both reflect and advance new social terms. Several characteristics of the fundamentalists—their prudishness, anti-intellectualism, denial of reality or preference for repression, and their intense desire to guard children against moral corruption and restore a sort of collective social innocence—incline them toward revulsion and rejection of many artists currently at work.

MAGIC UNREALISM

A letter to the editor recounted an episode in Fresno, California, which illustrates another feature of the fundamentalist world view: its literalness. A religious group took issue with the book *Making It With Mademoiselle*. Upon examination, it turned out to be a sewing manual.[45] These concrete and fallacious perceptions commonly lead fundamentalists to goofy conclusions. There is an underlying paternalistic notion in their crusades that some vulnerable groups need to be protected from certain ideas. This generates a theory of subliminal effects that we may term "magic unrealism." Magic *realism*, of course, is that rich blend of fantasy and reality that South American writers in particular have produced. Gabriel Garcia Marquez's *One Hundred Years of Solitude* is one of the better-known examples. But some religious leaders employ a type of magical thinking in which the devil is the source of a wide variety of moral ills, his presence reflected in cultural products which threaten the safety of children, the God-fearing, and the well-being of society in general.

Magic unrealism has been at work in California, where there has been a continuing dispute over a K–6 textbook series for elementary schools entitled *Impressions*. Fundamentalist parents insist that the face of the devil can be seen in the picture of a field of flowers in one of the books. But to view it requires an extraordinary series of maneuvers. According to a curriculum coordinator, "They asked me to take the picture, Xerox it, turn it upside down, and then hold it up to the mirror, and I honestly did that, but I did not see the satanic image they said was there."[46]

Discussion of the textbooks in Focus on the Family's newsletter precipitated parents' outrage in other locales because of their alleged emphasis on the occult, violence, rebellion to authority, and "negative" feelings. For example, because of

Dr. Dobson's influence the issue was picked up in Wheaton, Illinois, a center of conservative religion. And Reverend Wildmon and his group also joined the crusade against the books for similar reasons, even filing suit against them in Sacramento, CA through the AFA Law Center. The AFA alleged that the series endorses Wicca or Witchcraft, in violation of the doctrine of the separation of church and state.[47]

Interestingly, a line in a poem in one of the books—a parody of "The Twelve Days of Christmas"—was altered for publication from "10 devils grinning" to "10 groundhogs grinning," without the authors' permission.[48] So at least in this one instance, a potential occult reference was exorcised, not appended. But when people want to see the "devil's hand" at work, it can appear to be transparent and pervasive. That was the view of the authors of the *Malleus Maleficarum*: "there are as many different unclean spirits as there are different desires in men."[49] They neatly transferred responsibility for all moral difficulties to a supernatural, devious sphere. This medieval frame of reference persists: in Toccoa, Georgia, a government-sponsored yoga class was canceled because local church members feared that "people who relax their minds by performing yoga are opening the door to the Devil. The people who are signed up for the class are just walking into it like cattle to a slaughter."[50]

Whether or not the devil is explicitly cited as the source of evil, moral crusaders generally arm themselves with a theory of effects. They infer the impact of cultural products to be immediate and direct, from their anxiety over "dime novels" of the late 1800's to their misgivings about video games a century later. This was Anthony Comstock's stance: "a single book or a single picture may taint forever the soul of the person who reads or sees it."[51] It was the same perspective adopted by the State Representative in Chicago who wished to block the Gran Fury AIDS awareness poster from public transportation, shared by Wildmon as he remarked on the influence of pornography, and revealed by the president of the Massachusetts branch of Morality in Media who opposed the exhibition of the Mapplethorpe photographs in Boston: "People looking at these kind [sic] of pictures become addicts and spread AIDS."[52] From this perspective, mass media and artistic messages are received in an unmediated fashion, relatively undifferentiated from one person to another, and their response reflects the stimulus, posthaste.

Moral crusaders have long speculated that such dynamics are particularly acute in popular music. That was the assumption of the book *Rhythm, Riots and Revolution*, a '60s era treatise that "documented" the communist influence in contemporary folk and protest songs. The title encapsulates the purported causal relationship, one where there was a simple sequence of hearing the lyrical text and being directly swayed by it.[53] But as technology has become more sophisticated, fundamentalists are convinced that deceitful techniques have become more insidious. They now emphasize "back-masking," or the intentional insertion of subliminal messages into recordings. As with the magic decoding of *Impressions*, uncovering these alleged

messages often requires patience (playing songs backwards or at different speeds), or complex equipment.[54]

These assumptions were put to legal tests in 1990 and 1991 in several cases. One of the most notable was a suit brought by the families of two young men who shot themselves in 1985 (they were eighteen and twenty years old at the time), reportedly after listening to the Judas Priest album "Stained Class." One died instantly, and the other lived for three more years, although he sustained massive facial injuries. The plaintiffs claimed that the subliminal command "Do it" was inserted into the music. They downplayed the social factors in the boys' background that could have contributed to their state of mind and conduct, such as family violence, child abuse, and prior behavioral and mental problems in both situations. The survivor told the mother of the other young man, "I believe that alcohol and heavy-metal music such as Judas Priest led us to be mesmerized."[55]

The suit sought damages on the basis of product liability, but the plaintiffs failed to prove their case. The judge ruled that subliminals did not seem to be involved in *this* instance, but did not dispute their possible existence and potential impact on behavior in other cases. He also concluded that subliminals were not constitutionally protected speech. A similar suit against Ozzie Osbourne and his song "Suicide Solution" brought in Macon, Georgia was also dismissed at about the same time. One of the tangible results of such actions is that recording companies have instituted in-house lyric review panels. These are designed to legally protect themselves, even though there is little scientific data to substantiate the power of such a concealed realm. Most of the research on subliminals has concentrated on visual rather than aural stimuli, and although some simple and immediate effects can be demonstrated in a controlled experimental environment, "There are *no* studies that have shown subliminal effects of an enduring or motivational nature."[56]

Nevertheless, there is widespread popular belief in the power of the media and its ability to shape behavior. In the 1977 Zamora case, for example, psychiatrist Dr. Michael Gilbert introduced the TV intoxication defense, claiming that a teenaged defendant could no longer distinguish fantasy from reality: Zamora's murder of an elderly woman was attributed to "too much TV." The argument jibed with public perceptions, even though it did not exonerate the boy. There is also comfort in attributing anti-social actions to imitation. "Violent movie 'turned me on,' says man who shot up convent" blared a headline about the impact of the movie "Taxi Driver." And the *AFA Journal* reported that the movie "Heathers" spawned two imitation poisonings; in one case a teacher was the victim of a nine-year-old student.[57] While such dramatic occurrences undoubtedly happen, they are explained by monocausal theories. These avoid confronting the complexities of many human actions, and cannot explain why this type of influence is so *infrequent*. If imitation were as pervasive as the sensational examples cited above would have us believe, the crime index would undoubtedly be multiplied many times over.

As recounted, the Reverend Wildmon believes that images the media and artists project about Christians not only are denigrating, but may portend physical assaults (see Chapter Four). Many of his cohorts share this equation between life and art. In Costa Mesa, California, for example, a man who protested municipal art funds going to what he deemed "political art" also made reference to NEA-supported works he felt vilified Christians: "I don't want to pay for the rope they want to hang me with."[58] But many artists reject this position. Andres Serrano feels that Wildmon "pretends to be the injured party," and arts activist Jim Fouratt angrily declared "It is hard for me to accept that the kind of physical violence that's experienced by women and gay people and people of color in this country at the hands of the Helms-think forces is anything that they [moral crusaders] have experienced. The worst that they have done is lost some court battles and been told legally that they can't do certain things. I'm not aware of people going around and beating the shit out of them."

The scientific jury is still out on the nature and potency of media and artistic effects. Whatever their character, such effects are doubtlessly mediated by other factors, notably sex and sex roles, class, ethnicity, religion, age and parenting style. Logically, children could be affected more profoundly than older individuals, as the periodic concern about cartoons and comic books reflects. The recent campaign against Teenage Mutant Ninja Turtles is merely the latest episode in challenging "the seduction of the innocent." However, most teenagers are more than "hormones with sneakers," as an official of Focus on the Family asserted. And Jack Thompson, mastermind of the Florida campaign against 2 Live Crew, also exaggerates when he claims "Bruce Springsteen is *facilitating* the sexual abuse of women and the mental molestation of children by giving 2 Live Crew the use of his music [to incorporate into their own]."[59] Fundamentalists often assign responsibility for social ills to symbolic representations out of proportion to what their effects could reasonably be, and the public's continued belief in these effects deflects attention away from examining the complex impact of numerous social factors on human behavior.

ON THE POLITICAL FRONT

Politicians also jumped into the conflict over controversial art, joining their religious confederates. Sometimes their participation derives from sincerely held values, but in other instances it stems from expediency, even though these politicians claim to be defending more than their own posts or self-images. In the late 1980s we generally did not see actions which were as blatantly partisan as what happened in 1984 in Racine, Wisconsin, when the school board rejected texts that had "funny pictures of Republicans and nicer pictures of Democrats."[60] Nor were there many established procedures to *officially* suppress symbolic expres-

sions as there had been with local film censorship boards, which were standard in many American cities until the 1970s. In the case of Chicago, there was a distinctly political flavor to the proceedings: in the late 1950s, *all* the members of the tribunal were widows of Democratic politicos.[61] But while today's anti-art crusaders profess to rise above party politics (not incidentally, they are overwhelmingly Republicans), the aroma of self-interest often permeates the air when they launch into their harangues.

We've already noted the close connections between the religious and political spheres in the 2 Live Crew prosecution. Lawyer/politician Jack Thompson is a zealous Christian, and also a scrappy political fighter. His conversion to the anti-obscenity cause derives from his defense of a woman who had been raped as a teenager and subjected to sexual abuse by her husband. Even though many commentators focused on the class and racial components of the charges against the Black rap group, a relatively overlooked aspect to the case were Thompson's anti-gay sentiments.

In 1988 Thompson gay-baited his female opponent in a race for Florida State Attorney. Luther Campbell, 2 Live Crew's leader, claims that Thompson had been after him ever since, because another group which Campbell's record company handles had recorded a song for Thompson's rival. In addition, Thompson released a statement to the trial judge and news organizations while the trial was proceeding, in an attempt to discredit the jury foreman because he was gay. The disclosure claimed that "The fact is that a homosexual who engages in bizarre sex acts described in 2 Live Crew's 'music'—anal sex, oral sex, licking excrement from the anus of a man . . . is far from likely to find such representations obscene."[62] Homosexuality is a fearsome threat to Jack Thompson, as it is to many of his Christian brothers.[63]

Homosexuality is also the bête noire of another politician, Representative William Dannemeyer (R-CA). His book *Shadow in the Land: Homosexuality in America* (see Chapter Seven) is his defense of the "heterosexual ethic." The book is suffused with images of social decline and chaos, triggered by the ascendance of gay activists. Tolerance of homosexuals has a moral price tag for Dannemeyer. In a section entitled "What Orthodox People Are Being Asked to Give Up," he argued "In order to accept homosexual behavior as permissible in a Judeo-Christian community, traditionalists would have to renounce or ignore several of the most important assumptions about their faith."[64]

Dannemeyer has consistently attempted to block measures which would help guarantee civil rights for gays, such as the inclusion of sexual orientation in the Hate Crimes Statistics Act. He has also fought for mandatory reporting of HIV-positive people, sought to bar them from entering the country, and helped thwart a government-sponsored survey of sexual practices.[65] And he caused a stir in the House when he entered a graphic account of "What Homosexuals Do" into the *Congressional Record*. His diatribe included "gerbiling" (the *supposed* practice of

inserting the animal into the anus), and the allegation that people with AIDS "emit spores."[66] While he has not targeted the media and the arts to the extent some of his other conservative colleagues have, he suggested "airwave emission standards" to cleanse the media of obscenity, and criticized NEA sponsorship of the Mapplethorpe retrospective.[67]

Two other Representatives adopted a somewhat different posture as overseers of the public treasury and champions of accountability. Dick Armey (R-TX), a former economics professor, leads a Spartan Washington life: he sleeps in his office rather than maintaining a separate Capital household. He tries to trim the fat wherever he sees it in the national budget, from military bases to the NEA. He asks "Is there a commandment, 'Thou shalt not waste?' If not, there ought to be."[68] He is against all federal funding of the arts because he believes that there are sufficient private sources of support to take care of this special interest.

Armey made the statement on CNN's "Crossfire," "If you want to show it [art] in such a tasteless way, do it on your own dime and your own time."[69] That sentiment became one of the elements in Susan Wyatt's calculus which led her to report the nature of the "Witnesses" show to the NEA in advance of its opening. But Armey's repulsion by Serrano and Mapplethorpe was not the first occasion that he challenged the legitimacy of federal funding of the arts. In 1985 he and two other Texas Congressmen accused the agency of mismanagement over the support of pornographic and politically unacceptable (that is, Marxist) poetry. In an extremely paternal statement he proposed strict discipline for recipients of government assistance: "I'm asking the NEA to live by the same standards that I set for my daughter: He who pays the bills, sets the standards. My daughter wanted to go to college, I told her you'll go to a school I approve of and major in an area I approve of."[70]

Dana Rohrabacher (R-CA) shares his colleague Dick Armey's perspective. Rohrabacher supports the dissolution of the NEA, in conjunction with increased incentives for private contributions to the arts.[71] A former leader of Youth for Reagan and Young Americans for Freedom in California, Rohrabacher presents himself as a friend and benefactor of the common man. He affects an unassuming manner (commonly using "darn" and "gosh"), and often suggests shifting NEA funds to social programs such as Head Start and school lunch plans.[72] As a participant in a forum sponsored by the Volunteer Lawyers for the Arts in New York City (September, 1989), he ceaselessly alluded to a hypothetical hardworking, tax-paying truck driver in his home district. Rohrabacher empathically related this man's disgust at the work of a Serrano or Mapplethorpe, and contrasted the amount of physical (that is, "real") labor this worker would have to do to earn wages equal to an NEA grant. But the audience could not abide Rohrabacher's custodial role, nor his denigration of artistic work. They derided him with counter-arguments and even "boos!"

Rohrabacher's tersest remark of the evening was "When you get in bed with

the government, you can't expect to have a good night's sleep." The man who has helped guarantee that this would be so is Senator Jesse Helms (R-NC). In office since 1972, Helms has distinguished himself as an obstinate, bullying thorn in his colleagues' sides. Although his record of successful sponsorship of legislation is weak, his persistent, extreme proposals push the terms of debate to the far right. When compromise on an issue is gradually effected, it often reflects accommodation to Helms in some respect. In addition, his National Congressional Club has perfected the direct mail solicitation technique, and is one of the richest political action committees (PACs) in operation.

Helms has earned the nickname "Senator No" because of the obstructions he frequently erects to legislation. The Helms Amendment to prohibit alleged obscenity in publicly funded art (discussed in Chapter Seven) is one example of how Helms engineers restrictions on what he judges inappropriate or excessive governmental expense. It also highlights the fact that there is not *one* Helms Amendment, but a bounty of them. In the past he has opposed school busing, the Panama Canal treaty, and the Martin Luther King holiday (Helms insists that King was a communist).

With the advent of the AIDS epidemic, Helms has attempted to halt a number of measures to assist those with AIDS, or advanced other bills which would limit individual freedoms or dissemination of important information. He led the successful fight to cut off funds for GMHC's safer sex comic books, and tried to block emergency disaster relief to major US cities in 1990 to help them cope with the AIDS crisis. Helms argued that this legislation was an hysterical response. Stronger morals, not more money, was what was needed: "[it is] 'perverted, illegal and immoral activity' that must be stopped in order to end the AIDS epidemic."[73] Helms also fought to prevent anti-AIDS workers from giving bleach to addicts to clean their needles, wrote the 1987 law which denied entry of people with AIDS into the country, and in 1991 proposed that health care workers who were HIV-infected and did not inform their patients before performing invasive procedures be subject to penalties of up to ten thousand dollars and ten years in jail. In each of these instances he pushed for extreme measures, and in some cases he intimidated his associates into supporting him.

Much of Helms's behavior is explained by a statement in his book *When Free Men Shall Stand*. He declares "Our political problems are nothing but our psychological and moral problems writ large."[74] In other words, because people have strayed from traditional values and lifestyles, they have gotten themselves—and society—into trouble. The corrective is a return to "the straight and narrow," not accepting other belief systems as legitimate. As he explained, "I was taught to hate the sin and love the sinner . . . but these [gay] guys who are parading and demanding that they be allowed to marry and that sort of thing, they make the second part of that tough."[75] Helms opposed collecting hate crime statistics on gays because it was part of a "radical agenda" and *might* ultimately lead to greater social understanding

and tolerance. He authored a bill to restrict "dial-a-porn" telephone numbers, even though these services have provided an important safe sex outlet, as well as being a crucial source of advertising revenue for the gay press.[76] And Helms even opposed a special postmark to commemorate the twentieth anniversary of the Stonewall Rebellion, the beginning of the modern gay rights movement. To Helms this was pandering to perversion: "Bosh and nausea and a pox upon whoever in the Postal Service made this irrational decision."[77]

When Christian crusaders started to rage against art with sexual and religious themes, it was an ideal issue for Helms. Not only did he share his brethren's disgust at what artists were producing, but the timing was propitious. Helms faced reelection in 1990, and controversial art was a diversion from conditions back home, a beneficial "hot button." North Carolina's Research Triangle represents the "New South," but many other areas of the state languish, with the highest infant mortality rate in the country, and the lowest industrial wages and average SAT scores. Helms's state ranks thirty fourth in income, and thirty ninth in the percentage of people living below the poverty line.[78] The Senator's concern about artistic degeneracy was a way to deflect attention away from his own responsibility for abysmal local conditions, and project blame for the state of the social world onto so-called radicals and deviants. In a campaign letter he claimed his opponents were "the radical feminist crowd, the 'radical chic' artists and Union Bosses They want to destroy what Jesse Helms stands for: traditional American values, faith in God, love of country and family."[79]

Helms is a master at creating and exploiting media images. He should be: his career before he arrived in the Senate was as a radio and television commentator. These were important training grounds for his political pursuits, for they allowed him a regular soapbox from which to preach. The artist Leon Golub notes that Helms is "An interesting combination of serious believer and a great manipulator all in one. It's no coincidence that he and Reagan came through radio, where you present things which are not really seen. There's a discrepancy between the presence of the person and the words of a person. . . . Because of a lack of visual cues, you can't tell when someone's lying."[80] Not only is Helms "media savvy," he denounces the "liberal bias" in the media, as does Reverend Wildmon. In fact in 1985, before Helms was concerned about art and artists, he tried unsuccessfully to take over CBS in order to neutralize that inferred political slant.[81]

At the same time that Helms was attacking the NEA and its artistic decision-making process, he also wrote letters to Chairman John Frohnmayer to get special consideration for people whom he sponsored. These included a man Helms endorsed to be NEA general counsel, and the application of an adult art education organization in North Carolina for an NEA grant.[82] Helms also moved to ensure that his point of view would be enshrined in more than various types of restrictive legislation. The Jesse Helms Citizenship Center is scheduled to open in 1992, underwritten by more than four million dollars in support, primarily from North

Carolina banks and utility companies. The largest donation to this library, research center and replica of Helms's Senate office—the only such institution for a living member of Congress—was two hundred thousand dollars from Philip Morris, Inc.[83] This is but another scheme by the man whose domestic tranquility was shaken by the nude and multiracial photographs of Robert Mapplethorpe to extol and preserve a traditional, religious way of life.

CRITICISM FROM ON HIGH

The voices of religious and political critics of government patronage of certain types of contemporary art have been joined by another group, the neoconservatives. Broadly speaking, the neoconservatives are a group of intellectuals who draw from a number of political traditions to critically appraise social trends and policies. Like the religious traditionalists, they react negatively to the politics and permissiveness of the 1960s; that's when order began to unravel. And, like specific political incumbents, they are also concerned about how to manage a society that has lost its religiously based culture. While neoconservatives may share some root concerns with the religious and political leaders discussed previously, they maintain that such resemblances are merely superficial.

The neoconservatives carefully distance themselves from these other circles, and they formulate their objections in somewhat different terms. They substitute the artistic canon for the Bible as the ultimate source of value, and are generally not officeholders themselves, although they generate public policy positions they hope to get implemented. Befitting Rohrabacher's comment about incompatible bedfellows and restless sleep, the neoconservatives are uneasy and incongruous allies with the other two groups. There is a great deal of social and intellectual distance between Lou Sheldon and Hilton Kramer, for example. And neoconservative Samuel Lipman confirms that not only does he not associate with right-wing members of Congress, he would not support Jesse Helms's attack on the arts.[84] Although armed with different arguments and proximate goals, all these groups aim to radically reformulate the structure of public sponsorship.

The neoconservatives developed their critiques of the NEA over a long stretch of time. Like picadors they had been throwing barbs at this governmental beast for at least a decade. NEA support of the work of Serrano and Mapplethorpe provided new opportunities for the neoconservatives to cripple and attempt to tame the creature.

A thorough neoconservative evaluation of the government as cultural patron was included in *Mandate for Leadership*, a collection of essays on the federal cabinet and government agencies. This book was published in 1981 by The Heritage Foundation, a public policy research institution designed as a politically conservative counterbalance to the Brookings Institution. The document was intended to

provide direction for the new president, Ronald Reagan. The chapter on The National Endowments for the Humanities and the Arts was penned by Michael S. Joyce, executive director of the John M. Olin Foundation, a major underwriter of neoconservative scholars.[85]

Joyce expressed some concern about bloated budgets; he advised that the NEH not become "the fat boy in the canoe."[86] But the bulk of the essay spoke about "noble ideals" of dispassionate inquiry and artistic standards which were being sacrificed to radical/liberal social agendas and political goals. In the author's estimation, the NEH and NEA had supplanted genuine scholarship and art *qua* art with social service: "the best of these projects do no more than fossilize the popular culture of the past, and the worst are little more than high-flown welfare and employment schemes."[87] Joyce reproached this lowering of standards and called for a return to "excellence," as measured by traditional criteria. His position dismissed both the avant garde (they reject established conventions, but should know better) and the populist (they have not been sufficiently trained, so aren't suitably accomplished).

Neoconservatives developed this line of thought throughout the 1980s. And they occasionally scored actual victories: in 1983, for example, Joseph Epstein, Jacob Neusner, Samuel Lipman, and Helen Frankenthaler orchestrated the demise of the NEA's art critic fellowships, a program they perceived as decisively "left-leaning." To confederate Hilton Kramer, the "movement" of the 1960s "was now on the inside, running or advising the bureaucracy."[88] But neoconservatives had to wait some additional time before the cultural moment permitted a wide audience to be receptive to their views. In 1991 The Heritage Foundation seized the opportunity to rearticulate its perspective: "NEA has become a platform for attacks on religion, traditional art forms, traditional families, and traditional values. In the name of tolerance it has shown increasing intolerance toward standards of any kind. . . . It is a long way from the paintings of Andrew Wyeth to the antics of Annie Sprinkle."[89] In this incarnation, neoconservative thought could hardly be differentiated from the beliefs of the outspoken religious and political foes of the NEA.

The neoconservatives both took advantage of the politically-charged climate of the late 1980s and early 1990s, as well as helped to bring it about through their prolific writing. Irving Kristol, for example, reflected on obscenity and pornography early in the '80s. After arguing that they were a serious problem, he declared "I will put it as bluntly as possible: If you care for the quality of life in our American democracy, then you have to be for censorship."[90] By 1990 he virtually conflated obscenity with art and with a fundamentalist sense of Armageddon, imagining contemporary events as the final convulsion of modern art, or perhaps even of Western civilization.[91]

Allan Bloom's remarkably successful *The Closing of the American Mind* (1987) likewise capitalized upon and articulated a conservative shift in the public mood.

Bloom's description of popular music has an Elmer Gantry-like quality to it, as he works himself up into an evangelistic frenzy describing "A pubescent child whose body throbs with orgasmic rhythms."[92] And his lamentations over the loss of biblical and Old World authority in families and society in general duplicates the most fervent fundamentalist sermon. But Bloom is firmly within the neoconserva-tive camp with his espousal of a "trickle-down theory" of transhistorical and transcultural standards: "The awareness of the highest is what points the lower upward."[93] This statement demonstrates the same type of paternalism which sanctions moral entrepreneurship.

One of the most important neoconservative mouthpieces has been *The New Criterion*, published since 1982 by Samuel Lipman and edited by Hilton Kramer. The journal received start-up funds from the Olin Foundation, and receives continued support from it and other politically conservative sources. Their raison d'etre was conspicuously presented in a "Dear Reader" letter sent to potential subscribers in 1990: "Do you have the feeling nowadays that something has gone terribly wrong with the arts? Do you sometimes have the impression that our culture has fallen into the hands of the barbarians? . . . Are you apprehensive about what the politics of 'multiculturalism' is going to mean to the future of our civilization?"[94] The language may be somewhat different, but the sentiments are much the same as fundamentalist religious leaders express: there is horror over shifting social standards and the relative standings of different groups.

The New Criterion objects to the "vulgarization" of culture and the appropriation of art for purposes of redress by formerly marginalized groups. It stands *for* "defending public decency against antinomian assaults" and the preservation of the best from the past.[95] And as much as the neoconservatives wish to distance themselves from the likes of Wildmon et al., they also exhibit a strict fundamental-ism: "There is only one magazine that tells you what is right and what is wrong with our cultural life today."[96] Such aesthetic arrogance can originate only from confidence in an enduring canon that *may* gradually accommodate some modifica-tion. This reliance on tradition also reveals a yearning for a stable, fixed society.

These notions aptly reflect the sentiments of *The New Criterion's* publisher, and its editor. Samuel Lipman is a pianist and music critic. His field is one of the most canonically based, where mastery of an established body of work is the measure of achievement. Lipman dislikes contemporary composers, such as John Cage or Philip Glass, who seem to him to spurn rather than engage in musical dialogue with the masters who preceded them. As a member of the NEA National Advisory Council, his was a consistently outspoken conservative voice against what he saw as the intrusion of politics into art, what he called "a revival of the sixties' attitude."[97] He has negatively remarked on the NEA and what he feels is the triumph of quantity over quality in art: the yardstick for success has become mass appeal through blockbuster spectacles, not the level of artistic accomplishment. Lipman's criticism has become more shrill as the arts have become more socially

conscious. When the controversy over the Mapplethorpe show erupted at the Corcoran, Lipman condemned the photographer's "gross images of sexual profligacy," and counseled "just saying no" to such outrageous depictions. He later denounced gay artists who made their art "bear the burden of the coming out process, seeking legitimation."[98]

Lipman's objections to the contemporary arts have ranged from their anti-traditional style and content to the bureaucratic organization of their presentation. But in all respects he calls for a return to decency and custom. His colleague Hilton Kramer concurs. Kramer is an eminent art critic whose stature has been established through his evaluations of art produced since World War Two. This is art which is largely devoid of direct political references, art which is assessed on formalist terms in relation to aesthetic traditions. The return of socially and politically oriented art in the 1980s threatens, among other things, the dominance of authorities like Kramer.

Kramer has an obvious vested interest in subduing this "upstart" art. Rather than support the dismantling of the NEA, however, he argues for its redirection: funds should be withdrawn from underwriting individual creativity and rechanneled to preservation, and enhancing great arts institutions.[99] As in a centuries-old formal garden, Kramer's logic is to prune established specimens and pull up any invading species. He could well be answering the question posed by a "letter to the editor" writer regarding the NEA: "does it exist to support exhibits or exhibitionists?"[100] Kramer cautions that the government has misstepped with its support of certain types of artistic work and needs to tighten its reins: "It's not the proper role of a government agency to sponsor art that causes the public pain; the government should leave to private initiative those artistic initiatives [such as Mapplethorpe] that are likely to be socially divisive."[101]

The conservative critique is part moral outrage and part aesthetic insult. Some adherents decry mediocrity and the lack of quality control in contemporary art,[102] and react with fury when the traditional is tampered with: To wit, this review of a gender-reversed production of Shakespeare's *King Lear* by New York's Mabou Mines: "What would you cast a small, obese, unsightly, classically untrained, moderately untalented, ill-spoken actress . . . as? Why, naturally, as Lear. . . . Jesse Helms, where are you when we need you?"[103] This mean-spiritedness draws from the fear of displacement that the devoutly religious, or conservative politicians, or neoconservative critics may all experience. Each of these constituencies has been challenged by newly ascendent social groups. The values they espouse threaten to alter, or overturn, what preceded them. When these cheeky groups have expressed their beliefs through art and popular culture, they have been subject to attack by any or all of these entrenched orthodoxies and incumbents.

The three major groups which have maligned contemporary art share more similarities than they might care to admit. But none of them have gone unchallenged: artists and their partisans have mounted assorted counter-strikes to rally

support for their viewpoints. The relationship between these antagonists has been an oddly symbiotic and dialectical one: artists have given critics a focus for their rage, but the adverse response had also propelled artists in particular directions. As one gallery director remarked: "I think Jesse Helms is the avant garde's best friend because he's made us into a valuable commodity and something to be fought over, and this is very good. For each generation there needs to be this kind of test about what it means to be in a democratic society. Somebody else would have done it if he hadn't. He's the evil genius of this generation." And an activist observed, "What Jesse Helms has done has backfired. I now know more about lesbian sexuality than I had hoped to know, quite honestly, because I have seen artist upon artist find the authentic voice that has been told it cannot speak out. And because *they* have defined what the territory is, *we're* now in their territory, pushing, pushing, pushing."[104]

10

ARTISTS EN GARDE

I'm trying to remember if I've ever been censored. I hope I have so I can remain part of this community.
Spalding Gray [ironically delivered monologue], "Dangerous Ideas," 1990

Art and politics make for a co-dependent, dysfunctional relationship.
John Fleck [ironically delivered monologue], "Dangerous Ideas," 1990

Artists reacted to their crusading opponents with a sense of injury, accented by anger and a determination to fight back. Some of the results were capricious, like Yoko Ono's "participant art piece" where viewers were invited to hammer nails into a wooden cross, thereby striking symbolic blows against censorship. Many responses combined humor with a more serious intent, such as F.F.F.Art (Freedom & Funding for Art) in Chicago, which sponsored a letter-writing party to Congress: "Help us make a counter stink! F.F.F.Art BACK!" And ad hoc groups blossomed and subsequently wilted throughout the country, their efforts sometimes melding with those of well-established progressive lobbying organizations. The advocates of orthodoxy definitely did not go unchallenged; they were met by a panoply of defiant words, images and actions.

Proposed restrictions called out rebelliousness. Representative Armey's remark about his right to dictate choices to his daughter *and* to NEA grantees (Chapter Nine) was just one of the more blatant examples of paternalism, an attitude that artists did not abide easily. The playwright Terrence McNally characterized the withdrawal of NEA subsidies from four performance artists as a public spanking and grumbled "suddenly I have Big Daddy and Big Mama to deal with and I don't enjoy feeling like a boy again."[1] John Fleck, one of the "NEA 4," worked the same theme into his act at "Dangerous Ideas," an extravaganza of live performance in

New York City in October, 1990. Fleck removed his raincoat, revealing a symbolic emasculation: he had tucked his genitals behind his crossed legs. Fleck ranted in a pseudo-operatic voice that had to be translated by another man. He later let his penis spring forth, a self-possessed gesture which freed him to communicate clearly and directly. And at the same event artist Nina Wise used her voice and body in a verbatim improvisational enactment of the Helms Amendment. The phrase "use of children" provoked a poignant digression on child abuse, and she concluded by appealing for the government's approval of her behavior, much as a young daughter would seek permission from her father. "Is this all right?" she queried, infantilized by the behest.

In many respects artists' reactions embodied a spirit similar to Jefferson Airplane's 1969 countercultural anthem "We Can Be Together":

> We are all outlaws in the eyes of America . . .
> We are obscene lawless hideous dirty violent and young . . .
> We are forces of chaos and anarchy
> Everything you say we are we are
> And we are very proud of ourselves.[2]

In both instances marginalized groups boldly embraced rather than denied the assumptions conventional society held about them. They changed "deviance" into a badge of honor,[3] and aggressively pushed their beliefs into the light, refusing to slink back into the shadows.

The artistic responses to the cultural battles of the late 1980s and early '90s displayed the enormous resourcefulness of the creative community. But the struggles between artists and their antagonists also raised complicated questions about the sponsorship of artistic endeavors (including, but not limited to, the government and the NEA), and counterpoised contrary notions of censorship to one another. In addition, these conflicts exposed significant divisions among artists and revealed the range of political sentiments and strategies that contemporary artists may espouse.

A FULL CALENDAR

Exhibits, performances, readings, panel discussions, rallies and countless other events mushroomed in response to the public debate over art. Chicago is a good example in this regard. Concerned artists started to meet almost immediately after the controversy broke over David Nelson's painting of Mayor Washington. Two months following the seizure of the portrait by the Chicago Police, the Chicago Artists Network sponsored a forum, "Arts & Ethics (Censorship and Morality)" at Columbia College, a local arts school. The ad hoc Committee for Artists' Rights

also developed, later becoming a subcommittee of the well-established Chicago Artists' Coalition. As events escalated throughout the next year, this group sponsored "Inalienable Rights, Alienable Wrongs" in the fall of 1989, a two-month series of exhibits, forums, films and performances addressing issues of artistic freedom and control, in which over three hundred artists showed their work.

Such multi-media events were not limited to the locales where dramatic fights had taken place, however; they spread to artists' communities throughout the country. In Buffalo, New York, for example, the Hallwalls Contemporary Arts Center presented "An Evening of Objectionable Art" (1989); in Kansas City, Missouri, Gorilla Theatre Productions and the Human Observation Lab offered "Cabaret Gorilla: An Evening of Censorship Awareness" (1990); and in Los Angeles, the Woman's Building mounted "Taking Liberties" (1990). The National Writers' Union sponsored a five-city event in 1990 in New York, Boston, Amherst, MA, Los Angeles, and Santa Cruz, with different combinations of performances and readings. In New York it became "Breaking the Silence: A Forum of Objectionable Art," with poets, musicians, playwrights, and performance artists;[4] in Santa Cruz, speakers sat underneath the banner "In Your Ear, Jesse Helms!"

In New York City such presentations became a standard feature of the art scene. A good part of one's social calendar could be filled going from event to event, which also provided an excellent opportunity to see many of the controversial artists in person. All of these affairs were intended to gather the righteous together, diffuse information, raise consciousness, and solicit funds. The embattled Franklin Furnace staged "Franklin Furnace Fights for First Amendment Rights" as a benefit, offering an impressive array of contemporary talent, including Karen Finley, Annie Sprinkle, and Eric Bogosian, all of whom who had performed at the Furnace at the beginning of their careers. The Ad Hoc Artists Group in Response to the Battle for the National Endowment for the Arts presented "Obscene and Not Heard" at a club in New York City's Flatiron district to subsidize a demonstration at the NEA National Council meeting in August, 1990. This event featured performance artists and musicians, including The Travelling Millies, a lesbian country and western troupe. Its members sported everything from a rural feminine ensemble of an old-fashioned dress, gloves and handbag, to a man's dress shirt and tie. They flavored standard songs with humor and a homoerotic twist. Four thousand dollars was raised, more than enough to subsidize free bus transportation to the D.C. demo. And Judson Memorial Church, a prime mover on the avant-garde art scene in an earlier generation (and the site of the controversial "People's Flag Show" in 1970), presented "A Multimedia Manifestation of Artistic, Social and Religious Heresies" in November, 1990. As part of Judson's Centennial, the event marked the twentieth anniversary of the arrest of artists in a previous cycle of controversies.

Artists and their supporters also staged public dialogues. Artists Space sponsored one of the first of these in New York in July, 1989. It was billed as an NEA Town

Meeting, called in response to the debate over Serrano and Mapplethorpe. This predated Artists Space's own difficulties with the NEA, and led to the formation of a working committee to plan a public demonstration. Many other institutions and organizations also presented their own symposia; a partial list includes the Public Theater, the New Museum of Contemporary Art, the Whitney Museum, the Gay and Lesbian Community Center, *The Advocate*, the Greater Gotham Business Council, the PEN Center, the New School for Social Research, Cooper Union, *The Nation*, the Playboy Foundation, Volunteer Lawyers for the Arts, the International Center of Photography, the Aperture Foundation, the Burden Gallery, and SOHO 20 Gallery. One could go to "Red White and Censored" or "Black Listed White-washed Red Handed." Some gatherings emphasized particular concerns: "Representing the Body" accentuated the problems swirling around photography. "Choking on Silence: The NEA's Gag on Lesbian and Gay Culture" and "Censorship As Gay-Bashing: The War on Homoerotic Art" focused on the role of anti-gay prejudice in many of the repressive actions [see Plates section]. Other panels in New York and across the country echoed similar concerns.

The profusion of art controversies provided a tremendous impetus to the creation of new art, as well as the conspicuous display of previously controversial work. In Los Angeles, for example, Studio Leonardogavinci presented "Uncensored" in 1989, a group show including many sexually themed works. The opening reception featured a flutist in boxer shorts and bartenders sporting only "body paint and disarming grins."[5] From Denver to Columbus, and at points in between and beyond, artists defiantly tackled controversial issues.[6] Many of the titles revealed the intent of the artists and presenters: "To Probe & To Push: Artists of Provocation" (Wessel O'Connor, 1989) and "The First (Amendment) Show" (Sally Hawkins Gallery, 1989) are but two examples.

In some instances the pieces in these shows were "second generation" productions, such as the "Cum Paintings" by the team Ridgeway Bennett. This work featured triangular and cross-shaped canvasses slathered with a mixture of vinyl, wax, and the artists' own semen, spelling out C U M. The theme and method of execution pay obvious homage to other disputed works, such as Andres Serrano's explorations with urine and semen. But one critic bemoaned this "aesthetic of indecent materials," which she claimed owed its genesis to Senator Helms.[7] And Erika Rothenberg's installation "Have You Attacked America Today?" featured a quintessential young blonde couple demonstrating a series of "freedom of expression products" (example: a do-it-yourself flag-burning kit—"It's the ultimate American protest; We urge you to do it often!"). It nodded to Dread Scott's piece, and elicited similar resistance: when it was displayed in the front window of New York's New Museum of Contemporary Art, someone smashed the glass and stole part of the exhibit.

Other types of artists also assimilated references to controversial themes into their work, ranging from the sublime to the ridiculous. Richard Serra, whose

abstract sculpture "Tilted Arc" was removed from a public plaza by its government sponsors in 1989 after lengthy and acrimonious hearings, wove verbal allusions to this and other disputes into a 1989 show. "Weights and Measures" at Leo Castelli consisted of a series of eight abstract paintings on paper. The titles bore an additional level of meaning, such as "The United States Government destroys art," "Support indecent and uncivil art!" and "No mandatory patriotism." Chicago's Second City tackled censorship in "Flag Smoking in Lobby Only or Censorama," and the venerable Bread and Puppet Theater lampooned Wildmon and Helms in a performance during the 1990 L.A. Festival. Director Clay Shirky "deconstructed" the report of the Meese Commission as the basis for a theater work, and did something similar in *Limits*, using key texts from the NEA debates. Virgin Records stickered their records with a "Censorship Is Unamerican" message and distributed thousands of copies of posters making the same point. And in the category of "imitation is the sincerest form of flattery," the musical duo 2 Live Jews released the album "As Kosher as They Wanna Be," with singles such as "Oy! It's So Humid," "Young Jews Be Proud," and "Shake Your Tuchas."

In a more serious vein, some artists dug into history and drew parallels with contemporary events. In New York, the Village Theatre Company revived Eric Bentley's 1972 "Are You Now Or Have You Ever Been." Bentley drew his dialogue directly from testimony given before the House Un-American Activities Committee (HUAC) between 1947 and 1956, in hearings which led to jail terms in some cases, and the destruction of the careers of many creative individuals. The 1990 production was done in period costume, but the set was dressed with front pages from the *New York Times* referring to battles over the NEA.

Several victims of that era's blacklisting spoke after a special performance of the play, highlighting both the similarities and differences between the two periods. Many expressed concern over what they took as ominous signs of a cultural crackdown, an uncanny dis-ease over current circumstances. But several people also pointed out that the contemporary flash point was sexual, not political; that government sponsorship was at issue, not private industries such as movies and television as was the case in the 1940s and '50s; and that the denial of an NEA grant might seem like vindictive and moralistic governmental action, but it was not comparable to the complete loss of opportunities to practice one's craft that blacklisted artists once confronted.

Despite these significant divergences, the specter of a neo-McCarthyism gained enormous currency among artists. The image emerged frequently: Tim Miller used it in "An Artist's Declaration of Independence"; in a press release Nan Goldin cited her family's fight with McCarthyism, and refused to sign the acceptance form for a five thousand dollar NEA grant because she felt the restrictive language entailed a loyalty oath; and Karen Finley proclaimed herself a political prisoner and maintained she had been blacklisted because of the denial of her NEA grant.[8] Get Smart (one of several New York ad hoc artist groups) produced a widely

distributed poster which matched pictures of Joseph McCarthy and Jesse Helms under the caption "Separated at Birth?"[9] [see Plates section] And even a memorial service for blacklist-buster John Henry Faulk at Joseph Papp's Public Theater in 1990 provided the occasion to draw explicit analogies between the two eras. Depending upon one's political proclivities, these references could seem either inappropriate, prescient or paranoid.

The impulse to reanimate cultural expressions from the past surfaced repeatedly in the visual arts. For example, in 1990 Exit Art reconstructed an exhibit in its own gallery which it had originally mounted at Franklin Furnace in 1982. "Illegal America" documented the activities of thirty six individual artists and artist groups whose concern over a variety of political and social issues led them to produce work which violated legal statutes. Cellist Charlotte Moorman was represented, as was Carolee Schneeman, Chris Burden, Vito Acconci, and the Guerrilla Art Action Group (GAAG). Some more recent artists, such as Dread Scott, were added to the original roster. As an accompanying brochure asserted, "These works are evidence of the artist's subversive role, documents of illegal poetics as commentaries on the system."

Another exhibition which tethered the past to the present was Joseph Kosuth's installation at the Brooklyn Museum, "The Play of the Unmentionable" (1990). Kosuth combed the collections of the museum to assemble an assortment of paintings, sculptures and photographs which pushed the boundaries of decency and propriety—be it religiously, politically or morally defined—works which in many instances had been targets of repression and censorship. Kosuth's selections ranged from antiquity to the modern, from an Egyptian stone relief to the photographs of Larry Clark and Robert Mapplethorpe, arranged salon-style throughout the lobby of the museum. Drawing also upon his background as a conceptual artist, Kosuth sprinkled quotations throughout the exhibit, mingling a selection of texts from aphorisms to art historical and classic anthropological statements.

Kosuth invited his audience to draw their own conclusions, taking their cue, of course, from his arrangement of pieces (with the use of NEA funds, incidentally). The most dramatic of these was his juxtaposition of Bauhaus-designed objects with the incendiary words of Goebbels and Hitler. This section recalled the infamous "Entartete Kunst" ("Degenerate Art Show") staged by Hitler in Munich in 1937 to publicly remonstrate modern, "un-German" artists and art trends. The New Criterion hated the Brooklyn museum show: "Kosuth neglects the difficult task of thinking through the issues. Instead, he relies on verbal collage to produce the desired imitation of thinking, what we might call the aroma of thought."[10] These editorialists had a point. As with the McCarthyism allusions, the temptation was to make loose associations while dodging a more thorough analysis.[11] With such an emotionally loaded issue, people's hearts frequently overruled their heads.

VOTING WITH YOUR FEET

Nothing equals a march or rally for discharging pent-up feelings. Locales such as New York and Washington, D.C. were a frequent site, but demonstrations were staged in many other places as well. In Chicago, more than two hundred artists rallied at the State of Illinois Center, part of a series of gatherings held in Los Angeles, New York, Philadelphia and Minneapolis in August, 1989 for Arts Emergency Day.[12] Over two thousand people gathered in New York's Union Square in May, 1990 to urge Congress to reauthorize the NEA without content restrictions. Attendees were regaled by a wide range of luminaries. The next month, arts institutions coast to coast participated in "Arts Day USA" to highlight the danger they faced if government funding programs were to be tampered with. And in Kansas City, four hundred marchers made their way to a rally on the lawn of the Nelson Gallery of Art in August, 1990. What was possibly the largest gathering assembled in Chicago's Daley Plaza the day after Labor Day, 1990, when an estimated five thousand people came together under the slogan "Creativity is our greatest natural resource." It was coordinated by VAN (the Visual Arts Network), which linked small not-for-profit arts groups with larger arts establishments in that city [see Plates section].

But while such events are often splendid morale boosters, they may also accentuate fundamental divisions within a coalition. Event organizers have tremendous power to orchestrate which opinions are given voice and which are not. Participants can feel shortchanged or betrayed if they don't believe their point of view has been adequately relayed. One participant criticized the 1990 Union Square rally in the following way: "Homophobia was not mentioned until the last speaker . . . [by] a gay man [who] said 'Let's face it, what we're talking about is fag-bashing.' And we had a whole array of lovely stars and art people and theater people all wanting to support the NEA, and [he] was the only one who brought up the issue. Art + Positive's position is that we cannot buy into the argument 'Let's deal with the other issues first, because they're more acceptable, more presentable, more agreeable.' "[13] Disagreements over discordant strategies, and disputes over what the primary issue in fact was, would arise time and again.

These problems were foregrounded on Advocacy Day, 1990. Advocacy Day is an annual event with a decade-long history. It is coordinated by a consortium of arts advocacy organizations and attracts people to Washington from across the country to lobby members of Congress for continued support of the arts. It was infused with a sense of urgency in 1990, swelling the ranks of attendees. For registrants there were meetings with lawyers and celebrities, and addresses by Speaker of the House Tom Foley and other members of Congress. The afternoon was devoted to individual Congressional visits. Participants were given sheets of objectives as well as vital information and arguments to facilitate their meetings, including lists of previously controversial works dating back to Homer. But the

intention was to deflect attention away from contemporary controversial works executed with NEA support; they were to be considered anomalies rather than an integral part of the NEA's record.

Other groups joined in that day because of this politically charged climate. Arts administrators were aided by the Creative Coalition, a new group comprised of well-known artists from performing and other creative fields. Their aim was to parlay their star appeal into pressure to help assure the NEA's reauthorization. A few months after Advocacy Day, the Creative Coalition, in alliance with People for the American Way, devised the notion of a SWAT-team—famous-named individuals who would undergo intensive briefings on the NEA crisis, and rush into service to pressure pivotal politicians as conditions dictated.[14] In contrast to this glamour were rank-and-file artists who assembled for a demonstration on Capitol Hill (many of whom travelled from New York).

All these events took place on a brutally cold March day. And there could not have been a sharper contrast than between the Advocacy Day registrants in their business attire (generally arts administrators officially representing arts groups and institutions), the assembly of artists and activists (representing themselves, or a variety of grass-roots organizations), and the stars. There was the variation in personal style, certainly. And whereas the registrants and stars spent most of their time inside the halls of government, the artists were primarily outside, using chants, broadsides and placards to communicate their point of view [see Plates section].[15] The "National Association for the Transmission of Safe Images" distributed "What You Need To Know About Safe Art," a satiric ten-point inventory of prescriptions and proscriptions. ACT UP circulated Day-Glo colored sheets declaring "Buttfuckers United Against Censorship!" lauding homoeroticism and squaring off against Senator Helms's equation of homoeroticism with obscenity. Representatives of Refuse and Resist! dispensed their Statement of Non-Compliance, a declaration which already had amassed over six hundred signatories who promised to fight NEA restrictions and self-censorship, and pledged not to adhere to the terms of the Helms Amendment. And Art+Positive circulated its new catchphrase "AIDS Is Killing Hundreds of Artists/Now Homophobia Is Killing Art."

The rally brought all these groups to the same site, melding a '60s style and sensibility with '90s savvy, and highlighting the tremendous stratification within the art world.[16] Main players in some of the recent battles, such as Nan Goldin and Andres Serrano, addressed the crowd, but the media snapped to attention when the stars arrived. There was tremendous excitement when actors Alec Baldwin, Ron Silver, Susan Sarandon and others spoke, but the media essentially abandoned the scene after their brief appearance was over; they had gotten the photos and quotes they wanted. To many people's obvious embarrassment, personality largely outweighed political posture in garnering attention.

Five months later, another significant art rally took place in Washington under very different circumstances. It was a typically steamy August day in D.C. The

political climate had also heated up over John Frohnmayer's defunding of four performance artists during the summer. Angry artists and their supporters converged on the Post Office Pavilion, location of a meeting of the NEA's National Council. The penalized artists were to be discussed at these sessions, and their advocates wanted decision-makers to be aware of their anger and dissatisfaction over the decision. Unlike what occurred at the Union Square rally, homophobia was not a whispered subtext at this event. Rather, it provided the main theme for the event.

The rally was coordinated by Get Smart (formerly the New York Ad Hoc Artists Group) and Oppression Under Target (OUT!), a D.C. direct action group fighting for lesbian and gay rights, and against AIDS. Organizers distributed chant sheets to help guarantee that the anti-homophobia and pro-gay themes would stay in focus, with refrains such as "Fight For Freedom Of Expression/No More Homo-Art Repression!" "Out Of The Galleries, Into The Street!/Homophobia Must Be Beat!" and "Censorship? Never Again! Art's Not Just For Straight White Men!" The scene puzzled many of the tourists who stumbled upon the portion of the demonstration outside the building, and scared and amazed those inside the public parts of the building (filled with atrium shops and restaurants) where additional scores of protesters gathered. Part of the rally eventually spilled into the meeting, to which the public was allowed as space permitted. Demonstrators exploded when Chairman Frohnmayer announced that decisions on the contested performance grants would be postponed until another committee was to meet in November. Then whistle-blowing and shouting within the chamber joined the muffled voices and foot-stomping of the people outside; the demonstrators were removed by police.

The number of participants here may not have matched the turnout of some other events, but most such occurrences were of very modest size and attracted only a modicum of media and official attention. These were not like some civil rights actions which have filled the mall in Washington, or whose lines of march can choke city streets for hours. But this action was distinct from many of its predecessors. Rather than playing only to the converted, these demonstrators pressed their point to the public and directly to NEA decision makers. They made themselves much more difficult to ignore, and their principal chant reverberated throughout pro-gay rallies from that time forward: "We're Here!/We're Queer!/We're Fabulous!/Get Used To It!"

THE ARTISTIC COUNTER ASSAULT: RETURNING THE FAVOR

One of the most noticeable targets throughout the 1980s and '90s battles over the arts was Senator Jesse Helms. Artists could not resist skewering him, and they

pulled out all the creative stops to that end. At Advocacy Day 1990, for example, the group ARTFUX positioned an unflattering statue of the Senator on the Capitol steps: paunchy, naked and anatomically complete (albeit under-endowed). They smashed the effigy before the demonstration ended: "ARTFUX everything and everything ARTFUX." Tim Rollins + K.O.S. transplanted Helms's head onto the body of a bulldog in "From the Animal Farm (Jesse Helms)," 1984–1987; David Wojnarowicz grafted his head onto a plastic spider with a swastika on his back in the color photo "In the garden (sub-species *Helms Senatorius*)" in a show at P.P.O.W. in 1990; and the artist Cactus Jack displayed "Piss Helms" at a Washington, D.C. gallery, a photograph of the Senator submerged in amber liquid (beer, not urine). The Coalition Opposed to Censorship in the Arts also organized "Helms' Degenerate Art Show," their emblem a forlorn, crucified Helms, naked except for a necktie emblazoned with a swastika. In promotional material the organizers equated statements made by Hitler and by Helms, and drew parallels between the 1937 German show and what they felt the US government was trying to do to silence certain contemporary artists [see Plates section].

Helms also adorned the cover of the national gay magazine *The Advocate* on July 3, 1990, the lipsticked cover boy for the first annual Sissy Awards. He joined other winners such as Representative William Dannemeyer, Reverend Lou Sheldon, John Frohnmayer, and the city of Cincinnati, all cited for their anti-gay activities. Elsewhere a graphic artist superimposed the senator's image onto a *Vogue* photo and produced a simulated portrait of him in drag, and another artist spliced the head of Helms onto a figure having anal intercourse with a man whose torso was crowned with George Bush's likeness. The message: "READ MY HIPS: Mr. President, Jesse Helms loves your position on AIDS. Get off your knees, George."[17] Artist Cheri Gaulke presented "Hey Jesse, You Ain't Seen Nothing Yet" at L.A.'s "Taking Liberties"; she performed nude with frames around her breasts and pubic region. And even a 1990 Christmas window at Manhattan's upscale clothier Barney's mocked the man: a cranky looking Helms as Censor Claws sat with a Mapplethorpe catalog spread across his lap, with his reindeer "Homophobia" by his side, and the motto "Merry Xmas to All & to All a Far Right" [see Plates section].

During this period Helms was the target of barbs thrown by a variety of types of artists. The Washington, D.C. satirists the Capitol Steps offered the musical spoof "Pardon Me Boys, But Give the Statue Here a Tu-Tu," and songwriter Loudon Wainwright III composed "Jesse Don't Like It." Laurie Anderson penned "Big Black Dick," a parable about Helms' reaction to some of the Mapplethorpe photos, and a film program at a downtown New York City venue adopted the title "Reel Time—Six Films to Shock and Disgust Jesse Helms." In addition, Manbites Dog Theater of North Carolina developed "Indecent Materials," based upon extracts from their senator's own statements. After a theatrical run in Helms's

home state, it moved to the Public Theater in New York. This is merely a *sample* of such artistic reactions.

As was the case with most artists' demonstrations, many of these responses reflected strong emotions and displayed great wit, but played to modestly sized crowds of like-minded people.[18] In some instances, however, the critiques became controversial themselves, or raised extremely complicated questions about political collaboration, strategizing and commitment. One artist whose symbolic protest developed a strange life of its own was the L.A.-based Robbie Conal. Conal is primarily a poster artist who represents a prankster mode of expression, a "guerrilla semiotician," if you will.[19] He is known for his unflattering portraits of political and other public figures, which he commonly pastes onto walls, light posts, traffic light switch boxes—wherever—under cover of darkness. His images and tactics are cheeky: Conal's dual portraits of Jim and Tammy Bakker bear the titles "False" under her face and "Profit" under his.

In 1990 the artist tackled his first billboard, a legal venture where he leased a space in West Hollywood from 3M National Advertising Co. The portrait was of Jesse Helms, in typically uncomplimentary Conal style: Helms appears wary, and his sagging flesh almost looks like it could slide off his face. He is displayed on an artist's palette, the thumb hole positioned on his forehead, squarely between his eyes. The piece was titled "Artificial Art Official," after the title "Holy Homopho-bia" was rejected by the company.

3M ordered it removed shortly after its installation, without informing Conal. But company officials reconsidered a day later. They decided to reinstall it, in a dazzling display of corporate double-talk: "We took a look at this one again and figured that we *perhaps should go in the direction of* putting it back up."[20] Conal's experience echoed the difficulties which Gran Fury encountered with their "Kissing Doesn't Kill" poster, yet with a satisfactory resolution coming within a much shorter time. Even so, Conal vowed "The experience with that billboard taught me never to do anything legal ever again."[21]

Something similar happened to artist Charles Sherman at about the same time in Los Angeles. Sherman contracted with 3M to display an anti-tobacco industry billboard. The design featured a cigarette burning a large hole into the American flag. The original text read "Jesse Helms Is Burning America" (within the singed portion of the flag), and "Just Say No To Taxpayer Subsidies To The Tobacco Industry." His intention was to direct attention to Helms's scapegoating of artists, while many of the Senator's own actions went unremarked. 3M officials requested that he alter this text because it was too controversial, so it became "Who's Burning America?" But company officials subsequently reneged on their promise to exhibit even the edited version, citing the escalation of tensions in the Mideast because of Iraq's invasion of Kuwait. Sherman's message was eventually seen from a different company's billboard.[22]

Helms was the target of yet another artist/gadfly in the person of Hans Haacke. For over twenty years Haacke has addressed the complex conjunction between artists and the corporate state, business interests and the quality of contemporary life, and compliance and resistance to dominant ideologies. In an unprecedented move the Guggenheim Museum canceled his investigative show "Shapolsky et al." in 1971. In this, Haacke painstakingly documented the real estate machinations of one New York company in Harlem and the Lower East Side with pictures and text. The Guggenheim dismissed it as "artistically inappropriate" and "extra-aesthetic" in nature. His 1975 show "On Social Grease" used quotations from politicians, media and business moguls to highlight how corporations enlist the arts to help create consent. Businesses cultivate liberal support when they underwrite cultural endeavors, defusing potential hostility and friction: "a company that supports the arts cannot be all bad."[23] Haacke has also been concerned about how arts institutions become co-opted because of their dependence upon this type of patronage, leading to their employing discretion and self-censorship.

Haacke found a marvelous subject in Helms. The artist once again took on the role of sleuth and uncovered links between the Senator and Philip Morris corporation, a major contributor to both Helms and to the arts. Haacke presented "Helmsboro Country" at the John Weber Gallery in New York in 1990. The work was a gigantic flip-top cigarette box on the order of a Claes Oldenburg sculpture, the familiar Marlboro design and logo altered to read "Helmsboro" and featuring the Senator's likeness in the center of the seal. In place of the usual fine print on the package, Haacke substituted quotes from Helms and Philip Morris officials. In one passage Helms rails against the NEA grant to Mapplethorpe, obviously concerned that the NEA's gatekeeping mission has broken down. And each of the cigarettes tumbling out of the package was encased in a copy of the Bill of Rights, a reference to Philip Morris's sponsorship of a nationwide tour of the document to celebrate its two hundredth anniversary.[24]

Haacke supplemented this Pop Art-type creation with two Cubist-inspired collages, knockoffs of famous works by Picasso and Braque. Haacke's "Violin and Cigarette: 'Picasso and Braque'" was based upon Braque's "Violin and Pipe: Le Quotidien" (1913). Haacke used fragments of text to construct the design, disclosing tantalizing bits of information: contributions by Philip Morris to Rohrabacher, Dannemeyer, and a 1989 Museum of Modern Art exhibit on Braque and Picasso; details of the company's Bill of Rights campaign; and information disclosing Philip Morris's exploitation of foreign markets for their products. Haacke also presented "Cowboy with Cigarette," based upon Picasso's "Man with a Hat" (1912). Here, too, remnants of news stories and corporate statements divulged details about the social and physical costs of smoking, and revealed large pledges of money by Philip Morris to the Jesse Helms Center.

Haacke indicted the company for its simultaneous art subsidies and its support of Jesse Helms, considered by so many artists to be their chief enemy. In addition,

Haacke's juxtaposition of the company's corporate practices next to its promotion of such important beneficiaries as the Dance Theater of Harlem, the Joffrey Ballet, the Alvin Ailey American Dance Theater, Lincoln Center, and the Whitney Museum—even Franklin Furnace—corroborated his thesis that such contributions may lubricate the social machinery so that not too much heat is generated. In fact, Philip Morris is one of the largest corporate contributors to the arts, in the amount of approximately fifteen million dollars in 1990.[25] With Helmsboro, Haacke once again sought to unmask the corporate avarice and deviousness concealed behind a benevolent mask.[26]

Haacke's work forced people in the art world to consider what the price of corporate sponsorship might be. He compelled them to look at their potential collusion with "the enemy." This is but one example of artists being alert to the possibility that government or corporate funds might be tainted money, or that they might be dupes for endeavors they do not agree with. These concerns ushered in a period when artists closely scrutinized themselves, others, and arts institutions, searching for moral purity in a complex and imperfect world. For example, in 1990 anti-apartheid activists in San Francisco pressured the M. H. de Young Memorial Museum to seek new sponsors for an exhibition of seventeenth century Dutch Old Master paintings. Artistic content was not the sticking point. But the exhibit was organized by the Royal Dutch Petroleum Company (the parent company of Shell Oil) in honor of its centenary. Because the multinational corporation has substantial holdings in South Africa, organizers of Nelson Mandela's US tour threatened that the leader would not stop in San Francisco if this tie remained intact.

San Francisco's mayor joined the chorus of critics, as did the Board of Supervisors. That body endorsed a resolution stating that the oil company's sponsorship violated a city ordinance requiring divestment of stock in corporations doing business in South Africa. Royal Dutch Petroleum bowed to the pressure to pull out, and the museum then had to search for support in a politically cautious and economically recessionary time. As in the cases of the Chicago Show and the affirmative action policy at the Detroit Symphony Orchestra (see Chapter Three), political realities intruded into a realm that previously thought itself to be isolated from or above such considerations.

The notion of collaboration also surfaced in relation to the seventh annual New York Dance and Performance Awards, known as the "Bessies." These are the "downtown" equivalent of the Oscars or Emmys, but they very nearly did not take place in 1990. When insufficient funding threatened to cancel the show, Philip Morris increased its financial backing as one of the major sponsors. But the association with this corporation which also supports Jesse Helms seemed too hypocritical for some artists. Karen Finley withdrew, as did her co-host Danitra Vance. Ms. Vance declared "in this war of symbols I can't just put on a pretty red dress, sit in the middle on a fence and hope folks will shoot around me."[27] The

sponsoring Dance Theater Workshop (DTW) met to debate the issue and decided to proceed. As one of the members of the Bessie committee anguished, "all of us are now being faced with ethical questions we've never had to think about before."[28]

Politics reigned inside and outside the Brooklyn Academy of Music the evening of the awards, as artists exercised a range of protest options. Outside, members of Get Smart dressed as "cigarette girls" and "Marlboro men" leafleted the crowd with information both about Philip Morris's contributions to the arts, and its support of Helms's reelection campaign and the Helms museum. Karen Finley assigned her fifteen hundred-dollar award to the election campaign of Harvey Gantt, Helms's Democratic opponent. And emcees, presenters, performers and recipients used the podium to address a broad range of social issues. Censorship and homophobia were the primary concerns for this constituency, and the tone of the evening was set by the co-hosts at the outset. A gay man and a lesbian, they spoke in turn to orchestrate the following scenario: "I'd like to ask everyone in the audience who's gay or lesbian, a fag, a dyke or a queer, to please stand." (Cheers and applause.) "Now I'd like anyone who's ever slept with anybody of the same sex to please stand up." (Laughter and more applause.) "Could everybody whose work contains gay and lesbian content please join them in standing?" At this point a large portion of the audience was on its feet. Then citing examples such as Rosa Parks and the drag queens at the Stonewall Rebellion, the questioners asked, "for those of you who are sitting . . . what issues would you be willing to stand up for?"[29] This was a singular declaration of pride and solidarity, one which underscored the common humanity and potential fate of all artists.[30]

Once activists began to draw lines of moral purity and impurity between funding sources, it roused a flurry of attempts to sniff out malodorous situations. Certain individuals acted like orthodox Jewish housekeepers needing to cleanse their homes of any trace of leavening before Passover. Some AIDS activists were troubled because the Gay Men's Health Crisis accepted support from RJ Reynolds and Lorillard, two tobacco companies which also contributed to Jesse Helms. And ACT UP initiated a boycott against Miller Beer, a Philip Morris subsidiary. But gay leaders and business owners in some cities were reluctant to join in because local Miller distributors and Philip Morris had become important patrons of AIDS organizations. The decision to assist or resist this protest effort drove a wedge between different segments of the gay community, much as alternative courses of action in relation to other issues split the art community. In direct response to the boycott—which Philip Morris claimed had had no economic impact—the company pledged to double its contributions to AIDS medical research.[31] It was a shrewd corporate decision: they raised the ante, making the cost of noncompliance for resource-poor organizations ever more dear, even if what they appeared to be offering was guilt money.

Politically progressive artists, aesthetically innovative artists, and social activists are all in the uncomfortable position of being dependent upon funding sources

whose business practices or portfolios of other recipients they may not approve of. It was necessary for those who wished to remain virtuous and unblemished to be continually vigilant, which possibly meant working under more impoverished conditions, if at all. For others there was the torment of endless dialogue and uneasy compromise, perhaps an inevitability in today's world. As DTW's executive director reflected, "We are living in a time of relativity. To depend on absolutes in all areas will potentially lessen the forces we can use."[32]

One enterprise that managed to override many shades of opinion and unite artists of different stations and beliefs was the campaign to defeat Jesse Helms in the election of November, 1990. Helms was challenged by Harvey Gantt, the first Black man ever nominated to run for the Senate as a Democrat in the South. The battle spilled far beyond the borders of North Carolina, as Mrs. Helms acknowledged when she hit the campaign trail. Her direct involvement was a rare occurrence in previous, less tightly contested electoral races: "I wouldn't be doing this if we weren't up against people from out of state, all these funny people. . . . the homosexuals and the lesbians and the odd arts groups. . . . those people who want to control our lives here in North Carolina and across America."[33] Those groups that Mrs. Helms cited felt that her husband was trying to manage *their* lives, and they indeed mobilized to assist the candidate who pledged to replace the anti-gay, anti-art "Senator No" with a more progressive agenda.

Gantt campaign literature was distributed at New York galleries and circulated at pro-NEA and anti-censorship rallies throughout the country, and Gantt buttons and T-shirts were proudly worn by far-flung supporters when they could secure them. Artists initiated fund-raising parties and auctions, and a consortium of New York galleries and dealers organized the sale of limited edition prints for a contribution of one thousand dollars to the Gantt campaign. The prints bore the signatures of such notables as Serra, Oldenburg, Rauschenberg, Motherwell, and Lichtenstein. Other artists donated works for auctions in North Carolina to subsidize voter registration drives, and Gantt himself toured New York's SoHo to press the flesh. Artists' efforts were complemented by gay involvement, including the formation of North Carolina Senate Vote '90 and contributions of money and manpower by the Human Rights Campaign Fund. Helms also relied heavily upon resources outside the state to augment his war chest, but he cited the out-of-state support Gantt received from artists and gays as confirmation that alien and dangerous values were being foisted upon traditional Americans. In a television commercial Helms disparaged fund-raising efforts for Gantt in gay and lesbian bars in New York, San Francisco, and Washington, D.C.

Gantt offered Helms his most serious recent challenge. Polls failed to identify an obvious winner up until the election, but Helms finally triumphed, by 53 to 47 percent. Yet it is difficult to interpret the victory as a decisive endorsement of Helms, inasmuch as he knew which hot buttons to push. With his back up against the wall, he pandered to racial and sexual fears. Artists, who often ignore electoral

politics, rallied enthusiastically to this cause; it fell within their ideological, if not immediate, backyard. And Helms never let them forget where he stood; he menacingly predicted "Assuming I may be in this Senate next year, I say to all the arts community and to all homosexuals: You ain't seen nothing yet."[34]

"WHICH SIDE ARE YOU ON?"

Just as artists felt they had to weigh the implications of accepting money from particular corporations, they faced a Hobson's choice over whether or not to assent to the NEA's anti-obscenity clause. To sign and accept the funds could seriously compromise an artist's or a group's beliefs. But to refuse support on principle might in some cases seriously imperil future operations. It was another costly instance of deciding "which side are you on?" However, some NEA recipients had a much wider latitude of alternatives than others, which allowed them to venture onto the moral high ground.

One alternative was to sign but not alter artistic plans. That was the approach of Martha Wilson of Franklin Furnace: "It's my job to put it [the work] up and then let the chips fall. Let the responsibility for determining its obscene qualities fall on them [NEA officials]." And the thinking of The Ridiculous Theatrical Company, a troupe distinguished by its broad camp sensibility, was similar. According to Steve Asher, the managing director: "Everett [Quinton, artistic director] believes that the best form of protest is to take their money and to do with it as you usually do. . . . we've been doing a lot of things that the restrictive language entails for 24 years [now]—with NEA money—and have always been considered critically successful . . . and we're not about to start changing what we do. . . . Artistically, the restrictive language has had the opposite effect of what they [members of Congress] would expect. Naturally, the onus is on us to prove that it's artistic. We feel, 'let 'em sue and prove that it's *not* artistic.' "[35]

Another strategy was to refuse the money. That was the choice of Creative Time, an eighteen-year-old New York nonprofit group which "de-ghettoizes" art by putting it in public places. As director Cee Brown argued, "I'm surprised that there aren't more organizations who understand that right now it is more important to say 'No' and we'll do more good for artists in the long run than if we let people think for one minute that this is okay. . . . [Yet] there are some organizations that would fold if they didn't take their money—so they shouldn't not take the money. There are some individuals who are getting large fellowships which mean a year's worth of time. They shouldn't not take the money. But there are organizations like mine that can trim off this amount right now to make a very clear stance."[36] But this was a decision with profound implications for Creative Time. NEA support accounted for approximately twenty percent of the organization's funding. This meant that programming had to be slashed, and staff members had to absorb

additional responsibilities as personnel left; positions could not be refilled. And Creative Time could not ferret out new funding sources. As Brown lamented, "The corporate sector is maxed. And I believe the corporate sector and many— not all—foundations will start to follow the national lead. Conservatism begets conservatism."[37]

Actions such as these demonstrated a quiet courage and integrity. Generally only like-minded organizations and individuals knew that they had occurred. A similar move by another NEA beneficiary garnered a great deal of attention, however. On April 9, 1990, producer-director Joseph Papp wrote to John Frohn-mayer on his concerns about accepting a fifty thousand dollar grant for Festival Latino, an annual celebration of Latin American culture. He asked "must I play the censor too, subject all plays and films from Latin America to microscopic scrutiny for some clue to sexual 'aberration?' . . . With what yardstick am I to measure the community standards of Rio de Janeiro? . . . something in my mind, my throat or my heart tells me not to go along."[38] Frohnmayer could not prescribe a course of action, and Papp opted to reject the grant.

While this was a large amount of money, it constituted a minuscule portion of the fourteen million-dollar annual budget of the New York Shakespeare Festival, of which Festival Latino is a part. The decision to reject the grant rapidly generated eighty two thousand dollars in private replacement donations, and the festival doubled the number of films it showed and nearly doubled the number of plays.[39] Later that year Papp declined an additional 323,000 dollars in NEA money. Once again this was a large amount, but merely a few percentage points of the organization's overall budget. But it was done during a year when there was a budget shortfall, and Papp found it necessary to dip into the organization's own endowment to meet operating expenses. Artists reacted to Papp's actions with mixed emotions. On the one hand, many people applauded his moral stewardship. But on the other hand, many others cynically noted that Papp was not risking much, and in the end made up his losses with a combination of real and symbolic capital.[40]

By November, 1990, more than thirty groups and individuals had refused to sign the anti-obscenity pledge, spurning 750,000 dollars in grants.[41] These included the *Boston Review*, the *American Poetry Review*, the *Paris Review* and the *Kenyon Review*; the University of Iowa, the Lehman College Art Gallery, the Art Institute of Southern California, and Gettysburg College; the Oregon Shakespeare Festival, the Los Angeles Festival, and San Francisco's Northern California Grantmakers. Choosing the same course of action were people such as performance artist Rachel Rosenthal: she rejected an 11,250-dollar grant that was awarded in the same round of deliberations where "the NEA 4" were recommended for support, only to have the panel's directions canceled by Chairman Frohnmayer.

In some of these cases the grants were relatively minor parts of an awardee's total resources; in others, a lion's share. And in some instances other donors quickly

stepped in to make up the loss. A charitable foundation did so to recompense the L.A. Festival, for example. But in others, artists and organizations had to absorb the full costs of standing up for their beliefs.

Yet another method of challenging the anti-obscenity pledge was through the courts. The New School for Social Research initiated things with a suit filed in May, 1990 by renowned First Amendment lawyer Floyd Abrams. The New School had been awarded a 45,000-dollar grant to redesign a courtyard, a collaboration between sculptor Martin Puryear and architect Michael Van Valkenburgh. The university claimed that the language of the pledge was too vague and unconstitutional, an attempt to institute prior restraint upon not-as-yet completed projects. It was extremely unlikely that this particular enterprise would run afoul of the NEA's broad standards, but this suit put the resources of an organization behind a crucial test of the language. The lawsuit was undertaken because, as President Jonathan Fanton stated, the so-called obscenity clause was akin to a loyalty oath and would have a chilling effect on expression.[42]

A similar suit was filed by L.A.-based choreographer Bella Lewitsky. Lewitsky's company, with a budget of 850,000 dollars, was awarded 72,000 dollars by the NEA. But Lewitsky crossed out the anti-obscenity clause, an action which was presaged by her refusal to testify before HUAC in the 1950s.[43] The NEA ruled that she was not at liberty to do this and invalidated the grant. Lewitsky's suit was comparable to the New School's, challenging the nature of the language, not the acceptability of an actual project. An amici curiae brief filed by the Theater Communications Group, Inc.[44] and sixty nine artists and concerned individuals plucked the NEA's requirement apart phrase by phrase. Assailing the NEA for aspiring to become an "art cop," the brief reiterated arguments about indistinct wording, the chilling of speech, and content-based censorship. It asserted "The constitution does not permit the government to manipulate a federal arts subsidy program into a vehicle for suppressing controversial speech."[45] A suit nearly identical to Lewitsky's was also filed against the NEA by the Newport Harbor Art Museum in California.

The anti-obscenity pledge was ultimately scrapped. The stipulation technically lapsed at the end of the 1990 fiscal year on October 1, 1990, and in the following January Lewitsky won her suit, compelling the NEA to release her grant funds. The judge in the case ruled that the NEA was attempting to act as a federal arbiter of obscenity, when that was a determination to be made according to "local community standards." And in February, 1991, the New School dropped its lawsuit when the NEA agreed to void the restrictions in its case. But legal matters did not end here. When the NEA was reauthorized by Congress in 1990, it mandated that awards be made on the basis of "artistic excellence and artistic merit," but also stipulated that they take into consideration "general standards of decency and respect for the diverse beliefs and values of the American public." Many artists felt this vague provision would give unbridled power to the NEA and also lead to

self-censorship. The NEA 4 challenged this provision in an amendment to the lawsuit they had filed against the NEA in 1990 (discussed in Chapter Six), alleging that the denial of their solo performance grants was based on political, not artistic criteria.[46]

MAYFLY ORGANIZATIONS AND FLEETING COMMITMENTS

These struggles prompted established organizations to swing into action, and spawned a number of new ones as well. Groups such as the American Library Association, the American Civil Liberties Union, and People for the American Way lent their expertise and support to defending artists and pressing for the reauthorization of the NEA with no restrictions. All these groups retain experienced advocates and lobbyists, and the art battles resonated with many issues similar to other conflicts these organizations have enjoined. Arts advocacy groups also were mobilized, like the American Arts Alliance and the National Association of Artists' Organizations.

What was also quickly evident was the generation of all manner of fresh groups composed of artists responding to what they saw as emergency conditions. Many of these were "mayfly organizations,"[47] loose confederations of aroused individuals who briefly came together, organized some type of response, and then dissipated. The aforementioned Committee for Artists' Rights in Chicago is one variation, an ad hoc group which prolonged its life by absorption into another organization. Art+Positive also shares some mayfly characteristics. It was formed in reaction to rabidly anti-gay comments made by artist Mark Kostabi and quoted in an article written by Anthony Hayden-Guest in *Vanity Fair* in June, 1989. The group has a small and variable composition, but has been sustained because of the continuation of the AIDS crisis, and the group's perception of homophobia within the art world. In Philadelphia there was the Art Emergency Coalition; in Santa Monica, Artists Take The Action in Cultural Krisis (ATTACK). The names succinctly convey the emergent nature of these associations, and their sense of urgency.

The Arts Coalition for Freedom of Expression (ACFE) is a prototypical example of a mayfly organization. ACFE grew out of discussions begun at the loft of artist Leon Golub. These developed into weekly meetings attracting more than two hundred concerned artists. Operating procedures were modelled after ACT UP; participatory democracy was the method of conducting meetings and reaching consensus. Individuals broke into committees to devise plans of action, one of which was the Advocacy Day demonstration in March, 1990. A core group emerged over time, fortified by a larger contingent of "floaters." ACFE lasted only eight or nine months, its life cycle of birth, maturation and death compressed into a relatively short period. It would be a mistake to consider it a failure, however.

According to visual artist-participant Sandy Hirsch, no one felt it had any need to last; it was not created with that intention. Hirsch concluded "People did as much as they were able to do. If the group was somewhat haphazard, somewhat floppy or sloppy, there was no chance for it to be different."[48]

The Ad Hoc Artists Group is another example. The group began meeting in Spring, 1990 in response to the proposed restrictive language for the NEA. Between two hundred and three hundred different people attended the weekly meetings over the course of the next year, with approximately one hundred at the largest sessions, thirty to fifty on a typical evening. The group drew heavily from the performance art and theater communities, but many types of artists (and arts administrators) participated. The group eventually adopted the name Get Smart, and as mentioned, produced the Helms-Joseph McCarthy poster, sent informational pickets to the Bessie Awards, and cosponsored the demonstration at the August, 1990 NEA National Council Meeting. A much smaller group returned to Washington in November, 1990 to attend another National Council Meeting. Dressed in Nazi-like outfits, they claimed to represent "White Out!" (a psuedo-White supremacist group) and noisily presented Frohnmayer an "award" for "purifying the nation's art." In addition, members staged a routine where they threw a penis-shaped beanbag at Jesse Helms during the annual Greenwich Village Halloween parade, and produced a thirty-second anti-censorship commercial "Recipe for Repression," which they paid to have broadcast on WNBC with money left over from their July, 1990 benefit.[49]

Like ACFE, Get Smart operated on the ACT UP model. There were no officers or hierarchy, and the group existed through the impetus of individual participants. As one person explained, "Get Smart is an ad hoc group of activist artists that flirts with ad hocking itself to death at every meeting."[50] Its emphasis on direct action was inspired by both ACT UP and Queer Nation. The group became more formless after the NEA was reauthorized; even though many participants weren't pleased with the terms, it was a resolution of sorts. The group struggled and failed to define a new direction, and meetings stretched out to a monthly schedule. By the last gathering in June, 1991, only six people were in attendance. According to participant Jesse Allen, Get Smart was moribund "spiritually and technically, but actually, not exactly." Since nothing was ever formally established, there was nothing to formally dissolve. But Allen prophesied, "If anything happens which requires immediate action, it will be easy to resurrect the core group."

It is simply too early to predict if other groups will also fade quickly, or if they will display greater staying power. The National Campaign for Freedom of Expression (NCFE) is an organization which originated with the debate over the reauthorization of the NEA, but has developed a structure to bolster its potential for endurance. It was initiated by a national coalition of arts activists who felt that many of the organizations concerned about artistic freedom and the NEA were too far removed from actual artists, and too tied into the establishment. These

people spoke by conference-call once a week for approximately six months before they arranged a meeting where many of them met for the first time. From the vantage point of the NCFE organizers, many arts advocacy groups were willing to compromise basic principles for their own survival; they were not ready to go to the mat for all artists and artistic freedom.

NCFE has affiliates in New York, Los Angeles, Boston, Chicago, Seattle and Washington, D.C. In most cases NCFE piggybacks its operations onto other organizations, relying upon part-time assistance quartered in host offices. In August, 1991, there was one full time staff member in the NCFE Washington headquarters, and the executive director and a part-time assistant in Seattle. However, in little more than a year they amassed over eleven hundred individual and group members, and in FY 1991 NCFE had an income of 378,000 dollars, half from grants and the rest from memberships and donations by patrons.

NCFE exploits the most recent technology to perform its work. It established Artswire, the first E-mail, on-line arts column to alert members to issues as soon as they develop. In addition, affiliates in Chicago collected information for two years to establish a censorship data base. They also have a SWAT team that can provide advice and legal assistance on short notice to people confronting difficult situations, and NCFE works closely with other groups such as the ACLU and People for the American Way.[51]

Some NCFE board members participated in a unique conference sponsored by the La Napoule Art Foundation in France in July, 1990 to develop strategies to redirect attacks on the arts and help assure the reauthorization of the NEA without compromise. One of the outcomes of the gathering was a long list of sound bites to help prepare people to be effective spokespeople for the arts. They recognized that a smart, concise presentation was often as important as the message itself. These included "We must invest in the arts. We must leave our children something other than the national debt"; "For the past 25 years, the NEA has effectively and efficiently seeded American culture at its roots. It has never purchased a $5,000 screwdriver nor a $68,000 FAX machine"; and "Confucius said, 'You can tell the state of a man's kingdom by the state of the arts you find there.' What will history say about us?"[52]

This type of strategy reflects the generally high degree of technological sophistication that contemporary activists command. For example, different organizations distributed information for phone zaps—deluging elected officials with calls at strategic times. And the Andrea Ruggieri Gallery in Washington, D.C. sponsored The Great American Fax Attack, an event where artists faxed art works to the gallery, which were then sold for 25 dollars to support Harvey Gantt's campaign against Jesse Helms.[53]

Other artists have targeted the electoral process. Recall, for example, that Madonna urged MTV viewers to get out the vote before the November, 1990 elections. Some have tried to initiate more sustained efforts in this direction,

however, with the formation of political clubs and political action committees (PACs). The prototype is the San Francisco Arts Democratic Club. The group was founded only recently (in 1989), but has become an important player on the local scene; candidates regularly court its endorsement. Similar groups have emerged in three other locales: Chicago (Greater Chicago Citizens for the Arts), New York (Arts Coalition of Independent Democrats) and Los Angeles (Los Angeles Arts Democratic Club).

The Long Beach/Orange County chapter of NCFE also organized a PAC to work for the defeat of Representative Dana Rohrabacher in 1990, the Southern California Coalition for Responsible Government. They did not have much lead time, and Republican registrations outnumber Democratic ones in the district. Rohrabacher won, but after the election he backed away somewhat from the arts issue. Whether or not the PAC had a direct impact is difficult to assess.[54]

This experience, and the Helms-Gantt campaign, demonstrated that artists could lend their many talents to fund-raising ventures, but were relatively unsophisticated in most political matters. The new artist groups aim to change that, although they must work against the romantic notion of the artist as existing apart from society. As a twenty-four-year-old female filmmaker wryly noted "We enjoy being disenfranchised because then we can comment on it."[55] And according to Tom Tresser, a leader in the Chicago effort to pull artists into the political process, "Many artists feel that they're special, and somehow that that part of their brain that they use to be artistic will somehow be polluted if they know who their alderman is, or attend a ward meeting."[56] But this is a gradualist approach, and frustrating to many people who wish to see more immediate results from their efforts, especially when they feel there is an emergency. Even more basic, however, is that artists tend to be a very independent and skeptical lot. To Cee Brown, "Most artists are anarchists at heart. Tell them what to do and they don't want to. 'Call your senator.' 'I don't want to call my senator.' [This is] in contrast to Wildmon's people; the fact is, Wildmon's people *love* to be told what to do."

There are several other factors contributing to the lack of sustained political efforts on the part of artists. It is difficult to maintain the intensity of involvement after a crisis starts to cool down. Meanwhile, the day-to-day crises of overseeing an artistic career or an arts organization can be continual. Fatigue sets in, and many people start to drift off. Most artists who become politically active typically do so while balancing other obligations; they are not full-time, paid lobbyists or politicians. When they are employed by nonprofit organizations, their political work can sometimes impede fulfilling their other obligations, and may hasten burnout, a possibility under the best of conditions. Nonprofits generally, and arts advocacy groups more particularly, are undercapitalized, fragile operations. They frequently spring up and then collapse into a steep death spiral. According to Tresser, "Arts organizations sort of rise and fall in a sine wave. They start with

nothing and build up and then their atoms dissipate. Every once in a while one breaks out of the cycle and becomes institutionalized. That's a rare story." Artists and their incipient organizations are severely disadvantaged players in the political arena.

Another difficulty is the diversity of the artistic community and the difficulty of defining issues, settling on goals, and working together. For example, the aforementioned female filmmaker described the reaction of two musician friends to signing a letter to NEA Chairman Frohnmayer, protesting the adverse reaction to the Mapplethorpe exhibit: "[One] said the minute he read it he just crumpled the thing up and threw it away. Then I had another friend say 'If we start addressing the homophobia issue, we're going to turn off a lot of artists who don't think that's their issue and they don't want to be associated with it.' So it's disposable [to them]. But it isn't." A twenty-five-year-old visual artist relayed a similar scenario with one of her teachers when she distributed a pro-Mapplethorpe leaflet in a class: " 'How could you do this?' he screamed. 'He's a diseased man, and he's dead anyway and it doesn't matter. . . . They don't want *us*. They're not after *us*. So you really shouldn't be worried. I've never gotten any funding from them [NEA] so they can just dissolve.' "

A thirty-year-old male musician-arts administrator proposed that "Everyone from old hippies, punk rockers, and leftists of all stripes . . . share a certain fear of and distaste of homosexuality. There are straight people on this bus who were yelling 'We're here, We're queer.' But they are exceptions." This once again underscores the fact that there are art *communities*, not *an* art community, supporting an immense range of beliefs. Bridge building is not a simple process, an observation with which performance artist Holly Hughes would concur: "What [would] an effective response to this crisis have been [?]. All of the communities saying 'When an artist is under attack, I'm going to be there.' To see it as an attack on themselves. That didn't happen. It didn't happen because artists are so used to getting a tiny pie and killing each other over who gets the crumbs from that pie that they can't stop long enough to think about 'How can we get a bigger pie?' "[57]

As it turned out, the spectacle of the audience united on its feet at the Bessies was something of an aberration. For the most part, such solidarity was not present in sufficient enough quantities to bear the load of ongoing organizational demands.[58] A telling example of the cross-pressures on activists and their groups was the reaction to a slogan formulated by Art+Positive: "AIDS Is Killing Artists/Now Homophobia Is Killing Art" [see Plates section]. In the gay magazine *Outweek*, Sarah Schulman and Kathryn Thomas criticized the message as elitist and implying that artists' lives are more important than others. They proposed instead, "AIDS Is Killing/Homophobia Is Killing." The subsequent debate was divisive, and demonstrated the common tendency within activist communities to rechannel fury inward and to cannibalize one's fellows.

THE BIG CHILL AND THE POLITICAL THAW

Among the most important consequences and reactions to this cycle of art battles was the personal impact upon the artists who were the target of critical assaults, those who rallied to their defense, and those who felt endangered by the adverse cultural climate and concluded that they might need to temper the type of work they do. Many of those whose work was directly embroiled in controversy experienced great disruptions in their creative and personal lives. Andres Serrano complained "It's put an emotional strain on me. It's a lot of pressure for someone who is basically a pretty quiet person to . . . explain and defend the work. I mean, up until this point I never spoke about my work, I never gave lectures. I never had to, you know—it was accepted." Serrano refused to be photographed or to speak on camera for a considerable length of time, both to keep the attention on the art and not the personality, and also to minimize the probability of physical assault. David Wojnarowicz reacted similarly, requesting that curator Nan Goldin substitute another image in place of a Peter Hujar photo portrait of him in the Witnesses show. And Holly Hughes found the controversy swirling about her to be "both an exciting and an exhausting time."

Some cynical observers focused upon the positive repercussions of negative attention, the paradox of the forbidden fruit called the Tacitean principle.[59] Indeed, in some cases artists' careers seemed to get a lift when Jesse Helms, the Rev. Wildmon and others turned their critical spotlights on them. The *NYPress*, a trendy downtown New York paper, scornfully exploited this angle: a category in their annual readers' poll was "Best Blatant Bid for Jesse Helms' Attention." The editors explained, "All over the city and the nation, unknown and often untalented artistes saw what a great career boost the censorship controversy has been for Finley, Serrano and others. [And they have wondered] 'Why her? Why not me?' "[60] But such attention could be a mixed blessing.

There *were* some immediate payoffs: the market for Mapplethorpe and Serrano's work heated up, and Finley profited from the addition of an extra (sold out) appearance at Lincoln Center's Serious Fun! in 1990. But investments in real goods are different from the long-haul marketability of a performer. Finley and others became white hot for a time—too hot for some places, in fact. And then at the other extreme, their "star quality" may rapidly cool, freezing them out of other locales. Nothing is as stale as the person behind yesterday's disreputable headline. As Holly Hughes noted, "I have not gotten bright new opportunities, I've probably lost some opportunities, and I've certainly gotten a ton of things to perform for free."

Finally, notoriety exposes artists to a much wider audience and heightens the probability of critical misunderstanding, a cruel analog to intra-art world jealousies. Hughes summed up her experience in this way: "People who feel there is no such thing as bad publicity have never *had* bad publicity." She continued, "There's a

real qualitative difference between getting attention because your work is good—even if you're seen as a freak or token—and to wake up one morning and find that simply because you've applied for [NEA] funding, your identity and the kind of work you do is ridiculed and taken out of context by people who have never seen it. It puts you completely on the defensive. So what happens is that whoever hated your work or hated you personally from the left, the right, from every community, comes out from under a rock and slings mud at you."

Negative consequences extended far beyond people who were direct targets of critical attacks. Caution and self-censorship enveloped many parts of the art world. To Cee Brown, "This wet blanket has been placed over the field"—a superb way to cause chilling. Joseph Papp feared that "The damage has been done. It's like radiation—it will take a long time to get it out of the system." And Harvard law professor Kathleen Sullivan borrowed an image from Justice Thurgood Marshall to capture the same sense of foreboding: "the problem with 'a sword of Damocles is that it hangs—not that it drops.' "[61] Disquiet may not be easy to measure, but it permeated the atmosphere at this time, surfacing in a variety of ways.

Many examples have already been cited: record companies instituted in-house lyric review panels after the Judas Priest trial to try to anticipate and stifle future complications, and opera companies were concerned about nudity in their productions. Disclaimers posted at the entrance to exhibits featuring sexual material became de rigueur, and free-floating worries appeared to contribute to the pruning of some shows. For example, the Laguna Art Museum exhibited nineteen of twenty one works from Mark Heresy's "Flags" series. One of the excluded pieces was "Freedom of the Press," where the artist fashioned a US flag out of photos from pornographic magazines. The director of the museum denied that there was anything but informed "curatorial choice" operating here, although his defense dodged most of the serious issues. In his words, "We had 19 flags—enough to give the sense of the work without unduly diverting viewer attention to the strong sexual content of 'Freedom of the Press.' "[62]

A similar sort of apprehension surfaced in some unexpected spots. In 1990 Lincoln Center complemented its Serious Fun! performance series with "Offstage Attitudes," visual art created by performance artists. But officials draped some of the work displayed in the lobby of Alice Tully Hall with black cloths to "protect the sensibilities" of congregants of the First Church of Religious Science, which rents the hall on Sundays. This was a preemptive action; no complaints had been received. The president of Lincoln Center justified the decision in the following way: "It is inappropriate to ask a person who enters the hall for another purpose, in this case to attend a religious gathering, to view art he or she did not expect or choose to see. Our intention is to make all users . . . feel welcome and well-served."[63] And a joint U.S.-Hong Kong show (mounted in Washington, D.C.) commemorating the student uprising in China's Tiananmen Square was spoiled when some Senators objected to certain American contributions. The disputed

works included one where *The Last Supper* was reinterpreted with Mao's face on all the figures; another alluded to abortion in China; and yet another included vials of the artist's blood. The American component was withdrawn from the show, with explicit reference to the recent troubles the NEA had experienced.[64]

Many artists could also testify to the more subtle effects the turmoil over the arts and the NEA anti-obscenity pledge had on the development and execution of their work. A 33 year-old performer who combines movement with text reported "My partner and I both are straight, but we do have a piece called 'Brotherly Love' in which we hug. So there are two men showing affection for one another and you can interpolate from the [NEA anti-obscenity] language that they can say 'Gee, there's two guys hugging and that's homoerotic.' And that's frightening." And a twenty-seven-year-old female dancer-performance artist remarked, "I'm a lesbian. The essence of my work is threatened because it comes from who I am and my experience. . . . There are some things in my dances that are about women being together—women's physicality, women's sexuality, women's power. That is something they're [religious and political conservatives] trying to crush."

Demoralization saturated many parts of the art world, and was a *contributing* factor to some momentous decisions: choreographer Senta Driver dissolved her troupe to become a nurse, and Lee Breuer, founder of the experimental theater troupe Mabou Mines, decided to "pull back" his efforts after twenty years: "As we go into the era of Helms, radical work becomes more useless: less funded, less received, less listened to."[65] The art battles did not cause these decisions to be made, but merged with the countless other difficulties of producing art to push these practitioners in certain directions. Foundations supporting controversial work reported increased demands for their patronage, and anxiety even spilled into the advertising world. According to one agency spokesperson in an industry magazine, "I think there is a creative recession and it scares the hell out of me. . . . We're getting batted down for trying to do art—whether it's obscene or not doesn't seem to matter."[66]

But artists also savored the fact that art was being taken so seriously, and many felt individually empowered by the actions they joined. They could draw legacies of participation from their involvement, and could counterbalance the gloom and doom to some extent, even when they were associated with groups which did not persist. For example, the male performer who commented on his fears about how his work might be misinterpreted also noted "It's difficult trying to survive in New York as an artist. You're very isolated. [But] this issue can be binding; there really is a community of support. It brings people together. It makes me feel better. I have not in the past been a very political person. But this [NEA] language, this obscenity issue is making me think you have to be political. You do have to speak out." And the female dancer-performance artist noted the rebirth of political activity among her fellows: "Life is really hard as an artist. We all have a few jobs, everyone is very busy, so the kind of networking that has to happen has to be

something where you can let go of it and somebody else can pick it up because you might not be able to be there. I see it being reactivated." A great many of the artists who became mobilized in fighting back against the attacks on art were young (thirty five years old or below), and their involvement commonly served as their introduction to practical politics. The struggle kindled a spark of participation which might otherwise have lain dormant for a considerable time.[67]

BUSINESS AS USUAL?

Some artists viewed all these activities with a somewhat skeptical eye. They might share the concerns about the defunding of the NEA 4, or feel distressed over the apparent homophobia certain religious leaders, politicians or arts administrators displayed. But what were fresh insights and experiences for some were old hat to others. Those who already had been struggling on the margins of systems of recognition and financial support might empathize with the newer victims of discrimination and exclusion, but they found it difficult to sympathize with their plight wholeheartedly: an enormous clamor was being raised over the predicament of a few artists, whereas the habitual circumstances of others continued to be largely disregarded. The nascent, relative deprivation of certain individuals hardly seemed to measure up to the more absolute levels of adversity others routinely experience.

After a time, however, the dialogue opened up somewhat to consider the broad implications of oppression. Artists and others declared that "radical" artists were not radical enough, and needed to turn their critical gaze to the art world itself. Of course the Guerrilla Girls broached the subject of institutionalized sexism in the art world with their poster "Relax Senator Helms, The Art World *Is* Your Kind of Place!" (see Chapter Six). There they highlighted the ways in which the art world reproduces the larger world of male privilege. And a writer in *The Nation* charged that Karen Finley "symbolizes" and "collaborates" in a type of censorship, the largely unexamined convention of White, middle-class inclusion in the art world. She concluded, "Any battle against censorship that fails to clamor in outrage against this massive smothering of [other] voices has already torpedoed its own cause with narcissism."[68] And additional commentators introduced the operation of institutionalized racism into the debate, another barrier to full participation in artistic reward systems.[69]

One of the most insistent voices coming from the gay and lesbian community calling for the scope of the debate to be expanded was that of writer Sarah Schulman. Schulman balked at the grievances of artists who had been "ultra rewarded," yet who claimed to be censored. To her mind, some artists were disingenuously presenting themselves as deprived: "People are probably embarrassed. On the one hand, they're asking for people to rally behind them. On the

other hand, it really exposes who they are and how they've been operating for a long time. That goes against the ethos of who they're supposed to be. They're living in the East Village, they're struggling. They've waited tables, they've done everything they're supposed to do. So they're earning their credentials and they don't want those credentials to be challenged."

Schulman argued that "only the most upper class gay people with the right connections get grants," but that even those "working in marketable forms have now moved into the unacceptable category. That's what's changed." In other words, in this view the government was seeking to supplement the rules of exclusion to bar even more individuals and types of expression. It was this shift that disrupted taken-for-granted assumptions and derailed particular people's prospects. For Schulman this breach of customary procedures offered a unique opportunity to examine the art world as a whole—including the structure of the NEA—and potentially overhaul it in a more equitable manner. As she put it, "We know we are opposed to Helms. But what ideals guide our actions? . . . Right now we're being offered two choices: Helms or The Same Old Thing. We have to say no to both."[70]

What she was alluding to was the difference between overt censorship and covert controls, or the difference between regulative and constituent censorship.[71] The first of these has a dramatic, emergency quality; it is imposed when the routine of the latter fractures. Such fissures expose the inner workings of social practices and render them accessible to close scrutiny and possible reassembly. Constituent or de facto censorship—the conditions that limit participation or success secondary to race, class, sex, sexual orientation, or aesthetic creed, for example—is the more pervasive form, and the one to which most people unconsciously assent most of the time. People generally do not get as worked up about it as they do over regulative or de jure censorship, so that when they fight the latter, they usually leave the former intact. It is easier to mobilize against egregious or unanticipated sanctions than it is to sustain a thorough investigation of everyday practices which habitually exert more control.

Such examinations do not take place frequently or on a large scale. We have already noted significant divisions within the artistic community over the framing of issues and the range of possible strategies to address them. Many artists and arts administrators emphasized that the NEA worked well for the most part; controversial grants were the exception, not the rule. When the NEA's obscenity clause was dropped, therefore, it signalled to them a return to normalcy. At an awards ceremony for the California Arts Council, for example, beneficiaries proclaimed with relief, "There's hope!," "we won," and "The system works!"[72] But for other observers, the meager number of controversial NEA grants indicated that decision-making practices embedded within the agency led it to toe a conservative line. To them this was a liability, not an asset, but one which they could not convince many more people to face.

The direction and even the continued existence of the NEA weren't the only issues in the art battles of the late 1980s and early '90s. But the NEA was an obvious setting for conflict because its status as a government agency made it subject to public oversight. The history, development and structure of the National Endowment for the Arts warrant closer examination to understand how attacks were launched, and which ones found their mark.

11

THE GOVERNMENT AS PATRON:
ANGEL OR DEMON?

Art has always needed patrons.
Patrons . . . have always needed
something to patronize.
Penelope Lively, *Next To Nature, Art*, 1982

Americans delight in investigative reports which uncover the ineptness or flagrant wastefulness of elected officials and bureaucracies. Such revelations confirm a deep-seated conviction that government is inefficient, corrupt and beholden to special interest groups. They expose the chinks in the armor of authorities, a tendency that has accelerated in recent years, stripping many public trustees of their patina of trustworthiness and aplomb. Scandalous tales are commonly trumpeted by the media and sometimes by officials themselves: former Senator Proxmire of Wisconsin made these disclosures a personal campaign, "honoring" them with his Golden Fleece awards.

One curious episode surfaced in the fall of 1990. The media revealed that Congress had authorized the Department of Agriculture to make a grant of five hundred thousand dollars toward the renovation of Lawrence Welk's North Dakota boyhood home as a museum. There was more to the story, of course: the project was a German-Russian Interpretive History Center, intended to recreate pioneer life on the high plains and to give a small town's economy a much-needed boost. But calls of "boondoggle" and "pork barrel" went up, eventually derailing the project. The kitschy nature of the "champagne music maker" interacted with a Congressional watchdog attitude—heightened by all the turmoil over the arts— to seal the proposal's fate.

A critical hue and cry has been heard whenever the government has become a patron of the arts. Republican antagonists of the Works Progress Administration (WPA) arts projects in the 1930s assailed them as Democratic public relations ploys, and commentators in the late 1970s and early 1980s launched similar attacks against the Comprehensive Employment and Training (CETA) arts projects. Contemporary critics have used many of the same arguments to try to force the government from its current patronage role. Robert J. Samuelson, for example, labelled the NEA a "highbrow pork barrel," arguing that it should be scrapped because it underwrote private interests. But artists responded to such critics with the mantra-like repetition of "64 cents," the amount of each American's tax bill which reportedly goes directly to art subsidies.[1] Defenders of public support of the arts[2] felt it was irrational for the average citizen to get upset when a relatively small amount of funds was under discussion, especially when compared to what other agencies may routinely squander. They claimed there was nothing in the public art field comparable to the notorious six hundred dollar hammers or thousand-dollar toilet seats attributed to other government agencies.

The fate and direction of the National Endowment for the Arts were not the only issues in the art battles of the late 1980s and early 1990s. But the NEA quickly took center stage because of its status and visibility as a public agency. It was a handy target, and it was also a pivotal one: foundations and corporations which support the arts often use NEA decisions as a guide to what funding actions to take themselves. In crucial respects, as the NEA goes, so goes much of the rest of the arts subsidy realm. This became the site, therefore, where antagonists as well as supporters pressed their cases.

WHOSE NEA?

Government support of the arts is as old as the United States. But in the past it generally took the form of ceremonials (military bands), the adornment of public buildings, or emergency jobs programs (the WPA). President Lyndon Johnson ushered in a new era in public funding of the arts in 1965 when he signed the National Foundation on the Arts and the Humanities Act, establishing both the National Endowment for the Arts and the National Endowment for the Humanities.[3] Throughout its twenty-five-year history, the NEA has been crosscut by underlying tensions of philosophy and practice. There have been many rehearsals for the current spate of controversies; they are merely the most recent and most acute symptoms of some basic contradictions within the NEA.

The NEA has always been an agency in search of an identity. The central, persistent source of friction has been the struggle for influence between those holding elitist and those holding populist views of the arts. To the former, the arts are traditionally based within special institutions, and preserve the best that

civilization has to offer. Excellence is the chief criterion for support. But populists argue for democratization according to the principles of geography, diversity and participation.[4] Access, decentralization and diverse standards of evaluation (self-expression, fulfillment and local or nontraditional identities, for example) are the most important considerations. The fortunes of advocates of each position have ebbed and flowed at various times in the organizational chronicles of the NEA.

One of the most important determinants of the character of the agency has been the person at the helm. Nancy Hanks, chairperson from 1969 to 1977, was responsible for explosive growth in the NEA: its budget ballooned from a meager two and a half million dollars in 1965 to nearly one hundred and twenty five million dollars when she stepped down. Political scientist Edward Arian claims that Hanks was responsible for perpetuating elite domination of the arts by accommodating the interests of the most powerful cultural institutions throughout the country. With what he describes as a quid pro quo, Arian charges that Hanks swapped consistently large NEA allocations to symphony orchestras and museums in exchange for the political support of their influential allies in Congress. In his estimation Hanks promoted the cooptation of the NEA by elite interests, and the agency has fallen far short of achieving cultural democracy.[5] And yet when Samuel Lipman surveyed the same history he saw something quite different. Lipman alleges that Hanks arrived at her position through happenstance, and that quality never figured into her calculus: "Her emphasis seems always to have been on the growth of the NEA, and on a kind of simple arts boosterism."[6] In his judgment the Hanks years left a sad legacy of quantity over quality as the measure of accomplishment.

Fears over the triumph of populism intensified when President Carter appointed Livingston Biddle in 1978. Biddle's populist outlook seemed harmonious with Carter's "grass-roots" philosophy, but critics feared the NEA would turn to a social casework model instead of making meaningful aesthetic judgments and authenticating professional standards. Michael Straight, deputy chairman under Hanks, condemned the appointment as politicizing the agency.[7] Critic Hilton Kramer concurred, employing a sardonic image to convey his apprehension: "A specter is haunting the arts and humanities in the United States today—the specter of a catastrophic shift of government policy in cultural affairs." And another viewer observed, "Rightly or wrongly, art has been called in to do the work of sociology."[8] The chairman's concession to the conflicting claims of elitists and populists was the notion of "access to the best," an adroitly expedient expression. Biddle's tenure was indeed marked by greater inclusiveness, of varieties of expression as well as types of audiences.

Anxieties developed anew when Ronald Reagan was elected president and assumed office in 1981. With the assistance of Budget Director David Stockman, Reagan instituted a cut-and-slash policy to trim what he viewed as the governmental fat that remained from his predecessors' social programs. For example, one of the President's first sacrifices was CETA, the Comprehensive Employment and

Training Act. The arts were the beneficiaries of a minuscule portion of those funds, which nonetheless supported a vast array of artistic endeavors.[9]

Government officials acted particularly ruthlessly when they turned their attention to the NEA and NEH: Reagan suggested eliminating the agencies altogether, and the Office of Management and Budget (OMB) proposed to prune their budgets by just over fifty percent. Artists recoiled in disbelief and then responded with anger, especially those whose opportunities had flourished under previous administrations. Artists met throughout the country to protest, and administrators developed doomsday plans for their imperiled institutions. The *Village Voice* ran a lengthy front-page symposium entitled "Artists: An Endangered Species," presenting representatives of various arts fields and their opinions about how the cuts would curtail creativity. Of special concern was the fate of the Expansion Arts program, implemented in 1971 to emphasize the "minority, low-income, blue-collar, rural and tribal."[10] A public demonstration announced in *New York* magazine in May, 1981 could easily be reprinted ten years later: "the Pentagon's yearly expenditure for military bands remains greater than the maximum combined budgets for the endowments. Will America sing out or let the Pentagon toot its own horn?"

The storm blew over that time because arts allies pressured the administration and Congress to back off. And OMB proposals for significant reductions in allocations in the two following years were also defeated. But Reagan was successful in appointing Frank Hodsoll as NEA chairman, a change in personnel that the *Village Voice* decried as "a James Watt for the arts,"[11] and which helped insure that the spirit of the 1981 Heritage Foundation's critique would find an advocate: "The arts that NEA funds must support belong primarily to the area of high culture; such culture is more than mere entertainment and is concerned with permanent values beyond current tastes and wide appeal. . . . [Art] must be granted an existence independent from the proclaimed social goals of the state. . . ."[12]

Hodsoll displayed some of the hallmarks of a conservative organization man: he supported the President's reduced budget requests, introduced tighter management to the agency, and cultivated new partnerships with the public sector. Hodsoll also imposed personal oversight onto the grant making process. From 1981 to 1983 he questioned 5.5 percent of the grants recommended for funding by peer panels, 316 out of 5,727. In the end, twenty of these were rejected.[13] Although the number may sound low, this was an unprecedented action, and sent waves of anxiety throughout the arts community. But while the Hodsoll administration was also conspicuous for the appointment of several conservatives to the National Council on the Arts[14] and the elimination of fellowships for art critics (see Chapter Nine), the NEA did not sail full speed to the right as some observers feared it might when Hodsoll first took over.[15]

The NEA featured a mix of conservative and adventurous tendencies when the outbreak of controversies developed in the late 1980s. The agency was also without a permanent head after Hodsoll left it in February, 1989. John Frohnmayer was

nominated by President Bush to fill the post in July of that year, and was confirmed by October. But in the interim the NEA was in an extremely vulnerable position, while the terms of the debate over obscenity and the future of government support of the arts were largely dictated by people outside the agency.

EARLY SIGNS OF TROUBLE

The earlier controversies over the direction and fate of the NEA were dry runs for the heated quarrels which broke out in the late 1980s. One observer was particularly prescient when he reflected on the turmoil occuring in 1981: "All this hullabaloo is no one-shot, classic cliff-hanger. . . . For the arts, the 1980s will be a perpetual 'Perils of Pauline.' "[16] And indeed, controversies displaying most of the characteristics of their latter-day counterparts periodically sprung up throughout the NEA's history. One of the earliest occurred in 1970 when Representative William Scherle (R-IA) encountered a "concrete poem" by Aram Saroyan, "lighght." The work was an example of "word art," an attempt to portray words in graphic design. But its status as art was bewildering to the Congressman, who reacted in the paternalistic manner some of his colleagues would echo later: "[I]f my kid came home from school spelling that, I would have stood him in the corner with a dunce cap."[17]

Saroyan's poem was included in the second volume of an NEA-subsidized series edited by George Plimpton, *The American Literary Anthology*. Controversy arose within the NEA when Plimpton planned to include an Ed Sanders' story, "The Hairy Table," in the third volume. The story included vivid sexual interludes, a feature that Nancy Hanks and Michael Straight feared could be exploited by Congressional critics during imminent reappropriations hearings. They skillfully avoided sustained conflict by curtailing NEA support for the series early on procedural grounds. The volume with the disputed material was published instead under private auspices.[18]

Literature continued to be a hot medium after a 1973 fellowship was awarded to poet and novelist Erica Jong. Jong received five thousand dollars which helped her complete *Fear of Flying*, published in 1974. The lusty novel has at its center the notion of the "Zipless Fuck," a recurrent, quick and nonemotional sexual encounter. Jong acknowledged the NEA at the beginning of her book, a detail noted by members of the public and some critics. The book became a significant subtext in the debate over appropriations in 1975, and Jesse Helms sent the NEA a blistering set of letters demanding an explanation of the agency's actions. Deputy chairman Straight characterized the first in this series as a "have you stopped beating your wife" letter, forcing the NEA into an impossibly defensive position.[19] And in 1985 alleged pornographic poems raised the ire of Texas Representatives Dick Armey and Tom DeLay. Included in the group was "Bodies" by gay poet

Jack Grapes, a piece which the author claims was misinterpreted as being about two male lovers, but which in fact was about a heterosexual couple.[20]

Livingston Biddle reflected that he only once canceled a grant which had been endorsed by a peer panel and the National Council, a situation in which a filmmaker shot a dog and recorded its anguished death on camera.[21] But conflicts within the NEA multiplied as the nature of art and the art world changed in the 1980s, and artists began to reflect the political, social and sexual changes reshaping their environment. In 1982, for example, the Washington Women's Arts Center credited the NEA and the Pleasure Chest (a sexual aids emporium) for supporting its "Erotic Art Show." A member of Congress protested, and the center received no NEA funds thereafter.[22] Hodsoll and/or the National Council nixed grants to the Heresies Collective and Political Art Documentation Distribution group to support forums on "the role of the creative individual within changing social structures"; a documentary film project "De Peliculas: Archives of Latin American Conflict 1890–1940"; and a project by Jenny Holzer sponsored by the Washington Project for the Arts proposing to place a "high tech soapbox" in front of the White House, Supreme Court and Congress.[23]

Haphazard potshots taken at the NEA nearly from its inception turned into a major offensive by 1989. The significant issues were always there in latent form: populism versus elitism, imbalances in the geographic distribution of grants, perplexing art styles, and agency accountability for topics which could offend some viewers, especially topics with blatantly sexual or adversarial political themes. The NEA's contemporary critics carried with them the experience garnered from all these previous battles. Their negative reviews carried more bite, and their proposed adjustments were backed by more muscle, for they were also served by the growing power of political conservatism and religious fundamentalism which marked a social landscape very different from the one into which the NEA was born. In addition, the potential targets were becoming more dramatic and more numerous. It was not until the late 1980s that all these factors coalesced to provoke a nationwide dialogue.

POLITICAL WAFFLING

Representative Paul Henry of Michigan declared in 1990 "I believe in the NEA, but I think in order to save it we are going to have to reform it."[24] His statement reverberated with a viewpoint expressed by some US strategists during the Vietnam War that a village might have to be destroyed to "save" it from Communist rule. In each case those in control felt drastic action was called for, and demolition might be preferable to what they saw as sorry (and dangerous) states of affairs. Without doubt, neither setting was the same after the smoke cleared.

Many (if not most) politicians are merely fair-weather friends of the arts. As long as art brings people together, soothes and celebrates, it is a political asset. But

it can move swiftly into the liability column when it challenges the status quo and disturbs public sensibilities. Then politicians frantically brush it aside, disavow any association with it, and attempt to pull governmental purse strings ever tighter. Few of them are willing to maintain their artistic allegiance when the going gets rough.

Senator Alphonse D'Amato (R-NY) provides a superb example of political opportunism on the art issue. Recall that D'Amato melodramatically tore up an NEA-sponsored catalogue containing Andres Serrano's work during a harangue he delivered to the Senate. When one of his constituents wrote to D'Amato in protest, he received in return a form letter where the Senator proclaimed his solidarity with the correspondent's outrage over Serrano's work. Obviously, the wrong letter went out from the Senator's office. When the man again wrote to D'Amato to complain about what he considered an "insulting reply," he received another form letter which highlighted D'Amato's endorsement of diverse forms of art, his reluctance to be a censor, and reiterated his supposed support for the NEA. Political machinations are seldom so transparent.

President Bush also waffled when the NEA became controversial. In March, 1990 he made two announcements which heartened the arts community: he recommended modest increases in the budgets of the NEA and the NEH, and he refused to endorse content restrictions in the proposed reauthorization of the NEA. For a brief time it seemed as if the so-called obscenity issue had been laid to rest. But political conservatives such as Helms and religious fundamentalists such as Pat Robertson were outraged, and stepped up their anti-NEA and anti-obscenity crusade. Bush was in a delicate position: he commanded a fragile coalition, and could not afford any defections from his supporters. Social issues like abortion, gay rights, crime and gun control promised no easy solutions, but Bush could appease some of his most extremist followers by standing firm against offensive art. While this was not necessarily a pivotal issue, it represented a grievous affront to many conservatives.

Bush reversed himself in June, acknowledging that restrictions would be a requisite part of the reauthorization process. And his appointee Frohnmayer followed suit, apparently due to the intervention of Bush's Chief of Staff, John Sununu.[25] For a president renowned for equivocating, this issue did not justify its divisive potential.

When the NEA was established, conservatives expressed the greatest concerns over possible government provisions which could constrain the arts. By 1990, however, conservatives were no longer necessarily libertarians, especially when it came to particular moral issues. And in the art of compromise, the arts typically lose.

A NEW HEAD ON THE BLOCK

Conciliation was also a byword for Bush's appointee to head the NEA, John Frohnmayer. As mentioned, Frohnmayer inherited an embattled agency in October,

1989. The work of Mapplethorpe and Serrano had already raised the hackles of fundamentalists and had been debated in Congress, a modified version of the Helms Amendment had been passed, and the "Witnesses" show was about to go up. It would have been a difficult position for anyone to assume. And although Frohn-mayer was largely unknown to the Washington establishment and to the art world, his nomination was ballyhooed as a refreshing choice. This lawyer, amateur baritone, and former chairman of the Oregon Arts Commission easily secured Senate confirmation.

Hopes plummeted when Frohnmayer envisioned controversy at Artists Space and attempted to mollify potential Congressional and cultural critics by suspending the gallery's grant. His bureaucratic personality appeared to take over quickly. And it was under his signature that the anti-obscenity pledge was sent out to NEA grantees. Frohnmayer renounced responsibility for the oath, yet he was inextricably associated with it. He declared "my position is not one where I can unilaterally declare a law inoperative or unconstitutional."[26] He was in a lose-lose situation. Had he been a forceful advocate for Nan Goldin or David Wojnarowicz, or refused to administer the anti-obscenity clause, he would have virtually guaranteed additional Congressional debate and seriously jeopardized his newly acquired position. But many artists withdrew their support from Frohnmayer, whom they viewed as a bumbler. By the time he strongly defended NEA support of the movie "Poison" eighteen months later, much of his Congressional and fundamentalist pacification program had collapsed. Nearly everyone was angry at him at some juncture—even Jewish groups after he announced in late July, 1990 that Holocaust photographs might be inappropriate if displayed in a museum entrance—as he ricocheted from one crisis to the next.

It is difficult to know to what extent Frohnmayer's fears of Congress or of pressure groups were real or imagined. However, as noted in Chapter Nine, the disclosure of letters between Helms and Frohnmayer by the Los Angeles Times provides some insight into the type and amount of backstage pressure and maneu-vering which occurred. In some instances Helms requested detailed information on NEA grantees, and in others he lobbied on behalf of his own candidates for NEA staff positions or advocated approval of certain NEA grant applicants. On still other occasions Helms pressed Frohnmayer to make judgment calls on hypo-thetical art projects which suspiciously appeared to be modelled upon the work of Robert Mapplethorpe and Annie Sprinkle. Helms demanded to know if Frohnmayer deemed them obscene.[27] Being subjected to this type of scrutiny and interrogation logically leads to circumspection.

Artists could fathom this even without being privy to the details of how certain officials were nudging others. But that did not mean they could excuse Frohnmayer's behavior. While Jim Fouratt intellectually understood many of the choices Frohnmayer made, the Chairman's conduct made him angry: "He should have taken a principled stand. Because he's a sacrificial lamb no matter how it's sliced. And he lost his moment of character by trying to play politics. He should

have remained who he was [but] he got caught up in the romance of being a politician."[28] And Leon Golub assessed the situation similarly: "His [Frohnmayer's] job is to satisfy totally contradictory constituencies, and he's a totally trapped man. . . . The only type of person who could have handled this would be someone who had the sufficient audacity and authority to take on Congress in a strong way. They might have gone down to defeat, but they may also have been able to cow Congress, embarrass them. . . . some crusty aristocrat, for example."[29]

BALANCE OF POWER/POWER PLAY

Frohnmayer conveyed an ironic sense of foreboding after just a few months at his post by his oft-quoted remark "My great hope is to exit alive." He survived the worst for some time. But in February, 1992, President Bush forced Frohnmayer's resignation, effective May 1. By demanding that the Chairman step down, Bush succumbed to the pressure of his opponent in the Presidential primary campaign, Patrick Buchanan. As a newspaper columnist and political commentator, Buchanan had been a long-standing, vocal critic of government support of certain artists. The primary election in Georgia merely provided him a new soapbox from which to excoriate the NEA as "the upholstered playpen of the arts and crafts auxiliary of the Eastern liberal establishment."[30] Buchanan also illustrated his opposition to the NEA with a television commercial deploring what he considered to be "art [that] has glorified homosexuality," and art that was "filthy," "blasphemous," and "pornographic," all paid for at public expense [see Plates section]. Projected in the background were images of men dancing semi-clothed, extracted from the film "Tongues Untied," by Marlon T. Riggs (see Chapter Twelve). Never mind the commercial's bigotry, distortions and inaccuracies; it served its purpose.[31] President Bush hastily reacted so as to appear to be in control of what Buchanan and many others viewed as a rogue agency.

In response to this continual agitation, the NEA was changed in significant ways. Open season was declared on the organization. Many smelled blood in the water and sensed the opportunity to advance schemes which had been tossed around over the years. Some critics merely circled in for the kill. Representative Philip Crane (R-IL) was one of those in 1990, introducing legislation to abolish the agency. He declaimed, "such funding is not needed at this time, however fashionable it is to pander to the 'sophisticates' of the art community."[32] He was arguing against one type of elitism, that which pits a narrow avant garde against everybody else. Northwestern University law professor Daniel Polsby took the classic anti-pork barrel stance, condemning federal support for art catering to another elite: "Rick [sic] folks ought to pay for their own hobby horses," he declared.[33] Either way, this faction felt that the NEA was an ill-conceived venture and they called for junking, not fine-tuning it.

Frohnmayer had been committed to overhauling the agency in accord with his populist position, and wagered that a greater inclusiveness of artistic approaches and wider geographical representation on the peer panels would counteract elitist biases. But that was not sufficient to quiet supporters of a more radical reformulation. Republican Representatives Tom Coleman (MO) and Steve Gunderson (WI) proposed that the NEA be required to channel sixty percent of its funds to state arts agencies for distribution, a conspicuous increase from the 1990 proportion of twenty percent. Their rationale was that this would enable the public and their elected representatives to enforce greater accountability according to local standards. Another component of the plan mandated that the NEA would only fund major cultural institutions, with a minimum grant amount of fifty thousand dollars.

When the National Assembly of State Arts Agencies rushed to endorse the plan, many artists denounced what they saw as political opportunism: while the NEA was being forced to its knees over the obscenity and censorship issues, it appeared that other agencies were trying to strengthen their own relative positions within the ecology of arts organizations. Martha Wilson of Franklin Furnace articulated what scores of people felt about such a decentralization: "It takes the sin out of Sin City and gives it to the corn-fed counties, and that must feel very good to the politicians from the corn-fed counties. The truth is there *are* very good artists in the corn-fed counties, but the critical mechanism that's here [in New York City] continues to hold the art world here. So you go to New York and you try to make it."[34]

A modified Gunderson plan was adopted after compromises were made during the NEA reauthorization process: the NEA is required to increase the increment of its contribution to state arts councils to thirty five percent by 1993. This was a welcome development to some, signalling diminished "redlining" of particular zip codes. But to others this raised fears of the arts being more vulnerable to political pressure. Recall, for example, that in incidents as diverse as the presentation of "The Normal Heart" at Southwest Missouri State University, the "Transformations" photography project on transvestites, and the "Nigger Drawings" show at Artists Space, local disgruntled constituencies applied pressure on state arts councils and state legislatures to punish projects which they found offensive. In some instances such protests are linked to national pressure group efforts. But often they represent parochial concerns, thereby enlarging the potential for conflict many times over.

Scrupulous research has documented that some of the concerns artists might have about this shift of funds to the states are unsupported. According to Paul J. DiMaggio, *until the present time* the NEA and state arts councils have supported the same general mix of cultural institutions and individual artists. This finding runs counter to the conventional wisdom that the NEA promotes "excellence" and the state councils emphasize diversity and access.[35] In fact, DiMaggio persuasively argues that greater control had already devolved to the state arts councils on a de

facto basis because the NEA's allocations have not kept up with inflation, a trend which will now accelerate because of consciously devised policy.[36] He advises that "no particular kinds of artists or arts organizations obviously stand to lose or benefit from increased devolution from the Endowment to the states."[37]

However, the environment in which these agencies operate has undergone sea changes, making it difficult to predict the future from past tendencies. Lengthy and divisive controversies have naturally made agencies cautious. And recessionary conditions complicate the picture. President Bush proposed an NEA budget freeze for 1992 at the same time that he recommended modest increases for other cultural agencies and institutions, including the NEH. Factoring in inflation, this means a continued erosion in the actual amount of money that the NEA has to distribute, in addition to the increased siphoning of its funds to the states. This has necessitated stretching less money over the same number of grants, thus decreasing the potential impact of any of them. With scarcer resources at its disposal, it would be foolish, from an organizational point of view, for the NEA to invest what remains in "risky" projects.

State arts councils also experienced a double whammy. They are susceptible to negative fallout from what befell their federal counterpart, in the form of increased public anger and general misgivings over the principle of government support of the arts. These agencies, too, feel tremendous pressure to play it safe with their granting decisions. And while in many instances the increased infusion of NEA funds would have been a nice supplementary dividend, the recessionary squeeze soaked it up instead, and then some: in places where the recession was particularly acute, the magnitude of state budget cuts to the arts was not offset by the NEA bonus—New York, Michigan and Massachusetts, for example.[38] Capital which might otherwise have provided new opportunities for supporting a wide range of artistic endeavors was instead necessary to buoy up distressed granting organizations.

Not only do individual artists and small arts organizations (as well as any cutting-edge artistic endeavor) suffer under adverse economic conditions, but they have fewer resources than elite cultural institutions do to mobilize on their own behalf to protect what they have managed to create. Many artists and arts organizations may take it on the chin during tough economic times, but some step into the ring with much better training and equipment than others. The modified Gunderson provision accelerated established trends in the federal-state arts agency relationship. It formalized a de facto tendency, yet its timing may have fundamentally disrupted the patterns of subsidies.

A JURY OF ONE'S PEERS

Another struggle erupted over peer panels. More properly known as policy and grant advisory panels, the NEA has used these two types of bodies to make

recommendations to its chairman, the National Council on the Arts and NEA staff since 1966. But while they are seen as central to the NEA's work, they routinely have come under careful scrutiny by congressional investigators since shortly after their inception.[39] To NEA critics these were the soft underbelly of the organization, whereas NEA defenders were determined to champion them vigorously.

When the reauthorization legislation provided that one layperson be included on each panel (which number from five to twenty members), many artists exploded with outrage. Martha Wilson claimed the NEA was "eviscerated," even though she admitted that good laypeople had been selected to serve. Nevertheless, she surmised that "If you're not an artist, you will be representing the status quo." Rank-and-file artists assented, feeling that the purity of the system had been sullied irreparably: "The intention behind a peer panel was to push the outside of the envelope. . . . By including a layperson it's not a group of peers anymore, it's an audience. Hopefully, these are the people you're trying to impress, the people you're trying to affect. It's as if the cart were leading the horse."[40] The guardians of the peer panels' honor were generally those individuals who focused upon regulative censorship. They did not feel the system needed fixing and were intransigent in their support of "purity"; the inclusion of one non-artist seemed to them to contaminate the entire process.

Critics of the peer panel process, on the other hand, were primarily drawn from those whose target was constitutive censorship. These analysts embodied the broadest array of political stripes. Sarah Schulman represented a radical position, for example, and condemned the panels for cronyism: "They [panelists] went to college together. 'How's your wife?' 'Let's get so-and-so a grant.' Your birthday party invitation list is who you're going to fund." Edward Arian, arguing for "cultural democracy," noted that the panels were a self-perpetuating, closed circle. And conservatives James J. Kilpatrick and Hilton Kramer agreed: Kramer complained that the panels were a sort of private club, and Kilpatrick concluded "Have you ever looked at the tangled roots of a mangrove tree? Same thing."[41] Whether they viewed the system as too radical or not nearly radical enough, as a lifeline or a pork barrel, all these observers agreed that the panels had ossified into a tit-for-tat arrangement which systematically excluded certain groups.[42]

The modification in the panels was prompted in large part because of the continued spotlight fixed upon two NEA applicants, Holly Hughes and Karen Finley. In August, 1990, the National Council voted to postpone approval of five grants in the experimental arts category until November, *after* Congress would have considered the NEA's reauthorization. Hughes and Finley would have been partial beneficiaries of two of the proposed grants, recommended by a peer panel to be made to the Downtown Arts Center and The Kitchen. But the National Council tabled them on procedural grounds, citing a possible conflict of interest because artistic collaborators of Hughes and Finley were members of the panel.

That in itself was not unusual: whenever such working associations occur,

NEA staffers typically excise pertinent information from the binder containing application material for the allied individual, and the panelist is asked to leave the proceedings while the sensitive grant is discussed. What *was* distinctive to this situation was the NEA's admission that this might not be sufficient prophylaxis against improper influence, since the excused panelists would return to continue their work with their fellows.

Standards and assumptions are quite fluid in the contemporary art world; professional relationships among artists can be highly incestuous. The layperson was intended to help guarantee that deliberations would be conducted in a scrupulous manner, and to be the vox populi: unaffiliated with the art world, this member would supposedly be unencumbered with reciprocal debts and obligations, or stylistic axes to grind. The idea was that the layperson would be more likely to smell something foul (and comment on it), and challenge taken-for-granted understandings about quality or legitimacy. But artists who already felt under attack for the type of work they do noted how conveniently the NEA's new diligence continued to derail *their* work. Just as the National Council was somewhat disingenuous in calling the issue of conflict of interest to the fore at the moment it did, artists who criticized the inclusion of one layperson probably overestimated the degree to which this modification could possibly alter the balance of power on the panels. But by this juncture individuals on both sides were battle-weary and prone to overreaction.[43]

CLOSE SCRUTINY

The process which led to the NEA's reauthorization (and the refinement of the peer panel system, for example) was protracted and complex. The legislation which established the NEA stipulated that the agency face reauthorization every five years. While this had occasioned modest confrontations in the past, they paled in comparison to the struggles in 1990. Members of both the Senate and the House loaded their bills down with an array of amendments—twenty six at one count in the House version—giving everyone an opportunity to register their special concerns or foster particular schemes. These ranged from abolition of the NEA to prohibiting artworks which incorporated images of fetuses or desecrated flags. And after each chamber passed its own version, a House-Senate Subcommittee had to hammer out differences between the proposals. A process which began in 1989 was not completed until over a year later.

The House Subcommittee on Postsecondary Education held hearings throughout the country, in locales as diverse as Washington, D.C., Charleston, South Carolina, and Bozeman, Montana. A stream of witnesses presented their testimony, from artists living in Two Dot, Montana, Salina, Kansas and Corrales, New Mexico, to Hollywood members of the Creative Coalition, to the shrillest Congressional critics

of the agency. The latter had numerous opportunities to present their position, but for many others it was a unique occasion. As the artist from Two Dot, Montana reported, "Art is like news, we need news from those deep in the city and we need news from those far from it."[44]

Congress also empowered a bipartisan independent commission to examine the NEA. The commission released its report on September 11, 1990, amidst the Congressional debate on reauthorization. (The legal franchise for the NEA expired on September 1, 1990, but Congress was unable to muddle its way through the issue by then.) The report came out strongly against specific content restrictions, much to the relief of advocates of freedom of expression. It argued that obscenity should be determined by the courts via the Miller decision,[45] and that the anti-obscenity pledge should be eliminated. But commission members also called for structural and procedural reforms, underscoring, for example, that the grant advisory panels were *advisory*. The report proposed that the chairman and National Council take a more authoritative role in grant-making decisions, and suggested that the panels hand up a range of possible grantees from which the chairman would draw the final awards. Overall, the report diffused anxieties over the obscenity issue but suggested changes which could profoundly alter the NEA's future day-to-day operations.

During the August National Council meeting Frohnmayer indicated his concerns over the NEA's "responsibility, accountability and sensitivity," anxieties which led National Council member Lloyd Richards of the Yale School of Drama to caution "We could end up with the National Endowment of the Agreeable."[46] It was not until October, 1990 that Congress worked out the final compromise. The NEA was extended for three years with no explicit restrictions on content. Should a court determine any work done under a NEA grant to be obscene, the artist would be required to repay the money and face exclusion from additional funding for three years if the money were not repaid within that time. And a fresh statement on artistic suitability was substituted in lieu of any specific anti-obscenity provision: "the Chairman shall ensure that artistic excellence and artistic merit are criteria by which applications are judged, taking into consideration general standards of decency and respect for the diverse beliefs and values of the American public." This underscored a more pivotal role for Frohnmayer or any subsequent incumbent as arbiter of the acceptable, even though it was presented in such broad terms that its interpretation raised more questions than it answered.

THE INEVITABILITY OF CONTROL

The decency clause marked a general battening down of the NEA's hatches. Mark Hatfield, Republican Senator from Oregon and a Frohnmayer supporter, felt confident about the new chairman's ability to lead through "consensus leadership"

and the "soft touch," without imposing an enormous structure of controls: "There's more than one way of disciplining your child than kicking him in the tail."[47] The clause was not presented to grantees as a written pledge to sign, as was the anti-obscenity oath. It loomed instead as a backdrop to the relationship between the NEA and its beneficiaries: with the possibility of enforcement at any moment, activated by undefined breaches of propriety, it bore similarities to the iron fist within the velvet glove.

Frohnmayer decided that the spirit of the decency provision could be addressed by insuring a diversity of opinions on the peer panels, a broad sample of "community standards," if you will. He insisted that he did not intend to become a "decency czar." But legal experts assailed the vagueness of the new stipulation and some peer panelists resigned,[48] indignant that they might be asked to render more than artistic judgments. Yet even more menacing was the proposal in August, 1990, that a panel be established to receive and then investigate charges "from any reliable source" that NEA recipients were producing work that might be obscene. This evoked the image of Big Brother, an ominous complement to the self-restraint and internal doubts that the possible enforcement of the decency clause engendered.

Still other alterations betrayed the drift toward subduing a noisy bureaucratic beast. For example, the program of individual fellowships for visual artists was revamped, eliminating a two-tiered system of twenty thousand-dollar and five thousand-dollar grants in favor of one amount, fifteen thousand dollars. Politics reportedly played no role in the overhaul; the smaller amount no longer seemed viable. But the smaller grants typically went to younger, less established artists,[49] and throwing everyone into the same pool was one way to increase the probability that a greater number of newly maturing artists would be eliminated from the keener competition. This was a fortuitous decision, for this is the same group which could otherwise cast an embarrassing light on the NEA.

Additional procedural innovations also had a self-protective character. Applicants were required to present more detailed proposals and submit interim reports and extensive final documentation, to expedite comparisons of the original submission with the ultimate outcome. Significant digressions therefore could be perceived at their beginning. The agency also planned for disbursement of grant monies in increments, again affording a higher degree of control throughout the process of creation.[50] These revisions paralleled those undertaken by the WPA and other Depression-era arts projects of the 1930s and the CETA projects of the late 1970s and early '80s to a remarkable extent. In all these instances, government sponsors gradually evolved more encompassing systems of control of their artists to answer the critics of their agencies and to help assure the survival of their programs. In some form or another, *every* one of these provisos duplicated arrangements in the programs which preceded the NEA. During each era, bureaucrats buckled under

intense political pressure and discovered the wisdom of limiting their imprimatur to safer projects.[51]

Yet once the air cleared after the compromise reauthorization of 1990, the struggle was not over. The National Endowment for the Arts faced continual pummeling from adversaries hellbent on imposing their will on the agency. In June, 1991, for example, opponents once again tried to abolish the agency when its appropriation for the coming year was under consideration. While that attempt was unsuccessful, in the following September Senator Jesse Helms managed to orchestrate passage of another measure limiting specific types of content in NEA-sponsored projects, particularly depictions of "sexual or excretory functions in an offensive way."[52]

Adversaries of the NEA are doggedly persistent in their quest to eliminate or substantially alter government support of the arts. Placing the history of that patronage alongside the provocative nature of much contemporary art, the changes that these critics exacted were probably inescapable. The only surprise is how long the NEA sailed along relatively peacefully and undamaged.

To describe what the NEA's opponents did in the late 1980s and early 1990s as censorship requires a significant enlargement of that term's meaning. As Holly Hughes ruminated, "I would say that what was happening in the NEA is not so neatly called censorship; it would be easier to fight if it were."[53] But undeniably, significant advances were made to rein in artists and regulate what they produce, at least with government funds. And while censorship per se might not have occurred—except in instances when the NEA violated its own procedures—the nature of *sponsorship* certainly did. It was a clash of temperature extremes: some art and artists became too hot to handle, and the chill which set in at this government agency threatened to freeze out a wide range of artistic opportunities, far beyond its initial locus.

Artist Leon Golub addressed what had transpired with the resigned and disgusted tone of many of his fellows: "The NEA has received blows from which it will probably never recover, and it will end up either as a tame organization giving out tame grants to artists, or stop giving grants to artists altogether and simply give them to the Metropolitan Opera and places like that."

12

THE ART OF CONTROVERSY

... by blurring the we/they line we'd
swollen the ranks of those he'd have to
define.

Hettie Jones, *How I Became Hettie Jones*, 1990

If the notion of Zeitgeist retains any utility or plausibility, at minimum it would need to encompass the following themes as the 1980s slipped into the 1990s: multiculturalism, tribalism, special interest pressure groups and identity politics, and skirmishes over freedom of expression. An immense disparity of opinion was conspicuous as people turned to the airwaves, the streets and every imaginable outlet to press their point of view. The melting pot curdled with ingredients which refused to blend together, and the marketplace of ideas reverberated with factions speaking exotic tongues to one another or shouting each other down.[1] Political polarization was keen and sensitivities acute. Time and again, one person's rallying point sounded another's alarm to shove back. While these were not new occurrences, they intensified and reached a new plateau during this period. Many people talked about a mosaic replacing the outmoded notion of America as a gigantic ethnic, religious and sexual stew, but few people were sufficiently skilled to mold the disparate parts into a harmonious whole.

The First Amendment was a prime site where disparate values and interests clashed. Many challengers smudged the line between proper and improper, legal and illegal, as they provocatively tested social boundaries. Some locales tried to restrict expression. In Quincy, Massachusetts, it was a public ban on "profane or offensive words"; in Georgia, lewd or offensive bumper stickers were disallowed;

and in Ladue, Missouri, there was a prohibition on signs in front of private homes. All these statutes were subsequently challenged. And in 1991 the Supreme Court ruled that states could ban nude dancing in the interest of "protecting order and morality." It was, Chief Justice Rehnquist declared, an activity *within the outer perimeters* of the First Amendment," yet subject to strict controls nevertheless.[2]

Other cases pertained to regulating intergroup relations or establishing culpability when situations go awry. An Oregon jury levied twelve million dollars in damages against the supremacist group White Aryan Resistance (WAR) for the racially motivated beating death of an Ethiopian man at the hands of skinheads. Jurors decided that the deed was directly incited by the speech of WAR leader Tom Metzger. But what about the right of Ku Klux Klan members to wear hoods or masks? A 39-year-old Georgia law prohibiting such disguises was struck down in 1990, only to be reinstated by the state Supreme Court later that same year. Although the judge in the first instance ruled that Klan members were "a persecuted group" and needed the cover of masks to exercise free speech, the higher court ruled that the garb was historically and inherently intimidating. And in 1991, the Supreme Court agreed to hear a challenge to a St. Paul, Minnesota ordinance prohibiting behavior such as putting a burning cross, swastika, or other hate symbols likely to "arouse anger, alarm, or resentment in others on the basis of race, color, creed, religion or gender" on private property.[3]

The desire to insure individual safety and preserve social tranquility collided with the potential for curbing personal freedoms in all these instances. Typically, the most sacred principles of the republic were called into question on behalf of acts and individuals which many people felt to be the most profane. People continually attempted to stretch or crop the First Amendment during this period as rapidly shifting values and circumstances brought new tests of its meaning to the fore. For example, in 1991 a Florida judge ruled that the display of nude and pornographic pictures in the work place created a hostile work environment for women. As such, it was deemed a form of sexual harassment.

But as is also often the case, some of the most suggestive markers of an age appear relatively unheralded, and in an unsensational manner. In the summer of 1991, for instance, Random House published a new edition of *Webster's College Dictionary*. Its entries reflected contemporary social movements, particularly feminism. "Herstory" and "womyn" gained admission, as did gender-blind terms such as "watron" and "waitperson" for food servers. The trend toward nonsexist language was a milestone for those who believe that the ability to name is also the ability to control, and marked the toppling of another (symbolic) barrier to social equality. But etymological purists and other traditionalists saw these and other additions (heightism, weightism) as catering to fashion and running roughshod over the conventions of language. From their vantage point this was a frivolous, misguided enterprise, encouraging the replacement of perfectly sensible and serviceable expressions with fabrications which sometimes flirted with caricature.

These different reactions condense the opposing viewpoints on many cultural issues. On the left there is the desire to expunge the history of oppression by altering standard words or prevailing images. And on the right there is the impulse to retard or neutralize social change through omitting or prohibiting nonconventional representations. Both quests have a chimeric quality.

At the same time that the publishers of the dictionary were at work, some entertainers ensured that offense would be taken. Comedian Andrew Dice Clay developed a misogynist, homophobic and racist routine, chiefly tapping into the fears of a segment of white, working-class heterosexual men. If Karen Finley is the unsocialized female, Clay represents increasingly disaffected youths who feel confused or displaced by the breakthroughs of women, gays, and various nonwhite racial groups. To use another contemporary phrase, both these performers "push the envelope" of public propriety. But while Finley garnered much liberal support for her vulgarity, Clay mostly collected condemnation from those same critics. From the liberal perspective, the "freedom to" was at stake in the first case; in the latter instance, the "freedom from."

Finley supposedly represented a progressive agenda, whereas Clay embodied a retrogressive one. But neither the political left nor the right has a monopoly on defending its interests, and defending them passionately. The profusion of battles over art was related to other struggles in society, revolving around the right to express new or unpopular ideas, or the right to be protected from the imposition of certain beliefs. These issues of identity and power commonly focus on language and representation, so that paintings, photographs, performances, movies, school curricula and campus speech all became battle sites in the oscillation between resistance and accommodation to social change.

THE NEW AMERICAN DREAM

In 1991 some residents in the Southern California city of Lawndale complained to city officials. They were distressed about the murals an auto repair shop owner commissioned two former graffiti taggers to spray paint onto the walls of his business. "I'm not prejudiced or anything," one local insisted. "It just makes me feel like I'm in [predominately Hispanic] East L.A."[4] It's not surprising that such a clash of styles should occur in California. Along with states like Texas and New York, it is in the vanguard of a multiethnic future, when Whites will no longer be the predominant racial group in the United States.[5] Those murals represented an alien culture to this community, one that is rapidly gaining in size and political influence. Officials simplified the problem into a procedural matter: permits had not been properly secured, and the dimensions were too large. But the attempted rejection of the ornamentation signified something much larger, the desire to suppress this significant demographic shift.

The expanding dimensions of so-called minority communities and their divergent cultural styles only reveal part of the story. Significant segments of these groups, primarily based upon race, ethnicity, gender or sexual orientation, now repudiate the American ideal of assimilation and increasingly insist upon cultural distinctiveness and self-determination. They are disturbed that they don't have the same social opportunities, legal guarantees, and access to the channels of cultural expression as other groups do. In the gay community, for instance, young homosexuals who reject the direction the gay movement has taken have replaced "gay" with "queer" as their preferred term. For them gay denotes middle-class assimilation in word and deed. This type of adversarial stance is now duplicated in countless groups. It signals a very different chapter in intergroup relationships in this society, displacing the goal of integration which marked earlier civil rights movements.

Identity politics has encouraged an insistence upon distinctiveness rather than commonality. This was one of the issues activated in the dispute over Dread Scott's treatment of the flag. On one side was a Black artist who refused to embrace a national symbol he believed represented tyranny and inequality; on the other were those who maintained that the emblem universally cloaked all its citizens. The flag represented shared ideals to some, while to others it shrouded misdeeds. This contentious approach to what it means to be American has caused many commentators to grieve, fearing a Balkanization or Beirutization of the social fabric if groups insist on their rights superseding individual rights.[6]

There is an abundance of evidence of such polarization. The celebration of uniqueness has erected barriers between groups and undercut a collective identity. In the Black community the phrase "It's a Black Thing. . . . You Wouldn't Understand" accentuates the difficulties of communication and empathy across group lines. This notion was spoofed in a cartoon entitled "2001: Spike Lee's Remake," where two astronauts confront the black monolith of the Stanley Kubrick movie and one repeats the aforementioned phrase to the other.[7]

Spike Lee is a notable example here, for he argued strenuously against the prospect of a White person directing the film biography of Malcolm X. This was similar to the protest mounted by playwright August Wilson that a White director could not and should not translate his play "Fences" to the screen. After insisting that Whites share a common history and sensibility, he claimed "white directors are not qualified for the job. . . . Let's make a rule. Blacks don't direct Italian films. Italians don't direct Jewish films. Jews don't direct black American films."[8]

But the situation is even more complicated. After Lee successfully secured the director's job for the Malcolm X project, *he* was criticized by other Blacks (most notably, Amiri Baraka) who feared that Lee's version might not satisfactorily capture their sense of the man. And Lee was also accused of anti-Semitism for his depiction of the avaricious Flatbush brothers in "Mo' Better Blues," a charge he vehemently denied.[9] With so many groups entering the fray to secure equal rights and exercise control over how they are represented, artists who wish to "do the

right thing" can be spun in countless directions by those who wish to oversee and influence what they produce.

While the worlds of mass and fine arts have gradually expanded somewhat to accommodate the needs and interests of a greater variety of groups, there is an impatience on the part of underrepresented people to press forward for greater inclusion at a faster and more directed pace. At present this translates into an "every clique for itself" mentality, as more groups vie for their own slice of the American pie. It is, in essence, an example of a "revolution of rising expectations." In absolute terms, excluded groups may be better off than they were in the past. But this heightens their sense of *relative* deprivation and stokes their desire for immediate redress, increased consideration and enlarged opportunities.

UNFLATTERING REFLECTIONS

Various special interest groups have taken potshots at what they consider negative cultural depictions of themselves for some time. Movies are an especially apt example. Poles took exception to the profusion of jokes about them in the 1979 Burt Reynolds film "The End," and in 1983 the Polish American Guardian Society convinced a Chicago alderman to propose a municipal ban on films which denigrated race or national origin.[10] Subsequently, such protests have proliferated. The Pakistan Action Committee picketed the multiracial, gay-themed "My Beautiful Laundrette" in New York City in 1986, and Rastafarians protested the dreadlocked gang of criminals in "Marked for Death" in 1990.

Concern has spread beyond race and ethnicity. Advocates for the homeless successfully pressured the Walt Disney Company to withdraw the plastic Steve the Tramp doll based on a character from their movie "Dick Tracy." The packaging described him as dangerous, an "ignorant Bum," and a "reeking piece of filth."[11] And NBC edited two films for broadcast to minimize the chances for insult: executives ordered that belittling references to an adopted child in "Problem Child" be cut (the National Committee for Adoption called for a boycott), and reduced the scenes with a stuttering character in "A Fish Called Wanda," a target of criticism by the National Stuttering Project.[12] Pressure from the National Federation of the Blind also helped sink ABC's *Good & Evil* shortly into the fall, 1991 season because of a bumbling blind character. And even the turmoil over the retirement of the eight classic Crayola colors resulted in a gesture of appeasement: Binney & Smith temporarily revived them for a few months in the fall of 1991 in a special commemorative tin. The company followed with an additional demonstration of its responsiveness to public opinion when it released an eight-pack of "multicultural colors," flesh tones ranging from black to white, mahogany to apricot.

These protests are seldom sustained for long, and have restricted impact. Such

groups simply do not have the numbers to muster enough social guilt, nor do they evoke sufficient compassion, to affect the bulk of what is produced. As one man lamented about anti-Muslim slurs, "Though a small Arab-American group does try to write letters to the media objecting to this onslaught of insults, it is like emptying the ocean with a teaspoon."[13] But the small victories turn on support for what John Murray Cuddihy has called the "Protestant smile," a "certain bland, generalized politeness and good will."[14]

It's a different story for other interest groups. While religious fundamentalists may have perfected pressure group tactics, others have as well. And in some cases the same groups the fundamentalists routinely target have likewise mastered those techniques. Threatened or real boycotts have become a weapon of choice in a world where many groups feel the government is unwilling or unable to effectively advocate on their behalf. They have blended a roll-up-your-sleeves, do-it-yourself attitude with a new sophistication about orchestrating opinion in the media to mobilize a powerful arsenal against what offends them.

Catholic groups were distressed in the fall of 1991, when Miramax Pictures released the Monty-Pythonesque "The Pope Must Die." The US Catholic Conference's Office for Film & Broadcasting censured the film and branded it with an "adults only" rating. And while this did not bear the weight that the Church once commanded in matters of acceptable entertainment, it was complemented by the refusal of all three major television networks and many major newspapers to carry ads for it. In deference to the prestige of the Catholic Church, and wishing to keep their product viable, the company subsequently retitled the film "The Pope Must Diet."[15]

Jews have also repudiated negative portrayals of themselves. In June, 1991, for example, the Anti-Defamation League [of B'nai B'rith] protested a New York radio station's sponsorship of a "Be a JAP for a Day" contest. JAP, of course, is the acronym for Jewish American Princess, an unflattering depiction of a spoiled, materialistic creature. Prizes included a shopping spree at Bloomingdale's, a cosmetic make-over, dinner reservations, and limo and maid service. The ADL had publicly expressed concern over the apparent acceptability of this stereotype in a 1988 bulletin on "Jap Baiting," and sent a letter of complaint to the FCC in this instance.[16]

While they did not derail the radio venture, the ADL was successful in effecting its will when it teamed up with the Simon Wiesenthal Foundation in another dispute a few months later. Officials of these two organizations condemned an "infomercial" for a series of "Animated Stories From the New Testament." They complained that Jews were cast as mercenary, sinister characters with grotesquely stereotypical physical features, who persecuted Jesus and habitually victimized Christians. For some, this shockingly recalled Nazi propaganda.[17] And for others, the portrayal also mirrored the character of Shylock, Shakespeare's despised money lender in "The Merchant of Venice."

This image can be as difficult for many modern Jews to accept as Nigger Jim is for contemporary African Americans (see Chapter Three). And when two productions of the play were proposed in 1991, the directors consulted with Jewish leaders for advice on how to place the work in its social context and present it with sensitivity.[18] Because *The Adventures of Huckleberry Finn* and "The Merchant of Venice" are both complex works, various interpretations are possible. But the Family Entertainment Network—sponsor of the video series, whose board included Art Linkletter and the Reverend Wildmon—was persuaded that its presentation was uni-dimensional, and came to understand how it could be offensive. The producers answered the complaint with an agreement to modify the derogatory characterization.

This type of challenge has burgeoned. Some feminists were incensed over country singer Holly Dunn's song "Maybe I Mean Yes," an ode to sexual ambivalence. Complainants felt it broadcast a dangerous message to men that women don't mean what they say, potentially undermining women's attempts to set limits on what's acceptable to them in sexual situations. In critics' minds, it was "an invitation to rape." Dunn eventually acquiesced and sent a letter to radio and TV stations requesting that they not play her record. And activists from Queer Nation picketed the New York Historical Society when a work by David Wojnarowicz was included in a show along with a work by Mark Kostabi, considered by many in the gay community to be a virulent homophobe. Wojnarowicz withdrew his painting (it was later rehung), and protesters demanded redress for what they claimed was the institution's previous inattention to lesbian and gay concerns in its programming.[19]

Such actions represent attempts to dictate tolerance, obliterate uncomplimentary representations, and enforce inclusion. While the ultimate goals of greater intergroup acceptance and respect may be noble, some of the stratagems their advocates employ have seemed heavy-handed at times.[20]

UNDER PRESSURE

Perceived or real audience reactions have assumed greater importance in the calculus of those who produce culture. And nowhere is this more apparent than in relation to gays, who have escalated their use of direct pressure techniques. GLAAD, the Gay & Lesbian Alliance Against Defamation, Inc., is a watchdog group whose mission is to monitor homophobia in the media. The style of their bimonthly bulletin resembles the *AFA Journal*, reporting positive and negative portrayals of gays, and furnishing the addresses and telephone numbers of those responsible for them. It lauds those who affirm the strengths of the community and exposes the misdeeds of others who confirm unflattering stereotypes. It is the mirror image of the campaigns of conservative and fundamentalist moral entrepreneurs, albeit with

the ultimate goal of a society with *greater* tolerance and the unremarked acceptance of diversity. That situation may occur in the twenty-fourth-century world of *Star Trek*—where gay and lesbian characters complacently take their places alongside many other types of people aboard the Enterprise—but it is far from realization in contemporary America.

In alliance with direct action groups such as Queer Nation and ACT UP, GLAAD took part in a funding boycott against the New York City PBS affiliate WNET to demand increased coverage of the gay community. Activists felt that their concerns were not as adequately addressed as those of other minority communities, and demanded the creation of a regularly scheduled gay public affairs program and the appointment of gays and lesbians to the local PBS advisory committee. Their tactics ranged from demonstrations to encouraging gays not to participate in the Winter 1990 pledge campaign that the television station relies upon to raise its operating expenses. WNET's Vice President rejected the coalition's logic, arguing "I submit that in a tight economic climate, the opportunity lies in pulling up a chair at the main banquet table, rather than demanding a seat off to the side."[21] Nevertheless, six months later PBS had developed "Out in America" and "In the Life," programs specifically geared toward this influential audience segment.

There were also squabbles at PBS over the broadcast of two works as part of its P.O.V. (Point of View) series. Marlon T. Riggs's "Tongues Untied" is a sometimes lyrical, sometimes disturbing look at gay male life. It combines poetry with street language, a camp sensibility and nudity with the ugliness of racism. As the filmmaker stated, "Rather than . . . making everything sound palatable for mainstream society both in the specific word choice and the inflection and the emotion, the slang phrases, the vernacular, we kept it all real."[22] That frankness scared off a reported twenty one of fifty PBS stations in the country's largest markets, including Houston, Denver, Milwaukee, Portland, OR, and Chapel Hill, NC., which refused to air the work. Other stations rescheduled it for later than the ten p.m. broadcast time, even though it had been shown on public television in 1990 in New York, San Francisco and Los Angeles with no difficulty. Time and place made an obviously critical difference in this case.

Both Riggs and the P.O.V. series received NEA funding, providing critics of that agency with additional evidence of misappropriation of funds. Yet in an odd shift of approach the Reverend Wildmon actually *encouraged* the public to watch the broadcast so that they could witness firsthand what he judged to be publicly supported perversion. The telecast garnered thirteen formal complaints to the FCC, filed by conservative advocacy groups.

This was a warm-up for the turmoil over Robert Hilferty's documentary video "Stop the Church." Hilferty chronicled the 1989 ACT UP demonstration outside and inside New York's St. Patrick's Cathedral. The protest was against church policy which obstructs the distribution of safe sex information and which AIDS

activists believe thrusts the church into the public policy arena. The video was scheduled as part of the P.O.V. series, but dropped from the line-up after PBS decided it ridiculed the church. This occurred mainly through editing and the use of music, most notably Tom Lehrer's satiric 1965 song "The Vatican Rag" [see Plates section]. What ensued is a textbook model of contemporary cultural controversies.

P.O.V. President David Davis explained, "I felt another controversy at this time would break the [affiliates'] backs and undermine their confidence in *P.O.V.*" [23] In other words, the struggle over "Tongues Untied" made PBS feel vulnerable and forced them to look at their long-term survival. PBS is in a sensitive, dependent situation because it must renew its quest for funds every year, relying upon the continued goodwill of corporations, foundations, and the general public. Screening one more controversial show was not worth the diversion of staff time and energies, nor the potential financial fallout. [24] But heeding the desires and interests of some constituencies necessarily alienated others.

GLAAD, ACT UP and Queer Nation announced plans to protest in major cities, and in Los Angeles the coalition devised a "phone zap" to jam the lines during affiliate KCET's annual fund-raising drive. Instead of pledges, callers were poised to urge the airing of "Stop the Church" and "Son of Sam and Delilah," a video about anti-gay violence which had been dropped from PBS's "New Television" series because of "excessive violence" and "lack of clarity." The threatened action prompted KCET to reassess its position and to air Hilferty's work. But a cycle of recriminations was launched when the station was targeted by Cardinal Roger Mahony, who paid to publish an open letter in the major LA newspapers denouncing the video and PBS's judgment. Mahony cited hate crimes directed against various types of local religious institutions, and equated them with the impending broadcast: "This is an irresponsible decision which can only encourage the hate mongers in our midst, for this film glorifies and celebrates anti-religious bigotry, specifically, Catholic-bashing." [25] To Mahony's mind, KCET was complicitous with the bigots.

The screening took place, sheathed with clips of the Cardinal's statements and two panel discussions, in which Mahony proscribed Archdiocese participation. The program did not draw a large audience, however, and did not successfully retain viewers until the end. Many new subscribers came forward in support of the station, offsetting those who cancelled their memberships. But the resignation of a board member and his withdrawal of a ninety-eight-thousand-dollar pledge by his business put the station in the loss column over this venture. [26] The New York affiliate later joined L.A., San Francisco and Boston in screening Hilferty's work, although it provided only one day's advance notice, and broadcast it at 11:35 p.m.

The controversy would not die, and continued to prompt impassioned responses. Some thought that the video glorified a serious violation of sacred space and ritual, and precluded civil discussion. For instance, an editorial writer blasted it as

demonstrating the "four classic tactics of the demagogue": "Ridicule, demonology, deliberate falsification and desecration are inimical to democracy. They are inimical to real art."[27] Supporters of the video, on the other hand, maintained that it had indeed opened debate. Hilferty strongly rejected the way his opponents framed their grievance: "It is a linguistic travesty to equate my political critique of Cardinal [John J.] O'Connor with the fists, knives and bats of gay bashers."[28]

The conflict outlasted the contested broadcast in yet other ways. The Catholic Campaign for America was formed to counter a perceived rise of anti-Catholic sentiment, organizers citing "Stop the Church" along with other verbal and actual assaults against Catholics and their institutions. That meant that an additional special interest group entered an already crowded field of associations, with members prepared to defend their honor against the perceived attacks of others. And the Right to Life League of Southern California demanded equal consideration. It petitioned KCET to screen the anti-abortion film "Eclipse of Reason," a work that depicts a sixteen-week-old fetus destroyed by medical procedures.[29] While parties to these disputes may gain a temporary advantage, decisive victories are rare. Once initiated, these clashes over symbolic representations typically develop a dynamic of their own and frequently boast a long life span.

The same gay coalitions which went to battle in these incidents also mobilized against two fictionalized gay depictions in films. The ghoulish serial killer in "Silence of the Lambs" was a character with confused sexuality, but many features of his life pointed to him being gay, including a reference to his having killed a male lover. The victims were primarily women in this case, consistent with the facts of most mass murder cases. But "Buffalo Bill's" imputed sexual preference violated the profile of the typical perpetrator, enraging many activists. As one writer noted, ". . . just as the movie-goers of the '20s believed that Jews spread their matzoh with the blood of Christian babies, so does middle America believe that today's serial killers are queers."[30] Boycotts and demonstrations were launched blasting the preponderance of deranged gay characters, and in essence demanding that depictions of villainy correspond to its statistical incidence within the gay community.

The outrage over the movie "Basic Instinct" was even more dramatically vented. GLAAD targeted the media with ads in the trade press, and ACT UP and Queer Nation took to the streets to disrupt the production in San Francisco. Vandals damaged shooting locations, and protesters used whistles or encouraged drivers to honk their horns to prevent filming. The issue was that all three major female characters were lesbian or bisexual, and suspected killers—additional entries in the log of gay maniacs.

The response split the gay community: when one bar owner rented his property to the production company for some scenes, his life was threatened and his property was damaged. For those who believe that such negative representations kindle prejudicial attitudes and fuel anti-gay behavior, these were serious offenses

that must be rebutted. And those holding this position could cite many celluloid affronts from the past. But other gays saw such protests as foolish, an attempt to put a stranglehold on artistic expression by forcing adherence to a particular party line. One weary observer claimed that protesters had overlooked the main sacrilege in the film, its stereotypical depiction of the killer's dog: "The character of Precious, as played by the poodle Darla, was a complete and total lie. Another in a long and shameless line of yapping, brainless creatures with pom-poms for hair. . . . An intensely spiritual dog, sensitive yet sprightly in movement, the poodle remains one of the most maligned creatures in fiction and film."[31] His satire was a way of saying "lighten up" to activists who solemnly and chronically discover affronts and danger in various forms of culture.

SYNCOPATED SCORN

A primary theme in these situations is the conviction that the dominant culture is opposing or slighting minorities. But it has also been the case that relatively disenfranchised segments have tussled amongst themselves, at times hatefully snipping at each other as if they had no common interests or shared pain. Rap music, and the response to it, represents both possibilities.

Rap springs directly from the urban Black ghetto. Braggadocio about sexual prowess is conspicuous, as is political commentary on drugs, racial discrimination, violence and police brutality. Afrocentrism and the Nation of Islam are the inspiration for some "radical rappers," dictating their support of racial separation, not integration. Rap is raunchy, threatening and renegade in many respects, including its maverick use of "sampling" (the direct incorporation of bits of other music) and its initial market success outside of regular distribution channels. As rapper Ice-T explained, "I don't have evil intent. I just make records in the format that, you know, me and my home boys talk. . . . If I had grown up like [NBC newscaster] Bryant Gumbel, I'd rap like Bryant Gumbel, but I didn't."[32]

Mainstream society has tried to blunt rap's force in two ways. The first is co-optation, absorbing the style and some of the performers into versions which are more palatable for a mass audience. We've witnessed, therefore, the Pillsbury Dough Boy rapping his sales pitch, Young MC hawking Pepsi (replete with title cards translating the lyrics for the uninitiated), and the TV show *Fresh Prince of Bel Air,* a rather standard situation comedy format reconditioned with a young rap artist. Housewives and suburban teens are two target viewer segments for these transformations, draining much of the original emotion and meaning from this music.

Co-optation is a gradual, subtle process muting rap's authenticity. Legal proceedings bring out bigger weaponry; and in 1990 a series of prosecutions was initiated against the rap group 2 Live Crew and individuals marketing their album "As

Nasty as They Wanna Be" because of its graphic sexual nature. In June a US District judge in Florida ruled the album obscene. Ft. Lauderdale record store owner Charles Freeman was arrested, tried and ultimately convicted of obscenity and fined one thousand dollars and court costs for selling it. One of the curious twists to this situation was that 2 Live Crew released both a "clean" and an unexpurgated version of this album, and voluntarily put warning stickers on the latter one to alert buyers to what they were purchasing. But this did not halt zealous prosecutors.

The artists themselves went on trial in October for a public performance of the album, but were subsequently acquitted. And a White band from New York, which travelled to Florida and played the same music as a political protest, was placed on trial but also vindicated. Prosecutions were launched in other locales as well, including Texas and Louisiana. It was a period the president of the Florida branch of the ACLU declaimed as "the silly season."[33]

The jury which convicted Mr. Freeman was all-White, a concern in the rappers' trial because minorities and the young were not abundant in the jury pool. Defense attorneys felt that Whites were not sufficiently prepared to pass judgment on a form of expression which would be foreign to them.[34] And yet the jury found the musicians innocent, clearly swayed by expert testimony. Professor Henry Louis Gates, Jr. (then at Duke University) provided a scholarly analysis which decoded the group's words and intentions and put them into an historical context—much as defense witnesses did at the Mapplethorpe trial. Citing the bawdy precedents of Shakespeare, Chaucer and Joyce, Gates celebrated 2 Live Crew as "astonishing and refreshing" "literary geniuses," their work a "sexual carnivalesque." Again, the parallels with the role specialists played in the Mapplethorpe case are remarkable.

Gates also placed these performers within a venerable African-American oral tradition of "signifying," where risque insults are ritually exchanged.[35] But the music itself also influenced the outcome, for jury members could not help but laugh at many of the exaggerated lyrics. Humor outstripped danger for them. The jurists accepted leader Luther Campbell's notion that this was comedy, "nothing but a group of fellas bragging."[36]

Others were not so sure. Misogyny and homophobia appear as key motifs in rap.[37] One response to this has come from within the world of rap itself. Rap's routine characterization of "bitches" has rankled many Black women. Female rappers have surfaced to refute being reduced to merely orifices for men's pleasure; Queen Latifah, M.C. Lyte, Yo-Yo and the groups Salt-N-Pepa, H.W.A. (Hoes Wit Attitude) and BWP (Bytches With Problems) are just a few examples. BWP's satirical "Two Minute Brother" deflates male sexual claims, turning their boasting into absurd, flaccid delusions. These rappers have turned sexual invective into a sexual dialogue, reflecting rapidly changing gender roles.

The misogyny in rap has a counterpart in heavy metal music, which appeals to a primarily White, working-class audience. And both forms of music also share a

homophobic streak, to the dismay of gays who wish that there could be a natural compassion between groups which are socially marginal. Lyrics in "One in a Million" by Guns N' Roses are just as offensive to gays as those sung by rappers Audio Two in "Whatcha Lookin At?" Both these songs express a sense of victimization: allegedly being displaced by new groups, or being the target of male-to-male sexual come-ons. But the fear and anger in these tunes drive additional wedges between people who might otherwise be allies. For some gays this music calls out the impulse to censor in order to clear the air of all repugnant sentiments. These tensions are another representation of the extreme polarization evident in society and the constant push and pull between groups for power and self respect. As Steven Pico sadly reflected, "I get really angry when communities which have been discriminated against turn against the First Amendment and become part of the censorship movement. It's understandable sometimes, but it's obviously misguided. These groups should know better."[38]

Rap music constantly attracts controversy. Its claim to being a genuine voice of the ghetto highlights, rather than reduces, intra- and intergroup tensions. Rap's association with the Black underclass guarantees it will frighten and confuse many Whites. Its misogyny and homophobia enlist additional enemies. Like other contemporary forms of expression, rap crystallizes sensitive matters into a shape audiences can respond to, with either applause or contempt. Both its accommodation and renunciation are notable examples of the difficulties of engineering and maintaining harmony in a multicultural society.

BEAUTIFUL MOSAIC OR DISHEARTENING MUDDLE?

African-Americans, Hispanics, gays and lesbians, and women are some of the primary groups which have brought themselves out of the shadows in recent years. They challenge those in power and compete with one another for wider social recognition and acceptance. They have insinuated themselves into school curricula, museum exhibitions, and most of all, public debate.

Social conservatives see themselves as loyalist forces, guarding the gates against the advancing barbarians. What's classic in the arts comprises one of their canons; the traditional school curriculum is another. But different groups now demand consideration and incorporation, embodied dramatically in a chant by Stanford University students who wished to dismantle a Western Civilization/Great Books program and replace it with a multicultural emphasis: "Hey hey, Ho ho, Western culture, got to go." The traditionalists accuse these upstarts of "ethnic cheerleading" for a "victims' revolution," a faddish and political, but ultimately artificial maneuver, in their view.[39] This battle for hearts and minds spawned a striking incarnation at Columbia University in 1990: a woman unfurled a 140-foot long banner atop Butler Library during graduation exercises, her streamer brandishing

the names of great women writers above the ancient men inscribed into the neoclassical edifice.

Many liberals, meanwhile, wish to compensate for past injustices. But they often fumble over how best to oblige group demands for greater recognition. In California, for instance, the State Board of Education agonized over developing a history curriculum which would fairly chronicle the social experiences and contributions of a wide variety of groups. No sooner was a multiculturally oriented textbook series approved, however, than it was decried. Jews and Muslims were upset; so were Koreans and gays and lesbians. Coverage was inadequate from each distinct vantage point. The state Superintendent of Public Instruction asked in frustration, "do we break up in tribal warfare?"[40] And when a curricular overhaul was proposed in New York, review committee member Arthur Schlesinger, Jr. dissented from the final report ("One Nation, Many Peoples"), distressed that "[it] is saturated with *pluribus* and neglectful of *unum*."[41] No one has as yet devised a magic formula to balance the interests of those who believe in a core culture which would bind everyone with a common heritage, and those who wish to revise it to give greater recognition to diversity. In the meantime, factionalism has triumphed in many of the attempts to address these issues.

The past few years have been a transitional time in group relations. Changing populations and curricula—in some measure due to policies such as affirmative action—have begun to transform colleges and universities. And there has been a backlash in many places, including some of the most prestigious campuses. It has been a time of excess and mutual readjustment on all sides, which at moments has had the feel of a never-ending war of all against all. This has resulted in the implementation of campus speech codes to restrain verbal harassment of African Americans, gays, women, Asians or Hispanics, for example.

How else should officials at Syracuse University deal with fraternity members who wore T-shirts proclaiming "Homophobic and Proud of It!" and "Club Faggots Not Seals!"? Or at the University of Iowa, where an advertisement in the campus newspaper showed cartoon character Bart Simpson with a slingshot, warning "Back Off Faggot!," or at George Mason University, where a fraternity held an "ugly woman" contest and a White male contestant dressed in drag and blackface? It is Dartmouth College which has garnered the greatest amount of negative attention, largely because the ultra-conservative *Dartmouth Review* has ridiculed Jews, Blacks, gays and Native Americans, among others. To many minds, the magnitude of this newspaper's scorn has poisoned the college environment, at times crossing the line between opinion and active intimidation.

Concerned students, faculty and administrators have devised regulations for conduct in response to both physical and figurative attacks. The goal: to provide a safer and more civil environment for all students. Part of the underlying rationale for these codes is the Fourteenth Amendment, guaranteeing equal protection under the law. Codes attempt to expand the notion of what may be regulated beyond

direct provocations to bodily harm, or the standard of "fighting words." But striving to protect the sense of well-being of some groups can clash with First Amendment guarantees of free expression for others.

Many of these codes have been struck down because they are too vague, not unlike the restrictive language on NEA grants.[42] The issue has prompted spirited debate on many campuses and has split the ACLU between First Amendment "absolutists" (who will not support restrictions on expression), and "frontierists" (who feel restrictions may be necessary to ensure that minority rights are preserved).[43] The first stance insists that offensive speech is a symptom of deeper pathologies which will not be addressed by covering over their expression. But those upholding the second position acutely feel the sting of epithets. They argue that verbal abuse must be neutralized in order to give minorities a chance to participate fully in the college environment.

Is this unwarranted coddling of some groups at the expense of others, or facilitating the survival of a diverse mix of students in the academy? Once again, the parallel between restrictions on artistic production and campus speech should be apparent; a similar impulse underlies both. In each case there is a fear of certain types of expression, and an overestimation of the impact and consequences of symbols. In each instance there is an attempt to obliterate what is noxious by chopping it off at the head, rather than at the root. And in each situation the impulse to shield some individuals from possible offense merely postpones—but does not totally preclude—their confrontation with these ideas elsewhere in their lives.

Even Miss Manners felt it vital to comment on this escalation of attacks and counter-attacks. In her view people needed guidance to find their way through this largely uncharted social ground, and "The rougher the conflict," she counseled, "the more manners are needed."[44] But President Bush rebuked those who would impose their notions of proper speech on others. He remarked during a commencement address at the University of Michigan, "The notion of political correctness has ignited controversy across the land. And although the movement arises from the laudable desire to sweep away the debris of racism and sexism and hatred, it replaces old prejudices with new ones. . . . What began as a crusade for civility has soured into a cause of conflict and even censorship."[45]

As the President's comment indicates, the notion of "political correctness" became a hot topic during this period. Opponents of "p.c." maintained that dissidents on the political left were imposing their strict definition of what was acceptable in private thought and public discourse. *New York* magazine, for example, rather cynically reduced the dispute to catchphrases when they ran two versions of the cover of their January 21, 1991 issue. They both posed the question "Am I Politically Correct?" One featured a woman whose string of self-indictments began "Am I Guilty of Racism, Sexism, Classism?" The other presented a man asking "Am I Misogynistic, Patriarchal, Gynophobic, Phallocentric, Logocentric?"

Both figures were flagellating themselves for possibly supporting orthodoxies which were being discredited as oppressive.

Conservatives have amplified p.c. from a tendency into a ubiquitous danger. They tend to accept militant rhetoric at face value, confusing words with the ability or opportunity to translate them into concrete actions. Anxious traditionalists cite abundant curricular or regulative outrages with a sense of injury but also a perverse delight, from multicultural-oriented core courses to student dismissals over noxious language or behavior. And yet a survey of college administrators conducted by the American Council on Education discovered that such controversies had occurred on less than ten percent of college campuses.[46]

This is not to say that there has not been intemperance on the part of the insurgents. Indeed, there have been many disturbances to the peace. Artist John de Fazio brazenly mixed his metaphors in the brochure accompanying "Offstage Attitudes," a 1990 exhibit held at New York's Lincoln Center (see Chapter Ten): "White people are corpses—their culture is stale and rotting like a beached whale, but is being impregnated with Black, Hispanic and Asian beauty, compassion and hope." More accurately, the two sides have *traded* tyrannies. For example, there was a sense of enforced patriotism during and after Desert Storm in early 1991. Fervent supporters of administration policies physically attacked anti-war protesters or seriously challenged their loyalty, and campus officials in several locales declined to prosecute students who flew American flags in defiance of building regulations.[47]

Roger Kimball matched de Fazio's bombast when he stated: "The multiculturalist imperative holds that there is no center, only a series of equally valid peripheries. ... It is an insidious doctrine, spelling new forms of intellectual and moral separatism."[48] Kimball nervously equated the revisionist impulse with a plan for the total elimination of the conventional and traditional. Conservatives displace their fears of social realignment onto the symbolic sphere when they allege that "political correctness" leads to uncompromising intolerance of opposing ideas and insistence upon intellectual conformity.

The fierce impatience on the part of marginal groups to eliminate their own silence and invisibility is equaled by the conservatives' fright that society is going to hell in a handbasket. The two sides assign blame and exchange insults in a manner which suggests the child's taunt "I know you are, but what am I?" Both have been prone to exaggeration; the dangers of the "slippery slope" that insurgents alert us to is comparable to the total collapse of civilization that conservatives foresee. The truth, of course, lies somewhere in between.

The obsession of conservatives with political correctness on campuses echoes their analogous fears of incorporating new viewpoints and artistic approaches into the art world. It is, as one observer noted, "a bogyman magnified by leftover cold war hysteria."[49] But in point of fact, moral armies have been raised by both the left and the right. For example, they were engaged over an exhibition at Washing-

ton, D.C.'s National Museum of American Art, "The West as America: Reinterpreting Images of the Frontier, 1820–1920" in 1991. The intention of the presentation of paintings, sculpture, photographs and prints was to demythologize the West. The catalog and wall texts critically reassessed works by Catlin, Remington, Bierstadt, Bingham and others, demonstrating how visual art dispatched the ideology of Manifest Destiny and presented a prettified version of conquest and expansion.

But some critics, visitors and Congressmen bristled at the show's political bent. Republican Senators Ted Stevens (Alaska) and Slade Gorton (Washington) denounced it at a Senate Appropriations Committee meeting and threatened to cut funding to the Smithsonian Institution, NMAA's parent. One visitor noted in the book provided for comments: "The curators . . . took a small truth and made it into THE TRUTH." And one critic concurred, arguing that the show "does not allow for ambiguity." But he also let loose a barrage of reproaches: "forced analyses," "inflammatory observations," "a series of harangues," a show which "preaches" "from a leftist slant."[50] Bowing to such critical pressure, curators modified some of the wall texts and added some supplementary ones.

Even critics who were positively disposed to the organizers' intentions felt that their reinterpretations went too far. Dense with contemporary insights, the written text seemed freighted with one ideology displacing another. The furor reveals not only how eager some people are to dismantle accepted truths they find to be oppressive, but it likewise highlights how reluctant others are to give them up. A *Los Angeles Times* columnist found comfort by visiting the Gene Autry Western Heritage Museum while this debate was unfolding. As he declared "I do not give up easily my belief that the American West was much as it is portrayed in Western movies. . . . Revisionists are tearing our myths apart."[51] It should be clear that both parties to the struggle recognize their symbolic importance, and neither is very open to arbitration at this juncture.

This incident was an interesting display of the cycles of reception (see Chapter Three). Contemporary opinion suddenly cast material which was considered quintessential Americana into a different light. And shortly thereafter, the same museum and its director Elizabeth Broun were embroiled in additional controversy, in essence another dispute based upon changing group self-perceptions. "Eadweard Muybridge and Contemporary American Photography" paid homage to the great nineteenth century explorer of the visual dynamics of human and animal locomotion. Broun became alarmed, however, over a 1964 piece by Sol LeWitt, "Muybridge 1," a wide black box with a series of ten apertures through which a viewer could watch a female nude gradually come nearer. Broun decided to pull the work, deeming it comparable to the voyeuristic experience of a peephole, and thereby a "degrading pornographic experience."[52]

Exhibit organizer Jock Reynolds (former director of Washington's WPA gallery, the site where the Mapplethorpe retrospective was successfully exhibited after the

Corcoran canceled it) was outraged. He demanded that LeWitt's work be reinstated or the show would have to be canceled. Many of the other participating artists supported his position. After a standoff, an agreement was reached whereby two wall labels would be posted: one composed by Reynolds, and another by Broun and the museum, the latter arguing that the work had "different associations" given the passage of time and certain social changes in the status of women. A book was also added for the public to record its comments.

As in the controversy over "The West as America," the museum attempted to champion one viewpoint. Director Broun quipped "I've now offended both camps [right and left], so I must be doing something right."[53] But beneath the drollery was the complex issue of who controls what images are seen in contemporary art settings, and to further what ends. And there is an additional peculiarity in this case. LeWitt's work was targeted as sexist by bringing history and broader social debates to bear on it. It was tried by a one-person tribunal for "crimes" unwittingly committed in the past. But LeWitt himself played the role of accuser a dozen years earlier in the case of "The Nigger Drawings" as a signatory to a letter condemning the alleged racism of artist Donald Newman.[54] Once again we understand that the generation of meaning is a continual and conflictual process. It comes as much from within artistic work as from without. And artists are simply one part of a cast of players who construct what their creations mean. No one, it seems, provides the definitive interpretation.

NEA National Council member Jacob Neusner proposed in 1990 that the agency not fund art which was "political, ideological or advocating social change."[55] That would certainly eliminate a great many contemporary productions. But artists are not likely to quickly retreat from using their work to reflect their experiences and to sound off about what matters most to them. Not unlike the archaic medical practice of cupping, art controversies draw toxins to the surface. Because these conflicts are fostered by the expression and rejection of significant social and demographic shifts, art controversies are destined to continue until these changes decelerate and their effects can be accommodated. Yet beyond the pain these disputes cause, they also offer the prospect of cleansing the blood of the community through the resulting debate.

NOTES

Introduction

1. Woolf, Virginia. *To The Lighthouse* (San Diego: Harcourt, Brace & World, Inc., 1927): 235.

2. See Hobsbawm, Eric. *Primitive Rebels: Studies in Archaic Forms of Social Movements in the 19th and 20th Centuries* (New York: W.W. Norton, 1965).

3. I draw heavily here from the perspective of the French social theorist Emile Durkheim (1858–1917). Durkheim believed deviance was a normal, ubiquitous feature of societies. "Imagine a society of saints," he proposes in a well-known passage, "a perfect cloister of exemplary individuals . . . faults which appear venial to the layman will create there the same scandal that the ordinary offense does in ordinary consciousness" (*The Rules of Sociological Method* New York: Free Press, 1938: 69). Durkheim also understood the social response: "[d]eviance brings together upright consciences and concentrates them" (*The Division of Labor in Society* New York: Free Press, [1933] 1964: 102).

4. This did not, of course, prevent actual assaults. Bias-related crimes also increased dramatically during this period, and the rise can be attributed only partially to increased vigilence in collecting statistics. For example, the 1990 Annual Report of the New York City Gay and Lesbian Anti-Violence Project detailed a 65 per cent increase in bias-related crimes from the previous year, a trend recorded in other locales as well. Clearly, as gays and lesbians become less closeted they also become more obvious targets of hatred. And intergroup tensions exploded in relation to other groups, e.g., anti-Semitic incidents likewise increased; see Dart, John, "Anti-Semitic Incidents Set Record, Study Finds," *Los Angeles Times*, February 7, 1991: A3, 25.

5. Benjamin, Walter, "The Work of Art in the Age of Mechanical Reproduction," pp. 217–251 in *Illuminations: Essays and Reflections* edited and with an Introduction by Hannah Arendt (New York: Schocken Books, 1969).

6. Interview conducted August 29, 1990.

314

7. Interview conducted March 28, 1990.

8. Of critical importance in establishing this approach was *Art Worlds*, by Howard S. Becker (Berkeley: University of California Press, 1982); many others have subsequently elaborated his theoretical points.

9. For discussions of these contrasting research strategies see Hirsch, Paul M., "Production and Distribution Roles Among Cultural Organizations: On the Division of Labor Across Intellectual Disciplines," *Social Research*, Vol. 45 (2), Summer, 1978: 315–330; Peterson, Richard A., "Where The Two Cultures Meet: Popular Culture," *Journal of Popular Culture*, Vol. XI (2), Fall, 1977: 385–400. Later analysts have proposed frameworks to bridge the gap; see Griswold, Wendy, "A Methodological Framework for the Sociology of Culture," pp. 1–35 in Clogg, Clifford C., ed., *Sociological Methodology*, Vol. 17 (Washington, D.C.: American Sociological Association, 1987); and Zolberg, Vera, *Constructing a Sociology of the Arts* (New York: Cambridge University Press, 1990).

10. This is an illusion. The milk and blood were separated in a Plexiglas container with a divider down the middle. Light reflected from the blood onto the partition caused the "bleeding" effect.

11. Although these themes run through much of Douglas's work, see in particular *Purity and Danger: An Analysis of the Concepts of Pollution and Taboo* (London: Ark Paperbacks, 1984 [1966]) and *Natural Symbols: Explorations in Cosmology* (New York: Vintage Books, 1973 [1970]). Douglas examines many phenomena which are "in-between" categories. She would characterize those who react negatively to the sorts of contemporary art I discuss here as operating with a "restricted" linguistic code.

12. Davies, Robertson. *The Maticore* (Hammondsworth, Middlesex, England: Penguin, 1976): 37.

13. Weber, Max. *Economy and Society* edited by Guenther Roth and Claus Wittich (New York: Bedminster Press, 1968): 5. My choice of sources reflects this goal. I personally interviewed many individuals on the "front lines" in order to discover their distinct viewpoints. I also sampled a broad array of media accounts, including publications aimed at artists, Blacks, gays and lesbians, and religious fundamentalists. These reveal the types of information various publics were privy to, upon which they based their beliefs and actions.

14. McKeon, Richard, Robert Merton and Walter Gellhorn. *The Freedom to Read: Perspective and Program* (New York: R.R. Bowker Co., 1957). I thank Doug Mitchell for calling my attention to this important book.

15. These categories are discussed by Herbert Gans in *Popular Culture and High Culture* (New York: Basic Books, 1974); Levine, Lawrence, *Highbrow/Lowbrow: The Emergence of Cultural Hierarchy in America* (Cambridge, MA: Harvard University Press, 1988); and DiMaggio, Paul, "Cultural Entrepreneurship in Nineteenth-Century Boston, I: The Creation of an Organizational Base for High Culture in America," *Media, Culture and Society*, Vol. 4, 1982: 33–50, and "Cultural Entrepreneurship in Nineteenth-Century Boston II: The Classification and Framing of American Art," *Media, Culture and Society*, Vol. 4, 1982: 303–22. The interrelations between these realms were highlighted in the Whitney Museum's 1989 show "Image World"; and they were the subject of much critical debate in respect to the show organized by the Museum of Modern Art in New York in 1990, "High and Low."

16. Concern over the potential for running afoul of anti-obscenity guidelines issued by the NEA escalated to such an extent during 1990 that a memorandum was circulated at the New York City Opera questioning "Will the three naked virgins in [Arnold Schoenberg's] 'Moses und Aron' jeopardize our [NEA] funding?" (quoted in Kozinn, Allan, "Obscenity Guidelines Worry Opera," *New York Times*, July 20, 1990: C13). Directors of companies throughout the country expressed similar apprehensions over their productions, including Dvorak's "The Devil and Kate," Alban Berg's "Lulu," Richard Strauss' "Salome" [the libretto based on Oscar Wilde's play], Benjamin Britten's "Death in Venice," and Giuseppe Verdi's "Rigoletto," among others (Kennicott, Philip, "Sex, Obscenity Giving Opera Companies Pause," *New York Newsday*, July 24, 1990, Part II: 2).

17. See H. Jack Geiger's review of Barbara Ehrenreich's *The Worst Years of Our Lives: Irreverent Notes From a Decade of Greed* (New York: Pantheon, 1990), in *New York Times Book Review*, May 20, 1990: 9.

18. Rimer, Sara, "In Rap Obscenity Trial, Cultures Failed to Clash," *New York Times*, October 22, 1990: A12.

The Politics of Diversion

1. Yeats, William Butler, "The Second Coming," in *Collected Poems* (New York: Macmillan, 1924).

2. "Czechs Try to Sell a Stalin," *New York Times*, December 8, 1989: A17; "Lenin Statue in Mothballs," *New York Times*, December 11, 1989: A8.

3. Binder, David, "2 Days Labor Fells Bucharest's Lenin," *New York Times*, March 6, 1990: A12; Clines, Francis X., "Where to Put Lenin, Not to Mention His Pedestal," *New York Times*, September 18, 1989: A4.

4. Keller, Bill, "A Soviet Memorial to the Victimized," *New York Times*, October 31, 1990: A10; Pace, Eric, "An Unusual Proposal for a Stalin Statue," *New York Times*, August 15, 1990: B5. Before long, a portion of Moscow's Gorky Park became a memorial garden of fallen icons.

5. Kifner, John, "Rumanian Revolt, Live and Uncensored," *New York Times*, December 28, 1989: A1.

6. Bohlen, Celestine, "Rumanians Moving To Abolish Worst of Repressive Era," *New York Times*, December 28, 1989: A1.

7. "Poland Publishes 'The Painted Bird,'" *New York Times*, April 22, 1989: A16; Whitney, Craig R., "Now *That's* Really a Premiere," *New York Times*, January 13, 1990: 13; Bollag, Burton, "The Rolling Stones Take on Prague," *New York Times*, August 20, 1990: C13.

8. Bohlen, Celestine, "East Europe's Cultural Life, Once a Refuge, Now Eclipsed," *New York Times*, November 13, 1990: A12; Ringle, Ken, "The Eastern Bunny," *Washington Post*, December 28, 1989: C1; Shalin, Dmitri N., "Glasnost and Sex," *New York Times*, January 23, 1990: A23; Bohlen, Celestine, "Sex Magazines and Massage Parlors Test Hungary's New Limits," *New York Times*, May 12, 1990: 6. Writer Valentin Rasputin deplored the profusion of pornography in Russia as a "spiritual Chernobyl"; see Goldberg, Carey, "Soviets Act on Furor Over Pornography," *Los Angeles Times*, April 13, 1991: A11.

9. *New York Times*, December 28, 1989: A22.

10. Keller, Bill, "NATO Allies, After 40 Years, Proclaim End of Cold War; Invite Gorbachev to Speak," *New York Times*, July 7, 1990: A1, 4. Books elaborating this topic proliferated; see, for example, Denitch, Bogdan, *The End of the Cold War: European Unity, Socialism, and the Shift in Global Power* (Minneapolis: University of Minnesota Press, 1990); and Hyland, William G., *The Cold War Is Over* (New York: Times Books, 1990).

11. Updike, John, *Rabbit at Rest* (New York: Alfred A. Knopf, 1990): 353.

12. For a sociological analysis of boundaries and the Salem Witch Trials, see Erikson, Kai T., *Wayward Puritans: A Study in the Sociology of Deviance* (New York: John Wiley & Sons, Inc., 1966). A recent book details the domestic consequences of World War One for English culture, leading to heightened repression, prudery and patriotism; see Hynes, Samuel, *A War Imagined: The First World War and English Culture* (London: The Bodley Head, 1990).

13. The full title is *The Rise and Fall of the Great Powers: Economic Change and Military Conflict from 1500 to 2000* (New York: Random House, 1987).

14. For an additional example of the declinist argument, see Lewis, Anthony, "When Decline Hurts," *New York Times*, September 24, 1990: A19. Examples of the revivalist approach include Balk, Alfred, *The Myth of American Eclipse: The New Global Age* (New Brunswick, NJ: Transaction, 1990), and Nye, Joseph S., Jr., "No, the U.S. Isn't in Decline," *New York Times* October 3, 1990: A33.

15. Rothenberg, Randall, "U.S. Ads Increasingly Attack Japanese and Their Culture," *New York Times*, July 11, 1990: A1, D7.

16. Champlin, Charles, "The Film Industry Is Not Just Another Business," *Los Angeles Times*, November 28, 1990: F1. The customary fear about escalating concentration in the mass media is that fewer people will be able to exercise more control over what is offered to the public. This is compounded when takeovers are foreign-based, as when movie industry insiders wondered if Matsushita executives would allow a movie with Tom Selleck as an American baseball player who confronts difficulties playing in Japan to proceed unimpeded; see Cieply, Michael, and Alan Citron, "Universal's 'Diamond' in the Rough," *Los Angeles Times*, February 5, 1991: F1, 6. When script changes in "Mr. Baseball" were reported, they were allegedly dictated by artistic and not political concerns, although two jokes about World War Two were eliminated; see Weisman, Steven R., "Japanese Buy Studio, and Coaching Starts," *New York Times*, November 20, 1991: A1, C21.

17. See Choate, Pat, *Agents of Influence* (New York: Random House, 1990), and Foderaro, Lisa W., "Japanese in the New York Region Begin to Feel the Sting of Prejudice," *New York Times*, July 22, 1990: A1, 24.

18. Kolbert, Elizabeth, "Cuomo Uses Image of F.D.R. and '32," *New York Times*, January 30, 1991: B1, 3. Generational appellations multiplied throughout this time, "yuppies" being replaced by "schleppies," those people forced to live with diminished earnings and expectations.

19. Kagay, Michael R., "Deficit Raises as Much Alarm As Illegal Drugs, a Poll Finds," *New York Times*, July 25, 1990: A9.

20. Nash, Nathaniel C., "Public Dismay on Savings Disaster Grows, Poll Finds," *New York Times*, August 26, 1990: A30.

21. Rosenblatt, Robert A., "Bennett Likens 'Keating 5' to 800-Pound Gorilla," *Los Angeles Times*, January 17, 1991: A4.

22. Connelly, Michael, "Victim of S&L Loss Kills Self," *Los Angeles Times*, November 29, 1990: B4. In the example of the insolvent Lincoln Savings & Loan, the negative net worth of the institution was calculated in the billions.

23. "Capital Awash in Neil Bush Posters," *Kansas City Star*, August 12, 1990: A6.

24. Baker, Russell, "Neil Bush, Meet Mr. Kafka," *New York Times*, July 14, 1990: 21. Filmmaker Marlon T. Riggs declared himself and his work to be the "new Willie Horton," after Patrick Buchanan extracted images from the Riggs film "Tongues Untied" for use in a television commercial, part of his challenge to George Bush during the 1992 Presidential primary campaign; see Riggs, Marlon T., "Meet the New Willie Horton," *New York Times*, March 6, 1992: A33. See Chapters Eleven and Twelve for further details.

25. Witness the cases of Michael Milken, Leona Helmsley, and Claus von Bulow.

26. Kagay, Michael R., "In Poll, Both Bush and Congress Faulted for Crisis," *New York Times*, October 9, 1990: A21.

27. Bush's leadership in the Gulf conflict inspired headlines such as "Bush's War Success Confers An Aura of Invincibility in '92" (Toner, Robin, *New York Times*, February 27, 1991: A1, B10). But political fortunes sometimes collapse as quickly as they rise.

28. Baker, *op. cit.*

29. Toner, Robin, "New Political Realities Create Conservative Identity Crisis," *New York Times*, May 13, 1990: A1, 20; Toner, Robin, "Taxes, S&L's, Anxiety: Recipe For a Political Shakeout?" *New York Times*, July 22, 1990: E1, 5.

30. Letter to the Editor, *The Washington Times*, May 17, 1990.

31. Viguerie, Richard A., and Steve Allen, "Bush Loses the Right Wing," *New York Times*, December 18, 1990: A25.

32. Dodson, Marcida, "Eisenhower Work With Canvas and Oils Shown," *Los Angeles Times*, November 19, 1990: A3, 25. The fact that this exhibit was held at the Richard Nixon Library in California adds a curious dimension: the public presentation of self in this institution attempts to obfuscate the turmoil and dishonesty that marked Nixon's presidency.

33. Gorman, James, "Nostalgia Can Choke the Ongoing Stream of Your Life," *New York Times*, July 1, 1990, H16; see, also, Davis, Fred, *Yearning For Yesterday: A Sociology of Nostalgia* (New York: Free Press, 1979). A good example of this creation of value was revealed when the estate of Andy Warhol was auctioned by Sotheby's in New York in 1988. Alongside the paintings by major contemporary artists were collections of Fiesta dinnerware and cookie jars. One lot of 124 cookie jars sold for $198,605, 41 times the pre-sale estimate ("Taking Up a Collection," *Newsweek*, May 9, 1988: 63). Similar inflationary trends were demonstrated in auctions of Elton John's personal property ($16,830 for a pair of secondhand eyeglasses: Trucco, Terry, "Sales Pitch: Who the Owner Was," *New York Times*, September 11, 1988: E7), and the estate of Liberace (see Timmins, Stuart, "The Liberace Auction: The Way of All Flash," *The Advocate*, July 5, 1988: 51).

34. The old colors were lemon yellow, raw umber, maize, orange yellow, orange red, violet blue, green blue, and blue gray; the new ones are fuchsia, vivid tangerine, jungle green, cerulean, dandelion, teal blue, wild strawberry and royal purple. The withdrawn hues reappeared in the satirical 15th Annual Doo Dah Parade in Pasadena, CA (see Pasternak, Judy and Josh Meyer, "Doo Dah Parade Turns 15 But Refuses to Act Its Age," *Los Angeles Times*, November 26, 1990: B1, 6). The spirit of the dispute was also captured in this exchange between two characters on ABC's *thirtysomething* in an episode broadcast in New York on January 22, 1991:

Billy: "What's your favorite color?"
Ellen: "Flesh, like the Crayola color."
Billy: "Didn't the NEA cut off funding for that color?"

35. Letter from Karen E. Latinik, President, National Campaign to Save Lemon Yellow (Alexandria, Virgina), July 10, 1990.

36. Toner, "Taxes, S&L's, Anxiety . . ."

37. Riding, Alan, "France Questions Its Identity As It Sinks Into 'Le Malaise'," *New York Times*, December 23, 1990: A1, 8.

38. See Greenhouse, Steven, "A Morphological Compromise in France's War of Words," *New York Times*, January 27, 1991: E6.

39. Elsworth, Peter C. T., "The Art Boom: Is It Over, or Is This Just a Correction?" *New York Times*, December 16, 1990: F4.

40. Schjeldahl, Peter, "Art Gavel Comes Down, Hard," *Village Voice*, November 27, 1990: 123.

41. In a cover story on art and money, *Time* traced the financial history of this painting. Van Gogh sold only one painting in his lifetime, and received nothing for "Irises." It was sold to a private collector in 1947 for $80,000, and for 140 times that amount in 1987 (Hughes, Robert, "The Anatomy of a Deal," *Time*, November 27, 1989: 66–68).

42. See Muchnic, Suzanne, "N.Y. Art Auction Scene: A Still Life," *Los Angeles Times*, November 17, 1990: F1, 11.

43. Servin, James, "SoHo Stares at Hard Times," *The New York Times Magazine*, January 20, 1991: 25–29.

44. Swaim, C. Richard, editor, *The Modern Muse: The Support and Condition of Artists* (New York: American Council for the Arts, 1989).

45. Reported by Robinson, Walter, "Art Careers Still Pay Poorly, Surveys Find," *Art in America*, February, 1990: 35.

46. Baumol, William J., and William G. Bowen, *Performing Arts—The Economic Dilemma* (Cambridge, MA: The M.I.T. Press, 1966).

47. Dunning, Jennifer, "After the Boom, Tough Times for Dance," *New York Times*, February 5, 1990: C11, 14.

48. Rockwell, John, "Many Orchestras in Financial Straits," *New York Times*, January 19, 1987: C11.

49. See Passell, Peter, "Broadway and the Bottom Line," *New York Times*, December 10, 1989: H1, 8; Cohen, Roger, "In re: Marketing Parameters For Great American Novel," *New York Times*, March 25, 1990: E5; and McDowell, Edwin, "Publishers Cut Back on New Titles in '89, a Study Shows," *New York Times*, March 7, 1990: C23.

50. Muchnic, Suzanne, "Where Is Arts Support Coming From?" *Los Angeles Times*, December 10, 1990: F4.

51. Dear, Nick. "The Art of Success," in *The Art of Success, In the Ruins: Two Plays* (London: Methuen, 1989).

52. Stoppard, Tom, *Artist Descending a Staircase & Where Are They Now? Two Plays for Radio* (London: Faber & Faber, 1973): 21. This play's successful revival and adaptation for the stage demonstrates how art may be produced in one cultural milieu and subsequently resonate with the concerns of another; see Griswold, Wendy, *Renaissance Revivals: City Comedy and Revenge Tragedy in the London Theatre, 1576–1980* (Chicago: University of Chicago Press, 1986).

53. Stoppard, *op. cit.*, 24.

54. See Baxandall, Michael, *Painting and Experience in Fifteenth Century Italy* (Oxford: Oxford University Press, 1974); and Berger, John, *Ways of Seeing* (Hammondsworth, England: Penguin, 1972), for discussions of these historical functions of art.

55. Quoted by Smith, Roberta, "Jasper Johns, Incessant Recycler of Images," *New York Times*, July 29, 1990: H29.

56. See Rosenberg, Harold, *The Anxious Object: Art Today and Its Audience* (New York: Horizon Press, 1964); and "De-Aestheticization," pp. 178–87 in Battcock, Gregory, ed, *The New Art: A Critical Anthology* (New York: E.P. Dutton & Co., Inc., 1973).

57. Fuller, Peter, *Beyond the Crisis in Art* (London: Writers and Readers Publishing Cooperative, Ltd., 1980): 56, 63.

58. *Ibid.*, 27–8.

59. Wolfe, Tom, *The Painted Word* (New York: Bantam Books, 1976): 60. These critics are obviously opposed to Clement Greenberg, the champion of formalism.

60. See Danto, Arthur C., "Approaching the End of Art," pp. 202–218 in *The State of the Art* (New York: Prentice Hall, 1987); and "Bad Aesthetic Times," pp. 297–312 in *Encounters & Reflections: Art in the Historical Present* (New York: Farrar Straus Giroux, 1990).

61. Hughes, Robert. *Nothing If Not Critical: Selected Essays on Art and Artists* (New York: Alfred A. Knopf, 1990): 8.

62. Not surprisingly, his statements that homosexuals control the art world, and that the devastation of their ranks by AIDS was sad but "for the better," outraged many people. See Haden-Guest, Anthony, "The Art of the Hype," *Vanity Fair*, June, 1989: 140–43, 186–88. The tenor of his remarks echoes similarly anti-gay sentiments made by artist Thomas Hart Benton in the 1940s complaining that museums were run by "pretty boys."

63. Smith, Roberta, "Once a Wunderkind, Now Robert 'Long Ago'?" *New York Times*, October 29, 1989: H37, 46.

64. See Levin, Kim, "Artwalk," *Village Voice*, May 29, 1990: 119. As the author points out, this concept was not even original; it had been done at least 15 years earlier.

65. See Parachini, Allan, "NEA Board Rejects 'Decency' Grant Guidelines," *Los Angeles Times*, December 15, 1990: F7.

66. Frohnmayer later reversed himself and approved the grant.

67. Williams, Henry F., "The upward path to greatness," *The Cincinnati Enquirer*, April 4, 1990.

68. Grenier, Richard, "A burning issue lights artistic ire," *The Washington Times*, June 28, 1989.

69. Unsigned editorial, "Artists Mugged by Reality," *Wall Street Journal*, July 25, 1989.

70. Socially and politically oriented art has continued to exist since the anti-war movement of the '60s, but for the most part it has been produced by a few individuals working outside the main currents of the art world. A sustained political effort, engaging significant numbers of people, has not seemed likely until recently, when social and political concerns have come back into favor. For examples of the astonishing range of projects which have been undertaken since the 1960s, see Lippard, Lucy, *Get the Message? A Decade of Art for Social Change* (New York: E.P. Dutton, Inc., 1984), and Raven, Arlene, ed, *Art in the Public Interest* (Ann Arbor: UMI Research Press, 1989).

71. This is most evident in the emphasis on multiculturalism. Examples are "The Decade Show," mounted by three museums in New York in 1990, and the work presented in Lippard, Lucy, *Mixed Blessings: New Art in a Multicultural America* (New York: Pantheon, 1990).

The Bachelor Stripped Bare

1. See "Chicago Upset by Promotion That Uses Nude Illustration," *San Francisco Chronicle*, August 16, 1989: A8; and "Chicago: Hog Butcher for the World, City of . . . Nudes?" *New York Times*, August 18, 1989: A19.

2. Davenport, Joni, "History Made in Chicago (Chicago's First Black Mayor)," April, 1983.

3. Stamets, Bill, "Theater of power, theater of the absurd," *New Art Examiner*, Summer, 1988: 29–31. Contention over Washington's mantle continued during the next two mayoral elections, with Blacks who felt their candidate had lost out for the position of interim mayor immediately after Washington's death deserting the Democratic Party and forming the Washington Party. The son of the late boss, Richard M. Daley, won the 1989 election and handily prevailed in 1991 as well. His victories capitalized upon the divisiveness within the Black community, but—surprisingly—his skilled leadership created coalitions and contributed to some diminution of race as the critical factor in Chicago elections.

4. Magida, Arthur J., "Chicago's Blacks Blast Jews," *Detroit Jewish News*, July 15, 1988. It was never clear how

the aldermen found out about the painting. Various reports cited a secretary or other workers at the school providing the tip.

5. The best known incident where a riot was the direct response to a work of art was the premiere of Stravinsky's "Rite of Spring" in 1916. Some observers also blamed the inflammatory nature of D.W. Griffith's "Birth of a Nation" for the 1919 race riots on the South Side of Chicago (see Sawyers, June, "Passions erupt over 'Birth of a Nation,' " *Chicago Tribune*, October 11, 1987).

6. At the time of the incident, SAIC had eighteen percent minority enrollment, reported to be high in comparison to similar institutions (Glab, Michael, "School survives brush with infamy," *Skyline* newspapers, November 10, 1988). In May the Park District issued an order to all the city's cultural institutions to implement affirmative action policies (Cronin, Barry, "Museums to get Park Dist. order: Hire minorities," *Chicago Sun-Times*, May 16, 1988). And in a survey done the following year, the Art Institute ranked comparatively high in relative percentage of minority employees, although they were concentrated in lower-level positions (Stebbins, John, "Museums face minority-hiring push," *Chicago Sun-Times*, March 12, 1989: 34).

7. The two affiliated institutions are private, but do receive some government funds and are located on public land. In 1987 the Art Institute secured about twelve percent of its budget from the City of Chicago ("Art censors," *Southwest Times Record* [Fort Smith, AR] editorial, May 17, 1988).

8. See the 1988–1989 legal docket of the Roger Baldwin Foundation of the American Civil Liberties Union of Illinois, *Nelson v. Streeter*, U.S. District Court. The suit named three aldermen, the police commissioner and unidentified policemen, and sought $50,000 compensatory damages and $50,000 punitive damages. The ACLU highlighted their defense of this artist in a June, 1988 mail membership drive. They stressed that by accepting this case they did not wish to appear to be taking a position against the interests of Blacks. And for a fine insider's account of the incident by a SAIC administrator, see Becker, Carol, "Private Fantasies Shape Public Events: And Public Events Invade and Shape Our Dreams," pp. 231–253 in Raven, Arlene, ed., *Art in the Public Interest* (Ann Arbor: UMI Research Press, 1989).

9. Clapp, Jane, *Art Censorship: A Chronology of Proscribed and Prescribed Art* (Metuchen, N.J.: Scarecrow Press, 1972): 120–122.

10. "Museum Removes Hitler Caricature," *New York Times*, April 20, 1934.

11. Eliasoph, Philip, "Censorship stormed into the Corcoran Gallery once before," *The Artists Proof* (New York Artists Equity Association, Inc.), Vol. 3 (#2), January, 1990: 1–2.

12. Bowman, Jim, "The night Mayor Kelly protected the morals of innocent Chicagoans," *Chicago Tribune Magazine*, May 22, 1983: 30.

13. Clapp, *op. cit.*: 201, 175–176.

14. *Ibid.*: 194–195. See, also, Miner, Michael, "Big Fuss at the Art Institute," *Chicago Reader*, March 10, 1989, Sec. 1: 4. And according to SAIC director Anthony Jones (from an interview conducted March 28, 1990), students also made drawings of the modernist paintings, placed them upon the floor, and then walked on them, a striking prelude to what would happen when outraged veterans reacted similarly to the work of SAIC student Scott Tyler in 1990 (see Chapter Five).

15. See Brenson, Michael, "A Savage Painting Raises Troubling Questions," *New York Times*, May 29, 1988: 29, 37, and Schlesinger, Toni, "The mayoral painter's 15 minutes of fame," *Chicago Tribune*, May 22, 1988: Sec. 5: 4.

16. Miner, Michael, "Outlaw Art," *Chicago Reader*, May 27, 1988: 4. The artist's motives were much debated. He was castigated in the Black press for being opportunistic (Strausberg, Chinta, "Aldermen and artists clash over student's portrait of Washington," *Chicago Defender*, May 12, 1988: 3), and for trying to build publicity for himself (Strausberg, Chinta, "Racism cited at art school," *Chicago Defender*, May 16, 1988: 1). Such calculation was intimated by others as well (Artner, Alan G., "Two sides hit a wall in Art Institute furor," *Chicago Tribune*, May 22, 1988: Section 13: 31), but one of the most damning charges was made by a columnist who reported he'd gotten a call *before* the controversy erupted from someone claiming to be Nelson, urging him to write about it (Greene, Bob, "Editors choose to say 'no,' " *Chicago Tribune*, May 18, 1988: Section 5: 1). And even though the artist was placed in a tradition of prankster art dating back to the nineteenth century (Miner, *op. cit.*), he claimed he did not intentionally provoke this controversy. He

acknowledged producing other iconoclastic paintings, however, and affirmed "I don't want to make art that everybody loves" (Schlesinger, *op. cit.*).

17. Jones interview, March 28, 1990. Nelson was advised by his attornyes not to grant interviews to anyone until his legal proceedings were completed. Unfortunately, at the time of this writing the case was still open, and Nelson had not addressed the charges that he planned this as a performance piece. Alene Valkanas, executive director of the Illinois Arts Alliance, shared the view that Nelson and his fellow student Scott Tyler were savvy, not naive: "I see them as children of their age and highly manipulative of the media. They understand it much better than their predecessors, and possibly even leading them to using the media as part of their art. . . . I also see them as being very young, so that their sense of the whole and their impact on the whole—all the checks and balances that a mature person would have—isn't there" (from an interview conducted March 30, 1990).

18. See Carmilly-Weinberger, Moshe, *Fear of Art: Censorship and Freedom of Expression in Art* (New York: R.R. Bowker, 1986), Chap. 1.

19. Transcript of WGN-TV (Ch. 9) Nine O'Clock News, May 12, 1988, David Nelson voiceover. As was the case with the central figures in many other art controversies, Nelson refused to be interviewed on camera or to have his picture taken for print (these decisions made even before attornies advised him against a high public profile).

20. See Frueh, Joanna, "Chicago's Emotional Realists," *Artforum*, September, 1978: 41–47. Some of the best known representatives are Jim Nutt, Ed Paschke, Leon Golub, and Karl Wirsum. Certain commentators merely dismissed Nelson's work as the insensitive expression of someone of affluence and leisure; see Redcloud, C.C., "Left Side," *Industrial Worker*, June, 1988. David Nelson once again stirred up controversy with a drawing he published in the *Chicago Reader* over three years later (December 20, 1991: 12). He satirized Alderman Dorothy Tillman, one of the officials who helped remove his portrait of Mayor Washington from SAIC, with a paper doll display. Tillman was pictured stripped down to her underwear, with two possible outfits to wear. Both came with her trademark hats, and one also included a handgun as an accessory, while the other featured a machine gun. These were allusions to rumors that she routinely armed herself with a weapon. The cartoon enraged many people—some of whom staged a demonstration outside the newspaper's offices—and invigorated "letters-to-the-editor" columns for weeks.

21. Greene, Bob, *op. cit.* It's impossible to test the veracity of this claim, but Nelson certainly did not capitalize on this incident. He refused offers to buy the painting and opportunities to appear on national TV talk shows; he was even reluctant to pursue the lawsuit. On one of the few occasions that he broke his silence he stated: "I'm glad I didn't allow my image to be reproduced anywhere because I'm the same old schmo I was before and that's fine with me" (Snow, Deborah, "Art Institute student ends silence over painting," *Chicago Daily Calumet and Pointer* [Lansing, IL], August 10, 1988).

22. Strahler, Steven R., "Uproar trips resurgent Art Institute," *Crain's Chicago Business*, May 23–29, 1988: 1, 53.

23. Alderman Allan Streeter, in Donahue, Phil, Transcript of broadcast on censorship, June 14, 1988, Cincinnati, Ohio: Multimedia Entertainment, Inc., 061488: 6.

24. See coverage in the major Black newspaper the *Chicago Defender*, May 12, 14, 16, 28, 1988; and in the major gay newspapers, *Windy City Times*, May 19, 26, and June 2, 1988, and *Outlines*, June, 1988.

25. Schmidt, William E., "Chicago Still Haunted By the Ghost of Capone," *New York Times*, September 20, 1987: 26.

26. Schmidt, William E., "On the Lam in Chicago," *New York Times*, November 19, 1989: Section xx: 8,9; Tempest, Rone, "What, Vienna Becoming Chicago? Crime, Foreigners Are Voter Issues," *Los Angeles Times*, October 4, 1990: A14.

27. Oreskes, Michael, "Political War Erupts In Chicago Streets," *New York Times*, October 26, 1990: A14.

28. Quoted in Dubin, Steven C., *Bureaucratizing the Muse: Public Funds and the Cultural Worker* (Chicago, University of Chicago Press, 1987): 6.

29. See Mutter, Alan D., " 'Blues' pix put Byrne photog out of picture," *Chicago Sun-Times*, February 9, 1980: 1, 10.

30. *New York Times* obituary, November 26, 1987: D19.

31. Stamets, *Theatre of power*: 30. Washington had been married previously and fathered two children. He also had a fiancee of ten years.

32. Fox, Mario, *New York Daily News*, May 13, 1988: 23.

33. *New York Post*, May 13, 1988: 5.

34. Jim Bohannon on "America in the Morning," the Mutual Broadcasting System, May 13, 1988.

35. Brenson, *A Savage Painting*: 29.

36. See Jarrett, Vernon, "Art deserves lot better judgment," *Chicago Sun-Times*, May 15, 1988: 13.

37. "Arts and Ethics (Censorship and Morality)," symposium held at Columbia College, July 29, 1988.

38. "Must everything be black or white?" *Chicago Sun-Times* editorial, June 27, 1988. Chicago has a long history of residential segregation. An example of an attempt to preserve it is captured in Lorraine Hansberry's "A Raisin in the Sun," where a "neighborhood improvement" association offers to buy a home from a Black family *before* they are able move into it—a "grass-roots" version of an equity law.

39. Quoted in Strausberg, Chinta, "Barrow: No more apologies for remarks," *Chicago Defender*, May 16, 1988: 3.

40. The sense of siege in the Black community is vividly conveyed by this additionnal quote from director (Reverend) Willie Barrow of Operation PUSH: "We are still suffering from that great loss [Mayor Washington's death]. When a community is divided, it makes it more vulnerable to attack by its enemies . . . like flies to an open sore . . . A united Black community should not continue to have to defend itself against questionable charges of anti-Semitism and racism . . . the gross depiction of Washington . . . is but the latest in a series of escalating attacks and assaults against the Black community"; Strausberg, Chinta, "Aldermen and artists clash over student's portrait of Washington," *Chicago Defender*, May 12, 1988: 3. For two of the best treatments of the Cokely issue and Black/White relations more generally, see Levinsohn, Florence Hamlish, "The Cokely Question," *Chicago Magazine*, August, 1988: 112–115, 138–140; and Branch, Taylor, "The Uncivil War," *Esquire*, May, 1989: 89–96, 105–116.

41. Quoted in "Ready Or Not, Reform Must Come," *Windy City Times* editorial, May 12, 1988: 11.

42. Dubin, *Bureaucratizing*: 171–74.

43. Stamets, *op. cit.*: 31.

44. Hentoff, Nat, "The Day They Came To Arrest the Painting," *Village Voice*, June 21, 1988: 37; "Chicagoans Protest a Fresco Project," *New York Times*, August 31, 1985: 9; and Newman, M. W., " 'Posse' grab of student art stirs protests," *Chicago Sun-Times*, May 15, 1988: 3.

45. One notable exception was the physical damage done to the painting.

46. Newman, *op. cit.* Two sample headlines will convey the flavor of much of the news commentary: "Jackboots crash Chicago art scene," *News-Press* (Nebraska City, NE) editorial, May 13, 1988; and Kadner, Phil, "Untouchables meet the unmentionables," *Suburban Daily Calumet and Pointer* (Lansing, IL), May 15, 1988 (an imagined dialogue between Elliot Ness, Scarface, Monet and Lautrec). Some writers could not resist making light of the affair; quipped one journalist, "Q: How many Chicago aldermen does it take to judge an art exhibit? A: Nine. One to drive to the exhibit. And eight to stick the artist in the trunk" (Simon, Roger, "Bad taste dealt with in bad taste," *Baltimore Sun*, May 22, 1988: B1–2).

47. For the record, he is *not* Jewish.

48. Hentoff, *op. cit.* Justification for the impoundment of the painting was derived from a local statute regarding incitement to riot. The constitutional basis for bringing legal action against the seizure rests on the rights of free expression, freedom from unreasonable seizure, and freedom from deprivation of property without due process. Potentially relevant to the case is the 1988 Supreme Court decision in favor of *Hustler* magazine, upholding its right to publish a scathing parody of evangelist Jerry Falwell. This reaffirmed the broad protection of editorial criticism of public officials. And according to the local ACLU director, there is nothing obscene or inherently defamatory about the painting (see Donahue transcript, *op. cit.*: 5).

49. See Donahue transcript, *op. cit.*: 5, and "Art Criticism: The Chicago School" (*Washington Post* editorial), May 14, 1988: A26. And there is a further irony: one of the aldermen who seized the painting was formerly a Black Panther Party member who was defended by the ACLU in 1969 when it protected *his* right to distribute his group's literature (see Donahue transcript, *op. cit.*: 14). One article ran a 1969 picture of this

individual—Bobby Rush—posed in Black Panther garb in front of a large map of Chicago, a gun in his upraised hand (see Tuohy, James, "The Gang of Eight," *Chicago Lawyer*, June, 1988: 11).

50. Allan Streeter in Donahue transcript, *op. cit.*: 3.

51. See Lester, Julius, "When Black Unity Works Against Critical Inquiry," *New York Times*, July 12, 1988: A25, and Williams, Lena, "Black Woman's Book Starts a Predictable Storm," *New York Times*, October 2, 1990: C11, 15, for other instances of intolerance of self-criticism or of the penalties incurred over the failure to strictly adhere to accepted lines of thought within a minority community. In a much lighter vein, see Roth, Philip, *The Ghost Writer*, New York: Farrar, Straus and Giroux, 1979.

52. Quoted in Muwakkil, Salim, "Harold Washington's fractured legacy," *In These Times*, May 25–June 7, 1988: 6.

53. Strong, James, "Sawyer puts salve on racial wounds," *Chicago Tribune*, May 19, 1988: Section 2: 1. As outspoken as some players became in this drama, they could also maintain silence. In June, 1988 I surveyed all fifty aldermen by mail, soliciting any public statements they had made in relation to the incident, relevant ward publications, etc. I carefully worded my cover letter so it would not offend either side to the dispute, highlighted my past residency in Chicago, and my ongoing professional interest in public art and "the social role and responsibility of the artist," and included self-addressed, postpaid envelopes. Significantly, I received *no* responses to my request.

54. "Judge Under Fire For a Speech," *New York Times*, July 24, 1988: 29.

55. Royko, Mike, "Alderman's brain is a museum piece," *Chicago Tribune*, May 17, 1988: 3. See, also, my examination of the images of Blacks in popular material culture, and the symbolic violence encoded into it: "Symbolic Slavery: Black Representations in Popular Culture," *Social Problems*, Volume 32 (2), April, 1987: 122–140.

56. Quoted in "An Uproar Over 'Mirth and Girth,' " *Newsweek*, May 23, 1988: 25.

57. See the coverage in *The Philadelphia Inquirer*, July 13–15 and 19, 1987; also, Price, Debbie M., "Philadelphia Asks, Is It Art Or Politics?" *New York Times*, January 10, 1988: 35. Move was a Black radical organization. It had a history of conflicts with its neighbors and the police, and in 1985 Mayor Wilson Goode authorized the police to bomb Move headquarters, in a residential rowhouse. Eleven children and adults were killed as a result, and the surrounding neighborhood was gutted by fire.

58. Interestingly, the critic Harold Rosenberg reported that artist Claes Oldenburg stated "Chicago gives him a 'sepulchral feeling,' and that it has 'a strange metaphysical elegance of death about it,' " in "Place Patriotism and the New York Mainstream," pp. 206–215 in *Art on the Edge: Creators and Situations* (New York, Macmillan Publishing Co, 1975): 209.

59. See Dubin, *Bureaucratizing*: 171–74.

60. Green, Paul M., and Melvin G. Holli, eds., *The Mayors: The Chicago Political Tradition* (Carbondale and Edwardsville: Southern Illinois University, 1987).

61. See Fleeson, Lucinda and Edward J. Sozanski, "Artist's view of the city gets trashed," *Philadelphia Inquirer*, July 13, 1987, A10; and Price, *op. cit.*

62. "Art or 'Trash' in Philadelphia," *New York Times*, July 26, 1987: 30.

63. Price, *op. cit.*

64. Stevens, William K., "Philadelphia Neighborhood Torn by Racial Tension Starts to Simmer Down," *New York Times*, December 1, 1985: 34.

65. Schlesinger, *op. cit.*

66. Sozanski, Edward J., "Politics versus Art," *Philadelphia Inquirer*, July 19, 1987: K1, 14.

67. See Dubin, 1987, *op. cit.*: 155–179 for similar evidence regarding government control of the arts in the 1930s and the late 1970s.

68. This was certainly the case with the Vietnam Veterans' Memorial in Washington, D.C.: the stark abstract design of Maya Lin was very controversial and was later augmented by a more traditional, realistic tableaux of soldiers. See Wagner-Pacifici, Robin and Barry Schwartz, "The Vietnam Veterans' Memorial: Commemorating a Difficult Past," *American Journal of Sociology*, Vol. 97 (2), September, 1991: 376–420.

Hue and Cry

1. Barringer, Felicity, "Census Shows Profound Change In Racial Makeup of the Nation," *New York Times*, March 11, 1991: A1, B8.

2. See Young, Perry Deane, *God's Bullies: Power Politics and Religious Tyranny* (New York: Holt, Rinehart and Winston, 1982).

3. Quoted in Gillam, Jerry, "Proposed Legislation Would Stiffen Hate Crime Penalties," *Los Angeles Times*, February 9, 1991: A28.

4. Applebome, Peter, "Louisiana Tally Is Seen as a Sign of Voter Unrest," *New York Times*, October 8, 1990: A1, 12.

5. Letter to the editor, *Kansas City Star*, February 3, 1991: K3.

6. "Klan Is Told to Stop Imitating 'Mister Rogers' on the Phone," *New York Times*, October 12, 1990: A22; "Queers In Mister Rogers' Neighborhood," *The Advocate*, November 11, 1990: 9. Mister Rogers successfully sued the Klan for copyright infringement, and local KKK members were forced to destroy the tapes. In an unrelated incident, Nike discontinued a commercial for $135 basketball shoes in which star David Robinson asked, "Can you say, 'Kick some butt?' "; large numbers of viewers complained about this additional parody of Mister Rogers (see Horovitz, Bruce, "Nike Pulls Ads Parodying Mr. Rogers' Neighborhood," *Los Angeles Times*, October 26, 1990: D4).

7. Rothstein, Mervyn, "Martha Clarke's Thorny Garden," *New York Times*, June 12, 1988; H1, 26; and Stewart, Robert W., "The True Believer," *Los Angeles Times*, July 11, 1990: E5, emphasis added.

8. Knight, Robert H., "The National Endowment For The Arts: Misusing Taxpayers' Money," *The Heritage Foundation Backgrounder*, No. 803, January 18, 1991: 21–28.

9. Campbell, James, "School board bans book with 4-letter words," *Chicago Sun-Times*, November 2, 1972: 44; and Yates, Ron, "Book Ban Triggers High School Uproar," *Chicago Tribune*, November 2, 1972.

10. Scott, Ernest D., "Insane Coho Lips take over," *Illinois Entertainer*, July, 1979, Vol. 2 (64): 1; Rose, Frank, "Rock & Roll Fights Back: Discophobia," *Village Voice*, November 12, 1979: 37. See, also, Barker, Noel and John Fleming, "Who Is Steve Dahl and Why Are They Saying Those Terrible Things About Him? Notes on a Comic Revolutionary," *Chicago Reader*, July 20, 1979: 8–9, 22.

11. Briggs, Kenneth A., "Cathedral Removing Statue of Crucified Woman," *New York Times*, April 28, 1984: 27.

12. Torres, Vicki, "Cafe's Art Takes Bite at Pasadena," *Los Angeles Times*, January 21, 1991: B1. Recall, also, that Bruce Springsteen's song "Born in the U.S.A." was turned into a patriotic anthem by the Bush campaign in 1984, deflecting its original viewpoint.

13. Danto, Arthur C., *Encounters & Reflections: Art in the Historical Present* (New York: Farrar, Strauss & Giroux, 1990): 216, emphasis added.

14. MacMonnies, Frederick, testimony from New York Board of Estimate Proceedings, March 22, 1922.

15. Quoted in Bogart, Michele, *Public Sculpture and the Civic Ideal in New York City, 1890–1930* (Chicago: University of Chicago Press, 1989): 268.

16. Fried, Joseph P., "Statue Showing Women as 'Evil' May Be Moved," *New York Times*, October 13, 1987: B3. Queens, incidentally, is also home to the first female Vice-Presidential candidate, Geraldine Ferraro.

17. This and all other unattributed information on this sculpture was derived from an interview with the Director of Cultural Affairs, Borough of Queens, March 6, 1991.

18. See Worthington, Rogers, "Huck Finn still suspect at age 100," *Chicago Tribune*, May 19, 1985; and Shipp, E.R., "A Century Later, Huck's Still Stirring Up Trouble," *New York Times*, February 4, 1985.

19. Brune, Tom, "School shucks 'Huck Finn,' " *Chicago Sun-Times*, August 24, 1984.

20. Wisby, Gary, "Waukegan alderman sees racism in literary classic," *Chicago Sun-Times*, May 8, 1984.

21. "2 Texas Statues Embody Century of Racial Views," *New York Times*, September 10, 1989: 26.

22. At the same in Austin, additional attempts were made to modify the symbolic landscape. The president of the local branch of the NAACP demanded that place names such as "Nigger Creek" and "Niggerhead

Hill" be changed. He suggested the names of noted local Black citizens as substitutes, so that honor would replace denigration. See Belkin, Lisa, "On Geographic Names And Cleaning Them Up," *New York Times*, February 14, 1990: A16.

23. "New Orleans Tries to Erase a Symbol," *New York Times*, October 16, 1989: A18

24. See Holden, Stephen, " 'Show Boat' Makes New Waves," *New York Times*, September 25, 1988: Sec. 2: 1; and Feingold, Michael, " 'Show Boat' Keeps On Rollin,' " *Village Voice*, November 29, 1988: 69, 173.

25. "A New State Song For Old Virginia?" *New York Times*, January 31, 1988: 46.

26. Herbert, Bob, "Unsophisticated Ladies," *New York Daily News*, May 3, 1990: 4; and Hevesi, Dennis, "Ellington Sculpture Puts Some Critics in a Mood Indigo," *New York Times*, May 4, 1990: B1, 3.

27. Edelman, Rob, *Films in Review*, March, 1981: 185; and Thomas, Kevin, *Los Angeles Times*, February 6, 1981: Part VI: 1.

28. Lippard, Lucy, "Cashing in a Wolf Ticket," pp. 303–314 in *Get The Message? A Decade of Art for Social Change* (New York: E.P. Dutton, Inc., 1984): 312.

29. Newkirk, Pamela and Peter Moses, "Bronx Burning Over 'Bonfire,' " *New York Post*, April 26, 1990: 3.

30. "Judge Sued in Barring Filming in Courthouse," *New York Times*, May 17, 1990: B5.

31. See his *The Empire's Old Clothes: What the Lone Ranger, Babar, and other innocent heroes do to our minds* (New York: Pantheon, 1983).

32. Crouch, Stanley, "Animated Coon Show," *Village Voice*, December 16–22, 1981: 96, emphasis added.

33. O'Connor, John J., "Insidious Elements in Television Cartoons," *New York Times*, February 20, 1990: C20.

34. This received extensive media coverage; see, for example, Prince, Richard, "Restyled Symbol: There's another side to Aunt Jemima," *Chicago Tribune*, October 15, 1989: Sec. 6: 5; and Mabry, Marcus, "A Long Way From 'Aunt Jemima,' " *Newsweek*, August 14, 1989: 34–35. The restaurant chain "Sambo's" experienced a similar type of pressure and decided to drop its name: Fox, Stephen, "Sambo's seeks new name and image," *Chicago Tribune*, July 5, 1982: Sec. 4: 10.

35. See Moore, Keith, "City is hit over photo," and "Harlem, city dancing over mural resolution," *New York Daily News*, March 8, 1989: BW1; March 9, 1989: BW3.

36. For basic coverage of the events see Fisher, Adam, "Newschoolspeak," *Village Voice*, December 5, 1989: 67; and Holmes, Steven A., "Debating Art: Censorship Or Protest?" *New York Times*, December 6, 1989: B1, 2.

37. Boskin, Joseph, *Sambo: The Rise & Demise of an American Jester* (New York: Oxford University, 1986): 76–77.

38. Quoted in "Black Stereotypes Used To Market Products in Japan," *Jet*, Vol. 74 (20), January 15, 1988: 37.

39. Fanton, Jonathan F., "Letter to the University Community," November 21, 1989.

40. Toth, Robert C., "Blacks Pressing Japanese to Halt Slurs, Prejudice," *Los Angeles Times*, December 13, 1990: A5. For a report on a more grass-roots anti-discrimination campaign, see McCombs, Phil, "One Small Force Against Racism," *Washington Post*, August 12, 1989: C1, 2.

41. For a statement of the president's position, see Fanton, Jonathan F., "Between Freedom of Expression and Freedom From Intolerance," letter to the editor, *New York Times*, December 28, 1989: A20.

42. Zaslow, Janet and Bronwen Latimer, "New School Students Turn Up The Heat," *The West Side Spirit*, February 27, 1990: 4ff. This gesture takes on additional meaning when it is considered in context: the New School was founded as the "University in Exile," providing refuge to intellectuals forced to flee Hitler.

43. See "Perils of Public Exhibitions," *Art in America*, September 1988: 212.

44. Quoted in Kastor, Elizabeth, "The Jackson Artist on the Painting That Hit a Nerve," *Washington Post*, December 1, 1989: B1, 4.

45. *Ibid.*: B4.

46. It is also important to note that the sponsor of the show and installation series was the Washington Project for the Arts (WPA). This institution was no stranger to controversy: earlier in the year the WPA was the

site of the Robert Mapplethorpe retrospective, a show it took after it had been rejected by the Corcoran Gallery of Art (see Chapter Seven).

47. Gussow, Mel, "The Stage: 'Route 1 & 9,' " *New York Times*, October 29, 1981: C15.

48. Howell, John, "Routes," *The Soho News*, January 5, 1982.

49. Jones, Jeffrey M., "An Appeal of the Decision of the New York State Council on the Arts to Withhold Public Funds from the Production of 'Route 1 & 9,' " submitted by The Wooster Group, Inc., March 3, 1982: 9–10.

50. Howell, *op. cit.*

51. Jones, *op. cit.*: Appendix IV.

52. *Ibid.*: 11, 13.

53. Audiences were primarily (but not exclusively) made up of Whites, although several of the letters of protest to NYSCA were written by Blacks.

54. *Ibid.*: 18. Interestingly, controversy did not arise when Dance Theater Workshop (DTW) and Donald Byrd/The Group presented "The Minstrel Show" ten years later, even though the entire multiracial troupe performed in blackface, and the show included racial slurs and jokes. Important mediating factors were that Byrd is a Black man, and stereotypes were "deconstructed" throughout the performance. Strangely, however, a minor controversy did arise over a visual arts exhibit hanging in a gallery area at DTW at the same time. Lee Brozgold's "40 Patriots/Countless Americans" was blasted on the front page of *The Washington Times* (November 13, 1991) for being an illegitimate, politicized use of NEA funds (the artist featured forty "death masks" of prominent conservatives and Republicans). NEA funds were *not* used in this case, however.

55. Artist's typewritten statement, March 17, 1979.

56. This and all subsequent unattributed quotes are from an interview conducted August 4, 1991.

57. See, for example, Blair, Eileen, "Pure Art or 'Brutality Chic': Artists Space Accused of Racism Over Exhibit Title," *The Villager*, April 26, 1979: 15–16.

58. Letter to Kitty Carlisle Hart, chairperson of New York State Council on the Arts, March 14, 1979.

59. Cartoon accompanying Hess, Elizabeth, "Art-World Apartheid," *Seven Days*, May 18, 1979: 27; and Blair, *op. cit.*: 15. Winer now expresses regret over the entire incident, using a contemporary sensibility to tactfully reevaluate past "miscalculations."

60. See Crimp, Douglas, "Commentaries on Artists Space's exhibit of 'Nigger Drawings,' " *Artworkers News*, June, 1979; and von Brandenburg, Peter, "Donald's 'The Nigger Drawings,' " *Arts Magazine*, June, 1979: 125–127.

61. This and all subsequent unattributed quotes are from an interview conducted September 20, 1991.

62. Letter to James Reinish, NYSCA Visual Arts Services, March 6, 1979.

63. For one such argument see Goldstein, Richard, "Donald's Legacy," *Village Voice*, April 30, 1979: 48.

64. This and all subsequent unattributed quotes are from an interview conducted with von Brandenburg, August 2, 1991.

65. Telegram from NYSCA to Artists Space, March 5, 1979.

66. Reported in Fulwood, Sam III, "Attitudes on Minorities in Conflict," *Los Angeles Times*, January 9, 1991: A13.

67. Lippard, Lucy, "Rx-Rated Art," pp. 255–258, in *Get the Message*.

68. Merritt, Robert, "Exhibit succeeds at controversy," *Richmond Times-Dispatch*, June 17, 1990: K9.

69. Wilkerson, Isabel, "Discordant Notes in Detroit: Music and Affirmative Action," *New York Times*, March 5, 1989: 1, 30. This incident also lead to the establishment of a fellowship program to enable two Black musicians to play with the orchestra each year, and the organization now sponsors an African-American Composers Forum to feature the work of Black composers; see Kozinn, Allan, "Despite Odds, Many of Them, A Bedeviled Orchestra Persists," *New York Times*: C15, 17.

70. This show was jointly sponsored by the Department of Cultural Affairs (a city agency), the Art Institute

of Chicago, the Museum of Contemporary Art, and a large local bank. The Nelson/Washington incident has been related in detail, and some additional episodes have been referred to. Preceding The Chicago Show were two other tumultuous art events, both involving the Art Institute: one was the demand that it return an important temple lintel the Thai government claimed had been illegally plundered, and the other a major dispute over the placement of an American flag on the floor within a student's mixed-media installation. Both of these events will be examined more closely in later chapters, but they need to be mentioned here to help the reader understand the almost constant state of siege the Art Institute felt itself to be under, and the general state of affairs regarding art and politics in the city.

71. Brochures, Chicago Department of Cultural Affairs, October, 1989.

72. Yood, James, "Cowardice and politics ruin 'The Chicago Show,' " *New Art Examiner*, Summer, 1990: 25; and Fishman, Ted C., "Jury-Mandering: How Do You Judge Chicago's Art?" *NewCity*, April 12, 1990: 7–8.

73. Letter to the Commissioner, Department of Cultural Affairs, March 14, 1990.

74. Fishman, Ted C., "A Knockout," *NewCity*, May 10, 1990: 19; Artner, Alan G., "Conflicting agendas hobble 'The Chicago Show,' " *Chicago Tribune* May 6, 1990: Section 13: 14–15; and Yood, *op. cit.*: 26.

75. Miller, Molly, "How Firm is the Library's Affirmative Art?" *NewCity*, July 5, 1990: 16.

76. Interview with Alene Valkanas, March 30, 1990.

77. Rich, Frank, "Jonathan Pryce, 'Miss Saigon' and Equity's Decision," *New York Times*, August 10, 1990: C3.

78. Rothstein, Mervyn, "Mackintosh and Equity Plan Meeting," *New York Times*, August 24, 1990: C3.

79. See Sheehan, Henry, "When Asians are Caucasians," *Boston Globe*, August 19, 1990: B30; and Gussow, Mel, "Striding Past Dragon Lady and No. 1 Son," *New York Times*, September 3, 1990: 11, 15.

80. Rothstein, Mervyn, "Equity Panel Head Criticizes 'Saigon' Producer," *New York Times*, August 16, 1990: C17. A Black actress argued in almost the exact words, and recounted a similar history of Whites usurping Black roles in Holly, Ellen, " 'The Ideal World We All Long For' Is Not the World We Live In," *New York Times*, August 26, 1990: H7, 27.

81. Rothstein, Mervyn, "Producer Demands A Free Hand to Cast 'Miss Saigon' Roles," *New York Times*, August 22, 1990: C11; and Gutmann, Stephanie and Phil West, "Casting Call Still a Whisper," *Los Angeles Times*, August 16, 1990: F8.

82. Rothstein, Mervyn, "Equity Reverses 'Saigon' Vote And Welcomes English Star," *New York Times*, August 17, 1990: C3.

83. Gussow, *op. cit.* And further, in 1973 the New York State Human Rights Appeal Board condemned as discriminatory the casting policy of the Lincoln Center theater, the venue where Dewhurst had appeared. The reference to minstrel shows was repeated by others, and was partially based upon the report that Pryce supposedly relied upon yellow make-up and a prosthetic facial device when he initially created the role, but dropped them later.

84. Will, George, F., "The Trendy Racism of Actors' Equity," *Washington Post*, August 12, 1990: C7.

85. Winer, Linda, *New York Newsday*, August 10, 1990: Part II: 3; *Los Angeles Times*, August 10, 1990: B6; and *New York Times*, August 9, 1990: A22.

86. "Error, Stage Left," *New York Times*, August 12, 1990: E21.

87. Stuart, Otis, "The 'Miss Saigon' Mess," *Village Voice*, August 21, 1990: 87.

88. Quoted in Gelb, Hal, "Should Equal Opportunity Apply on the Stage?" *New York Times*, August 28, 1988: H3.

89. Koenenn, Joseph C., "Efforts At Casting Compromise," *New York Newsday*, August 10, 1990: Part II: 3. Reviews of the show were mixed, and Pryce came in for especially brutal criticism by one critic: "the worst Asian-American actor imaginable would be better in the role. . . . [Pryce] looks exactly as silly as Carol Channing would playing the life of Lena Horne"; see Feingold, Michael, "Heat-Seeking Bomb," *Village Voice*, April 23, 1991: 91.

90. Cavett, Dick, "My Union, Actors' Inequity," *New York Times*, August 10, 1990: A25.

91. Finkle, David, "The Casting Line," *Village Voice*, August 21, 1990: 86.

92. The situation became even more complex when groups such as Asian Lesbians of the East Coast and Gay Asian and Pacific Islander Men of New York criticized New York's Lesbian and Gay Community Services Center and the Lambda Legal Defense and Education Fund for sponsoring theater party benefits at "Miss Saigon." When LLDEF decided it was not financially feasible to cancel its plans, theatergoers were met by a large group of demonstrators protesting what they judged to be the play's racism and sexism. LLDEF later released a statement whose chastened tone sounded like it was written by a graduate of a totalitarian reeducation camp: "We have learned an important lesson on the need to think more carefully, do more research, and be more sensitive before embarking on fund-raising and other programs. We will apply that lesson from now on" (*The Lambda Update*, Spring, 1991: 19).

93. Fox, David J., "Gere Casting Rates Soft Protest by Asia Americans," *Los Angeles Times*, August 15, 1990: F1, 4; and "Navajos Defend Redford's Casting of Phillips," *Los Angeles Times*, September 3, 1990: F2.

94. Vanderknyff, Rick, "Theater Rejects Interracial 'Romeo and Juliet,' " *Los Angeles Times*, August 25, 1990: F5; and Braxton, Greg, "Students Stage a Show of Protest," *Los Angeles Times*, November 15, 1990: B3. Producer Macintosh pledged to Equity that he would expand minority opportunities in two of his other musicals, "Les Miserables" and "Phantom of the Opera," and in March, 1991 "Les Mis" got its first Black cast member in the national touring company; see Shewey, Don, "Cameron Crow," *Village Voice*, March 12, 1991: 86 (and "Phantom" presented a Black actor in the starring role).

95. Quoted in Christgau, Robert, "Creative Censorship," *Village Voice*, February 3, 1987: 72.

96. *Ibid.*: 67, 73.

97. Quoted in Trend, David, "Your Money Or Your Politics," *Afterimage*, March, 1989: 3.

98. Yarrow, Andrew L., "Papp Agrees to Present Palestinian Troupe," *New York Times*, July 25, 1989: C20.

99. Markham, James M., "Jewish Protesters Halt Fassbinder Play's Debut," *New York Times*, November 1, 1985: C33, emphasis added.

100. Markham, James M., "A Cultural Equivalent of Bitberg Unsettles West Germany," *New York Times*, November 10, 1985: E10.

101. "Israeli Publishers Are Balking at 'Mein Kampf,' " *New York Times*, August 27, 1989: 10.

102. Gradstein, Linda, "The Intifada at the Movies," *Washington Post*, August 6, 1989: G1,8.

103. Censorship in the theater was lifted in 1989, although it was left intact for movies because the younger and larger audiences they generally attract might be more easily influenced by them. See "Israel Bans Arab's Play As Racist and Inciteful," *New York Times*, July 3, 1989: 17; "Israeli Theater Gets A Censor-Free Run," *New York Times*, August 10, 1989: C13, 20.

104. Corry, John, " 'The Africans' Renews a Funding Fight," *New York Times*, September 14, 1986.

105. McCombs, Phil, "Jo Franklin-Trout, in The Palestinian Storm," *Washington Post*, September 6, 1989: B1.

106. Ireland, Doug, "Days of Outrage," *Village Voice*, July 25, 1989: 8.

107. "Palestinian Broadcast Gets Mediocre Ratings," *New York Times*, September 8, 1989: C24; Gerard, Jeremy, "PBS to Show Film on the Intifada Despite Protests," *New York Times*, July 20, 1989: C21.

108. A similar scenario ensued over a program organized by Artists Space, "Uprising: Videotapes on the Palestinian Resistance." When the series was scheduled to travel to Boston's Institute of Contemporary Art (earlier, one of the hosts of the Robert Mapplethorpe retrospective), officials there first requested the addition of Israeli videos for "balance," and then suggested a panel discussion. According to curator Micki McGee, the show's fatigued organizers eventually decided to withdraw it because they felt it had been politicized (remarks made at "Auto-Censorship: The Chilling Effect," Parsons School of Design, May 4, 1991). A *Boston Globe* editorial blasted the extended wrangling initiated by the ICA, facetiously suggesting that in the future every cowboy movie would need to be balanced by a panel of American Indians, as would countless other subjects ("Cowboy movie, Indian panel," May 3, 1991: 14).

109. Goodman, Walter, "How PBS Handles Arab and Israeli Views in 2 Documentaries," *New York Times*, December 5, 1989: C19, 22. A number of aspects of this controversy were repeated in 1991 over broadcast of "Stop the Church"; see Chapter Twelve for details.

110. "A Sculpture And a Charge Of Censorship," *New York Times*, January 21, 1986.

111. It is interesting to note that a large part of the official argument for removing Richard Serra's "Tilted Arc" from the Federal Plaza in New York City was also "security": some experts claimed it could be used as a protected staging area from which to launch a terrorist assault on the adjoining building.

112. See Marks, Laura U., "Boarded Over," *Afterimage*, Vol. 17 (4) September, 1989: 3. See, also, Joselit, David, "Living on the Border," *Art in America*, Vol. 77 (2), December, 1989: 120–28 for discussions of these and other examples of "border culture."

113. Quoted in Harrington, Richard, "On the Beat: Odds and Ends," *Washington Post*, December 20, 1989: B7.

114. Quoted by Wallace, Michele, "When Black Feminism Faces The Music, and the Music Is Rap," *New York Times*, July 29, 1990: H20; quoted by Cube, Ice, "Black Culture Still Getting a Bum Rap," *Los Angeles Times*, June 25, 1990: F3.

115. See the discussion of rap and particularly 2 Live Crew in Chapter Twelve.

116. Editors of *Rock & Roll Confidential*, *You've Got A Right To Rock: Don't Let Them Take It Away* (Long Beach, CA: Duke & Duchess Ventures, 1989): 6.

117. *Ibid.*, and Pareles, Jon, "Outlaw Rock: More Skirmishes on the Censorship Front," *New York Times*, December 10, 1989: H32.

118. Other occurrences also blurred the line between art and reality. N.W.A. invited Rodney King to join them on a new version of "——— Tha Police" [this is, incidentally, the wording used on the record itself]. King, of course, was the black motorist who was brutally beaten by several L.A.P.D. officers, an incident captured on a widely shown videotape. King's fate seemed to substantiate the song's claims. See Eazy-E, "The Outsider and the Inner Circle," *Los Angeles Times*, March 25, 1991: F3.

119. Smith, R J, "The Enemy Within," *Village Voice*, June 20, 1989: 102–103. The interview was originally published in *The Washington Times*, but with sections reprinted verbatim in the Smith article, it reached a much wider (and very different) audience.

120. Hellman, Rick, "Racist rapper rejoins Public Enemy, performs at Kansas City concert," *The Kansas City Jewish Chronicle*, August 11, 1989: 1, 21A.

Spiritual Tests

1. Kuntz, Tom, "In Highgate Cemetery, Marx Is Safe on a Pedestal," *New York Times*, March 14, 1990: A4.

2. Durkheim, Emile, *The Elementary Forms of the Religious Life: A Study in Religious Sociology* trans. by Joseph Ward Swaim (London: George Allen S. Unwin, 1915): 38.

3. Quoted in Graham, Renee, "Morality's defenders or freedom's enemies?" *The Boston Globe*, August 6, 1990: 13, 15.

4. Skold, Walter, "Besieged by Demands for More Money, Taxpayers See Funds Descending Into Cesspool of 'Art' Filth," *New York City Tribune*, February 5, 1990: 1; and Grenier, Richard, "Pulling cat litter over our eyes," *The Washington Times*, May 23, 1990: F3.

5. Haberman, Clyde, "Cleansed of Centuries of Grime, Sistine Ceiling Shines Anew," *New York Times*, March 29, 1990: C17, 18; and "A Chapel in Florence Reveals Its Wonders Anew," *New York Times*, June 9, 1990: 11.

6. Steinberg, Leo, *The Sexuality of Christ in Renaissance Art and in Modern Oblivion* (New York: Pantheon, 1983). Jane Addams Allen analyses a number of examples of art works (primarily pre-twentieth century) that combine sacred and profane elements and which have prompted adverse responses in "Obscene Art Through the Ages," *New Art Examiner*, Summer, 1990: 18–22.

7. Rohter, Larry, "Marilyn and Virgin: Art or Sacrilege?" *New York Times*, April 2, 1988: 4. The same article reported that this artist produced another work showing a pair of boots trampling the Mexican flag, and one where he inserted a well-known singer into Christ's place at the Last Supper. This particular artistic sensibility is shared by some of his American counterparts.

8. "Artists Defend First Film Banned for Blasphemy in Britain," *New York Times*, December 9, 1989: 17.

9. "Sentenced for poem painting Christ as gay," *Chicago Sun-Times*, July 13, 1977: 48.

10. In all fairness, it must be noted that the Roman Catholic and Anglican Churches *did not* support the ban on this film: "Artists Defend First Film," 15.

11. Solomon, Alisa, "A Few Bad Men," *Village Voice*, July 24, 1990: 102.

12. "No 'Spunk,' Please. They're British," *New York Times*, November 30, 1990: C2.

13. Wockner, Rex, "British censorship far exceeds American," *Outlines*, May, 1990; Kaye, Jeff, "The Fuehrer in Britain," *Los Angeles Times* October 23, 1990: F1, 8.

14. "Clash Over Madonna," *New York Times*, July 14, 1990: 8; and Tomasson, Robert E., "Chronicle," *New York Times*, July 11, 1990: B7.

15. See Philips, Chuck, "Anger Over Madonna Single," *Los Angeles Times*, January 4, 1991: F1, 17. Madonna's quick response to the rabbi that the song was pro-tolerance and anti-hate assuaged his concern: "Madonna Placates Rabbi Over a Recording," *New York Times*, January 6, 1990: 15.

16. Ellison, Ralph in "Words for Salman Rushdie," *The New York Times Book Review*, March 12, 1989: 28.

17. "The Stranger," pp. 143–149 in *Georg Simmel: On Individuality and Social Forms* ed. by Donald N. Levine (Chicago: University of Chicago Press, 1971): 148.

18. See, for example, Stonequist, Everett, *The Marginal Man* (New York: Scribner's, 1937).

19. Weatherby, W.J., *Salman Rushdie: Sentenced to Death* (New York: Carroll & Graf): 50–51. Most of the biographical information on Rushdie is also drawn from this book.

20. *Ibid.*: 61, 79.

21. Gurewich, David, "Piccadilly's Scheherazade," *The New Criterion*, March, 1989: 70.

22. Weatherby, *op. cit.*: 95.

23. See Carmilly-Weinberger, Moshe, *Fear of Art: Censorship and Freedom of Expression in Art* (New York: R.R. Bowker Company, 1986): 32–38.

24. Clapp, Jane, *Art Censorship: A Chronology of Proscribed and Prescribed Art* (Metcuhen, NJ: Scarecrow, 1972): 334–335, 308.

25. "Islam zealots threaten Dante's tomb over Mohammed slur," *New York Post*, March 6, 1989: 2.

26. "Moslems protest symbol on slippers," *Chicago Tribune*, June 25, 1989: Section 1: 5. On the third anniversary of the the fatwa, Rushdie's friend Paul Theroux reported that toys and mugs bearing the Muppets' "Miss Piggy" are destroyed by Islamic religious police. He reflected "You know you have traveled through the looking glass when you are in a land where Miss Piggy is seen as the very embodiment of evil" ("What About Rushdie?" *New York Times*, February 13, 1992: A27).

27. "Islam's Satanic Comics," *Newsweek*, February 5, 1990: 36.

28. Weatherby, *op. cit.*: 127–128.

29. Sciolino, Elaine, "Khomeini Purifies, and Confuses, Iran's Future," *New York Times*, April 2, 1989: E2.

30. Cowell, Alan, "Omens of Intolerance Among Cairo's Muslims," *New York Times*, April 12, 1990: A15.

31. Weatherby, *op. cit.*: 131; and Haberman, Clyde, "Turkey Feels The Pull of The Islamic," *New York Times*, March 26, 1989: E2.

32. In 1991 both the Japanese and Italian translators of Rushdie's novels were the victims of stabbing attacks; the Japanese man died.

33. "Bid to Prosecute Rushdie is Rejected," *New York Times*, April 10, 1990: C16.

34. See Green, S.J.D., "Beyond The Satanic Verses: Conservative Religion & the Liberal Society," *Encounter*, June, 1990: 12–20.

35. " 'Rushdie' a Pakistani Film Star," *New York Newsday*, June 27, 1990: Part II: 10.

36. "Britain Lifts Ban on Anti-Rushdie Film," *Los Angeles Times*, August 18, 1990: F2; and Cassidy, Suzanne, "With Rushdie's Approval, Britain Lifts Its Ban on Anti-Rushdie Film," *New York Times*, August 18, 1990: 13.

37. Whitney, Craig R., "A British Play Lampoons in Behalf of Rushdie," *New York Times*, April 20, 1989: C21; and " 'Iranian Nights': But Will It Play in Tehran?" *Newsweek*, May 1, 1989: 43.

38. Carter, Jimmy, "Rushdie's Book Is an Insult," *New York Times*, March 5, 1989: E23.

39. Weatherby, *op. cit.*: 180.

40. Barr, Robert, "Defending a writer but not his 'Verses,' " *New York Daily News*, March 6, 1989: 7; and Whitney, Craig R., "Britain, in Talk Aimed at Iran, Calls Rushdie Book Offensive," *New York Times*, March 3, 1989: A1, 6.

41. Blaise, Clark, and Bharati Mukherjee, "Publish *and* Perish," *Mother Jones*, April/May, 1990: 62.

42. Baker, John F., "A Rushdie Paperback?" *Publishers Weekly*, October 13, 1989: 6.

43. McDowell, Edwin, "2 Books By Rushdie Are Sold," *New York Times*, July 13, 1990: C28.

44. Blaise, Clark and Bharati Mukherjee, "After the Fatwa," *Mother Jones*, April/May, 1990: 65. Rushdie is one of many Indian-born authors who write in English and attract a wide audience, such as Anita Desai and Shashi Tharoor. An interesting contrast to Rushdie is Rohinton Mistry, Bombay-born but living in Canada. Mistry is Zoroastrian, a religion without a central religious text and therefore with considerably less potential for zealous defense of the literalness of its doctrines. Mistry's documentary realism style has not brought him difficulties with his coreligionists (see Marchand, Philip, "Bombay viewed from Brampton," *Toronto Star*, May 21, 1991: D3).

45. Rushdie, Salman, "A Pen Against the Sword: In Good Faith," *Newsweek*, February 12, 1990: 52–53.

46. See Roth, Philip, *The Ghost Writer* (New York: Farrar, Straus and Giroux, 1979): especially 100–105.

47. Rushdie, *op. cit.*: 54.

48. Quoted in Weatherby, *op. cit.*: 185.

49. Rushdie, Salman, "Now I Can Say, I Am a Muslim," *New York Times*, December 28, 1990: A35.

50. "Rushdie Disavows Parts of His Novel 'Satanic Verses,' " *Los Angeles Times*, December 25, 1990: A1, 34.

51. Rushdie reversed positions once again in December, 1991 when he spoke before a surprised crowd at Columbia University. There he reaffirmed his commitment to free expression, advocated publication of a paperback version of his novel, and expressed hope that the recent release of Western hostages from Lebanon might permit Western governments to pressure Iran more aggressively for a lifting of the death sentence against him. A coalition of publishers and writers groups pledged to cosponsor the paperback, but progress towards that goal was stalled, until an anonymous group calling itself the Consortium announced plans in March, 1992 to produce the new edition.

52. Stayskal, in *Los Angeles Times*, December 28, 1990: B7.

53. This was a misconception, as will be explained later in this chapter.

54. See Sack, Kevin, "School Mural: Sociology or Religion?" *New York Times*, May 1, 1990: B1, 4; and Verhovek, Sam Howe, "U.S. Judge Orders School to Remove Mural Depicting Crucifixion," *New York Times*, August 30, 1990: B1, 6.

55. Maslin, Janet, " 'Last Temptation,' Scorcese's View Of Jesus' Sacrifice," *New York Times*, August 12, 1988: C1. In 1977 an NBC TV movie also angered conservative religious groups: "Jesus of Nazareth" likewise presented Jesus as a fallible human.

56. Wildmon, Donald E., with Randall Nulton, *Don Wildmon: The Man the Networks Love to Hate* (Wilmore, KY: Bristol Books, 1989): 188, 192, 200; Harmetz, Aljean, "7,500 Picket Universal Over Movie About Jesus," *New York Times*, August 12, 1988: C4. As anyone who has ever been involved in a political protest knows, there are inevitably discrepancies between the estimates of organizers, their opponents, and those of various media reports.

57. Casuso, Jorge, and Charles Mount, "Protesters, fans flock to 'Last Temptation,' " *Chicago Tribune*, August 13, 1988: Sec. 1: 1.

58. *Ibid.*: 2; and Cronin, Barry and Tom Gibbons, "600 Picket as Christ film opens," *Chicago Sun-Times*, August 13, 1988: 4, emphasis added.

59. Wildmon and Nulton, *op. cit.*: 191, 193; "O'Connor Criticizes Movie," *New York Times*, August 14, 1988: 36.

60. Wildmon and Nulton, *op. cit.*: 194, 199.

61. Greeley, Andrew, "Blasphemy or Artistry?" *New York Times*, August 14, 1988: H1, 22.

62. In fact, screenwriter Paul Schrader was raised in the conservative but questioning tradition of the Christian Reformed Church. He did not see a movie until high school, due to a church ban. See James, Caryn, "Paul Schrader Talks Of 'Last Temptation' And His New Film," *New York Times*, September 1, 1988: C19, 21.

63. "Judge Overturns Ban on Film," *New York Times*, September 11, 1988: 34.

64. "The Fire This Time," *Village Voice*, November 20, 1990: 9.

65. As just two examples of such studies, see the classic Schumach, Murray, *The Face on the Cutting Room Floor* (New York: William Morrow, 1964); and Leff, Leonard J., and Jerold L. Simmons, *The Dame in the Kimono* (New York: Grove Weidenfeld, 1989).

66. Strong, James, " 'Hail Mary' leaves council offended, box office booming," *Chicago Tribune*, April 17, 1986; and Smith, Wes, "Ecumenical crowd of protesters pans 'Hail Mary,' " *Chicago Tribune*, April 5, 1986: Sec. 1: 5.

67. Wilmington, Michael, " 'Hail Mary' A Godard Pirouette," *Los Angeles Times*, November 20, 1985: F1, 4.

68. A pertinent example is the Dead Sea Scrolls. First discovered in 1947, a small group of scholars tightly regulated access to them. They include biblical texts, commentaries and laws, and could possibly disclose new information about the origins of Christianity and Judaism. This is both an exciting and threatening prospect. They were finally released to a larger community of researchers in 1991.

69. Ginnetti, Toni, "Ho-ho horror gets ax at some theaters," *Chicago Sun-Times*, November 18, 1984.

70. Cohen, Roger, "Cardinal and Doubleday Are at Odds Over a Book," *New York Times*, December 5, 1990: C19, 25.

71. Quoted in Goldstein, Richard, "Defunding 'the Devil's Work,' " *Village Voice*, June 14, 1983: 37.

72. See Fanelli, Sean A., "Drawing Lines at Nassau Community College," *Academe*, July–August, 1990: 24–27, and Udow, Roz, "Tax Dollars and the Responsibilities of Trusteeship," *Academe*, July–August, 1990: 28–29.

73. See "Costa Mesa to Look at 'Sister Mary Ignatius' for Arts-Grant Violations," *Los Angeles Times*, September 13, 1990: F9; and "Sister Mary Ignatius Isn't Happy," *Los Angeles Times* (editorial), September 13, 1990: B6. The measure was modelled upon the NEA's "obscenity pledge."

74. Letofsky, Irv, "A Question of Faith," *Los Angeles Times*, October 13, 1990: F1, 8. This article also cited a study that uncovered 100 cases of child sexual molestation for which the Catholic Church paid out between $100 and $300 million in damages in the last six years of the 1980s.

75. Sullivan, Ronald, "Church Loses Bid to Bar Play It Contends Is Blasphemous," *New York Times*, October 12, 1990: B2. The archdiocese also claimed the group owed it $25,000 in back rent, a claim the lessee disputed.

76. Sullivan, Ronald, "Inspectors Try to Close Play Opposed by Church," *New York Times*, October 16, 1990: B3. An interesting letter to the editor by a representative of a theater company that rented a building owned by the Church of the Nazarine also told of restrictive language in its lease. Because they conformed to these terms, however, they claimed they had been rejected for funding by foundations and the NEA for embracing *wholesome* American values too strongly: *New York Times*, September 30, 1990: H5.

77. See Kimmelman, Michael, "Venice Biennale Opens With Surprises," *New York Times*, May 28, 1990: C11, 17; and Wallach, Amei, "Controversial Work Displayed," *New York Newsday*, May 25, 1990: Part II: 14.

78. Quoted in *Journal of the American Family Association*, February, 1991: 8.

79. Reverend Donald Wildmon to former Congressman Les Smith, Jr. of Alabama, April 5, 1989.

80. Memo from museum director, March 25 1989. This incident occurred nearly two months after the exhibition with Serrano's work in it closed.

81. Letter from Jesse Helms to constituents, July 17, 1989.

82. Letter to Andrea [sic] Serrano, c/o Stux Gallery, May 1, 1989.

83. This and all additional unattributed quotes are derived from an interview conducted October 21, 1989.

84. An interesting precedent to Serrano's work was Paulette Nenner's 1981 "Crucified Coyote: He Died Because of Our Sins." Nenner nailed the body of a coyote to an eleven-foot cross for the exhibit "Animals

in the Arsenal" at New York's Central Park Zoo. As in the case in Serrano's photo "The Scream," it was a road-kill. The Parks Commissioner ordered its removal because it might disturb viewers, especially children or those who unintentionally encountered the piece. A judge upheld this decision, citing the right to protect "captive audiences." Nenner explained that her work addressed how the Judeo-Christian heritage treated animals as opposed to other religious traditions, including paganism.

85. In a humorous vein, a murderer in a satirical play in New York in 1990 asked, "What does a real artist do when he sees blood? He uses it." James, Caryn, "In a Satire, Many Are Killed but Few Stay Dead" (review of "The Golden Boat"), *New York Times*, September 29, 1990: 16.

86. Carr, C., "Going to Extremes," *Village Voice*, November 20, 1990: 108.

87. Quoted in James, Caryn, "Fascination With Faith Fuels Work By Scorcese," *New York Times*, August 8, 1988: C11.

88. SECCA continued to receive NEA funds, but in 1991 it was forced to temporarily suspend the Awards in the Visual Arts program because of a decline in corporate support.

89. See Brenson, Michael, "Andres Serrano: Provocation and Spirituality," *New York Times*, December 8, 1989: C1, 28.

90. Tully, Judd, "Fired Up Over Bible Burning," *Washington Post*, August 15, 1990: C1, 11.

91. Robinson, Walter, "Artpark Squelches Bible Burning," *Art in America*, October, 1990: 45.

Rally 'Round the Flag

1. Landers, Ann, " 'That 1st Amendment thing?' Just a minute!" *Chicago Tribune*, July 4, 1990: Sec. 5: 3.

2. This quote is from an interview conducted March 29, 1990. All subsequent unattributed quotes derive from that interview.

3. The impetus to mount a compensatory exhibit was also evident at the Parsons School of Design in 1991, after the display of the Shin Matsunaga caricature. In response, "Visual Perceptions: Twenty-Two African-American Designers Challenge Modern Stereotypes" was assembled.

4. This refers, of course, to the release of poison gas by Union Carbide in India which killed thousands of people, and the massive oil spill in Alaska. This and all subsequent unattributed quotes by Jones are from an interview conducted March 28, 1990.

5. See Fremon, David K., "No Melons," *NewCity*, April 18, 1991: 6.

6. Hoffman was tried in 1968 for wearing a shirt that resembled the American flag in his appearance before the Committee on Un-American Activities of the House of Representatives.

7. See Green, Martin, *New York 1913: The Armory Show and the Paterson Strike Pageant* (New York: Charles Scribner's Sons, 1988): 183.

8. See Crimp, Douglas, and Adam Rolston, *AIDS demo graphics* (Seattle: Bay Press, 1990): 108.

9. "The New Condom: Larger Than Life," *Newsweek*, October 30, 1989: 10. While *Newsweek* reported this as an authentic business venture, *Village Voice* columnist Robert Atkins identified it as a conceptual art project by Jay Critchley; "Scene & Heard: There They Go Again," November 26, 1991: 108.

10. Advertisement, *New York*, May 1, 1989: 146.

11. Quoted in Adams, Laurie, *Art on Trial: From Whistler to Rothko* (New York: Walker and Company, 1976): 149.

12. See, also, Tully, Judd, "Star-Spangled Banter," *Art & Auction*, June, 1989: 28ff.; and Baldwin, Carl R., "Art & the Law: The Flag in Court Again," *Art in America*, May/June, 1974: 50–54.

13. See Hill, Kathleen, "Art uproar stirred by 'Flag in Chains,' " *Herald-Review* [Decatur, Il], April 2, 1989.

14. See the account in Hendricks, Jon and Jean Toche, *G A A G: The Guerrilla Art Action Group* (New York, Printed Matter, Inc., 1978); section 12.

15. I have emphasized only the negative; there were statements of support in the books as well. It is interesting to note that in Radich's case he also received many threats, including one that threatened to "burn 'Jew

Bastard' Radich in the ovens." Radich is not Jewish, but recall the similar misconception regarding David Nelson; Adams, *op. cit.*: 158.

16. Wockner, Rex, "WGN talk host calls flag artist 'fag,' " *Outlines*, April, 1989: 16.

17. This information comes from the interview with Tyler conducted in March, 1990. See, also, the vignette on the artist by Cohen, Charles E. *et al.*, "Will We Beat Swords Into Plowshares?" *People* January 8, 1990: 32. Despite Dread Scott's identification with the working class, a columnist from an archetypal working class Chicago neighborhood rejected him (and David Nelson) as "arteests." "You have to wonder," he wrote, "how much they have learned about the real world which goes on outside their incubated existence of pastels, water colors and charcoal"; see O'Connor, John, "Smug cheapshots are out of line," *Back of the Yards Journal*, March 8, 1989.

18. Royko, Mike, "Ah, the flag: Such a useful symbol," *Chicago Tribune*, March 15, 1989: Sec. 1: 3.

19. Quoted in "Using the flag," *Southtown Economist* [editorial], March 12, 1989.

20. Williams, Lillian, "Sen. Dudycz pushes Constitutional change," *Chicago Sun-Times*, June 26, 1989: 5.

21. Hinz, Greg, "Which of the weenies deserves an Oscar?" *Portage Park Times*, March 23, 1989; and McNicholas, Mick, "For a good egg, Wally, you've got it scrambled," *Schiller Park Times*, March 15, 1989.

22. See Royko, *op. cit.*

23. "Flag Exhibit Upheld In Chicago by Judge," *New York Times*, March 3, 1989: A16.

24. Quoted in Finley, Larry, "2,000 unfurl flag protest," *Chicago Sun-Times*, March 13, 1989: 1.

25. Kimble, Virginia, "Wilmington citizens join in art protest," *Free Press* [Wilmington, IL], March 15, 1989: 1.

26. *Ibid.*: 2. For another forthright personal account, see Arnoldt, Robert P., and Robert A. Jones, "March 5, 1989 Veterans' Demonstration At The Art Institute of Chicago," *Veterans' Voice*, Vol. 2 (9), March, 1989: 1, 3. The best source for the range of student responses is *F: The Student Newsmagazine of the School of the Art Institute*, Vol. 8 (2), March, 1989.

27. Rose, Sonya, "Residents mixed on Art Institute flag controversy," *Chicago Defender*, March 15, 1989: 5.

28. See Bray, Hiawatha, "Scott's dreadful work of art has strengthened one viewer's patriotism," *Journal* [Wheaton, IL], March 12, 1989; Clay, Nate, "The dreaded art of 'Dread Scott,' " *Metro News* [Chicago], March 11, 1989; and The Axeman (pseudonym), "What does the U.S. flag symbolize?" *Metro News*, March 18, 1989.

29. Dixon, Willie, "Don't Tread on Me!" *Metro News*, March 25, 1989. Tyler claims he saw eleven blacks at the largest demonstration: six were Navy men visiting the city, four were cops, and only one could have been an actual local demonstrator.

30. See picture in *Herald* [Morris, IL], March 13, 1989; Saunders, Barry, "Flag flap draws display at home in Crown Point," *Gary Post-Tribune*, March 11, 1989; Kopp, Kris, "Songwriters show their respect for the flag," *Daily Herald* [Rolling Meadows, IL], March 18, 1989; "Reed-Custer bans trips over flag art," *Herald-News* [Joliet, IL], March 17, 1989; Jimenez, Gilbert, "64 pairs of Polish eyes are smiling, too," *Chicago Sun-Times*, March 18, 1989; and Pattison, Lynn, "Flag display a message you can't miss," *Review* [Evanston, IL], April 13, 1989.

31. See the article by Pat Cunningham, *Register-Star*, March 15, 1989.

32. See the coverage in publications as diverse as Maiman, Joan M., "The Proper Way To Display An Artist," *Stars & Stripes*, April 3, 1989; 3; and "Tread on Dread," *In These Times*, April 5–11, 1989: 4.

33. See "American flag stolen from school's art exhibit," *Daily Breeze* [Torrance, CA], March 8, 1989.

34. Letter to the editor, *Chicago Tribune*, March 2, 1989: Sec. 1: 22.

35. Letter to the editor, *Times Daily* [Florence, AL], March 15, 1989. The reference is to George M. Cohan, the songwriter of "You're a Grand Old Flag."

36. "Marxists Pushing Revival," *The Daily Oklahoman* [editorial], March 20, 1989.

37. The law states that "any person who publicly mutilates, defaces, defiles or defies, tramples or casts contempt upon, whether by words or acts, an (American) flag, standard, color or ensign shall be guilty of a Class 4

felony." Cited in "Hotline," *Journal-Star* [Peoria, IL], March 20, 1989. According to an attorney at Jenner & Block, these charges were eventually dropped. Local prosecutors decided they didn't have a case after the Supreme Court issued the Johnson decision (see the discussion later in this chapter).

38. Quoted in Schmid, John, "Council's wrath unfurled in flag debate," *Sunday Star* [Chicago], March 12, 1989.

39. Recktenwald, William, and James Strong, "Flag art turning into a federal case," *Chicago Tribune*, March 9, 1989: Sec. 2: 6.

40. From an interview with Diane Grams, August 27, 1991.

41. Schmidt, William E., "Judge Overturns Chicago Statute on Flag," *New York Times*, November 1, 1989: B7.

42. From an interview conducted March 30, 1990.

43. Quoted in Buse, George S., "Legislature Slices Art Institute Funds," *Windy City Times*, July 27, 1989: 2.

44. A number of prominent artists filed an *amicus curiae* brief in support of Johnson, including Jasper Johns, Claes Oldenburg, Faith Ringgold, and Leon Golub. They argued that flag descecration laws lead to self-censorship and eliminate artists' "tools of the trade." And in one of the stranger artistic collaborations of the time, Johnson and rapper Chuck D teamed up with 2 Black, 2 Strong and MMG (Militant Manhattan Gangsters) to record "Burn Baby Burn."

45. Greenhouse, Linda, "Justices, 5–4, Back Protesters' Right To Burn The Flag," *New York Times*, June 22, 1989: A1.

46. Buchanan, Patrick, "Congress can write law to protect the flag," *San Antonio Express-News*, June 24, 1989. While Bush and Buchanan held similar positions on this issue, they found few areas of agreement as they faced off as opponents during the 1992 Presidential primary campaign.

47. Reported in *Newsweek*, July 3, 1989: 18.

48. Brinkley, Alan, "Old Glory: The Saga of A National Love Affair," *New York Times*, July 1, 1990: E2. Jingoism was definitely in the air at this time: in February, 1989, a West Virginia Representative introduced the American Flag Fidelity Act into Congress, which would have prohibited the importation of U.S. flags from foreign manufacturers. "Foreign workers simply do not have enough respect for our national symbol," he argued. See "Protecting the flag," *The Economist*, March 11, 1989: 34.

49. Cited in Brinkley, *op. cit.* This is the law which the schoolteacher who stepped on the flag at SAIC was charged with violating; states duplicated the federal statute in their own versions.

50. Quoted in "Overheard," *Newsweek*, October 16, 1989: 23.

51. See the dual brief for *United States of America v. Shawn D. Eichman, et al.*, and *United States of America v. Mark John Haggerty, et al.*, Nos. 89–1433 and 89–1434, Supreme Court of the United States, October term, 1989: 19.

52. Trippett, Frank, "A Few Symbol-Minded Questions," *Time*, August 28, 1989: 72. The next year a philatelist discovered a printing error in 25-cent flag stamps where an ink smudge made the flag look as if it were burning. This made it a collectible. The same collector commented, "If we get an anti-flag-desecration law, are we to be concerned about any cruel and unusual cancellations?" See Healey, Barth, "Gravure press printing freaks and other errors and oddities attract interest," *New York Times*, November 4, 1990: 73.

53. "Doonesbury," November 5, 1989.

54. Letter from Joyce Fernandes, Director of Exhibitions and Events, April 20, 1989.

55. Letter from Marshall Field, June, 1989.

56. There was sweeping censorship of press reports during this military campaign. On the war front, one of the more curious examples of suppression of images occurred when American military families stationed in Germany decided to sponsor a "magazine airlift" to soldiers before actual combat began. They shipped thousands of American publications, altered so as not to offend Islamic sensibilities: lingerie models were clothed in dresses that had been methodically penned in, for example; see Fisher, Marc, "Desert Shield's Prudent Pens," *Washington Post*, November 22, 1990.

57. Sipchen, Bob, "Stars, Stripes, Hype," *Los Angeles Times*, September 20, 1990: E1, 20.

58. See my "Visual Onomatopoeia," *Symbolic Interaction*, 14 (1), 1990: 185–216 for a discussion (and photos)

of earlier displays. According to the *Today Show* (June 14, 1991), monumental flags were also assembled in Virginia and Florida, and the output of the flag industry nearly doubled during the conflict.

59. Kandel, Susan, " 'Storms': Another Kind of Flag Waving," *Los Angeles Times*, November 1, 1991: F18.

60. Personal communication, Dread Scott, June 10, 1991.

The Body As Spectacle

1. Lewis, Bill, "World's Best Avant Garde Cellist Comes Home," *Arkansas Gazette*, July 25, 1975.

2. Decision in *People v. Charlotte Moorman*, *New York Law Journal*, May 11, 1967: Part 1E; all subsequent direct quotes are taken from that document.

3. Roth, Jack, "Topless Cellist Is Convicted Here," *New York Times*, May 10, 1967. In spite of the fact that the judge convicted Moorman, there is a great deal of evidence that portrayals of female nudity are more acceptable (and certainly more frequent) than depictions of naked men. The latter are more likely to be judged obscene, as suggested by the album cover for "Tin Machine II" (from David Bowie's latest band) in 1991. The design featured four kouri, Greek statues from the sixth century BC. But retailers and even Gannett Outdoor (the billboard company) refused to display it, and the cover was changed.

4. Lipton, Eunice, *Looking Into Degas: Uneasy Images of Women & Modern Life* (Berkeley: University of California, 1986): 188.

5. Chicago published several books to accompany her work. See, for example, *Through the Flower: My Struggle As a Woman Artist* (New York: Anchor/Doubleday, 1977), and *The Dinner Party: A Symbol of Our Heritage* (New York: Anchor/Doubleday, 1979).

6. Rickey, Carrie, "Judy Chicago, 'The Dinner Party,' The Brooklyn Museum," *Artforum*, January, 1981: 72.

7. Hughes, Robert, "An Obsessive Feminist Pantheon," *Time*, December 15, 1980: 85–6.

8. Kramer, Hilton, "Art: Judy Chicago's 'Dinner Party' Comes to Brooklyn Museum," *New York Times*, October 17, 1980: C1, 18.

9. Chicago, Judy, with Susan Hill, *Embroidering Our Heritage: The Dinner Party Needlework* (Garden City, New York: Anchor Books, 1980): 21.

10. Pedersen, Robert, "The Bitter Taste of 'The Dinner Party,' " *Los Angeles Times*, November 5, 1990: F3.

11. Barras, Jonetta Rose, "UDC's $1.6 million 'Dinner': Feminist artwork causes some indigestion," *The Washington Times*, July 18, 1990: A1, 7. This article and two others by the same author were entered into *The Congressional Record* as "evidence." The NEA contribution was $36,000 out of a budget of over $250,000, a figure that does *not* include the value of hundreds of hours of volunteer labor.

12. It followed on the heels of many other controversies, including some to be detailed later in this chapter, and also the Mapplethorpe debate, to be chronicled in the next chapter.

13. See *Congressional Record*, 101st Session, Volume 136 (No. 98), July 26, 1990: H5668–5679; each man repeated these characterizations several times. The 1990 debate was a replay of the sexual division of critical response so evident when the work was first displayed. A reporter who wrote in favor of an alternative plan to renovate the proposed museum space into a home for UDC's fledgling architecture program described "the muscular arrangement of Ionic columns, arches, pediments, putti and so on that distinguish its main facade." Such a "virile" space, he reasoned, would be inappropriate for a feminist monument; see Forgey, Benjamin, "Study in Campus Creativity: UDC Architecture Professor's Vision for the Carnegie Library," *Washington Post*, August 4, 1990: G1, 8.

14. *Congressional Record*, *op. cit.*: 5670, emphasis added. See, also, O'Neill, Cliff, "House cuts D.C. funding over Judy Chicago display," *Outweek*, August 15, 1990: 22–3.

15. *Congressional Record*, *op. cit.*: 5678.

16. See Harriston, Keith, and Gabriel Escobar, "UDC Students Take Over Two Buildings," *Washington Post*, September 27, 1990: A1, 27; and De Witt, Karen, "Washington Students Gain in Protest," *New York Times*, September 29, 1990: 10.

17. De Witt, Karen, "Donation of Artwork to School Is Withdrawn," *New York Times*, October 3, 1990: A22.

18. Goldstein, Richard, "Doowutchyalike: In the Brave New World, Sex Sells," *Village Voice*, November 6, 1990: 49.

19. Goldstein, Richard, "Medium Cruel," *Village Voice*, October 26, 1982: 47. This type of comment was chillingly repeated in one of the most repellent sound bites of 1990. Clayton Williams, Republican candidate for Texas governor, crudely compared inclement weather to rape. "If it's inevitable," he wisecracked, "relax and enjoy it."

20. See Du Brow, Rick, "A Pregnant Episode in TV History," *Los Angeles Times*, June 1, 1991: F9. The main character in "The Days and Nights of Molly Dodd" had a baby as a single mother during the same season, but that series appeared on cable.

21. Lewin, Tamar, *New York Times*, March 8, 1987: H29, 40.

22. Dorfman, Ariel, *The Empire's Old Clothes* (New York: Pantheon, 1983): 192.

23. See Wildmon, Donald E., *The Home Invaders* (Wheaton, IL: Victor Books, 1985): 19–22.

24. Carter, Bill, "Screeners Help Advertisers Avoid Prime-Time Trouble," *New York Times*, January 29, 1990: D1, 12.

25. Quoted in Farber, Stephen, "They Watch What We Watch," *New York Times Magazine*, May 7, 1989: 58. In 1972 there was an extended battle over a two-part episode of the popular television show *Maude*, where the lead character decided to have an abortion. This occurred just before the Supreme Court ruled in *Roe v. Wade*, so that abortion was illegal in many parts of the country. The acrimony between the two sides—with the network caught in the middle—undoubtedly entered into the collective memory of television industry executives whenever they considered addressing the topic again.

26. Carter, Bill, "Crafting 'Roe v. Wade': Tiptoeing on a Tightrope," *New York Times*, May 14, 1989: H33, 48.

27. See Farber, *op. cit.*: 58, 62.

28. McDougal, Dennis, "Battle Lines Form Over 'Strangers,'" *Los Angeles Times*, March 13, 1991: F1, 7. And because Maxwell House Coffee chose to be one of these advertisers, the Pro-Life Action League announced a year-long boycott against all General Foods products; see Savan, Leslie, "Where the Boycotts Are," *Village Voice*, June 6, 1989: 47.

29. Wildmon *claimed* that CBS incurred two million dollars in advertising losses due to his campaigning against this telecast; see "AFA beginning to get networks' attention," *AFA Journal*, July, 1991: 22.

30. Technological advances typically bear new possibilities for exploring sexual frontiers, from nickelodeons to computer billboards, dial-a-porn and cable TV. Negative reactions to these fresh forms are routine, especially because they can provide a forum for sexually marginalized groups such as gays, and because they are potentially widely accessible.

31. See Bernstein, Sharon, "A No-Progress Report on Women in TV," *Los Angeles Times*, November 15, 1990: F1, 6.

32. See Hentoff, Nat, "Has This Painting Committed a Crime?" *Village Voice*, February 28, 1984: 6, and "If It's Not a Human Being, What's The Crime?" *Village Voice*, March 6, 1984: 6.

33. See Knight, Robert H., *The National Endowment For The Arts: Misusing Taxpayers' Money* (Backgrounder Report 803, January 18, 1991): 26. A *tiny* amount of public funds was involved: a 250 dollar subgrant out of a 70,000 dollar organizational grant went to the sponsorship of a show where this piece appeared. The artist is the same Shawn Eichman who was a codefendant with Dread Scott in a flag-burning incident at the US Capitol (see Chapter Five).

34. Putnam, George P., ed., *Nonesenseorship* (New York: G.P. Putnam's Sons, 1922). The association between art, birth control and abortion was made by Anthony Comstock, beginning in the 1870s. He saw all these as arenas of social decline and disorder, and led the fight for regulation. For details see Beisel, Nicole, "Class, Culture, and Campaigns Against Vice in Three American Cities, 1872–1892," *American Sociological Review*, February 1990, Vol. 55: 44–62; for parallels with our era, see Shapiro, Bruce, "From Comstockery To Helmsmanship," *The Nation*, October 1, 1990: 335–338.

35. See Lewin, Tamar, "Ending Aid to Family Planning, Large Retailer Is Caught in Storm," *New York Times*, September 15, 1990: 8; and De Witt, Karen, "Company Resumes Planned Parenthood Gift," *New York Times*, September 21, 1990: A12.

36. See Parachini, Allan, "NEA Modifies Obscenity Guidelines," February 13, 1991: F1, 3.

37. For a sample of the Guerrilla Girls' work, see the reproductions in *New Observations*, September, 1989, Issue No. 70.

38. Beach, Randall, "Sculptor baffled at uproar," *New Haven Register*, November 19, 1983: 34.

39. "Public funds, questionable 'art,' " *New York Post*, January 3, 1989: 18.

40. See Tully, Judd, "Photos provoke political protest: En Foco founders feel the heat," *New Art Examiner*, June, 1989: 32–33. Earlier (in 1981 and 1982) *Show Me*, a graphic sex education book, was the target of protests in several Illinois communities. A proposed state statute which would have punished librarians who allowed patrons under eighteen to see it was defeated, only after a pitched battle.

41. Kaltenheuser, Skip, "Artist harassment: a family affair," *New Art Examiner*, December, 1988: 42.

42. *Ibid.*: 43. See, also, Hess, Elizabeth, "Snapshots, Art, Or Porn?" *Village Voice*, October 25, 1988: 31–32.

43. Quoted in Bishop, Katherine, "Photos of Nude Children Spark Obscenity Debate," *New York Times*, July 23, 1990: A8.

44. Sturges related this story during a panel discussion at the Burden Gallery in New York City, "Representing the Body," January 31, 1991. This and other unattributed facts and quotes are taken from that public appearance.

45. Lufkin, Liz, "Porno Charges Suspended In Photo-Lab Nude Kids Case," *San Francisco Chronicle*, July 14, 1990.

46. At a panel discussion, former art dealer Marcuse Pfeifer detailed a pattern of government harassment and raids directed against collectors of sexually explicit photos. She indicated that many people were very fearful that they, too, would encounter legal difficulties ("Black Listed, Whitewashed, Red Handed," SOHO20 Gallery, New York City, December 10, 1990).

47. Another similar case occurred in November, 1991, when a female photographer in California was investigated after a processing lab alerted police to pictures of a twelve-year-old girl, nude from the waist up. The photos were taken at a professional workshop, and in the end no charges were brought.

48. "Naked Repression," *Popular Photography*, July, 1989: 12. The courts have frequently ruled that the greater good of protecting children is paramount over other privileges, for example, the right to privacy. In April, 1990, the Supreme Court ruled that states can make it a crime to possess pornographic photos of children, making an exception to its 1969 ruling that protects the possession of obscene materials in one's own home.

49. "Excerpts From the Attorney General's Report on Pornography," by Hard Place Theater, New York City, January, 1991. This appropriation of testimony to make a contradictory political point is somewhat similar to what Manbites Dog Theater of Carrboro, North Carolina did when it used statements by Jesse Helms in *The Congressional Record* to form the basis of their "Indecent Materials."

50. Quoted in Mansnerus, Laura and Katherine Roberts, "Publishers Sue Meese's Panel," *New York Times*, May 25, 1986: E7.

51. See Ginsberg, Allen, and Joseph Richey, "The Right to Depict Children in the Nude," pp. 42–45 in Harris, Melissa, ed., *The Body in Question* (New York: Aperture, 1990); and Parachini, Allan, "Child Pornography Law Won't Be Pressed—for Now," *Los Angeles Times*, February 27, 1991: F3.

52. Garbus, Martin, "Thornburgh's Morality Brigade," *New York Times*, April 28, 1990: 25. A good example of the scope and force of these prosecutions is what happened to the American Exxxstasy station, a subscription adult cable station operated by New York-based Home Dish Satellite Corporation. Prosecutors in Montgomery County, Alabama, where there were approximately 50 subscribers (out of 30,000 nationwide), used their local obscenity laws to force the station to cease operations. Officials were ordered to turn over their adult movie library to the government, and were also fined 155,000 dollars, most of which went to two children's homes. See Lewis, Neil A., "Obscenity Law Used in Alabama Breaks New York Company," *New York Times*, May 2, 1990: A1, 23; "TV Concern Fined In Adult Film Case," *New York Times*, October 31, 1990: A22; and Christian, Sue Ellen, "Justice Dept. Pulls the Plug on Satellite Pornography," *Los Angeles Times*, November 30, 1990: A4.

53. See Philips, Chuck, "Artists Fear Racketeering Prosecution," *Los Angeles Times*, November 1, 1990: F1, 6.

In 1990 Waldenbooks and other plantiffs attempted to turn RICO against anti-porn crusader Donald Wildmon, alleging that his boycotts constituted harassment and prevented them from conducting their business; see Cohen, Roger, "With Boycott and Ads, A Battle Over Selling," *New York Times*, April 13, 1990: C18.

54. Ginsberg and Richey, *op. cit.*; Atkins, Robert, "Art Police Strike in S.F.," *Village Voice*, June 12, 1990: 75–76.

55. Reisman, Judith, "Promoting child abuse as art," *The Washington Times*, July 7, 1989: F4.

56. Personal communication, Pauline Bart, September 22, 1990.

57. Scruggs, Kathy, "Arts Festival puppets depict oral sex," *Atlanta Journal and Constitution*, September 23, 1990: D1.

58. Parachini, Allan, "Pat Robertson Steps Up NEA Broadsides," *Los Angeles Times*, October 5, 1990: F1, 18.

59. Atkins, *op. cit.*; Duggan, Lisa, "Lisa Duggan on Sex Panics," *Artforum*, October, 1989, Vol. 28 (2): 26–27.

60. See Cohen, Stanley, *Folk Devils and Moral Panics: The Creation of the Mods and the Rockers* (New York, St. Martin's Press, 1980 [1972]).

61. Webster, Paula, "Pornography And Pleasure," pp. 30–35 in Ellis, Kate, *et al.*, eds., *Caught Looking: Feminism, Pornography & Censorship* (New York: Caught Looking, Inc., 1986): 35. Allan Bloom saw this struggle as the inevitable conflict between the sexual revolution and the feminist push for equality and resentment against stereotyping; see *The Closing of the American Mind* (New York: Simon and Schuster, 1987): 98.

62. Others have explored similar terrain in other media, for instance, "Psycho Killer" by Talking Heads, and "Mind of a Lunatic" by Geto Boys. And some East Indian character actors specialize in portraying rapists, an almost obligatory act in Hindi-language films; see Hazarika, Sanjoy, "India's Top Censor Says Films Must Be Cleaner," *New York Times*, January 3, 1991: C18.

63. Mehren, Elizabeth, "Simon & Schuster Pulls the Plug on Novel," *Los Angeles Times*, November 16, 1990: E4.

64. See, Sheppard, R.Z., "A Revolting Development," *Time*, October 29, 1990: 100; Stiles, Todd, "How Bret Ellis Turned Michael Korda Into Larry Flynt," *Spy*, December, 1990: 43; and Gillette, Josh, " 'Dear *Penthouse*: I Never Thought I'd Be Writing for You . . . ,' " *Spy*, February, 1991: 22.

65. Letter to the Editor, Robert K. Massie, President, The Authors Guild, *New York Times*, December 6, 1990: A38. Ironically, Paramount's movie division produced "The Godfather" and "Friday the 13th," two series known for their violence. The Ellis book stimulated debate about the power of different media, for instance, whether the intimate nature of reading makes books more influential than the potential impact of the flashes of violence which may appear on the movie screen, and the different tolerance levels associated with each medium. See Bernstein, Richard, " 'American Psycho,' Going So Far That Many Say It's Too Far," *New York Times*, December 10, 1990. C13, 18.

66. Cohen, Roger, "Bret Easton Ellis Answers Critics of 'American Psycho,' " *New York Times*, March 6, 1991: C18; and Pristin, Terry, "Gruesome Novel 'American Psycho' Hits Bookstores," *Los Angeles Times*, March 1, 1991: B1, 8.

67. Mailer, Norman, "Children Of The Pied Piper," *Vanity Fair*, March, 1991: 157, 159.

68. Rosenblatt, Roger, "Snuff This Book! Will Bret Easton Ellis Get Away With Murder?" *New York Times Book Review*, December 16, 1990: 3.

69. But by no means were all women against the book. In a *Village Voice* review, Mim Udovitch put it into a broad literary context and also traced connections with Ellis' earlier work. In her final judgment she dismissed many other critics' arguments, yet found little to celebrate: "the book is unbearably bad, more to be pitied than censored," she declared; "Intentional Phalluses," March 19, 1991: 66.

70. Venant, Elizabeth, "An 'American Psycho' Drama," *Los Angeles Times*, December 11, 1990: E1.

71. Vintage is a division of Random House.

72. Quoted in O'Brien, Maureen J., "The Book From Hell," *Village Voice*, December 18, 1990: 14.

73. Letter to the editor, *Kansas City Star*, December 9, 1990: J3; Lawrence, Kathleen R., "Public Spaces or Peep Shows?" *New York Times*, January 8, 1991: A21; and letter to the editor, *Los Angeles Times*, December

26, 1990: B4 [the writer, a man, listed his affiliation as executive director of People Against Pornography]. The *New York Times* piece did not directly mention the Ellis book, but it was written during the height of the brouhaha over it.

74. Mailer, *op. cit.*: 221.

75. Rubin, Merle, "Ellis in Blunderland," *The Advocate*, January 29, 1991: 79.

76. Ellis, Bret Easton, "The Twentysomethings: Adrift in a Pop Landscape," *New York Times*, December 2, 1990: Sec. 2: 1.

77. Cohen, *op. cit.*

78. Anderson, Laurie, "Judith Bernstein (AIR)," *Art News*, December, 1973: 94.

79. Quoted in Weiffenbach, Jeanie, "Interview with Judith Bernstein," *Criss-Cross Art Communications*, January, 1977: 28. Her oeuvre also includes such works as "Supercock" (a superman with a penis twice the size of his body, flying through the air), and the "Union Jack-Off Series" (flags with phalluses in the star field). The aforementioned "Lipstick" spawned controversy when it was erected on the Yale campus in May, 1969, a time already marked by intense political strife. Yale is also the institution where Bernstein received her MFA, in 1967.

80. Quoted in Quinn, Jim, "The Castration of Judith Bernstein," *Philadelphia Magazine*, June, 1974: 57-A.

81. Mike Luckovich, reprinted in *Los Angeles Times*, August 25, 1990: B7.

82. Burnham, Linda, "Running Commentary," *High Performance*, Summer, 1990: 13.

83. It is worth noting, however, that the ICA presented the disputed Robert Mapplethorpe retrospective, and all four of the performance artists known as the "NEA 4."

84. A not-for-profit gallery and performance space in New York City.

85. From an interview with director Martha Wilson, January 9, 1991. All subsequent unattributed information and quotes are from that interview.

86. Other Carnival Knowledge projects included the Jerry Falwell Kissing Booth (Falwell with a Hitler mustache, drawing parallels between some of their repressive tactics), The Last Great Jack-Off (a giant jack-in-the-box, with various puppet/politicians/religious leaders and their quotes), Know Your Right-to-Life Legislators ("Squeeze their balls and see their state"), and the Working Woman's Wheel of Misfortune. See fact sheet/press release, Carnival Knowledge, October, 1983.

87. I take this from a live performance at New York's Public Theater, July, 1990.

88. "NEA supports Annie Sprinkle with tax dollars—again," *American Family Association Journal*, March, 1991: 10; "Onward and upward with the arts" (editorial), *The New Criterion*, March, 1990: 4–5; quoted in Bull, Chris, "A Cruel And Artless World?" *The Advocate*, April 24, 1990: 16.

89. Skold, Walter, "Beseiged by Demands for More Money, Taxpayers See Funds Descending Into Cesspool of 'Art' Filth," *New York City Tribune*, February 5, 1990: 1. The series was prefaced by a warning and apology about the nature of the reports.

90. Finley's work commonly evokes strong and contradictory responses. *Downtown* (July 11, 1990: 16A–17A) presented simultaneous reviews of this show. The "Supportive View" likened it to cave paintings on contemporary topics. The "Critical View" faulted it as one-dimensional and meeting vulgarities with vulgarities. Martha Wilson reports that someone defaced a drawing in the show, and Franklin Furnace personnel later "fixed it up."

91. Letter from Paul Britner to Martha Wilson, July 17, 1990.

92. Carr, C., "The New Outlaw Art," *Village Voice*, July 17, 1990: 61. Note that the New York City Department of Cultural Affairs gave Franklin Furnace 5,000 dollars to offset its financial difficulties, and awarded Artists Space the same amount. In addition, Franklin Furnace netted 20,000 dollars from a benefit extravaganza. See Mitchell, C., "City Backs Art in NEA Dispute," *Downtown Express*, July 19, 1990. Franklin Furnace made news again in February, 1992, when the NEA's National Council on the Arts rejected their 25,000 dollar funding request in the visual arts category. The NEA also denied a 5,000 dollar request by Highways performance space in Santa Monica (whose artistic director is Tim Miller, a member of the "NEA 4" [see below]). Both grants had been recommended by a peer panel, renewing concern over the

NEA's caution in funding sexually explicit art. Chairman Frohnmayer insisted that the rejection was based on artistic grounds, of material that was of questionable quality. Battle lines were predictably drawn, but once again it was difficult to discern the truth in such a heated political climate.

93. Both quotes from "New 'Art' Storm Brewing," *New York Post*, May 11, 1990: 23.

94. "She walks in chocolate," *The Washington Times*, May 17, 1990.

95. This is from a confidential document of May 4, 1990. It is part of the collection of documents released in September, 1991 in the discovery phase of a lawsuit brought on behalf of the NEA 4 by the National Campaign For Freedom Of Expression, the Center for Constitutional Rights, and the American Civil Liberties Union. Subsequent references to NEA records derive from that packet of materials.

96. This is a reference to the work of John Fleck; see below.

97. Both Holly Hughes and Lenora Champagne reported this in interviews. Interestingly, in the transcribed deliberations of the solo performers and mimes category, one panelist mistakingly stated about Finley "This is strong women's stuff, *lesbian stuff.*"

98. According to a *New York Times* editorial, the NEA reversed peer panel recommendations only thirty five times previously, out of 33,700 potential grants; see "Where's Mr. Bush on the Arts?" July 4, 1990: 30. All four of these performance artists had been funded previously by the NEA.

99. The week of August 6–10, 1990.

100. Carr, C., "Unspeakable Practices, Unnatural Acts," *Village Voice*, June 24, 1986: 17.

101. See Finley, Karen, "The Constant State of Desire," *The Drama Review*, Spring, 1988 (T117): 139–151. Both "Cut Off Balls" and "Refrigerator" are segments of a work with the same title as the cited article.

102. Finley has an M.F.A. from the San Francisco Art Institute.

103. Adler, Anthony, "Dangerous Women: Karen Finley," *Chicago Reader*, October 26, 1990: 36.

104. Thomas J. Scheff has termed these "residual rules," unwritten codes which regulate when we are permitted to be mentally "away," and how we interact with others (for instance, notions of personal space and the "proper" physical distance to maintain when talking with someone). If these commonly understood rules are violated, questions may be raised about a person's sanity; see *Being Mentally Ill: A Sociological Theory* (Chicago, Aldine: 1966).

105. Lacayo, Richard, "Talented Toiletmouth," *Time*, June 4, 1990: 48.

106. Quoted in Joseph, Miranda, "Further Finley," *The Drama Review*, Winter, 1990 (T128): 13.

107. One critic offered a particularly intriguing reading of the chocolate: she saw it as a type of blackface, confirming Finley's identification with the downtrodden. See Larson, Kay, "Censor Deprivation," *New York*, August 6, 1990: 49.

108. Carr, *op. cit.*, makes similar observations. See the discussion of the work of Mary Douglas in the Introduction for the importance of social boundaries and individual composure.

109. See Schuler, Catherine, "Spectator Response and Comprehension: The Problem of Karen Finley's *Constant State of Desire*," *The Drama Review*, Spring, 1990 (T125): 131–145.

110. Barnes, Clive, "Finley's Fury," *New York Post*, July 24, 1990: 27.

111. Page, Tim, "Karen Finley's Tantrum, Amid Chocolate," *New York Newsday*, July 24, 1990: Part II: 2.

112. Gamarekian, Barbara, "Frohnmayer Said to See Peril to Theater Grants," *New York Times*, June 29, 1990: C15. Not everyone believed that negative publicity was such a bad thing, however. For example, a hip, downtown New York City newspaper cited Karen Finley as the "Best NEA Sob Story" in a roundup of local superlatives. They claimed that Jesse Helms *et al.* were a boon to her career; *NYPress*, September 12–18, 1990: 8. And there were unusual references even in positive reviews, for instance, a female critic who tried to diffuse any anxiety about Finley's performance described her as "a normal woman with ordinary knockers"; see Larson, *op. cit.*: 48.

113. Quoted in Parachini, Allan, "NEA Panel Asks to Meet After Grant Denials," *Los Angeles Times*, July 2, 1990: F7.

114. Gergen, David, "Who Should Pay For Porn?" *U.S. News & World Report*, July 30, 1990: 80, emphasis added.

115. *Ibid.*

116. See Goldberg, RoseLee, *Performance: Live Art 1909 to the Present* (New York: Abrams, 1979).

117. See Sayre, Henry M., *The Object of Performance: The American Avant-Garde since 1970* (Chicago: University of Chicago, 1989).

118. Danto, Arthur C., "Bad Aesthetic Times," pp. 297–312 in *Encounters & Reflections: Art in the Historical Present* (New York: Farrar Straus Giroux, 1990): 300.

119. Quoted in Sadownick, Doug, "The NEA's Latest Bout of Homophobia: Four Rejected Artists Talk Queer," *The Advocate*, August 14, 1990: 51.

120. Witness novelist Paul Monette's mocking description: "Sorrowfully, inevitably, the woman in the spotlight begins to shuck her black clothes. So raw and authentic"; *Halfway Home* (New York: Crown Publishers, 1991): 44.

121. From an interview conducted January 22, 1991. All subsequent unattributed quotes are taken from that interview.

122. From an interview conducted November 9, 1990. This and all subsequent unattributed quotes are from that interview.

123. Fuchs, Elinor, "Staging the Obscene Body," *The Drama Review*, Spring, 1989 (T121): 33.

124. See addendum of court papers, *Karen Finley, John Fleck, Holly Hughes and Tim Miller v. National Endowment for the Arts, and John E. Frohnmayer*, U.S. District Court, Central District of California, Case 5236.

125. In Sadownick, *op. cit.*: 51.

126. Miller, Tim, "An Artist's Declaration of Independence," *Frontiers*, August 3, 1990: 25.

127. One of the ironies of this situation is that Hughes was awarded an NEA grant in the playwriting category in 1990 for the same material that she was denied a grant for in the solo performance category in the 1991 competition.

128. There are recurrent references in the transcript of the National Council on the Arts Meeting (May 13, 1990 in Winston-Salem, North Carolina) to a fifth potentially controversial solo performance artist. His or her name is always crossed out, however.

129. See *Finley et al.*, U.S. District Court, *op. cit.*: 7, 17.

130. From an interview conducted January 25, 1991. All subsequent unattributed quotes derive from that session.

131. These were the sentiments of Helen Frankenthaler, Joseph Epstein and Phyllis Curtain, respectively.

132. None of these suits had been settled at the time of this writing. See also note 46, p. 361.

133. Quoted in Honan, William H., "Endowment Gives Grants to 2 Artists Rejected Last Year," *New York Times*, November 6, 1991: C21.

134. "Holly Hughes' NEA-funded explicit sex act will include two 12-year-old girls," *American Family Association Journal*, April, 1991: 3.

135. Hughes, Holly, and Richard Elovich, "Homophobia at the N.E.A.," *New York Times*, July 28, 1990: 21. Resistence and denial continued to mark many events, however. A public meeting with NEA chairman Frohnmayer in Los Angeles was primarily attended by gays and lesbians, and the mainstream media either failed to report it, or downplayed the prominence of the theme of homophobia in the discussion; see Sadownick, Doug, "Frohnmayer Faces Gay and Lesbian Critics," *The Advocate*, March 12, 1991: 50–51.

Gay Images and the Social Construction of Acceptability

1. Dannemeyer, William, *Shadow in the Land: Homosexuality in America* (San Francisco: Ignatius Press, 1989): 227.

2. *Ibid.*: 221.

3. Medved, Michael, "Popular culture and the war against standards," *American Family Association Journal*, April, 1991: 14.

4. One of the cultural outcomes is the development of "camp" within the gay subculture. Esther Newton notes that incongruity is the subject matter of camp, when gays juxtapose otherwise discrepant elements to one another to form something fresh and unexpected. This may include mixing typically masculine and feminine attributes, or objects of high and low status, for example. She intriguingly argues that this penchant for reformulating categories and relationships springs from the ostensible incongruity of two men or two women being together in bed. Once the "natural categories" of heterosexuality and male/female are shattered, the rest of the world is likewise subject to transformation. See *Mother Camp: Female Impersonators in America* (University of Chicago Press, 1979), esp. 104–111.

5. Letter to the editor, *Los Angeles Times*, January 12, 1991: F3. Madonna evokes the most contradictory reactions. When ABC's "Nightline" showed the video and interviewed her, the show garnered its second highest rating ever (see James, Caryn, "Beneath All That Black Lace Beats the Heart of a Bimbo . . . ," *New York Times*, December 16, 1990: H38). *Forbes* featured her on its cover with the question "America's Smartest Business Woman?" (October 1, 1990), while *Outweek*'s adulatory paean trumpeted across its cover "immaculate connection: madonna and us" (March 20, 1991). And in a particularly contrary op-ed piece, renegade Camille Paglia championed the video "Justify My Love" but also supported the MTV ban of it ("Madonna—Finally, a Real Feminist," *New York Times*, December 14, 1990: A39). Like other commanding cultural figures, Madonna attracts the fears and accolades of various constituencies.

6. Lathem, Niles and Doug Feiden, "Madman Moammar Now a Druggie Drag Queen," *New York Post*, June 17, 1986: 4, emphasis added.

7. "Gay" is an anachronism, for the word replaced "homosexual" in general use only after the political struggles that were spawned by Stonewall. A new quarrel over terminology began in 1990 with younger, more militant men and women embracing "queer" instead of "gay," a term which they associated with white, middle-class assimilationists. The quote from Queer Nation that introduces this chapter reflects this new activist stance. I will generally use "homosexual" to describe same-sex *behavior*, and "gay" to denote a self-conscious, public presentation and *identification* of self as someone who is primarily attracted to the same sex.

8. It will quickly become apparent that my examples are almost exclusively drawn from gay men's experiences, not lesbians. Two notes of explanation. The same forces which have blocked opportunities for artistic success for women in general also apply to lesbians. Circumstances are changing, however, and lesbians are making more of an impact. This is particularly the case in some fields like performance art, as the previous chapter indicated. And lesbian sexuality tends not to call out as fierce a negative response as does male homoeroticism. One of the few controversial incidents directly related to lesbian representations occurred in a show at the New York State Museum in Albany, "The State of Upstate: New York Women Artists" (1989). Julie Zando withdrew a series of videos after museum officials questioned their "appropriateness" in this venue.

9. See Goffman, Erving, *Stigma: Notes on the Management of Spoiled Identity* (Englewood Cliffs, NJ: Prentice-Hall, 1963).

10. Jussim, Estelle, *Slave to Beauty: The Eccentric Life and Controversial Career of F. Holland Day, Photographer, Publisher, Aesthete* (Boston: David R. Godine, 1981): 168. Jussim claims there is no tangible evidence to document Day's physical relationships, but there are abundant signs on which to base inferences about homosexual conduct.

11. *Ibid.*: 173.

12. The circumspection of biographers and estates in regard to renowned individuals who happen to be homosexual was apparent once again when *Letters From a Life: Selected Letters and Diaries of Benjamin Britten* (Faber and Faber Ltd., and University of California) was published in 1991. Composer Britten was discreet about his relationship with tenor Peter Pears, and extraordinary measures were taken to insure a restricted and "suitable" readership for the details of his life. For example, the price was prohibitive ($125 for the US edition), the two-volume set was shrink-wrapped in plastic within a boxed casing, and few review copies were distributed. See Lebrecht, Norman, "The Secret Life of Benjamin Britten," *Los Angeles Times*, June 20, 1991: F4; and Moor, Paul, "Britten in Love," *The Advocate*, August 13, 1991: 64–5.

13. Jussim, *op. cit.*: 107. Later on in his career, Day's portrayal of Blacks became less exotic.

14. Quoted in *ibid.*: 134.

15. Quoted in *ibid.*: 135.

16. The relative lack of mediation also characterizes performance art, discussed in the preceding chapter. Such performers are not interpreting someone else's script, they're more frequently presenting their own lives.

17. Sischy, Ingrid, "Photography: White and Black," *The New Yorker*, November 13, 1989: 130.

18. *Ibid.*: 130, 135.

19. See Haskell, Barbara, *Charles Demuth* (New York: Harry N. Abrams, 1987). The poster portraits require substantial decoding to understand the allusions.

20. Cooper, Emmanuel, *The Sexual Perspective: Homosexuality and Art in the Last 100 Years in the West* (New York: Routledge & Kegan Paul Ltd., 1986): 119.

21. *Ibid.*: 122.

22. Artist Robert Indiana has memorialized the relationship between Hartley and von Freyburg in "The Hartley Elegies," appropriating much of Hartley's original iconography. Indiana's work became a subject of controversy when it was shown at Bates College in Maine. Gay activists protested that the gallery slighted the relationship between Indiana's subjects in their presentation of the work, and that they failed to acknowledge that Indiana is gay, and the possible influence of that fact on his choice and execution of his own work (see "Artist, title, media, . . . and sexual preference," *New Art Examiner*, November, 1991: 48).

23. Cooper, *op. cit.*: 125–126. Cooper indicates there was reciprocated sexual interest between the men, citing an autobiographical story by Hartley as evidence. Other commentators overlook this possibility; see, e.g., Scott, Gail R., *Marsden Hartley* (New York, Abbeville Press, 1988).

24. Actor Brad Davis died of AIDS in 1991. After his death his wife released a book prospectus in which he planned to discuss his fears that he would become unemployable in Hollywood if he went public with his health condition.

25. In 1987 researchers discovered that Leonardo had performed his own gender identity sleight of hand when computer imaging revealed that the Mona Lisa was actually a self-portrait; see Schwartz, Lillian, "Leonardo's Mona Lisa," *Art & Antiques*, January 1987: 50–55 ff.

26. Austen, Roger, *Playing the Game: The Homosexual Novel in America* (Indianapolis: Bobbs-Merrill, 1977).

27. See, for example, Deuel, Peter, "Daley: Council Has Right To Assail Baldwin Book," *Chicago Sun-Times*, January 15, 1965: 1; and "Here Is Text of Resolution by Aldermen," *Chicago Tribune*, January 28, 1965.

28. "Moral Abdication," *Chicago Tribune*, January 30, 1965: Sec. 1: 10.

29. "Art Row In Navy Surprises Painter," *New York Times*, April 20, 1934: 24.

30. Waterman, Daniel, "Bell-Bottom Scandal," *ARTnews*, April, 1990: 37.

31. See Marling, Karal Ann, *Wall-to-Wall America: A Cultural History of Post-Office Murals in the Great Depression* (Minneapolis: University of Minnesota Press, 1982): 282–289.

32. Cunningham, Al, "Courage, Canvas, And Cadmus," *The Advocate*, July 31, 1990: 65.

33. Shehadi, Philip, "Community Board Approves Christopher Park Statue," *Gay Community News*, November 1, 1980: 1. See, also, Hager, Steve, "Gay Sculpture Controversy," *Horizon*, December, 1980: 10, 12.

34. Segal has been no stranger to controversy. In 1973 an Israeli foundation commissioned a work from him. But "Abraham and Isaac" was rejected because it might be interpreted as critical of the Jewish state sacrificing its young to wars. Another version of the statue was offered to Kent State University in 1978 to commemorate the slaying of four students during demonstrations in 1970. It, too, was rejected.

35. Quoted in Mehren, Elizabeth, "Damage To Gay Art Shocks Stanford," *Los Angeles Times*, March 12, 1984: Part VI: 1.

36. See Davis, Phil, "Trash or Treasure?" *Isthmus*, August 22, 1986: 26; Kaufman, L. Aaron, " 'Gay Liberation': hardly either," *OUT!*, June, 1986; Waller, Thomas M., "Gay statue opposition continues," *Wisconsin State*

Journal, June 27, 1986: Sec. 4, p. 6; and "Sculpture kept in Orton Park," *Wisconsin State Journal*, June 11, 1987.

37. See Dehli, Joyce, "Sculpture of gay community moving on," *Wisconsin State Journal*, December 22, 1990, Sec. 1, p. 1.

38. Quoted in Schmeling, Sharon L., " 'Gay Lib' statue to stay," *Capitol Times Area News*, June 11, 1987.

39. Kramer, Hilton, "When George Segal Goes Public," *New York Times*, October 19, 1980: D36.

40. "All dressed up, nowhere to go," *New York Post*, March 17, 1988: 28.

41. As any semi-regular viewer of television talk shows undoubtedly knows, transvestism is primarily an interest of heterosexual, not homosexual, men. The photo exhibit in question was later published in book form: Allen, Mariette Pathy, *Transformations: Crossdressers And Those Who Love Them* (New York: E.P. Dutton, 1989); see it for details.

42. Jim Fouratt interview, August 6, 1990.

43. See Weinstein, Steve, "When Gay Means Loss of Revenue," *Los Angeles Times*, December 22, 1990: F1, 3. It ran without difficulty in England, however: see Kaye, Jeff, " 'Banned' Lifts Lid Off Censored Fare," *Los Angeles Times*, April 27, 1991: F1, 13. This is somewhat ironic because England has many repressive laws regarding freedom of expression and homosexuality, for instance, the notorious Clause 28, which forbids local government funding of activities believed to "promote homosexuality." And as mentioned in Chapter Six, another ABC series, *China Beach*, ran into similar difficulties over an episode dealing with abortion, a program that also became one of the only ones not to be re-broadcast: see Rosenberg, Howard, "Advertisers Cooling Off to Hot Topics," *Los Angeles Times*, July 26, 1990: F1, 11. *thirtysomething*'s producers may have had the last laugh, however. In the last season, the pivotal character Michael resigned his high-level advertising position rather than carry out an order to fire an actor who participated in an anti-war rally and offended his firm's client/sponsor. The episode put individual conscience above success as a "company man."

44. It is notable that this occurred between two women, not two men. As Wildmon stated, "I would imagine it's not as repulsive as seeing two men" (quoted in Enrico, Dottie, "TV Politics And Strange Bedfellows," *New York Newsday*, March 4, 1991: 35). And, it was not clear whether or not these historic kissers actually regarded themselves as lesbians; one stated that she was attracted to men, but considered herself "flexible."

45. Clark, Jil, "Ohio Court Upholds Dismissal of Charges Against Gay Broadcaster," *Gay Community News*, January 22, 1983: 3.

46. The parameters of this time frame changed periodically. It always ended at six a.m., but began at eight p.m., ten p.m. or midnight in various plans.

47. All the Ginsberg quotes are from the program "Open Ears/Open Minds," broadcast on January 7, 1988 in New York. For a discussion of the Joyce controversy, see Hentoff, Nat, "Saying No to Molly Bloom," *Village Voice*, June 9, 1987: 42.

48. See Masters, Kim, "For the Artist's Father, a Painful Rejection of the Ordinary," *Washington Post*, May 3, 1990: D1, 6. This remarkably sensitive article is suffused with a sense of sorrow and a degree of insight that distinguishes it from most newspaper reporting.

49. That's the image the son of writer Shirley Jackson used to describe his mother and grandmother: "A goldfish giving birth to a porpoise"; see Oppenheimer, Judy, *Private Demons: The Life of Shirley Jackson* (New York: Fawcett Columbine, 1988): 14. Here, however, the respective species seem to be reversed.

50. Dunne, Dominick, "Robert Mapplethorpe's Proud Finale," *Vanity Fair*, February, 1989: 132.

51. One critic drew the parallel between the phallic cane and the fist Mapplethorpe had pictured in an earlier image in an instance of "fisting"; he therefore saw this later imagery as unrepentant. See Brenson, Michael, "The Many Roles of Mapplethorpe, Acted Out in Ever-Shifting Images," *New York Times*, July 22, 1989: 11.

52. Miller, Robert, "From the Publisher," *Time*, April 24, 1989: 4.

53. Quoted in Hodges, Parker, "Robert Mapplethorpe, Photographer," *MANhattan Gaze*, December 10, 1979: 5. In an interview given ten years later, Mapplethorpe maintained the same position: "Whether it's a cock

or a flower, I'm looking at it in the same way"; see the interview by Chua, Lawrence, "Robert Mapplethorpe," *Flash Art*, January/February, 1989: 103.

54. Kuspit, Donald, "Robert Mapplethorpe: Aestheticizing the Perverse," *Artscribe International*, November/December 1988: 65.

55. Ribalta, Jorge, "Decorative Heroism. The Death of Mapplethorpe," *Lapiz*, April 1989.

56. Schjeldahl, Peter, "The Mainstreaming of Mapplethorpe: Taste and Hunger," *7 Days*, August 10, 1988.

57. Rooney, Robert, "The unambiguous stare of Mapplethorpe's lens," *Australian*, February 25, 1986; and Schoofs, Mark, "Robert Mapplethorpe: Exquisite Subversions," *Windy City Times*, March 16, 1989: 28.

58. Langdon, Ann, "Fire and Ice," *The Hartford Advocate*, October 16, 1989: 16.

59. Hemphill, Essex, "The Imperfect Moment," *High Performance*, Summer 1990: 18. Hemphill drew upon the work of Isaac Julien and Kobena Mercer for these quotes.

60. *Ibid.* Dennis Barrie, director of Cincinnati's Contemporary Art Center, offered a different account of Black reactions. During a First Amendment colloquium sponsored by The Playboy Foundation and The Nation Institute (New York City, October 24, 1990), Barrie reported that the Mapplethorpe exhibition drew a larger than usual number of Blacks to his institution. Based on what Black visitors told him, he surmised that "he [Mapplethorpe] glorified and gave great credibility to the black male—in a time when the black male was demeaned in society" (transcript, p. 49).

61. Danto, Arthur C., "Robert Mapplethorpe," pp. 211–217 in *Encounters & Reflections: Art in the Historical Present* (New York: Farrar Straus Giroux, 1990): 216.

62. Letter to the editor, *The Advocate*, January 15, 1991: 13.

63. Quoted in Dowd, Maureen, "Unruffled Helms Basks in Eye of Arts Storm of His Own Making," *New York Times*, July 28, 1989: B6.

64. Also referred to as "Rosie," this photograph has been one of the most disputed within a notably controversial body of work. When the *New Art Examiner* wished to use it to accompany an article on the difficulties the Mapplethorpe exhibit encountered in Cincinnati, their printer from Pontiac, Illinois, balked. The magazine substituted a photo of this image being projected upon the side of the Corcoran Gallery. NAE's editors previously had been prevented by the printers from running two other photographs: a photo of Lynda Benglis which showed her wearing a dildo, and a Joe Ziolkowski image of two nude men embracing. See Miner, Michael, "A Printer's Perogative," *Chicago Reader*, November 9, 1990: 4.

65. Dowd, *op. cit.*

66. Grenier, Richard, "A burning issue lights artistic ire," *The Washington Times*, June 28, 1989; and Reisman, Judith, "Promoting child abuse as art," *The Washington Times*, July 7, 1989: F1, 4.

67. Buchanan, Patrick J., "Why Subsidize Defamation?" *New York Post*, November 22, 1989: 31.

68. See Buchanan, Patrick J., "Jesse Helms' Valiant War Against Filth In The Arts," *New York Post*, August 2, 1989; "In the New *Kulturkampf*, the First Battles Are Being Fought," *Richmond [VA] Times-Dispatch*, June 19, 1989; and "Artists seek to create 'pagan' society," *Chicago Sun-Times*, March 23, 1990.

69. Kramer, Hilton, "Mapplethorpe Show at the Whitney: A Big, Glossy, Offensive Exhibit," *The New York Observer*, August 22, 1988: 12.

70. Kramer, Hilton, "Is Art Above the Laws of Decency?" *New York Times*, July 2, 1989: H7.

71. *Ibid.*

72. The tour included Philadelphia, Chicago, Washington, D.C., Hartford, CT, Berkeley, CA, Cincinnati, and Boston.

73. Miner, Michael, "Mapplethorpe in Chicago: The Lucky Moment," *Chicago Reader*, August 18, 1989: Sec. 1: 4.

74. See Schoofs, *op. cit.*, and the obituary in *Windy City Times*, March 16, 1989: 12.

75. Conroy, Sarah Booth, "A Scandalous Precedent," *Washington Post*, June 18, 1989: F1, 5.

76. Quoted in Whiting, Cecile, *Antifascism in American Art* (New Haven: Yale University, 1989): 55. The painting now hangs in the Museum of Modern Art, New York.

77. Clapp, Jane, *Censorship: A Chronology of Proscribed and Prescribed Art* (Metuchen, NJ: Scarecrow Press, 1972): 361.

78. As heated as the atmosphere was in Washington, there was one potential controversy that fizzled. About two weeks after the Corcoran cancelled the Mapplethorpe retrospective, the June 29 *Washington Times* reported a raid on a homosexual escort service. Officials seized files which reportedly contained the names of Reagan and Bush Administration officials among the clients, and the paper anticipated a large scandal. It never congealed, although it remained a minor story in the news because one of the people named, lobbyist Craig Spence, later committed suicide. See O'Neill, Cliff, "*Washington Times* Alleges 'Nest of Homosexuals' in White House," *Outweek*, July 17, 1989: 16–17; and Randolph, Eleanor, "The Bombshell That Didn't Explode," *Washington Post*, August 1, 1989: D1, 6.

79. Quoted in Kastor, Elizabeth, "Corcoran Cancels Photo Exhibit," *Washington Post*, June 13, 1989: C1.

80. Statement dated June 13, 1989.

81. Kastor, Elizabeth, "Gays, Artists to Protest at Corcoran," *Washington Post*, June 16, 1989: B1, 6; and Hinckle, Doug, "Gay, arts communities join forces," *Washington Blade*, June 23, 1989: 4.

82. Hinckle, Doug, "Eight-foot penis at the Corcoran," *Washington Blade*, December 8, 1989: 1; see, also, Kastor, Elizabeth, "Corcoran Students on The March," *Washington Post*, September 21, 1989: C1, 10.

83. Yasui, Todd Allan, "The Mapplethorpe Bonanza," *Washington Post*, August 21, 1989: B7.

84. Somewhat ironically, and apparently unbeknownst to the curator who proffered the suggestion, one of the members of Group Material is married to Serrano.

85. See her letter, reprinted in *New Art Examiner*, January, 1990: 7.

86. *The Washington Times*, June 23, 1989.

87. Buckley, William F., Jr., "The Corcoran Caves In," *Washington Post*, September 22, 1989: A27.

88. Kilpatrick, James J., "The Corcoran's Wise Decision," *Washington Post*, June 19, 1989: A9.

89. Quoted in Kastor, Elizabeth, and Carla Hall, "Mapplethorpe Aftermath," *Washington Post*, June 23, 1989: F6.

90. "... And the Corcoran Mess," *Washington Post*, June 29, 1989: A24.

91. Quoted in Dowd, "Unruffled Helms."

92. In the case of the Mapplethorpe retrospective, the NEA's $30,000 of support supplemented the $180,000 raised from private sources; see Collins, Glenn, "On Helms and Grants With Poison Pills," *New York Times*, August 7, 1989: C11.

93. Swisher, Kara, "Helms's 'Indecent' Sampler," *Washington Post*, August 8, 1989: B2.

94. Quoted in Honan, William H., "Compromise Is Proposed on Helms Amendment," *New York Times*, September 28, 1989: C14.

95. Punitive action was taken against ICA in the next grant-making cycle: two of three of their requests were approved by the peer panels, but overturned by NEA's National Council. According to council member Jacob Nuesner, awarding them at that time "would be tweaking the nose of Congress." See Taylor, Kimberly, "NEA National Council vetoes ICA grants," *New Art Examiner*, Summer, 1990: 11.

96. From an interview conducted October 21, 1989.

97. Sign at an anti-censorship rally in Cincinnati. See the photo in the *New York Times*, April 6, 1990: A15 (the phrase intended to feign a German accent, making the implicit link with Nazism).

98. It's difficult to view Mapplethorpe as a provocateur when you examine his own statements regarding his work, for instance, a 1988 interview: "I don't care if somebody just wants to show flowers; I'll just show flowers. ... Sometimes they feel they can put certain kinds of pictures in, but can't go any further. ... That's all right. I've seen too many artists being so overly sensitive to how their work is represented, and it's so unattractive that I try to avoid it at all costs." See Indiana, Gary, "Robert Mapplethorpe, *Bomb*, Winter, 1988: 18.

99. McNally, Owen, "Art exhibit draws protesters," *The Hartford Courant*, October 22, 1989: A1, 12; see, also,

Merkling, Frank, "Mapplethorpe: A Perfect moment in Hartford," *The News-Times* [Danbury, Ct], October 27, 1989: 31.

100. Wolfe, Tom, *The Painted Word*. New York: Bantam, 1976: 15.

101. See Vitz, Robert C., *The Queen and the Arts: Cultural Life in Nineteenth-Century Cincinnati* (Kent, Ohio: The Kent State University Press, 1989).

102. Quoted in Clapp, Jane, *Censorship: A Chronology*: 133.

103. See The Federal Writers Project, *Cincinnati: A Guide to the Queen City and Its Neighborhoods* (Cincinnati: The Wiesen-Hart Press, 1943): 73–78.

104. Knippenberg, Jim, "Have the arts gone too far? Or are we more conservative?" *The Cincinnati Enquirer*, April 8, 1990: D5.

105. See Lyman, David, "Huffing and puffing over four little pigs," *New Art Examiner*, October, 1988: 43–44. Similar imagery was used one hundred years earlier: when the renowned conductor Theodore Thomas was summoned to Cincinnati to head a proposed music school, *Puck* pictured him directing before an audience of pigs; see Vitz, *op. cit.*: 106–107.

106. From an interview conducted August 26, 1991. This and all subsequent unattributed quotes are from that interview.

107. Valin, Jonathan, *Day of Wrath* (New York: Congdon and Lattes, Inc., 1982): 23.

108. See transcript No. 3044, "Cleaning Up Sin City," September 28, 1990.

109. Knippenberg, *op. cit.*: D1.

110. Another Cincinnatian, baseball's Pete Rose, had recently been convicted in a bribery scandal, and Auditor Joseph L. DeCourcy was linked to unscrupulous activities. In some respects we encounter the politics of diversion once again: attempts to divert the public's attention away from official misconduct.

111. See Mannheimer, Steven, "Cincinnati joins the censorship circus," *New Art Examiner*, June, 1990: 33–35.

112. Wilkerson, Isabel, "Trouble Right Here in Cincinnati: Furor Over Mapplethorpe Exhibit," *New York Times*, March 29, 1990: A21.

113. Wilkerson, Isabel, "Sheriff: When a Crusade Is a Career," *New York Times*, April 14, 1990: 6.

114. Wilkerson, Isabel, "Focus Is On Judge In Trial Of Museum," *New York Times*, October 2, 1990: A16.

115. Kaufman, Ben L., "Familiar adversaries to try CAC case," *The Cincinnati Enquirer*, April 17, 1990: A9, 10.

116. Prendergast, Jane, "Grand jury: Mapplethorpe photos obscene," *The Cincinnati Enquirer*, April 8, 1990: A1.

117. Ibid.

118. Sawyer reports having paranoid feelings at the height of the tensions, fearing for example that the Sheriff's office might raid his home for "obscenity" (might he have an old *Playboy* lying around?). But given the collusion between business interests and public officials in Cincinnati, this is surely one of the many instances where paranoia has a real basis. In August, 1991, a dramatic display of corporate and governmental complicity surfaced. Procter & Gamble was the subject of a *Wall Street Journal* story which reported some impending personnel and organizational changes. P & G pressured the Hamilton County prosecutor to invoke an Ohio statute which prohibits the release of confidential information (a felony). The prosecutor then subpoenaed the records of Cincinnati Bell, Inc. for *all* the calls made during a three-and-a-half-month period to the area code where the reporter lived. Officials inspected the phone records of hundreds of thousands of area residents, an act of intimidation which confirmed Cincinnati's image as a "company town." After enormous public outcry, P & G later apologized for its actions.

119. *New York Times*, April 18, 1990: A25.

120. See CAA press release, April 9, 1990; Prendergast, Jane, "CAC gets national support," *The Cincinnati Enquirer*, April 14, 1990: A8; and Geyelin, Milo, "Cincinnati Sends a Warning to Censors," *Wall Street Journal*, October 8, 1990: B1, 3.

121. Findsen, Owen, " 'Perfect Moment's' time arrives," *The Cincinnati Enquirer*, April 6, 1990: C19.

122. Vester, John W., William J. Gerhardt and Mark Snyder, "Mapplethorpe in Cincinnati," *The Cincinnati Enquirer*, March 24, 1990: 46, and Mark Snyder on "Nightline," April 10, 1990.

123. Williams, Henry F., "The upward path to greatness," *The Cincinnati Enquirer*, April 6, 1990.

124. Christenson, Reo M., "Cincinnati as the last redoubt," *The Cincinnati Enquirer*, April 20, 1990.

125. *The Cincinnati Enquirer*, April 8, 1990.

126. *Three* conditions must be met to satisfy a *legal* definition of obscenity. First, "the average person, applying contemporary community standards, would find that the work, taken as a whole, appeals to the prurient interest [in sex]." Second, "the work depicts or describes, in a patently offensive way, sexual conduct specifically defined by the applicable state [or federal] law." *And* the third condition, as described in the text, emphasis added. See *Final Report of the Attorney General's Commission on Pornography* (Nashville: Rutledge Hill Press, 1986): 17–18.

127. Quoted in Kaufman, Ben L., "Mapplethorpe issue before court," *The Cincinnati Enquirer*, August 21, 1990: A5, 8.

128. Findsen, Owen, "Ruling that CAC is not a museum jolts art world," *The Cincinnati Enquirer*, June 21, 1990.

129. See two articles by Isabel Wilkerson: "Selection of Jury Begins In Ohio Obscenity Trial," *New York Times*, September 25, 1990: A16, and "Jury Selected in Ohio Obscenity Trial," *New York Times*, September 28, 1990: A10.

130. Jurors did not see the original photos, but "fuzzy copies." The homosexual pictures were larger than the originals, and the photos of the two children were smaller. See Merkel, Jayne, "Art on Trial," *Art in America*, December, 1990, 78 (12): 46. Such "distortions" can be significant to how an image is received and evaluated; see, for instance, the discussion of Serrano's "Piss Christ."

131. Span, Paula, "For His Friends, Portraits of Children's Beauty And Innocence," *Washington Post*, May 3, 1990: D1, 12.

132. Hartigan, Patti, "The Picture Of Innocence," *Boston Globe*, August 8, 1990: 40.

133. See Carr, C., "Suffer the Children," *Village Voice*, June 5, 1990: 27.

134. See Harrison, Eric, "Gallery Photos Compared to Child Porn," *Los Angeles Times*, October 5, 1990: A27; and Wilkerson, Isabel, "Witness in Obscenity Trial Calls Explicit Photographs 'Destructive,'" *New York Times*, October 5, 1990: A20.

135. Quindlen, Anna, *New York Times*, October 25, 1990: A27; and Margolick, David, *New York Times*, October 6, 1990: 5.

136. Quoted in Wilkerson, Isabel, "Obscenity Jurors Were Pulled 2 Ways," *New York Times*, October 10, 1990: A12.

137. See "I Want To Hold Your Hand," *The Advocate*, December 4, 1990: 8; and Richards, Dell, "Activism=Arrests?" *The Advocate*, April 4, 1991: 48–49.

138. News item, *The Advocate*, July 3, 1990: 16.

139. CAC's membership swelled during the controversy and then dipped somewhat, later on. Even so, its ranks remained significantly enlarged.

140. Kay, Joe, "Obscenity case makes folk hero of CAC director," *The Cincinnati Enquirer*, August 25, 1991: B8. Although the report emphasized the applause that Barrie now garners, Sawyer related an incident from about the same time where someone recognized Barrie on the street and called out "scum."

141. See, for example, Cembalest, Robin, "After the Acquittal," *ARTnews*, February, 1991: 31; and Lyman, David, "Post-Mapplethorpe blues in Cincinnati," *New Art Examiner*, January, 1991: 56. But Sawyer reported that some conciliatory gestures were being made a year after the trial, including some degree of cooperation from members of the business community, who were making their own art work available for loans for CAC shows.

142. See Hartigan, Patti, "Mapplethorpe show to open amid controversy," *Boston Globe*, August 1, 1990: 1, 16; Catalano, Peter, "Mapplethorpe Not Banned in Boston," *Los Angeles Times*, July 30, 1990: F1, 8; and "Mapplethorpe Complaints Denied," *Los Angeles Times*, September 6, 1990: F2. Hartigan reported that among the members of the coalition were representatives from Morality in Media, Citizens for Family First, and the Catholic League for Religious and Civil Rights.

143. Hartigan, Patti, "The Pilot joins Mapplethorpe fray," *Boston Globe*, July 27, 1990: 29, 36; and Catalano, *op. cit.*, F8.

144. Temin, Christine, "A poetic and seductive 'Perfect Moment,' " *Boston Globe*, July 31, 1990: 57, 62.

145. See letter from Roy J. Stewart to Donald E. Wildmon, April 26, 1991.

146. See French, Desiree, and Vernon Silver, "Shouting breaks the calm at ICA," *Boston Globe*, August 2, 1990; and Longcope, Kay, "Boston gay groups vow new militancy against hate crimes," *Boston Globe*, August 2, 1990: 25, 31.

147. Findsen, Owen, "Controversy brought crowds," *The Cincinnati Enquirer*, May 26, 1990: A1; and Thomas, Scipio, "Exhibit leaves; debate remains," *The Cincinnati Enquirer*, May 27, 1990: A1, 4.

148. See Jansen, Sue Curry, *Censorship: The Knot That Binds Power and Knowledge* (New York: Oxford University Press, 1991): 41–42.

149. Letter dated July 24, 1989.

150. Quoted in Dawes, K.O., "Picketing groups assail and hail nude painting," *Chicago Sun-Times*, July 15, 1989.

151. This and all subsequent unattributed information and quotes derived from an interview conducted February 19, 1991.

152. Wildmon, *The Washington Times* and others also criticized grants to the San Francisco International Lesbian and Gay Film Festival in 1990 and 1991. At about the same time the *Poison* controversy was unfolding, however, John Frohnmayer defended the grants. See "The NEA's Porn Festival," *Richmond Times Dispatch* (editorial), June 24, 1990; "NEA gives homosexual film festival $12,000 tax grant," *AFA Journal*, June, 1991: 17; and O'Neill, Cliff, "NEA Chief Stands By Film Festival," *Outweek*, May 22, 1991: 19–20.

153. See Parachini, Allan, "Conservative Group Renews Attack on NEA," *Los Angeles Times*, March 27, 1991: F1, 5; and Wilson, Daniel, "Far Right Mounts Anti-NEA Charge," *The Advocate*, May 7, 1991: 52–53. Frohnmayer's tenure outlasted Sununu's, but conservative opponents of the NEA chief were finally able to force his resignation in February, 1992, after the Presidential primary campaign heated up; see Chapter Eleven.

154. Quoted in Richter, Paul, "The NEA Defends Funding of Controversial Film," *Los Angeles Times*, March 30, 1991: F1. Frohnmayer went on to distill the movie's message as "violence breeds violence, lust breeds destruction, and, in our society, we reap what we sow"; quoted in Gamarekian, Barbara, "Frohnmayer Defends Grant for Prize Film," *New York Times*, March 30, 1991: 9.

155. *Ibid.*

156. This is preceded by the following dialogue:

> Olivier: Do you eat oysters?
> Curtis: When I have them, master.
> O: Do you eat snails?
> C: No, master.
> O: Do you consider the eating of oysters to be moral and the eating of snails to be immoral?
> C: No, master.
> O: Of course not. It is all a matter of taste.
> C: Yes, master.
> O: And taste is not the same as appetite and therefore not a question of morals. Hmmmm?
> C: It could be so argued, master.

157. It is interesting to note that visual media did not predominate in the post-Stonewall, pre-AIDS interregnum. Literary output, however, was impressive: fiction and nonfiction, and particularly "coming-out" tales, both male and female.

AIDS: Bearing Witness

1. See Carmilly-Weinberger, Moshe, *Fear of Art: Censorship and Freeedom of Expression in Art* (New York: R.R. Bowker Company, 1986): 16–17; and Weinstein, Donald, "Girolamo Savonarola," pp. 89–90 in Mircea Eliade, ed., *The Encyclopedia of Religion* Vol. 13 (New York: Macmillan, 1987).

2. Quoted in Harmetz, Aljean, "Split Over Kissing Rule," *New York Times*, November 1, 1985: C21.

3. Analogs to the AIDS quilt are projects sponsored by the New York City Public Library at Lincoln Center oral history project, and Legacy in San Francisco, to collect the biographies of dancers afflicted with AIDS. There is also The Witness Project: A Census of AIDS in the Arts, which is compiling a census of those in the creative community lost to the disease.

4. March 18, 1988: 41.

5. Independent video makers frequently adapt this nascent technology to political ends. For the consequences of this renegade approach in another context, see Dubin, Steven C., *Bureaucratizing the Muse: Public Funds and the Cultural Worker* (Chicago: University of Chicago Press, 1987): 143–150.

6. Taavel, Raymond, "Beyond the limit," *XTRA!* [Toronto], May 10, 1991: 9. For a general discussion of AIDS videos see Danzig, Alexis, "Acting Up: Independent Video and the AIDS Crisis," *Afterimage*, May, 1989: 5–7.

7. Quoted in Munk, Erika, "Stage Left," *Village Voice*, November 14, 1989: 49.

8. See Rottmann, Larry, "The Battle of *The Normal Heart*," *Academe*, July–August, 1990: 30–35 for a first-person account. Rottmann also reports that CDS led the charge against "Oh, Calcutta," forcing actors in the play to wear body stockings instead of performing in the nude for the first time in the play's twenty one-year history.

9. See Rogers, Deborah, "AIDS Spreads To the Soaps, Sort Of," *New York Times*, August 28, 1988: H29.

10. Farber, Stephen, "They Watch What We Watch," *New York Times Magazine*, May 7, 1989: 62, 64.

11. See Michaud, Christopher, "Is There a Distributor Out There for This Film?" *New York Times*, March 18, 1990: H15, 22.

12. "ABC pro-homosexual theme recurs, Chrysler, Unilever ad support," *American Family Association Journal*, June, 1991: 8.

13. The network estimated revenues to be five hundred thousand dollars less than they might be for the time slot, even for a rerun of another series; see Weinstein, Steve, "NBC Puts Message Over Money With AIDS Show," *Los Angeles Times*, December 18, 1990: F1, 11.

14. Farber, Stephen, "AIDS Groups Protest Series Episode," *New York Times*, December 8, 1988: C24.

15. The November, 1991 announcement by basketball star Magic Johnson that he is HIV-positive stunned many people. But there were great outpourings of sympathy and support because he claimed to be heterosexual. While his candidness promised to invigorate public discussion of AIDS, in many respects it also continued to ratify the distinction between "guilty" and "innocent" victims.

16. Starr, Victoria, "Against All Odds," *Outweek*, December 5, 1990: 36–37.

17. Rosenberg, Howard, "ABC Takes Strides With 'Red, Hot'—and Bold—Special," *Los Angeles Times*, November 30, 1990: F24.

18. Bernstein, Sharon, "TV Still Says No to Condoms, Movies Say Maybe," *The Advocate*, February 26, 1991: 44–45.

19. See Rosenberg, Howard, "It's More Fun to Sell Sex Than Protection," *Los Angeles Times*, October 19, 1990: F1, 26.

20. Policies may be gradually changing. In November, 1991 the upstart Fox network aired an ad for Trojan condoms during prime time. This organizational "outlyer" has influenced programming on the major newtworks before, and this could be the breakthrough event in this matter.

21. "Condom Art in Grand Rapids," *Newsweek*, August 28, 1989: 8.

22. See "Japanese Art Features Fight Against AIDS," *Chicago Magazine*, December, 1989: 28.

23. Her combination of social commentary with elements of church liturgy evoked a critical press response in Italy; see Hilferty, Robert, "Mourning Becomes Diamanda," *Outweek*, October 17, 1990: 41–43.

24. From an interview conducted January 4, 1990. This and all subsequent unattributed quotes are from that interview.

25. Quoted in Honan, William H., "Arts Endowment Withdraws Grant for AIDS Show," *New York Times*, November 9, 1989: C28. Interestingly, the grant money had not yet been issued when it was rescinded.

26. In addition, several groups and individuals pledged to replace the threatened ten thousand dollars of NEA money, among them the Art Dealers Association of America, Pace Gallery, and artist Robert Motherwell. According to one report, Artists Space received six ten thousand dollar donations (Lubell, Ellen, "Dealers on NEA: No Sale," *Village Voice*, February 13, 1990: 57).

27. Quoted in Swisher, Kara, "Bernstein Comments On Arts Controversy," *Washington Post*, November 18, 1989: C9.

28. See McMurtry, Larry, "When Art Is 'Too Political,' " *Washington Post*, November 10, 1989: A27.

29. Quoted in Gamarekian, Barbara, "Bush Gives Arts Medals to 12, but Not to Bernstein," *New York Times*, November 18, 1989: 17.

30. This conflict between artistic principles and the more inherent conservatism of organizations is commonly played out in avant-garde settings. For example, the third annual Cleveland Public Theater Performance Art Festival in 1990 presented many of the foremost performance artists, but also attracted the media and vice cops. Performers proceeded with their work *relatively* unaltered, but the director reflected: "We've damaged things here. Artists come and go, but they don't realize how difficult it is to present their work. ... It's not just the art, it's a whole process. ... Without the support of everyone in the structure, it doesn't work." Quoted in Burnham, Linda, "Running Commentary," *High Performance*, Summer, 1990: 13.

31. This quote is from an interview conducted January 2, 1990. This and all subsequent quotations are taken from that interview.

32. New York: Aperture Foundation, 1986.

33. Goldin admits to having lived as a separatist lesbian and as an exclusively heterosexual woman, with many variations in between. As a result, standard sexual categories are not very meaningful to her.

34. Yablonsky, Linda, "Et Tu, Brute?" pp. 12–13 in *Witnesses: Against Our Vanishing* (New York: Artists Space, 1989): 12.

35. *Witnesses, op. cit.*: 23.

36. Loughery, John, "Frohnmayer's Folly," *New Art Examiner*, February, 1990: 24.

37. For the record, O'Connor supported Wojnarowicz's right to criticize him and felt the NEA should *not* have rescinded the grant to Artists Space. As noted in the preceding chapter, Richard Grenier's anger over the Mapplethorpe exhibit prompted the following statement, several months *before* Wojnarowicz's text was publicized: "I'd set fire to this Mapplethorpe, and not just as self-expression, but as *performance art*" ("A burning issue lights artistic ire," *The Washington Times*, June 28, 1989). It seems that incendiary fantasies are not restricted to just certain social or political groups.

38. "Offensive art exhibit," *New York Post*, November 11, 1989: 14. Art critics lined up for or against the show in a rather predictable manner according to their liberal or conservative reputations. One of Patrick J. Buchanan's most hateful pieces of cultural criticism was spurred by this show ("Why Subsidize Defamation?" *New York Post*, November 22, 1989). But another reviewer highlighted the "tempest in a teapot" nature of the dispute: " 'Witnesses' is not obscene, or saucy, or outrageous. It is no better, and no worse, than most young artists' group shows seen in urban alternative spaces. ... It is a surprisingly innocuous, often amateurish, cry of lamentation"; Richard, Paul, " 'Witnesses': Testimony to the Power of an Age-Old Taboo," *Washington Post*, November 17, 1989: D1.

39. Quoted in Kastor, Elizabeth, "NEA Pulls Grant to 'Political' Exhibit," *Washington Post*, November 9, 1989: F18.

40. The following information was gleaned from an interview conducted January 1, 1990. All subsequent unattributed quotes also derive from that interview.

41. Interview conducted January 15, 1990. Pico was the plaintiff in *Pico v. Board of Education, Island Trees*, a case decided by the Supreme Court in 1982 which struck down the banning of books from public school libraries.

42. See Note 26.

43. See Parachini, Allan, "NEA Chief Admits Misstep," *Los Angeles Times*, January 26, 1991: F1, 10; and

Sadownick, Doug, "Frohnmayer Faces Gay and Lesbian Critics," *The Advocate*, March 12, 1991: 50–51. Sadownick was sharply critical of Parachini for not reporting that the audience was primarily gay and lesbian at this confrontation.

44. Myers, Christopher, "Colleges Urged to Back Academic Freedom in the Teaching and Exhibition of Art; Controversial Show Puts Illinois State U. in the Center of Debate Over Federal Aid," *The Chronicle of Higher Education*, May 9, 1990: A26.

45. *Ibid.*: A27; Durant, Mark Alice, "Sustained rage in a hostile landscape," *New Art Examiner*, September 1990: 35–36.

46. See Rohrabacher, Dana, "The National Endowment For The Arts Is At It Again! Again!" February 20, 1990.

47. See letter from Donald E. Wildmon to members of Congress, April 12, 1990, including "Your Tax Dollars Helped Pay For These 'Works Of Art' "; and John E. Frohnmayer to Donald E. Wildmon, April 20, 1990. Wildmon used this illustrated indictment as a fundraising device in a huge mailing he described in the letter to Congress. The exhibit appeared at ISU January 23 to March 4; this aspect of the dispute raged while the actual work was not on public display.

48. See *David Wojnarowicz v. American Family Association and Donald E. Wildmon*, United States District Court, Southern District of New York, Civil Action No. 90 Civ. 3457 (WCC): 12.

49. *Ibid.*: 7–8.

50. See *Wojnarowicz v. AFA and Wildmon*, Plaintiff's Post-Trial Memorandum: 42.

51. Quoted in Phillips, Christopher, "Wojnarowicz Bags Buck," *Art in America*, October, 1990: 240.

52. This was not the last lawsuit connected to the retrospective, however. The Charlottesville, VA-based Rutherford Institute, a nonprofit group concerned with religious freedom, filed suit against the NEA in August, 1990. They charged that support of "Tongues of Flame" violated the separation of church and state, and constituted official hate towards organized religion.

53. Quoted in Allen, Mike, "Protester plucks gallery's 'fig leaf,' " *Richmond Times-Dispatch*, June 4, 1990: B1.

54. This was a magazine cover appropriated from the *New Art Examiner* showing Jesse Helms, with the title "Art Bigot." It was amended to incorporate the local enemy, Morrisey. Personal communication, James Boyles.

55. Merritt, Robert, "Exhibit succeeds at controversy," *Richmond Times-Dispatch*, June 17, 1990: K9.

56. See Bacque, Peter, "Nude sculpture pulled from show," *Richmond Times-Dispatch*, March 27, 1989: B1, 3; and Merritt, *op. cit.*

57. Green, Frank, "Painting of nude men in window of gallery not obscene, judge rules," *Richmond Times-Dispatch*, June 28, 1990: A1.

58. In the case of "The Lazaretto: An Installation About the Current Status of the AIDS Crisis," an unamed group of individuals came together solely to assemble and mount this installation.

59. Quoted in Soehnlein, Karl, "Art for AIDS's Sake," *The Advocate*, November 11, 1990: 50.

60. Crimp, Douglas, "The Boys in My Bedroom," *Art in America*, February, 1990: 49.

61. Henry Street officials deny making these statements; see information sheet, Steven Pico, December 1, 1989.

62. Green, Martin, *New York 1913: The Armory Show and the Paterson Strike Pageant* (New York: Charles Scribner's Sons, 1988): 272.

63. Steven Pico interview.

64. The poster was even pictured in *Vogue*, accompanying a story on the organizer of the Whitney show; see Woodward, Richard B., "Marvin Heiferman's all-encompassing eye has redefined photography," November, 1989: 284.

65. This is not the first occasion that the CTA has balked at displaying certain themes. In 1985 it rejected a show called "Critical Messages" by a women's collective, Artemesia; several of the images were deemed unsettling. In 1990, the CTA rejected a poster depicting political executions in El Salvador, sponsored by the Chicago Chapter of the Committee in Solidarity with the People of El Salvador (CISPES). In this case, the CTA cited the violence and "possible obscenity" of the image. In addition, Planned Parenthood

successfully sued the CTA for refusing to carry an announcement on abortion; the agency was prohibited from rejecting messages in an arbitrary manner, based upon their content.

66. Quoted in Atkins, Robert, "Scene & Heard," *Village Voice*, June 26, 1990: 92.

67. According to an official of the AIDS Foundation of Chicago (one of the organizational beneficiaries of Art Against AIDS), someone paraded a copy of the poster around the State House as the bill to restrict its public display was being debated. At that time, only the CTA possessed copies. Although the CTA denied lobbying the legislature to pass the bill in order to get themselves off the hook, this official doubts the CTA's claim. This information is derived from an interview conducted April 4, 1991; the informant prefers to remain anonymous. Additional information on the controversy was provided by Nina Schroeder, director of Art Against AIDS/Chicago, during an interview conducted April 11, 1991.

68. Quoted in Wockner, Rex, "ACT UP tackles Royko," *Outlines*, September, 1990: 20.

69. Quoted in Bonnarens, Michele Marie, " 'Kissing posters displayed, defaced; action on 'hate crimes' urged," *Outlines*, September, 1990: 22.

70. Engberg, Kristen, "Marketing the (ad)just(ed) cause," *New Art Examiner*, May, 1991: 22–28. This exhaustive article about Art Against AIDS, which explores the disjunction between the large, national establishment and ongoing, grass-roots efforts, also did not mention the defacement. Because Art Against AIDS did not focus on the reception of the posters, they did not photodocument what had happened. In Washington, as in Chicago, much of the public opposition to the art works was from the Black community.

71. Quoted in Olson, David, "ACT UP Pressures CTA to Display 'Kissing Poster,' " *Windy City Times*, July 19, 1990.

72. I have emphasized Gran Fury to the relative exclusion of other groups. Their works are the most visible, and the most consistently controversial. It is also worth noting that other collectives which generally focus on social and political themes have also tackled the subject of AIDS. Group Material, for example, assembled "AIDS and Democracy: A Case Study" for the Dia Foundation in 1989. Shown within an alternative gallery setting and not funded with public resources, it spurred artistic—but not public—debate.

73. For expositions of this position see Crimp, *op. cit.*: 24; and Grover, Jan Zita, "Visible Lesions: Images of the PWA," *Afterimage*, Summer, 1989: 10–15. Photos from the exhibit were eventually published as *Bearing Witness: People With AIDS*, text by Bebe Nixon (Boston: David R. Godine, 1991). By supplementing them with interviews with the PWA's and their loved ones, the book presents a more complete account of these peoples' lives than the display of the images was able to convey previously.

Defenders of the Faith: Twentieth Century Puritans and Conniosseurs

1. The so-called "Monkey trial."

2. Quoted in Young, Perry Deane, *God's Bullies: Power Politics and Religious Tyranny*. New York: Holt, Rinehart and Winston, 1982: 59.

3. See Becker, Howard S., *Outsiders: Studies in the Sociology of Deviance* (New York: The Free Press, 1963): 147–163. I will focus on conservative critics (those primarily on the political right) in this chapter. Later on I will address the orthodoxies of the political left. The main reason for separating them is that the former often emphasize *exclusion*, and try to *officially* limit some types of expression. The primary goal of the latter is the inclusion of a wide range of presentations *in the long run*, even though some zealots on the left have tried to informally hinder the production or distribution of images they find to be offensive. Orthodoxies of the left have frequently developed in reaction to those of the right in the battle over representation.

4. "What Parents Don't Know about Comic Books," *Ladies' Home Journal*, November, 1953: 214; and "The Comics . . . Very Funny!" *The Saturday Review of Literature*, May 29, 1948: 29. The "bible" of Wertham's crusade was his *Seduction of the Innocent* (Port Washington, NY: Kennikat Press, 1953). In 1990 Huntington House released John Fulce's *Seduction of the Innocent Revisited*, an update exposing subjects in contemporary comics: alleged obscenity, Satanism, and anti-Christian themes.

5. An important exception is Terry Rakolta, the suburban Detroit housewife who took offense at Fox's "Married . . . With Children" and wrote letters of complaint to program sponsors. Rakolta touched a

nerve with many people who felt television had gotten too racy; she received some sympathetic and apologetic responses to her communiqué and there were some sponsor defections. She was both hailed (by Jesse Helms, for example, on the Senate floor), and denounced (christened "Mrs. Khomeini of Bloomfield Hills" by a local newspaper). She garnered more than just her fifteen minutes of fame: she formed a group—Americans for Responsible Television (ART)—and demonstrated that individuals without established institutional authority may sometimes have an influential voice. See Span, Paula, "The Mother Who Took On Trash TV," *Washington Post*, October 10, 1989: C1, 8, 9.

6. See Wildmon, Donald E., with Randall Nulton, *Don Wildmon: The Man The Networks Love To Hate* (Wilmore, KY: Bristol Books, 1989): 35, 57, 110–112.

7. *Ibid.*: 167.

8. *Ibid.*: 109–110; 26–29. John Fulce, the man who revised Wertham's book, is a born-again Christian who also underwent a conversion to put him on the crusading path: for seven years he was a comic book dealer. He confirms the adage about the moral fervor of the reformed sinner.

9. Quoted in Reich, Howard, "The arts under assault," *Chicago Tribune*, June 24, 1990: Sec. 13: 5.

10. Hallman, Steve, *Christianity and Humanism: A Study in Contrasts* (Tupelo, MS: American Family Association, 1984): 7. See, also, Wildmon and Nulton, *op. cit.*: 135–147. Both authors cite the *Humanist Manifesto I & II* as the primary source of secular humanist thought. However, it is quite possible that more Christians are familiar with these documents through their leaders' discussion of them than are so-called secular humanists!

11. Quoted in Uzelac, Ellen, "Obscenity on the outs," *Kansas City Star*, September 23, 1990: A19.

12. Wildmon, Donald E., *The Home Invaders* (Wheaton, IL: Victor Books, 1985): 24. These domains intersected in an incident during the summer of 1991, when Pee-wee Herman was arrested in a porn theater in Sarasota, Florida on indecent exposure charges for allegedly masturbating there. He was hurriedly tried in the court of public opinion, and in response CBS yanked the remaining rerun episodes of his popular Saturday morning *Pee-wee's Playhouse* from its schedule, Disney-MGM Studios in Florida withdrew a tape with the actor from its studio tour, and Toys-R-Us removed toys with his image from their stores. Some people—in the cause of "protecting" children—were unable to separate an actor from the character he played, and brought the man's career to a standstill (at least for the time being, with this persona).

13. Wildmon, *op. cit.*, 1989: 154.

14. Sewall, Gilbert T., "Goodbye Channel J—and Good Riddance," *New York Times*, September 29, 1990: 23. The statement contains an interesting class bias. The implication: it is the working classes that need to be reined in.

15. Parachini, Allan, and Dennis McDougal, "Censorship and the Arts Reach the Boiling Point," *Los Angeles Times*, June 18, 1990: F5.

16. Cited in *David Wojnarowicz v. American Family Association and Donald E. Wildmon*, United States District Court, Southern District of New York, Civil Action No. 90 Civ. 3457 (WCC), Plaintiff's Post-Trial Memorandum: 37. Wildmon's reported annual salary is still rather modest, however.

17. See *The Malleus Maleficarum of Heinrich Kramer and James Springer* trans. by Montigue Summers (New York: Dover, 1971): xxxix; and Ben-Yehuda, Nachman, "The European Witchcraze of the Fifteenth-Seventeenth Centuries: A Sociologist's Perspective," *American Journal of Sociology*, 86 (1), 1980: 1–31. Wildmon shows even more continuity with his predecessors: see "Purina, Pfizer support movie with witchcraft, mockery of Christianity," *AFA Journal*, February, 1991: 7.

18. *AFA Journal*, February, 1991: 8.

19. See the deconstruction and recontextualization of this statement by Hefter, Richard, "Copy Righting: A Reverence for the Facts," *NewCity*, January 3, 1991: 7. Interestingly, *USA Today* refused to run this ad because of its explicit nature; see Fox, Nichols, "Rev. Donald Wildmon censored by USA Today," *New Art Examiner*, April, 1990: 64.

20. Young, *God's Bullies*: 218.

21. Quoted in Brownstein, Ronald and Robert Shogan, "Jesse's Glimpse," *Los Angeles Times*, August 3, 1990: A5.

22. Wildmon was a cofounder and executive director of the group.

23. See Ramirez, Anthony, "Burger King Ads Help End Boycott by Religious Group," *New York Times*, November 7, 1990: D1, 19; and Rosenberg, Howard, "Burger King Bows to TV Watchdogs," *Los Angeles Times*, November 14, 1990: F1, 12.

24. See Puig, Claudia, "Mother and Child Reunion," *Los Angeles Times*, November 29, 1990: F2; and "1990 Accomplishments of the American Family Association," fund-raising pamphlet, 1991.

25. Fox, David J., "Blockbuster Video Rates NC–17 Films Unsuitable for All," *Los Angeles Times*, January 14, 1991: F1, 9.

26. See two articles by Dennis McDougal: "Hitting TV with the Off Switch," *Los Angeles Times*, October 28, 1991: F1, 10; and "TV Boycott Fails to Dent Tuesday Ratings," *Los Angeles Times*, October 31, 1991: F5.

27. Young, *op. cit.*: 229–230.

28. See *AFA Journal*, February, 1991: 14–18, 20. In fact, Dobson uses a great deal of battle imagery: "Open any daily newspaper and you'll find accounts of the latest Gettysburg, Waterloo, Normandy, or Stalingrad" (14). For a critique of the authoritarianism of Dobson's theories see Lifton, Robert Jay, and Charles B. Strozier, "Waiting for Armageddon," *New York Times Book Review*, August 12, 1990: 1, 24–25.

29. For a critique of this event see Goldstein, Al, "Ted Bundy's Last Lie," *New York Times*, February 18, 1989: 29. One of Mr. Dobson's colleagues on the Meese Commission was Father Bruce Ritter of New York's Covenant House. Ritter, an outspoken opponent of pornography for its deleterious impact on young people, was forced from his organization in disgrace when young men detailed their sexual involvements with him. And a member of the preceding 1970 Presidential Commission on Obscenity and Pornography was Charles H. Keating, Jr. As noted in Chapter Seven, Keating was a prime mover on the Cincinnati scene for many years who helped develop the official and unofficial mechanisms to combat moral evils in that area, some of which subsequently figured into the attempted prosecution of Dennis Barrie in the Mapplethorpe case. He dissented from the 1970 report that dismissed the purported evils of pornography, but later this moral crusader was indicted for illegal business dealings and influence peddling in the S&L scandal.

30. See Stepp, Laura Sessions, "The Empire Built on Family & Faith," *Washington Post*, August 8, 1990: C1–3; and Steinfels, Peter, "No Church, No Ministry, No Pulpit, He Is Called Religious Right's Star," *New York Times*, June 5, 1990: A22. This will be discussed in greater detail in Chapter 12.

31. See Osborne, Duncan, "Group with 'cure' for gays rebuffed by feds," *Outweek*, July 4, 1990: 28.

32. See Bernstein, Richard, "Arts Endowment's Opponents Are Fighting With Fire," *New York Times*, May 30, 1990: C13, 15.

33. "700 Club," March 1, 1990, and June 9, 1989. See, also, Robertson's mailing of October 25, 1989. As noted in Chapter One, the discrediting of several prominent fundamentalist religious leaders provoked a crisis of confidence in many other ministers as well, and led to a decline in support for electronic ministries (see Shipp, E.R., "Scandals Emptied Pews Of Electronic Churches," *New York Times*, March 3, 1991: A24). The impassioned moral sense some religious leaders directed against the arts must be evaluated alongside their inability to keep their own colleagues toeing the virtuous mark.

34. Johnson, Dirk, "Group Links Pornography Support To Lawmaker's Vote on Art Funds," *New York Times*, November 3, 1990: 11.

35. See "More than 800 Christian leaders call on networks, studios to end anti-Christian bigotry," *AFA Journal*, March, 1991: 1, 24.

36. Quoted in "Southern Baptists speak out on alcohol, sex, art," *AFA Journal* (Christianity and Society Today section), July, 1991: 1.

37. Parachini, Allan, "Falwell Joins NEA Controversy, Sides With Helms," *Los Angeles Times*, May 13, 1991: F9.

38. Miller, Andrew, "GMHC makes Ollie North's skin crawl," *Outweek*, August 8, 1990: 26; and "North Warns Southern Baptists of Sodom on Potomac," *Los Angeles Times*, June 4, 1991: A21.

39. Stepp, *op. cit.*: C1. Another important link between government officials and "private initiative" is the Parents' Music Resource Center (PMRC), cofounded in 1985 by Susan Baker and Tipper Gore, wife of

Tennessee Senator Albert Gore, Jr. One of the group's main initiatives has been to demand labelling of record albums containing explicit material; see Gore, Tipper, *Raising PG Kids in an X-Rated Society* (Nashville: Abingdon Press, 1987).

40. See Himmelstein, Jerome L., *To the Right: The Transformation of American Conservatism* (Berkeley: University of California Press, 1990).

41. On Sally Jesse Raphael, March 7, 1991.

42. Young, *op. cit.*: 224.

43. "Only One U.S. Family in Four Is 'Traditional,' " *New York Times*, January 30, 1991: A19. Interestingly, this subject was addressed in all its complexity by an exhibit, video and public reading program at Artists Space in 1991: "Reframing the Family: An Exhibition Investigating the Mythology of the American Family & the Machinations of the Nuclear Family."

44. "Sex, lies and Dr. Kinsey," *AFA Journal*, February, 1991: 19.

45. Letter to the editor, *Los Angeles Times*, March 16, 1991: F4.

46. Quoted in Warren, Jenifer, "Schoolbook Furor Rends Rural Town," *Los Angeles Times*, August 20, 1990: A3.

47. "AFA sues California school district over Impressions curriculum," *AFA Journal*, February, 1991: 12. To appreciate the interconnections between some of these leaders and their organizations, see an article by Deborah Mendenhall, reprinted in the *AFA Journal*, but originating in Focus on the Family's *Citizen Magazine*: " 'Impressions' readers have violent occult themes for teaching children," *AFA Journal*, January, 1991: 16– 21. The review demonstrates how series editors rewrote classic children's stories (to undesirable ends), details material which indisputably would be frightening to children, offers sample arguments for contesting the books' adoption, and specifies which officials to pressure to ensure that the books not be used in the reader's own locale. Incidentally, the school board in Wheaton voted in March, 1991 to retain the series.

48. Anderson, Susan Heller, "Who bowdlerized the Wart Snake?" *New York Times*, December 25, 1990: 64.

49. See *The Malleus Maleficarum*, *op. cit.*: 106. It should be noted that unlike visual imagery—where the impact on the viewer is often immediate—written material requires more reflection. That may partially explain the extended analysis that moral crusaders feel is necessary to expose the insidiousness of textbooks such as "Impressions."

50. See "Yoga and the Devil: Issue for Georgia Town," *New York Times*, September 8, 1990: 11; and Goldman, Ari L., "Yoga-Devil compromise," *New York Times*, September 22, 1990: 11. The class was later conducted under private auspices.

51. Comstock, Anthony, *Traps for the Young* (New York: Funk & Wagnalls, 1883): xi (quoted in editor's introduction). The absurdity of some of these drives against schoolbooks was evident in 1990 when the small town of Empire, CA locked away four hundred copies of "Little Red Ridinghood" because the girl of the title carried a bottle of wine in the basket she took to her grandmother. The curriculum director felt this condoned the use of alcohol, an unsavory message; see Cohen, Roger, "With Boycott and Ads, A Battle Over Selling," *New York Times*, April 13, 1990: C18.

52. Butterfield, Fox, "In Furor Over Photos, An Echo of City's Past," *New York Times*, July 31, 1990: A8.

53. Noebel, David A. (Tulsa, Oklahoma: Christian Crusade Publications, 1966). This was a companion to the author's earlier best seller, *Communism, Hypnotism & the Beatles*.

54. See Peters, Dan and Steve, *Rock's Hidden Persuader: The Truth About Backmasking* (Minneapolis: Bethany House Publishers, 1985).

55. Quoted in Rohter, Larry, "2 Families Sue Heavy-Metal Band As Having Driven Sons to Suicide," *New York Times*, July 17, 1991: C13.

56. Moore, Timothy, "Subconscious Stimuli Can't Make You Commit Suicide," *Los Angeles Times*, August 27, 1990: F3, emphasis in the original. See, also, two articles by Chuck Philips: "The Music Didn't Make Them Do It," and "Judas Priest Verdict Offers Small Comfort to Music Industry," *Los Angeles Times*, August 25, 1990: F1, 16.

57. O'Connor, Phillip J., *Chicago Daily News*, April 28, 1976; and "Student gets idea to poison teacher from movie," *AFA Journal*, January, 1991: 15. Two movies which garnered notoriety in 1991 were "New Jack

City" and "Boyz N the Hood." Each focused on Black youth and had anti-drug and anti-gang themes. But violence broke out in theaters featuring them throughout the country, and some deaths were recorded. While some people argued that the movies *caused* the violence, other factors have to be taken into account. For example, "New Jack City" opened one week after the brutal videotaped beating of a Black motorist by L.A. police was publicized, and violence attended showings of the movie in that city. Also, theaters are likely to bring rival gang members together on the same turf, a dangerous sort of proximity. Although these recent examples involved Blacks, "The Warriors" (about White gangs) and "Colors" and "Boulevard Nights" (about Hispanics) spawned similar violence, as far back as 1979.

58. Quoted in Vanderknyff, Rick, "Restrictions on Arts Grants Set by Costa Mesa," *Los Angeles Times*, July 18, 1990: F1, 8.

59. Bob DeMoss in transcript of Geraldo show, "Is It a Bad Rap?" June 15, 1990 (Transcript No. 717): 5; and Philips, Chuck, "Boss Apparently OKs Crew's Use of 'U.S.A.,' " *Los Angeles Times*, June 26, 1990: F1, emphasis added.

60. "Books censored; teachers will sue," *Chicago Sun-Times*, June 13, 1984.

61. Gruenberg, Robert, "A Coincidence, Says O'Connor Of Woman Film Guardians," *Chicago Daily News*, April 8, 1959.

62. Philips, Chuck, "The 'Batman' Who Took On Rap," *Los Angeles Times*, June 18, 1990: F1, 4, 6; and quoted in Clary, Mike, "Florida Attorney Jack Thompson Guns for Gays, Hopes to Spank Madonna Too," *The Advocate*, January 15, 1991: 46.

63. Except for Anita Bryant's 1977 "Save Our Children" campaign against gay rights in Dade County, Florida, and the occasional public statements of Phyllis Schlafly, the campaigns against homosexuality and allegedly obscene art have largely been "men's work."

64. Dannemeyer, William, *Shadow in the Land: Homosexuality in America* (San Francisco: Ignatius Press, 1989): 91.

65. Dannemeyer's opposition to the proposed survey of the sexual behavior of teens stems from his belief that it was advanced by a "cell" of homosexuals or their supporters operating within the Department of Health and Human Services. See Rutten, Tim, "One Congressman's Fight Against a Sexual 'Conspiracy,' " *Los Angeles Times*, August 9, 1991: E1, 6.

66. See Stewart, Robert W., "The True Believer," *Los Angeles Times*, July 11, 1990: E1, 5; and Wilson, Daniel, "Mr. Gay Basher Goes to Washington," *The Advocate*, April 9, 1991: 56–57.

67. See Dannemeyer, *op. cit.*: 152.

68. Quoted in Piccoli, Sean, "Nay, big spender," *The Washington Times*, June 26, 1989: E2.

69. *Ibid.*

70. Quoted in Battiata, Mary, "NEA's Pornography Ruckus," *Washington Post*, September 12, 1985: C6.

71. See Rohrabacher, Dana, "The Art of Picking Taxpayers' Pockets," *Los Angeles Times*, September 10, 1990: F3.

72. See his comments in the transcript of the "700 Club," March 1, 1990. Representative Armey also appeared on Pat Robertson's show, June 9, 1989.

73. Quoted in Hilts, Philip J., "$2.9 Billion AIDS Relief Measure Easily Wins Approval in Senate," *New York Times*, May 17, 1990: B10.

74. Grand Rapids, Michigan: Zondervan Publishing House, 1976: 11.

75. Quoted in Applebome, Peter, "Pit-Bull Politician," *New York Times Magazine*, October 28, 1990: 49.

76. That bill, which requires people to formally request access to such numbers, was upheld in an appeals court challenge in March, 1991, as it also was by the Supreme Court in January, 1992.

77. Quoted in Rauber, Marilyn, "Pro-Gay Postmark Infuriates Helms," *New York Post*, June 24, 1989: 10.

78. See Chase, Nan, "North Carolina's Natural Beauty Masks a Bleak Social Reality," *Washington Post*, March 20, 1990: A4; and Applebome, Peter, "In North Carolina, the New South Rubs Uneasily With the Old Ways," *New York Times*, July 2, 1990: A1, 12. Helms used the hot button of race to tap into the politics

of resentment during his reelection campaign. His emphasis on racial quotas played into White fears that minorities were inequitably benefiting from government policies.

79. Quoted in Donat, Henri, "Censorship: Handmaid of Homophobia," *Frontiers*, August 3, 1990: 9.

80. From interview conducted August 29, 1990.

81. See Shales, Tom, "The Helms Men, A Bizarre '60 Minutes' Looks at Jesse's Team," *Washington Post*, September 13, 1985: B1, 8.

82. See Parachini, Allan, "Helms Letters Add Fuel to the Arts Controversy," *Los Angeles Times*, January 29, 1990: F1, 3.

83. See Christensen, Rob, "Businesses dig deep to aid center for Helms," *The News and Observer* [Raleigh, N.C.], April 11, 1990: 1, 18A.

84. Comments made during a symposium at SUNY—New Paltz, "Art in America Now: The Current Controversy," November 17, 1990.

85. *Mandate for Leadership: Policy Management in a Conservative Administration*, ed. by Charles L. Heatherly (Washington, D.C.: The Heritage Foundation, 1981), esp. 1039–1056. See Joyce's biography on p. xvii, and his acknowledgment of other neoconservatives, such as William J. Bennett and Samuel Lipman, on p. 1039. See, also, Young, *op. cit.*: 127; and Wiener, Jon, "Dollars for Neocon Scholars," *The Nation*, January 1, 1990: 12–14.

86. *Mandate*, *op. cit.*: 1049.

87. *Ibid.*: 1052.

88. Kramer, Hilton, "Criticism endowed: reflections on a debacle," *The New Criterion*, November, 1983: 5.

89. Knight, Robert H., *The National Endowment For The Arts: Misusing Taxpayers' Money* (Washington, D.C.: The Heritage Foundation, 1991): 2, 18.

90. See Kristol, Irving, *Reflections of a Neoconservative: Looking Back, Looking Ahead* (New York: Basic Books, 1983): 51.

91. Kristol, Irving, "It's Obscene but Is It Art?" *Wall Street Journal*, August 7, 1990: A16.

92. Bloom, Allan, *The Closing of the American Mind: How Higher Education Has Failed Democracy and Impoverished the Souls of Today's Students* (New York: Simon and Schuster, 1987): 75.

93. *Ibid.*: 321. Some radicals have grouped Bloom with William Bennett and Saul Bellow as "the Killer B's."

94. Letter dated August, 1990.

95. See "The NEA after Mapplethorpe," *The New Criterion*, September, 1989: 1–2 (editorial); and "Presenting politics, not art," *The New Criterion*, March, 1990: 2–3 (editorial).

96. Letter dated August, 1990.

97. "Lipman Speaks: The conservative voice on the National Endowment," interview with Derek Guthrie, *New Art Examiner*, October, 1984: 31. See, also, Lipman, Samuel, *The House of Music: Art in an Era of Institutions* (Boston: David R. Godine, 1984), and *Arguing for Music/Arguing for Standards* (Boston: David R. Godine, 1990).

98. See Lipman, Samuel: "The NEA: Looking back, and looking ahead," *The New Criterion*, September, 1988: 6–13; "Say No To Trash," *New York Times*, June 23, 1989: A29; and, transcript of ABC's "Nightline," April 10, 1990.

99. See "Turning Back the Clock: Art and Politics in 1984," pp. 386–394 in *The Revenge of the Philistines: Art and Culture, 1972–1984* (New York: The Free Press, 1985); and Kimmelman, Michael, "Helms Bill, Whatever Its Outcome, Could Leave Mark on Arts Grants," *New York Times*, July 30, 1989: 1, 26.

100. *New York Times*, December 9, 1990: H4.

101. "Kramer vs. Kramer," *7 Days*, October 25, 1989: 17.

102. See Bernstein, Richard, "Arts Advisor Says the Problem Isn't Obscenity: It's Mediocrity," *New York Times*, August 14, 1990: C13, 14; and Frankenthaler, Helen, "Did We Spawn an Arts Monster?" *New York Times*, July 17, 1989: A17.

103. Simon, John, "Diminished 'Dilemma,' Lethal 'Lear,' " *New York*, February, 1990: 84–85.

104. Interviews with Martha Wilson, January 9, 1991, and Jim Fouratt, August 6, 1990.

Artists En Garde

1. McNally, Terrence, "Art, and My First Dirty Word," *New York Times*, July 19, 1990: A23.

2. From "Volunteers," RCA Corporation, 1969. Mapplethorpe demonstrates this stance in his self-portrait with bullwhip and in another self-portrait from 1985 where he wore tiny horns. He literally demonized himself in these works by embodying the worst fears of his critics.

3. This type of self-veneration burgeoned, spilling into the lives of popular culture characters who were not themselves artists. Dr. Joel Fleischman of TV's *Northern Exposure* established how hip he was when he boasted he had seen artists *before* their NEA grants were rejected (February 3, 1992). And B. J. Rosenthal, the protagonist of David B. Feinberg's novel *Spontaneous Combustion*, described his apartment as "the usual combination of underwear ads, gym promotions, Saint invitations, Chicago Film Festival posters, and pages torn from *Advocate Men*. The level of homoeroticism was high enough to deny me a grant from the National Endowment for the Arts. Somehow this pleased me" (New York: Viking, 1991: 146).

4. See the description of the performance duo Les Cargo in Chapter Six, for example.

5. Franklin, William, "Uncensored: A Forum for Artistic Freedom Takes Flight in the City of Angels," *The Advocate*, November 21, 1989: 60.

6. See Frank, Patrick, review of "The Right to View" (Robischon Gallery, Denver), *New Art Examiner*, April, 1990: 51; and Fryer-Kohles, Jeanne, review of "Community Standards" (Katz and Dawgs, The Gallery), *New Art Examiner*, Summer, 1990: 44.

7. Hess, Elizabeth, "Gutter Politics," *Village Voice*, July 3, 1990: 89.

8. See Ervolino, Bill, "Karen Finley Speaks Out," *New York Post*, July 19, 1990: 31.

9. Writer Sarah Schulman denounced such easy analogies as a cynical manipulation of history by some artists. She argued, "Remember, artists who were blacklisted in the '50s were Communists. They represented a working-class politic. These [contemporary] artists are not connected to a political movement. To adapt that vocabulary is really exploitative. [Some] people [today] have cloaked themselves in self-righteousness and said they were radical." From an interview conducted April 1, 1991; all subsequent unattributed quotes are taken from that interview.

10. "After Cincinnati, Brooklyn gives us 'the Unspeakable,' " editorial, *The New Criterion*, November, 1990: 4.

11. Predating Kosuth, a writer in Chicago took an irreverent romp through the galleries of the Art Institute and provided a guide to the penises in the collection. Her rationale: censorious hands might remove the organs in the near future in a nod to contemporary sexual anxieties; see Stoll, Patricia, "Hanging Out at the Art Institute Before It's Too Late: A Tour of Picturesque Penises," *Chicago Reader*, December 22, 1989: 10, 38. A writer in Washington, D.C. conducted a similar tour of museums in that city to uncover "pornographic depictions"; see Negin, Elliot, "Dicking Around," *City Paper*, June 23, 1989: 16–17. In addition, viewers in Los Angeles, Chicago and Washington, D.C. were invited to draw comparisons between the "official" art standards of Nazi Germany and present-day American trends because of the recreation of the Degenerate Art Show. This exhibition was in the making before the round of US controversies, but its appearance in 1991 prompted many associations to be drawn. And finally, the artist Beth B created a poster which appeared on many downtown Manhattan walls with the image of Hitler, a swastika, and the motto "Censorship: Never Again" (1990).

12. See the videotape "National Arts Emergency," produced by Branda Miller and Joy Silverman for the National Campaign for Freedom of Expression.

13. Interview with Jim Fouratt, August 6, 1990.

14. See Parachini, Allan, "Coalition Will Try Star Power for NEA," *Los Angeles Times*, July 17, 1990: F1, 5.

15. This difference in strategies was not absolute. Demonstrators who rode chartered buses from New York City were encouraged by protest organizers to visit the offices of their Congressional representatives. Many did, including one artist originally from North Carolina who met with an aide to Jesse Helms and returned

with an autographed photo of the Senator. And artists and administrators drew upon established ties and mingled at the rally, even though those who were acting in the role of official representatives of organizations were obviously constrained to act in ways that individual demonstrators or members of radical groups were not.

16. Major arts institutions were relatively quiet throughout this period. One exception was the Whitney Museum of American Art, which sponsored a full page ad in the *New York Times* headlined "Are you going to let politics kill Art?" But some members of Congress criticized it as counterproductive: they felt that it was an ostentatious display which might lead some people to feel the art world was flush with funds, and that it focused undesirable attention on the Helms Amendment, whose opponents hoped to defeat it with behind-the-scenes strategizing; see Glueck, Grace, "Museum Criticized for Ad on Grants," *New York Times*, September 8, 1989: C26.

17. See "Helms Belle," *The Advocate*, October 23, 1990: 8; and "And You Thought Mapplethorpe Was Controversial," *The Advocate*, September 9, 1990: 10. AIDS activists, enraged over Helms's opposition to safe sex education campaigns and his general refusal to enter the battle against the disease, targeted the senator in an even more unusual way: they sheathed his home in Arlington, VA with a giant replica of a condom; see "Safe Housekeeping," *The Advocate*, October 8, 1991.

18. Critic Donald Kuspit was highly critical of contemporary activist art, or "superego art" as he called it; see "Art and the moral imperative: Analyzing activist art," *New Art Examiner*, January, 1991: 18–25. In this densely argued article he claimed "the moralizing artist uses art in a fundamentally inappropriate way. . . . superego art is the sign of a completely unbalanced psyche" (19, 25). While other critics and artists also disapproved of this type of art, they seldom bolstered their critiques with psychoanalytic judgements.

19. See Dery, Mark, "The Merry Pranksters And The Art of the Hoax," *New York Times*, December 23, 1990: H1, 36.

20. Quoted in "Anti-Helms Billboard: Up, Down and Up," *New York Times*, August 18, 1990: 13, emphasis added.

21. Quoted in Allman, Kevin, "A Benefit Bash for 'Guerrilla Artist,' " *Los Angeles Times*, November 12, 1990: E4.

22. Philips, Chuck, "3M, Billboard Artist in Dispute," *Los Angeles Times*, September 19, 1990: F1, 7.

23. Haacke, Hans, "Working Conditions," *Artforum*, Summer, 1981: 57.

24. The tour was condemned in many places as a public relations ploy, yet another attempt to hide dangerous products such as cigarettes and alcohol under a patriotic cover.

25. Rothstein, Mervyn, "Uneasy Partners: Arts and Philip Morris," *New York Times*, December 18, 1990: C15, 20. Philip Morris has been a significant corporate supporter of the arts for over thirty years. A recent estimate pegged the total contributions of US businesses to the arts at almost five hundred million dollars annually; see Epstein, Robert, "Absolut-ly Linked: Arts, Corporations," *Los Angeles Times*, April 6, 1991: F1, 3.

26. As much as Haacke may be considered to be a maverick (and casts himself as such), he is, to use Howard S. Becker's terms, an integrated professional (see *Art Worlds*, Berkeley: University of California Press, 1982). His work is definitely oriented toward the art world—even if it may turn a deaf ear to him at times—and it is interesting to note that "Helmsboro" was offered for sale for ninety thousand dollars.

27. "Second Co-Host Withdraws From Bessie Awards Show," *New York Times*, September 7, 1990: C16.

28. Carr, C., "Life During Wartime," *Village Voice*, September 11, 1990: 88.

29. See the videotape of Seventh Annual Bessie Awards, September 12, 1990, Video D Productions.

30. This exercise was an obvious reference to—and reversal of—the statement about the Holocaust made by Martin Niemoller: "When Hitler attacked the Jews I was not a Jew, therefore, I was not concerned. And when Hitler attacked the Catholics, I was not a Catholic, and therefore, I was not concerned. And when Hitler attacked the unions and the industrialists, I was not a member of the unions and I was not concerned. Then, Hitler attacked me and the Protestant church—and there was nobody left to be concerned"; *Congressional Record*, 14 October 1968: 31636, reprinted in Augarde, Tony, ed. (*Oxford Dictionary of Modern Quotations*, New York: Oxford University Press, 1991).

31. Ramirez, Anthony, "Philip Morris to Increase AIDS Donations," *New York Times*, May 30, 1991: D4.

32. Quoted in Stuart, Otis, "The Bessies or Bust," *Outweek*, September 19, 1990: 52.

33. Quoted in Baum, Geraldine, "Mrs. Helms Doffs Apron and Campaigns for Jesse," *Los Angeles Times*, November 2, 1990: E10.

34. Quoted in *The Advocate*, December 4, 1990: 8.

35. Martha Wilson interview, January 9, 1991; Steve Asher interview, August 4, 1990.

36. Interview with Cee Brown, October 18, 1990.

37. In 1991 Creative Time was awarded 45,000 dollars by the NEA.

38. Reprinted in Papp, Joseph, "I'm a Producer, Not a Censor," *New York Times*, April 24, 1990: A23.

39. Blau, Eleanor, "Festival Latino to Double Film Fare," *New York Times*, June 28, 1990: C15.

40. And some people felt that Papp hardly had his own house in order, referring back to his prohibition of the performance of the Palestinian theater group in 1989 (see Chapter Three). See, for example, a harsh letter to the editor in the *Village Voice*, June 12, 1990: 4.

41. Parachini, Allan, "Papp Rejects the NEA Again," *Los Angeles Times*, November 2, 1990: F1, 32.

42. See "The New School files lawsuit against NEA obscenity condition for grants," *The New School Observer*, June/July, 1990: 1,7.

43. Perlmutter, Donna, "Lewitsky and Stoltzman's 'Love Affair' Proves Fruitful," *Los Angeles Times*, February 15, 1991: F12, 14.

44. The national organization for nonprofit professional theater.

45. Memorandum of Law of *Amici Curiae* in Support of Plantiff in *Bella Lewitsky Dance Foundation v. John E. Frohnmayer and the National Endowment for the Arts*, Case No. 90–3616 JGD (BX), United States District Court, Central District of California: 14.

46. A judge ruled against the decency standard in June, 1992. But settlement of this part of the suit in the artists' favor does not ensure that the issue of government support of controversial subjects will be concluded.

47. I take this notion from Samuel Steward, a literature professor turned tattoo artist. He describes the periodic attempts to form a "union" of tattoo artists, ventures which inevitably fail because they are a fiercely independent and competitive lot, and no set of issues has ever been compelling enough to unite them. See his *Bad Boys and Tough Tattoos: A Social History of the Tattoo with Gangs, Sailors, and Street-Corner Punks, 1950– 1965* (Binghamton, New York: Harrington Park Press, 1990).

48. From an interview conducted August 5, 1991.

49. According to Get Smart participant Jesse Allen, the production costs for this venture would have been perhaps as high as one hundred thousand dollars, but Get Smart managed to use donated and bartered materials and labor to produce it for practically nothing. The major expense was air time. The group met a great deal of resistance by the networks to run it because it represented "advocacy"; eventually WNBC accepted it for an after-midnight slot. Interview, August 12, 1991; all subsequent quotes are from that interview.

50. See *Smart Talk*, the Get Smart newsletter, Number 1, January, 1991: 3.

51. Both these organizations undertook new initiatives to confront what was going on. The ACLU launched the Arts Censorship Project in May, 1991, and one of the activities of People For the American Way was a "Survey on Challenges to Freedom of Artistic Expression," to document and publicize controversial incidents.

52. "Notes on La Napoule Meeting," July, 1990. Much of the information on NCFE was obtained from interviews with Cee Brown, October 18, 1990, Gaylen Nelson, August 9, 1991, and Diane Grams, August 27, 1991.

53. ACT UP has also used the FAX machine and telephone effectively to get their point of view across, or to jam the lines of communication of those they oppose. In addition, anti-war activists during Desert Storm

in 1991 were linked together nationally by PeaceNet, an information service which allowed them to supplement or rebut mainstream news reports.

54. Parachini, Allan, "Artists Draw a New Kind of Party Line," *Los Angeles Times*, February 19, 1991: F1, 8, 9.

55. This quotation is from a lengthy series of interviews I conducted on the chartered bus trips from New York to Washington, D.C. and back for the August 4, 1990 demonstration at the NEA National Council Meeting. All subsequent quotes which are not identified by name are taken from those interviews.

56. Interview with Tom Tresser, April 10, 1991.

57. Artists proposed various schemes to help out their fellows during this time. One was a suggestion championed by Richard Elovich that those awarded NEA grants for solo performance contribute some of their funds to a common pool, to be distributed to those whose grants were denied by Chairman Frohnmayer. Conceived in the manner of a tithe, this became a limited, voluntary endeavor. Money that was collected was contributed to the the the National Campaign for Freedom of Expression. And Cee Brown headed a group called Art Matters Inc./National Trust for the Visual Arts, a scheme to raise a private endowment of one hundred million dollars to underwrite grants to individual artists. At this writing, the plan had not advanced very far.

58. Mayfly organizations breed under many conditions, throughout the seasons. Just as many such ad hoc groups were perishing in 1991, some others which may represent this species were born. Two examples: the Independent Artists' Group, an association mainly of visual artists in New York and Los Angeles, and the Free Speech Legal Defense Fund, Inc., a nonprofit latter industry group for independent producers and distributors of adult entertainment. A leader of the latter group explained, "If Americans refuse to admit publicly that they either have sex or masturbate, they won't be able to complain when the government comes to cut off their genitals." Quoted in Fleming, Charles, "Adult Video Producers Organize for Free Speech And a New Image," *The Advocate*, July 16, 1991: 54.

59. See the reference in Chapter Seven, and Jansen, Sue Curry, *Censorship: The Knot That Binds Power and Knowledge* (New York: Oxford University Press, 1991): 42–43.

60. *NYPress*, September 12–18, 1990.

61. Quoted in Raymond, Gerard, "Spotlight on the NEA Drama," *The Advocate*, September 9, 1990: 75; and Sullivan, Kathleen M., "A Free Society Doesn't Dictate to Artists," *New York Times*, May 18, 1990: A31. The chilling effect also underwent formal government scrutiny during several Congressional hearings; some of that testimony is chronicled in the report of a hearing held in Washington, D.C., June 19, 1991, by the Government Activities and Transportation Subcommittee of the Committee on Government Operations, House of Representatives.

62. Desmarais, Charles, "Who Should Choose Art Shown to the Public?" *Los Angeles Times*, October 15, 1990: F3.

63. Nathan Leventhal, letter to the editor, *Village Voice*, August 21, 1990: 6.

64. See Francia, Luis H., "Tiananmen Show Gutted," *Village Voice*, July 31, 1990: 93.

65. See Dunning, Jennifer, "Why a Dance-World Veteran Decided to Pack It All In," *New York Times*, April 28, 1991: H8, 17; and Harris, William, "Mabou Mines Sets Lear on a Hot Tin Roof," *New York Times*, January 21, 1990: H5, 33.

66. Muchnic, Suzanne, "A Showcase for Controversial Art in Marina del Rey," *Los Angeles Times*, July 10, 1990: F1, 6; and quoted in Gintovt, Karen, "Riding Out the Storm, Ad Industry Faces Dire Forecast," *In Motion*, September, 1990: 53.

67. I base this conclusion on my observations and interviews. Of the many people I talked with at the August 4, 1990 demonstration in Washington, D.C., for example, nearly everyone fell into this age category, and only a few reported prior political involvements. In most of those instances where artists had a history of activity, they had been raised in highly politicized communities such as Berkeley, California. Otherwise, artists overcame the resistance of their friends and the inertia of their own biographies to become active.

68. Spillane, Margaret, "The Culture of Narcissism," *The Nation*, December 10, 1990: 740.

69. See, for example, a two-part essay by Howardena Pindell: "Breaking the Silence," *New Art Examiner*, October, 1990: 18–23, and November, 1990: 23–27, 50–51.

70. Schulman, Sarah, "What Ideals Guide Our Actions?" *OUT/LOOK*, Winter, 1991: 50–51.

71. See my "Artistic Production and Social Control," *Social Forces*, 64:3 (March, 1986): 667–688; and Jansen, *op. cit.*: 7–8.

72. Quoted in Haithman, Diane, "Arts Award Winners Celebrate a Double Victory," *Los Angeles Times*, October 13, 1990: F5.

The Government as Patron: Angel or Demon?

1. See "Highbrow Pork Barrel," *Newsweek*, August 21, 1989: 44; and Obejas, Achy, "The 64-Cent Question," *Chicago Reader*, October 12, 1990: 45–46, for a comical report on a group of local artists who each volunteered to try to spend that amount on posh Michigan Avenue. By all reports, the US lags *far* behind other Western countries in government support of the arts. To cite just one example: the cultural budget for the city of Paris in 1990 was roughly equivalent to the entire allocation for the NEA; see Marmer, Nancy, "Paris Culture Budget Tops Billion Francs," *Art in America*, February, 1990: 37.

2. One of the most passionate (yet reasoned) defenders of government support of the arts was Arthur C. Danto ("Art and Taxpayers," *The Nation*, August 21/28, 1989: 192–93). He argued that all Americans should be united around concerns about freedom of expression, notwithstanding differences in their aesthetic preferences.

3. A number of such schemes had been proposed in the past; see Larson, Gary O., *The Reluctant Patron: The United States Government and the Arts, 1943–1965* (Philadelphia: University of Pennsylvania Press, 1983). The NEH has been the locus of controversy much less frequently than has its sister agency. In recent times, however, progressives criticized it as being too traditional, a charge which heated up with its rejection of a grant for a "revisionist" history of Columbus in the New World, and in the fight over (and ultimate rejection of) the nomination of conservative critic Carol Iannone for a seat on the National Council of Humanities. Conservative William J. Bennett quipped about NEH chairman Lynne Cheney and her husband Dick (US Secretary of Defense), "Between her and her husband, they have the entire defense of Western civilization as their responsibility"; quoted in Parachini, Allan, "U.S. Humanities Chairman Criticized as Tilting to West," *Los Angeles Times*, July 5, 1991: A22.

4. I draw heavily here from DiMaggio, Paul and Michael Useem, "Cultural Property and Public Policy: Emerging Tensions in Government Support for the Arts," *Social Research*, Summer, 1978 (45): 356–389; and DiMaggio, Paul, "Elitists & Populists: Politics for Art's Sake," *Working Papers for a New Society*, September/ October, 1978: 23–31.

5. Arian, Edward, *The Unfulfilled Promise: Public Subsidy of the Arts in America* (Philadelphia: Temple University Press, 1989), esp. Chapter Three.

6. Lipman, Samuel, "Leadership in democratic culture: the case of Nancy Hanks," *The New Criterion*, November, 1988: 6.

7. See Glueck, Grace, "Endowment Head Decries 'Politics,' " *New York Times*, October 12, 1977: C19 (Straight was acting chairman between the tenures of Hanks and Biddle).

8. Kramer, Hilton, "The Threat of Politicization of the Federal Arts Program," *New York Times*, October 16, 1977: D1; and Dempsey, David, "Funding Culture, High and Low, And Calling it All Art," *New York Times*, October 16, 1977: D34.

9. See my *Bureaucratizing the Muse: Public Funds and the Cultural Worker* (Chicago: University of Chicago Press, 1987).

10. For a sample of the concern throughout the country, see Lavallee, Wendy, "How many curtains will Reagan cuts bring down?" *Rocky Mountain News* (Denver), October 21, 1981: 62; and Christiansen, Richard, "State arts leaders meet in concern over Reagan cuts," *Chicago Tribune*, May 17, 1981: Sec. 6: 13; see, also, the *Village Voice* symposium, May 13–19, 1981: 1, 39–46, quotation from Davis, Thulani, "Expansion Arts," p. 40.

11. Goldstein, Richard, "A James Watt for the Arts?" *Village Voice*, February 10–16, 1982: 47. Carole S. Vance skillfully reviews the aborted Reagan attack in "Reagan's Revenge: Restructuring the NEA," *Art in America*,

November, 1990: 49–55. While I agree with the gist of her argument, I would supplement her discussion of sex panics with the public fear and rejection of disenfranchised groups and their values more generally.

12. Joyce, Michael S., "The National Endowments for the Humanities and the Arts," Pp. 1039–1056 in Heatherly, Charles L., ed., *Mandate for Leadership: Policy Management in a Conservative Administration* (Washington, D.C.: The Heritage Foundation, 1981): 1055.

13. Pear, Robert, "Reagan's Arts Chairman Brings Subtle Changes to the Endowment," *New York Times*, April 10, 1983: section 2: 26.

14. The National Council on the Arts is a twenty-six member committee of private citizens appointed by the President to advise the NEA Chairman on policy and grant making. The final authority for decisions rests with the Chairman.

15. The NEH under William J. Bennett, who assumed his post in 1981 as did Hodsoll, became a much more conservative agency than its sister; see Friedman, John S. and Eric Nadler, "Hard Right Rudder At The N.E.H.," *The Nation*, April 14, 1984: 433, 448–451 for a catalogue of rejected projects. And Edward Arian found that the imbalance of support toward elite arts rather than those with a mass constituency "slightly intensified" within the NEA during the Reagan years; Arian, *op. cit.*: 62–66.

16. Arnebeck, Bob, "Files on parade—The federal art scene," *New Art Examiner*, October, 1981: 32.

17. Quoted in Epstein, Noel, "Politics and the Arts," *Washington Post*, August 25, 1974: C4.

18. *Ibid.*, and Straight, Michael, *Twigs For An Eagle's Nest: Government And The Arts: 1965–1978* (New York: Devon Press, 1979): 26–28.

19. Straight, *op. cit.*: 134–148, esp. p. 142.

20. Njeri, Itabari, "A City of Poets: L.A. Emerges as a Place of Verse, Diversity," *Los Angeles Times*, October 19, 1990: E7. See, also, Chapter Nine.

21. Biddle, Livingston, "Arts Chairman Has a Special Role," *Los Angeles Times*, August 6, 1990: F5.

22. See letter to the editor, *New Art Examiner*, September, 1989: 2.

23. Pear, *op. cit.*; Editorial, *New Art Examiner*, January, 1987: 5; and Honan, William H., "Art Chief's Potholed Path to a Grants Decision," *New York Times*, November 20, 1989: C13.

24. "Quotelines," *USA Today*, March 27, 1990: 10A.

25. Wallis, Brian, "Bush's Compromise: A Newer Form of Censorship?" *Art in America*, November, 1990: 57–63, 210. This account is provocative, but elides the distinction between constitutive and regulative censorship.

26. Quoted in Myers, Christopher, "Fresh Focus," *University of Chicago Magazine*, April 1991: 31. Interestingly, the NEH originally included the obscenity statute in their guidelines, but removed it after it sparked a number of complaints.

27. See two articles by Allan Parachini in the *Los Angeles Times*: "Helms Letters Add Fuel to the Arts Controversy," January 29, 1990: F1, 3, and "Men of Letters," April 4, 1991: F1, 5.

28. Interview, August 6, 1990.

29. Interview, August 29, 1990.

30. Quoted in Masters, Kim, "Arts Endowment Chief Forced Out," *Washington Post*, February 22, 1992: A7.

31. For example, Buchanan's commercial used the familiar tactic of sensationalizing images by taking them out of context. It also fallaciously asserted that "Bush Used Your Tax $$ For This." In fact, the film was produced during the Reagan administration.

32. Crane, Philip M., "Abolish the Arts Agency," *New York Times*, June 6, 1990: A27.

33. Polsby, Daniel, "Fine arts don't need public dole," *Chicago Sun-Times*, August 4, 1989: 26.

34. Interview, January 9, 1991.

35. DiMaggio, Paul J., "Decentralization of Arts Funding from the Federal Government to the States," pp. 216–256 in Benedict, Stephen, ed., *Public Money & the Muse: Essays on Government Funding for the Arts* (New York: W.W. Norton & Company, 1991).

36. *Ibid.*: 222–224.

37. *Ibid.*: 251.

38. See Parachini, Allan, "States' Arts Support Off $30 Million," *Los Angeles Times*, February 4, 1991: F1, 4.

39. See *A Report to Congress on The National Endowment for the Arts*, submitted by The Independent Commission, Washington, D.C., 1990: 25–31 for a history of the panels' operation and the critical reaction to them.

40. 24-year-old female filmmaker, interview August 4, 1990.

41. Schulman interview, April 1, 1991; Arian, *op. cit.*: 7, 57; Kramer, Hilton, "Criticism endowed: reflections on a debacle," *The New Criterion*, November, 1983: 1–5; and Kilpatrick, James J., "NEA: Nobody here but us artists," *AFA Journal*, May, 1991: 17. Despite this conjunction of opinion, it should be noted that in the transcribed May 4, 1990 telephone conversations between John Frohnmayer and panelists of the solo performance and mimes category (released in relation to the NEA 4 suit), several panelists remarked that they had not seen the work of the disputed artists, *at least in this instance* confuting the view that the panels demonstrate a high degree of collusion.

42. The impudent *Spy* magazine ran a long-winded denouncement of the peer panel system where the writer highlighted a successful artist who claimed to have paid one-quarter of his income taxes with his NEA grant, an example of "willful tossing of money at those who need it least"; see Lasswell, Mark, "How the NEA really works," *Spy*, November, 1990: 52–58.

43. The NEA finally authorized the grants supporting Hughes and Finley via the presenting organizations in January, 1991.

44. Statement of Dennis Voss, Proceedings of Hearing before the Subcommittee on Postsecondary Education of the Committee of Education and Labor, House of Representatives, One Hundred First Congress, Second Session, Hearing Held in Malibu, CA., March 5, 1990 (Serial No. 101–76): 92.

45. The NEA had issued new guidelines in July, 1990 indicating that Miller was the standard they would use henceforth.

46. Quoted in Parachini, Allan, "NEA Panel Ends Weekend With a Bow to the Right," *Los Angeles Times*, August 6, 1990: F10; and Masters, Kim, "Arts Panel Urges End To Grant Pledge," *Washington Post*, August 4, 1990: G5.

47. Quoted in Kastor, Elizabeth, "The Frohnmayer Phenomenon," *Washington Post*, August 4, 1989: B4.

48. The NEA 4 amended their suit seeking restitution of their grants by the NEA with a call for an injunction against the enforcement of the decency clause; see Chapter 10.

49. "NEA Revamps Fellowships," *Art in America*, November, 1990: 222, 224.

50. Parachini, Allan, "NEA Compromise Still Troubles Artists," *Los Angeles Times*, October 13, 1990: F1, 4.

51. See my articles, "The Politics of Public Art," *Urban Life* 14 (3) October 1985: 274–299, and "Artistic Production and Social Control," *Social Forces* 64 (3) March 1986: 667–688, for details of these earlier experiences. These procedures particularly parallel those of the Treasury Section of Painting and Sculpture, one of the government's art programs in the 1930s.

52. The House quickly followed suit, but the measures were rejected by House and Senate negotiators who cut a deal with Western Senators in exchange for support of low grazing fees on Federal lands. Representative Dannemeyer fumed that it was a "swap of corn for porn"; see "Congressional Negotiators Reject Curb on Arts Grants," *New York Times*, October 18, 1991: C4.

53. Interview, January 22, 1991.

The Art of Controversy

1. The 1991 revival of an advertising campaign from the 1960s taps a nostalgia for a time when the melting pot still held credibility. Levy's "Real Jewish Rye" reprinted a series of posters in their ads which they had used over twenty years earlier, where different types of people relished their product: an Asian boy, a Black boy, an Irish cop and an American Indian, for example. The catchphrase on each image was "You don't have to be Jewish to love Levy's." Presumably *everyone* could meet on this common gustatory ground.

2. Quoted in Greenhouse, Linda, "States May Ban Nude Dancing To Protect 'Order,' Justices Rule," *New York Times*, June 22, 1991: A1, emphasis added.

3. Harding, Rick, "Supreme Court Takes Minnesota Hate Case; Many Dread Fallout," *The Advocate*, July 16, 1991: 20.

4. Quoted in Kowsky, Kim, "Painted Into a Corner," *Los Angeles Times*, June 22, 1991: B6.

5. In cities such as New York City, Whites are already a minority.

6. See Buchanan, Patrick J., "Can The U.S. Avoid Balkanization?" *New York Post*, March 23, 1991: 15; and Bernstein, Richard, "The Arts Catch Up With a Society in Disarray," *New York Times*, September 2, 1990: H1, 12–13.

7. See R. Hutter in *Spy*, December, 1990: 30.

8. Wilson, August, " 'I Want a Black Director,' " *New York Times*, September 26, 1990: A25.

9. Lee, Spike, "I Am Not an Anti-Semite," *New York Times*, August 22, 1990: A25.

10. Palinkas, Klaus, "Alderman seeks ban on slurs in ethnic films," *Southtown Economist*, December 16, 1983.

11. Kristof, Kathy M., "Activists for Homeless Decry Disney Doll," *Los Angeles Times*, December 10, 1990: D2.

12. Herbert, Steven, "Network Editing Elicits Mixed Reaction," *Los Angeles Times*, September 14, 1991: F7.

13. Letter to the editor, *New York Times*, September 29, 1991: H4. Interestingly, coalition-building does not necessarily work: in 1991 an umbrella group of sixty six organizations—the National Ethnic Coalition of Organizations, Inc.—tried unsuccessfully to convince CBS not to broadcast Spike Lee's "Do The Right Thing." The coalition believed the film promotes racial violence. See Kleid, Beth, "Morning Report," *Los Angeles Times*, July 10 and July 12, 1991: F2.

14. Quoted in Bernstein, Richard, " 'Just Kidding'—But at Whose Expense?" *New York Times*, April 8, 1990: H34.

15. Religious groups proposed to formalize their stance when the Christian Film and Television Commission presented a production code to evaluate movies and television programs according to biblical standards. This new version of the so-called Hays Code—endorsed by LA's Cardinal Mahony—was greeted with derision by media executives in early 1992.

16. See " 'Jap Rap' Song Anything But a Hit With the ADL," *Jewish Forward*, June 14, 1991: 4; and Bell, Charles W., "ADL zaps 'JAP Day,' " *New York Daily News*, June 7, 1991: 3.

17. See letter to the editor, *Los Angeles Times*, September 14, 1991: F3, where the writer recalled the terrors of her childhood in Frankfurt with a letter beginning "Here we go again!"

18. Bravin, Jess, "Shylock: The Stereotype Is Still a Problem," *Los Angeles Times*, June 5, 1991: F1, 8.

19. Recall that Kostabi made anti-gay remarks in a *Vanity Fair* article in 1989 (see Chapters One and Ten). Queer Nation's demands also included putting the Kostabi work in context (exposing his homophobia in the catalogue and on the painting's label), and posting a "warning label" on the exhibit indicating its sponsorship by Philip Morris, Inc. See leaflet "New York Historical Society: 'Queers Drop Dead,' " December, 1990.

20. *New York Times* critic Andy Grundberg expressed some similar concerns, arguing that when sexually- and politically-oriented artwork came under attack, many people rallied to its defense and were averse to evaluating it by aesthetic criteria; see "Art Under Attack: Who Dares Say That It's No Good?" November 25, 1990: H1, 39.

21. Quoted in Reyes, Nina, "Punishing PBS," *Outweek*, December 12, 1990: 39.

22. Interview conducted by Phil Zwickler, "Marlon Riggs: *Tongues Untied* Filmmaker Talks About His Work," *PWA Coalition Newsline*, June 1990 (Issue No.56): 14.

23. Quoted in Provenzano, Jim, "PBS Flight From Controversy Causes a Furor," *The Advocate*, September 24, 1991: 76.

24. Recall the earlier controversies PBS was embroiled in, such as those around "Days of Rage" and "A Search for Solid Ground: The Intifada Through Israeli Eyes," for instance (see Chapter Three). Fears of financial repercussions turned out to be well-founded: in 1992 disgruntled Senate Republicans held up authorization

of federal contributions to the Corporation for Public Broadcasting after this series of disputes. This effort was amplified after Patrick Buchanan incorporated portions of "Tongues Untied" into an "anti-pornography" commercial he broadcast in Georgia in February, 1992, during his Presidential bid (see Chapter Eleven).

25. Mahony, Cardinal Roger, "A Case of Bigotry?" *Los Angeles Times*, September 6, 1991: A50.

26. See Snow, Shauna, "Few Watch 'Church,' " *Los Angeles Times*, September 10, 1991: F2; and Bernstein, Sharon, "KCET Pays Price in Flap With Church," *Los Angeles Times*, October 10, 1991: F1, 10.

27. Weigel, George, "KCET's Action: the Antithesis of Freedom," *Los Angeles Times*, September 17, 1991: B7.

28. Quoted in Zonana, Victor F., "AIDS Activist Finds Creative Outlet in 'Church,' " *Los Angeles Times*, September 6, 1991: F8.

29. Kuebelbeck, Amy, "Under Fire?" *Los Angeles Times*, September 9, 1991: E1, 6; and MacMinn, Aleene, "Demands on KCET," *Los Angeles Times*, October 1, 1991: F2.

30. Brownworth, Victoria A., "Homo Killer on the Lamb," *Outweek*, May 15, 1990: 54.

31. Letter to the editor, *Outweek*, March 20, 1991: 7.

32. Transcript of "The Oprah Winfrey Show," "Controversial Lyrics," December 14, 1989: 3 (Transcript No.849).

33. Personal communication, Paul R. Joseph, February 11, 1991.

34. The jury was composed of one Black and five White members.

35. See Gates, Henry Louis, Jr., "2 Live Crew, Decoded," *New York Times*, June 19, 1990: A23; Clary, Mike, "Professor Calls 2 Live Crew 'Refreshing,' " *Los Angeles Times*, October 20, 1990: A20; and Rimer, Sara, "Rap Band Members Found Not Guilty In Obscenity Trial," *New York Times*, October 21, 1990: A30.

36. Campbell, Luther, "Today They're Trying to Censor Rap, Tomorrow . . . ," *Los Angeles Times*, November 5, 1990: F3.

37. And, as noted in Chapter Three, so do anti-Semitism and other inter-ethnic animosities, as in Ice Cube's 1991 album "Death Certificate." Jews and Koreans were upset at the apparent calls for violence against them in the music, leading Rabbi Abraham Cooper of the Simon Wiesenthal Center to condemn it as "a cultural molotov cocktail"; quoted in Philips, Chuck, "Wiesenthal Center Denounces Ice Cube's Album," *Los Angeles Times*, November 2, 1991: F3.

38. Interview, January 15, 1990.

39. See, for example, Kimball, Roger, *Tenured Radicals: How Politics Has Corrupted Our Higher Education* (New York: Harper & Row, 1990); and D'Souza, Dinesh, *Illiberal Education: The Politics of Sex and Race on Campus* (New York: Free Press, 1991).

40. Quoted in Trombley, William, "New History Curriculum Stirs Passionate Dissent," *Los Angeles Times*, October 9, 1990: A20.

41. Schlesinger, Arthur, Jr., "Toward a Divisive Diversity," *The Wall Street Journal*, June 25, 1991: A22.

42. This occurred in the matter of codes at the Universities of Wisconsin and Michigan, for example. One of the strangest working coalitions to develop in support of speech codes was the alliance of the ACLU and Representative Henry J. Hyde (R-IL) in support of a proposed Collegiate Speech Protection Act. Hyde— who supported the Helms Amendment, cosponsored a constitutional amendment banning flag desecration, and endorsed the prohibition against discussing abortion in federally funded family planning clinics—sought to extend free speech guarantees to students in public and private institutions, but excluded religious schools. Many observers wondered about the sincerity of his sudden concern about protecting expression, in many instances speech that was offensive to many of Hyde's opponents.

43. See Hentoff, Nat, "The Civil Liberties Shootout," *Village Voice*, June 19, 1990: 26–27. One estimate is that speech codes were enacted on over two hundred college and university campuses; see Savage, David G., "Forbidden Words on Campus," *Los Angeles Times*, February 12, 1991: A1, 16–17.

44. Martin, Judith and Gunther Smith, "Say the Right Thing—or Else," *New York Times*, March 20, 1991: A29.

45. "Excerpts From President's Speech to University of Michigan Graduates," *New York Times*, May 5, 1991: A32.

46. See D'Souza, Dinesh, " 'Island of repression in a sea of freedom,' " *Kansas City Star*, April 14, 1991: I1, 4 for a firsthand account of the "horrors"; Cooper, Kenneth J., " 'Political Correctness' Conflicts Not Widespread, College Administrators Say," *Washington Post*, July 29, 1991: A5 for details of the survey.

47. "It's a Grand Old (Politically Correct) Flag," *Time*, February 25, 1991: 55.

48. Kimball, Roger, "The periphery vs. the center: the MLA in Chicago," *The New Criterion*, February, 1991: 17.

49. Staples, Brent, "Politically Correct: False Slogan," *New York Times*, April 17, 1991: A22. The National Association of Scholars is a group of academics opposed to "political trendiness"; Teachers for a Democratic Culture has formed to defend the multicultural imperative.

50. See quote in Barringer, Felicity, "Vox Populi," *New York Times*, July 7, 1991: H25; and Kimmelman, Michael, "Old West, New Twist At the Smithsonian," *New York Times*, May 26, 1991: H1, 27.

51. Smith, Jack, "Sold Out on the Romanticized Sagas of the Old West," *Los Angeles Times*, July 18, 1991: E1.

52. Gamarekian, Barbara, "Show Closing Demanded At Washington Museum," *New York Times*, July 13, 1991: 11.

53. Quoted in Lewis, Jo Ann, "Museum Director at Storm Center," *Washington Post*, August 3, 1991: C1.

54. Letter to the editor, *Village Voice*, April 9, 1979.

55. Quoted in Honan, William H., "2 Who Lost Arts Grants Are Up for New Ones," *New York Times*, August 2, 1990: C19.

INDEX